The Story of my Life

Vol. 2 To Paris and Prison

The Story of my Life

Vol. 2 To Paris and Prison
Translated by Arthur Machen
by Giacomo Casanova

©2012 SMK Books

Wilder Publications, LLC.
PO Box 3005
Radford VA 24143-3005

ISBN 10: 1-61720-760-8
ISBN 13: 978-1-61720-760-0

The Story of my Life

Vol 2 To Paris and Prison

Translated by Arthur Machen

by Giacomo Casanova

Wildside Press LLC

www.wildsidebooks.com

ISBN-10: 1-61720-760-X
ISBN-13: 978-1-61720-760-0

Table of Contents:

Episode 6 — Paris

CHAPTER I

Leave Bologna a Happy Man—The Captain Parts from Us in Reggio, where I Spend a Delightful Night with Henriette—Our Arrival in Parma—Henriette Resumes the Costume of a Woman; Our Mutual Felicity—I Meet Some Relatives of Mine, but Do not Discover Myself

The reader can easily guess that there was a change as sudden as a transformation in a pantomime, and that the short but magic sentence, "Come to Parma," proved a very fortunate catastrophe, thanks to which I rapidly changed, passing from the tragic to the gentle mood, from the serious to the tender tone. Sooth to say, I fell at her feet, and lovingly pressing her knees I kissed them repeatedly with raptures of gratitude. No more 'furore', no more bitter words; they do not suit the sweetest of all human feelings! Loving, docile, grateful, I swear never to beg for any favour, not even to kiss her hand, until I have shewn myself worthy of her precious love! The heavenly creature, delighted to see me pass so rapidly from despair to the most lively tenderness, tells me, with a voice the tone of which breathes of love, to get up from my knees.

"I am sure that you love me," says she, "and be quite certain that I shall leave nothing undone to secure the constancy of your feelings." Even if she had said that she loved me as much as I adored her, she would not have been more eloquent, for her words expressed all that can be felt. My lips were pressed to her beautiful hands as the captain entered the room. He complimented us with perfect good faith, and I told him, my face beaming with happiness, that I was going to order the carriage. I left them together, and in a short time we were on our road, cheerful, pleased, and merry.

Before reaching Reggio the honest captain told me that in his opinion it would be better for him to proceed to Parma alone, as, if we arrived in that city all together, it might cause some remarks, and people would talk about us much less if we were without him. We both thought him quite right, and we immediately made up our minds to pass the night in Reggio, while the captain would take a post-chaise and go alone to Parma. According to that arrangement his trunk was transferred to the vehicle which he hired in

Reggio, he bade us farewell and went away, after having promised to dine with us on the following day in Parma.

The decision taken by the worthy Hungarian was, doubtless, as agreeable to my lovely friend as to me, for our delicacy would have condemned us to a great reserve in his presence. And truly, under the new circumstances, how were we to arrange for our lodgings in Reggio? Henriette could not, of course, share the bed of the captain any more, and she could not have slept with me as long as he was with us, without being guilty of great immodesty. We should all three have laughed at that compulsory reserve which we would have felt to be ridiculous, but we should, for all that, have submitted to it. Love is the little impudent god, the enemy of bashfulness, although he may very often enjoy darkness and mystery, but if he gives way to it he feels disgraced; he loses three-fourths of his dignity and the greatest portion of his charms.

Evidently there could be no happiness for Henriette or for me unless we parted with the person and even with the remembrance of the excellent captain.

We supped alone. I was intoxicated with a felicity which seemed too immense, and yet I felt melancholy, but Henriette, who looked sad likewise, had no reproach to address to me. Our sadness was in reality nothing but shyness; we loved each other, but we had had no time to become acquainted. We exchanged only a few words, there was nothing witty, nothing interesting in our conversation, which struck us both as insipid, and we found more pleasure in the thoughts which filled our minds. We knew that we were going to pass the night together, but we could not have spoken of it openly. What a night! what a delightful creature was that Henriette whom I have loved so deeply, who has made me so supremely happy!

It was only three or four days later that I ventured on asking her what she would have done, without a groat in her possession, having not one acquaintance in Parma, if I had been afraid to declare my love, and if I had gone to Naples. She answered that she would doubtless have found herself in very great difficulties, but that she had all along felt certain of my love, and that she had foreseen what had happened. She added that, being impatient to know what I thought of her, she had asked me to translate to the captain what she had expressed respecting her resolution, knowing that he could neither oppose that resolution nor continue to live with her, and that, as she had taken care not to include me in the prayer which she had addressed to him through me, she had thought it impossible that I should fail to ask whether I could be of some service to her, waiting to take a decision until she could have ascertained the nature of my feelings towards her. She concluded

by telling me that if she had fallen it was the fault of her husband and of her father-in-law, both of whom she characterized as monsters rather than men.

When we reached Parma, I gave the police the name of Farusi, the same that I had assumed in Cesena; it was the family name of my mother; while Henriette wrote down, "Anne D'Arci, from France." While we were answering the questions of the officer, a young Frenchman, smart and intelligent-looking, offered me his services, and advised me not to put up at the posting-inn, but to take lodgings at D'Andremorit's. hotel, where I should find good apartments, French cooking, and the best French wines.

Seeing that Henriette was pleased with the proposal, I told the young man to take us there, and we were soon very comfortably lodged. I engaged the Frenchman by the day, and carefully settled all my arrangements with D'Andremont. After that I attended to the housing of my carriage.

Coming in again for a few minutes, I told Henriette that I would return in time for dinner, and, ordering the servant to remain in the ante-room, I went out alone.

Parma was then groaning under a new government. I had every reason to suppose that there were spies everywhere and under every form. I therefore did not want to have at my heels a valet who might have injured rather than served me. Though I was in my father's native city, I had no acquaintances there, but I knew that I should soon find my way.

When I found myself in the streets, I scarcely could believe that I was in Italy, for everything had a tramontane appearance. I heard nothing but French and Spanish, and those who did not speak one of those languages seemed to be whispering to one another. I was going about at random, looking for a hosier, yet unwilling to enquire where I could find one; at last I saw what I wanted.

I entered the shop, and addressing myself to a stout, good-looking woman seated behind the counter, I said,

"Madam, I wish to make some purchases."

"Sir, shall I send for someone speaking French?"

"You need not do so, I am an Italian."

"God be praised! Italians are scarce in these days."

"Why scarce?"

"Do you not know that Don Philip has arrived, and that his wife, Madame de France, is on the road?"

"I congratulate you, for it must make trade very good. I suppose that money is plentiful, and that there is abundance of all commodities."

"That is true, but everything is high in price, and we cannot get reconciled to these new fashions. They are a bad mixture of French freedom and Spanish haughtiness which addles our brains. But, sir, what sort of linen do you require?"

"In the first place, I must tell you that I never try to drive a hard bargain, therefore be careful. If you charge me too much, I shall not come again. I want some fine linen for twenty-four chemises, some dimity for stays and petticoats, some muslin, some cambric for pocket-handkerchiefs, and many other articles which I should be very glad to find in your shop, for I am a stranger here, and God knows in what hands I am going to trust myself!"

"You will be in honest ones, if you will give me your confidence."

"I am sure that you deserve it, and I abandon my interests to you. I want likewise to find some needlewomen willing to work in the lady's room, because she requires everything to be made very rapidly."

"And dresses?"

"Yes, dresses, caps, mantles-in fact, everything, for she is naked."

"With money she will soon have all she wants. Is she young?"

"She is four years younger than I. She is my wife."

"Ah! may God bless you! Any children?"

"Not yet, my good lady; but they will come, for we do all that is necessary to have them."

"I have no doubt of it. How pleased I am! Well, sir, I shall send for the very phoenix of all dressmakers. In the mean time, choose what you require, it will amuse you."

I took the best of everything and paid, and the dressmaker making her appearance at that moment I gave my address, requesting that various sorts of stuff might be sent at once. I told the dressmaker and her daughter, who had come with her, to follow me and to carry the linen. On my way to the hotel I bought several pairs of silk stockings, and took with me a bootmaker who lived close by.

Oh, what a delightful moment! Henriette, who had not the slightest idea of what I had gone out for, looked at everything with great pleasure, yet without any of those demonstrations which announce a selfish or interested disposition. She shewed her gratitude only by the delicate praise which she bestowed upon my taste and upon the quality of the articles I had purchased. She was not more cheerful on account of my presents, but the tender affection with which she looked at me was the best proof of her grateful feelings.

The valet I had hired had entered the room with the shoemaker. Henriette told him quietly to withdraw, and not to come unless he was called. The dressmaker set to work, the shoemaker took her measure, and I told him to bring some slippers. He returned in a short time, and the valet came in again with him without having been called. The shoemaker, who spoke French, was talking the usual nonsense of dealers, when she interrupted him to ask the valet, who was standing familiarly in the room, what he wanted.

"Nothing, madam, I am only waiting for your orders."

"Have I not told you that you would be called when your services were required?"

"I should like to know who is my master, you or the gentleman?"

"Neither," I replied, laughing. "Here are your day's wages. Be off at once."

The shoemaker, seeing that Henriette spoke only French, begged to recommend a teacher of languages.

"What country does he belong to?" she enquired.

"To Flanders, madam," answered Crispin, "he is a very learned man, about fifty years old. He is said to be a good man. He charges three libbre for each lesson of one hour, and six for two hours, but he requires to be paid each time."

"My dear," said Henriette to me, "do you wish me to engage that master?"

"Yes, dearest, it will amuse you."

The shoemaker promised to send the Flemish professor the next morning.

The dressmakers were hard at work, the mother cutting and the daughter sewing, but, as progress could not be too rapid, I told the mother that she would oblige us if she could procure another seamstress who spoke French.

"You shall have one this very day, sir," she answered, and she offered me the services of her own son as a servant, saying that if I took him I should be certain to have neither a thief nor a spy about me, and that he spoke French pretty well. Henriette thought we could not do better than take the young man. Of course that was enough to make me consent at once, for the slightest wish of the woman we love is our supreme law. The mother went for him, and she brought back at the same time the half-French dressmaker. It all amused my goddess, who looked very happy.

The young man was about eighteen, pleasant, gentle and modest. I enquired his name, and he answered that it was Caudagna.

The reader may very likely recollect that my father's native place had been Parma, and that one of his sisters had married a Caudagna. "It would be a curious coincidence," I thought, "if that dressmaker should be my aunt, and my valet my cousin!" but I did not say it aloud.

Henriette asked me if I had any objection to the first dressmaker dining at our table.

"I entreat you, my darling," I answered, "never, for the future, to ask my consent in such trifling matters. Be quite certain, my beloved, that I shall always approve everything you may do."

She smiled and thanked me. I took out my purse, and said to her;

"Take these fifty sequins, dearest, to pay for all your small expenses, and to buy the many trifles which I should be sure to forget."

She took the money, assuring me that she was vastly obliged to me.

A short time before dinner the worthy captain made his appearance. Henriette ran to meet him and kissed him, calling him her dear father, and I followed her example by calling him my friend. My beloved little wife invited him to dine with us every day. The excellent fellow, seeing all the women working busily for Henriette, was highly pleased at having procured such a good position for his young adventuress, and I crowned his happiness by telling him that I was indebted to him for my felicity.

Our dinner was delicious, and it proved a cheerful meal. I found out that Henriette was dainty, and my old friend a lover of good wines. I was both, and felt that I was a match for them. We tasted several excellent wines which D'Andremont had recommended, and altogether we had a very good dinner.

The young valet pleased me in consequence of the respectful manner in which he served everyone, his mother as well as his masters. His sister and the other seamstress had dined apart.

We were enjoying our dessert when the hosier was announced, accompanied by another woman and a milliner who could speak French. The other woman had brought patterns of all sorts of dresses. I let Henriette order caps, head-dresses, etc., as she pleased, but I would interfere in the dress department although I complied with the excellent taste of my charming friend. I made her choose four dresses, and I was indeed grateful for her ready acceptance of them, for my own happiness was increased in proportion to the pleasure I gave her and the influence I was obtaining over her heart.

Thus did we spend the first day, and we could certainly not have accomplished more.

In the evening, as we were alone at supper, I fancied that her lovely face looked sad. I told her so.

"My darling," she answered, with a voice which went to my heart, "you are spending a great deal of money on me, and if you do so in the hope of my loving you more dearly I must tell you it is money lost, for I do not love you now more than I did yesterday, but I do love you with my whole heart. All you

may do that is not strictly necessary pleases me only because I see more and more how worthy you are of me, but it is not needed to make me feel all the deep love which you deserve."

"I believe you, dearest, and my happiness is indeed great if you feel that your love for me cannot be increased. But learn also, delight of my heart, that I have done it all only to try to love you even more than I do, if possible. I wish to see you beautiful and brilliant in the attire of your sex, and if there is one drop of bitterness in the fragrant cup of my felicity, it is a regret at not being able to surround you with the halo which you deserve. Can I be otherwise than delighted, my love, if you are pleased?"

"You cannot for one moment doubt my being pleased, and as you have called me your wife you are right in one way, but if you are not very rich I leave it to you to judge how deeply I ought to reproach myself."

"Ah, my beloved angel! let me, I beg of you, believe myself wealthy, and be quite certain that you cannot possibly be the cause of my ruin. You were born only for my happiness. All I wish is that you may never leave me. Tell me whether I can entertain such a hope."

"I wish it myself, dearest, but who can be sure of the future? Are you free? Are you dependent on anyone?"

"I am free in the broadest meaning of that word, I am dependent on no one but you, and I love to be so."

"I congratulate you, and I am very glad of it, for no one can tear you from my arms, but, alas! you know that I cannot say the same as you. I am certain that some persons are, even now, seeking for me, and they will not find it very difficult to secure me if they ever discover where I am. Alas! I feel how miserable I should be if they ever succeeded in dragging me away from you!"

"You make me tremble. Are you afraid of such a dreadful misfortune here?"

"No, unless I should happen to be seen by someone knowing me."

"Are any such persons likely to be here at present?"

"I think not."

"Then do not let our love take alarm, I trust your fears will never be verified. Only, my darling one, you must be as cheerful as you were in Cesena."

"I shall be more truly so now, dear friend. In Cesena I was miserable; while now I am happy. Do not be afraid of my being sad, for I am of a naturally cheerful disposition."

"I suppose that in Cesena you were afraid of being caught by the officer whom you had left in Rome?"

"Not at all; that officer was my father-in-law, and I am quite certain that he never tried to ascertain where I had gone. He was only too glad to get rid of me. I felt unhappy because I could not bear to be a charge on a man whom I could not love, and with whom I could not even exchange one thought. Recollect also that I could not find consolation in the idea that I was ministering to his happiness, for I had only inspired him with a passing fancy which he had himself valued at ten sequins. I could not help feeling that his fancy, once gratified, was not likely at his time of life to become a more lasting sentiment, and I could therefore only be a burden to him, for he was not wealthy. Besides, there was a miserable consideration which increased my secret sorrow. I thought myself bound in duty to caress him, and on his side, as he thought that he ought to pay me in the same money, I was afraid of his ruining his health for me, and that idea made me very unhappy. Having no love for each other, we allowed a foolish feeling of regard to make both of us uncomfortable. We lavished, for the sake of a well-meaning but false decorum, that which belongs to love alone. Another thing troubled me greatly. I was afraid lest people might suppose that I was a source of profit to him. That idea made me feel the deepest shame, yet, whenever I thought of it, I could not help admitting that such a supposition, however false, was not wanting in probability. It is owing to that feeling that you found me so reserved towards you, for I was afraid that you might harbour that fearful idea if I allowed you to read in my looks the favourable impression which you had made on my heart."

"Then it was not owing to a feeling of self-love?"

"No, I confess it, for you could but judge me as I deserved. I had been guilty of the folly now known to you because my father-in-law intended to bury me in a convent, and that did not suit my taste. But, dearest friend, you must forgive me if, I cannot confide even to you the history of my life."

"I respect your secret, darling; you need not fear any intrusion from me on that subject. All we have to do is to love one another, and not to allow any dread of the future to mar our actual felicity."

The next day, after a night of intense enjoyment, I found myself more deeply in love than before, and the next three months were spent by us in an intoxication of delight.

At nine o'clock the next morning the teacher of Italian was announced. I saw a man of respectable appearance, polite, modest, speaking little but well, reserved in his answers, and with the manners of olden times. We conversed, and I could not help laughing when he said, with an air of perfect good faith, that a Christian could only admit the system of Copernicus as a clever

hypothesis. I answered that it was the system of God Himself because it was that of nature, and that it was not in Holy Scripture that the laws of science could be learned.

The teacher smiled in a manner which betrayed the Tartufe, and if I had consulted only my own feelings I should have dismissed the poor man, but I thought that he might amuse Henriette and teach her Italian; after all it was what I wanted from him. My dear wife told him that she would give him six libbre for a lesson of two hours: the libbra of Parma being worth only about threepence, his lessons were not very expensive. She took her first lesson immediately and gave him two sequins, asking him to purchase her some good novels.

Whilst my dear Henriette was taking her lesson, I had some conversation with the dressmaker, in order to ascertain whether she was a relative of mine.

"What does your husband do?" I asked her.

"He is steward to the Marquis of Sissa."

"Is your father still alive?"

"No, sir, he is dead."

"What was his family name?"

"Scotti."

"Are your husband's parents still alive?"

"His father is dead, but his mother is still alive, and resides with her uncle, Canon Casanova."

That was enough. The good woman was my Welsh cousin, and her children were my Welsh nephews. My niece Jeanneton was not pretty; but she appeared to be a good girl. I continued my conversation with the mother, but I changed the topic.

"Are the Parmesans satisfied with being the subjects of a Spanish prince?"

"Satisfied? Well, in that case, we should be easily pleased, for we are now in a regular maze. Everything is upset, we do not know where we are. Oh! happy times of the house of Farnese, whither have you departed? The day before yesterday I went to the theatre, and Harlequin made everybody roar with laughter. Well, now, fancy, Don Philipo, our new duke, did all he could to remain serious, and when he could not manage it, he would hide his face in his hat so that people should not see that he was laughing, for it is said that laughter ought never to disturb the grave and stiff countenance of an Infante of Spain, and that he would be dishonoured in Madrid if he did not conceal his mirth. What do you think of that? Can such manners suit us? Here we laugh willingly and heartily! Oh! the good Duke Antonio (God rest his soul!) was certainly as great a prince as Duke Philipo, but he did not hide himself

from his subjects when he was pleased, and he would sometimes laugh so heartily that he could be heard in the streets. Now we are all in the most fearful confusion, and for the last three months no one in Parma knows what's o'clock."

"Have all the clocks been destroyed?"

"No, but ever since God created the world, the sun has always gone down at half-past five, and at six the bells have always been tolled for the Angelus. All respectable people knew that at that time the candle had to be lit. Now, it is very strange, the sun has gone mad, for he sets every day at a different hour. Our peasants do not know when they are to come to market. All that is called a regulation but do you know why? Because now everybody knows that dinner is to be eaten at twelve o'clock. A fine regulation, indeed! Under the Farnese we used to eat when we were hungry, and that was much better."

That way of reasoning was certainly singular, but I did not think it sounded foolish in the mouth of a woman of humble rank. It seems to me that a government ought never to destroy ancient customs abruptly, and that innocent errors ought to be corrected only by degrees.

Henriette had no watch. I felt delighted at the idea of offering her such a present, and I went out to purchase one, but after I had bought a very fine watch, I thought of ear-rings, of a fan, and of many other pretty nicknacks. Of course I bought them all at once. She received all those gifts offered by love with a tender delicacy which overjoyed me. She was still with the teacher when I came back.

"I should have been able," he said to me, "to teach your lady heraldry, geography, history, and the use of the globes, but she knows that already. She has received an excellent education."

The teacher's name was Valentin de la Haye. He told me that he was an engineer and professor of mathematics. I shall have to speak of him very often in these Memoirs, and my readers will make his acquaintance by his deeds better than by any portrait I could give of him, so I will merely say that he was a true Tartufe, a worthy pupil of Escobar.

We had a pleasant dinner with our Hungarian friend. Henriette was still wearing the uniform, and I longed to see her dressed as a woman. She expected a dress to be ready for the next day, and she was already supplied with petticoats and chemises.

Henriette was full of wit and a mistress of repartee. The milliner, who was a native of Lyons, came in one morning, and said in French:

"Madame et Monsieur, j'ai l'honneur de vous souhaiter le bonjour."

"Why," said my friend, "do you not say Monsieur et madame?"

"I have always heard that in society the precedence is given to the ladies."

"But from whom do we wish to receive that honour?"

"From gentlemen, of course."

"And do you not see that women would render themselves ridiculous if they did not grant to men the same that they expect from them. If we wish them never to fail in politeness towards us, we must shew them the example."

"Madam," answered the shrewd milliner, "you have taught me an excellent lesson, and I will profit by it. Monsieur et madame, je suis votre servante."

This feminine controversy greatly amused me.

Those who do not believe that a woman can make a man happy through the twenty-four hours of the day have never possessed a woman like Henriette. The happiness which filled me, if I can express it in that manner, was much greater when I conversed with her even than when I held her in my arms. She had read much, she had great tact, and her taste was naturally excellent; her judgment was sane, and, without being learned, she could argue like a mathematician, easily and without pretension, and in everything she had that natural grace which is so charming. She never tried to be witty when she said something of importance, but accompanied her words with a smile which imparted to them an appearance of trifling, and brought them within the understanding of all. In that way she would give intelligence even to those who had none, and she won every heart. Beauty without wit offers love nothing but the material enjoyment of its physical charms, whilst witty ugliness captivates by the charms of the mind, and at last fulfils all the desires of the man it has captivated.

Then what was my position during all the time that I possessed my beautiful and witty Henriette? That of a man so supremely happy that I could scarcely realize my felicity!

Let anyone ask a beautiful woman without wit whether she would be willing to exchange a small portion of her beauty for a sufficient dose of wit. If she speaks the truth, she will say, "No, I am satisfied to be as I am." But why is she satisfied? Because she is not aware of her own deficiency. Let an ugly but witty woman be asked if she would change her wit against beauty, and she will not hesitate in saying no. Why? Because, knowing the value of her wit, she is well aware that it is sufficient by itself to make her a queen in any society.

But a learned woman, a blue-stocking, is not the creature to minister to a man's happiness. Positive knowledge is not a woman's province. It is antipathetic to the gentleness of her nature, to the amenity, to the sweet timidity which are the greatest charms of the fair sex, besides, women never

carry their learning beyond certain limits, and the tittle-tattle of blue-stockin gs can dazzle no one but fools. There has never been one great discovery due to a woman. The fair sex is deficient in that vigorous power which the body lends to the mind, but women are evidently superior to men in simple reasoning, in delicacy of feelings, and in that species of merit which appertains to the heart rather than to the mind.

Hurl some idle sophism at a woman of intelligence. She will not unravel it, but she will not be deceived by it, and, though she may not say so, she will let you guess that she does not accept it. A man, on the contrary, if he cannot unravel the sophism, takes it in a literal sense, and in that respect the learned woman is exactly the same as man. What a burden a Madame Dacier must be to a man! May God save every honest man from such!

When the new dress was brought, Henriette told me that she did not want me to witness the process of her metamorphosis, and she desired me to go out for a walk until she had resumed her original form. I obeyed cheerfully, for the slightest wish of the woman we love is a law, and our very obedience increases our happiness.

As I had nothing particular to do, I went to a French bookseller in whose shop I made the acquaintance of a witty hunchback, and I must say that a hunchback without wit is a raga avis; I have found it so in all countries. Of course it is not wit which gives the hump, for, thank God, all witty men are not humpbacked, but we may well say that as a general rule the hump gives wit, for the very small number of hunchbacks who have little or no wit only confirms the rule: The one I was alluding to just now was called Dubois-Chateleraux. He was a skilful engraver, and director of the Mint of Parma for the Infante, although that prince could not boast of such an institution.

I spent an hour with the witty hunchback, who shewed me several of his engravings, and I returned to the hotel where I found the Hungarian waiting to see Henriette. He did not know that she would that morning receive us in the attire of her sex. The door was thrown open, and a beautiful, charming woman met us with a courtesy full of grace, which no longer reminded us of the stiffness or of the too great freedom which belong to the military costume. Her sudden appearance certainly astonished us, and we did not know what to say or what to do. She invited us to be seated, looked at the captain in a friendly manner, and pressed my hand with the warmest affection, but without giving way any more to that outward familiarity which a young officer can assume, but which does not suit a well-educated lady. Her noble and modest bearing soon compelled me to put myself in unison with her, and I did

so without difficulty, for she was not acting a part, and the way in which she had resumed her natural character made it easy for me to follow her on that ground.

I was gazing at her with admiration, and, urged by a feeling which I did not take time to analyze, I took her hand to kiss it with respect, but, without giving me an opportunity of raising it to my lips, she offered me her lovely mouth. Never did a kiss taste so delicious.

"Am I not then always the same?" said she to me, with deep feeling.

"No, heavenly creature, and it is so true that you are no longer the same in my eyes that I could not now use any familiarity towards you. You are no longer the witty, free young officer who told Madame Querini about the game of Pharaoh, end about the deposits made to your bank by the captain in so niggardly a manner that they were hardly worth mentioning."

"It is very true that, wearing the costume of my sex, I should never dare to utter such words. Yet, dearest friend, it does not prevent my being your Henriette—that Henriette who has in her life been guilty of three escapades, the last of which would have utterly ruined me if it had not been for you, but which I call a delightful error, since it has been the cause of my knowing you."

Those words moved me so deeply that I was on the point of throwing myself at her feet, to entreat her to forgive me for not having shewn her more respect, but Henriette, who saw the state in which I was, and who wanted to put an end to the pathetic scene, began to shake our poor captain, who sat as motionless as a statue, and as if he had been petrified. He felt ashamed at having treated such a woman as an adventuress, for he knew that what he now saw was not an illusion. He kept looking at her with great confusion, and bowing most respectfully, as if he wanted to atone for his past conduct towards her. As for Henriette, she seemed to say to him, but without the shadow of a reproach;

"I am glad that you think me worth more than ten sequins."

We sat down to dinner, and from that moment she did the honours of the table with the perfect ease of a person who is accustomed to fulfil that difficult duty. She treated me like a beloved husband, and the captain like a respected friend. The poor Hungarian begged me to tell her that if he had seen her, as she was now, in Civita Vecchia, when she came out of the tartan, he should never have dreamed of dispatching his cicerone to her room.

"Oh! tell him that I do not doubt it. But is it not strange that a poor little female dress should command more respect than the garb of an officer?"

"Pray do not abuse the officer's costume, for it is to it that I am indebted for my happiness."

"Yes," she said, with a loving smile, "as I owe mine to the sbirri of Cesena."

We remained for a long time at the table, and our delightful conversation turned upon no other topic than our mutual felicity. If it had not been for the uneasiness of the poor captain, which at last struck us, we should never have put a stop either to the dinner or to, our charming prattle.

CHAPTER II

I Engage a Box at the Opera, in Spite of Henriette's
Reluctance—M. Dubois Pays Us a Visit and Dines with Us;
My Darling Plays Him a Trick—Henriette Argues on Happiness—
We Call on Dubois, and My Wife Displays Her Marvellous Talent—
M. Dutillot The Court gives a Splendid Entertainment in the
Ducal Gardens—A Fatal Meeting—I Have an Interview with
M. D'Antoine, the Favourite of the Infante of Spain

The happiness I was enjoying was too complete to last long. I was fated to lose it, but I must not anticipate events. Madame de France, wife of the Infante Don Philip, having arrived in Parma, the opera house was opened, and I engaged a private box, telling Henriette that I intended to take her to the theatre every night. She had several times confessed that she had a great passion for music, and I had no doubt that she would be pleased with my proposal. She had never yet seen an Italian opera, and I felt certain that she wished to ascertain whether the Italian music deserved its universal fame. But I was indeed surprised when she exclaimed,

"What, dearest! You wish to go every evening to the opera?"

"I think, my love, that, if we did not go, we should give some excuse for scandal-mongers to gossip. Yet, should you not like it, you know that there is no need for us to go. Do not think of me, for I prefer our pleasant chat in this room to the heavenly concert of the seraphs."

"I am passionately fond of music, darling, but I cannot help trembling at the idea of going out."

"If you tremble, I must shudder, but we ought to go to the opera or leave Parma. Let us go to London or to any other place. Give your orders, I am ready to do anything you like."

"Well, take a private box as little exposed as possible."

"How kind you are!"

The box I had engaged was in the second tier, but the theatre being small it was difficult for a pretty woman to escape observation.

I told her so.

"I do not think there is any danger," she answered; "for I have not seen the name of any person of my acquaintance in the list of foreigners which you gave me to read."

Thus did Henriette go to the opera. I had taken care that our box should not be lighted up. It was an opera-buffa, the music of Burellano was excellent, and the singers were very good.

Henriette made no use of her opera-glass except to look on the stage, and nobody paid any attention to us. As she had been greatly pleased with the finale of the second act, I promised to get it for her, and I asked Dubois to procure it for me. Thinking that she could play the harpsichord, I offered to get one, but she told me that she had never touched that instrument.

On the night of the fourth or fifth performance M. Dubois came to our box, and as I did not wish to introduce him to my friend, I only asked what I could do for him. He then handed me the music I had begged him to purchase for me, and I paid him what it had cost, offering him my best thanks. As we were just opposite the ducal box, I asked him, for the sake of saying something, whether he had engraved the portraits of their highnesses. He answered that he had already engraved two medals, and I gave him an order for both, in gold. He promised to let me have them, and left the box. Henriette had not even looked at him, and that was according to all established rules, as I had not introduced him, but the next morning he was announced as we were at dinner. M. de la Haye, who was dining with us, complimented us upon having made the acquaintance of Dubois, and introduced him to his pupil the moment he came into the room. It was then right for Henriette to welcome him, which she did most gracefully.

After she had thanked him for the 'partizione', she begged he would get her some other music, and the artist accepted her request as a favour granted to him.

"Sir," said Dubois to me, "I have taken the liberty of bringing the medals you wished to have; here they are."

On one were the portraits of the Infante and his wife, on the other was engraved only the head of Don Philip. They were both beautifully engraved, and we expressed our just admiration. "The workmanship is beyond all price," said Henriette, "but the gold can be bartered for other gold." "Madam," answered the modest artist, "the medals weight sixteen sequins." She gave him the amount immediately, and invited him to call again at dinner-time. Coffee was just brought in at that moment, and she asked him to take it with us. Before sweetening his cup, she enquired whether he liked his coffee very sweet.

"Your taste, madam," answered the hunchback, gallantly, "is sure to be mine."

"Then you have guessed that I always drink coffee without sugar. I am glad we have that taste in common."

And she gracefully offered him the cup of coffee without sugar. She then helped De la Haye and me, not forgetting to put plenty of sugar in our cups, and she poured out one for herself exactly like the one she handed to Dubois. It was much ado for me not to laugh, for my mischievous French-woman, who liked her coffee in the Parisian fashion, that is to say very sweet, was sipping the bitter beverage with an air of delight which compelled the director of the Mint to smile under the infliction. But the cunning hunchback was even with her; accepting the penalty of his foolish compliment, and praising the good quality of the coffee, he boldly declared that it was the only way to taste the delicious aroma of the precious berry.

When Dubois and De la Haye had left us, we both laughed at the trick.

"But," said I to Henriette, "you will be the first victim of your mischief, for whenever he dines with us, you must keep up the joke, in order not to betray yourself."

"Oh! I can easily contrive to drink my coffee well sweetened, and to make him drain the bitter cup."

At the end of one month, Henriette could speak Italian fluently, and it was owing more to the constant practice she had every day with my cousin Jeanneton, who acted as her maid, than to the lessons of Professor de la Haye. The lessons only taught her the rules, and practice is necessary to acquire a language. I have experienced it myself. I learned more French during the too short period that I spent so happily with my charming Henriette than in all the lessons I had taken from Dalacqua.

We had attended the opera twenty times without making any acquaintance, and our life was indeed supremely happy. I never went out without Henriette, and always in a carriage; we never received anyone, and nobody knew us. Dubois was the only person, since the departure of the good Hungarian, who sometimes dined with us; I do not reckon De la Haye, who was a daily guest at our table. Dubois felt great curiosity about us, but he was cunning and did not shew his curiosity; we were reserved without affectation, and his inquisitiveness was at fault. One day he mentioned to us that the court of the Infante of Parma was very brilliant since the arrival of Madame de France, and that there were many foreigners of both sexes in the city. Then, turning towards Henriette, he said to her;

"Most of the foreign ladies whom we have here are unknown to us."

"Very likely, many of them would not shew themselves if they were known."

"Very likely, madam, as you say, but I can assure you that, even if their beauty and the richness of their toilet made them conspicuous, our sovereigns wish for freedom. I still hope, madam, that we shall have the happiness of seeing you at the court of the duke."

"I do not think so, for, in my opinion, it is superlatively ridiculous for a lady to go to the court without being presented, particularly if she has a right to be so."

The last words, on which Henriette had laid a little more stress than upon the first part of her answer, struck our little hunchback dumb, and my friend, improving her opportunity, changed the subject of conversation.

When he had gone we enjoyed the check she had thus given to the inquisitiveness of our guest, but I told Henriette that, in good conscience, she ought to forgive all those whom she rendered curious, because.... she cut my words short by covering me with loving kisses.

Thus supremely happy, and finding in one another constant satisfaction, we would laugh at those morose philosophers who deny that complete happiness can be found on earth.

"What do they mean, darling—those crazy fools—by saying that happiness is not lasting, and how do they understand that word? If they mean everlasting, immortal, unintermitting, of course they are right, but the life of man not being such, happiness, as a natural consequence, cannot be such either. Otherwise, every happiness is lasting for the very reason that it does exist, and to be lasting it requires only to exist. But if by complete felicity they understand a series of varied and never-interrupted pleasures, they are wrong, because, by allowing after each pleasure the calm which ought to follow the enjoyment of it, we have time to realize happiness in its reality. In other words those necessary periods of repose are a source of true enjoyment, because, thanks to them, we enjoy the delight of recollection which increases twofold the reality of happiness. Man can be happy only when in his own mind he realizes his happiness, and calm is necessary to give full play to his mind; therefore without calm man would truly never be completely happy, and pleasure, in order to be felt, must cease to be active. Then what do they mean by that word lasting?

"Every day we reach a moment when we long for sleep, and, although it be the very likeness of non-existence, can anyone deny that sleep is a pleasure? No, at least it seems to me that it cannot be denied with consistency, for, the moment it comes to us, we give it the preference over all other pleasures, and we are grateful to it only after it has left us.

"Those who say that no one can be happy throughout life speak likewise frivolously. Philosophy teaches the secret of securing that happiness, provided one is free from bodily sufferings. A felicity which would thus last throughout life could be compared to a nosegay formed of a thousand flowers so beautifully, so skillfully blended together, that it would look one single flower. Why should it be impossible for us to spend here the whole of our life as we have spent the last month, always in good health, always loving one another, without ever feeling any other want or any weariness? Then, to crown that happiness, which would certainly be immense, all that would be wanted would be to die together, in an advanced age, speaking to the last moment of our pleasant recollections. Surely that felicity would have been lasting. Death would not interrupt it, for death would end it. We could not, even then, suppose ourselves unhappy unless we dreaded unhappiness after death, and such an idea strikes me as absurd, for it is a contradiction of the idea of an almighty and fatherly tenderness."

It was thus that my beloved Henriette would often make me spend delightful hours, talking philosophic sentiment. Her logic was better than that of Cicero in his Tusculan Disputations, but she admitted that such lasting felicity could exist only between two beings who lived together, and loved each other with constant affection, healthy in mind and in body, enlightened, sufficiently rich, similar in tastes, in disposition, and in temperament. Happy are those lovers who, when their senses require rest, can fall back upon the intellectual enjoyments afforded by the mind! Sweet sleep then comes, and lasts until the body has recovered its general harmony. On awaking, the senses are again active and always ready to resume their action.

The conditions of existence are exactly the same for man as for the universe, I might almost say that between them there is perfect identity, for if we take the universe away, mankind no longer exists, and if we take mankind away, there is no longer an universe; who could realize the idea of the existence of inorganic matter? Now, without that idea, 'nihil est', since the idea is the essence of everything, and since man alone has ideas. Besides, if we abstract the species, we can no longer imagine the existence of matter, and vice versa.

I derived from Henriette as great happiness as that charming woman derived from me. We loved one another with all the strength of our faculties, and we were everything to each other. She would often repeat those pretty lines of the good La, Fontaine:

'Soyez-vous l'un a l'autre un monde toujours beau,
Toujours divers, toujours nouveau;

Tenez-vous lieu de tout; comptez pour rien le reste.'

And we did not fail to put the advice into practice, for never did a minute of ennui or of weariness, never did the slightest trouble, disturb our bliss.

The day after the close of the opera, Dubois, who was dining with us, said that on the following day he was entertaining the two first artists, 'primo cantatore' and 'prima cantatrice', and added that, if we liked to come, we would hear some of their best pieces, which they were to sing in a lofty hall of his country-house particularly adapted to the display of the human voice. Henriette thanked him warmly, but she said that, her health being very delicate, she could not engage herself beforehand, and she spoke of other things.

When we were alone, I asked her why she had refused the pleasure offered by Dubois.

"I should accept his invitation," she answered, "and with delight, if I were not afraid of meeting at his house some person who might know me, and would destroy the happiness I am now enjoying with you."

"If you have any fresh motive for dreading such an occurrence, you are quite right, but if it is only a vague, groundless fear, my love, why should you deprive yourself of a real and innocent pleasure? If you knew how pleased I am when I see you enjoy yourself, and particularly when I witness your ecstacy in listening to fine music!"

"Well, darling, I do not want to shew myself less brave than you. We will go immediately after dinner. The artists will not sing before. Besides, as he does not expect us, he is not likely to have invited any person curious to speak to me. We will go without giving him notice of our coming, without being expected, and as if we wanted to pay him a friendly visit. He told us that he would be at his country-house, and Caudagna knows where it is."

Her reasons were a mixture of prudence and of love, two feelings which are seldom blended together. My answer was to kiss her with as much admiration as tenderness, and the next day at four o'clock in the afternoon we paid our visit to M. Dubois. We were much surprised, for we found him alone with a very pretty girl, whom he presented to us as his niece.

"I am delighted to see you," he said, "but as I did not expect to see you I altered my arrangements, and instead of the dinner I had intended to give I have invited my friends to supper. I hope you will not refuse me the honour of your company. The two virtuosi will soon be here."

We were compelled to accept his invitation.

"Will there be many guests?" I enquired.

"You will find yourselves in the midst of people worthy of you," he answered, triumphantly. "I am only sorry that I have not invited any ladies."

This polite remark, which was intended for Henriette, made her drop him a curtsy, which she accompanied with a smile. I was pleased to read contentment on her countenance, but, alas! she was concealing the painful anxiety which she felt acutely. Her noble mind refused to shew any uneasiness, and I could not guess her inmost thoughts because I had no idea that she had anything to fear.

I should have thought and acted differently if I had known all her history. Instead of remaining in Parma I should have gone with her to London, and I know now that she would have been delighted to go there.

The two artists arrived soon afterwards; they were the 'primo cantatore' Laschi, and the 'prima donna' Baglioni, then a very pretty woman. The other guests soon followed; all of them were Frenchmen and Spaniards of a certain age. No introductions took place, and I read the tact of the witty hunchback in the omission, but as all the guests were men used to the manners of the court, that neglect of etiquette did not prevent them from paying every honour to my lovely friend, who received their compliments with that ease and good breeding which are known only in France, and even there only in the highest society, with the exception, however, of a few French provinces in which the nobility, wrongly called good society, shew rather too openly the haughtiness which is characteristic of that class.

The concert began by a magnificent symphony, after which Laschi and Baglioni sang a duet with great talent and much taste. They were followed by a pupil of the celebrated Vandini, who played a concerto on the violoncello, and was warmly applauded.

The applause had not yet ceased when Henriette, leaving her seat, went up to the young artist, and told him, with modest confidence, as she took the violoncello from him, that she could bring out the beautiful tone of the instrument still better. I was struck with amazement. She took the young man's seat, placed the violoncello between her knees, and begged the leader of the orchestra to begin the concerto again. The deepest silence prevailed. I was trembling all over, and almost fainting. Fortunately every look was fixed upon Henriette, and nobody thought of me. Nor was she looking towards me, she would not have then ventured even one glance, for she would have lost courage, if she had raised her beautiful eyes to my face. However, not seeing her disposing herself to play, I was beginning to imagine that she had only been indulging in a jest, when she suddenly made the strings resound. My heart was beating with such force that I thought I should drop down dead.

But let the reader imagine my situation when, the concerto being over, well-merited applause burst from every part of the room! The rapid change from extreme fear to excessive pleasure brought on an excitement which was like a violent fever. The applause did not seem to have any effect upon Henriette, who, without raising her eyes from the notes which she saw for the first time, played six pieces with the greatest perfection. As she rose from her seat, she did not thank the guests for their applause, but, addressing the young artist with affability, she told him, with a sweet smile, that she had never played on a finer instrument. Then, curtsying to the audience, she said,

"I entreat your forgiveness for a movement of vanity which has made me encroach on your patience for half an hour."

The nobility and grace of this remark completely upset me, and I ran out to weep like a child, in the garden where no one could see me.

"Who is she, this Henriette?" I said to myself, my heart beating, and my eyes swimming with tears of emotion, "what is this treasure I have in my possession?"

My happiness was so immense that I felt myself unworthy of it.

Lost in these thoughts which enhanced the pleasure of any tears, I should have stayed for a long tune in the garden if Dubois had not come out to look for me. He felt anxious about me, owing to my sudden disappearance, and I quieted him by saying that a slight giddiness had compelled me to come out to breathe the fresh air.

Before re-entering the room, I had time to dry my tears, but my eyelids were still red. Henriette, however, was the only one to take notice of it, and she said to me,

"I know, my darling, why you went into the garden"

She knew me so well that she could easily guess the impression made on my heart by the evening's occurrence.

Dubois had invited the most amiable noblemen of the court, and his supper was dainty and well arranged. I was seated opposite Henriette who was, as a matter of course, monopolizing the general attention, but she would have met with the same success if she had been surrounded by a circle of ladies whom she would certainly have thrown into the shade by her beauty, her wit, and the distinction of her manners. She was the charm of that supper by the animation she imparted to the conversation. M. Dubois said nothing, but he was proud to have such a lovely guest in his house. She contrived to say a few gracious words to everyone, and was shrewd enough never to utter something witty without making me take a share in it. On my side, I openly shewed my submissiveness, my deference, and my respect for that divinity, but it was all

in vain. She wanted everybody to know that I was her lord and master. She might have been taken for my wife, but my behaviour to her rendered such a supposition improbable.

The conversation having fallen on the respective merits of the French and Spanish nations, Dubois was foolish enough to ask Henriette to which she gave preference.

It would have been difficult to ask a more indiscreet question, considering that the company was composed almost entirely of Frenchmen and Spaniards in about equal proportion. Yet my Henriette turned the difficulty so cleverly that the Frenchmen would have liked to be Spaniards, and 'vice versa'. Dubois, nothing daunted, begged her to say what she thought of the Italians. The question made me tremble. A certain M. de la Combe, who was seated near me, shook his head in token of disapprobation, but Henriette did not try to elude the question.

"What can I say about the Italians," she answered, "I know only one? If I am to judge them all from that one my judgment must certainly be most favourable to them, but one single example is not sufficient to establish the rule."

It was impossible to give a better answer, but as my readers may well imagine, I did not appear to have heard it, and being anxious to prevent any more indiscreet questions from Dubois I turned the conversation into a different channel.

The subject of music was discussed, and a Spaniard asked Henriette whether she could play any other instrument besides the violoncello.

"No," she answered, "I never felt any inclination for any other. I learned the violoncello at the convent to please my mother, who can play it pretty well, and without an order from my father, sanctioned by the bishop, the abbess would never have given me permission to practise it."

"What objection could the abbess make?"

"That devout spouse of our Lord pretended that I could not play that instrument without assuming an indecent position."

At this the Spanish guests bit their lips, but the Frenchmen laughed heartily, and did not spare their epigrams against the over-particular abbess.

After a short silence, Henriette rose, and we all followed her example. It was the signal for breaking up the party, and we soon took our leave.

I longed to find myself alone with the idol of my soul. I asked her a hundred questions without waiting for the answers.

"Ah! you were right, my own Henriette, when you refused to go to that concert, for you knew that you would raise many enemies against me. I am

certain that all those men hate me, but what do I care? You are my universe! Cruel darling, you almost killed me with your violoncello, because, having no idea of your being a musician, I thought you had gone mad, and when I heard you I was compelled to leave the room in order to weep undisturbed. My tears relieved my fearful oppression. Oh! I entreat you to tell me what other talents you possess. Tell me candidly, for you might kill me if you brought them out unexpectedly, as you have done this evening."

"I have no other accomplishments, my best beloved. I have emptied my bag all at once. Now you know your Henriette entirely. Had you not chanced to tell me about a month ago that you had no taste for music, I would have told you that I could play the violoncello remarkably well, but if I had mentioned such a thing, I know you well enough to be certain that you would have bought an instrument immediately, and I could not, dearest, find pleasure in anything that would weary you."

The very next morning she had an excellent violoncello, and, far from wearying me, each time she played she caused me a new and greater pleasure. I believe that it would be impossible even to a man disliking music not to become passionately fond of it, if that art were practised to perfection by the woman he adores.

The 'vox humana' of the violoncello; the king of instruments, went to my heart every time that my beloved Henriette performed upon it. She knew I loved to hear her play, and every day she afforded me that pleasure. Her talent delighted me so much that I proposed to her to give some concerts, but she was prudent enough to refuse my proposal. But in spite of all her prudence we had no power to hinder the decrees of fate.

The fatal hunchback came the day after his fine supper to thank us and to receive our well-merited praises of his concert, his supper, and the distinction of his guests.

"I foresee, madam," he said to Henriette, "all the difficulty I shall have in defending myself against the prayers of all my friends, who will beg of me to introduce them to you."

"You need not have much trouble on that score: you know that I never, receive anyone."

Dubois did not again venture upon speaking of introducing any friend.

On the same day I received a letter from young Capitani, in which he informed me that, being the owner of St. Peter's knife and sheath, he had called on Franzia with two learned magicians who had promised to raise the treasure out of the earth, and that to his great surprise Franzia had refused to receive him: He entreated me to write to the worthy fellow, and to go to him

myself if I wanted to have my share of the treasure. I need not say that I did not comply with his wishes, but I can vouch for the real pleasure I felt in finding that I had succeeded in saving that honest and simple farmer from the impostors who would have ruined him.

One month was gone since the great supper given by Dubois. We had passed it in all the enjoyment which can be derived both from the senses and the mind, and never had one single instant of weariness caused either of us to be guilty of that sad symptom of misery which is called a yawn. The only pleasure we took out of doors was a drive outside of the city when the weather was fine. As we never walked in the streets, and never frequented any public place, no one had sought to make our acquaintance, or at least no one had found an opportunity of doing so, in spite of all the curiosity excited by Henriette amongst the persons whom we had chanced to meet, particularly at the house of Dubois. Henriette had become more courageous, and I more confident, when we found that she had not been recognized by any one either at that supper or at the theatre. She only dreaded persons belonging to the high nobility.

One day as we were driving outside the Gate of Colorno, we met the duke and duchess who were returning to Parma. Immediately after their carriage another vehicle drove along, in which was Dubois with a nobleman unknown to us. Our carriage had only gone a few yards from theirs when one of our horses broke down. The companion of Dubois immediately ordered his coachman to stop in order to send to our assistance. Whilst the horse was raised again, he came politely to our carriage, and paid some civil compliment to Henriette. M. Dubois, always a shrewd courtier and anxious to shew off at the expense of others, lost no time in introducing him as M. Dutillot, the French ambassador. My sweetheart gave the conventional bow. The horse being all right again, we proceeded on our road after thanking the gentlemen for their courtesy. Such an every-day occurrence could not be expected to have any serious consequences, but alas! the most important events are often the result of very trifling circumstances!

The next day, Dubois breakfasted with us. He told us frankly that M. Dutillot had been delighted at the fortunate chance which had afforded him an opportunity of making our acquaintance, and that he had entreated him to ask our permission to call on us.

"On madam or on me?" I asked at once.

"On both."

"Very well, but one at a time. Madam, as you know, has her own room and I have mine."

"Yes, but they are so near each other!"

"Granted, yet I must tell you that, as far as I am concerned, I should have much pleasure in waiting upon his excellency if he should ever wish to communicate with me, and you will oblige me by letting him know it. As for madam, she is here, speak to her, my dear M. Dubois, for I am only her very humble servant."

Henriette assumed an air of cheerful politeness, and said to him,

"Sir, I beg you will offer my thanks to M. Dutillot, and enquire from him whether he knows me."

"I am certain, madam," said the hunchback, "that he does not."

"You see he does not know me, and yet he wishes to call on me. You must agree with me that if I accepted his visits I should give him a singular opinion of my character. Be good enough to tell him that, although known to no one and knowing no one, I am not an adventuress, and therefore I must decline the honour of his visits."

Dubois felt that he had taken a false step, and remained silent. We never asked him how the ambassador had received our refusal.

Three weeks after the last occurrence, the ducal court residing then at Colorno, a great entertainment was given in the gardens which were to be illuminated all night. Everybody had permission to walk about the gardens. Dubois, the fatal hunchback appointed by destiny, spoke so much of that festival, that we took a fancy to see it. Always the same story of Adam's apple. Dubois accompanied us. We went to Colorno the day before the entertainment, and put up at an inn.

In the evening we walked through the gardens, in which we happened to meet the ducal family and suite. According to the etiquette of the French court, Madame de France was the first to curtsy to Henriette, without stopping. My eyes fell upon a gentleman walking by the side of Don Louis, who was looking at my friend very attentively. A few minutes after, as we were retracing our steps, we came across the same gentleman who, after bowing respectfully to us, took Dubois aside. They conversed together for a quarter of an hour, following us all the time, and we were passing out of the gardens, when the gentleman, coming forward, and politely apologizing to me, asked Henriette whether he had the honour to be known to her.

"I do not recollect having ever had the honour of seeing you before."

"That is enough, madam, and I entreat you to forgive me."

Dubois informed us that the gentleman was the intimate friend of the Infante Don Louis, and that, believing he knew madam, he had begged to be introduced. Dubois had answered that her name was D'Arci, and that, if he

was known to the lady, he required no introduction. M. d'Antoine said that the name of D'Arci was unknown to him, and that he was afraid of making a mistake. "In that state of doubt," added Dubois, "and wishing to clear it, he introduced himself, but now he must see that he was mistaken."

After supper, Henriette appeared anxious. I asked her whether she had only pretended not to know M. d'Antoine.

"No, dearest, I can assure you. I know his name which belongs to an illustrious family of Provence, but I have never seen him before."

"Perhaps he may know you?"

"He might have seen me, but I am certain that he never spoke to me, or I would have recollected him."

"That meeting causes me great anxiety, and it seems to have troubled you."

"I confess it has disturbed my mind."

"Let us leave Parma at once and proceed to Genoa. We will go to Venice as soon as my affairs there are settled."

"Yes, my dear friend, we shall then feel more comfortable. But I do not think we need be in any hurry."

We returned to Parma, and two days afterwards my servant handed me a letter, saying that the footman who had brought it was waiting in the ante-room.

"This letter," I said to Henriette, "troubles me."

She took it, and after she had read it—she gave it back to me, saying,

"I think M. d'Antoine is a man of honour, and I hope that we may have nothing to fear."

The letter ran as, follows:

"Either at your hotel or at my residence, or at any other place you may wish to appoint, I entreat you, sir, to give me an opportunity of conversing with you on a subject which must be of the greatest importance to you.

"I have the honour to be, etc.

 "D'ANTOINE."

It was addressed M. Farusi.

"I think I must see him," I said, "but where?"

"Neither here nor at his residence, but in the ducal gardens. Your answer must name only the place and the hour of the meeting."

I wrote to M. d'Antoine that I would see him at half-past eleven in the ducal gardens, only requesting him to appoint another hour in case mine was not convenient to him.

I dressed myself at once in order to be in good time, and meanwhile we both endeavoured, Henriette and I, to keep a cheerful countenance, but we

could not silence our sad forebodings. I was exact to my appointment and found M. d'Antoine waiting for me. As soon as we were together, he said to me,

"I have been compelled, sir, to beg from you the favour of an interview, because I could not imagine any surer way to get this letter to Madame d'Arci's hands. I entreat you to deliver it to her, and to excuse me if I give it you sealed. Should I be mistaken, my letter will not even require an answer, but should I be right, Madame d'Arci alone can judge whether she ought to communicate it to you. That is my reason for giving it to you sealed. If you are truly her friend, the contents of that letter must be as interesting to you as to her. May I hope, sir, that you will be good enough to deliver it to her?"

"Sir, on my honour I will do it."

We bowed respectfully to each other, and parted company. I hurried back to the hotel.

CHAPTER III

Henriette Receives the Visit of M. d'Antoine I Accompany Her as Far as Geneva and Then I Lose Her—I Cross the St. Bernard, and Return to Parma—A Letter from Hensiette—My Despair—De La Haye Becomes Attached to Me—Unpleasant Adventure with an Actress and Its Consequences—I Turn a Thorough Bigot—Bavois—I Mystify a Bragging Officer.

As soon as I had reached our apartment, my heart bursting with anxiety, I repeated to Henriette every word spoken by M. d'Antoine, and delivered his letter which contained four pages of writing. She read it attentively with visible emotion, and then she said,

"Dearest friend, do not be offended, but the honour of two families does not allow of my imparting to you the contents of this letter. I am compelled to receive M. d'Antoine, who represents himself as being one of my relatives."

"Ah!" I exclaimed, "this is the beginning of the end! What a dreadful thought! I am near the end of a felicity which was too great to last! Wretch that I have been! Why did I tarry so long in Parma? What fatal blindness! Of all the cities in the whole world, except France, Parma was the only one I had to fear, and it is here that I have brought you, when I could have taken you anywhere else, for you had no will but mine! I am all the more guilty that you never concealed your fears from me. Why did I introduce that fatal Dubois here? Ought I not to have guessed that his curiosity would sooner or later prove injurious to us? And yet I cannot condemn that curiosity, for it is, alas! a natural feeling. I can only accuse all the perfections which Heaven has bestowed upon you!—perfections which have caused my happiness, and which will plunge me in an abyss of despair, for, alas! I foresee a future of fearful misery."

"I entreat you, dearest, to foresee nothing, and to calm yourself. Let us avail ourselves of all our reason in order to prove ourselves superior to circumstances, whatever they may be. I cannot answer this letter, but you must write to M. d'Antoine to call here tomorrow and to send up his name."

"Alas! you compel me to perform a painful task."

"You are my best, my only friend; I demand nothing, I impose no task upon you, but can you refuse me?"

"No, never, no matter what you ask. Dispose of me, I am yours in life and death."

"I knew what you would answer. You must be with me when M. d'Antoine calls, but after a few minutes given to etiquette, will you find some pretext to go to your room, and leave us alone? M. d'Antoine knows all my history; he knows in what I have done wrong, in what I have been right; as a man of honour, as my relative, he must shelter me from all affront. He shall not do anything against my will, and if he attempts to deviate from the conditions I will dictate to him, I will refuse to go to France, I will follow you anywhere, and devote to you the remainder of my life. Yet, my darling, recollect that some fatal circumstances may compel us to consider our separation as the wisest course to adopt, that we must husband all our courage to adopt it, if necessary, and to endeavour not to be too unhappy.

"Have confidence in me, and be quite certain that I shall take care to reserve for myself the small portion of happiness which I can be allowed to enjoy without the man who alone has won all my devoted love. You will have, I trust, and I expect it from your generous soul, the same care of your future, and I feel certain that you must succeed. In the mean time, let us drive away all the sad forebodings which might darken the hours we have yet before us."

"Ah! why did we not go away immediately after we had met that accursed favourite of the Infante!"

"We might have made matters much worse; for in that case M. d'Antoine might have made up his mind to give my family a proof of his zeal by instituting a search to discover our place of residence, and I should then have been exposed to violent proceedings which you would not have endured. It would have been fatal to both of us."

I did everything she asked me. From that moment our love became sad, and sadness is a disease which gives the death-blow to affection. We would often remain a whole hour opposite each other without exchanging a single word, and our sighs would be heard whatever we did to hush them.

The next day, when M. d'Antoine called, I followed exactly the instructions she had given me, and for six mortal hours I remained alone, pretending to write.

The door of my room was open, and a large looking-glass allowed us to see each other. They spent those six hours in writing, occasionally stopping to talk of I do not know what, but their conversation was evidently a decisive one. The reader can easily realize how much I suffered during that long torture, for I could expect nothing but the total wreck of my happiness.

As soon as the terrible M. d'Antoine had taken leave of her, Henriette came to me, and observing that her eyes were red I heaved a deep sigh, but she tried to smile.

"Shall we go away to-morrow, dearest?"

"Oh! yes, I am ready. Where do you wish me to take you?"

"Anywhere you like, but we must be here in a fortnight."

"Here! Oh, fatal illusion!"

"Alas! it is so. I have promised to be here to receive the answer to a letter I have just written. We have no violent proceedings to fear, but I cannot bear to remain in Parma."

"Ah! I curse the hour which brought us to this city. Would you like to go to Milan?"

"Yes."

"As we are unfortunately compelled to come back, we may as well take with us Caudagna and his sister."

"As you please."

"Let me arrange everything. I will order a carriage for them, and they will take charge of your violoncello. Do you not think that you ought to let M. d'Antoine know where we are going?"

"No, it seems to me, on the contrary, that I need not account to him for any of my proceedings. So much the worse for him if he should, even for one moment, doubt my word."

The next morning, we left Parma, taking only what we wanted for an absence of a fortnight. We arrived in Milan without accident, but both very sad, and we spent the following fifteen days in constant tete-a-tete, without speaking to anyone, except the landlord of the hotel and to a dressmaker. I presented my beloved Henriette with a magnificent pelisse made of lynx fur—a present which she prized highly.

Out of delicacy, she had never enquired about my means, and I felt grateful to her for that reserve. I was very careful to conceal from her the fact that my purse was getting very light. When we came back to Parma I had only three or four hundred sequins.

The day after our return M. d'Antoine invited himself to dine with us, and after we had drunk coffee, I left him alone with Henriette. Their interview was as long as the first, and our separation was decided. She informed me of it, immediately after the departure of M. d'Antoine, and for a long time we remained folded in each other's arms, silent, and blending our bitter tears.

"When shall I have to part from you, my beloved, alas! too much beloved one?"

"Be calm, dearest, only when we reach Geneva, whither you are going to accompany me. Will you try to find me a respectable maid by to-morrow? She will accompany me from Geneva to the place where I am bound to go."

"Oh! then, we shall spend a few days more together! I know no one but Dubois whom I could trust to procure a good femme-de-chambre; only I do not want him to learn from her what you might not wish him to know."

"That will not be the case, for I will take another maid as soon as I am in France."

Three days afterwards, Dubois, who had gladly undertaken the commission, presented to Henriette a woman already somewhat advanced in years, pretty well dressed and respectable-looking, who, being poor, was glad of an opportunity of going back to France, her native country. Her husband, an old military officer, had died a few months before, leaving her totally unprovided for. Henriette engaged her, and told her to keep herself ready to start whenever M. Dubois should give her notice. The day before the one fixed for our departure, M. d'Antoine dined with us, and, before taking leave of us, he gave Henriette a sealed letter for Geneva.

We left Parma late in the evening, and stopped only two hours in Turin, in order to engage a manservant whose services we required as far as Geneva. The next day we ascended Mont Cenis in sedan-chairs, and we descended to the Novalaise in mountain-sledges. On the fifth day we reached Geneva, and we put up at the Hotel des Balances. The next morning, Henriette gave me a letter for the banker Tronchin, who, when he had read it, told me that he would call himself at the hotel, and bring me one thousand louis d'or.

I came back and we sat down to dinner. We had not finished our meal when the banker was announced. He had brought the thousand louis d'or, and told Henriette that he would give her two men whom he could recommend in every way.

She answered that she would leave Geneva as soon as she had the carriage which he was to provide for her, according to the letter I had delivered to him. He promised that everything would be ready for the following day, and he left us. It was indeed a terrible moment! Grief almost benumbed us both. We remained motionless, speechless, wrapped up in the most profound despair.

I broke that sad silence to tell her that the carriage which M. Tronchin would provide could not possibly be as comfortable and as safe as mine, and I entreated her to take it, assuring her that by accepting it she would give me a last proof of her affection.

"I will take in exchange, my dearest love, the carriage sent by the banker."

"I accept the change, darling," she answered, "it will be a great consolation to possess something which has belonged to you."

As she said these words, she slipped in my pocket five rolls containing each one hundred louis d'or—a slight consolation for my heart, which was almost broken by our cruel separation! During the last twenty-four hours we could boast of no other eloquence but that which finds expression in tears, in sobs, and in those hackneyed but energetic exclamations, which two happy lovers are sure to address to reason, when in its sternness it compels them to part from one another in the very height of their felicity. Henriette did not endeavour to lure me with any hope for the future, in order to allay my sorrow! Far from that, she said to me,

"Once we are parted by fate, my best and only friend, never enquire after me, and, should chance throw you in my way, do not appear to know me."

She gave me a letter for M. d'Antoine, without asking me whether I intended to go back to Parma, but, even if such had not been my intention, I should have determined at once upon returning to that city. She likewise entreated me not to leave Geneva until I had received a letter which she promised to, write to me from the first stage on her journey. She started at day-break, having with her a maid, a footman on the box of the carriage, and being preceded by a courier on horseback. I followed her with my eyes as long as I could, see her carriage, and I was still standing on the same spot long after my eyes had lost sight of it. All my thoughts were wrapped up in the beloved object I had lost for ever. The world was a blank!

I went back to my room, ordered the waiter not to disturb me until the return of the horses which had drawn Henriette's carriage, and I lay down on my bed in the hope that sleep would for a time silence a grief which tears could not drown.

The postillion who had driven Henriette did not return till the next day; he had gone as far as Chatillon. He brought me a letter in which I found one single word: Adieu! He told me that they had reached Chatillon without accident, and that the lady had immediately continued her journey towards Lyons. As I could not leave Geneva until the following day, I spent alone in my room some of the most melancholy hours of my life. I saw on one of the panes of glass of a window these words which she had traced with the point of a diamond I had given her: "You will forget Henriette." That prophecy was not likely to afford me any consolation. But had she attached its full meaning to the word "forget?" No; she could only mean that time would at last heal the deep wounds of my heart, and she ought not to have made it deeper by leaving behind her those words which sounded like a reproach. No, I have not forgotten her, for even now, when my head is covered with white hair, the recollection of her is still a source of happiness for my heart! When I think

that in my old age I derive happiness only from my recollections of the past, I find that my long life must have counted more bright than dark days, and offering my thanks to God, the Giver of all, I congratulate myself, and confess that life is a great blessing.

The next day I set off again for Italy with a servant recommended by M. Tronchin, and although the season was not favourable I took the road over Mont St. Bernard, which I crossed in three days, with seven mules carrying me, my servant, my luggage, and the carriage sent by the banker to the beloved woman now for ever lost to me. One of the advantages of a great sorrow is that nothing else seems painful. It is a sort of despair which is not without some sweetness. During that journey I never felt either hunger or thirst, or the cold which is so intense in that part of the Alps that the whole of nature seems to turn to ice, or the fatigue inseparable from such a difficult and dangerous journey.

I arrived in Parma in pretty good health, and took up my quarters at a small inn, in the hope that in such a place I should not meet any acquaintance of mine. But I was much disappointed, for I found in that inn M. de la Haye, who had a room next to mine. Surprised at seeing me, he paid me a long compliment, trying to make me speak, but I eluded his curiosity by telling him that I was tired, and that we would see each other again.

On the following day I called upon M. d'Antoine, and delivered the letter which Henriette had written to him. He opened it in my presence, and finding another to my address enclosed in his, he handed it to me without reading it, although it was not sealed. Thinking, however, that it might have been Henriette's intention that he should read it because it was open, he asked my permission to do so, which I granted with pleasure as soon as I had myself perused it. He handed it back to me after he had read it, telling me very feelingly that I could in everything rely upon him and upon his influence and credit.

Here is Henriette's letter

"It is I, dearest and best friend, who have been compelled to abandon you, but do not let your grief be increased by any thought of my sorrow. Let us be wise enough to suppose that we have had a happy dream, and not to complain of destiny, for never did so beautiful a dream last so long! Let us be proud of the consciousness that for three months we gave one another the most perfect felicity. Few human beings can boast of so much! Let us swear never to forget one another, and to often remember the happy hours of our love, in order to renew them in our souls, which, although divided, will enjoy them as acutely as if our hearts were beating one against the other. Do not

make any enquiries about me, and if chance should let you know who I am, forget it for ever. I feel certain that you will be glad to hear that I have arranged my affairs so well that I shall, for the remainder of my life, be as happy as I can possibly be without you, dear friend, by my side. I do not know who you are, but I am certain that no one in the world knows you better than I do. I shall not have another lover as long as I live, but I do not wish you to imitate me. On the contrary I hope that you will love again, and I trust that a good fairy will bring along your path another Henriette. Farewell . . . farewell."

. .

I met that adorable woman fifteen years later; the reader will see where and how, when we come to that period of my life.

. .

I went back to my room, careless of the future, broken down by the deepest of sorrows, I locked myself in, and went to bed. I felt so low in spirits that I was stunned. Life was not a burden, but only because I did not give a thought to life. In fact I was in a state of complete apathy, moral and physical. Six years later I found myself in a similar predicament, but that time love was not the cause of my sorrow; it was the horrible and too famous prison of The Leads, in Venice.

I was not much better either in 1768, when I was lodged in the prison of Buen Retiro, in Madrid, but I must not anticipate events. At the end of twenty-four hours, my exhaustion was very great, but I did not find the sensation disagreeable, and, in the state of mind in which I was then, I was pleased with the idea that, by increasing, that weakness would at last kill me. I was delighted to see that no one disturbed me to offer me some food, and I congratulated myself upon having dismissed my servant. Twenty-four more hours passed by, and my weakness became complete inanition.

I was in that state when De la Haye knocked at my door. I would not have answered if he had not said that someone insisted upon seeing me. I got out of bed, and, scarcely able to stand, I opened my door, after which I got into bed again.

"There is a stranger here," he said, "who, being in want of a carriage, offers to buy yours"

"I do not want to sell it."

"Excuse me if I have disturbed you, but you look ill."

"Yes, I wish to be left alone."

"What is the matter with you?"

Coming nearer my bed, he took my hand, and found my pulse extremely low and weak.

"What did you eat yesterday?"

"I have eaten nothing, thank God I for two days."

Guessing the real state of things, De la Haye became anxious, and entreated me to take some broth. He threw so much kindness, so much unction, into his entreaties that, through weakness and weariness, I allowed myself to be persuaded. Then, without ever mentioning the name of Henriette, he treated me to a sermon upon the life to come, upon the vanity of the things of this life which we are foolish enough to prefer, and upon the necessity of respecting our existence, which does not belong to us.

I was listening without answering one word, but, after all, I was listening, and De la Haye, perceiving his advantage, would not leave me, and ordered dinner. I had neither the will nor the strength to resist, and when the dinner was served, I ate something. Then De la Have saw that he had conquered, and for the remainder of the day devoted himself to amusing me by his cheerful conversation.

The next day the tables were turned, for it was I who invited him to keep me company and to dine with me. It seemed to me that I had not lost a particle of my sadness, but life appeared to me once more preferable to death, and, thinking that I was indebted to him for the preservation of my life, I made a great friend of him. My readers will see presently that my affection for him went very far, and they will, like me, marvel at the cause of that friendship, and at the means through which it was brought about.

Three or four days afterwards, Dubois, who had been informed of everything by De la Haye, called on me, and persuaded me to go out. I went to the theatre, where I made the acquaintance of several Corsican officers, who had served in France, in the Royal Italian regiment. I also met a young man from Sicily, named Paterno, the wildest and most heedless fellow it was possible to see. He was in love with an actress who made a fool of him. He amused me with the enumeration of all her adorable qualities, and of all the cruelties she was practising upon him, for, although she received him at all hours, she repulsed him harshly whenever he tried to steal the slightest favour. In the mean time, she ruined him by making him pay constantly for excellent dinners and suppers, which were eaten by her family, but which did not advance him one inch towards the fulfilment of his wishes.

He succeeded at last in exciting my curiosity. I examined the actress on the stage, and finding that she was not without beauty I expressed a wish to know her. Paterno was delighted to introduce me to her.

I found that she was of tolerably easy virtue, and, knowing that she was very far from rolling in riches, I had no doubt that fifteen or twenty sequins would be quite sufficient to make her compliant. I communicated my thoughts to Paterno, but he laughed and told me that, if I dared to make such a proposition to her, she would certainly shut her door against me. He named several officers whom she had refused to receive again, because they had made similar offers.

"Yet," added the young man, "I wish you would make the attempt, and tell me the result candidly."

I felt piqued, and promised to do it.

I paid her a visit in her dressing-room at the theatre, and as she happened during our conversation to praise the beauty of my watch, I told her that she could easily obtain possession of it, and I said at what price. She answered, according to the catechism of her profession, that an honourable man had no right to make such an offer to a respectable girl.

"I offer only one ducat," said I, "to those who are not respectable."

And I left her.

When I told Paterno what had occurred, he fairly jumped for joy, but I knew what to think of it all, for 'cosi sono tutte', and in spite of all his entreaties, I declined to be present at his suppers, which were far from amusing, and gave the family of the actress an opportunity of laughing at the poor fool who was paying for them.

Seven or eight days afterwards, Paterno told me that the actress had related the affair to him exactly in the same words which I had used, and she had added that, if I had ceased my visits, it was only because I was afraid of her taking me at my word in case I should renew my proposal. I commissioned him to tell her that I would pay her another visit, not to renew my offer, but to shew my contempt for any proposal she might make me herself.

The heedless fellow fulfilled his commission so well that the actress, feeling insulted, told him that she dared me to call on her. Perfectly determined to shew that I despised her, I went to her dressing-room the same evening, after the second act of a play in which she had not to appear again. She dismissed those who were with her, saying that she wanted to speak with me, and, after she had bolted the door, she sat down gracefully on my knees, asking me whether it was true that I despised her so much.

In such a position a man has not the courage to insult a woman, and, instead of answering, I set to work at once, without meeting even with that show of resistance which sharpens the appetite. In spite of that, dupe as I always was of a feeling truly absurd when an intelligent man has to deal with

such creatures, I gave her twenty sequins, and I confess that it was paying dearly for very smarting regrets. We both laughed at the stupidity of Paterno, who did not seem to know how such challenges generally end.

I saw the unlucky son of Sicily the next morning, and I told him that, having found the actress very dull, I would not see her again. Such was truly my intention, but a very important reason, which nature took care to explain to me three days afterwards, compelled me to keep my word through a much more serious motive than a simple dislike for the woman.

However, although I was deeply grieved to find myself in such a disgraceful position, I did not think I had any right to complain. On the contrary, I considered that my misfortune to be a just and well-deserved punishment for having abandoned myself to a Lais, after I had enjoyed the felicity of possessing a woman like Henriette.

My disease was not a case within the province of empirics, and I bethought myself of confiding in M. de is Haye who was then dining every day with me, and made no mystery of his poverty. He placed me in the hands of a skilful surgeon, who was at the same time a dentist. He recognized certain symptoms which made it a necessity to sacrifice me to the god Mercury, and that treatment, owing to the season of the year, compelled me to keep my room for six weeks. It was during the winter of 1749.

While I was thus curing myself of an ugly disease, De la Haye inoculated me with another as bad, perhaps even worse, which I should never have thought myself susceptible of catching. This Fleming, who left me only for one hour in the morning, to go—at least he said so—to church to perform his devotions, made a bigot of me! And to such an extent, that I agreed with him that I was indeed fortunate to have caught a disease which was the origin of the faith now taking possession of my soul. I would thank God fervently and with the most complete conviction for having employed Mercury to lead my mind, until then wrapped in darkness, to the pure light of holy truth! There is no doubt that such an extraordinary change in my reasoning system was the result of the exhaustion brought on by the mercury. That impure and always injurious metal had weakened my mind to such an extent that I had become almost besotted, and I fancied that until then my judgment had been insane. The result was that, in my newly acquired wisdom, I took the resolution of leading a totally different sort of life in future. De la Haye would often cry for joy when he saw me shedding tears caused by the contrition which he had had the wonderful cleverness to sow in my poor sickly soul. He would talk to me of paradise and the other world, just as if he had visited them in person, and I never laughed at him! He had accustomed me to renounce my reason; now

to renounce that divine faculty a man must no longer be conscious of its value, he must have become an idiot. The reader may judge of the state to which I was reduced by the following specimen. One day, De la Haye said to me:

"It is not known whether God created the world during the vernal equinox or during the autumnal one."

"Creation being granted," I replied, in spite of the mercury, "such a question is childish, for the seasons are relative, and differ in the different quarters of the globe."

De la Haye reproached me with the heathenism of my ideas, told me that I must abandon such impious reasonings.... and I gave way!

That man had been a Jesuit. He not only, however, refused to admit it, but he would not even suffer anyone to mention it to him. This is how he completed his work of seduction by telling me the history of his life.

"After I had been educated in a good school," he said, "and had devoted myself with some success to the arts and sciences, I was for twenty years employed at the University of Paris. Afterwards I served as an engineer in the army, and since that time I have published several works anonymously, which are now in use in every boys' school. Having given up the military service, and being poor, I undertook and completed the education of several young men, some of whom shine now in the world even more by their excellent conduct than by their talents. My last pupil was the Marquis Botta. Now being without employment I live, as you see, trusting in God's providence. Four years ago, I made the acquaintance of Baron Bavois, from Lausanne, son of General Bavois who commanded a regiment in the service of the Duke of Modem, and afterwards was unfortunate enough to make himself too conspicuous. The young baron, a Calvinist like his father, did not like the idle life he was leading at home, and he solicited me to undertake his education in order to fit him for a military career. Delighted at the opportunity of cultivating his fine natural disposition, I gave up everything to devote myself entirely to my task. I soon discovered that, in the question of faith, he knew himself to be in error, and that he remained a Calvinist only out of respect to his family. When I had found out his secret feelings on that head, I had no difficulty in proving to him that his most important interests were involved in that question, as his eternal salvation was at stake. Struck by the truth of my words, he abandoned himself to my affection, and I took him to Rome, where I presented him to the Pope, Benedict XIV., who, immediately after the abjuration of my pupil got him a lieutenancy in the army of the Duke of Modena. But the dear proselyte, who is only twenty-five years of age, cannot

live upon his pay of seven sequins a month, and since his abjuration he has received nothing from his parents, who are highly incensed at what they call his apostasy. He would find himself compelled to go back to Lausanne, if I did not assist him. But, alas! I am poor, and without employment, so I can only send him the trifling sums which I can obtain from the few good Christians with whom I am acquainted.

"My pupil, whose heart is full of gratitude, would be very glad to know his benefactors, but they refuse to acquaint him with their names, and they are right, because charity, in order to be meritorious, must not partake of any feeling of vanity. Thank God, I have no cause for such a feeling! I am but too happy to act as a father towards a young saint, and to have had a share, as the humble instrument of the Almighty, in the salvation of his soul. That handsome and good young man trusts no one but me, and writes to me regularly twice a week. I am too discreet to communicate his letters to you, but, if you were to read them, they would make you weep for sympathy. It is to him that I have sent the three gold pieces which you gave me yesterday."

As he said the last words my converter rose, and went to the window to dry his tears, I felt deeply moved, anal full of admiration for the virtue of De la Haye and of his pupil, who, to save his soul, had placed himself under the hard necessity of accepting alms. I cried as well as the apostle, and in my dawning piety I told him that I insisted not only upon remaining unknown to his pupil, but also upon ignoring the amount of the sums he might take out of my purse to forward to him, and I therefore begged that he would help himself without rendering me any account. De la Haye embraced me warmly, saying that, by following the precepts of the Gospel so well, I should certainly win the kingdom of heaven.

The mind is sure to follow the body; it is a privilege enjoyed by matter. With an empty stomach, I became a fanatic; and the hollow made in my brain by the mercury became the home of enthusiasm. Without mentioning it to De la Haye, I wrote to my three friends, Messrs. Bragadin and company, several letters full of pathos concerning my Tartufe and his pupil, and I managed to communicate my fanaticism to them. You are aware, dear reader, that nothing is so catching as the plague; now, fanaticism, no matter of what nature, is only the plague of the human mind.

I made my friends to understand that the good of our society depended upon the admission of these two virtuous individuals. I allowed them to guess it, but, having myself became a Jesuit, I took care not to say it openly. It would of course be better if such an idea appeared to have emanated from those men, so simple, and at the same time so truly virtuous. "It is God's will," I

wrote to them (for deceit must always take refuge under the protection of that sacred name), "that you employ all your influence in Venice to find an honourable position for M. de la Haye, and to promote the interests of young M. Bavois in his profession."

M. de Bragadin answered that De la Haye could take up his quarters with us in his palace, and that Bavois was to write to his protector, the Pope, entreating His Holiness to recommend him to the ambassador of Venice, who would then forward that recommendation to the Senate, and that Bavois could, in that way, feel sure of good employment.

The affair of the Patriarchate of Aquileia was at that time under discussion; the Republic of Venice was in possession of it as well as the Emperor of Austria, who claimed the 'jus eligendi': the Pope Benedict XIV. had been chosen as arbitrator, and as he had not yet given his decision it was evident that the Republic would shew very great deference to his recommendation.

While that important affair was enlisting all our sympathies, and while they were expecting in Venice a letter stating the effect of the Pope's recommendation, I was the hero of a comic adventure which, for the sake of my readers, must not pass unnoticed.

At the beginning of April I was entirely cured of my last misfortune. I had recovered all my usual vigour, and I accompanied my converter to church every day, never missing a sermon. We likewise spent the evening together at the cafe, where we generally met a great many officers. There was among them a Provencal who amused everybody with his boasting and with the recital of the military exploits by which he pretended to have distinguished himself in the service of several countries, and principally in Spain. As he was truly a source of amusement, everybody pretended to believe him in order to keep up the game. One day as I was staring at him, he asked me whether I knew him.

"By George, sir!"—I exclaimed, "know you! Why, did we not fight side by side at the battle of Arbela?"

At those words everybody burst out laughing, but the boaster, nothing daunted, said, with animation,

"Well, gentlemen, I do not see anything so very laughable in that. I was at that battle, and therefore this gentleman might very well have remarked me; in fact, I think I can recollect him."

And, continuing to speak to me, he named the regiment in which we were brother officers. Of course we embraced one another, congratulating each other upon the pleasure we both felt in meeting again in Parma. After that

truly comic joke I left the coffee-room in the company of my inseparable preacher.

The next morning, as I was at breakfast with De la Haye, the boasting Provencal entered my room without taking off his hat, and said,

"M. d'Arbela, I have something of importance to tell you; make haste and follow me. If you are afraid, you may take anyone you please with you. I am good for half a dozen men."

I left my chair, seized my pistols, and aimed at him.

"No one," I said, with decision, "has the right to come and disturb me in my room; be off this minute, or I blow your brains out."

The fellow, drawing his sword, dared me to murder him, but at the same moment De la Haye threw himself between us, stamping violently on the floor. The landlord came up, and threatened the officer to send for the police if he did not withdraw immediately.

He went away, saying that I had insulted him in public, and that he would take care that the reparation I owed him should be as public as the insult.

When he had gone, seeing that the affair might take a tragic turn, I began to examine with De la Haye how it could be avoided, but we had not long to puzzle our imagination, for in less than half an hour an officer of the Infante of Parma presented himself, and requested me to repair immediately to head-quarters, where M. de Bertolan, Commander of Parma, wanted to speak to me.

I asked De la Haye to accompany me as a witness of what I had said in the coffee-room as well as of what had taken place in my apartment.

I presented myself before the commander, whom I found surrounded by several officers, and, among them, the bragging Provencal.

M. de Bertolan, who was a witty man, smiled when he saw me; then, with a very serious countenance, he said to me,

"Sir, as you have made a laughing-stock of this officer in a public place, it is but right that you should give him publicly the satisfaction which he claims, and as commander of this city I find myself bound in duty to ask you for that satisfaction in order to settle the affair amicably."

"Commander," I answered, "I do not see why a satisfaction should be offered to this gentleman, for it is not true that I have insulted him by turning him into ridicule. I told him that I had seen him at the battle of Arbela, and I could not have any doubt about it when he said that he had been present at that battle, and that he knew me again."

"Yes," interrupted the officer, "but I heard Rodela and not Arbela, and everybody knows that I fought at Rodela. But you said Arbela, and certainly with the intention of laughing at me, since that battle has been fought more

than two thousand years ago, while the battle of Rodela in Africa took place in our time, and I was there under the orders of the Duke de Mortemar."

"In the first place, sir, you have no right to judge of my intentions, but I do not dispute your having been present at Rodela, since you say so; but in that case the tables are turned, and now I demand a reparation from you if you dare discredit my having been at Arbela. I certainly did not serve under the Duke de Mortemar, because he was not there, at least to my knowledge, but I was aid-de-camp of Parmenion, and I was wounded under his eyes. If you were to ask me to shew you the scar, I could not satisfy you, for you must understand that the body I had at that time does not exist any longer, and in my present bodily envelope I am only twenty-three years old."

"All this seems to me sheer madness, but, at all events, I have witnesses to prove that you have been laughing at me, for you stated that you had seen me at that battle, and, by the powers! it is not possible, because I was not there. At all events, I demand satisfaction."

"So do I, and we have equal rights, if mine are not even better than yours, for your witnesses are likewise mine, and these gentlemen will assert that you said that you had seen me at Rodela, and, by the powers! it is not possible, for I was not there."

"Well, I may have made a mistake."

"So may I, and therefore we have no longer any claim against one another."

The commander, who was biting his lips to restrain his mirth, said to him,

"My dear sir, I do not see that you have the slightest right to demand satisfaction, since this gentleman confesses, like you, that he might have been mistaken."

"But," remarked the officer, "is it credible that he was at the battle of Arbela?"

"This gentleman leaves you free to believe or not to believe, and he is at liberty to assert that he was there until you can prove the contrary. Do you wish to deny it to make him draw his sword?"

"God forbid! I would rather consider the affair ended."

"Well, gentlemen," said the commander, "I have but one more duty to perform, and it is to advise you to embrace one another like two honest men."

We followed the advice with great pleasure.

The next day, the Provencal, rather crestfallen, came to share my dinner, and I gave him a friendly welcome. Thus was ended that comic adventure, to the great satisfaction of M. de la Haye.

CHAPTER IV

I Receive Good News From Venice, to Which City I Return with
De la Haye and Bavois—My Three Friends Give Me a Warm
Welcome; Their Surprise at Finding Me a Model of Devotion—
Bavois Lures Me Back to My Former Way of Living—De la Haye
a Thorough Hypocrite—Adventure with the Girl Marchetti—
I Win a Prize in the Lottery—I Meet Baletti—De la Haye
Leaves M. de Bragadin's Palace—My Departure for Paris

Whilst De la Haye was every day gaining greater influence over my weakened mind, whilst I was every day devoutly attending mass, sermons, and every office of the Church, I received from Venice a letter containing the pleasant information that my affair had followed its natural course, namely, that it was entirely forgotten; and in another letter M. de Bragadin informed me that the minister had written to the Venetian ambassador in Rome with instructions to assure the Holy Father that Baron Bavois would, immediately after his arrival in Venice, receive in the army of the Republic an appointment which would enable him to live honourably and to gain a high position by his talents.

That letter overcame M. de la Haye with joy, and I completed his happiness by telling him that nothing hindered me from going back to my native city.

He immediately made up his mind to go to Modena in order to explain to his pupil how he was to act in Venice to open for himself the way to a brilliant fortune. De la Haye depended on me in every way; he saw my fanaticism, and he was well aware that it is a disease which rages as long as the causes from which it has sprung are in existence. As he was going with me to Venice, he flattered himself that he could easily feed the fire he had lighted. Therefore he wrote to Bavois that he would join him immediately, and two days after he took leave of me, weeping abundantly, praising highly the virtues of my soul, calling me his son, his dear son, and assuring me that his great affection for me had been caused by the mark of election which he had seen on my countenance. After that, I felt my calling and election were sure.

A few days after the departure of De la Haye, I left Parma in my carriage with which I parted in Fusina, and from there I proceeded to Venice. After an absence of a year, my three friends received me as if I had been their guardian angel. They expressed their impatience to welcome the two saints announced by my letters. An apartment was ready for De la Haye in the

palace of M. de Bragadin, and as state reasons did not allow my father to receive in his own house a foreigner who had not yet entered the service of the Republic, two rooms had been engaged for Bavois in the neighbourhood.

They were thoroughly amazed at the wonderful change which had taken place in my morals. Every day attending mass, often present at the preaching and at the other services, never shewing myself at the casino, frequenting only a certain cafe which was the place of meeting for all men of acknowledged piety and reserve, and always studying when I was not in their company. When they compared my actual mode of living with the former one, they marvelled, and they could not sufficiently thank the eternal providence of God whose inconceivable ways they admired. They blessed the criminal actions which had compelled me to remain one year away from my native place. I crowned their delight by paying all my debts without asking any money from M. de Bragadin, who, not having given me anything for one year, had religiously put together every month the sum he had allowed me. I need not say how pleased the worthy friends were, when they saw that I had entirely given up gambling.

I had a letter from De la Haye in the beginning of May. He announced that he was on the eve of starting with the son so dear to his heart, and that he would soon place himself at the disposition of the respectable men to whom I had announced him.

Knowing the hour at which the barge arrived from Modena, we all went to meet them, except M. de Bragadin, who was engaged at the senate. We returned to the palace before him, and when he came back, finding us all together, he gave his new guests the most friendly welcome. De la Haye spoke to me of a hundred things, but I scarcely heard what he said, so much was my attention taken up by Bavois. He was so different to what I had fancied him to be from the impression I had received from De la Haye, that my ideas were altogether upset. I had to study him; for three days before I could make up my mind to like him. I must give his portrait to my readers.

Baron Bavois was a young man of about twenty-five, of middle size, handsome in features, well made, fair, of an equable temper, speaking well and with intelligence, and uttering his words with a tone of modesty which suited him exactly. His features were regular and pleasing, his teeth were beautiful, his hair was long and fine, always well taken care of, and exhaling the perfume of the pomatum with which it was dressed. That individual, who was the exact opposite of the man that De la Haye had led me to imagine, surprised my friends greatly, but their welcome did not in any way betray their astonishment, for their pure and candid minds would not admit a judgment

contrary to the good opinion they had formed of his morals. As soon as we had established De la Haye in his beautiful apartment, I accompanied Bavois to the rooms engaged for him, where his luggage had been sent by my orders. He found himself in very comfortable quarters, and being received with distinction by his worthy host, who was already greatly prejudiced in his favour, the young baron embraced me warmly, pouring out all his gratitude, and assuring me that he felt deeply all I had done for him without knowing him, as De la Haye had informed him of all that had occurred. I pretended not to understand what he was alluding to, and to change the subject of conversation I asked him how he intended to occupy his time in Venice until his military appointment gave him serious duties to perform. "I trust," he answered, "that we shall enjoy ourselves in an agreeable way, for I have no doubt that our inclinations are the same."

Mercury and De la Haye had so completely besotted me that I should have found some difficulty in understanding these words, however intelligible they were; but if I did not go any further than the outward signification of his answer, I could not help remarking that he had already taken the fancy of the two daughters of the house. They were neither pretty nor ugly, but he shewed himself gracious towards them like a man who understands his business. I had, however, already made such great progress in my mystical education, that I considered the compliments he addressed to the girls as mere forms of politeness.

For the first day, I took my young baron only to the St. Mark's Square and to the cafe, where we remained until supper-time, as it had been arranged that he would take his meals with us. At the supper-table he shewed himself very witty, and M. Dandolo named an hour for the next day, when he intended to present him to the secretary for war. In the evening I accompanied him to his lodging, where I found that the two young girls were delighted because the young Swiss nobleman had no servant, and because they hoped to convince him that he would not require one.

The next day, a little earlier than the time appointed, I called upon him with M. Dandolo and M. Barbaro, who were both to present him at the war office. We found him at his toilet under the delicate hands of the eldest girl, who was dressing his hair. His room, was fragrant with the perfumes of his pomatums and scents. This did not indicate a sainted man; yet my two friends did not feel scandalized, although their astonishment was very evident, for they had not expected that show of gallantry from a young neophyte. I was nearly bursting into a loud laugh, when I heard M. Dandolo remark that, unless we hurried, we would not have time to hear mass, whereupon Bavois

enquired whether it was a festival. M. Dandolo, without passing any remark, answered negatively, and after that, mass was not again mentioned. When Bavois was ready, I left them and went a different way. I met them again at dinner-time, during which the reception given to the young baron by the secretary was discussed, and in the evening my friends introduced him to several ladies who were much pleased with him. In less than a week he was so well known that there was no fear of his time hanging wearily on his hands, but that week was likewise enough to give me a perfect insight into his nature and way of thinking. I should not have required such a long study, if I had not at first begun on a wrong scent, or rather if my intelligence had not been stultified by my fanaticism. Bavois was particularly fond of women, of gambling, of every luxury, and, as he was poor, women supplied him with the best part of his resources. As to religious faith he had none, and as he was no hypocrite he confessed as much to me.

"How have you contrived," I said to him one day, "such as you are, to deceive De la Haye?"

"God forbid I should deceive anyone. De la Haye is perfectly well aware of my system, and of my way of thinking on religious matters, but, being himself very devout, he entertains a holy sympathy for my soul, and I do not object to it. He has bestowed many kindnesses upon me, and I feel grateful to him; my affection for him is all the greater because he never teases me with his dogmatic lessons or with sermons respecting my salvation, of which I have no doubt that God, in His fatherly goodness, will take care. All this is settled between De la Haye and me, and we live on the best of terms:"

The best part of the joke is that, while I was studying him, Bavois, without knowing it, restored my mind to its original state, and I was ashamed of myself when I realized that I had been the dupe of a Jesuit who was an arrant hypocrite, in spite of the character of holiness which he assumed, and which he could play with such marvellous ability. From that moment I fell again into all my former practices. But let us return to De la Haye.

That late Jesuit, who in his inmost heart loved nothing but his own comfort, already advanced in years, and therefore no longer caring for the fair sex, was exactly the sort of man to please my simpleminded trio of friends. As he never spoke to them but of God, of His angels, and of everlasting glory, and as he was always accompanying them to church, they found him a delightful companion. They longed for the time when he would discover himself, for they imagined he was at the very least a Rosicrucian, or perhaps the hermit of Courpegna, who had taught me the cabalistic science and made me a present of the immortal Paralis. They felt grieved because the oracle had

forbidden them, through my cabalistic lips, ever to mention my science in the presence of Tartufe.

As I had foreseen, that interdiction left me to enjoy as I pleased all the time that I would have been called upon to devote to their devout credulity, and besides, I was naturally afraid lest De la Haye, such as I truly believed him to be, would never lend himself to that trifling nonsense, and would, for the sake of deserving greater favour at their hands, endeavour to undeceive them and to take my place in their confidence.

I soon found out that I had acted with prudence, for in less than three weeks the cunning fox had obtained so great an influence over the mind of my three friends that he was foolish enough, not only to believe that he did not want me any more to support his credit with them, but likewise that he could supplant me whenever he chose. I could see it clearly in his way of addressing me, as well as in the change in his proceedings.

He was beginning to hold with my friends frequent conversations to which I was not summoned, and he had contrived to make them introduce him to several families which I was not in the habit of visiting. He assumed his grand jesuitic airs, and, although with honeyed word he would take the liberty of censuring me because I sometimes spent a night out, and, as he would say, "God knows where!"

I was particularly vexed at his seeming to accuse me of leading his pupil astray. He then would assume the tone of a man speaking jestingly, but I was not deceived. I thought it was time to put an end to his game, and with that intention I paid him a visit in his bedroom. When I was seated, I said,

"I come, as a true worshipper of the Gospel, to tell you in private something that, another time, I would say in public."

"What is it, my dear friend?"

"I advise you for the future not to hurl at me the slightest taunt respecting the life I am leading with Bavois, when we are in the presence of my three worthy friends. I do not object to listen to you when we are alone."

"You are wrong in taking my innocent jests seriously."

"Wrong or right, that does not matter. Why do you never attack your proselyte? Be careful for the future, or I might on my side, and only in jest like you, throw at your head some repartee which you have every reason to fear, and thus repay you with interest."

And bowing to him I left his room.

A few days afterwards I spent a few hours with my friends and Paralis, and the oracle enjoined them never to accomplish without my advice anything that might be recommended or even insinuated by Valentine; that was the

cabalistic name of the disciple of Escobar. I knew I could rely upon their obedience to that order.

De la Haye soon took notice of some slight change; he became more reserved, and Bavois, whom I informed of what I had done, gave me his full approbation. He felt convinced, as I was, that De la Haye had been useful to him only through weak or selfish reasons, that is, that he would have cared little for his soul if his face had not been handsome, and if he had not known that he would derive important advantages from having caused his so-called conversion.

Finding that the Venetian government was postponing his appointment from day to day, Bavois entered the service of the French ambassador. The decision made it necessary for him not only to cease his visits to M. de Bragadin, but even to give up his intercourse with De la Haye, who was the guest of that senator.

It is one of the strictest laws of the Republic that the patricians and their families shall not hold any intercourse with the foreign ambassadors and their suites. But the decision taken by Bavois did not prevent my friends speaking in his favour, and they succeeded in obtaining employment for him, as will be seen further on.

The husband of Christine, whom I never visited, invited me to go to the casino which he was in the habit of frequenting with his aunt and his wife, who had already presented him with a token of their mutual affection. I accepted his invitation, and I found Christine as lovely as ever, and speaking the Venetian dialect like her husband. I made in that casino the acquaintance of a chemist, who inspired me with the wish to follow a course of chemistry. I went to his house, where I found a young girl who greatly pleased me. She was a neighbour, and came every evening to keep the chemist's elderly wife company, and at a regular hour a servant called to take her home. I had never made love to her but once in a trifling sort of way, and in the presence of the old lady, but I was surprised not to see her after that for several days, and I expressed my astonishment. The good lady told me that very likely the girl's cousin, an abbe, with whom she was residing, had heard of my seeing her every evening, had become jealous, and would not allow her to come again.

"An abbe jealous?"

"Why not? He never allows her to go out except on Sundays to attend the first mass at the Church of Santa Maria Mater Domini, close by his dwelling. He did not object to her coming here, because he knew that we never had any visitors, and very likely he has heard through the servant of your being here every evening."

A great enemy to all jealous persons, and a greater friend to my amorous fancies, I wrote to the young girl that, if she would leave her cousin for me, I would give her a house in which she should be the mistress, and that I would surround her with good society and with every luxury to be found in Venice. I added that I would be in the church on the following Sunday to receive her answer.

I did not forget my appointment, and her answer was that the abbe being her tyrant, she would consider herself happy to escape out of his clutches, but that she could not make up her mind to follow me unless I consented to marry her. She concluded her letter by saying that, in case I entertained honest intentions towards her, I had only to speak to her mother, Jeanne Marchetti, who resided in Lusia, a city thirty miles distant from Venice.

This letter piqued my curiosity, and I even imagined that she had written it in concert with the abbe. Thinking that they wanted to dupe me, and besides, finding the proposal of marriage ridiculous, I determined on having my revenge. But I wanted to get to the bottom of it, and I made up my mind to see the girl's mother. She felt honoured by my visit, and greatly pleased when, after I had shewn her her daughter's letter, I told her that I wished to marry her, but that I should never think of it as long as she resided with the abbe.

"That abbe," she said, "is a distant relative. He used to live alone in his house in Venice, and two years ago he told me that he was in want of a housekeeper. He asked me to let my daughter go to him in that capacity, assuring me that in Venice she would have good opportunities of getting married. He offered to give me a deed in writing stating that, on the day of her marriage, he would give her all his furniture valued at about one thousand ducats, and the inheritance of a small estate, bringing one hundred ducats a year, which lie possesses here. It seemed to me a good bargain, and, my daughter being pleased with the offer, I accepted. He gave me the deed duly drawn by a notary, and my daughter went with him. I know that he makes a regular slave of her, but she chose to go. Nevertheless, I need not tell you that my most ardent wish is to see her married, for, as long as a girl is without a husband, she is too much exposed to temptation, and the poor mother cannot rest in peace."

"Then come to Venice with me. You will take your daughter out of the abbe's house, and I will make her my wife. Unless that is done I cannot marry her, for I should dishonour myself if I received my wife from his hands."

"Oh, no! for he is my cousin, although only in the fourth degree, and, what is more, he is a priest and says the mass every day."

"You make me laugh, my good woman. Everybody knows that a priest says the mass without depriving himself of certain trifling enjoyments. Take your daughter with you, or give up all hope of ever seeing her married."

"But if I take her with me, he will not give her his furniture, and perhaps he will sell his small estate here."

"I undertake to look to that part of the business. I promise to take her out of his hands, and to make her come back to you with all the furniture, and to obtain the estate when she is my wife. If you knew me better, you would not doubt what I say. Come to Venice, and I assure you that you shall return here in four or five days with your daughter."

She read the letter which had been written to me by her daughter again, and told me that, being a poor widow, she had not the money necessary to pay the expenses of her journey to Venice, or of her return to Louisa.

"In Venice you shall not want for anything," I said; "in the mean time, here are ten sequins."

"Ten sequins! Then I can go with my sister-in-law?"

"Come with anyone you like, but let us go soon so as to reach Chiozza, where we must sleep. To-morrow we shall dine in Venice, and I undertake to defray all expenses."

We arrived in Venice the next day at ten o'clock, and I took the two women to Castello, to a house the first floor of which was empty. I left them there, and provided with the deed signed by the abbe I went to dine with my three friends, to whom I said that I had been to Chiozza on important business. After dinner, I called upon the lawyer, Marco de Lesse, who told me that if the mother presented a petition to the President of the Council of Ten, she would immediately be invested with power to take her daughter away with all the furniture in the house, which she could send wherever she pleased. I instructed him to have the petition ready, saying that I would come the next morning with the mother, who would sign it in his presence.

I brought the mother early in the morning, and after she had signed the petition we went to the Boussole, where she presented it to the President of the Council. In less than a quarter of an hour a bailiff was ordered to repair to the house of the priest with the mother, and to put her in possession of her daughter, and of all the furniture, which she would immediately take away.

The order was carried into execution to the very letter. I was with the mother in a gondola as near as possible to the house, and I had provided a large boat in which the sbirri stowed all the furniture found on the premises. When it was all done, the daughter was brought to the gondola, and she was extremely surprised to see me. Her mother kissed her, and told her that I

would be her husband the very next day. She answered that she was delighted, and that nothing had been left in her tyrant's house except his bed and his clothes.

When we reached Castello, I ordered the furniture to be brought out of the boat; we had dinner, and I told the three women that they must go back to Lusia, where I would join them as soon as I had settled all my affairs. I spent the afternoon gaily with my intended. She told us that the abbe was dressing when the bailiff presented the order of the Council of Ten, with injunctions to allow its free execution under penalty of death; that the abbe finished his toilet, went out to say his mass, and that everything had been done without the slightest opposition. "I was told," she added, "that my mother was waiting for me in the gondola, but I did not expect to find you, and I never suspected that you were at the bottom of the whole affair."

"It is the first proof I give you of my love."

These words made her smile very pleasantly.

I took care to have a good supper and some excellent wines, and after we had spent two hours at table in the midst of the joys of Bacchus, I devoted four more to a pleasant tete-a-tete with my intended bride.

The next morning, after breakfast, I had the whole of the furniture stowed in a peotta, which I had engaged for the purpose and paid for beforehand. I gave ten more sequins to the mother, and sent them away all three in great delight. The affair was completed to my honour as well as to my entire satisfaction, and I returned home.

The case had made so much noise that my friends could not have remained ignorant of it; the consequence was that, when they saw me, they shewed their surprise and sorrow. De la Haye embraced me with an air of profound grief, but it was a feigned feeling—a harlequin's dress, which he had the talent of assuming with the greatest facility. M. de Bragadin alone laughed heartily, saying to the others that they did not understand the affair, and that it was the forerunner of something great which was known only to heavenly spirits. On my side, being ignorant of the opinion they entertained of the matter, and certain that they were not informed of all the circumstances, I laughed like M. de Bragadin, but said nothing. I had nothing to fear, and I wanted to amuse myself with all that would be said.

We sat down to table, and M. Barbaro was the first to tell me in a friendly manner that he hoped at least that this was not the day after my wedding.

"Then people say that I am married?"

"It is said everywhere and by everybody. The members of the Council themselves believe it, and they have good reason to believe that they are right."

"To be right in believing such a thing, they ought to be certain of it, and those gentlemen have no such certainty. As they are not infallible any more than any one, except God, I tell you that they are mistaken. I like to perform good actions and to get pleasure for my money, but not at the expense of my liberty: Whenever you want to know my affairs, recollect that you can receive information about them only from me, and public rumour is only good to amuse fools."

"But," said M. Dandolo, "you spent the night with the person who is represented as your wife?"

"Quite true, but I have no account to give to anyone respecting what I have done last night. Are you not of my opinion, M. de la Haye?"

"I wish you would not ask my opinion, for I do not know. But I must say that public rumour ought not to be despised. The deep affection I have for you causes me to grieve for what the public voice says about you."

"How is it that those reports do not grieve M. de Bragadin, who has certainly greater affection for me than you have?"

"I respect you, but I have learned at my own expense that slander is to be feared. It is said that, in order to get hold of a young girl who was residing with her uncle—a worthy priest, you suborned a woman who declared herself to be the girl's mother, and thus deceived the Supreme Council, through the authority of which she obtained possession of the girl for you. The bailiff sent by the Council swears that you were in the gondola with the false mother when the young girl joined her. It is said that the deed, in virtue of which you caused the worthy ecclesiastic's furniture to be carried off, is false, and you are blamed for having made the highest body of the State a stepping-stone to crime. In fine, it is said that, even if you have married the girl, and no doubt of it is entertained, the members of the Council will not be silent as to the fraudulent means you have had recourse to in order to carry out your intentions successfully."

"That is a very long speech," I said to him, coldly, "but learn from me that a wise man who has heard a criminal accusation related with so many absurd particulars ceases to be wise when he makes himself the echo of what he has heard, for if the accusation should turn out to be a calumny, he would himself become the accomplice of the slanderer."

After that sentence, which brought the blood to the face of the Jesuit, but which my friends thought very wise, I entreated him, in a meaning voice, to

spare his anxiety about me, and to be quite certain that I knew the laws of honour, and that I had judgment enough to take care of myself, and to let foul tongues say what they liked about me, just as I did when I heard them speak ill of him.

The adventure was the talk of the city for five or six days, after which it was soon forgotten.

But three months having elapsed without my having paid any visit to Lusia, or having answered the letters written to me by the damigella Marchetti, and without sending her the money she claimed of me, she made up her mind to take certain proceedings which might have had serious consequences, although they had none whatever in the end.

One day, Ignacio, the bailiff of the dreaded tribunal of the State inquisitors, presented himself as I was sitting at table with my friends, De la Haye, and two other guests. He informed me that the Cavaliere Cantarini dal Zoffo wished to see me, and would wait for me the next morning at such an hour at the Madonna de l'Orto. I rose from the table and answered, with a bow, that I would not fail to obey the wishes of his excellency. The bailiff then left us.

I could not possibly guess what such a high dignitary of State could want with my humble person, yet the message made us rather anxious, for Cantarini dal Zoffo was one of the Inquisitors, that is to say, a bird of very ill omen. M. de Bragadin, who had been Inquisitor while he was Councillor, and therefore knew the habits of the tribunal, told me that I had nothing to fear.

"Ignacio was dressed in private clothes," he added, "and therefore he did not come as the official messenger of the dread tribunal. M. Cantarini wishes to speak to you only as a private citizen, as he sends you word to call at his palace and not at the court-house. He is an elderly man, strict but just, to whom you must speak frankly and without equivocating, otherwise you would make matters worse."

I was pleased with M. de Bragadin's advice, which was of great use to me. I called at the appointed time.

I was immediately announced, and I had not long to wait. I entered the room, and his excellency, seated at a table, examined me from head to foot for one minute without speaking to me; he then rang the bell, and ordered his servant to introduce the two ladies who were waiting in the next room. I guessed at once what was the matter, and felt no surprise when I saw the woman Marchetti and her daughter. His excellency asked me if I knew them.

"I must know them, monsignor, as one of them will become my wife when she has convinced me by her good conduct that she is worthy of that honour."

"Her conduct is good, she lives with her mother at Lusia; you have deceived her. Why do you postpone your marriage with her? Why do you not visit her? You never answer her letters, and you let her be in want."

"I cannot marry her, your excellency, before I have enough to support her. That will come in three or four years, thanks to a situation which M. de Bragadin, my only protector, promises to obtain for me. Until then she must live honestly, and support herself by working. I will only marry her when I am convinced of her honesty, and particularly when I am certain that she has given up all intercourse with the abbe, her cousin in the fourth degree. I do not visit her because my confessor and my conscience forbid me to go to her house."

"She wishes you to give her a legal promise of marriage, and sustentation."

"Monsignor, I am under no obligation to give her a promise of marriage, and having no means whatever I cannot support her. She must earn her own living with her mother"

"When she lived with her cousin," said her mother, "she never wanted anything, and she shall go back to him."

"If she returns to his house I shall not take the trouble of taking her out of his hands a second time, and your excellency will then see that I was right to defer my marriage with her until I was convinced of her honesty."

The judge told me that my presence, was no longer necessary. It was the end of the affair, and I never heard any more about it. The recital of the dialogue greatly amused my friends.

At the beginning of the Carnival of 1750 I won a prize of three thousand ducats at the lottery. Fortune made me that present when I did not require it, for I had held the bank during the autumn, and had won. It was at a casino where no nobleman dared to present himself, because one of the partners was an officer in the service of the Duke de Montalegre, the Spanish Ambassador. The citizens of Venice felt ill at ease with the patricians, and that is always the case under an aristocratic government, because equality exists in reality only between the members of such a government.

As I intended to take a trip to Paris, I placed one thousand sequins in M. de Bragadin's hands, and with that project in view I had the courage to pass the carnival without risking my money at the faro-table. I had taken a share of one-fourth in the bank of an honest patrician, and early in Lent he handed me a large sum.

Towards mid-Lent my friend Baletti returned from Mantua to Venice. He was engaged at the St. Moses Theatre as ballet-master during the Fair of the Assumption. He was with Marina, but they did not live together. She made the conquest of an English Jew, called Mendez, who spent a great deal of money for her. That Jew gave me good news of Therese, whom he had known

in Naples, and in whose hands he had left some of his spoils. The information pleased me, and I was very glad to have been prevented by Henriette from joining Therese in Naples, as I had intended, for I should certainly have fallen in love with her again, and God knows what the consequences might have been.

It was at that time that Bavois was appointed captain in the service of the Republic; he rose rapidly in his profession, as I shall mention hereafter.

De la Haye undertook the education of a young nobleman called Felix Calvi, and a short time afterwards he accompanied him to Poland. I met him again in Vienna three years later.

I was making my preparations to go to the Fair of Reggio, then to Turin, where the whole of Italy was congregating for the marriage of the Duke of Savoy with a princess of Spain, daughter of Philip V., and lastly to Paris, where, Madame la Dauphine being pregnant, magnificent preparations were made in the expectation of the birth of a prince. Baletti was likewise on the point of undertaking the same journey. He was recalled by his parents, who were dramatic artists: his mother was the celebrated Silvia.

Baletti was engaged at the Italian Theatre in Paris as dancer and first gentleman. I could not choose a companion more to my taste, more agreeable, or in a better position to procure me numerous advantageous acquaintances in Paris.

I bade farewell to my three excellent friends, promising to return within two years.

I left my brother Francois in the studio of Simonetti, the painter of battle pieces, known as the Parmesan. I gave him a promise to think of him in Paris, where, at that time particularly, great talent was always certain of a high fortune. My readers will see how I kept my word.

I likewise left in Venice my brother Jean, who had returned to that city after having travelled through Italy with Guarienti. He was on the point of going to Rome, where he remained fourteen years in the studio of Raphael Mengs. He left Rome for Dresden in 1764, where he died in the year 1795.

Baletti started before me, and I left Venice, to meet him in Reggio, on the 1st of June, 1750. I was well fitted out, well supplied with money, and sure not to want for any, if I led a proper life. We shall soon see, dear reader, what judgment you will pass on my conduct, or rather I shall not see it, for I know that when you are able to judge, I shall no longer care for your sentence.

CHAPTER V

I Stop at Ferrara, Where I Have a Comic Adventure—
My Arrival in Paris

Precisely at twelve o'clock the peotta landed me at Ponte di Lago Oscuro, and I immediately took a post-chaise to reach Ferrara in time for dinner. I put up at St. Mark's Hotel. I was following the waiter up the stairs, when a joyful uproar, which suddenly burst from a room the door of which was open, made me curious to ascertain the cause of so much mirth. I peeped into the room, and saw some twelve persons, men and women, seated round a well-supplied table. It was a very natural thing, and I was moving on, when I was stopped by the exclamation, "Ah, here he is!" uttered by the pretty voice of a woman, and at the same moment, the speaker, leaving the table, came to me with open arms and embraced me, saying,

"Quick, quick, a seat for him near me; take his luggage to his room."

A young man came up, and she said to him, "Well, I told you he would arrive to-day?"

She made me sit near her at the table, after I had been saluted by all the guests who had risen to do me honour.

"My dear cousin," she said, addressing me, "you must be hungry;" and as she spoke she squeezed my foot under the table. "Here is my intended husband whom I beg to introduce to you, as well as my father and mother-in-law. The other guests round the table are friends of the family. But, my dear cousin, tell me why my mother has not come with you?"

At last I had to open my lips!

"Your mother, my dear cousin, will be here in three or four days, at the latest."

I thought that my newly-found cousin was unknown to me, but when I looked at her with more attention, I fancied I recollected her features. She was the Catinella, a dancer of reputation, but I had never spoken to her before. I easily guessed that she was giving me an impromptu part in a play of her own composition, and I was to be a 'deux ex machina'. Whatever is singular and unexpected has always attracted me, and as my cousin was pretty, I lent myself most willingly to the joke, entertaining no doubt that she would reward me in an agreeable manner. All I had to do was to play my part well, but without implicating myself. Therefore, pretending to be very hungry, I gave her the opportunity of speaking and of informing me by hints of what I had to know, in order not to make blunders. Understanding the reason of

my reserve, she afforded me the proof of her quick intelligence by saying sometimes to one person, sometimes to the other, everything it was necessary for me to know. Thus I learnt that the wedding could not take place until the arrival of her mother, who was to bring the wardrobe and the diamonds of my cousin. I was the precentor going to Turin to compose the music of the opera which was to be represented at the marriage of the Duke of Savoy. This last discovery pleased me greatly, because I saw that I should have no difficulty in taking my departure the next morning, and I began to enjoy the part I had to play. Yet, if I had not reckoned upon the reward, I might very well have informed the honourable company that my false cousin was mad, but, although Catinella was very near thirty, she was very pretty and celebrated for her intrigues; that was enough, and she could turn me round her little finger.

The future mother-in-law was seated opposite, and to do me honour she filled a glass and offered it to me. Already identified with my part in the comedy, I put forth my hand to take the glass, but seeing that my hand was somewhat bent, she said to me,

"What is the matter with your hand, sir?"

"Nothing serious, madam; only a slight sprain which a little rest will soon cure."

At these words, Catinella, laughing heartily, said that she regretted the accident because it would deprive her friends of the pleasure they would have enjoyed in hearing me play the harpsichord.

"I am glad to find it a laughing matter, cousin."

"I laugh, because it reminds me of a sprained ankle which I once feigned to have in order not to dance."

After coffee, the mother-in-law, who evidently understood what was proper, said that most likely my cousin wanted to talk with me on family matters, and that we ought to be left alone.

Every one of the guests left the room.

As soon as I was alone with her in my room, which was next to her own she threw herself on a sofa, and gave way to a most immoderate fit of laughter.

"Although I only know you by name," she said to me, "I have entire confidence in you, but you will do well to go away to-morrow. I have been here for two months without any money. I have nothing but a few dresses and some linen, which I should have been compelled to sell to defray my expenses if I had not been lucky enough to inspire the son of the landlord with the deepest love. I have flattered his passion by promising to become his wife, and to bring him as a marriage portion twenty thousand crowns' worth of diamonds which I am supposed to have in Venice, and which my mother is

expected to bring with her. But my mother has nothing and knows nothing of the affair, therefore she is not likely to leave Venice."

"But, tell me, lovely madcap, what will be the end of this extravaganza? I am afraid it will take a tragic turn at the last."

"You are mistaken; it will remain a comedy, and a very amusing one, too. I am expecting every hour the arrival of Count Holstein, brother of the Elector of Mainz. He has written to me from Frankfort; he has left that city, and must by this time have reached Venice. He will take me to the Fair of Reggio, and if my intended takes it into his head to be angry, the count will thrash him and pay my bill, but I am determined that he shall be neither thrashed nor paid. As I go away, I have only to whisper in his ear that I will certainly return, and it will be all right. I know my promise to become his wife as soon as I come back will make him happy."

"That's all very well! You are as witty as a cousin of Satan, but I shall not wait your return to marry you; our wedding must take place at once."

"What folly! Well, wait until this evening."

"Not a bit of it, for I can almost fancy I hear the count's carriage. If he should not arrive, we can continue the sport during the night."

"Do you love me?"

"To distraction! but what does it matter? However, your excellent comedy renders you worthy of adoration. Now, suppose we do not waste our time."

"You are right: it is an episode, and all the more agreeable for being impromptu."

I can well recollect that I found it a delightful episode. Towards evening all the family joined us again, a walk was proposed, and we were on the point of going out, when a carriage drawn by six post-horses noisily entered the yard. Catinella looked through the window, and desired to be left alone, saying that it was a prince who had come to see her. Everybody went away, she pushed me into my room and locked me in. I went to the window, and saw a nobleman four times as big as myself getting out of the carriage. He came upstairs, entered the room of the intended bride, and all that was left to me was the consolation of having seized fortune by the forelock, the pleasure of hearing their conversation, and a convenient view, through a crevice in the partition, of what Catinella contrived to do with that heavy lump of flesh. But at last the stupid amusement wearied me, for it lasted five hours, which were employed in amorous caresses, in packing Catinella's rags, in loading them on the carriage, in taking supper, and in drinking numerous bumpers of Rhenish wine. At midnight the count left the hotel, carrying away with him the beloved mistress of the landlord's son.

No one during those long hours had come to my room, and I had not called. I was afraid of being discovered, and I did not know how far the German prince would have been pleased if he had found out that he had an indiscreet witness of the heavy and powerless demonstrations of his tenderness, which were a credit to neither of the actors, and which supplied me with ample food for thoughts upon the miseries of mankind.

After the departure of the heroine, catching through the crevice a glimpse of the abandoned lover, I called out to him to unlock my door. The poor silly fellow told me piteously that, Catinella having taken the key with her, it would be necessary to break the door open. I begged him to have it done at once, because I was hungry. As soon as I was out of my prison I had my supper, and the unfortunate lover kept me company. He told me that Catinella had found a moment to promise him that she would return within six weeks, that she was shedding tears in giving him that assurance, and that she had kissed him with great tenderness.

"Has the prince paid her expenses?"

"Not at all. We would not have allowed him to do it, even if he had offered. My future wife would have felt offended, for you can have no idea of the delicacy of her feelings."

"What does your father say of her departure?"

"My father always sees the worst side of everything; he says that she will never come back, and my mother shares his opinion rather than mine. But you, signor maestro, what do you think?"

"That if she has promised to return, she will be sure to keep her word."

"Of course; for if she did not mean to come back, she would not have given me her promise."

"Precisely; I call that a good argument."

I had for my supper what was left of the meal prepared by the count's cook, and I drank a bottle of excellent Rhenish wine which Catinella had juggled away to treat her intended husband, and which the worthy fellow thought could not have a better destination than to treat his future cousin. After supper I took post-horses and continued my journey, assuring the unhappy, forlorn lover that I would do all I could to persuade my cousin to come back very soon. I wanted to pay my bill, but he refused to receive any money. I reached Bologna a few minutes after Catinella, and put up at the same hotel, where I found an opportunity of telling her all her lover had said. I arrived in Reggio before her, but I could not speak to her in that city, for she was always in the company of her potent and impotent lord. After the fair, during which nothing of importance occurred to me, I left Reggio with my friend Baletti

and we proceeded to Turin, which I wanted to see, for the first time I had gone to that city with Henriette I had stopped only long enough to change horses.

I found everything beautiful in Turin, the city, the court, the theatre, and the women, including the Duchess of Savoy, but I could not help laughing when I was told that the police of the city was very efficient, for the streets were full of beggars. That police, however, was the special care of the king, who was very intelligent; if we are to believe history, but I confess that I laughed when I saw the ridiculous face of that sovereign.

I had never seen a king before in my life, and a foolish idea made me suppose that a king must be preeminent—a very rare being—by his beauty and the majesty of his appearance, and in everything superior to the rest of men. For a young Republican endowed with reason, my idea was not, after all, so very foolish, but I very soon got rid of it when I saw that King of Sardinia, ugly, hump-backed, morose and vulgar even in his manners. I then realized that it was possible to be a king without being entirely a man.

I saw L'Astrua and Gafarello, those two magnificent singers on the stage, and I admired the dancing of La Geofroi, who married at that time a worthy dancer named Bodin.

During my stay in Turin, no amorous fancy disturbed the peace of my soul, except an accident which happened to me with the daughter of my washerwoman, and which increased my knowledge in physics in a singular manner. That girl was very pretty, and, without being what might be called in love with her, I wished to obtain her favours. Piqued at my not being able to obtain an appointment from her, I contrived one day to catch her at the bottom of a back staircase by which she used to come to my room, and, I must confess, with the intention of using a little violence, if necessary.

Having concealed myself for that purpose at the time I expected her, I got hold of her by surprise, and, half by persuasion, half by the rapidity of my attack, she was brought to a right position, and I lost no time in engaging in action. But at the first movement of the connection a loud explosion somewhat cooled my ardour, the more so that the young girl covered her face with her hands as if she wished to hide her shame. However, encouraging her with a loving kiss, I began again. But, a report, louder even than the first, strikes at the same moment my ear and my nose. I continue; a third, a fourth report, and, to make a long matter short, each movement gives an explosion with as much regularity as a conductor making the time for a piece of music!

This extraordinary phenomenon, the confusion of the poor girl, our position—everything, in fact, struck me as so comical, that I burst into the

most immoderate laughter, which compelled me to give up the undertaking. Ashamed and confused, the young girl ran away, and I did nothing to hinder her. After that she never had the courage to present herself before me. I remained seated on the stairs for a quarter of an hour after she had left me, amused at the funny character of a scene which even now excites my mirth. I suppose that the young girl was indebted for her virtue to that singular disease, and most likely, if it were common to all the fair sex, there would be fewer gallant women, unless we had different organs; for to pay for one moment of enjoyment at the expense both of the hearing and of the smell is to give too high a price.

Baletti, being in a hurry to reach Paris, where great preparations were being made for the birth of a Duke of Burgundy—for the duchess was near the time of her delivery—easily persuaded me to shorten my stay in Turin. We therefore left that city, and in five days we arrived at Lyons, where I stayed about a week.

Lyons is a very fine city in which at that time there were scarcely three or four noble houses opened to strangers; but, in compensation, there were more than a hundred hospitable ones belonging to merchants, manufacturers, and commission agents, amongst whom was to be found an excellent society remarkable for easy manners, politeness, frankness, and good style, without the absurd pride to be met with amongst the nobility in the provinces, with very few honourable exceptions. It is true that the standard of good manners is below that of Paris, but one soon gets accustomed to it. The wealth of Lyons arises from good taste and low prices, and Fashion is the goddess to whom that city owes its prosperity. Fashion alters every year, and the stuff, to which the fashion of the day gives a value equal, say to thirty, is the next year reduced to fifteen or twenty, and then it is sent to foreign countries where it is bought up as a novelty.

The manufacturers of Lyons give high salaries to designers of talent; in that lies the secret of their success. Low prices come from Competition—a fruitful source of wealth, and a daughter of Liberty. Therefore, a government wishing to establish on a firm basis the prosperity of trade must give commerce full liberty; only being careful to prevent the frauds which private interests, often wrongly understood, might invent at the expense of public and general interests. In fact, the government must hold the scales, and allow the citizens to load them as they please.

In Lyons I met the most famous courtezan of Venice. It was generally admitted that her equal had never been seen. Her name was Ancilla. Every man who saw her coveted her, and she was so kindly disposed that she could

not refuse her favours to anyone; for if all men loved her one after the other, she returned the compliment by loving them all at once, and with her pecuniary advantages were only a very secondary consideration.

Venice has always been blessed with courtezans more celebrated by their beauty than their wit. Those who were most famous in my younger days were Ancilla and another called Spina, both the daughters of gondoliers, and both killed very young by the excesses of a profession which, in their eyes, was a noble one. At the age of twenty-two, Ancilla turned a dancer and Spina became a singer. Campioni, a celebrated Venetian dancer, imparted to the lovely Ancilla all the graces and the talents of which her physical perfections were susceptible, and married her. Spina had for her master a castrato who succeeded in making of her only a very ordinary singer, and in the absence of talent she was compelled, in order to get a living, to make the most of the beauty she had received from nature.

I shall have occasion to speak again of Ancilla before her death. She was then in Lyons with her husband; they had just returned from England, where they had been greatly applauded at the Haymarket Theatre. She had stopped in Lyons only for her pleasure, and, the moment she shewed herself, she had at her feet the most brilliant young men of the town, who were the slaves of her slightest caprice. Every day parties of pleasure, every evening magnificent suppers, and every night a great faro bank. The banker at the gaming table was a certain Don Joseph Marratti, the same man whom I had known in the Spanish army under the name of Don Pepe il Cadetto, and a few years afterwards assumed the name of Afflisio, and came to such a bad end. That faro bank won in a few days three hundred thousand francs. In a capital that would not have been considered a large sum, but in a commercial and industrial city like Lyons it raised the alarm amongst the merchants, and the Ultramontanes thought of taking their leave.

It was in Lyons that a respectable individual, whose acquaintance I made at the house of M. de Rochebaron, obtained for me the favour of being initiated in the sublime trifles of Freemasonry. I arrived in Paris a simple apprentice; a few months after my arrival I became companion and master; the last is certainly the highest degree in Freemasonry, for all the other degrees which I took afterwards are only pleasing inventions, which, although symbolical, add nothing to the dignity of master.

No one in this world can obtain a knowledge of everything, but every man who feels himself endowed with faculties, and can realize the extent of his moral strength, should endeavour to obtain the greatest possible amount of knowledge. A well-born young man who wishes to travel and know not only

the world, but also what is called good society, who does not want to find himself, under certain circumstances, inferior to his equals, and excluded from participating in all their pleasures, must get himself initiated in what is called Freemasonry, even if it is only to know superficially what Freemasonry is. It is a charitable institution, which, at certain times and in certain places, may have been a pretext for criminal underplots got up for the overthrow of public order, but is there anything under heaven that has not been abused? Have we not seen the Jesuits, under the cloak of our holy religion, thrust into the parricidal hand of blind enthusiasts the dagger with which kings were to be assassinated! All men of importance, I mean those whose social existence is marked by intelligence and merit, by learning or by wealth, can be (and many of them are) Freemasons: is it possible to suppose that such meetings, in which the initiated, making it a law never to speak, 'intra muros', either of politics, or of religions, or of governments, converse only concerning emblems which are either moral or trifling; is it possible to suppose, I repeat, that those meetings, in which the governments may have their own creatures, can offer dangers sufficiently serious to warrant the proscriptions of kings or the excommunications of Popes?

In reality such proceedings miss the end for which they are undertaken, and the Pope, in spite of his infallibility, will not prevent his persecutions from giving Freemasonry an importance which it would perhaps have never obtained if it had been left alone. Mystery is the essence of man's nature, and whatever presents itself to mankind under a mysterious appearance will always excite curiosity and be sought, even when men are satisfied that the veil covers nothing but a cypher.

Upon the whole, I would advise all well-born young men, who intend to travel, to become Freemasons; but I would likewise advise them to be careful in selecting a lodge, because, although bad company cannot have any influence while inside of the lodge, the candidate must guard against bad acquaintances.

Those who become Freemasons only for the sake of finding out the secret of the order, run a very great risk of growing old under the trowel without ever realizing their purpose. Yet there is a secret, but it is so inviolable that it has never been confided or whispered to anyone. Those who stop at the outward crust of things imagine that the secret consists in words, in signs, or that the main point of it is to be found only in reaching the highest degree. This is a mistaken view: the man who guesses the secret of Freemasonry, and to know it you must guess it, reaches that point only through long attendance in the lodges, through deep thinking, comparison, and deduction. He would

not trust that secret to his best friend in Freemasonry, because he is aware that if his friend has not found it out, he could not make any use of it after it had been whispered in his ear. No, he keeps his peace, and the secret remains a secret.

Everything done in a lodge must be secret; but those who have unscrupulously revealed what is done in the lodge, have been unable to reveal that which is essential; they had no knowledge of it, and had they known it, they certainly would not have unveiled the mystery of the ceremonies.

The impression felt in our days by the non-initiated is of the same nature as that felt in former times by those who were not initiated in the mysteries enacted at Eleusis in honour of Ceres. But the mysteries of Eleusis interested the whole of Greece, and whoever had attained some eminence in the society of those days had an ardent wish to take a part in those mysterious ceremonies, while Freemasonry, in the midst of many men of the highest merit, reckons a crowd of scoundrels whom no society ought to acknowledge, because they are the refuse of mankind as far as morality is concerned.

In the mysteries of Ceres, an inscrutable silence was long kept, owing to the veneration in which they were held. Besides, what was there in them that could be revealed? The three words which the hierophant said to the initiated? But what would that revelation have come to? Only to dishonour the indiscreet initiate, for they were barbarous words unknown to the vulgar. I have read somewhere that the three sacred words of the mysteries of Eleusis meant: Watch, and do no evil. The sacred words and the secrets of the various masonic degrees are about as criminal.

The initiation in the mysteries of Eleusis lasted nine days. The ceremonies were very imposing, and the company of the highest. Plutarch informs us that Alcibiades was sentenced to death and his property confiscated, because he had dared to turn the mysteries into ridicule in his house. He was even sentenced to be cursed by the priests and priestesses, but the curse was not pronounced because one of the priestesses opposed it, saying:

"I am a priestess to bless and not to curse!"

Sublime words! Lessons of wisdom and of morality which the Pope despises, but which the Gospel teaches and which the Saviour prescribes.

In our days nothing is important, and nothing is sacred, for our cosmopolitan philosophers.

Botarelli publishes in a pamphlet all the ceremonies of the Freemasons, and the only sentence passed on him is:

"He is a scoundrel. We knew that before!"

A prince in Naples, and M. Hamilton in his own house, perform the miracle of St. Januarius; they are, most likely, very merry over their performance, and many more with them. Yet the king wears on his royal breast a star with the following device around the image of St. Januarius: 'In sanguine foedus'. In our days everything is inconsistent, and nothing has any meaning. Yet it is right to go ahead, for to stop on the road would be to go from bad to worse.

We left Lyons in the public diligence, and were five days on our road to Paris. Baletti had given notice of his departure to his family; they therefore knew when to expect him. We were eight in the coach and our seats were very uncomfortable, for it was a large oval in shape, so that no one had a corner. If that vehicle had been built in a country where equality was a principle hallowed by the laws, it would not have been a bad illustration. I thought it was absurd, but I was in a foreign country, and I said nothing. Besides, being an Italian, would it have been right for me not to admire everything which was French, and particularly in France?—Example, an oval diligence: I respected the fashion, but I found it detestable, and the singular motion of that vehicle had the same effect upon me as the rolling of a ship in a heavy sea. Yet it was well hung, but the worst jolting would have disturbed me less.

As the diligence undulates in the rapidity of its pace, it has been called a gondola, but I was a judge of gondolas, and I thought that there was no family likeness between the coach and the Venetian boats which, with two hearty rowers, glide along so swiftly and smoothly. The effect of the movement was that I had to throw up whatever was on my stomach. My travelling companions thought me bad company, but they did not say so. I was in France and among Frenchmen, who know what politeness is. They only remarked that very likely I had eaten too much at my supper, and a Parisian abbe, in order to excuse me, observed that my stomach was weak. A discussion arose.

"Gentlemen," I said, in my vexation, and rather angrily, "you are all wrong, for my stomach is excellent, and I have not had any supper."

Thereupon an elderly man told me, with a voice full of sweetness, that I ought not to say that the gentlemen were wrong, though I might say that they were not right, thus imitating Cicero, who, instead of declaring to the Romans that Catilina and the other conspirators were dead, only said that they had lived.

"Is it not the same thing?"

"I beg your pardon, sir, one way of speaking is polite, the other is not." And after treating me to a long dissection on politeness, he concluded by saying, with a smile, "I suppose you are an Italian?"

"Yes, I am, but would you oblige me by telling me how you have found it out?"

"Oh! I guessed it from the attention with which you have listened to my long prattle."

Everybody laughed, and, I, much pleased with his eccentricity, began to coax him. He was the tutor of a young boy of twelve or thirteen years who was seated near him. I made him give me during the journey lessons in French politeness, and when we parted he took me apart in a friendly manner, saying that he wished to make me a small present.

"What is it?"

"You must abandon, and, if I may say so, forget, the particle 'non', which you use frequently at random. 'Non' is not a French word; instead of that unpleasant monosyllable, say, 'Pardon'. 'Non' is equal to giving the lie: never say it, or prepare yourself to give and to receive sword-stabs every moment."

"I thank you, monsieur, your present is very precious, and I promise you never to say non again."

During the first fortnight of my stay in Paris, it seemed to me that I had become the most faulty man alive, for I never ceased begging pardon. I even thought, one evening at the theatre, that I should have a quarrel for having begged somebody's pardon in the wrong place. A young fop, coming to the pit, trod on my foot, and I hastened to say,

"Your pardon, sir."

"Sir, pardon me yourself."

"No, yourself."

"Yourself!"

"Well, sir, let us pardon and embrace one another!" The embrace put a stop to the discussion.

One day during the journey, having fallen asleep from fatigue in the inconvenient gondola, someone pushed my arm.

"Ah, sir! look at that mansion!"

"I see it; what of it?"

"Ah! I pray you, do you not find it...."

"I find nothing particular; and you?"

"Nothing wonderful, if it were not situated at a distance of forty leagues from Paris. But here! Ah! would my 'badauds' of Parisians believe that such

a beautiful mansion can be found forty leagues distant from the metropolis? How ignorant a man is when he has never travelled!"

"You are quite right."

That man was a Parisian and a 'badaud' to the backbone, like a Gaul in the days of Caesar.

But if the Parisians are lounging about from morning till night, enjoying everything around them, a foreigner like myself ought to have been a greater 'badaud' than they! The difference between us was that, being accustomed to see things such as they are, I was astonished at seeing them often covered with a mask which changed their nature, while their surprise often arose from their suspecting what the mask concealed.

What delighted me, on my arrival in Paris, was the magnificent road made by Louis XV., the cleanliness of the hotels, the excellent fare they give, the quickness of the service, the excellent beds, the modest appearance of the attendant, who generally is the most accomplished girl of the house, and whose decency, modest manners, and neatness, inspire the most shameless libertine with respect. Where is the Italian who is pleased with the effrontery and the insolence of the hotel-waiters in Italy? In my days, people did not know in France what it was to overcharge; it was truly the home of foreigners. True, they had the unpleasantness of often witnessing acts of odious despotism, 'lettres de cachet', etc.; it was the despotism of a king. Since that time the French have the despotism of the people. Is it less obnoxious?

We dined at Fontainebleau, a name derived from Fontaine-belle-eau; and when we were only two leagues from Paris we saw a berlin advancing towards us. As it came near the diligence, my friend Baletti called out to the postillions to stop. In the berlin was his mother, who offered me the welcome given to an expected friend. His mother was the celebrated actress Silvia, and when I had been introduced to her she said to me;

"I hope, sir, that my son's friend will accept a share of our family supper this evening."

I accepted gratefully, sat down again in the gondola, Baletti got into the berlin with his mother, and we continued our journey.

On reaching Paris, I found a servant of Silvia's waiting for me with a coach; he accompanied me to my lodging to leave my luggage, and we repaired to Baletti's house, which was only fifty yards distant from my dwelling.

Baletti presented me to his father, who was known under the name of Mario. Silvia and Mario were the stage names assumed by M. and Madame Baletti, and at that time it was the custom in France to call the Italian actors by the names they had on the stage. 'Bon jour', Monsieur Arlequin; 'bon jour',

Monsieur Pantalon: such was the manner in which the French used to address the actors who personified those characters on the stage.

CHAPTER VI

My Apprenticeship in Paris—Portraits—Oddities—All Sorts
of Things

To celebrate the arrival of her son, Silvia gave a splendid supper to which
she had invited all her relatives, and it was a good opportunity for me to make
their acquaintance. Baletti's father, who had just recovered from a long
illness, was not with us, but we had his father's sister, who was older than
Mario. She was known, under her theatrical name of Flaminia, in the literary
world by several translations, but I had a great wish to make her acquaintance
less on that account than in consequence of the story, known throughout
Italy, of the stay that three literary men of great fame had made in Paris.
Those three literati were the Marquis Maffei, the Abbe Conti, and Pierre
Jacques Martelli, who became enemies, according to public rumour, owing to
the belief entertained by each of them that he possessed the favours of the
actress, and, being men of learning, they fought with the pen. Martelli
composed a satire against Maffei, in which he designated him by the anagram
of Femia.

I had been announced to Flaminia as a candidate for literary fame, and she
thought she honoured me by addressing me at all, but she was wrong, for she
displeased me greatly by her face, her manners, her style, even by the sound
of her voice. Without saying it positively, she made me understand that, being
herself an illustrious member of the republic of letters, she was well aware that
she was speaking to an insect. She seemed as if she wanted to dictate to
everybody around her, and she very likely thought that she had the right to
do so at the age of sixty, particularly towards a young novice only twenty-five
years old, who had not yet contributed anything to the literary treasury. In
order to please her, I spoke to her of the Abbe Conti, and I had occasion to
quote two lines of that profound writer. Madam corrected me with a
patronizing air for my pronunciation of the word 'scevra', which means
divided, saying that it ought to be pronounced 'sceura', and she added that I
ought to be very glad to have learned so much on the first day of my arrival
in Paris, telling me that it would be an important day in my life.

"Madam, I came here to learn and not to unlearn. You will kindly allow me
to tell you that the pronunciation of that word 'scevra' with a v, and not
'sceura' with a u, because it is a contraction of 'sceverra'."

"It remains to be seen which of us is wrong."

"You, madam, according to Ariosto, who makes 'scevra' rhyme with 'persevra', and the rhyme would be false with 'sceura', which is not an Italian word."

She would have kept up the discussion, but her husband, a man eighty years of age, told her that she was wrong. She held her tongue, but from that time she told everybody that I was an impostor.

Her husband, Louis Riccoboni, better known as Lelio, was the same who had brought the Italian company to Paris in 1716, and placed it at the service of the regent: he was a man of great merit. He had been very handsome, and justly enjoyed the esteem of the public, in consequence not only of his talent but also of the purity of his life.

During supper my principal occupation was to study Silvia, who then enjoyed the greatest reputation, and I judged her to be even above it. She was then about fifty years old, her figure was elegant, her air noble, her manners graceful and easy; she was affable, witty, kind to everybody, simple and unpretending. Her face was an enigma, for it inspired everyone with the warmest sympathy, and yet if you examined it attentively there was not one beautiful feature; she could not be called handsome, but no one could have thought her ugly. Yet she was not one of those women who are neither handsome nor ugly, for she possessed a certain something which struck one at first sight and captivated the interest. Then what was she?

Beautiful, certainly, but owing to charms unknown to all those who, not being attracted towards her by an irresistible feeling which compelled them to love her, had not the courage to study her, or the constancy to obtain a thorough knowledge of her.

Silvia was the adoration of France, and her talent was the real support of all the comedies which the greatest authors wrote for her, especially of, the plays of Marivaux, for without her his comedies would never have gone to posterity. Never was an actress found who could replace her, and to find one it would be necessary that she should unite in herself all the perfections which Silvia possessed for the difficult profession of the stage: action, voice, intelligence, wit, countenance, manners, and a deep knowledge of the human heart. In Silvia every quality was from nature, and the art which gave the last touch of perfection to her qualities was never seen.

To the qualities which I have just mentioned, Silvia added another which surrounded her with a brilliant halo, and the absence of which would not have prevented her from being the shining star of the stage: she led a virtuous life. She had been anxious to have friends, but she had dismissed all lovers, refusing to avail herself of a privilege which she could easily have enjoyed, but

which would have rendered her contemptible in her own estimation. The irreproachable conduct obtained for her a reputation of respectability which, at her age, would have been held as ridiculous and even insulting by any other woman belonging to the same profession, and many ladies of the highest rank honoured her with her friendship more even than with their patronage. Never did the capricious audience of a Parisian pit dare to hiss Silvia, not even in her performance of characters which the public disliked, and it was the general opinion that she was in every way above her profession.

Silvia did not think that her good conduct was a merit, for she knew that she was virtuous only because her self-love compelled her to be so, and she never exhibited any pride or assumed any superiority towards her theatrical sisters, although, satisfied to shine by their talent or their beauty, they cared little about rendering themselves conspicuous by their virtue. Silvia loved them all, and they all loved her; she always was the first to praise, openly and with good faith, the talent of her rivals; but she lost nothing by it, because, being their superior in talent and enjoying a spotless reputation, her rivals could not rise above her.

Nature deprived that charming woman of ten year of life; she became consumptive at the age of sixty, ten years after I had made her acquaintance. The climate of Paris often proves fatal to our Italian actresses. Two years before her death I saw her perform the character of Marianne in the comedy of Marivaux, and in spite of her age and declining health the illusion was complete. She died in my presence, holding her daughter in her arms, and she was giving her the advice of a tender mother five minutes before she breathed her last. She was honourably buried in the church of St. Sauveur, without the slightest opposition from the venerable priest, who, far from sharing the anti-christain intolerancy of the clergy in general, said that her profession as an actress had not hindered her from being a good Christian, and that the earth was the common mother of all human beings, as Jesus Christ had been the Saviour of all mankind.

You will forgive me, dear reader, if I have made you attend the funeral of Silvia ten years before her death; believe me I have no intention of performing a miracle; you may console yourself with the idea that I shall spare you that unpleasant task when poor Silvia dies.

Her only daughter, the object of her adoration, was seated next to her at the supper-table. She was then only nine years old, and being entirely taken up by her mother I paid no attention to her; my interest in her was to come.

After the supper, which was protracted to a late hour, I repaired to the house of Madame Quinson, my landlady, where I found myself very

comfortable. When I woke in the morning, the said Madame Quinson came to my room to tell me that a servant was outside and wished to offer me his services. I asked her to send him in, and I saw a man of very small stature; that did not please me, and I told him so.

"My small stature, your honour, will be a guarantee that I shall never borrow your clothes to go to some amorous rendezvous."

"Your name?"

"Any name you please."

"What do you mean? I want the name by which you are known."

"I have none. Every master I serve calls me according to his fancy, and I have served more than fifty in my life. You may call me what you like."

"But you must have a family name."

"I never had any family. I had a name, I believe, in my young days, but I have forgotten it since I have been in service. My name has changed with every new master."

"Well! I shall call you Esprit."

"You do me a great honour."

"Here, go and get me change for a Louis."

"I have it, sir."

"I see you are rich."

"At your service, sir."

"Where can I enquire about you?"

"At the agency for servants. Madame Quinson, besides, can answer your enquiries. Everybody in Paris knows me."

"That is enough. I shall give you thirty sous a day; you must find your own clothes: you will sleep where you like, and you must be here at seven o'clock every morning."

Baletti called on me and entreated me to take my meals every day at his house. After his visit I told Esprit to take me to the Palais-Royal, and I left him at the gates. I felt the greatest curiosity about that renowned garden, and at first I examined everything. I see a rather fine garden, walks lined with big trees, fountains, high houses all round the garden, a great many men and women walking about, benches here and there forming shops for the sale of newspapers, perfumes, tooth-picks, and other trifles. I see a quantity of chairs for hire at the rate of one sou, men reading the newspaper under the shade of the trees, girls and men breakfasting either alone or in company, waiters who were rapidly going up and down a narrow staircase hidden under the foliage.

I sit down at a small table: a waiter comes immediately to enquire my wishes. I ask for some chocolate made with water; he brings me some, but

very bad, although served in a splendid silver-gilt cup. I tell him to give me some coffee, if it is good.

"Excellent, I made it myself yesterday."

"Yesterday! I do not want it."

"The milk is very good."

"Milk! I never drink any. Make me a cup of fresh coffee without milk."

"Without milk! Well, sir, we never make coffee but in the afternoon. Would you like a good bavaroise, or a decanter of orgeat?"

"Yes, give me the orgeat."

I find that beverage delicious, and make up my mind to have it daily for my breakfast. I enquire from the waiter whether there is any news; he answers that the dauphine has been delivered of a prince. An abbe, seated at a table close by, says to him,—

"You are mad, she has given birth to a princess."

A third man comes forward and exclaims,—

"I have just returned from Versailles, and the dauphine has not been delivered either of a prince or of a princess."

Then, turning towards me, he says that I look like a foreigner, and when I say that I am an Italian he begins to speak to me of the court, of the city, of the theatres, and at last he offers to accompany me everywhere. I thank him and take my leave. The abbe rises at the same time, walks with me, and tells me the names of all the women we meet in the garden.

A young man comes up to him, they embrace one another, and the abbe presents him to me as a learned Italian scholar. I address him in Italian, and he answers very wittily, but his way of speaking makes me smile, and I tell him why. He expressed himself exactly in the style of Boccacio. My remark pleases him, but I soon prove to him that it is not the right way to speak, however perfect may have been the language of that ancient writer. In less than a quarter of an hour we are excellent friends, for we find that our tastes are the same.

My new friend was a poet as I was; he was an admirer of Italian literature, while I admired the French.

We exchanged addresses, and promise to see one another very often.

I see a crowd in one corner of the garden, everybody standing still and looking up. I enquire from my friend whether there is anything wonderful going on.

"These persons are watching the meridian; everyone holds his watch in his hand in order to regulate it exactly at noon."

"Is there not a meridian everywhere?"

"Yes, but the meridian of the Palais-Royal is the most exact."

I laugh heartily.

"Why do you laugh?"

"Because it is impossible for all meridians not to be the same. That is true 'badauderie'."

My friend looks at me for a moment, then he laughs likewise, and supplies me with ample food to ridicule the worthy Parisians. We leave the Palais-Royal through the main gate, and I observe another crowd of people before a shop, on the sign-board of which I read "At the Sign of the Civet Cat."

"What is the matter here?"

"Now, indeed, you are going to laugh. All these honest persons are waiting their turn to get their snuff-boxes filled."

"Is there no other dealer in snuff?"

"It is sold everywhere, but for the last three weeks nobody will use any snuff but that sold at the 'Civet Cat.'"

"Is it better than anywhere else?"

"Perhaps it is not as good, but since it has been brought into fashion by the Duchesse de Chartres, nobody will have any other."

"But how did she manage to render it so fashionable?"

"Simply by stopping her carriage two or three times before the shop to have her snuff-box filled, and by saying aloud to the young girl who handed back the box that her snuff was the very best in Paris. The 'badauds', who never fail to congregate near the carriage of princes, no matter if they have seen them a hundred times, or if they know them to be as ugly as monkeys, repeated the words of the duchess everywhere, and that was enough to send here all the snuff-takers of the capital in a hurry. This woman will make a fortune, for she sells at least one hundred crowns' worth of snuff every day."

"Very likely the duchess has no idea of the good she has done."

"Quite the reverse, for it was a cunning artifice on her part. The duchess, feeling interested in the newly-married young woman, and wishing to serve her in a delicate manner, thought of that expedient which has met with complete success. You cannot imagine how kind Parisians are. You are now in the only country in the world where wit can make a fortune by selling either a genuine or a false article: in the first case, it receives the welcome of intelligent and talented people, and in the second, fools are always ready to reward it, for silliness is truly a characteristic of the people here, and, however wonderful it may appear, silliness is the daughter of wit. Therefore it is not a paradox to say that the French would be wiser if they were less witty.

"The gods worshipped here although no altars are raised for them—are Novelty and Fashion. Let a man run, and everybody will run after him. The crowd will not stop, unless the man is proved to be mad; but to prove it is indeed a difficult task, because we have a crowd of men who, mad from their birth, are still considered wise.

"The snuff of the 'Civet Cat' is but one example of the facility with which the crowd can be attracted to one particular spot. The king was one day hunting, and found himself at the Neuilly Bridge; being thirsty, he wanted a glass of ratafia. He stopped at the door of a drinking-booth, and by the most lucky chance the poor keeper of the place happened to have a bottle of that liquor. The king, after he had drunk a small glass, fancied a second one, and said that he had never tasted such delicious ratafia in his life. That was enough to give the ratafia of the good man of Neuilly the reputation of being the best in Europe: the king had said so. The consequence was that the most brilliant society frequented the tavern of the delighted publican, who is now a very wealthy man, and has built on the very spot a splendid house on which can be read the following rather comic motto: 'Ex liquidis solidum,' which certainly came out of the head of one of the forty immortals. Which gods must the worthy tavern-keeper worship? Silliness, frivolity, and mirth."

"It seems to me," I replied, "that such approval, such ratification of the opinion expressed by the king, the princes of the blood, etc., is rather a proof of the affection felt for them by the nation, for the French carry that affection to such an extent that they believe them infallible."

"It is certain that everything here causes foreigners to believe that the French people adore the king, but all thinking men here know well enough that there is more show than reality in that adoration, and the court has no confidence in it. When the king comes to Paris, everybody calls out, 'Vive le Roi!' because some idle fellow begins, or because some policeman has given the signal from the midst of the crowd, but it is really a cry which has no importance, a cry given out of cheerfulness, sometimes out of fear, and which the king himself does not accept as gospel. He does not feel comfortable in Paris, and he prefers being in Versailles, surrounded by twenty-five thousand men who protect him against the fury of that same people of Paris, who, if ever they became wiser, might very well one day call out, 'Death to the King!' instead of, 'Long life to the King!' Louis XIV. was well aware of it, and several councillors of the upper chamber lost their lives for having advised the assembling of the states-general in order to find some remedy for the misfortunes of the country. France never had any love for any kings, with the exception of St. Louis, of Louis XII, and of the great and good Henry IV.; and

even in the last case the love of the nation was not sufficient to defend the king against the dagger of the Jesuits, an accursed race, the enemy of nations as well as of kings. The present king, who is weak and entirely led by his ministers, said candidly at the time he was just recovering from illness, 'I am surprised at the rejoicings of the people in consequence of my health being restored, for I cannot imagine why they should love me so dearly.' Many kings might repeat the same words, at least if love is to be measured according to the amount of good actually done. That candid remark of Louis XV. has been highly praised, but some philosopher of the court ought to have informed him that he was so much loved because he had been surnamed 'le bien aime'."

"Surname or nickname; but are there any philosophers at the court of France?"

"No, for philosophers and courtiers are as widely different as light and darkness; but there are some men of intelligence who champ the bit from motives of ambition and interest."

As we were thus conversing, M. Patu (such was the name of my new acquaintance) escorted me as far as the door of Silvia's house; he congratulated me upon being one of her friends, and we parted company.

I found the amiable actress in good company. She introduced me to all her guests, and gave me some particulars respecting every one of them. The name of Crebillon struck my ear.

"What, sir!" I said to him, "am I fortunate enough to see you? For eight years you have charmed me, for eight years I have longed to know you. Listen, I beg 'of you."

I then recited the finest passage of his 'Zenobie et Rhadamiste', which I had translated into blank verse. Silvia was delighted to see the pleasure enjoyed by Crebillon in hearing, at the age of eighty, his own lines in a language which he knew thoroughly and loved as much as his own. He himself recited the same passage in French, and politely pointed out the parts in which he thought that I had improved on the original. I thanked him, but I was not deceived by his compliment.

We sat down to supper, and, being asked what I had already seen in Paris, I related everything I had done, omitting only my conversation with Patu. After I had spoken for a long time, Crebillon, who had evidently observed better than anyone else the road I had chosen in order to learn the good as well as the bad qualities by his countrymen, said to me,

"For the first day, sir, I think that what you have done gives great hopes of you, and without any doubt you will make rapid progress. You tell your story well, and you speak French in such a way as to be perfectly understood; yet

all you say is only Italian dressed in French. That is a novelty which causes you to be listened to with interest, and which captivates the attention of your audience; I must even add that your Franco-Italian language is just the thing to enlist in your favour the sympathy of those who listen to you, because it is singular, new, and because you are in a country where everybody worships those two divinities—novelty and singularity. Nevertheless, you must begin to-morrow and apply yourself in good earnest, in order to acquire a thorough knowledge of our language, for the same persons who warmly applaud you now, will, in two or three months, laugh at you."

"I believe it, sir, and that is what I fear; therefore the principal object of my visit here is to devote myself entirely to the study of the French language. But, sir, how shall I find a teacher? I am a very unpleasant pupil, always asking questions, curious, troublesome, insatiable, and even supposing that I could meet with the teacher I require, I am afraid I am not rich enough to pay him."

"For fifty years, sir, I have been looking out for a pupil such as you have just described yourself, and I would willingly pay you myself if you would come to my house and receive my lessons. I reside in the Marais, Rue de Douze Portes. I have the best Italian poets. I will make you translate them into French, and you need not be afraid of my finding you insatiable."

I accepted with joy. I did not know how to express my gratitude, but both his offer and the few words of my answer bore the stamp of truth and frankness.

Crebillon was a giant; he was six feet high, and three inches taller than I. He had a good appetite, could tell a good story without laughing, was celebrated for his witty repartees and his sociable manners, but he spent his life at home, seldom going out, and seeing hardly anyone because he always had a pipe in his mouth and was surrounded by at least twenty cats, with which he would amuse himself all day. He had an old housekeeper, a cook, and a man-servant. His housekeeper had the management of everything; she never allowed him to be in need of anything, and she gave no account of his money, which she kept altogether, because he never asked her to render any accounts. The expression of Crebillon's face was that of the lion's or of the cat's, which is the same thing. He was one of the royal censors, and he told me that it was an amusement for him. His housekeeper was in the habit of reading him the works brought for his examination, and she would stop reading when she came to a passage which, in her opinion, deserved his censure, but sometimes they were of a different opinion, and then their discussions were truly amusing. I once heard the housekeeper send away an author with these words:

"Come again next week; we have had no time to examine your manuscript."

During a whole year I paid M. Crebillon three visits every week, and from him I learned all I know of the French language, but I found it impossible to get rid of my Italian idioms. I remark that turn easily enough when I meet with it in other people, but it flows naturally from my pen without my being aware of it. I am satisfied that, whatever I may do, I shall never be able to recognize it any more than I can find out in what consists the bad Latin style so constantly alleged against Livy.

I composed a stanza of eight verses on some subject which I do not recollect, and I gave it to Crebillon, asking him to correct it. He read it attentively, and said to me,

"These eight verses are good and regular, the thought is fine and truly poetical, the style is perfect, and yet the stanza is bad."

"How so?"

"I do not know. I cannot tell you what is wanting. Imagine that you see a man handsome, well made, amiable, witty-in fact, perfect, according to your most severe judgment. A woman comes in, sees him, looks at him, and goes away telling you that the man does not please her. 'But what fault do you find in him, madam?' 'None, only he does not please me.' You look again at the man, you examine him a second time, and you find that, in order to give him a heavenly voice, he has been deprived of that which constitutes a man, and you are compelled to acknowledge that a spontaneous feeling has stood the woman in good stead."

It was by that comparison that Crebillon explained to me a thing almost inexplicable, for taste and feeling alone can account for a thing which is subject to no rule whatever.

We spoke a great deal of Louis XIV., whom Crebillon had known well for fifteen years, and he related several very curious anecdotes which were generally unknown. Amongst other things he assured me that the Siamese ambassadors were cheats paid by Madame de Maintenon. He told us likewise that he had never finished his tragedy of Cromwell, because the king had told him one day not to wear out his pen on a scoundrel.

Crebillon mentioned likewise his tragedy of Catilina, and he told me that, in his opinion, it was the most deficient of his works, but that he never would have consented, even to make a good tragedy, to represent Caesar as a young man, because he would in that case have made the public laugh, as they would do if Madea were to appear previous to her acquaintances with Jason.

He praised the talent of Voltaire very highly, but he accused him of having stolen from him, Crebillon, the scene of the senate. He, however, rendered him full justice, saying that he was a true historian, and able to write history as well as tragedies, but that he unfortunately adulterated history by mixing with it such a number of light anecdotes and tales for the sake of rendering it more attractive. According to Crebillon, the Man with the Iron Mask was nothing but an idle tale, and he had been assured of it by Louis XIV. himself.

On the day of my first meeting with Crebillon at Silvia's, 'Cenie', a play by Madame de Graffigny, was performed at the Italian Theatre, and I went away early in order to get a good seat in the pit.

The ladies all covered with diamonds, who were taking possession of the private boxes, engrossed all my interest and all my attention. I wore a very fine suit, but my open ruffles and the buttons all along my coat shewed at once that I was a foreigner, for the fashion was not the same in Paris. I was gaping in the air and listlessly looking round, when a gentleman, splendidly dressed, and three times stouter than I, came up and enquired whether I was a foreigner. I answered affirmatively, and he politely asked me how I liked Paris. I praised Paris very warmly. But at that moment a very stout lady, brilliant with diamonds, entered the box near us. Her enormous size astonished me, and, like a fool, I said to the gentleman:

"Who is that fat sow?"

"She is the wife of this fat pig."

"Ah! I beg your pardon a thousand times!"

But my stout gentleman cared nothing for my apologies, and very far from being angry he almost choked with laughter. This was the happy result of the practical and natural philosophy which Frenchmen cultivate so well, and which insures the happiness of their existence under an appearance of frivolity!

I was confused, I was in despair, but the stout gentleman continued to laugh heartily. At last he left the pit, and a minute afterwards I saw him enter the box and speak to his wife. I was keeping an eye on them without daring to look at them openly, and suddenly the lady, following the example of her husband, burst into a loud laugh. Their mirth making me more uncomfortable, I was leaving the pit, when the husband called out to me, "Sir! Sir!"

"I could not go away without being guilty of impoliteness, and I went up to their box. Then, with a serious countenance and with great affability, he begged my pardon for having laughed so much, and very graciously invited me to come to his house and sup with them that same evening. I thanked him

politely, saying that I had a previous engagement. But he renewed his entreaties, and his wife pressing me in the most engaging manner I told them, in order to prove that I was not trying to elude their invitation, that I was expected to sup at Silvia's house.

"In that case I am certain," said the gentleman, "of obtaining your release if you do not object. Allow me to go myself to Silvia."

It would have been uncourteous on my part to resist any longer. He left the box and returned almost immediately with my friend Baletti, who told me that his mother was delighted to see me making such excellent acquaintances, and that she would expect to see me at dinner the next day. He whispered to me that my new acquaintance was M. de Beauchamp, Receiver-General of Taxes.

As soon as the performance was over, I offered my hand to madame, and we drove to their mansion in a magnificent carriage. There I found the abundance or rather the profusion which in Paris is exhibited by the men of finance; numerous society, high play, good cheer, and open cheerfulness. The supper was not over till one o'clock in the morning. Madame's private carriage drove me to my lodgings. That house offered me a kind welcome during the whole of my stay in Paris, and I must add that my new friends proved very useful to me. Some persons assert that foreigners find the first fortnight in Paris very dull, because a little time is necessary to get introduced, but I was fortunate enough to find myself established on as good a footing as I could desire within twenty-four hours, and the consequence was that I felt delighted with Paris, and certain that my stay would prove an agreeable one.

The next morning Patu called and made me a present of his prose panegyric on the Marechal de Saxe. We went out together and took a walk in the Tuileries, where he introduced me to Madame du Boccage, who made a good jest in speaking of the Marechal de Saxe.

"It is singular," she said, "that we cannot have a 'De profundis' for a man who makes us sing the 'Te Deum' so often."

As we left the Tuileries, Patu took me to the house of a celebrated actress of the opera, Mademoiselle Le Fel, the favourite of all Paris, and member of the Royal Academy of Music. She had three very young and charming children, who were fluttering around her like butterflies.

"I adore them," she said to me.

"They deserve adoration for their beauty," I answered, "although they have all a different cast of countenance."

"No wonder! The eldest is the son of the Duke d'Anneci, the second of Count d'Egmont, and the youngest is the offspring of Maison-Rouge, who has just married the Romainville."

"Ah! pray excuse me, I thought you were the mother of the three."

"You were not mistaken, I am their mother."

As she said these words she looked at Patu, and both burst into hearty laughter which did not make me blush, but which shewed me my blunder.

I was a, novice in Paris, and I had not been accustomed to see women encroach upon the privilege which men alone generally enjoy. Yet mademoiselle Le Fel was not a bold-faced woman; she was even rather ladylike, but she was what is called above prejudices. If I had known the manners of the time better, I should have been aware that such things were every-day occurrences, and that the noblemen who thus sprinkled their progeny everywhere were in the habit of leaving their children in the hands of their mothers, who were well paid. The more fruitful, therefore, these ladies were, the greater was their income.

My want of experience often led me into serious blunders, and Mademoiselle Le Fel would, I have no doubt, have laughed at anyone telling her that I had some wit, after the stupid mistake of which I had been guilty.

Another day, being at the house of Lani, ballet-master of the opera, I saw five or six young girls of thirteen or fourteen years of age accompanied by their mothers, and all exhibiting that air of modesty which is the characteristic of a good education. I addressed a few gallant words to them, and they answered me with down-cast eyes. One of them having complained of the headache, I offered her my smelling-bottle, and one of her companions said to her,

"Very likely you did not sleep well last night."

"Oh! it is not that," answered the modest-looking Agnes, "I think I am in the family-way."

On receiving this unexpected reply from a girl I had taken for a maiden, I said to her,

"I should never have supposed that you were married, madam."

She looked at me with evident surprise for a moment, then she turned towards her friend, and both began to laugh immoderately. Ashamed, but for them more than myself, I left the house with a firm resolution never again to take virtue for granted in a class of women amongst whom it is so scarce. To look for, even to suppose, modesty, amongst the nymphs of the green room, is, indeed, to be very foolish; they pride themselves upon having none, and laugh at those who are simple enough to suppose them better than they are.

Thanks to my friend Patu, I made the acquaintance of all the women who enjoyed some reputation in Paris. He was fond of the fair sex, but unfortunately for him he had not a constitution like mine, and his love of pleasure killed him very early. If he had lived, he would have gone down to posterity in the wake of Voltaire, but he paid the debt of nature at the age of thirty.

I learned from him the secret which several young French literati employ in order to make certain of the perfection of their prose, when they want to write anything requiring as perfect a style as they can obtain, such as panegyrics, funeral orations, eulogies, dedications, etc. It was by surprise that I wrested that secret from Patu.

Being at his house one morning, I observed on his table several sheets of paper covered with dode-casyllabic blank verse.

I read a dozen of them, and I told him that, although the verses were very fine, the reading caused me more pain than pleasure.

"They express the same ideas as the panegyric of the Marechal de Saxe, but I confess that your prose pleases me a great deal more."

"My prose would not have pleased you so much, if it had not been at first composed in blank verse."

"Then you take very great trouble for nothing."

"No trouble at all, for I have not the slightest difficulty in writing that sort of poetry. I write it as easily as prose."

"Do you think that your prose is better when you compose it from your own poetry?"

"No doubt of it, it is much better, and I also secure the advantage that my prose is not full of half verses which flow from the pen of the writer without his being aware of it."

"Is that a fault?"

"A great one and not to be forgiven. Prose intermixed with occasional verses is worse than prosaic poetry."

"Is it true that the verses which, like parasites, steal into a funeral oration, must be sadly out of place?"

"Certainly. Take the example of Tacitus, who begins his history of Rome by these words: 'Urbem Roman a principio reges habuere'. They form a very poor Latin hexameter, which the great historian certainly never made on purpose, and which he never remarked when he revised his work, for there is no doubt that, if he had observed it, he would have altered that sentence. Are not such verses considered a blemish in Italian prose?"

"Decidedly. But I must say that a great many poor writers have purposely inserted such verses into their prose, believing that they would make it more euphonious. Hence the tawdriness which is justly alleged against much Italian literature. But I suppose you are the only writer who takes so much pains."

"The only one? Certainly not. All the authors who can compose blank verses very easily, as I can, employ them when they intend to make a fair copy of their prose. Ask Crebillon, the Abby de Voisenon, La Harpe, anyone you like, and they will all tell you the same thing. Voltaire was the first to have recourse to that art in the small pieces in which his prose is truly charming. For instance, the epistle to Madame du Chatelet, which is magnificent. Read it, and if you find a single hemistich in it I will confess myself in the wrong."

I felt some curiosity about the matter, and I asked Crebillon about it. He told me that Fatu was right, but he added that he had never practised that art himself.

Patu wished very much to take me to the opera in order to witness the effect produced upon me by the performance, which must truly astonish an Italian. 'Les Fetes Venitiennes' was the title of the opera which was in vogue just then—a title full of interest for me. We went for our forty sous to the pit, in which, although the audience was standing, the company was excellent, for the opera was the favourite amusement of the Parisians.

After a symphony, very fine in its way and executed by an excellent orchestra, the curtain rises, and I see a beautiful scene representing the small St. Mark's Square in Venice, taken from the Island of St. George, but I am shocked to see the ducal palace on my left, and the tall steeple on my right, that is to say the very reverse of reality. I laugh at this ridiculous mistake, and Patu, to whom I say why I am laughing, cannot help joining me. The music, very fine although in the ancient style, at first amused me on account of its novelty, but it soon wearied me. The melopaeia fatigued me by its constant and tedious monotony, and by the shrieks given out of season. That melopaeia, of the French replaces—at least they think so—the Greek melapaeia and our recitative which they dislike, but which they would admire if they understood Italian.

The action of the opera was limited to a day in the carnival, when the Venetians are in the habit of promenading masked in St. Mark's Square. The stage was animated by gallants, procuresses, and women amusing themselves with all sorts of intrigues. The costumes were whimsical and erroneous, but the whole was amusing. I laughed very heartily, and it was truly a curious sight for a Venetian, when I saw the Doge followed by twelve Councillors appear on the stage, all dressed in the most ludicrous style, and dancing a 'pas

d'ensemble'. Suddenly the whole of the pit burst into loud applause at the appearance of a tall, well-made dancer, wearing a mask and an enormous black wig, the hair of which went half-way down his back, and dressed in a robe open in front and reaching to his heels. Patu said, almost reverently, "It is the inimitable Dupres." I had heard of him before, and became attentive. I saw that fine figure coming forward with measured steps, and when the dancer had arrived in front of the stage, he raised slowly his rounded arms, stretched them gracefully backward and forward, moved his feet with precision and lightness, took a few small steps, made some battements and pirouettes, and disappeared like a butterfly. The whole had not lasted half a minute. The applause burst from every part of the house. I was astonished, and asked my friend the cause of all those bravos.

"We applaud the grace of Dupres and, the divine harmony of his movements. He is now sixty years of age, and those who saw him forty years ago say that he is always the same."

"What! Has he never danced in a different style?"

"He could not have danced in a better one, for his style is perfect, and what can you want above perfection?"

"Nothing, unless it be a relative perfection."

"But here it is absolute. Dupres always does the same thing, and everyday we fancy we see it for the first time. Such is the power of the good and beautiful, of the true and sublime, which speak to the soul. His dance is true harmony, the real dance, of which you have no idea in Italy."

At the end of the second act, Dupres appeared again, still with a mask, and danced to a different tune, but in my opinion doing exactly the same as before. He advanced to the very footlights, and stopped one instant in a graceful attitude. Patu wanted to force my admiration, and I gave way. Suddenly everyone round me exclaimed,—

"Look! look! he is developing himself!"

And in reality he was like an elastic body which, in developing itself, would get larger. I made Patu very happy by telling him that Dupres was truly very graceful in all his movements. Immediately after him we had a female dancer, who jumped about like a fury, cutting to right and left, but heavily, yet she was applauded 'con furore'.

"This is," said Patu, "the famous Camargo. I congratulate you, my friend, upon having arrived in Paris in time to see her, for she has accomplished her twelfth lustre."

I confessed that she was a wonderful dancer.

"She is the first artist," continued my friend, "who has dared to spring and jump on a French stage. None ventured upon doing it before her, and, what is more extraordinary, she does not wear any drawers."

"I beg your pardon, but I saw...."

"What? Nothing but her skin which, to speak the truth, is not made of lilies and roses."

"The Camargo," I said, with an air of repentance, "does not please me. I like Dupres much better."

An elderly admirer of Camargo, seated on my left, told me that in her youth she could perform the 'saut de basque' and even the 'gargouillade', and that nobody had ever seen her thighs, although she always danced without drawers.

"But if you never saw her thighs, how do you know that she does not wear silk tights?"

"Oh! that is one of those things which can easily be ascertained. I see you are a foreigner, sir."

"You are right."

But I was delighted at the French opera, with the rapidity of the scenic changes which are done like lightning, at the signal of a whistle—a thing entirely unknown in Italy. I likewise admired the start given to the orchestra by the baton of the leader, but he disgusted me with the movements of his sceptre right and left, as if he thought that he could give life to all the instruments by the mere motion of his arm. I admired also the silence of the audience, a thing truly wonderful to an Italian, for it is with great reason that people complain of the noise made in Italy while the artists are singing, and ridicule the silence which prevails through the house as soon as the dancers make their appearance on the stage. One would imagine that all the intelligence of the Italians is in their eyes. At the same time I must observe that there is not one country in the world in which extravagance and whimsicalness cannot be found, because the foreigner can make comparisons with what he has seen elsewhere, whilst the natives are not conscious of their errors. Altogether the opera pleased me, but the French comedy captivated me. There the French are truly in their element; they perform splendidly, in a masterly manner, and other nations cannot refuse them the palm which good taste and justice must award to their superiority. I was in the habit of going there every day, and although sometimes the audience was not composed of two hundred persons, the actors were perfect. I have seen 'Le Misanthrope', 'L'Avare', 'Tartufe', 'Le Joueur', 'Le Glorieux', and many other comedies; and, no matter how often I saw them. I always fancied it was the

first time. I arrived in Paris to admire Sarrazin, La Dangeville, La Dumesnil, La Gaussin, La Clairon, Preville, and several actresses who, having retired from the stage, were living upon their pension, and delighting their circle of friends. I made, amongst others, the acquaintance of the celebrated Le Vasseur. I visited them all with pleasure, and they related to me several very curious anecdotes. They were generally most kindly disposed in every way.

One evening, being in the box of Le Vasseur, the performance was composed of a tragedy in which a very handsome actress had the part of a dumb priestess.

"How pretty she is!" I said.

"Yes, charming," answered Le Vasseur, "She is the daughter of the actor who plays the confidant. She is very pleasant in company, and is an actress of good promise."

"I should be very happy to make her acquaintance."

"Oh! well; that is not difficult. Her father and mother are very worthy people, and they will be delighted if you ask them to invite you to supper. They will not disturb you; they will go to bed early, and will let you talk with their daughter as long as you please. You are in France, sir; here we know the value of life, and try to make the best of it. We love pleasure, and esteem ourselves fortunate when we can find the opportunity of enjoying life."

"That is truly charming, madam; but how could I be so bold as to invite myself to supper with worthy persons whom I do not know, and who have not the slightest knowledge of me?"

"Oh, dear me! What are you saying? We know everybody. You see how I treat you myself. After the performance, I shall be happy to introduce you, and the acquaintance will be made at once."

"I certainly must ask you to do me that honour, but another time."

"Whenever you like."

CHAPTER VII

My Blunders in the French Language, My Success, My Numerous
Acquaintances—Louis XV.—My Brother Arrives in Paris.

All the Italian actors in Paris insisted upon entertaining me, in order to
shew me their magnificence, and they all did it in a sumptuous style. Carlin
Bertinazzi who played Harlequin, and was a great favourite of the Parisians,
reminded me that he had already seen me thirteen years before in Padua, at
the time of his return from St. Petersburg with my mother. He offered me an
excellent dinner at the house of Madame de la Caillerie, where he lodged.
That lady was in love with him. I complimented her upon four charming
children whom I saw in the house. Her husband, who was present, said to me;

"They are M. Carlin's children."

"That may be, sir, but you take care of them, and as they go by your name,
of course they will acknowledge you as their father."

"Yes, I should be so legally; but M. Carlin is too honest a man not to
assume the care of his children whenever I may wish to get rid of them. He is
well aware that they belong to him, and my wife would be the first to
complain if he ever denied it."

The man was not what is called a good, easy fellow, far from it; but he took
the matter in a philosophical way, and spoke of it with calm, and even with
a sort of dignity. He was attached to Carlin by a warm friendship, and such
things were then very common in Paris amongst people of a certain class. Two
noblemen, Boufflers and Luxembourg, had made a friendly exchange of each
other's wives, and each had children by the other's wife. The young Boufflers
were called Luxembourg, and the young Luxembourg were called Boufflers.
The descendants of those tiercelets are even now known in France under
those names. Well, those who were in the secret of that domestic comedy
laughed, as a matter of course, and it did not prevent the earth from moving
according to the laws of gravitation.

The most wealthy of the Italian comedians in Paris was Pantaloon, the
father of Coraline and Camille, and a well-known usurer. He also invited me
to dine with his family, and I was delighted with his two daughters. The
eldest, Coraline, was kept by the Prince of Monaco, son of the Duke of
Valentinois, who was still alive; and Camille was enamoured of the Count of
Melfort, the favourite of the Duchess of Chartres, who had just become
Duchess of Orleans by the death of her father-in-law.

Coraline was not so sprightly as Camille, but she was prettier. I began to make love to her as a young man of no consequence, and at hours which I thought would not attract attention: but all hours belong by right to the established lover, and I therefore found myself sometimes with her when the Prince of Monaco called to see her. At first I would bow to the prince and withdraw, but afterwards I was asked to remain, for as a general thing princes find a tete-a-tete with their mistresses rather wearisome. Therefore we used to sup together, and they both listened, while it was my province to eat, and to relate stories.

I bethought myself of paying my court to the prince, and he received my advances very well. One morning, as I called on Coraline, he said to me,

"Ah! I am very glad to see you, for I have promised the Duchess of Rufe to present you to her, and we can go to her immediately."

Again a duchess! My star is decidedly in the ascendant. Well, let us go! We got into a 'diable', a sort of vehicle then very fashionable, and at eleven o'clock in the morning we were introduced to the duchess.

Dear reader, if I were to paint it with a faithful pen, my portrait of that lustful vixen would frighten you. Imagine sixty winters heaped upon a face plastered with rouge, a blotched and pimpled complexion, emaciated and gaunt features, all the ugliness of libertinism stamped upon the countenance of that creature relining upon the sofa. As soon as she sees me, she exclaims with rapid joy,

"Ah! this is a good-looking man! Prince, it is very amiable on your part to bring him to me. Come and sit near me, my fine fellow!"

I obeyed respectfully, but a noxious smell of musk, which seemed to me almost corpse-like, nearly upset me. The infamous duchess had raised herself on the sofa and exposed all the nakedness of the most disgusting bosom, which would have caused the most courageous man to draw back. The prince, pretending to have some engagement, left us, saying that he would send his carriage for me in a short time.

As soon as we were alone, the plastered skeleton thrust its arms forward, and, without giving me time to know what I was about, the creature gave me a horrible kiss, and then one of her hands began to stray with the most bare-faced indecency.

"Let me see, my fine cock," she said, "if you have a fine . . ."

I was shuddering, and resisted the attempt.

"Well, well! What a baby you are!" said the disgusting Messaline; "are you such a novice?"

"No, madam; but...."

"But what?"

"I have...."

"Oh, the villain!" she exclaimed, loosing her hold; "what was I going to expose myself to!"

I availed myself of the opportunity, snatched my hat, and took to my heels, afraid lest the door-keeper should stop me.

I took a coach and drove to Coraline's, where I related the adventure. She laughed heartily, and agreed with me that the prince had played me a nasty trick. She praised the presence of mind with which I had invented an impediment, but she did not give me an opportunity of proving to her that I had deceived the duchess.

Yet I was not without hope, and suspected that she did not think me sufficiently enamoured of her.

Three or four days afterwards, however, as we had supper together and alone, I told her so many things, and I asked her so clearly to make me happy or else to dismiss me, that she gave me an appointment for the next day.

"To-morrow," she said, "the prince goes to Versailles, and he will not return until the day after; we will go together to the warren to hunt ferrets, and have no doubt we shall come back to Paris pleased with one another."

"That is right."

The next day at ten o'clock we took a coach, but as we were nearing the gate of the city a vis-a-vis, with servants in a foreign livery came tip to us, and the person who was in it called out, "Stop! Stop!"

The person was the Chevalier de Wurtemburg, who, without deigning to cast even one glance on me, began to say sweet words to Coraline, and thrusting his head entirely out of his carriage he whispered to her. She answered him likewise in a whisper; then taking my hand, she said to me, laughingly,

"I have some important business with this prince; go to the warren alone, my dear friend, enjoy the hunt, and come to me to-morrow."

And saying those words she got out, took her seat in the vis-a-vis, and I found myself very much in the position of Lot's wife, but not motionless.

Dear reader, if you have ever been in such a predicament you will easily realize the rage with which I was possessed: if you have never been served in that way, so much the better for you, but it is useless for me to try to give you an idea of my anger; you would not understand me.

I was disgusted with the coach, and I jumped out of it, telling the driver to go to the devil. I took the first hack which happened to pass, and drove straight to Patu's house, to whom I related my adventure, almost foaming

with rage. But very far from pitying me or sharing my anger, Patu, much wiser, laughed and said,

"I wish with all my heart that the same thing might happen to me; for you are certain of possessing our beautiful Coraline the very first time you are with her."

"I would not have her, for now I despise her heartily." "Your contempt ought to have come sooner. But, now that is too late to discuss the matter, I offer you, as a compensation, a dinner at the Hotel du Roule."

"Most decidedly yes; it is an excellent idea. Let us go."

The Hotel du Roule was famous in Paris, and I had not been there yet. The woman who kept it had furnished the place with great elegance, and she always had twelve or fourteen well-chosen nymphs, with all the conveniences that could be desired. Good cooking, good beds, cleanliness, solitary and beautiful groves. Her cook was an artist, and her wine-cellar excellent. Her name was Madame Paris; probably an assumed name, but it was good enough for the purpose. Protected by the police, she was far enough from Paris to be certain that those who visited her liberally appointed establishment were above the middle class. Everything was strictly regulated in her house and every pleasure was taxed at a reasonable tariff. The prices were six francs for a breakfast with a nymph, twelve for dinner, and twice that sum to spend a whole night. I found the house even better than its reputation, and by far superior to the warren.

We took a coach, and Patu said to the driver,

"To Chaillot."

"I understand, your honour."

After a drive of half an hour, we stopped before a gate on which could be read, "Hotel du Roule."

The gate was closed. A porter, sporting long mustachioes, came out through a side-door and gravely examined us. He was most likely pleased with our appearance, for the gate was opened and we went in. A woman, blind of one eye, about forty years old, but with a remnant of beauty, came up, saluted us politely, and enquired whether we wished to have dinner. Our answer being affirmative, she took us to a fine room in which we found fourteen young women, all very handsome, and dressed alike in muslin. As we entered the room, they rose and made us a graceful reverence; they were all about the same age, some with light hair, some with dark; every taste could be satisfied. We passed them in review, addressing a few words to each, and made our choice. The two we chose screamed for joy, kissed us with a voluptuousness which a novice might have mistaken for love, and took us to the garden until

dinner would be ready. That garden was very large and artistically arranged to minister to the pleasures of love. Madame Paris said to us,

"Go, gentlemen, enjoy the fresh air with perfect security in every way; my house is the temple of peace and of good health."

The girl I had chosen was something like Coraline, and that made me find her delightful. But in the midst of our amorous occupations we were called to dinner. We were well served, and the dinner had given us new strength, when our single-eyed hostess came, watch in hand, to announce that time was up. Pleasure at the "Hotel du Roule" was measured by the hour.

I whispered to Patu, and, after a few philosophical considerations, addressing himself to madame la gouvernante, he said to her,

"We will have a double dose, and of course pay double."

"You are quite welcome, gentlemen."

We went upstairs, and after we had made our choice a second time, we renewed our promenade in the garden. But once more we were disagreeably surprised by the strict punctuality of the lady of the house. "Indeed! this is too much of a good thing, madam."

"Let us go up for the third time, make a third choice, and pass the whole night here."

"A delightful idea which I accept with all my heart."

"Does Madame Paris approve our plan?"

"I could not have devised a better one, gentlemen; it is a masterpiece."

When we were in the room, and after we had made a new choice, the girls laughed at the first ones who had not contrived to captivate us, and by way of revenge these girls told their companions that we were lanky fellows.

This time I was indeed astonished at my own choice. I had taken a true Aspasia, and I thanked my stars that I had passed her by the first two times, as I had now the certainty of possessing her for fourteen hours. That beauty's name was Saint Hilaire; and under that name she became famous in England, where she followed a rich lord the year after. At first, vexed because I had not remarked her before, she was proud and disdainful; but I soon proved to her that it was fortunate that my first or second choice had not fallen on her, as she would now remain longer with me. She then began to laugh, and shewed herself very agreeable.

That girl had wit, education and talent-everything, in fact, that is needful to succeed in the profession she had adopted. During the supper Patu told me in Italian that he was on the point of taking her at the very moment I chose her, and the next morning he informed me that he had slept quietly all night. The Saint Hilaire was highly pleased with me, and she boasted of it before her

companions. She was the cause of my paying several visits to the Hotel du Roule, and all for her; she was very proud of my constancy.

Those visits very naturally cooled my ardour for Coraline. A singer from Venice, called Guadani, handsome, a thorough musician, and very witty, contrived to captivate her affections three weeks after my quarrel with her. The handsome fellow, who was a man only in appearance, inflamed her with curiosity if not with love, and caused a rupture with the prince, who caught her in the very act. But Coraline managed to coax him back, and, a short time after, a reconciliation took place between them, and such a good one, that a babe was the consequence of it; a girl, whom the prince named Adelaide, and to whom he gave a dowry. After the death of his father, the Duke of Valentinois, the prince left her altogether and married Mlle. de Brignole, from Genoa. Coraline became the mistress of Count de la Marche, now Prince de Conti. Coraline is now dead, as well as a son whom she had by the count, and whom his father named Count de Monreal.

Madame la Dauphine was delivered of a princess, who received the title of Madame de France.

In the month of August the Royal Academy had an exhibition at the Louvre, and as there was not a single battle piece I conceived the idea of summoning my brother to Paris. He was then in Venice, and he had great talent in that particular style. Passorelli, the only painter of battles known in France, was dead, and I thought that Francois might succeed and make a fortune. I therefore wrote to M. Grimani and to my brother; I persuaded them both, but Francois did not come to Paris till the beginning of the following year.

Louis XV., who was passionately fond of hunting, was in the habit of spending six weeks every year at the Chateau of Fontainebleau. He always returned to Versailles towards the middle of November. That trip cost him, or rather cost France, five millions of francs. He always took with him all that could contribute to the amusement of the foreign ambassadors and of his numerous court. He was followed by the French and the Italian comedians, and by the actors and actresses of the opera.

During those six weeks Fontainebleau was more brilliant than Versailles; nevertheless, the artists attached to the theatres were so numerous that the Opera, the French and Italian Comedies, remained open in Paris.

Baletti's father, who had recovered his health, was to go to Fontainebleau with Silvia and all his family. They invited me to accompany them, and to accept a lodging in a house hired by them.

It was a splendid opportunity; they were my friends, and I accepted, for I could not have met with a better occasion to see the court and all the foreign ministers. I presented myself to M. de Morosini, now Procurator at St. Mark's, and then ambassador from the Republic to the French court.

The first night of the opera he gave me permission to accompany him; the music was by Lulli. I had a seat in the pit precisely under the private box of Madame de Pompadour, whom I did not know. During the first scene the celebrated Le Maur gave a scream so shrill and so unexpected that I thought she had gone mad. I burst into a genuine laugh, not supposing that any one could possibly find fault with it. But a knight of the Order of the Holy Ghost, who was near the Marquise de Pompadour, dryly asked me what country I came from. I answered, in the same tone,

"From Venice."

"I have been there, and have laughed heartily at the recitative in your operas."

"I believe you, sir, and I feel certain that no one ever thought of objecting to your laughing."

My answer, rather a sharp one, made Madame de Pompadour laugh, and she asked me whether I truly came from down there.

"What do you mean by down there?"

"I mean Venice."

"Venice, madam, is not down there, but up there."

That answer was found more singular than the first, and everybody in the box held a consultation in order to ascertain whether Venice was down or up. Most likely they thought I was right, for I was left alone. Nevertheless, I listened to the opera without laughing; but as I had a very bad cold I blew my nose often. The same gentleman addressing himself again to me, remarked that very likely the windows of my room did not close well. That gentleman, who was unknown to me was the Marechal de Richelieu. I told him he was mistaken, for my windows were well 'calfoutrees'. Everyone in the box burst into a loud laugh, and I felt mortified, for I knew my mistake; I ought to have said 'calfeutrees'. But these 'eus' and 'ous' cause dire misery to all foreigners.

Half an hour afterwards M. de Richelieu asked me which of the two actresses pleased me most by her beauty.

"That one, sir."

"But she has ugly legs."

"They are not seen, sir; besides, whenever I examine the beauty of a woman, 'la premiere chose que j'ecarte, ce sont les jambes'."

That word said quite by chance, and the double meaning of which I did not understand, made at once an important personage of me, and everybody in the box of Madame de Pompadour was curious to know me. The marshal learned who I was from M. de Morosini, who told me that the duke would be happy to receive me. My 'jeu de mots' became celebrated, and the marshal honoured me with a very gracious welcome. Among the foreign ministers, the one to whom I attached myself most was Lord Keith, Marshal of Scotland and ambassador of the King of Prussia. I shall have occasion to speak of him.

The day after my arrival in Fontainebleau I went alone to the court, and I saw Louis XV., the handsome king, go to the chapel with the royal family and all the ladies of the court, who surprised me by their ugliness as much as the ladies of the court of Turin had astonished me by their beauty. Yet in the midst of so many ugly ones I found out a regular beauty. I enquired who she was.

"She is," answered one of my neighbours, "Madame de Brionne, more remarkable by her virtue even than by her beauty. Not only is there no scandalous story told about her, but she has never given any opportunity to scandal-mongers of inventing any adventure of which she was the heroine."

"Perhaps her adventures are not known."

"Ah, monsieur! at the court everything is known."

I went about alone, sauntering through the apartments, when suddenly I met a dozen ugly ladies who seemed to be running rather than walking; they were standing so badly upon their legs that they appeared as if they would fall forward on their faces. Some gentleman happened to be near me, curiosity impelled me to enquire where they were coming from, and where they were going in such haste.

"They are coming from the apartment of the queen who is going to dine, and the reason why they walk so badly is that their shoes have heels six inches high, which compel them to walk on their toes and with bent knees in order to avoid falling on their faces."

"But why do they not wear lower heels?"

"It is the fashion."

"What a stupid fashion!"

I took a gallery at random, and saw the king passing along, leaning with one arm on the shoulder of M. d'Argenson. "Oh, base servility!" I thought to myself. "How can a man make up his mind thus to bear the yoke, and how can a man believe himself so much above all others as to take such unwarrantable liberties!"

Louis XV. had the most magnificent head it was possible to see, and he carried it with as much grace as majesty. Never did even the most skilful painter succeed in rendering justice to the expression of that beautiful head, when the king turned it on one side to look with kindness at anyone. His beauty and grace compelled love at once. As I saw him, I thought I had found the ideal majesty which I had been so surprised not to find in the king of Sardinia, and I could not entertain a doubt of Madame de Pompadour having been in love with the king when she sued for his royal attention. I was greatly mistaken, perhaps, but such a thought was natural in looking at the countenance of Louis XV.

I reached a splendid room in which I saw several courtiers walking about, and a table large enough for twelve persons, but laid out only for one.

"For whom is this table?"

"For the queen. Her majesty is now coming in."

It was the queen of France, without rouge, and very simply dressed; her head was covered with a large cap; she looked old and devout. When she was near the table, she graciously thanked two nuns who were placing a plate with fresh butter on it. She sat down, and immediately the courtiers formed a semicircle within five yards of the table; I remained near them, imitating their respectful silence.

Her majesty began to eat without looking at anyone, keeping her eyes on her plate. One of the dishes being to her taste, she desired to be helped to it a second time, and she then cast her eyes round the circle of courtiers, probably in order to see if among them there was anyone to whom she owed an account of her daintiness. She found that person, I suppose, for she said,

"Monsieur de Lowendal!"

At that name, a fine-looking man came forward with respectful inclination, and said,

"Your majesty?"

"I believe this is a fricassee of chickens."

"I am of the same opinion, madam."

After this answer, given in the most serious tone, the queen continued eating, and the marshal retreated backward to his original place. The queen finished her dinner without uttering a single word, and retired to her apartments the same way as she had come. I thought that if such was the way the queen of France took all her meals, I would not sue for the honour of being her guest.

I was delighted to have seen the famous captain who had conquered Bergen-op-Zoom, but I regretted that such a man should be compelled to give

an answer about a fricassee of chickens in the serious tone of a judge pronouncing a sentence of death.

I made good use of this anecdote at the excellent dinner Silvia gave to the elite of polite and agreeable society.

A few days afterwards, as I was forming a line with a crowd of courtiers to enjoy the ever new pleasure of seeing the king go to mass, a pleasure to which must be added the advantage of looking at the naked and entirely exposed arms and bosoms of Mesdames de France, his daughters, I suddenly perceived the Cavamacchia, whom I had left in Cesena under the name of Madame Querini. If I was astonished to see her, she was as much so in meeting me in such a place. The Marquis of Saint Simon, premier 'gentilhomme' of the Prince de Conde, escorted her.

"Madame Querini in Fontainebleau?"

"You here? It reminds me of Queen Elizabeth saying,

"'Pauper ubique facet.'"

"An excellent comparison, madam."

"I am only joking, my dear friend; I am here to see the king, who does not know me; but to-morrow the ambassador will present me to his majesty."

She placed herself in the line within a yard or two from me, beside the door by which the king was to come. His majesty entered the gallery with M. de Richelieu, and looked at the so-called Madame Querini. But she very likely did not take his fancy, for, continuing to walk on, he addressed to the marshal these remarkable words, which Juliette must have overheard,

"We have handsomer women here."

In the afternoon I called upon the Venetian ambassador. I found him in numerous company, with Madame Querini sitting on his right. She addressed me in the most flattering and friendly manner; it was extraordinary conduct on the part of a giddy woman who had no cause to like me, for she was aware that I knew her thoroughly, and that I had mastered her vanity; but as I understood her manoeuvring I made up my mind not to disoblige her, and even to render her all the good offices I could; it was a noble revenge.

As she was speaking of M. Querini, the ambassador congratulated her upon her marriage with him, saying that he was glad M. Querini had rendered justice to her merit, and adding,

"I was not aware of your marriage."

"Yet it took place more than two years since," said Juliette.

"I know it for a fact," I said, in my turn; "for, two years ago, the lady was introduced as Madame Querini and with the title of excellency by General Spada to all the nobility in Cesena, where I was at that time."

"I have no doubt of it," answered the ambassador, fixing his eyes upon me, "for Querini has himself written to me on the subject."

A few minutes afterwards, as I was preparing to take my leave, the ambassador, under pretense of some letters the contents of which he wished to communicate to me, invited me to come into his private room, and he asked me what people generally thought of the marriage in Venice.

"Nobody knows it, and it is even rumoured that the heir of the house of Querini is on the point of marrying a daughter of the Grimani family; but I shall certainly send the news to Venice."

"What news?"

"That Juliette is truly Madame Querini, since your excellency will present her as such to Louis XV."

"Who told you so?"

"She did."

"Perhaps she has altered her mind."

I repeated to the ambassador the words which the king had said to M. de Richelieu after looking at Juliette.

"Then I can guess," remarked the ambassador, "why Juliette does not wish to be presented to the king."

I was informed some time afterwards that M. de Saint Quentin, the king's confidential minister, had called after mass on the handsome Venetian, and had told her that the king of France had most certainly very bad taste, because he had not thought her beauty superior to that of several ladies of his court. Juliette left Fontainebleau the next morning.

In the first part of my Memoirs I have spoken of Juliette's beauty; she had a wonderful charm in her countenance, but she had already used her advantages too long, and her beauty was beginning to fade when she arrived in Fontainebleau.

I met her again in Paris at the ambassador's, and she told me with a laugh that she had only been in jest when she called herself Madame Querini, and that I should oblige her if for the future I would call her by her real name of Countess Preati. She invited me to visit her at the Hotel de Luxembourg, where she was staying. I often called on her, for her intrigues amused me, but I was wise enough not to meddle with them.

She remained in Paris four months, and contrived to infatuate M. Ranchi, secretary of the Venetian Embassy, an amiable and learned man. He was so deeply in love that he had made up his mind to marry her; but through a caprice which she, perhaps, regretted afterwards, she ill-treated him, and the fool died of grief. Count de Canes. ambassador of Maria Theresa, had some

inclination for her, as well as the Count of Zinzendorf. The person who arranged these transient and short-lived intrigues was a certain Guasco, an abbe not over-favoured with the gifts of Plutus. He was particularly ugly, and had to purchase small favours with great services.

But the man whom she really wished to marry was Count Saint Simon. He would have married her if she had not given him false addresses to make enquiries respecting her birth. The Preati family of Verona denied all knowledge of her, as a matter of course, and M. de Saint Simon, who, in spite of all his love, had not entirely lost his senses, had the courage to abandon her. Altogether, Paris did not prove an 'el dorado' for my handsome countrywoman, for she was obliged to pledge her diamonds, and to leave them behind her. After her return to Venice she married the son of the Uccelli, who sixteen years before had taken her out of her poverty. She died ten years ago.

I was still taking my French lessons with my good old Crebillon; yet my style, which was full of Italianisms, often expressed the very reverse of what I meant to say. But generally my 'quid pro quos' only resulted in curious jokes which made my fortune; and the best of it is that my gibberish did me no harm on the score of wit: on the contrary, it procured me fine acquaintances.

Several ladies of the best society begged me to teach them Italian, saying that it would afford them the opportunity of teaching me French; in such an exchange I always won more than they did.

Madame Preodot, who was one of my pupils, received me one morning; she was still in bed, and told me that she did not feel disposed to have a lesson, because she had taken medicine the night previous. Foolishly translating an Italian idiom, I asked her, with an air of deep interest, whether she had well 'decharge'?

"Sir, what a question! You are unbearable."

I repeated my question; she broke out angrily again.

"Never utter that dreadful word."

"You are wrong in getting angry; it is the proper word."

"A very dirty word, sir, but enough about it. Will you have some breakfast?"

"No, I thank you. I have taken a 'cafe' and two 'Savoyards'."

"Dear me! What a ferocious breakfast! Pray, explain yourself."

"I say that I have drunk a cafe and eaten two Savoyards soaked in it, and that is what I do every morning."

"You are stupid, my good friend. A cafe is the establishment in which coffee is sold, and you ought to say that you have drunk 'use tasse de cafe'"

"Good indeed! Do you drink the cup? In Italy we say a 'caffs', and we are not foolish enough to suppose that it means the coffee-house."

"He will have the best of it! And the two 'Savoyards', how did you swallow them?"

"Soaked in my coffee, for they were not larger than these on your table."

"And you call these 'Savoyards'? Say biscuits."

"In Italy, we call them 'Savoyards' because they were first invented in Savoy; and it is not my fault if you imagined that I had swallowed two of the porters to be found at the corner of the streets—big fellows whom you call in Paris Savoyards, although very often they have never been in Savoy."

Her husband came in at that moment, and she lost no time in relating the whole of our conversation. He laughed heartily, but he said I was right. Her niece arrived a few minutes after; she was a young girl about fourteen years of age, reserved, modest, and very intelligent. I had given her five or six lessons in Italian, and as she was very fond of that language and studied diligently she was beginning to speak.

Wishing to pay me her compliments in Italian, she said to me,

"'Signore, sono in cantata di vi Vader in bona salute'."

"I thank you, mademoiselle; but to translate 'I am enchanted', you must say 'ho pacer', and for to see you, you must say 'di vedervi'."

"I thought, sir, that the 'vi' was to be placed before."

"No, mademoiselle, we always put it behind."

Monsieur and Madame Preodot were dying with laughter; the young lady was confused, and I in despair at having uttered such a gross absurdity; but it could not be helped. I took a book sulkily, in the hope of putting a stop to their mirth, but it was of no use: it lasted a week. That uncouth blunder soon got known throughout Paris, and gave me a sort of reputation which I lost little by little, but only when I understood the double meanings of words better. Crebillon was much amused with my blunder, and he told me that I ought to have said after instead of behind. Ah! why have not all languages the same genius! But if the French laughed at my mistakes in speaking their language, I took my revenge amply by turning some of their idioms into ridicule.

"Sir," I once said to a gentleman, "how is your wife?"

"You do her great honour, sir."

"Pray tell me, sir, what her honour has to do with her health?"

I meet in the Bois de Boulogne a young man riding a horse which he cannot master, and at last he is thrown. I stop the horse, run to the assistance of the young man and help him up.

"Did you hurt yourself, sir?"

"Oh, many thanks, sir, au contraire."

"Why au contraire! The deuce! It has done you good? Then begin again, sir."

And a thousand similar expressions entirely the reverse of good sense. But it is the genius of the language.

I was one day paying my first visit to the wife of President de N——, when her nephew, a brilliant butterfly, came in, and she introduced me to him, mentioning my name and my country.

"Indeed, sir, you are Italian?" said the young man. "Upon my word, you present yourself so gracefully that I would have betted you were French."

"Sir, when I saw you, I was near making the same mistake; I would have betted you were Italian."

Another time, I was dining at Lady Lambert's in numerous and brilliant company. Someone remarked on my finger a cornelian ring on which was engraved very beautifully the head of Louis XV. My ring went round the table, and everybody thought that the likeness was striking.

A young marquise, who had the reputation of being a great wit, said to me in the most serious tone,

"It is truly an antique?"

"The stone, madam, undoubtedly."

Everyone laughed except the thoughtless young beauty, who did not take any notice of it. Towards the end of the dinner, someone spoke of the rhinoceros, which was then shewn for twenty-four sous at the St. Germain's Fair.

"Let us go and see it!" was the cry.

We got into the carriages, and reached the fair. We took several turns before we could find the place. I was the only gentleman; I was taking care of two ladies in the midst of the crowd, and the witty marquise was walking in front of us. At the end of the alley where we had been told that we would find the animal, there was a man placed to receive the money of the visitors. It is true that the man, dressed in the African fashion, was very dark and enormously stout, yet he had a human and very masculine form, and the beautiful marquise had no business to make a mistake. Nevertheless, the thoughtless young creature went up straight to him and said,

"Are you the rhinoceros, sir?"

"Go in, madam, go in."

We were dying with laughing; and the marquise, when she had seen the animal, thought herself bound to apologize to the master; assuring him that

she had never seen a rhinoceros in her life, and therefore he could not feel offended if she had made a mistake.

One evening I was in the foyer of the Italian Comedy, where between the acts the highest noblemen were in the habit of coming, in order to converse and joke with the actresses who used to sit there waiting for their turn to appear on the stage, and I was seated near Camille, Coraline's sister, whom I amused by making love to her. A young councillor, who objected to my occupying Camille's attention, being a very conceited fellow, attacked me upon some remark I made respecting an Italian play, and took the liberty of shewing his bad temper by criticizing my native country. I was answering him in an indirect way, looking all the time at Camille, who was laughing. Everybody had congregated around us and was attentive to the discussion, which, being carried on as an assault of wit, had nothing to make it unpleasant.

But it seemed to take a serious turn when the young fop, turning the conversation on the police of the city, said that for some time it had been dangerous to walk alone at night through the streets of Paris.

"During the last month," he added, "the Place de Greve has seen the hanging of seven men, among whom there were five Italians. An extraordinary circumstance."

"Nothing extraordinary in that," I answered; "honest men generally contrive to be hung far away from their native country; and as a proof of it, sixty Frenchmen have been hung in the course of last year between Naples, Rome, and Venice. Five times twelve are sixty; so you see that it is only a fair exchange."

The laughter was all on my side, and the fine councillor went away rather crestfallen. One of the gentlemen present at the discussion, finding my answer to his taste, came up to Camille, and asked her in a whisper who I was. We got acquainted at once.

It was M. de Marigni, whom I was delighted to know for the sake of my brother whose arrival in Paris I was expecting every day. M. de Marigni was superintendent of the royal buildings, and the Academy of Painting was under his jurisdiction. I mentioned my brother to him, and he graciously promised to protect him. Another young nobleman, who conversed with me, invited me to visit him. It was the Duke de Matalona.

I told him that I had seen him, then only a child, eight years before in Naples, and that I was under great obligations to his uncle, Don Lelio. The young duke was delighted, and we became intimate friends.

My brother arrived in Paris in the spring of 1751, and he lodged with me at Madame Quinson's. He began at once to work with success for private individuals; but his main idea being to compose a picture to be submitted to the judgment of the Academy, I introduced him to M. de Marigni, who received him with great distinction, and encouraged him by assuring him of his protection. He immediately set to work with great diligence.

M. de Morosini had been recalled, and M. de Mocenigo had succeeded him as ambassador of the Republic. M. de Bragadin had recommended me to him, and he tendered a friendly welcome both to me and to my brother, in whose favour he felt interested as a Venetian, and as a young artist seeking to build up a position by his talent.

M. de Mocenigo was of a very pleasant nature; he liked gambling although he was always unlucky at cards; he loved women, and he was not more fortunate with them because he did not know how to manage them. Two years after his arrival in Paris he fell in love with Madame de Colande, and, finding it impossible to win her affections, he killed himself.

Madame la Dauphine was delivered of a prince, the Duke of Burgundy, and the rejoicings indulged in at the birth of that child seem to me incredible now, when I see what the same nation is doing against the king. The people want to be free; it is a noble ambition, for mankind are not made to be the slaves of one man; but with a nation populous, great, witty, and giddy, what will be the end of that revolution? Time alone can tell us.

The Duke de Matalona procured me the acquaintance of the two princes, Don Marc Antoine and Don Jean Baptiste Borghese, from Rome, who were enjoying themselves in Paris, yet living without display. I had occasion to remark that when those Roman princes were presented at the court of France they were only styled "marquis:" It was the same with the Russian princes, to whom the title of prince was refused when they wanted to be presented; they were called "knees," but they did not mind it, because that word meant prince. The court of France has always been foolishly particular on the question of titles, and is even now sparing of the title of monsieur, although it is common enough everywhere every man who was not titled was called Sieur. I have remarked that the king never addressed his bishops otherwise than as abbes, although they were generally very proud of their titles. The king likewise affected to know a nobleman only when his name was inscribed amongst those who served him.

Yet the haughtiness of Louis XV. had been innoculated into him by education; it was not in his nature. When an ambassador presented someone to him, the person thus presented withdrew with the certainty of having been

seen by the king, but that was all. Nevertheless, Louis XV. was very polite, particularly with ladies, even with his mistresses, when in public. Whoever failed in respect towards them in the slightest manner was sure of disgrace, and no king ever possessed to a greater extent the grand royal virtue which is called dissimulation. He kept a secret faithfully, and he was delighted when he knew that no one but himself possessed it.

The Chevalier d'Eon is a proof of this, for the king alone knew and had always known that the chevalier was a woman, and all the long discussions which the false chevalier had with the office for foreign affairs was a comedy which the king allowed to go on, only because it amused him.

Louis XV. was great in all things, and he would have had no faults if flattery had not forced them upon him. But how could he possibly have supposed himself faulty in anything when everyone around him repeated constantly that he was the best of kings? A king, in the opinion of which he was imbued respecting his own person, was a being of a nature by far too superior to ordinary men for him not to have the right to consider himself akin to a god. Sad destiny of kings! Vile flatterers are constantly doing everything necessary to reduce them below the condition of man.

The Princess of Ardore was delivered about that time of a young prince. Her husband, the Neapolitan ambassador, entreated Louis XV. to be god-father to the child; the king consented and presented his god-son with a regiment; but the mother, who did not like the military career for her son, refused it. The Marshal de Richelieu told me that he had never known the king laugh so heartily as when he heard of that singular refusal.

At the Duchess de Fulvie's I made the acquaintance of Mdlle. Gaussin, who was called Lolotte. She was the mistress of Lord Albemarle, the English ambassador, a witty and very generous nobleman. One evening he complained of his mistress praising the beauty of the stars which were shining brightly over her head, saying that she ought to know he could not give them to her. If Lord Albemarle had been ambassador to the court of France at the time of the rupture between France and England, he would have arranged all difficulties amicably, and the unfortunate war by which France lost Canada would not have taken place. There is no doubt that the harmony between two nations depends very often upon their respective ambassadors, when there is any danger of a rupture.

As to the noble lord's mistress, there was but one opinion respecting her. She was fit in every way to become his wife, and the highest families of France did not think that she needed the title of Lady Albemarle to be received with distinction; no lady considered it debasing to sit near her, although she was

well known as the mistress of the English lord. She had passed from her mother's arms to those of Lord Albemarle at the age of thirteen, and her conduct was always of the highest respectability. She bore children whom the ambassador acknowledged legally, and she died Countess d'Erouville. I shall have to mention her again in my Memoirs.

I had likewise occasion to become acquainted at the Venetian Embassy with a lady from Venice, the widow of an English baronet named Wynne. She was then coming from London with her children, where she had been compelled to go in order to insure them the inheritance of their late father, which they would have lost if they had not declared themselves members of the Church of England. She was on her way back to Venice, much pleased with her journey. She was accompanied by her eldest daughter—a young girl of twelve years, who, notwithstanding her youth, carried on her beautiful face all the signs of perfection.

She is now living in Venice, the widow of Count de Rosenberg, who died in Venice ambassador of the Empress-Queen Maria Theresa. She is surrounded by the brilliant halo of her excellent conduct and of all her social virtues. No one can accuse her of any fault, except that of being poor, but she feels it only because it does not allow her to be as charitable as she might wish.

The reader will see in the next chapter how I managed to embroil myself with the French police.

CHAPTER VIII

My Broil With Parisian Justice—Mdlle. Vesian

The youngest daughter of my landlady, Mdlle. Quinson, a young girl between fifteen and sixteen years of age, was in the habit of often coming to my room without being called. It was not long before I discovered that she was in love with me, and I should have thought myself ridiculous if I had been cruel to a young brunette who was piquant, lively, amiable, and had a most delightful voice.

During the first four or five months nothing but childish trifles took place between us; but one night, coming home very late and finding her fast asleep on my bed, I did not see the necessity of waking her up, and undressing myself I lay down beside her.... She left me at daybreak.

Mimi had not been gone three hours when a milliner came with a charming young girl, to invite herself and her friend to breakfast; I thought the young girl well worth a breakfast, but I was tired and wanted rest, and I begged them both to withdraw. Soon after they had left me, Madame Quinson came with her daughter to make my bed. I put my dressing-gown on, and began to write.

"Ah! the nasty hussies!" exclaims the mother.

"What is the matter, madam?"

"The riddle is clear enough, sir; these sheets are spoiled."

"I am very sorry, my dear madam, but change them, and the evil will be remedied at once."

She went out of the room, threatening and grumbling,

"Let them come again, and see if I don't take care of them!"

Mimi remained alone with me, and I addressed her some reproaches for her imprudence. But she laughed, and answered that Love had sent those women on purpose to protect Innocence! After that, Mimi was no longer under any restraint, she would come and share my bed whenever she had a fancy to do so, unless I sent her back to her own room, and in the morning she always left me in good time. But at the end of four months my beauty informed me that our secret would soon be discovered.

"I am very sorry," I said to her, "but I cannot help it."

"We ought to think of something."

"Well, do so."

"What can I think of? Well, come what will; the best thing I can do is not to think of it."

Towards the sixth month she had become so large, that her mother, no longer doubting the truth, got into a violent passion, and by dint of blows compelled her to name the father. Mimi said I was the guilty swain, and perhaps it was not an untruth.

With that great discovery Madame Quinson burst into my room in high dudgeon. She threw herself on a chair, and when she had recovered her breath she loaded me with insulting words, and ended by telling me that I must marry her daughter. At this intimation, understanding her object and wishing to cut the matter short, I told her that I was already married in Italy.

"Then why did you come here and get my daughter with child?"

"I can assure you that I did not mean to do so. Besides, how do you know that I am the father of the child?"

"Mimi says so, and she is certain of it."

"I congratulate her; but I warn you, madam, that I am ready to swear that I have not any certainty about it."

"What then?"

"Then nothing. If she is pregnant, she will be confined."

She went downstairs, uttering curses and threats: the next day I was summoned before the commissary of the district. I obeyed the summons, and found Madame Quinson fully equipped for the battle. The commissary, after the preliminary questions usual in all legal cases, asked me whether I admitted myself guilty towards the girl Quinson of the injury of which the mother, there present personally, complained.

"Monsieur le Commissaire, I beg of you to write word by word the answer which I am going to give you."

"Very well."

"I have caused no injury whatever to Mimi, the plaintiff's daughter, and I refer you to the girl herself, who has always had as much friendship for me as I have had for her."

"But she declares that she is pregnant from your doings."

"That may be, but it is not certain."

"She says it is certain, and she swears that she has never known any other man."

"If it is so, she is unfortunate; for in such a question a man cannot trust any woman but his own wife."

"What did you give her in order to seduce her?"

"Nothing; for very far from having seduced her, she has seduced me, and we agreed perfectly in one moment; a pretty woman does not find it very hard to seduce me."

"Was she a virgin?"

"I never felt any curiosity about it either before or after; therefore, sir, I do not know."

"Her mother claims reparation, and the law is against you."

"I can give no reparation to the mother; and as for the law I will obey it when it has been explained to me, and when I am convinced that I have been guilty against it."

"You are already convinced. Do you imagine that a man who gets an honest girl with child in a house of which he is an inmate does not transgress the laws of society?"

"I admit that to be the case when the mother is deceived; but when that same mother sends her daughter to the room of a young man, are we not right in supposing that she is disposed to accept peacefully all the accidents which may result from such conduct?"

"She sent her daughter to your room only to wait on you."

"And she has waited on me as I have waited on her if she sends her to my room this evening, and if it is agreeable to Mimi, I will certainly serve her as well as I can; but I will have nothing to do with her against her will or out of my room, the rent of which I have always paid punctually."

"You may say what you like, but you must pay the fine."

"I will say what I believe to be just, and I will pay nothing; for there can be no fine where there is no law transgressed. If I am sentenced to pay I shall appeal even to the last jurisdiction and until I obtain justice, for believe me, sir, I know that I am not such an awkward and cowardly fellow as to refuse my caresses to a pretty woman who pleases me, and comes to provoke them in my own room, especially when I feel myself certain of the mother's agreement."

I signed the interrogatory after I had read it carefully, and went away. The next day the lieutenant of police sent for me, and after he had heard me, as well as the mother and the daughter, he acquitted me and condemned Madame Quinson in costs. But I could not after all resist the tears of Mimi, and her entreaties for me to defray the expenses of her confinement. She was delivered of a boy, who was sent to the Hotel Dieu to be brought up at the nation's expense. Soon afterwards Mimi ran away from her mother's house, and she appeared on the stage at St. Laurent's Fair. Being unknown, she had no difficulty in finding a lover who took her for a maiden. I found her very pretty on the stage.

"I did not know," I said to her, "that you were a musician."

"I am a musician about as much as all my companions, not one of whom knows a note of music. The girls at the opera are not much more clever, and in spite of that, with a good voice and some taste, one can sing delightfully."

I advised her to invite Patu to supper, and he was charmed with her. Some time afterwards, however, she came to a bad end, and disappeared.

The Italian comedians obtained at that time permission to perform parodies of operas and of tragedies. I made the acquaintance at that theatre of the celebrated Chantilly, who had been the mistress of the Marechal de Saxe, and was called Favart because the poet of that name had married her. She sang in the parody of 'Thetis et Pelee', by M. de Fontelle, the part of Tonton, amidst deafening applause. Her grace and talent won the love of a man of the greatest merit, the Abbe de Voisenon, with whom I was as intimate as with Crebillon. All the plays performed at the Italian Comedy, under the name of Madame Favart, were written by the abbe, who became member of the Academie after my departure from Paris. I cultivated an acquaintance the value of which I could appreciate, and he honoured me with his friendship. It was at my suggestions that the Abbe de Voisenon conceived the idea of composing oratorios in poetry; they were sung for the first time at the Tuileries, when the theatres were closed in consequence of some religious festival. That amiable abbe, who had written several comedies in secret, had very poor health and a very small body; he was all wit and gracefulness, famous for his shrewd repartees which, although very cutting, never offended anyone. It was impossible for him to have any enemies, for his criticism only grazed the skin and never wounded deeply. One day, as he was returning from Versailles, I asked him the news of the court.

"The king is yawning," he answered, "because he must come to the parliament to-morrow to hold a bed of justice."

"Why is it called a bed of justice?"

"I do not know, unless it is because justice is asleep during the proceedings."

I afterwards met in Prague the living portrait of that eminent writer in Count Francois Hardig, now plenipotentiary of the emperor at the court of Saxony.

The Abbe de Voisenon introduced me to Fontenelle, who was then ninety-three years of age. A fine wit, an amiable and learned man, celebrated for his quick repartees, Fontenelle could not pay a compliment without throwing kindness and wit into it. I told him that I had come from Italy on purpose to see him.

"Confess, sir," he said to me, "that you have kept me waiting a very long time."

This repartee was obliging and critical at the same time, and pointed out in a delicate and witty manner the untruth of my compliment. He made me a present of his works, and asked me if I liked the French plays; I told him that I had seen 'Thetis et Pelee' at the opera. That play was his own composition, and when I had praised it, he told me that it was a 'tete pelee'.

"I was at the Theatre Francais last night," I said, "and saw Athalie."

"It is the masterpiece of Racine; Voltaire, has been wrong in accusing me of having criticized that tragedy, and in attributing to me an epigram, the author of which has never been known, and which ends with two very poor lines:

"Pour avoir fait pis qu'Esther,
Comment diable as-to pu faire"

I have been told that M. de Fontenelle had been the tender friend of Madame du Tencin, that M. d'Alembert was the offspring of their intimacy, and that Le Rond had only been his foster-father. I knew d'Alembert at Madame de Graffigny's. That great philosopher had the talent of never appearing to be a learned man when he was in the company of amiable persons who had no pretension to learning or the sciences, and he always seemed to endow with intelligence those who conversed with him.

When I went to Paris for the second time, after my escape from The Leads of Venice, I was delighted at the idea of seeing again the amiable, venerable Fontenelle, but he died a fortnight after my arrival, at the beginning of the year 1757.

When I paid my third visit to Paris with the intention of ending my days in that capital, I reckoned upon the friendship of M. d'Alembert, but he died, like Fontenelle, a fortnight after my arrival, towards the end of 1783. Now I feel that I have seen Paris and France for the last time. The popular effervescence has disgusted me, and I am too old to hope to see the end of it.

Count de Looz, Polish ambassador at the French court, invited me in 1751 to translate into Italian a French opera susceptible of great transformations, and of having a grand ballet annexed to the subject of the opera itself. I chose 'Zoroastre', by M. de Cahusac. I had to adapt words to the music of the choruses, always a difficult task. The music remained very beautiful, of course, but my Italian poetry was very poor. In spite of that the generous sovereign sent me a splendid gold snuff-box, and I thus contrived at the same time to please my mother very highly.

It was about that time that Mdlle. Vesian arrived in Paris with her brother. She was quite young, well educated, beautiful, most amiable, and a novice; her brother accompanied her. Her father, formerly an officer in the French army, had died at Parma, his native city. Left an orphan without any means of support, she followed the advice given by her friends; she sold the furniture left by her father, with the intention of going to Versailles to obtain from the justice and from the generosity of the king a small pension to enable her to live. As she got out of the diligence, she took a coach, and desired to be taken to some hotel close by the Italian Theatre; by the greatest chance she was brought to the Hotel de Bourgogne, where I was then staying myself.

In the morning I was told that there were two young Italians, brother and sister, who did not appear very wealthy, in the next room to mine. Italians, young, poor and newly arrived, my curiosity was excited. I went to the door of their room, I knocked, and a young man came to open it in his shirt.

"I beg you to excuse me, sir," he said to me, "if I receive you in such a state."

"I have to ask your pardon myself. I only come to offer you my services, as a countryman and as a neighbour."

A mattress on the floor told me where the young man had slept; a bed standing in a recess and hid by curtains made me guess where the sister was. I begged of her to excuse me if I had presented myself without enquiring whether she was up.

She answered without seeing me, that the journey having greatly tried her she had slept a little later than usual, but that she would get up immediately if I would excuse her for a short time.

"I am going to my room, mademoiselle, and I will come back when you send for me; my room is next door to your own."

A quarter of an hour after, instead of being sent for, I saw a young and beautiful person enter my room; she made a modest bow, saying that she had come herself to return my visit, and that her brother would follow her immediately.

I thanked her for her visit, begged her to be seated, and I expressed all the interest I felt for her. Her gratitude shewed itself more by the tone of her voice than by her words, and her confidence being already captivated she told me artlessly, but not without some dignity, her short history or rather her situation, and she concluded by these words:

"I must in the course of the day find a less expensive lodging, for I only possess six francs."

I asked her whether she had any letters of recommendation, and she drew out of her pocket a parcel of papers containing seven or eight testimonials of good conduct and honesty, and a passport.

"Is this all you have, my dear countrywoman?"

"Yes. I intend to call with my brother upon the secretary of war, and I hope he will take pity on me."

"You do not know anybody here?"

"Not one person, sir; you are the first man in France to whom I have exposed my situation."

"I am a countryman of yours, and you are recommended to me by your position as well as by your age; I wish to be your adviser, if you will permit me."

"Ah, sir! how grateful I would be!"

"Do not mention it. Give me your papers, I will see what is to be done with them. Do not relate your history to anyone, and do not say one word about your position. You had better remain at this hotel. Here are two Louis which I will lend you until you are in a position to return them to me."

She accepted, expressing her heart-felt gratitude.

Mademoiselle Vesian was an interesting brunette of sixteen. She had a good knowledge of French and Italian, graceful manners, and a dignity which endowed her with a very noble appearance. She informed me of her affairs without meanness, yet without that timidity which seems to arise from a fear of the person who listens being disposed to take advantage of the distressing position confided to his honour. She seemed neither humiliated nor bold; she had hope, and she did not boast of her courage. Her virtue was by no means ostentatious, but there was in her an air of modesty which would certainly have put a restraint upon anyone disposed to fail in respect towards her. I felt the effect of it myself, for in spite of her beautiful eyes, her fine figure, of the freshness of her complexion, her transparent skin, her negligee—in one word, all that can tempt a man and which filled me with burning desires, I did not for one instant lose control over myself; she had inspired me with a feeling of respect which helped me to master my senses, and I promised myself not only to attempt nothing against her virtue, but also not to be the first man to make her deviate from the right path. I even thought it better to postpone to another interview a little speech on that subject, the result of which might be to make me follow a different course.

"You are now in a city," I said to her, "in which your destiny must unfold itself, and in which all the fine qualities which nature has so bountifully bestowed upon you, and which may ultimately cause your fortune, may

likewise cause your ruin; for here, by dear countrywoman, wealthy men despise all libertine women except those who have offered them the sacrifice of their virtue. If you are virtuous, and are determined upon remaining so, prepare yourself to bear a great deal of misery; if you feel yourself sufficiently above what is called prejudice, if, in one word, you feel disposed to consent to everything, in order to secure a comfortable position, be very careful not to make a mistake. Distrust altogether the sweet words which every passionate man will address to you for the sake of obtaining your favours, for, his passion once satisfied, his ardour will cool down, and you will find yourself deceived. Be wary of your adorers; they will give you abundance of counterfeit coin, but do not trust them far. As far as I am concerned, I feel certain that I shall never injure you, and I hope to be of some use to you. To reassure you entirely on my account, I will treat you as if you were my sister, for I am too young to play the part of your father, and I would not tell you all this if I did not think you a very charming person."

Her brother joined us as we were talking together. He was a good-looking young man of eighteen, well made, but without any style about him; he spoke little, and his expression was devoid of individuality. We breakfasted together, and having asked him as we were at table for what profession he felt an inclination, he answered that he was disposed to do anything to earn an honourable living.

"Have you any peculiar talent?"

"I write pretty well."

"That is something. When you go out, mistrust everybody; do not enter any cafe, and never speak to anyone in the streets. Eat your meals in your room with your sister, and tell the landlady to give you a small closet to sleep in. Write something in French to-day, let me have it to-morrow morning, and we will see what can be done. As for you, mademoiselle, my books are at your disposal, I have your papers; to-morrow I may have some news to tell you; we shall not see each other again to-day, for I generally come home very late." She took a few books, made a modest reverence, and told me with a charming voice that she had every confidence in me.

Feeling disposed to be useful to her, wherever I went during that day I spoke of nothing but of her and of her affairs; and everywhere men and women told me that if she was pretty she could not fail, but that at all events it would be right for her to take all necessary steps. I received a promise that the brother should be employed in some office. I thought that the best plan would be to find some influential lady who would consent to present Mdlle. Vesian to M. d'Argenson, and I knew that in the mean time I could support

her. I begged Silvia to mention the matter to Madame de Montconseil, who had very great influence with the secretary of war. She promised to do so, but she wished to be acquainted with the young girl.

I returned to the hotel towards eleven o'clock, and seeing that there was a light still burning in the room of Mdlle. Vesian I knocked at her door. She opened it, and told me that she had sat up in the hope of seeing me. I gave her an account of what I had done. I found her disposed to undertake all that was necessary, and most grateful for my assistance. She spoke of her position with an air of noble indifference which she assumed in order to restrain her tears; she succeeded in keeping them back, but the moisture in her eyes proved all the efforts she was making to prevent them from falling. We had talked for two hours, and going from one subject to another I learned that she had never loved, and that she was therefore worthy of a lover who would reward her in a proper manner for the sacrifice of her virtue. It would have been absurd to think that marriage was to be the reward of that sacrifice; the young girl had not yet made what is called a false step, but she had none of the prudish feelings of those girls who say that they would not take such a step for all the gold in the universe, and usually give way before the slightest attack; all my young friend wanted was to dispose of herself in a proper and advantageous manner.

I could not help sighing as I listened to her very sensible remarks, considering the position in which she was placed by an adverse destiny. Her sincerity was charming to me; I was burning with desire. Lucie of Pasean came back to my memory; I recollected how deeply I had repented the injury I had done in neglecting a sweet flower, which another man, and a less worthy one, had hastened to pluck; I felt myself near a lamb which would perhaps become the prey of some greedy wolf; and she, with her noble feelings, her careful education, and a candour which an impure breath would perhaps destroy for ever, was surely not destined for a lot of shame. I regretted I was not rich enough to make her fortune, and to save her honour and her virtue. I felt that I could neither make her mine in an illegitimate way nor be her guardian angel, and that by becoming her protector I should do her more harm than good; in one word, instead of helping her out of the unfortunate position in which she was, I should, perhaps, only contribute to her entire ruin. During that time I had her near me, speaking to her in a sentimental way, and not uttering one single word of love; but I kissed her hand and her arms too often without coming to a resolution, without beginning a thing which would have too rapidly come to an end, and which would have compelled me to keep her for myself; in that case, there would have been no longer any hope of a

fortune for her, and for me no means of getting rid of her. I have loved women even to madness, but I have always loved liberty better; and whenever I have been in danger of losing it fate has come to my rescue.

I had remained about four hours with Mdlle. Vesian, consumed by the most intense desires, and I had had strength enough to conquer them. She could not attribute my reserve to a feeling of modesty, and not knowing why I did not shew more boldness she must have supposed that I was either ill or impotent. I left her, after inviting her to dinner for the next day.

We had a pleasant dinner, and her brother having gone out for a walk after our meal we looked together out of the window from which we could see all the carriages going to the Italian Comedy. I asked her whether she would like to go; she answered me with a smile of delight, and we started at once.

I placed her in the amphitheatre where I left her, telling her that we would meet at the hotel at eleven o'clock. I would not remain with her, in order to avoid the questions which would have been addressed to me, for the simpler her toilet was the more interesting she looked.

After I had left the theatre, I went to sup at Silvia's and returned to the hotel. I was surprised at the sight of an elegant carriage; I enquired to whom it belonged, and I was told that it was the carriage of a young nobleman who had supped with Mdlle. Vesian. She was getting on.

The first thing next morning, as I was putting my head out of the window, I saw a hackney coach stop at the door of the hotel; a young man, well dressed in a morning costume, came out of it, and a minute after I heard him enter the room of Mdlle. Vesian. Courage! I had made up my mind; I affected a feeling of complete indifference in order to deceive myself.

I dressed myself to go out, and while I was at my toilet Vesian came in and told me that he did not like to go into his sister's room because the gentleman who had supped with her had just arrived.

"That's a matter of course," I said.

"He is rich and very handsome. He wishes to take us himself to Versailles, and promises to procure some employment for me."

"I congratulate you. Who is he?"

"I do not know."

I placed in an envelope the papers she had entrusted to me, and I handed them to him to return to his sister. I then went out. When I came home towards three o'clock, the landlady gave me a letter which had been left for me by Mdlle. Vesian, who had left the hotel.

I went to my room, opened the letter, and read the following lines:

"I return the money you have lent me with my best thanks. The Count de Narbonne feels interested in me, and wishes to assist me and my brother. I shall inform you of everything, of the house in which he wishes me to go and live, where he promises to supply me all I want. Your friendship is very dear to me, and I entreat you not to forget me. My brother remains at the hotel, and my room belongs to me for the month. I have paid everything."

"Here is," said I to myself, "a second Lucie de Pasean, and I am a second time the dupe of my foolish delicacy, for I feel certain that the count will not make her happy. But I wash my hands of it all."

I went to the Theatre Francais in the evening, and enquired about Narbonne. The first person I spoke to told me,

"He is the son of a wealthy man, but a great libertine and up to his neck in debts."

Nice references, indeed! For a week I went to all the theatres and public places in the hope of making the acquaintance of the count, but I could not succeed, and I was beginning to forget the adventure when one morning, towards eight o'clock Vesian calling on me, told me that his sister was in her room and wished to speak to me. I followed him immediately. I found her looking unhappy and with eyes red from crying. She told her brother to go out for a walk, and when he had gone she spoke to me thus:

"M. de Narbonne, whom I thought an honest man, because I wanted him to be such, came to sit by me where you had left me at the theatre; he told me that my face had interested him, and he asked me who I was. I told him what I had told you. You had promised to think of me, but Narbonne told me that he did not want your assistance, as he could act by himself. I believed him, and I have been the dupe of my confidence in him; he has deceived me; he is a villain."

The tears were choking her: I went to the window so as to let her cry without restraint: a few minutes after, I came back and I sat down by her.

"Tell me all, my dear Vesian, unburden your heart freely, and do not think yourself guilty towards me; in reality I have been wrong more than you. Your heart would not now be a prey to sorrow if I had not been so imprudent as to leave you alone at the theatre."

"Alas, sir! do not say so; ought I to reproach you because you thought me so virtuous? Well, in a few words, the monster promised to shew me every care, every attention, on condition of my giving him an undeniable, proof of my affection and confidence—namely, to take a lodging without my brother in the house of a woman whom he represented as respectable. He insisted upon my brother not living with me, saying that evil-minded persons might

suppose him to be my lover. I allowed myself to be persuaded. Unhappy creature! How could I give way without consulting you? He told me that the respectable woman to whom he would take me would accompany me to Versailles, and that he would send my brother there so that we should be both presented to the war secretary. After our first supper he told me that he would come and fetch me in a hackney coach the next morning. He presented me with two louis and a gold watch, and I thought I could accept those presents from a young nobleman who shewed so much interest in me. The woman to whom he introduced me did not seem to me as respectable as he had represented her to be. I have passed one week with her without his doing anything to benefit my position. He would come, go out, return as he pleased, telling me every day that it would be the morrow, and when the morrow came there was always some impediment. At last, at seven o'clock this morning, the woman told me that the count was obliged to go into the country, that a hackney coach would bring me back to his hotel, and that he would come and see me on his return. Then, affecting an air of sadness, she told me that I must give her back the watch because the count had forgotten to pay the watchmaker for it. I handed it to her immediately without saying a word, and wrapping the little I possessed in my handkerchief I came back here, where I arrived half an hour since."

"Do you hope to see him on his return from the country?"

"To see him again! Oh, Lord! why have I ever seen him?"

She was crying bitterly, and I must confess that no young girl ever moved me so deeply as she did by the expression of her grief. Pity replaced in my heart the tenderness I had felt for her a week before. The infamous proceedings of Narbonne disgusted me to that extent that, if I had known where to find him alone, I would immediately have compelled him to give me reparation. Of course, I took good care not to ask the poor girl to give me a detailed account of her stay in the house of Narbonne's respectable procurers; I could guess even more than I wanted to know, and to insist upon that recital would have humiliated Mdlle. Vesian. I could see all the infamy of the count in the taking back of the watch which belonged to her as a gift, and which the unhappy girl had earned but too well. I did all I could to dry her tears, and she begged me to be a father to her, assuring me that she would never again do anything to render her unworthy of my friendship, and that she would always be guided by my advice.

"Well, my dear young friend, what you must do now is not only to forget the unworthy count and his criminal conduct towards you, but also the fault of which you have been guilty. What is done cannot be undone, and the past

is beyond remedy; but compose yourself, and recall the air of cheerfulness which shone on your countenance a week ago. Then I could read on your face honesty, candour, good faith, and the noble assurance which arouses sentiment in those who can appreciate its charm. You must let all those feelings shine again on your features; for they alone can interest honest people, and you require the general sympathy more than ever. My friendship is of little importance to you, but you may rely upon it all the more because I fancy that you have now a claim upon it which you had not a week ago: Be quite certain, I beg, that I will not abandon you until your position is properly settled. I cannot at present tell you more; but be sure that I will think of you."

"Ah, my friend! if you promise to think of me, I ask for no more. Oh! unhappy creature that I am; there is not a soul in the world who thinks of me."

She was so deeply moved that she fainted away. I came to her assistance without calling anyone, and when she had recovered her consciousness and some calm, I told her a hundred stories, true or purely imaginary, of the knavish tricks played in Paris by men who think of nothing but of deceiving young girls. I told her a few amusing instances in order to make her more cheerful, and at last I told her that she ought to be thankful for what had happened to her with Narbonne, because that misfortune would give her prudence for the future.

During that long tete-a-tete I had no difficulty in abstaining from bestowing any caresses upon her; I did not even take her hand, for what I felt for her was a tender pity; and I was very happy when at the end of two hours I saw her calm and determined upon bearing misfortune like a heroine.

She suddenly rose from her seat, and, looking at me with an air of modest trustfulness, she said to me,

"Are, you particularly engaged in any way to-day?"

"No, my dear:"

"Well, then, be good enough to take me somewhere out of Paris; to some place where I can breathe the fresh air freely; I shall then recover that appearance which you think I must have to interest in my favour those who will see me; and if I can enjoy a quiet sleep throughout the next night I feel I shall be happy again."

"I am grateful to you for your confidence in me. We will go out as soon as I am dressed. Your brother will return in the mean time."

"Oh, never mind my brother!"

"His presence is, on the contrary, of great importance. Recollect, my dear Vesian, you must make Narbonne ashamed of his own conduct. You must

consider that if he should happen to hear that, on the very day he abandoned you, you went into the country alone with me, he would triumph, and would certainly say that he has only treated you as you deserved. But if you go with your brother and me your countryman, you give no occasion for slander."

"I blush not to have made that remark myself. We will wait for my brother's return."

He was not long in coming back, and having sent for a coach we were on the point of going, when Baletti called on me. I introduced him to the young lady, and invited him to join our party. He accepted, and we started. As my only purpose was to amuse Mdlle. Vesian, I told the coachman to drive us to the Gros Caillou, where we made an excellent impromptu dinner, the cheerfulness of the guests making up for the deficiencies of the servants.

Vesian, feeling his head rather heavy, went out for a walk after dinner, and I remained alone with his sister and my friend Baletti. I observed with pleasure that Baletti thought her an agreeable girl, and it gave me the idea of asking him to teach her dancing. I informed him of her position, of the reason which had brought her to Paris, of the little hope there was of her obtaining a pension from the king, and of the necessity there was for her to do something to earn a living. Baletti answered that he would be happy to do anything, and when he had examined the figure and the general conformation of the young girl he said to her,

"I will get Lani to take you for the ballet at the opera."

"Then," I said, "you must begin your lessons tomorrow. Mdlle. Vesian stops at my hotel."

The young girl, full of wonder at my plan, began to laugh heartily, and said,

"But can an opera dancer be extemporized like a minister of state? I can dance the minuet, and my ear is good enough to enable me to go through a quadrille; but with the exception of that I cannot dance one step."

"Most of the ballet girls," said Baletti, "know no more than you do."

"And how much must I ask from M. Lani? I do not think I can expect much."

"Nothing. The ballet girls are not paid."

"Then where is the advantage for me?" she said, with a sigh; "how shall I live?"

"Do not think of that. Such as you are, you will soon find ten wealthy noblemen who will dispute amongst themselves for the honour of making up for the absence of salary. You have only to make a good choice, and I am certain that it will not be long before we see you covered with diamonds."

"Now I understand you. You suppose some great lord will keep me?"

"Precisely; and that will be much better than a pension of four hundred francs, which you would, perhaps, not obtain without making the same sacrifice."

Very much surprised, she looked at me to ascertain whether I was serious or only jesting.

Baletti having left us, I told her it was truly the best thing she could do, unless she preferred the sad position of waiting-maid to some grand lady.

"I would not be the 'femme de chambre' even of the queen."

"And 'figurante' at the opera?"

"Much rather."

"You are smiling?"

"Yes, for it is enough to make me laugh. I the mistress of a rich nobleman, who will cover me with diamonds! Well, I mean to choose the oldest."

"Quite right, my dear; only do not make him jealous."

"I promise you to be faithful to him. But shall he find a situation for my brother? However, until I am at the opera, until I have met with my elderly lover, who will give me the means to support myself?"

"I, my dear girl, my friend Baletti, and all my friends, without other interest than the pleasure of serving you, but with the hope that you will live quietly, and that we shall contribute to your happiness. Are you satisfied?"

"Quite so; I have promised myself to be guided entirely by your advice, and I entreat you to remain always my best friend."

We returned to Paris at night, I left Mdlle. Vesian at the hotel, and accompanied Baletti to his mother's. At supper-time, my friend begged Silvia to speak to M. Lani in favour of our 'protegee', Silvia said that it was a much better plan than to solicit a miserable pension which, perhaps, would not be granted. Then we talked of a project which was then spoken of, namely to sell all the appointments of ballet girls and of chorus singers at the opera. There was even some idea of asking a high price for them, for it was argued that the higher the price the more the girls would be esteemed. Such a project, in the midst of the scandalous habits and manners of the time, had a sort of apparent wisdom; for it would have ennobled in a way a class of women who with very few exceptions seem to glory in being contemptible.

There were, at that time at the opera, several figurantes, singers and dancers, ugly rather than plain, without any talent, who, in spite of it all, lived in great comfort; for it is admitted that at the opera a girl must needs renounce all modesty or starve. But if a girl, newly arrived there, is clever enough to remain virtuous only for one month, her fortune is certainly made, because then the noblemen enjoying a reputation of wisdom and virtue are

the only ones who seek to get hold of her. Those men are delighted to hear their names mentioned in connection with the newly-arrived beauty; they even go so far as to allow her a few frolics, provided she takes pride in what they give her, and provided her infidelities are not too public. Besides, it is the fashion never to go to sup with one's mistress without giving her notice of the intended visit, and everyone must admit that it is a very wise custom.

I came back to the hotel towards eleven o'clock, and seeing that Mdlle. Vesian's room was still open I went in. She was in bed.

"Let me get up," she said, "for I want to speak to you."

"Do not disturb yourself; we can talk all the same, and I think you much prettier as you are."

"I am very glad of it."

"What have you got to tell me?"

"Nothing, except to speak of the profession I am going to adopt. I am going to practice virtue in order to find a man who loves it only to destroy it."

"Quite true; but almost everything is like that in this life. Man always refers everything to himself, and everyone is a tyrant in his own way. I am pleased to see you becoming a philosopher."

"How can one become a philosopher?"

"By thinking."

"Must one think a long while?"

"Throughout life."

"Then it is never over?"

"Never; but one improves as much as possible, and obtains the sum of happiness which one is susceptible of enjoying."

"And how can that happiness be felt?"

"By all the pleasure which the philosopher can procure when he is conscious of having obtained them by his own exertions, and especially by getting rid of the many prejudices which make of the majority of men a troop of grown-up children."

"What is pleasure? What is meant by prejudices?"

"Pleasure is the actual enjoyment of our senses; it is a complete satisfaction given to all our natural and sensual appetites; and, when our worn-out senses want repose, either to have breathing time, or to recover strength, pleasure comes from the imagination, which finds enjoyment in thinking of the happiness afforded by rest. The philosopher is a person who refuses no pleasures which do not produce greater sorrows, and who knows how to create new ones."

"And you say that it is done by getting rid of prejudices? Then tell me what prejudices are, and what must be done to get rid of them."

"Your question, my dear girl, is not an easy one to answer, for moral philosophy does not know a more important one, or a more difficult one to decide; it is a lesson which lasts throughout life. I will tell you in a few words that we call prejudice every so-called duty for the existence of which we find no reason in nature."

"Then nature must be the philosopher's principal study?"

"Indeed it is; the most learned of philosophers is the one who commits the fewest errors."

"What philosopher, in your opinion, has committed the smallest quantity of errors?"

"Socrates."

"Yet he was in error sometimes?"

"Yes, in metaphysics."

"Oh! never mind that, for I think he could very well manage without that study."

"You are mistaken; morals are only the metaphysics of physics; nature is everything, and I give you leave to consider as a madman whoever tells you that he has made a new discovery in metaphysics. But if I went on, my dear, I might appear rather obscure to you. Proceed slowly, think; let your maxims be the consequence of just reasoning, and keep your happiness in view; in the end you must be happy."

"I prefer the lesson you have just taught me to the one which M. Baletti will give me to-morrow; for I have an idea that it will weary me, and now I am much interested."

"How do you know that you are interested?"

"Because I wish you not to leave me."

"Truly, my dear Vesian, never has a philosopher described sympathy better than you have just done. How happy I feel! How is it that I wish to prove it by kissing you?"

"No doubt because, to be happy, the soul must agree with the senses."

"Indeed, my divine Vesian? Your intelligence is charming."

"It is your work, dear friend; and I am so grateful to you that I share your desires."

"What is there to prevent us from satisfying such natural desires? Let us embrace one another tenderly."

What a lesson in philosophy! It seemed to us such a sweet one, our happiness was so complete, that at daybreak we were still kissing one another,

and it was only when we parted in the morning that we discovered that the door of the room had remained open all night.

Baletti gave her a few lessons, and she was received at the opera; but she did not remain there more than two or three months, regulating her conduct carefully according to the precepts I had laid out for her. She never received Narbonne again, and at last accepted a nobleman who proved himself very different from all others, for the first thing he did was to make her give up the stage, although it was not a thing according to the fashion of those days. I do not recollect his name exactly; it was Count of Tressan or Trean. She behaved in a respectable way, and remained with him until his death. No one speaks of her now, although she is living in very easy circumstances; but she is fifty-six, and in Paris a woman of that age is no longer considered as being among the living.

After she left the Hotel de Bourgogne, I never spoke to her. Whenever I met her covered with jewels and diamonds, our souls saluted each other with joy, but her happiness was too precious for me to make any attempt against it. Her brother found a situation, but I lost sight of him.

CHAPTER IX

The Beautiful O-Morphi—The Deceitful Painter—I Practice
Cabalism for the Duchess de Chartres I Leave Paris—My Stay
in Dresden and My Departure from that City

I went to St. Lawrence's Fair with my friend Patu, who, taking it into his head to sup with a Flemish actress known by the name of Morphi, invited me to go with him. I felt no inclination for the girl, but what can we refuse to a friend? I did as he wished. After we had supped with the actress, Patu fancied a night devoted to a more agreeable occupation, and as I did not want to leave him I asked for a sofa on which I could sleep quietly during the night.

Morphi had a sister, a slovenly girl of thirteen, who told me that if I would give her a crown she would abandon her bed to me. I agreed to her proposal, and she took me to a small closet where I found a straw palliasse on four pieces of wood.

"Do you call this a bed, my child?"

"I have no other, sir."

"Then I do not want it, and you shall not have the crown."

"Did you intend undressing yourself?"

"Of course."

"What an idea! There are no sheets."

"Do you sleep with your clothes on?"

"Oh, no!"

"Well, then, go to bed as usual, and you shall have the crown."

"Why?"

"I want to see you undressed."

"But you won't do anything to me?"

"Not the slightest thing."

She undressed, laid herself on her miserable straw bed, and covered herself with an old curtain. In that state, the impression made by her dirty tatters disappeared, and I only saw a perfect beauty. But I wanted to see her entirely. I tried to satisfy my wishes, she opposed some resistance, but a double crown of six francs made her obedient, and finding that her only fault was a complete absence of cleanliness, I began to wash her with my own hands.

You will allow me, dear reader, to suppose that you possess a simple and natural knowledge, namely, that admiration under such circumstances is inseparable from another kind of approbation; luckily, I found the young Morphi disposed to let me do all I pleased, except the only thing for which I

did not care! She told me candidly that she would not allow me to do that one thing, because in her sister's estimation it was worth twenty-five louis. I answered that we would bargain on that capital point another time, but that we would not touch it for the present. Satisfied with what I said, all the rest was at my disposal, and I found in her a talent which had attained great perfection in spite of her precocity.

The young Helene faithfully handed to her sister the six francs I had given her, and she told her the way in which she had earned them. Before I left the house she told me that, as she was in want of money, she felt disposed to make some abatement on the price of twenty-five louis. I answered with a laugh that I would see her about it the next day. I related the whole affair to Patu, who accused me of exaggeration; and wishing to prove to him that I was a real connoisseur of female beauty I insisted upon his seeing Helene as I had seen her. He agreed with me that the chisel of Praxiteles had never carved anything more perfect. As white as a lily, Helene possessed all the beauties which nature and the art of the painter can possibly combine. The loveliness of her features was so heavenly that it carried to the soul an indefinable sentiment of ecstacy, a delightful calm. She was fair, but her beautiful blue eyes equalled the finest black eyes in brilliance.

I went to see her the next evening, and, not agreeing about the price, I made a bargain with her sister to give her twelve francs every time I paid her a visit, and it was agreed that we would occupy her room until I should make up my mind to pay six hundred francs. It was regular usury, but the Morphi came from a Greek race, and was above prejudices. I had no idea of giving such a large sum, because I felt no wish to obtain what it would have procured me; what I obtained was all I cared for.

The elder sister thought I was duped, for in two months I had paid three hundred francs without having done anything, and she attributed my reserve to avarice. Avarice, indeed! I took a fancy to possess a painting of that beautiful body, and a German artist painted it for me splendidly for six louis. The position in which he painted it was delightful. She was lying on her stomach, her arms and her bosom leaning on a pillow, and holding her head sideways as if she were partly on the back. The clever and tasteful artist had painted her nether parts with so much skill and truth that no one could have wished for anything more beautiful; I was delighted with that portrait; it was a speaking likeness, and I wrote under it, "O-Morphi," not a Homeric word, but a Greek one after all, and meaning beautiful.

But who can anticipate the wonderful and secret decrees of destiny! My friend Patu wished to have a copy of that portrait; one cannot refuse such a

slight service to a friend, and I gave an order for it to the same painter. But the artist, having been summoned to Versailles, shewed that delightful painting with several others, and M. de St. Quentin found it so beautiful that he lost no time in shewing it the king. His Most Christian Majesty, a great connoisseur in that line, wished to ascertain with his own eyes if the artist had made a faithful copy; and in case the original should prove as beautiful as the copy, the son of St. Louis knew very well what to do with it.

M. de St. Quentin, the king's trusty friend, had the charge of that important affair; it was his province: He enquired from the painter whether the original could be brought to Versailles, and the artist, not supposing there would be any difficulty, promised to attend to it.

He therefore called on me to communicate the proposal; I thought it was delightful, and I immediately told the sister, who jumped for joy. She set to work cleaning, washing and clothing the young beauty, and two or three days after they went to Versailles with the painter to see what could be done. M. de St. Quentin's valet, having received his instructions from his master, took the two females to a pavilion in the park, and the painter went to the hotel to await the result of his negotiation. Half an hour afterwards the king entered the pavilion alone, asked the young O-Morphi if she was a Greek woman, took the portrait out of his pocket, and after a careful examination exclaimed,

"I have never seen a better likeness."

His majesty then sat down, took the young girl on his knees, bestowed a few caresses on her, and having ascertained with his royal hand that the fruit had not yet been plucked, he gave her a kiss.

O-Morphi was looking attentively at her master, and smiled.

"What are you laughing at?" said the king.

"I laugh because you and a crown of six francs are as like as two peas."

That naivete made the king laugh heartily, and he asked her whether she would like to remain in Versailles.

"That depends upon my sister," answered the child.

But the sister hastened to tell the king that she could not aspire to a greater honour. The king locked them up again in the pavilion and went away, but in less than a quarter of an hour St. Quentin came to fetch them, placed the young girl in an apartment under the care of a female attendant, and with the sister he went to meet at the hotel the German artist to whom he gave fifty Louis for the portrait, and nothing to Morphi. He only took her address, promising her that she would soon hear from him; the next day she received one thousand Louis. The worthy German gave me twenty-five louis for my

portrait, with a promise to make a careful copy of the one I had given to Patu, and he offered to paint for me gratuitously the likeness of every girl of whom I might wish to keep a portrait.

I enjoyed heartily the pleasure of the good Fleeting, when she found herself in possession of the thousand gold pieces which she had received. Seeing herself rich, and considering me as the author of her fortune, she did not know how to shew me her gratitude.

The young and lovely O-Morphi—for the king always called her by that name—pleased the sovereign by her simplicity and her pretty ways more even than by her rare beauty—the most perfect, the most regular, I recollect to have ever seen. He placed her in one of the apartments of his Parc-dux-cerfs—the voluptuous monarch's harem, in which no one could get admittance except the ladies presented at the court. At the end of one year she gave birth to a son who went, like so many others, God knows where! for as long as Queen Mary lived no one ever knew what became of the natural children of Louis XV.

O-Morphi fell into disgrace at the end of three years, but the king, as he sent her away, ordered her to receive a sum of four hundred thousand francs which she brought as a dowry to an officer from Britanny. In 1783, happening to be in Fontainebleau, I made the acquaintance of a charming young man of twenty-five, the offspring of that marriage and the living portrait of his mother, of the history of whom he had not the slightest knowledge, and I thought it my duty not to enlighten him. I wrote my name on his tablets, and I begged him to present my compliments to his mother.

A wicked trick of Madame de Valentinois, sister-in-law of the Prince of Monaco, was the cause of O-Morphi's disgrace. That lady, who was well known in Paris, told her one day that, if she wished to make the king very merry, she had only to ask him how he treated his old wife. Too simple to guess the snare thus laid out for her, O-Morphi actually asked that impertinent question; but Louis XV. gave her a look of fury, and exclaimed,

"Miserable wretch! who taught you to address me that question?"

The poor O-Morphi, almost dead with fright, threw herself on her knees, and confessed the truth.

The king left her and never would see her again. The Countess de Valentinois was exiled for two years from the court. Louis XV., who knew how wrongly he was behaving towards his wife as a husband, would not deserve any reproach at her hands as a king, and woe to anyone who forgot the respect due to the queen!

The French are undoubtedly the most witty people in Europe, and perhaps in the whole world, but Paris is, all the same, the city for impostors and quacks to make a fortune. When their knavery is found out people turn it into a joke and laugh, but in the midst of the merriment another mountebank makes his appearance, who does something more wonderful than those who preceded him, and he makes his fortune, whilst the scoffing of the people is in abeyance. It is the unquestionable effects of the power which fashion has over that amiable, clever, and lively nation. If anything is astonishing, no matter how extravagant it may be, the crowd is sure to welcome it greedily, for anyone would be afraid of being taken for a fool if he should exclaim, "It is impossible!" Physicians are, perhaps, the only men in France who know that an infinite gulf yawns between the will and the deed, whilst in Italy it is an axiom known to everybody; but I do not mean to say that the Italians are superior to the French.

A certain painter met with great success for some time by announcing a thing which was an impossibility—namely, by pretending that he could take a portrait of a person without seeing the individual, and only from the description given. But he wanted the description to be thoroughly accurate. The result of it was that the portrait did greater honour to the person who gave the description than—to the painter himself, but at the same time the informer found himself under the obligation of finding the likeness very good; otherwise the artist alleged the most legitimate excuse, and said that if the likeness was not perfect the fault was to be ascribed to the person who had given an imperfect description.

One evening I was taking supper at Silvia's when one of the guests spoke of that wonderful new artist, without laughing, and with every appearance of believing the whole affair.

"That painter," added he, "has already painted more than one hundred portraits, and they are all perfect likenesses."

Everybody was of the same opinion; it was splendid. I was the only one who, laughing heartily, took the liberty of saying it was absurd and impossible. The gentleman who had brought the wonderful news, feeling angry, proposed a wager of one hundred louis. I laughed all the more because his offer could not be accepted unless I exposed myself to being made a dupe.

"But the portraits are all admirable likenesses."

"I do not believe it, or if they are then there must be cheating somewhere."

But the gentleman, being bent upon convincing Silvia and me—for she had taken my part proposed to make us dine with the artist; and we accepted.

The next day we called upon the painter, where we saw a quantity of portraits, all of which the artist claimed to be speaking likenesses; as we did not know the persons whom they represented we could not deny his claim.

"Sir," said Silvia to the artist, "could you paint the likeness of my daughter without seeing her?"

"Yes, madam, if you are certain of giving me an exact description of the expression of her features."

We exchanged a glance, and no more was said about it. The painter told us that supper was his favourite meal, and that he would be delighted if we would often give him the pleasure of our company. Like all quacks, he possessed an immense quantity of letters and testimonials from Bordeaux, Toulouse, Lyons, Rouen, etc., which paid the highest compliments to the perfection of his portraits, or gave descriptions for new pictures ordered from him. His portraits, by the way, had to be paid for in advance.

Two or three days afterwards I met his pretty niece, who obligingly upbraided me for not having yet availed myself of her uncle's invitation to supper; the niece was a dainty morsel worthy of a king, and, her reproaches being very flattering to my vanity I promised I would come the next day. In less than a week it turned out a serious engagement. I fell in love with the interesting niece, who, being full of wit and well disposed to enjoy herself, had no love for me, and granted me no favour. I hoped, and, feeling that I was caught, I felt it was the only thing I could do.

One day that I was alone in my room, drinking my coffee and thinking of her, the door was suddenly opened without anyone being announced, and a young man came in. I did not recollect him, but, without giving me time to ask any questions, he said to me,

"Sir, I have had the honour of meeting you at the supper-table of M. Samson, the painter."

"Ah! yes; I beg you to excuse me, sir, I did not at first recollect you."

"It is natural, for your eyes are always on Mdlle. Samson."

"Very likely, but you must admit that she is a charming creature."

"I have no difficulty whatever in agreeing with you; to my misery, I know it but too well."

"You are in love with her?"

"Alas, yes! and I say, again, to my misery."

"To your misery? But why, do not you gain her love?"

"That is the very thing I have been striving for since last year, and I was beginning to have some hope when your arrival has reduced me to despair."

"I have reduced you to despair?"

"Yes, sir."

"I am very sorry, but I cannot help it."

"You could easily help it; and, if you would allow me, I could suggest to you the way in which you could greatly oblige me."

"Speak candidly."

"You might never put your foot in the house again."

"That is a rather singular proposal, but I agree that it is truly the only thing I can do if I have a real wish to oblige you. Do you think, however, that in that case you would succeed in gaining her affection?"

"Then it will be my business to succeed. Do not go there again, and I will take care of the rest."

"I might render you that very great service; but you must confess that you must have a singular opinion of me to suppose that I am a man to do such a thing."

"Yes, sir, I admit that it may appear singular; but I take you for a man of great sense and sound intellect, and after considering the subject deeply I have thought that you would put yourself in my place; that you would not wish to make me miserable, or to expose your own life for a young girl who can have inspired you with but a passing fancy, whilst my only wish is to secure the happiness or the misery of my life, whichever it may prove, by uniting her existence with mine."

"But suppose that I should intend, like you, to ask her in marriage?"

"Then we should both be worthy of pity, and one of us would have ceased to exist before the other obtained her, for as long as I shall live Mdlle. Samson shall not be the wife of another."

This young man, well-made, pale, grave, as cold as a piece of marble, madly in love, who, in his reason mixed with utter despair, came to speak to me in such a manner with the most surprising calm, made me pause and consider. Undoubtedly I was not afraid, but although in love with Mdlle. Samson I did not feel my passion sufficiently strong to cut the throat of a man for the sake of her beautiful eyes, or to lose my own life to defend my budding affection. Without answering the young man, I began to pace up and down my room, and for a quarter of an hour I weighed the following question which I put to myself: Which decision will appear more manly in the eyes of my rival and will win my own esteem to the deeper degree, namely-to accept coolly his offer to cut one another's throats, or to allay his anxiety by withdrawing from the field with dignity?

Pride whispered, Fight; Reason said, Compel thy rival to acknowledge thee a wiser man than he is.

"What would you think of me, sir," I said to him, with an air of decision, "if I consented to give up my visits to Mdlle. Samson?"

"I would think that you had pity on a miserable man, and I say that in that case you will ever find me ready to shed the last drop of my blood to prove my deep gratitude."

"Who are you?"

"My name is Garnier, I am the only son of M. Garnier, wine merchant in the Rue de Seine."

"Well, M. Gamier, I will never again call on Mdlle. Samson. Let us be friends."

"Until death. Farewell, sir."

"Adieu, be happy!"

Patu came in five minutes after Garnier had left me: I related the adventure to him, and he thought I was a hero.

"I would have acted as you have done," he observed, "but I would not have acted like Garnier."

It was about that time that the Count de Melfort, colonel of the Orleans regiment, entreated me through Camille, Coraline's sister, to answer two questions by means of my cabalism. I gave two answers very vague, yet meaning a great deal; I put them under a sealed envelope and gave them to Camille, who asked me the next day to accompany her to a place which she said she could not name to me. I followed her; she took me to the Palais-Royal, and then, through a narrow staircase, to the apartments of the Duchess de Chartres. I waited about a quarter of an hour, at the end of which time the duchess came in and loaded Camille with caresses for having brought me. Then addressing herself to me, she told me, with dignity yet very graciously, the difficulty she experienced in understanding the answers I had sent and which she was holding in her hand. At first I expressed some perplexity at the questions having emanated from her royal highness, and I told her afterwards that I understood cabalism, but that I could not interpret the meaning of the answers obtained through it, and that her highness must ask new questions likely to render the answers easier to be understood. She wrote down all she could not make out and all she wanted to know.

"Madam, you must be kind enough to divide the questions, for the cabalistic oracle never answers two questions at the same time."

"Well, then, prepare the questions yourself."

"Your highness will excuse me, but every word must be written with your own hand. Recollect, madam, that you will address yourself to a superior intelligence knowing all your secrets"

She began to write, and asked seven or eight questions. She read them over carefully, and said, with a face beaming with noble confidence,

"Sir, I wish to be certain that no one shall ever know what I have just written."

"Your highness may rely on my honour."

I read attentively, and I saw that her wish for secrecy was reasonable, and that if I put the questions in my pocket I should run the risk of losing them and implicating myself.

"I only require three hours to complete my task," I said to the duchess, "and I wish your highness to feel no anxiety. If you have any other engagement you can leave me here alone, provided I am not disturbed by anybody. When it is completed, I will put it all in a sealed envelope; I only want your highness to tell me to whom I must deliver the parcel."

"Either to me or to Madame de Polignac, if you know her."

"Yes, madam, I have the honour to know her."

The duchess handed me a small tinder-box to enable me to light a wax-candle, and she went away with Camille. I remained alone locked up in the room, and at the end of three hours, just as I had completed my task, Madame de Polignac came for the parcel and I left the palace.

The Duchess de Chartres, daughter of the Prince of Conti, was twenty-six years of age. She was endowed with that particular sort of wit which renders a woman adorable. She was lively, above the prejudices of rank, cheerful, full of jest, a lover of pleasure, which she preferred to a long life. "Short and sweet," were the words she had constantly on her lips. She was pretty but she stood badly, and used to laugh at Marcel, the teacher of graceful deportment, who wanted to correct her awkward bearing. She kept her head bent forward and her feet turned inside when dancing; yet she was a charming dancer. Unfortunately her face was covered with pimples, which injured her beauty very greatly. Her physicians thought that they were caused by a disease of the liver, but they came from impurity of the blood, which at last killed her, and from which she suffered throughout her life.

The questions she had asked from my oracle related to affairs connected with her heart, and she wished likewise to know how she could get rid of the blotches which disfigured her. My answers were rather obscure in such matters as I was not specially acquainted with, but they were very clear concerning her disease, and my oracle became precious and necessary to her highness.

The next day, after dinner, Camille wrote me a note, as I expected, requesting me to give up all other engagements in order to present myself at

five o'clock at the Palais-Royal, in the same room in which the duchess had already received me the day before. I was punctual.

An elderly valet de chambre, who was waiting for me, immediately went to give notice of my arrival, and five minutes after the charming princess made her appearance. After addressing me in a very complimentary manner, she drew all my answers from her pocket, and enquired whether I had any pressing engagements.

"Your highness may be certain that I shall never have any more important business than to attend to your wishes."

"Very well; I do not intend to go out, and we can work."

She then shewed me all the questions which she had already prepared on different subjects, and particularly those relating to the cure of her pimples. One circumstance had contributed to render my oracle precious to her, because nobody could possibly know it, and I had guessed it. Had I not done so, I daresay it would have been all the same. I had laboured myself under the same disease, and I was enough of a physician to be aware that to attempt the cure of a cutaneous disease by active remedies might kill the patient.

I had already answered that she could not get rid of the pimples on her face in less than a week, but that a year of diet would be necessary to effect a radical cure.

We spent three hours in ascertaining what she was to do, and, believing implicitly in the power and in the science of the oracle, she undertook to follow faithfully everything ordered. Within one week all the ugly pimples had entirely disappeared.

I took care to purge her slightly; I prescribed every day what she was to eat, and forbade the use of all cosmetics; I only advised her to wash herself morning and evening with plantain water. The modest oracle told the princess to make use of the same water for her ablutions of every part of her body where she desired to obtain the same result, and she obeyed the prescription religiously.

I went to the opera on purpose on the day when the duchess shewed herself there with a smooth and rosy shin. After the opera, she took a walk in the great alley of the Palais-Royal, followed by the ladies of her suite and flattered by everybody. She saw me, and honoured me with a smile. I was truly happy. Camille, Madame de Polignac, and M. de Melfort were the only persons who knew that I was the oracle of the duchess, and I enjoyed my success. But the next day a few pimples reappeared on her beautiful complexion, and I received an order to repair at once to the Palais-Royal.

The valet, who did not know me, shewed me into a delightful boudoir near a closet in which there was a bath. The duchess came in; she looked sad, for she had several small pimples on the forehead and the chin. She held in her hand a question for the oracle, and as it was only a short one I thought it would give her the pleasure of finding the answer by herself. The numbers translated by the princess reproached her with having transgressed the regimen prescribed; she confessed to having drunk some liquors and eaten some ham; but she was astounded at having found that answer herself, and she could not understand how such an answer could result from an agglomeration of numbers. At that moment, one of her women came in to whisper a few words to her; she told her to wait outside, and turning towards me, she said,

"Have you any objection to seeing one of your friends who is as delicate as discreet?"

With these words, she hastily concealed in her pocket all the papers which did not relate to her disease; then she called out.

A man entered the room, whom I took for a stableboy; it was M. de Melfort.

"See," said the princess to him, "M. Casanova has taught me the cabalistic science."

And she shewed him the answer she had obtained herself. The count could not believe it.

"Well," said the duchess to me, "we must convince him. What shall I ask?"

"Anything your highness chooses."

She considered for one instant, and, drawing from her pocket a small ivory box, she wrote, "Tell me why this pomatum has no longer any effect".

She formed the pyramid, the columns, and the key, as I had taught her, and as she was ready to get the answer, I told her how to make the additions and subtractions which seem to come from the numbers, but which in reality are only arbitrary; then I told her to interpret the numbers in letters, and I left the room under some pretext. I came back when I thought that she had completed her translation, and I found her wrapped in amazement.

"Ah, sir!" she exclaimed, "what an answer!"

"Perhaps it is not the right one; but that will sometimes happen, madam."

"Not the right one, sir? It is divine! Here it is: That pomatum has no effect upon the skin of a woman who has been a mother."

"I do not see anything extraordinary in that answer, madam."

"Very likely, sir, but it is because you do not know that the pomatum in question was given to me five years ago by the Abbe de Brosses; it cured me

at that time, but it was ten months before the birth of the Duke de Montpensier. I would give anything in the world to be thoroughly acquainted with that sublime cabalistic science."

"What!" said the count, "is it the pomatum the history of which I know?"

"Precisely."

"It is astonishing."

"I wish to ask one more question concerning a woman the name of whom I would rather not give."

"Say the woman whom I have in my thoughts."

She then asked this question: "What disease is that woman suffering from?" She made the calculation, and the answer which I made her bring forth was this: "She wants to deceive her husband." This time the duchess fairly screamed with astonishment.

It was getting very late, and I was preparing to take leave, when M. de Melfort, who was speaking to her highness, told me that we might go together. When we were out, he told me that the cabalistic answer concerning the pomatum was truly wonderful. This was the history of it:

"The duchess, pretty as you see her now, had her face so fearfully covered with pimples that the duke, thoroughly disgusted, had not the courage to come near her to enjoy his rights as a husband, and the poor princess was pining with useless longing to become a mother. The Abbe de Brosses cured her with that pomatum, and her beautiful face having entirely recovered it original bloom she made her appearance at the Theatre Francais, in the queen's box. The Duke de Chartres, not knowing that his wife had gone to the theatre, where she went but very seldom, was in the king's box. He did not recognize the duchess, but thinking her very handsome he enquired who she was, and when he was told he would not believe it; he left the royal box, went to his wife, complimented her, and announced his visit for the very same night. The result of that visit was, nine months afterwards, the birth of the Duke of Montpensier, who is now five years old and enjoys excellent health. During the whole of her pregnancy the duchess kept her face smooth and blooming, but immediately after her delivery the pimples reappeared, and the pomatum remained without any effect."

As he concluded his explanation, the count offered me a tortoise-shell box with a very good likeness of her royal highness, and said,

"The duchess begs your acceptance of this portrait, and, in case you would like to have it set she wishes you to make use of this for that purpose."

It was a purse of one hundred Louis. I accepted both, and entreated the count to offer the expressions of my profound gratitude to her highness. I

never had the portrait mounted, for I was then in want of money for some other purpose.

After that, the duchess did me the honour of sending for me several times; but her cure remained altogether out of the question; she could not make up her mind to follow a regular diet. She would sometimes keep me at work for five or six hours, now in one corner, now in another, going in and out herself all the time, and having either dinner or supper brought to me by the old valet, who never uttered a word.

Her questions to the oracle alluded only to secret affairs which she was curious to know, and she often found truths with which I was not myself acquainted, through the answers. She wished me to teach her the cabalistic science, but she never pressed her wish upon me. She, however, commissioned M. de Melfort to tell me that, if I would teach her, she would get me an appointment with an income of twenty-five thousand francs. Alas! it was impossible! I was madly in love with her, but I would not for the world have allowed her to guess my feelings. My pride was the corrective of my love. I was afraid of her haughtiness humiliating me, and perhaps I was wrong. All I know is that I even now repent of having listened to a foolish pride. It is true that I enjoyed certain privileges which she might have refused me if she had known my love.

One day she wished my oracle to tell her whether it was possible to cure a cancer which Madame de la Popeliniere had in the breast; I took it in my head to answer that the lady alluded to had no cancer, and was enjoying excellent health.

"How is that?" said the duchess; "everyone in Paris believes her to be suffering from a cancer, and she has consultation upon consultation. Yet I have faith in the oracle."

Soon afterwards, seeing the Duke de Richelieu at the court, she told him she was certain that Madame de la Popeliniere was not ill. The marshal, who knew the secret, told her that she was mistaken; but she proposed a wager of a hundred thousand francs. I trembled when the duchess related the conversation to me.

"Has he accepted your wages?" I enquired, anxiously.

"No; he seemed surprised; you are aware that he ought to know the truth."

Three or four days after that conversation, the duchess told me triumphantly that M. de Richelieu had confessed to her that the cancer was only a ruse to excite the pity of her husband, with whom Madame de la Popeliniere wanted to live again on good terms; she added that the marshal

had expressed his willingness to pay one thousand Louis to know how she had discovered the truth.

"If you wish to earn that sum," said the duchess to me, "I will tell him all about it."

But I was afraid of a snare; I knew the temper of the marshal, and the story of the hole in the wall through which he introduced himself into that lady's apartment, was the talk of all Paris. M. de la Popeliniere himself had made the adventure more public by refusing to live with his wife, to whom he paid an income of twelve thousand francs.

The Duchess de Chartres had written some charming poetry on that amusing affair; but out of her own coterie no one knew it except the king, who was fond of the princess, although she was in the habit of scoffing at him. One day, for instance, she asked him whether it was true that the king of Prussia was expected in Paris. Louis XV. having answered that it was an idle rumour,

"I am very sorry," she said, "for I am longing to see a king."

My brother had completed several pictures and having decided on presenting one to M. de Marigny, we repaired one morning to the apartment of that nobleman, who lived in the Louvre, where all the artists were in the habit of paying their court to him. We were shewn into a hall adjoining his private apartment, and having arrived early we waited for M. de Marigny. My brother's picture was exposed there; it was a battle piece in the style of Bourguignon.

The first person who passed through the room stopped before the picture, examined it attentively, and moved on, evidently thinking that it was a poor painting; a moment afterwards two more persons came in, looked at the picture, smiled, and said,

"That's the work of a beginner."

I glanced at my brother, who was seated near me; he was in a fever. In less than a quarter of an hour the room was full of people, and the unfortunate picture was the butt of everybody's laughter. My poor brother felt almost dying, and thanked his stars that no one knew him personally.

The state of his mind was such that I heartily pitied him; I rose with the intention of going to some other room, and to console him I told him that M. de Marigny would soon come, and that his approbation of the picture would avenge him for the insults of the crowd. Fortunately, this was not my brother's opinion; we left the room hurriedly, took a coach, went home, and sent our servant to fetch back the painting. As soon as it had been brought back my brother made a battle of it in real earnest, for he cut it up with a

sword into twenty pieces. He made up his mind to settle his affairs in Paris immediately, and to go somewhere else to study an art which he loved to idolatry; we resolved on going to Dresden together.

Two or three days before leaving the delightful city of Paris I dined alone at the house of the gate-keeper of the Tuileries; his name was Conde. After dinner his wife, a rather pretty woman, presented me the bill, on which every item was reckoned at double its value. I pointed it out to her, but she answered very curtly that she could not abate one sou. I paid, and as the bill was receipted with the words 'femme Conde', I took the pen and to the word 'Conde' I added 'labre', and I went away leaving the bill on the table.

I was taking a walk in the Tuileries, not thinking any more of my female extortioner, when a small man, with his hat cocked on one side of his head and a large nosegay in his button-hole, and sporting a long sword, swaggered up to me and informed me, without any further explanation, that he had a fancy to cut my throat.

"But, my small specimen of humanity," I said, "you would require to jump on a chair to reach my throat. I will cut your ears."

"Sacre bleu, monsieur!"

"No vulgar passion, my dear sir; follow me; you shall soon be satisfied."

I walked rapidly towards the Porte de l'Etoile, where, seeing that the place was deserted, I abruptly asked the fellow what he wanted, and why he had attacked me.

"I am the Chevalier de Talvis," he answered. "You have insulted an honest woman who is under my protection; unsheath!"

With these words he drew his long sword; I unsheathed mine; after a minute or two I lunged rapidly, and wounded him in the breast. He jumped backward, exclaiming that I had wounded him treacherously.

"You lie, you rascally mannikin! acknowledge it, or I thrust my sword through your miserable body."

"You will not do it, for I am wounded; but I insist upon having my revenge, and we will leave the decision of this to competent judges."

"Miserable wrangler, wretched fighter, if you are not satisfied, I will cut off your ears!"

I left him there, satisfied that I had acted according to the laws of the duello, for he had drawn his sword before me, and if he had not been skilful enough to cover himself in good time, it was not, of course, my business to teach him. Towards the middle of August I left Paris with my brother. I had made a stay of two years in that city, the best in the world. I had enjoyed myself greatly, and had met with no unpleasantness except that I had been

now and then short of money. We went through Metz, Mayence, and
Frankfort, and arrived in Dresden at the end of the same month. My mother
offered us the most affectionate welcome, and was delighted to see us again.
My brother remained four years in that pleasant city, constantly engaged in
the study of his art, and copying all the fine paintings of battles by the great
masters in the celebrated Electoral Gallery.

He went back to Paris only when he felt certain that he could set criticism
at defiance; I shall say hereafter how it was that we both reached that city
about the same time. But before that period, dear, reader, you will see what
good and adverse fortune did for or against me.

My life in Dresden until the end of the carnival in 1753 does not offer any
extraordinary adventure. To please the actors, and especially my mother, I
wrote a kind of melodrama, in which I brought out two harlequins. It was a
parody of the 'Freres Ennemis', by Racine. The king was highly amused at the
comic fancies which filled my play, and he made me a beautiful present. The
king was grand and generous, and these qualities found a ready echo in the
breast of the famous Count de Bruhl. I left Dresden soon after that, bidding
adieu to my mother, to my brother Francois, and to my sister, then the wife
of Pierre Auguste, chief player of the harpsichord at the Court, who died two
years ago, leaving his widow and family in comfortable circumstances.

My stay in Dresden was marked by an amorous souvenir of which I got rid,
as in previous similar circumstances, by a diet of six weeks. I have often
remarked that the greatest part of my life was spent in trying to make myself
ill, and when I had succeeded, in trying to recover my health. I have met with
equal success in both things; and now that I enjoy excellent health in that
line, I am very sorry to be physically unable to make myself ill again; but age,
that cruel and unavoidable disease, compels me to be in good health in spite
of myself. The illness I allude to, which the Italians call 'mal francais',
although we might claim the honour of its first importation, does not shorten
life, but it leaves indelible marks on the face. Those scars, less honourable
perhaps than those which are won in the service of Mars, being obtained
through pleasure, ought not to leave any regret behind.

In Dresden I had frequent opportunities of seeing the king, who was very
fond of the Count de Bruhl, his minister, because that favourite possessed the
double secret of shewing himself more extravagant even than his master, and
of indulging all his whims.

Never was a monarch a greater enemy to economy; he laughed heartily
when he was plundered and he spent a great deal in order to have occasion
to laugh often. As he had not sufficient wit to amuse himself with the follies

of other kings and with the absurdities of humankind, he kept four buffoons, who are called fools in Germany, although these degraded beings are generally more witty than their masters. The province of those jesters is to make their owner laugh by all sorts of jokes which are usually nothing but disgusting tricks, or low, impertinent jests.

Yet these professional buffoons sometimes captivate the mind of their master to such an extent that they obtain from him very important favours in behalf of the persons they protect, and the consequence is that they are often courted by the highest families. Where is the man who will not debase himself if he be in want? Does not Agamemnon say, in Homer, that in such a case man must necessarily be guilty of meanness? And Agamemnon and Homer lived long before our time! It evidently proves that men are at all times moved by the same motive-namely, self-interest.

It is wrong to say that the Count de Bruhl was the ruin of Saxony, for he was only the faithful minister of his royal master's inclinations. His children are poor, and justify their father's conduct.

The court at Dresden was at that time the most brilliant in Europe; the fine arts flourished, but there was no gallantry, for King Augustus had no inclination for the fair sex, and the Saxons were not of a nature to be thus inclined unless the example was set by their sovereign.

At my arrival in Prague, where I did not intend to stop, I delivered a letter I had for Locatelli, manager of the opera, and went to pay a visit to Madame Morelli, an old acquaintance, for whom I had great affection, and for two or three days she supplied all the wants of my heart.

As I was on the point of leaving Prague, I met in the street my friend Fabris, who had become a colonel, and he insisted upon my dining with him. After 'embracing him, I represented to him, but in vain, that I had made all my arrangements to go away immediately.

"You will go this evening," he said, "with a friend of mine, and you will catch the coach."

I had to give way, and I was delighted to have done so, for the remainder of the day passed in the most agreeable manner. Fabris was longing for war, and his wishes were gratified two years afterwards; he covered himself with glory.

I must say one word about Locatelli, who was an original character well worthy to be known. He took his meals every day at a table laid out for thirty persons, and the guests were his actors, actresses, dancers of both sexes, and a few friends. He did the honours of his well-supplied board nobly, and his real passion was good living. I shall have occasion to mention him again at

the time of my journey to St. Petersburg, where I met him, and where he died only lately at the age of ninety.

Episode 7 — Venice

CHAPTER X

My Stay in Vienna—Joseph II—My Departure for Venice

Arrived, for the first time, in the capital of Austria, at the age of eight-and-twenty, well provided with clothes, but rather short of money—a circumstance which made it necessary for me to curtail my expenses until the arrival of the proceeds of a letter of exchange which I had drawn upon M. de Bragadin. The only letter of recommendation I had was from the poet Migliavacca, of Dresden, addressed to the illustrious Abbe Metastasio, whom I wished ardently to know. I delivered the letter the day after my arrival, and in one hour of conversation I found him more learned than I should have supposed from his works. Besides, Metastasio was so modest that at first I did not think that modesty natural, but it was not long before I discovered that it was genuine, for when he recited something of his own composition, he was the first to call the attention of his hearers to the important parts or to the fine passages with as much simplicity as he would remark the weak ones. I spoke to him of his tutor Gravina, and as we were on that subject he recited to me five or six stanzas which he had written on his death, and which had not been printed. Moved by the remembrance of his friend, and by the sad beauty of his own poetry, his eyes were filled with tears, and when he had done reciting the stanzas he said, in a tone of touching simplicity,'Ditemi il vero, si puo air meglio'?

I answered that he alone had the right to believe it impossible. I then asked him whether he had to work a great deal to compose his beautiful poetry; he shewed me four or five pages which he had covered with erasures and words crossed and scratched out only because he had wished to bring fourteen lines to perfection, and he assured me that he had never been able to compose more than that number in one day. He confirmed my knowledge of a truth which I had found out before, namely, that the very lines which most readers believe to have flowed easily from the poet's pen are generally those which he has had the greatest difficulty in composing.

"Which of your operas," I enquired, "do you like best?"

"'Attilio Regolo; ma questo non vuol gia dire che sia il megliore'."

"All your works have been translated in Paris into French prose, but the publisher was ruined, for it is not possible to read them, and it proves the elevation and the power of your poetry."

"Several years ago, another foolish publisher ruined himself by a translation into French prose of the splendid poetry of Ariosto. I laugh at those who maintain that poetry can be translated into prose."

"I am of your opinion."

"And you are right."

He told me that he had never written an arietta without composing the music of it himself, but that as a general rule he never shewed his music to anyone.

"The French," he added, "entertain the very strange belief that it is possible to adapt poetry to music already composed."

And he made on that subject this very philosophical remark:

"You might just as well say to a sculptor, 'Here is a piece of marble, make a Venus, and let her expression be shewn before the features are chiselled.'"

I went to the Imperial Library, and was much surprised to meet De la Haye in the company of two Poles, and a young Venetian whom his father had entrusted to him to complete his education. I believed him to be in Poland, and as the meeting recalled interesting recollections I was pleased to see him. I embraced him repeatedly with real pleasure.

He told me that he was in Vienna on business, and that he would go to Venice during the summer. We paid one another several visits, and hearing that I was rather short of money he lent me fifty ducats, which I returned a short time after. He told me that Bavois was already lieutenant-colonel in the Venetian army, and the news afforded me great pleasure. He had been fortunate enough to be appointed adjutant-general by M. Morosini, who, after his return from his embassy in France, had made him Commissary of the Borders. I was delighted to hear of the happiness and success of two men who certainly could not help acknowledging me as the original cause of their good fortune. In Vienna I acquired the certainty of De la Haye being a Jesuit, but he would not let anyone allude to the subject.

Not knowing where to go, and longing for some recreation, I went to the rehearsal of the opera which was to be performed after Easter, and met Bodin, the first dancer, who had married the handsome Jeoffroi, whom I had seen in Turin. I likewise met in the same place Campioni, the husband of the beautiful Ancilla. He told me that he had been compelled to apply for a divorce because she dishonoured him too publicly. Campioni was at the same time a great dancer and a great gambler. I took up my lodgings with him.

In Vienna everything is beautiful; money was then very plentiful, and luxury very great; but the severity of the empress made the worship of Venus difficult, particularly for strangers. A legion of vile spies, who were decorated with the fine title of Commissaries of Chastity, were the merciless tormentors of all the girls. The empress did not practise the sublime virtue of tolerance for what is called illegitimate love, and in her excessive devotion she thought that her persecutions of the most natural inclinations in man and woman were very agreeable to God. Holding in her imperial hands the register of cardinal sins, she fancied that she could be indulgent for six of them, and keep all her severity for the seventh, lewdness, which in her estimation could not be forgiven.

"One can ignore pride," she would say, "for dignity wears the same garb. Avarice is fearful, it is true; but one might be mistaken about it, because it is often very like economy. As for anger, it is a murderous disease in its excess, but murder is punishable with death. Gluttony is sometimes nothing but epicurism, and religion does not forbid that sin; for in good company it is held a valuable quality; besides, it blends itself with appetite, and so much the worse for those who die of indigestion. Envy is a low passion which no one ever avows; to punish it in any other way than by its own corroding venom, I would have to torture everybody at Court; and weariness is the punishment of sloth. But lust is a different thing altogether; my chaste soul could not forgive such a sin, and I declare open war against it. My subjects are at liberty to think women handsome as much as they please; women may do all in their power to appear beautiful; people may entertain each other as they like, because I cannot forbid conversation; but they shall not gratify desires on which the preservation of the human race depends, unless it is in the holy state of legal marriage. Therefore, all the miserable creatures who live by the barter of their caresses and of the charms given to them by nature shall be sent to Temeswar. I am aware that in Rome people are very indulgent on that point, and that, in order to prevent another greater crime (which is not prevented), every cardinal has one or more mistresses, but in Rome the climate requires certain concessions which are not necessary here, where the bottle and the pipe replace all pleasures. (She might have added, and the table, for the Austrians are known to be terrible eaters.)

"I will have no indulgence either for domestic disorders, for the moment I hear that a wife is unfaithful to her husband, I will have her locked up, in spite of all, in spite of the generally received opinion that the husband is the real judge and master of his wife; that privilege cannot be granted in my kingdom where husbands are by far too indifferent on that subject. Fanatic

husbands may complain as much as they please that I dishonour them by punishing their wives; they are dishonoured already by the fact of the woman's infidelity."

"But, madam, dishonour rises in reality only from the fact of infidelity being made public; besides, you might be deceived, although you are empress."

"I know that, but that is no business of yours, and I do not grant you the right of contradicting me."

Such is the way in which Maria Teresa would have argued, and notwithstanding the principle of virtue from which her argument had originated, it had ultimately given birth to all the infamous deeds which her executioners, the Commissaries of Chastity, committed with impunity under her name. At every hour of the day, in all the streets of Vienna, they carried off and took to prison the poor girls who happened to live alone, and very often went out only to earn an honest living. I should like to know how it was possible to know that a girl was going to some man to get from him consolations for her miserable position, or that she was in search of someone disposed to offer her those consolations? Indeed, it was difficult. A spy would follow them at a distance. The police department kept a crowd of those spies, and as the scoundrels wore no particular uniform, it was impossible to know them; as a natural consequence, there was a general distrust of all strangers. If a girl entered a house, the spy who had followed her, waited for her, stopped her as she came out, and subjected her to an interrogatory. If the poor creature looked uneasy, if she hesitated in answering in such a way as to satisfy the spy, the fellow would take her to prison; in all cases beginning by plundering her of whatever money or jewellery she carried about her person, and the restitution of which could never be obtained. Vienna was, in that respect a true den of privileged thieves. It happened to me one day in Leopoldstadt that in the midst of some tumult a girl slipped in my hand a gold watch to secure it from the clutches of a police-spy who was pressing upon her to take her up. I did not know the poor girl, whom I was fortunate enough to see again one month afterwards. She was pretty, and she had been compelled to more than one sacrifice in order to obtain her liberty. I was glad to be able to hand her watch back to her, and although she was well worthy of a man's attention I did not ask her for anything to reward my faithfulness. The only way in which girls could walk unmolested in the streets was to go about with their head bent down with beads in hand, for in that case the disgusting brood of spies dared not arrest them, because they might be on their way to church, and Maria Teresa would certainly have sent to the gallows the spy guilty of such a mistake.

Those low villains rendered a stay in Vienna very unpleasant to foreigners, and it was a matter of the greatest difficulty to gratify the slightest natural want without running the risk of being annoyed. One day as I was standing close to the wall in a narrow street, I was much astonished at hearing myself rudely addressed by a scoundrel with a round wig, who told me that, if I did not go somewhere else to finish what I had begun, he would have me arrested!

"And why, if you please?"

"Because, on your left, there is a woman who can see you."

I lifted up my head, and I saw on the fourth story, a woman who, with the telescope she had applied to her eye, could have told whether I was a Jew or a Christian. I obeyed, laughing heartily, and related the adventure everywhere; but no one was astonished, because the same thing happened over and over again every day.

In order to study the manners and habits of the people, I took my meals in all sorts of places. One day, having gone with Campioni to dine at "The Crawfish," I found, to my great surprise, sitting at the table d'hote, that Pepe il Cadetto, whose acquaintance I had made at the time of my arrest in the Spanish army, and whom I had met afterwards in Venice and in Lyons, under the name of Don Joseph Marcati. Campioni, who had been his partner in Lyons, embraced him, talked with him in private, and informed me that the man had resumed his real name, and that he was now called Count Afflisio. He told me that after dinner there would be a faro bank in which I would have an interest, and he therefore requested me not to play. I accepted the offer. Afflisio won: a captain of the name of Beccaxia threw the cards at his face—a trifle to which the self-styled count was accustomed, and which did not elicit any remark from him. When the game was over, we repaired to the coffee-room, where an officer of gentlemanly appearance, staring at me, began to smile, but not in an offensive manner.

"Sir," I asked him, politely, "may I ask why you are laughing?"

"It makes me laugh to see that you do not recognize me."

"I have some idea that I have seen you somewhere, but I could not say where or when I had that honour."

"Nine years ago, by the orders of the Prince de Lobkowitz, I escorted you to the Gate of Rimini."

"You are Baron Vais:"

"Precisely."

We embraced one another; he offered me his friendly services, promising to procure me all the pleasure he could in Vienna. I accepted gratefully, and the same evening he presented me to a countess, at whose house I made the

acquaintance of the Abbe Testagrossa, who was called Grosse-Tete by everybody. He was minister of the Duke of Modem, and great at Court because he had negotiated the marriage of the arch-duke with Beatrice d'Este. I also became acquainted there with the Count of Roquendorf and Count Sarotin, and with several noble young ladies who are called in Germany frauleins, and with a baroness who had led a pretty wild life, but who could yet captivate a man. We had supper, and I was created baron. It was in vain that I observed that I had no title whatever: "You must be something," I was told, "and you cannot be less than baron. You must confess yourself to be at least that, if you wish to be received anywhere in Vienna."

"Well, I will be a baron, since it is of no importance."

The baroness was not long before she gave me to understand that she felt kindly disposed towards me, and that she would receive my attentions with pleasure; I paid her a visit the very next day. "If you are fond of cards," she said, "come in the evening." At her house I made the acquaintance of several gamblers, and of three or four frauleins who, without any dread of the Commissaries of Chastity, were devoted to the worship of Venus, and were so kindly disposed that they were not afraid of lowering their nobility by accepting some reward for their kindness—a circumstance which proved to me that the Commissaries were in the habit of troubling only the girls who did not frequent good houses.

The baroness invited me to introduce, all my friends, so I brought to her house Vais, Campioni, and Afflisio. The last one played, held the bank, won; and Tramontini, with whom I had become acquainted, presented him to his wife, who was called Madame Tasi. It was through her that Afflisio made the useful acquaintance of the Prince of Saxe-Hildburghausen. This introduction was the origin of the great fortune made by that contrabrand count, because Tramontini, who had become his partner in all important gambling transactions, contrived to obtain for him from the prince the rank of captain in the service of their imperial and royal majesties, and in less than three weeks Afflisio wore the uniform and the insignia of his grade. When I left Vienna he possessed one: hundred thousand florins. Their majesties were fond of gambling but not of punting. The emperor had a creature of his own to hold the bank. He was a kind, magnificent, but not extravagant, prince. I saw him in his grand imperial costume, and I was surprised to see him dressed in the Spanish fashion. I almost fancied I had before my eyes Charles V. of Spain, who had established that etiquette which was still in existence, although after him no emperor had been a Spaniard, and although Francis I. had nothing in common with that nation.

In Poland, some years afterwards, I saw the same caprice at the coronation of Stanislas Augustus Poniatowski, and the old palatine noblemen almost broke their hearts at the sight of that costume; but they had to shew as good a countenance as they could, for under Russian despotism the only privilege they enjoyed was that of resignation.

The Emperor Francis I. was, handsome, and would have looked so under the hood of a monk as well as under an imperial crown. He had every possible consideration for his wife, and allowed her to get the state into debt, because he possessed the art of becoming himself the creditor of the state. He favoured commerce because it filled his coffers. He was rather addicted to gallantry, and the empress, who always called him master feigned not to notice it, because she did not want the world to know that her charms could no longer captivate her royal spouse, and the more so that the beauty of her numerous family was generally admired. All the archduchesses except the eldest seemed to me very handsome; but amongst the sons I had the opportunity of seeing only the eldest, and I thought the expression of his face bad and unpleasant, in spite of the contrary opinion of Abbe Grosse-Tete, who prided himself upon being a good physiognomist.

"What do you see," he asked me one day, "on the countenance of that prince?"

"Self-conceit and suicide."

It was a prophecy, for Joseph II. positively killed himself, although not wilfully, and it was his self-conceit which prevented him from knowing it. He was not wanting in learning, but the knowledge which he believed himself to possess destroyed the learning which he had in reality. He delighted in speaking to those who did not know how to answer him, whether because they were amazed at his arguments, or because they pretended to be so; but he called pedants, and avoided all persons, who by true reasoning pulled down the weak scaffolding of his arguments. Seven years ago I happened to meet him at Luxemburg, and he spoke to me with just contempt of a man who had exchanged immense sums of money, and a great deal of debasing meanness against some miserable parchments, and he added,—

"I despise men who purchase nobility."

"Your majesty is right, but what are we to think of those who sell it?"

After that question he turned his back upon me, and hence forth he thought me unworthy of being spoken to.

The great passion of that king was to see those who listened to him laugh, whether with sincerity or with affectation, when he related something; he could narrate well and amplify in a very amusing manner all the particulars

of an anecdote; but he called anyone who did not laugh at his jests a fool, and that was always the person who understood him best. He gave the preference to the opinion of Brambilla, who encouraged his suicide, over that of the physicians who were directing him according to reason. Nevertheless, no one ever denied his claim to great courage; but he had no idea whatever of the art of government, for he had not the slightest knowledge of the human heart, and he could neither dissemble nor keep a secret; he had so little control over his own countenance that he could not even conceal the pleasure he felt in punishing, and when he saw anyone whose features did not please him, he could not help making a wry face which disfigured him greatly.

Joseph II. sank under a truly cruel disease, which left him until the last moment the faculty of arguing upon everything, at the same time that he knew his death to be certain. This prince must have felt the misery of repenting everything he had done and of seeing the impossibility of undoing it, partly because it was irreparable, partly because if he had undone through reason what he had done through senselessness, he would have thought himself dishonoured, for he must have clung to the last to the belief of the infallibility attached to his high birth, in spite of the state of languor of his soul which ought to have proved to him the weakness and the fallibility of his nature. He had the greatest esteem for his brother, who has now succeeded him, but he had not the courage to follow the advice which that brother gave him. An impulse worthy of a great soul made him bestow a large reward upon the physician, a man of intelligence, who pronounced his sentence of death, but a completely opposite weakness had prompted him, a few months before, to load with benefits the doctors and the quack who made him believe that they had cured him. He must likewise have felt the misery of knowing that he would not be regretted after his death—a grievous thought, especially for a sovereign. His niece, whom he loved dearly, died before him, and, if he had had the affection of those who surrounded him, they would have spared him that fearful information, for it was evident that his end was near at hand, and no one could dread his anger for having kept that event from him.

Although very much pleased with Vienna and with the pleasures I enjoyed with the beautiful frauleins, whose acquaintance I had made at the house of the baroness, I was thinking of leaving that agreeable city, when Baron Vais, meeting me at Count Durazzo's wedding, invited me to join a picnic at Schoenbrunn. I went, and I failed to observe the laws of temperance; the consequence was that I returned to Vienna with such a severe indigestion that in twenty-four hours I was at the point of death.

I made use of the last particle of intelligence left in me by the disease to save my own life. Campioni, Roquendorf and Sarotin were by my bedside. M. Sarotin, who felt great friendship for me, had brought a physician, although I had almost positively declared that I would not see one. That disciple of Sangrado, thinking that he could allow full sway to the despotism of science, had sent for a surgeon, and they were going to bleed me against my will. I was half-dead; I do not know by what strange inspiration I opened my eyes, and I saw a man, standing lancet in hand and preparing to open the vein.

"No, no!" I said.

And I languidly withdrew my arm; but the tormentor wishing, as the physician expressed it, to restore me to life in spite of myself, got hold of my arm again. I suddenly felt my strength returning. I put my hand forward, seized one of my pistols, fired, and the ball cut off one of the locks of his hair. That was enough; everybody ran away, with the exception of my servant, who did not abandon me, and gave me as much water as I wanted to drink. On the fourth day I had recovered my usual good health.

That adventure amused all the idlers of Vienna for several days, and Abbe Grosse-Tete assured me that if I had killed the poor surgeon, it would not have gone any further, because all the witnesses present in my room at the time would have declared that he wanted to use violence to bleed me, which made it a case of legitimate self-defence. I was likewise told by several persons that all the physicians in Vienna were of opinion that if I had been bled I should have been a dead man; but if drinking water had not saved me, those gentlemen would certainly not have expressed the same opinion. I felt, however, that I had to be careful, and not to fall ill in the capital of Austria, for it was likely that I should not have found a physician without difficulty. At the opera, a great many persons wished after that to make my acquaintance, and I was looked upon as a man who had fought, pistol in hand, against death. A miniature-painter named Morol, who was subject to indigestions and who was at last killed by one, had taught me his system which was that, to cure those attacks, all that was necessary was to drink plenty of water and to be patient. He died because he was bled once when he could not oppose any resistance.

My indigestion reminded me of a witty saying of a man who was not much in the habit of uttering many of them; I mean M. de Maisonrouge, who was taken home one day almost dying from a severe attack of indigestion: his carriage having been stopped opposite the Quinze-Vingts by some obstruction, a poor man came up and begged alms, saying,

"Sir, I am starving."

"Eh! what are you complaining of?" answered Maisonrouge, sighing deeply; "I wish I was in your place, you rogue!"

At that time I made the acquaintance of a Milanese dancer, who had wit, excellent manners, a literary education, and what is more—great beauty. She received very good society, and did the honours of her drawing-room marvellously well. I became acquainted at her house with Count Christopher Erdodi, an amiable, wealthy and generous man; and with a certain Prince Kinski who had all the grace of a harlequin. That girl inspired me with love, but it was in vain, for she was herself enamoured of a dancer from Florence, called Argiolini. I courted her, but she only laughed at me, for an actress, if in love with someone, is a fortress which cannot be taken, unless you build a bridge of gold, and I was not rich. Yet I did not despair, and kept on burning my incense at her feet. She liked my society because she used to shew me the letters she wrote, and I was very careful to admire her style. She had her own portrait in miniature, which was an excellent likeness. The day before my departure, vexed at having lost my time and my amorous compliments, I made up my mind to steal that portrait—a slight compensation for not having won the original. As I was taking leave of her, I saw the portrait within my reach, seized it, and left Vienna for Presburg, where Baron Vais had invited me to accompany him and several lovely frauleins on a party of pleasure.

When we got out of the carriages, the first person I tumbled upon was the Chevalier de Talvis, the protector of Madame Conde-Labre, whom I had treated so well in Paris. The moment he saw me, he came up and told me that I owed him his revenge.

"I promise to give it to you, but I never leave one pleasure for another," I answered; "we shall see one another again."

"That is enough. Will you do me the honour to introduce me to these ladies?"

"Very willingly, but not in the street."

We went inside of the hotel and he followed us. Thinking that the man, who after all was as brave as a French chevalier, might amuse us, I presented him to my friends. He had been staying at the same hotel for a couple of days, and he was in mourning. He asked us if we intended to go to the prince-bishop's ball; it was the first news we had of it. Vais answered affirmatively.

"One can attend it," said Talvis, "without being presented, and that is why we intend to go, for I am not known to anybody here."

He left us, and the landlord, having come in to receive our orders, gave us some particulars respecting the ball. Our lovely frauleins expressing a wish to attend it, we made up our minds to gratify them.

We were not known to anyone, and were rambling through the apartments, when we arrived before a large table at which the prince-bishop was holding a faro bank. The pile of gold that the noble prelate had before him could not have been less than thirteen or fourteen thousand florins. The Chevalier de Talvis was standing between two ladies to whom he was whispering sweet words, while the prelate was shuffling the cards.

The prince, looking at the chevalier, took it into his head to ask him, in a most engaging manner to risk a card.

"Willingly, my lord," said Talvis; "the whole of the bank upon this card."

"Very well," answered the prelate, to shew that he was not afraid.

He dealt, Talvis won, and my lucky Frenchman, with the greatest coolness, filled his pockets with the prince's gold. The bishop, astonished, and seeing but rather late how foolish he had been, said to the chevalier,

"Sir, if you had lost, how would you have managed to pay me?"

"My lord, that is my business."

"You are more lucky than wise."

"Most likely, my lord; but that is my business."

Seeing that the chevalier was on the point of leaving, I followed him, and at the bottom of the stairs, after congratulating him, I asked him to lend me a hundred sovereigns. He gave them to me at once, assuring me that he was delighted to have it in his power to oblige me.

"I will give you my bill."

"Nothing of the sort."

I put the gold into my pocket, caring very little for the crowd of masked persons whom curiosity had brought around the lucky winner, and who had witnessed the transaction. Talvis went away, and I returned to the ball-room.

Roquendorf and Sarotin, who were amongst the guests, having heard that the chevalier had handed me some gold, asked me who he was. I gave them an answer half true and half false, and I told them that the gold I had just received was the payment of a sum I had lent him in Paris. Of course they could not help believing me, or at least pretending to do so.

When we returned to the inn, the landlord informed us that the chevalier had left the city on horseback, as fast as he could gallop, and that a small traveling-bag was all his luggage. We sat down to supper, and in order to make our meal more cheerful, I told Vais and our charming frauleins the

manner in which I had known Talvis, and how I had contrived to have my share of what he had won.

On our arrival in Vienna, the adventure was already known; people admired the Frenchman and laughed at the bishop. I was not spared by public rumour, but I took no notice of it, for I did not think it necessary to defend myself. No one knew the Chevalier de Talvis, and the French ambassador was not even acquainted with his name. I do not know whether he was ever heard of again.

I left Vienna in a post-chaise, after I had said farewell to my friends, ladies and gentlemen, and on the fourth day I slept in Trieste. The next day I sailed for Venice, which I reached in the afternoon, two days before Ascension Day. After an absence of three years I had the happiness of embracing my beloved protector, M. de Bragadin, and his two inseparable friends, who were delighted to see me in good health and well equipped.

CHAPTER XI

I Return the Portrait I Had Stolen in Vienna I Proceed to
Padua; An Adventure on My Way Back, and Its Consequences—
I Meet Therese Imer Again—My Acquaintance With Mademoiselle
C. C.

I found myself again in my native country with that feeling of delight which
is experienced by all true-hearted men, when they see again the place in
which they have received the first lasting impressions. I had acquired some
experience; I knew the laws of honour and politeness; in one word, I felt
myself superior to most of my equals, and I longed to resume my old habits
and pursuits; but I intended to adopt a more regular and more reserved line
of conduct.

I saw with great pleasure, as I entered my study, the perfect 'statu quo'
which had been preserved there. My papers, covered with a thick layer of
dust, testified well enough that no strange hand had ever meddled with them.

Two days after my arrival, as I was getting ready to accompany the
Bucentoro, on which the Doge was going, as usual, to wed the Adriatic, the
widow of so many husbands, and yet as young as on the first day of her
creation, a gondolier brought me a letter. It was from M. Giovanni Grimani,
a young nobleman, who, well aware that he had no right to command me,
begged me in the most polite manner to call at his house to receive a letter
which had been entrusted to him for delivery in my own hands. I went to him
immediately, and after the usual compliments he handed me a letter with a
flying seal, which he had received the day before.

Here are the contents:

"Sir, having made a useless search for my portrait after you left, and not
being in the habit of receiving thieves in my apartment, I feel satisfied that it
must be in your possession. I request you to deliver it to the person who will
hand you this letter.

"FOGLIAZZI."

Happening to have the portrait with me, I took it out of my pocket, and
gave it at once to M. Grimani, who received it with a mixture of satisfaction
and surprise for he had evidently thought that the commission entrusted to
him would be more difficult to fulfil, and he remarked,

"Love has most likely made a thief of you but I congratulate you, for your
passion cannot be a very ardent one."

"How can you judge of that?"

"From the readiness with which you give up this portrait."

"I would not have given it up so easily to anybody else."

"I thank you; and as a compensation I beg you to accept my friendship."

"I place it in my estimation infinitely above the portrait, and even above the original. May I ask you to forward my answer?"

"I promise you to send it. Here is some paper, write your letter; you need not seal it."

I wrote the following words:

"In getting rid of the portrait, Casanova experiences a satisfaction by far superior to that which he felt when, owing to a stupid fancy, he was foolish enough to put it in his pocket."

Bad weather having compelled the authorities to postpone the wonderful wedding until the following Sunday, I accompanied M. de Bragadin, who was going to Padua. The amiable old man ran away from, the noisy pleasures which no longer suited his age, and he was going to spend in peace the few days which the public rejoicings would have rendered unpleasant for him in Venice. On the following Saturday, after dinner, I bade him farewell, and got into the post-chaise to return to Venice. If I had left Padua two minutes sooner or later, the whole course of my life would have been altered, and my destiny, if destiny is truly shaped by fatal combinations, would have been very different. But the reader can judge for himself.

Having, therefore, left Padua at the very instant marked by fatality, I met at Oriago a cabriolet, drawn at full speed by two post-horses, containing a very pretty woman and a man wearing a German uniform. Within a few yards from me the vehicle was suddenly upset on the side of the river, and the woman, falling over the officer, was in great danger of rolling into the Brenta. I jumped out of my chaise without even stopping my postillion, and rushing to the assistance of the lady I remedied with a chaste hand the disorder caused to her toilet by her fall.

Her companion, who had picked himself up without any injury, hastened towards us, and there was the lovely creature sitting on the ground thoroughly amazed, and less confused from her fall than from the indiscretion of her petticoats, which had exposed in all their nakedness certain parts which an honest woman never shews to a stranger. In the warmth of her thanks, which lasted until her postillion and mine had righted the cabriolet, she often called me her saviour, her guardian angel.

The vehicle being all right, the lady continued her journey towards Padua, and I resumed mine towards Venice, which I reached just in time to dress for the opera.

The next day I masked myself early to accompany the Bucentoro, which, favoured by fine weather, was to be taken to the Lido for the great and ridiculous ceremony. The whole affair is under the responsibility of the admiral of the arsenal, who answers for the weather remaining fine, under penalty of his head, for the slightest contrary wind might capsize the ship and drown the Doge, with all the most serene noblemen, the ambassadors, and the Pope's nuncio, who is the sponsor of that burlesque wedding which the Venetians respect even to superstition. To crown the misfortune of such an accident it would make the whole of Europe laugh, and people would not fail to say that the Doge of Venice had gone at last to consummate his marriage.

I had removed my mask, and was drinking some coffee under the 'procuraties' of St. Mark's Square, when a fine-looking female mask struck me gallantly on the shoulder with her fan. As I did not know who she was I did not take much notice of it, and after I had finished my coffee I put on my mask and walked towards the Spiaggia del Sepulcro, where M. de Bragadin's gondola was waiting for me. As I was getting near the Ponte del Paglia I saw the same masked woman attentively looking at some wonderful monster shewn for a few pence. I went up to her; and asked her why she had struck me with her fan.

"To punish you for not knowing me again after having saved my life." I guessed that she was the person I had rescued the day before on the banks of the Brenta, and after paying her some compliments I enquired whether she intended to follow the Bucentoro.

"I should like it," she said, "if I had a safe gondola."

I offered her mine, which was one of the largest, and, after consulting a masked person who accompanied her, she accepted. Before stepping in I invited them to take off their masks, but they told me that they wished to remain unknown. I then begged them to tell me if they belonged to the suite of some ambassador, because in that case I should be compelled, much to my regret, to withdraw my invitation; but they assured me that they were both Venetians. The gondola belonging to a patrician, I might have committed myself with the State Inquisitors-a thing which I wished particularly to avoid. We were following the Bucentoro, and seated near the lady I allowed myself a few slight liberties, but she foiled my intentions by changing her seat. After the ceremony we returned to Venice, and the officer who accompanied the lady told me that I would oblige them by dining in their company at "The Savage." I accepted, for I felt somewhat curious about the woman. What I had seen of her at the time of her fall warranted my curiosity. The officer left me alone with her, and went before us to order dinner.

As soon as I was alone with her, emboldened by the mask, I told her that I was in love with her, that I had a box at the opera, which I placed entirely at her disposal, and that, if she would only give me the hope that I was not wasting my time and my attentions, I would remain her humble servant during the carnival.

"If you mean to be cruel," I added, "pray say so candidly."

"I must ask you to tell me what sort of a woman you take me for?"

"For a very charming one, whether a princess or a maid of low degree. Therefore, I hope that you will give me, this very day, some marks of your kindness, or I must part with you immediately after dinner."

"You will do as you please; but I trust that after dinner you will have changed your opinion and your language, for your way of speaking is not pleasant. It seems to me that, before venturing upon such an explanation, it is necessary to know one another. Do you not think so?"

"Yes, I do; but I am afraid of being deceived."

"How very strange! And that fear makes you begin by what ought to be the end?"

"I only beg to-day for one encouraging word. Give it to me and I will at once be modest, obedient and discreet."

"Pray calm yourself."

We found the officer waiting for us before the door of "The Savage," and went upstairs. The moment we were in the room, she took off her mask, and I thought her more beautiful than the day before. I wanted only to ascertain, for the sake of form and etiquette, whether the officer was her husband, her lover, a relative or a protector, because, used as I was to gallant adventures, I wished to know the nature of the one in which I was embarking.

We sat down to dinner, and the manners of the gentleman and of the lady made it necessary for me to be careful. It was to him that I offered my box, and it was accepted; but as I had none, I went out after dinner under pretence of some engagement, in order to get one at the opera-buffa, where Petrici and Lasqui were then the shining stars. After the opera I gave them a good supper at an inn, and I took them to their house in my gondola. Thanks to the darkness of the night, I obtained from the pretty woman all the favours which can be granted by the side of a third person who has to be treated with caution. As we parted company, the officer said,

"You shall hear from me to-morrow."

"Where, and how?"

"Never mind that."

The next morning the servant announced an officer; it was my man. After we had exchanged the usual compliments, after I had thanked him for the honour he had done me the day before, I asked him to tell me his name. He answered me in the following manner, speaking with great fluency, but without looking at me:

"My name is P—— C——. My father is rich, and enjoys great consideration at the exchange; but we are not on friendly terms at present. I reside in St. Mark's Square. The lady you saw with me was a Mdlle. O——; she is the wife of the broker C——, and her sister married the patrician P—— M——. But Madame C—— is at variance with her husband on my account, as she is the cause of my quarrel with my father.

"I wear this uniform in virtue of a captaincy in the Austrian service, but I have never served in reality. I have the contract for the supply of oxen to the City of Venice, and I get the cattle from Styria and Hungary. This contract gives me a net profit of ten thousand florins a year; but an unforeseen embarrassment, which I must remedy; a fraudulent bankruptcy, and some extraordinary expenditure, place me for the present in monetary difficulties. Four years ago I heard a great deal about you, and wished very much to make your acquaintance; I firmly believe that it was through the interference of Heaven that we became acquainted the day before yesterday. I have no hesitation in claiming from you an important service which will unite us by the ties of the warmest friendship. Come to my assistance without running any risk yourself; back these three bills of exchange. You need not be afraid of having to pay them, for I will leave in your hands these three other bills which fall due before the first. Besides, I will give you a mortgage upon the proceeds of my contract during the whole year, so that, should I fail to take up these bills, you could seize my cattle in Trieste, which is the only road through which they can come."

Astonished at his speech and at his proposal, which seemed to me a lure and made me fear a world of trouble which I always abhorred, struck by the strange idea of that man who, thinking that I would easily fall into the snare, gave me the preference over so many other persons whom he certainly knew better than me, I did not hesitate to tell him that I would never accept his offer. He then had recourse to all his eloquence to persuade me, but I embarrassed him greatly by telling him how surprised I was at his giving me the preference over all his other acquaintances, when I had had the honour to know him only for two days.

"Sir" he said, with barefaced impudence, "having recognised in you a man of great intelligence, I felt certain that you would at once see the advantages of my offer, and that you would not raise any objection."

"You must see your mistake by this time, and most likely you will take me for a fool now you see that I should believe myself a dupe if I accepted."

He left me with an apology for having troubled me, and saying that he hoped to see me in the evening at St. Mark's Square, where he would be with Madame C——, he gave me his address, telling me that he had retained possession of his apartment unknown to his father. This was as much as to say that he expected me to return his visit, but if I had been prudent I should not have done so.

Disgusted at the manner in which that man had attempted to get hold of me, I no longer felt any inclination to try my fortune with his mistress, for it seemed evident that they were conspiring together to make a dupe of me, and as I had no wish to afford them that gratification I avoided them in the evening. It would have been wise to keep to that line of conduct; but the next day, obeying my evil genius, and thinking that a polite call could not have any consequences, I called upon him.

A servant having taken me to his room, he gave me the most friendly welcome, and reproached me in a friendly manner for not having shewn myself the evening before. After that, he spoke again of his affairs, and made me look at a heap of papers and documents; I found it very wearisome.

"If you make up your mind to sign the three bills of exchange," he said, "I will take you as a partner in my contract."

By this extraordinary mark of friendship, he was offering me—at least he said so—an income of five thousand florins a year; but my only answer was to beg that the matter should never be mentioned again. I was going to take leave of him, when he said that he wished to introduce me to his mother and sister.

He left the room, and came back with them. The mother was a respectable, simple-looking woman, but the daughter was a perfect beauty; she literally dazzled me. After a few minutes, the over-trustful mother begged leave to retire, and her daughter remained. In less than half an hour I was captivated; her perfection delighted me; her lively wit, her artless reasoning, her candour, her ingenuousness, her natural and noble feelings, her cheerful and innocent quickness, that harmony which arises from beauty, wit, and innocence, and which had always the most powerful influence over me—everything in fact conspired to make me the slave of the most perfect woman that the wildest dreams could imagine.

Mdlle. C—— C—— never went out without her mother who, although very pious, was full of kind indulgence. She read no books but her father's—a serious man who had no novels in his library, and she was longing to read some tales of romance. She had likewise a great wish to know Venice, and as no one visited the family she had never been told that she was truly a prodigy of beauty. Her brother was writing while I conversed with her, or rather answered all the questions which she addressed to me, and which I could only satisfy by developing the ideas that she already had, and that she was herself amazed to find in her own mind, for her soul had until then been unconscious of its own powers. Yet I did not tell her that she was lovely and that she interested me in the highest degree, because I had so often said the same to other women, and without truth, that I was afraid of raising her suspicions.

I left the house with a sensation of dreamy sadness; feeling deeply moved by the rare qualities I had discovered in that charming girl, I promised myself not to see her again, for I hardly thought myself the man to sacrifice my liberty entirely and to ask her in marriage, although I certainly believed her endowed with all the qualities necessary to minister to my happiness.

I had not seen Madame Manzoni since my return to Venice, and I went to pay her a visit. I found the worthy woman the same as she had always been towards me, and she gave me the most affectionate welcome. She told me that Therese Imer, that pretty girl who had caused M. de Malipiero to strike me thirteen years before, had just returned from Bayreuth, where the margrave had made her fortune. As she lived in the house opposite, Madame Manzoni, who wanted to enjoy her surprise, sent her word to come over. She came almost immediately, holding by the hand a little boy of eight years—a lovely child—and the only one she had given to her husband, who was a dancer in Bayreuth. Our surprise at seeing one another again was equal to the pleasure we experienced in recollecting what had occurred in our young days; it is true that we had but trifles to recollect. I congratulated her upon her good fortune, and judging of my position from external appearances, she thought it right to congratulate me, but her fortune would have been established on a firmer basis than mine if she had followed a prudent line of conduct. She unfortunately indulged in numerous caprices with which my readers will become acquainted. She was an excellent musician, but her fortune was not altogether owing to her talent; her charms had done more for her than anything else. She told me her adventures, very likely with some restrictions, and we parted after a conversation of two hours. She invited me to breakfast for the following day. She told me that the margrave had her narrowly watched, but being an old acquaintance I was not likely to give rise to any

suspicion; that is the aphorism of all women addicted to gallantry. She added that I could, if I liked, see her that same evening in her box, and that M. Papafava, who was her god-father, would be glad to see me. I called at her house early the next morning, and I found her in bed with her son, who, thanks to the principles in which he had been educated, got up and left the room as soon as he saw me seated near his mother's bed. I spent three hours with her, and I recollect that the last was delightful; the reader will know the consequence of that pleasant hour later. I saw her a second time during the fortnight she passed in Venice, and when she left I promised to pay her a visit in Bayreuth, but I never kept my promise.

I had at that time to attend to the affairs of my posthumous brother, who had, as he said, a call from Heaven to the priesthood, but he wanted a patrimony. Although he was ignorant and devoid of any merit save a handsome face, he thought that an ecclesiastical career would insure his happiness, and he depended a great deal upon his preaching, for which, according to the opinion of the women with whom he was acquainted, he had a decided talent. I took everything into my hands, and I succeeded in obtaining for him a patrimony from M. Grimani, who still owed us the value of the furniture in my father's house, of which he had never rendered any account. He transferred to him a life-interest in a house in Venice, and two years afterwards my brother was ordained. But the patrimony was only fictitious, the house being already mortgaged; the Abbe Grimani was, however, a kind Jesuit, and those sainted servants of God think that all is well that ends well and profitably to themselves. I shall speak again of my unhappy brother whose destiny became involved with mine.

Two days had passed since I had paid my visit to P—— C——, when I met him in the street. He told me that his sister was constantly speaking of me, that she quoted a great many things which I had told her, and that his mother was much pleased at her daughter having made my acquaintance. "She would be a good match for you," he added, "for she will have a dowry of ten thousand ducats. If you will call on me to-morrow, we will take coffee with my mother and sister."

I had promised myself never again to enter his house, but I broke my word. It is easy enough for a man to forget his promises under such circumstances.

I spent three hours in conversation with the charming girl and when I left her I was deeply in love. As I went away, I told her that I envied the destiny of the man who would have her for his wife, and my compliment, the first she had ever received, made her blush.

After I had left her I began to examine the nature of my feelings towards her, and they frightened me, for I could neither behave towards Mdlle. C——C—— as an honest man nor as a libertine. I could not hope to obtain her hand, and I almost fancied I would stab anyone who advised me to seduce her. I felt that I wanted some diversion: I went to the gaming-table. Playing is sometimes an excellent lenitive to calm the mind, and to smother the ardent fire of love. I played with wonderful luck, and I was going home with plenty of gold, when in a solitary narrow street I met a man bent down less by age than by the heavy weight of misery. As I came near him I recognized Count Bonafede, the sight of whom moved me with pity. He recognized me likewise. We talked for some time, and at last he told me the state of abject poverty to which he was reduced, and the great difficulty he had to keep his numerous family. "I do not blush," he added, "in begging from you one sequin which will keep us alive for five or six days." I immediately gave him ten, trying to prevent him from lowering himself in his anxiety to express his gratitude, but I could not prevent him from shedding tears. As we parted, he told me that what made him most miserable was to see the position of his daughter, who had become a great beauty, and would rather die than make a sacrifice of her virtue. "I can neither support her in those feelings," he said, with a sigh, "nor reward her for them."

Thinking that I understood the wishes with which misery had inspired him, I took his address, and promised to pay him a visit. I was curious to see what had become of a virtue of which I did not entertain a very high opinion. I called the next day. I found a house almost bare of furniture, and the daughter alone—a circumstance which did not astonish me. The young countess had seen me arrive, and received me on the stairs in the most amiable manner. She was pretty well dressed, and I thought her handsome, agreeable, and lively, as she had been when I made her acquaintance in Fort St. Andre. Her father having announced my visit, she was in high spirits, and she kissed me with as much tenderness as if I had been a beloved lover. She took me to her own room, and after she had informed me that her mother was ill in bed and unable to see me, she gave way again to the transport of joy which, as she said, she felt in seeing me again. The ardour of our mutual kisses, given at first under the auspices of friendship, was not long in exciting our senses to such an extent that in less than a quarter of an hour I had nothing more to desire. When it was all over, it became us both, of course, to be, or at least to appear to be, surprised at what had taken place, and I could not honestly hesitate to assure the poor countess that it was only the first token of a constant and true love. She believed it, or she feigned to believe it,

and perhaps I myself fancied it was true—for the moment. When we had become calm again, she told me the fearful state to which they were reduced, her brothers walking barefooted in the streets, and her father having positively no bread to give them.

"Then you have not any lover?"

"What? a lover! Where could I find a man courageous enough to be my lover in such a house as this? Am I a woman to sell myself to the first comer for the sum of thirty sous? There is not a man in Venice who would think me worth more than that, seeing me in such a place as this. Besides, I was not born for prostitution."

Such a conversation was not very cheerful; she was weeping, and the spectacle of her sadness, joined to the picture of misery which surrounded me, was not at all the thing to excite love. I left her with a promise to call again, and I put twelve sequins in her hand. She was surprised at the amount; she had never known herself so rich before. I have always regretted I did not give her twice as much.

The next day P—— C—— called on me, and said cheerfully that his mother had given permission to her daughter to go to the opera with him, that the young girl was delighted because she had never been there before, and that, if I liked, I could wait for them at some place where they would meet me.

"But does your sister know that you intend me to join you?"

"She considers it a great pleasure."

"Does your mother know it?"

"No; but when she knows it she will not be angry, for she has a great esteem for you."

"In that case I will try to find a private box."

"Very well; wait for us at such a place."

The scoundrel did not speak of his letters of exchange again, and as he saw that I was no longer paying my attentions to his mistress, and that I was in love with his sister, he had formed the fine project of selling her to me. I pitied the mother and the daughter who had confidence in such a man; but I had not the courage to resist the temptation. I even went so far as to persuade myself that as I loved her it was my duty to accept the offer, in order to save her from other snares; for if I had declined her brother might have found some other man less scrupulous, and I could not bear the idea. I thought that in my company her innocence ran no risk.

I took a box at the St. Samuel Opera, and I was waiting for them at the appointed place long before the time. They came at last, and the sight of my

young friend delighted me. She was elegantly masked, and her brother wore his uniform. In order not to expose the lovely girl to being recognized on account of her brother, I made them get into my gondola. He insisted upon being landed near the house of his mistress, who was ill, he said, and he added that he would soon join us in our box. I was astonished that C—— C—— did not shew any surprise or repugnance at remaining alone with me in the gondola; but I did not think the conduct of her brother extraordinary, for it was evident that it was all arranged beforehand in his mind.

I told C—— C—— that we would remain in the gondola until the opening of the theatre, and that as the heat was intense she would do well to take off her mask, which she did at once. The law I had laid upon myself to respect her, the noble confidence which was beaming on her countenance and in her looks, her innocent joy—everything increased the ardour of my love.

Not knowing what to say to her, for I could speak to her of nothing but love—and it was a delicate subject—I kept looking at her charming face, not daring to let my eyes rest upon two budding globes shaped by the Graces, for fear of giving the alarm to her modesty. "Speak to me," she said at last; "you only look at me without uttering a single word. You have sacrificed yourself for me, because my brother would have taken you with him to his lady-love, who, to judge from what he says, must be as beautiful as an angel."

"I have seen that lady."

"I suppose she is very witty."

"She may be so; but I have no opportunity of knowing, for I have never visited her, and I do not intend ever to call upon her. Do not therefore imagine, beautiful C—— C——, that I have made the slightest sacrifice for your sake."

"I was afraid you had, because as you did not speak I thought you were sad."

"If I do not speak to you it is because I am too deeply moved by your angelic confidence in me."

"I am very glad it is so; but how could I not trust you? I feel much more free, much more confident with you than with my brother himself. My mother says it is impossible to be mistaken, and that you are certainly an honest man. Besides, you are not married; that is the first thing I asked my brother. Do you recollect telling me that you envied the fate of the man who would have me for his wife? Well, at that very moment I was thinking that your wife would be the happiest woman in Venice."

These words, uttered with the most candid artlessness, and with that tone of sincerity which comes from the heart, had upon me an effect which it

would be difficult to describe; I suffered because I could not imprint the most loving kiss upon the sweet lips which had just pronounced them, but at the same time it caused me the most delicious felicity to see that such an angel loved me.

"With such conformity of feelings," I said, "we would, lovely C——, be perfectly happy, if we could be united for ever. But I am old enough to be your father."

"You my father? You are joking! Do you know that I am fourteen?"

"Do you know that I am twenty-eight?"

"Well, where can you see a man of your age having a daughter of mine? If my father were like you, he would certainly never frighten me; I could not keep anything from him."

The hour to go to the theatre had come; we landed, and the performance engrossed all her attention. Her brother joined us only when it was nearly over; it had certainly been a part of his calculation. I took them to an inn for supper, and the pleasure I experienced in seeing the charming girl eat with a good appetite made me forget that I had had no dinner. I hardly spoke during the supper, for love made me sick, and I was in a state of excitement which could not last long. In order to excuse my silence, I feigned to be suffering from the toothache.

After supper, P—— C—— told his sister that I was in love with her, and that I should certainly feel better if she would allow me to kiss her. The only answer of the innocent girl was to offer me her laughing lips, which seemed to call for kisses. I was burning; but my respect for that innocent and naive young creature was such that I only kissed her cheek, and even that in a manner very cold in appearance.

"What a kiss!" exclaimed P—— C——. "Come, come, a good lover's kiss!"

I did not move; the impudent fellow annoyed me; but his sister, turning her head aside sadly, said,

"Do not press him; I am not so happy as to please him."

That remark gave the alarm to my love; I could no longer master my feelings.

"What!" I exclaimed warmly, "what! beautiful C——, you do not condescend to ascribe my reserve to the feeling which you have inspired me with? You suppose that you do not please me? If a kiss is all that is needed to prove the contrary to you, oh! receive it now with all the sentiment that is burning in my heart!"

Then folding her in my arms, and pressing her lovingly against my breast, I imprinted on her mouth the long and ardent kiss which I had so much

wished to give her; but the nature of that kiss made the timid dove feel that she had fallen into the vulture's claws. She escaped from my arms, amazed at having discovered my love in such a manner. Her brother expressed his approval, while she replaced her mask over her face, in order to conceal her confusion. I asked her whether she had any longer any doubts as to my love.

"You have convinced me," she answered, "but, because you have undeceived me, you must not punish me."

I thought that this was a very delicate answer, dictated by true sentiment; but her brother was not pleased with it, and said it was foolish.

We put on our masks, left the inn, and after I had escorted them to their house I went home deeply in love, happy in my inmost soul, yet very sad.

The reader will learn in the following chapters the progress of my love and the adventures in which I found myself engaged.

CHAPTER XII

Progress of My Intrigue with the Beautiful C. C.

The next morning P—— C—— called on me with an air of triumph; he told me that his sister had confessed to her mother that we loved one another, and that if she was ever to be married she would be unhappy with any other husband.

"I adore your sister," I said to him; "but do you think that your father will be willing to give her to me?"

"I think not; but he is old. In the mean time, love one another. My mother has given her permission to go to the opera this evening with us."

"Very well, my dear friend, we must go."

"I find myself under the necessity of claiming a slight service at your hands."

"Dispose of me."

"There is some excellent Cyprus wine to be sold very cheap, and I can obtain a cask of it against my bill at six months. I am certain of selling it again immediately with a good profit; but the merchant requires a guarantee, and he is disposed to accept yours, if you will give it. Will you be kind enough to endorse my note of hand?"

"With pleasure."

I signed my name without hesitation, for where is the man in love who in such a case would have refused that service to a person who to revenge himself might have made him miserable? We made an appointment for the evening, and parted highly pleased with each other.

After I had dressed myself, I went out and bought a dozen pairs of gloves, as many pairs of silk stockings, and a pair of garters embroidered in gold and with gold clasps, promising myself much pleasure in offering that first present to my young friend.

I need not say that I was exact in reaching the appointed place, but they were there already, waiting for me. Had I not suspected the intentions of P—— C——, their coming so early would have been very flattering to my vanity. The moment I had joined them, P—— C—— told me that, having other engagements to fulfil, he would leave his sister with me, and meet us at the theatre in the evening. When he had gone, I told C—— C—— that we would sail in a gondola until the opening of the theatre.

"No," she answered, "let us rather go to the Zuecca Garden."

"With all my heart."

I hired a gondola and we went to St. Blaze, where I knew a very pretty garden which, for one sequin, was placed at my disposal for the remainder of the day, with the express condition that no one else would be allowed admittance. We had not had any dinner, and after I had ordered a good meal we went up to a room where we took off our disguises and masks, after which we went to the garden.

My lovely C—— C—— had nothing on but a bodice made of light silk and a skirt of the same description, but she was charming in that simple costume! My amorous looks went through those light veils, and in my imagination I saw her entirely naked! I sighed with burning desires, with a mixture of discreet reserve and voluptuous love.

The moment we had reached the long avenue, my young companion, as lively as a fawn, finding herself at liberty on the green sward, and enjoying that happy freedom for the first time in her life, began to run about and to give way to the spirit of cheerfulness which was natural to her. When she was compelled to stop for want of breath, she burst out laughing at seeing me gazing at her in a sort of ecstatic silence. She then challenged me to run a race; the game was very agreeable to me. I accepted, but I proposed to make it interesting by a wager.

"Whoever loses the race," I said, "shall have to do whatever the winner asks."

"Agreed!"

We marked the winning-post, and made a fair start. I was certain to win, but I lost on purpose, so as to see what she would ask me to do. At first she ran with all her might while I reserved my strength, and she was the first to reach the goal. As she was trying to recover her breath, she thought of sentencing me to a good penance: she hid herself behind a tree and told me, a minute afterwards, that I had to find her ring. She had concealed it about her, and that was putting me in possession of all her person. I thought it was a delightful forfeit, for I could easily see that she had chosen it with intentional mischief; but I felt that I ought not to take too much advantage of her, because her artless confidence required to be encouraged. We sat on the grass, I visited her pockets, the folds of her stays, of her petticoat; then I looked in her shoes, and even at her garters which were fastened below the knees. Not finding anything, I kept on my search, and as the ring was about her, I was of course bound to discover it. My reader has most likely guessed that I had some suspicion of the charming hiding-place in which the young beauty had concealed the ring, but before coming to it I wanted to enjoy myself. The ring was at last found between the two most beautiful keepers

that nature had ever rounded, but I felt such emotion as I drew it out that my hand was trembling.

"What are you trembling for?" she asked.

"Only for joy at having found the ring; you had concealed it so well! But you owe me a revenge, and this time you shall not beat me."

"We shall see."

We began a new race, and seeing that she was not running very fast, I thought I could easily distance her whenever I liked. I was mistaken. She had husbanded her strength, and when we had run about two-thirds of the race she suddenly sprang forward at full speed, left me behind, and I saw that I had lost. I then thought of a trick, the effect of which never fails; I feigned a heavy fall, and I uttered a shriek of pain. The poor child stopped at once, ran back to me in great fright, and, pitying me, she assisted me to raise myself from the ground. The moment I was on my feet again, I laughed heartily and, taking a spring forward, I had reached the goal long before her.

The charming runner, thoroughly amazed, said to me,

"Then you did not hurt yourself?"

"No, for I fell purposely."

"Purposely? Oh, to deceive me! I would never have believed you capable of that. It is not fair to win by fraud; therefore I have not lost the race."

"Oh! yes, you have, for I reached the goal before you."

"Trick for trick; confess that you tried to deceive me at the start."

"But that is fair, and your trick is a very different thing."

"Yet it has given me the victory, and

"Vincasi per fortund o per ingano,
Il vincer sempre fu laudabil cosa"...

"I have often heard those words from my brother, but never from my father. Well, never mind, I have lost. Give your judgment now, I will obey."

"Wait a little. Let me see. Ah! my sentence is that you shall exchange your garters for mine."

"Exchange our garters! But you have seen mine, they are ugly and worth nothing."

"Never mind. Twice every day I shall think of the person I love, and as nearly as possible at the same hours you will have to think of me."

"It is a very pretty idea, and I like it. Now I forgive you for having deceived me. Here are my ugly garters! Ah! my dear deceiver, how beautiful yours are! What a handsome present! How they will please my mother! They must be a present which you have just received, for they are quite new."

"No, they have not been given to me. I bought them for you, and I have been racking my brain to find how I could make you accept them. Love suggested to me the idea of making them the prize of the race. You may now imagine my sorrow when I saw that you would win. Vexation inspired me with a deceitful stratagem which arose from a feeling you had caused yourself, and which turned entirely to your honour, for you must admit that you would have shewn a very hard heart if you had not come to my assistance."

"And I feel certain that you would not have had recourse to that stratagem, if you could have guessed how deeply it would pain me."

"Do you then feel much interest in me?"

"I would do anything in the world to convince you of it. I like my pretty garters exceedingly; I will never have another pair, and I promise you that my brother shall not steal them from me."

"Can you suppose him capable of such an action?"

"Oh! certainly, especially if the fastenings are in gold."

"Yes, they are in gold; but let him believe that they are in gilt brass."

"Will you teach me how to fasten my beautiful garters?"

"Of course I will."

We went upstairs, and after our dinner which we both enjoyed with a good appetite, she became more lively and I more excited by love, but at the same time more to be pitied in consequence of the restraint to which I had condemned myself. Very anxious to try her garters, she begged me to help her, and that request was made in good faith, without mischievous coquetry. An innocent young girl, who, in spite of her fifteen years, has not loved yet, who has not frequented the society of other girls, does not know the violence of amorous desires or what is likely to excite them. She has no idea of the danger of a tete-a-tete. When a natural instinct makes her love for the first time, she believes the object of her love worthy of her confidence, and she thinks that to be loved herself she must shew the most boundless trust.

Seeing that her stockings were too short to fasten the garter above the knee, she told me that she would in future use longer ones, and I immediately offered her those that I had purchased. Full of gratitude she sat on my knees, and in the effusion of her satisfaction she bestowed upon me all the kisses that she would have given to her father if he had made her such a present. I returned her kisses, forcibly keeping down the violence of my feelings. I only told her that one of her kisses was worth a kingdom. My charming C——— C——— took off her shoes and stockings, and put on one of the pairs I had given her, which went halfway up her thigh. The more innocent I found her

to be, the less I could make up my mind to possess myself of that ravishing prey.

We returned to the garden, and after walking about until the evening we went to the opera, taking care to keep on our masks, because, the theatre being small, we might easily have been recognized, and my lovely friend was certain that her father would not allow her to come out again, if he found out that she had gone to the opera.

We were rather surprised not to see her brother. On our left we had the Marquis of Montalegre, the Spanish ambassador, with his acknowledged mistress, Mdlle. Bola, and in the box on our right a man and a woman who had not taken off their masks. Those two persons kept their eyes constantly fixed upon us, but my young friend did not remark it as her back was turned towards them. During the ballet, C—— C—— having left the libretto of the opera on the ledge of the box, the man with the mask stretched forth his hand and took it. That proved to me that we were known to him, and I said so to my companion, who turned round and recognized her brother. The lady who was with him could be no other than Madame C——. As P—— C—— knew the number of our box, he had taken the next one; he could not have done so without some intention, and I foresaw that he meant to make his sister have supper with that woman. I was much annoyed, but I could not prevent it without breaking off with him, altogether, and I was in love.

After the second ballet, he came into our box with his lady, and after the usual exchange of compliments the acquaintance was made, and we had to accept supper at his casino. As soon as the two ladies had thrown off their masks, they embraced one another, and the mistress of P—— C—— overwhelmed my young friend with compliments and attentions. At table she affected to treat her with extreme affability, and C—— C—— not having any experience of the world behaved towards her with the greatest respect. I could, however, see that C——, in spite of all her art, could hardly hide the vexation she felt at the sight of the superior beauty which I had preferred to her own charms. P—— C——, who was of an extravagant gaiety, launched forth in stupid jokes at which his mistress alone laughed; in my anger, I shrugged my shoulders, and his sister, not understanding his jests, took no notice of them. Altogether our 'partie caree' was not formed of congenial spirits, and was rather a dull affair.

As the dessert was placed on the table, P—— C——, somewhat excited by the wine he had drunk, kissed his lady-love, and challenged me to follow his example with his sister. I told him that I loved Mdlle. C—— C—— truly, and that I would not take such liberties with her until I should have acquired a

legal right to her favours. P—— C—— began to scoff at what I had said, but C—— stopped him. Grateful for that mark of propriety, I took out of my pocket the twelve pairs of gloves which I had bought in the morning, and after I had begged her acceptance of half a dozen pairs I gave the other six to my young friend. P—— C—— rose from the table with a sneer, dragging along with him his mistress, who had likewise drunk rather freely, and he threw himself on a sofa with her. The scene taking a lewd turn, I placed myself in such a manner as to hide them from the view of my young friend, whom I led into the recess of a window. But I had not been able to prevent C—— C—— from seeing in a looking-glass the position of the two impudent wretches, and her face was suffused with blushes; I, however, spoke to her quietly of indifferent things, and recovering her composure she answered me, speaking of her gloves, which she was folding on the pier-table. After his brutal exploit, P—— C—— came impudently to me and embraced me; his dissolute companion, imitating his example, kissed my young friend, saying she was certain that she had seen nothing. C—— C—— answered modestly that she did not know what she could have seen, but the look she cast towards me made me understand all she felt. If the reader has any knowledge of the human heart, he must guess what my feelings were. How was it possible to endure such a scene going on in the presence of an innocent girl whom I adored, when I had to fight hard myself with my own burning desires so as not to abuse her innocence! I was on a bed of thorns! Anger and indignation, restrained by the reserve I was compelled to adopt for fear of losing the object of my ardent love, made me tremble all over. The inventors of hell would not have failed to place that suffering among its torments, if they had known it. The lustful P—— C—— had thought of giving me a great proof of his friendship by the disgusting action he had been guilty of, and he had reckoned as nothing the dishonour of his mistress, and the delicacy of his sister whom he had thus exposed to prostitution. I do not know how I contrived not to strangle him. The next day, when he called on me, I overwhelmed him with the most bitter reproaches, and he tried to excuse himself by saying that he never would have acted in that manner if he had not felt satisfied that I had already treated his sister in the tete-a-tete in the same way that he treated his mistress before us.

My love for C—— C—— became every instant more intense, and I had made up my mind to undertake everything necessary to save her from the fearful position in which her unworthy brother might throw her by selling her for his own profit to some man less scrupulous than I was. It seemed to me urgent. What a disgusting state of things! What an unheard-of species of

seduction! What a strange way to gain my friendship! And I found myself under the dire necessity of dissembling with the man whom I despised most in the world! I had been told that he was deeply in debt, that he had been a bankrupt in Vienna, where he had a wife and a family of children, that in Venice he had compromised his father who had been obliged to turn him out of his house, and who, out of pity, pretended not to know that he had kept his room in it. He had seduced his wife, or rather his mistress, who had been driven away by her husband, and after he had squandered everything she possessed, and he found himself at the end of his wits, he had tried to turn her prostitution to advantage. His poor mother who idolized him had given him everything she had, even her own clothes, and I expected him to plague me again for some loan or security, but I was firmly resolved on refusing. I could not bear the idea of C—— C—— being the innocent cause of my ruin, and used as a tool by her brother to keep up his disgusting life.

Moved by an irresistible feeling, by what is called perfect love, I called upon P—— C—— on the following day, and, after I had told him that I adored his sister with the most honourable intentions, I tried to make him realize how deeply he had grieved me by forgetting all respect, and that modesty which the most inveterate libertine ought never to insult if he has any pretension to be worthy of respectable society.

"Even if I had to give up," I added, "the pleasure of seeing your angelic sister, I have taken the firm resolution of not keeping company with you; but I candidly warn you that I will do everything in my power to prevent her from going out with you, and from being the victim of some infamous bargain in your hands."

He excused himself again by saying that he had drunk too much, and that he did not believe that my love for his sister was such as to despise the gratification of my senses. He begged my pardon, he embraced me with tears in his eyes, and I would, perhaps have given way to my own emotion, when his mother and sister entered the room. They offered me their heart-felt thanks for the handsome present I had given to the young lady. I told the mother that I loved her daughter, and that my fondest hope was to obtain her for my wife.

"In the hope of securing that happiness, madam," I added, "I shall get a friend to speak to your husband as soon as I shall have secured a position giving me sufficient means to keep her comfortably, and to assure her happiness."

So saying I kissed her hand, and I felt so deeply moved that the tears ran down my cheeks. Those tears were sympathetic, and the excellent woman was

soon crying like me. She thanked me affectionately, and left me with her daughter and her son, who looked as if he had been changed into a statue.

There are a great many mothers of that kind in the world, and very often they are women who have led a virtuous life; they do not suppose that deceit can exist, because their own nature understands only what is upright and true; but they are almost always the victims of their good faith, and of their trust in those who seem to them to be patterns of honesty. What I had told the mother surprised the daughter, but her astonishment was much greater when she heard of what I had said to her brother. After one moment of consideration, she told him that, with any other man but me, she would have been ruined; and that, if she had been in the place of Madame C——, she would never have forgiven him, because the way he had treated her was as debasing for her as for himself. P—— C—— was weeping, but the traitor could command tears whenever he pleased.

It was Whit Sunday, and as the theatres were closed he told me that, if I would be at the same place of Appointment as before, the next day, he would leave his sister with me, and go by himself with Madame C——, whom he could not honourably leave alone.

"I will give you my key," he added, "and you can bring back my sister here as soon as you have supper together wherever you like."

And he handed me his key, which I had not the courage to refuse. After that he left us. I went away myself a few minutes afterwards, having previously agreed with C—— C—— that we would go to the Zuecca Garden on the following day.

I was punctual, and love exciting me to the highest degree I foresaw what would happen on that day. I had engaged a box at the opera, and we went to our garden until the evening. As it was a holiday there were several small parties of friends sitting at various tables, and being unwilling to mix with other people we made up our minds to remain in the apartment which was given to us, and to go to the opera only towards the end of the performance. I therefore ordered a good supper. We had seven hours to spend together, and my charming young friend remarked that the time would certainly not seem long to us. She threw off her disguise and sat on my knees, telling me that I had completed the conquest of her heart by my reserve towards her during the supper with her brother; but all our conversation was accompanied by kisses which, little by little, were becoming more and more ardent.

"Did you see," she said to me, "what my brother did to Madame C—— when she placed herself astride on his knees? I only saw it in the looking-glass, but I could guess what it was."

"Were you not afraid of my treating you in the same manner?"

"No, I can assure you. How could I possibly fear such a thing, knowing how much you love me? You would have humiliated me so deeply that I should no longer have loved you. We will wait until we are married, will we not, dear? You cannot realize the extent of the joy I felt when I heard you speak to my mother as you did! We will love each other for ever. But will you explain to me, dearest, the meaning of the words embroidered upon my garters?"

"Is there any motto upon them? I was not aware of it."

"Oh, yes! it is in French; pray read it."

Seated on my knees, she took off one of her garters while I was unclasping the other, and here are the two lines which I found embroidered on them, and which I ought to have read before offering them to her:

'En voyant chaque jour le bijou de ma belle,
Vous lui direz qu'Amour veut qu'il lui soit fidele.'

Those verses, rather free I must confess, struck me as very comic. I burst out laughing, and my mirth increased when, to please her, I had to translate their meaning. As it was an idea entirely new to her, I found it necessary to enter into particulars which lighted an ardent fire in our veins.

"Now," she observed, "I shall not dare to shew my garters to anybody, and I am very sorry for it."

As I was rather thoughtful, she added,

"Tell me what you are thinking of?"

"I am thinking that those lucky garters have a privilege which perhaps I shall never enjoy. How I wish myself in their place: I may die of that wish, and die miserable."

"No, dearest, for I am in the same position as you, and I am certain to live. Besides, we can hasten our marriage. As far as I am concerned, I am ready to become your wife to-morrow if you wish it. We are both free, and my father cannot refuse his consent."

"You are right, for he would be bound to consent for the sake of his honour. But I wish to give him a mark of my respect by asking for your hand, and after that everything will soon be ready. It might be in a week or ten days."

"So soon? You will see that my father will say that I am too young."

"Perhaps he is right."

"No; I am young, but not too young, and I am certain that I can be your wife."

I was on burning coals, and I felt that it was impossible for me to resist any longer the ardent fire which was consuming me.

"Oh, my best beloved!" I exclaimed, "do you feel certain of my love? Do you think me capable of deceiving you? Are you sure that you will never repent being my wife?"

"More than certain, darling; for you could not wish to make me unhappy."

"Well, then, let our marriage take place now. Let God alone receive our mutual pledges; we cannot have a better witness, for He knows the purity of our intentions. Let us mutually engage our faith, let us unite our destinies and be happy. We will afterwards legalize our tender love with your father's consent and with the ceremonies of the Church; in the mean time be mine, entirely mine."

"Dispose of me, dearest. I promise to God, I promise to you that, from this very moment and for ever, I will be your faithful wife; I will say the same to my father, to the priest who will bless our union—in fact, to everybody."

"I take the same oath towards you, darling, and I can assure you that we are now truly married. Come to my arms! Oh, dearest, complete my felicity!"

"Oh, dear! am I indeed so near happiness!"

After kissing her tenderly, I went down to tell the mistress of the house not to disturb us, and not to bring up our dinner until we called for it. During my short absence, my charming C—— C—— had thrown herself dressed on the bed, but I told her that the god of love disapproved of unnecessary veils, and in less than a minute I made of her a new Eve, beautiful in her nakedness as if she had just come out of the hands of the Supreme Artist. Her skin, as soft as satin, was dazzlingly white, and seemed still more so beside her splendid black hair which I had spread over her alabaster shoulders. Her slender figure, her prominent hips, her beautifully-modelled bosom, her large eyes, from which flashed the sparkle of amorous desire, everything about her was strikingly beautiful, and presented to my hungry looks the perfection of the mother of love, adorned by all the charms which modesty throws over the attractions of a lovely woman.

Beside myself, I almost feared lest my felicity should not prove real, or lest it should not be made perfect by complete enjoyment, when mischievous love contrived, in so serious a moment, to supply me with a reason for mirth.

"Is there by any chance a law to prevent the husband from undressing himself?" enquired beautiful C—— C——.

"No, darling angel, no; and even if there were such a barbarous law, I would not submit to it."

In one instant, I had thrown off all my garments, and my mistress, in her turn, gave herself up to all the impulse of natural instinct and curiosity, for every part of my body was an entirely new thing to her. At last, as if she had

had enough of the pleasure her eyes were enjoying, she pressed me against her bosom, and exclaimed,

"Oh! dearest, what a difference between you and my pillow!"

"Your pillow, darling? You are laughing; what do you mean?"

"Oh! it is nothing but a childish fancy; I am afraid you will be angry."

"Angry! How could I be angry with you, my love, in the happiest moment of my life?"

"Well, for several days past, I could not go to sleep without holding my pillow in my arms; I caressed it, I called it my dear husband; I fancied it was you, and when a delightful enjoyment had left me without movement, I would go to sleep, and in the morning find my pillow still between my arms."

My dear C—— C—— became my wife with the courage of a true heroine, for her intense love caused her to delight even in bodily pain. After three hours spent in delicious enjoyment, I got up and called for our supper. The repast was simple, but very good. We looked at one another without speaking, for how could we find words to express our feelings? We thought that our felicity was extreme, and we enjoyed it with the certainty that we could renew it at will.

The hostess came up to enquire whether we wanted anything, and she asked if we were not going to the opera, which everybody said was so beautiful.

"Have you never been to the opera?"

"Never, because it is too dear for people in our position. My daughter has such a wish to go, that, God forgive me for saying it! she would give herself, I truly believe, to the man who would take her there once."

"That would be paying very dear for it," said my little wife, laughing. "Dearest, we could make her happy at less cost, for that hurts very much."

"I was thinking of it, my love. Here is the key of the box, you can make them a present of it."

"Here is the key of a box at the St. Moses Theatre," she said to the hostess; "it costs two sequins; go instead of us, and tell your daughter to keep her rose-bud for something better."

"To enable you to amuse yourself, my good woman; take these two sequins," I added. "Let your daughter enjoy herself well."

The good hostess, thoroughly amazed at the generosity of her guests, ran in a great hurry to her daughter, while we were delighted at having laid ourselves under the pleasant necessity of again going to bed. She came up with her daughter, a handsome, tempting blonde, who insisted upon kissing the hands of her benefactors.

"She is going this minute with her lover," said the mother. "He is waiting for her; but I will not let her go alone with him, for he is not to be trusted; I am going with them."

"That is right, my good woman; but when you come back this evening, let the gondola wait for us; it will take us to Venice."

"What! Do you mean to remain here until we return?"

"Yes, for this is our wedding-day."

"To-day? God bless you!"

She then went to the bed, to put it to rights, and seeing the marks of my wife's virginity she came to my dear C—— C—— and, in her joy, kissed her, and immediately began a sermon for the special benefit of her daughter, shewing her those marks which, in her opinion, did infinite honour to the young bride: respectable marks, she said, which in our days the god of Hymen sees but seldom on his altar.

The daughter, casting down her beautiful blue eyes, answered that the same would certainly be seen on her wedding-day.

"I am certain of it," said the mother, "for I never lose sight of thee. Go and get some water in this basin, and bring it here. This charming bride must be in need of it."

The girl obeyed. The two women having left us, we went to bed, and four hours of ecstatic delights passed off with wonderful rapidity. Our last engagement would have lasted longer, if my charming sweetheart had not taken a fancy to take my place and to reverse the position. Worn out with happiness and enjoyment, we were going to sleep, when the hostess came to tell us that the gondola was waiting for us. I immediately got up to open the door, in the hope that she would amuse us with her description of the opera; but she left that task to her daughter, who had come up with her, and she went down again to prepare some coffee for us. The young girl assisted my sweetheart to dress, but now and then she would wink at me in a manner which made me think that she had more experience than her mother imagined.

Nothing could be more indiscreet than the eyes of my beloved mistress; they wore the irrefutable marks of her first exploits. It is true that she had just been fighting a battle which had positively made her a different being to what she was before the engagement.

We took some hot coffee, and I told our hostess to get us a nice dinner for the next day; we then left in the gondola. The dawn of day was breaking when we landed at St. Sophia's Square, in order to set the curiosity of the gondoliers at fault, and we parted happy, delighted, and certain that we were

thoroughly married. I went to bed, having made up my mind to compel M. de Bragadin, through the power of the oracle, to obtain legally for me the hand of my beloved C—— C——. I remained in bed until noon, and spent the rest of the day in playing with ill luck, as if Dame Fortune had wished to warn me that she did not approve of my love.

CHAPTER XIII

Continuation of My Intrigues with C. C.—M. de Bragadin Asks
the Hand of That Young Person for Me—Her Father Refuses,
and Sends Her to a Convent—De la Haye—I Lose All my Money
at the Faso-table—My Partnership with Croce Replenishes My
Purse—Various Incidents

The happiness derived from my love had prevented me from attaching any importance to my losses, and being entirely engrossed with the thought of my sweetheart my mind did not seem to care for whatever did not relate to her.

I was thinking of her the next morning when her brother called on me with a beaming countenance, and said,

"I am certain that you have slept with my sister, and I am very glad of it. She does not confess as much, but her confession is not necessary. I will bring her to you to-day."

"You will oblige me, for I adore her, and I will get a friend of mine to ask her in marriage from your father in such a manner that he will not be able to refuse."

"I wish it may be so, but I doubt it. In the mean time, I find myself compelled to beg another service from your kindness. I can obtain, against a note of hand payable in six months, a ring of the value of two hundred sequins, and I am certain to sell it again this very day for the same amount. That sum, is very necessary to me just now, but the jeweller, who knows you, will not let me have it without your security. Will you oblige me in this instance? I know that you lost a great deal last night; if you want some money I will give you one hundred sequins, which you will return when the note of hand falls due."

How could I refuse him? I knew very well that I would be duped, but I loved his sister so much:

"I am ready," said I to him, "to sign the note of hand, but you are wrong in abusing my love for your sister in such a manner."

We went out, and the jeweller having accepted my security the bargain was completed. The merchant, who knew me only by name, thinking of paying me a great compliment, told P—— C—— that with my guarantee all his goods were at his service. I did not feel flattered by the compliment, but I thought I could see in it the knavery of P—— C——, who was clever enough to find out, out of a hundred, the fool who without any reason placed confidence in

me when I possessed nothing. It was thus that my angelic C—— C——, who seemed made to insure my happiness, was the innocent cause of my ruin.

At noon P—— C—— brought his sister; and wishing most likely to prove its honesty—for a cheat always tries hard to do that—he gave me back the letter of exchange which I had endorsed for the Cyprus wine, assuring me likewise that at our next meeting he would hand me the one hundred sequins which he had promised me.

I took my mistress as usual to Zuecca; I agreed for the garden to be kept closed, and we dined under a vine-arbour. My dear C—— C—— seemed to me more beautiful since she was mine, and, friendship being united to love we felt a delightful sensation of happiness which shone on our features. The hostess, who had found me generous, gave us some excellent game and some very fine fish; her daughter served us. She also came to undress my little wife as soon as we had gone upstairs to give ourselves up to the sweet pleasures natural to a young married couple.

When we were alone my loved asked me what was the meaning of the one hundred sequins which her brother had promised to bring me, and I told her all that had taken place between him and me.

"I entreat you, darling," she said to me, "to refuse all the demands of my brother in future; he is, unfortunately, in such difficulties that he would at the end drag you down to the abyss into which he must fall"

This time our enjoyment seemed to us more substantial; we relished it with a more refined delight, and, so to speak, we reasoned over it.

"Oh, my best beloved!" she said to me, "do all in your power to render me pregnant; for in that case my father could no longer refuse his consent to my marriage, under the pretext of my being too young."

It was with great difficulty that I made her understand that the fulfilment of that wish, however much I shared it myself, was not entirely in our power; but that, under the circumstances, it would most probably be fulfilled sooner or later.

After working with all our might at the completion of that great undertaking, we gave several hours to a profound and delightful repose. As soon as we were awake I called for candles and coffee, and we set to work again in the hope of obtaining the mutual harmony of ecstatic enjoyment which was necessary to insure our future happiness. It was in the midst of our loving sport that the too early dawn surprised us, and we hurried back to Venice to avoid inquisitive eyes.

We renewed our pleasures on the Friday, but, whatever delight I may feel now in the remembrance of those happy moments, I will spare my readers the

description of my new enjoyment, because they might not feel interested in such repetitions. I must therefore only say that, before parting on that day, we fixed for the following Monday, the last day of the carnival, our last meeting in the Garden of Zuecca. Death alone could have hindered me from keeping that appointment, for it was to be the last opportunity of enjoying our amorous sport.

On the Monday morning I saw P—— C——, who confirmed the appointment for the same hour, and at the place previously agreed upon, and I was there in good time. In spite of the impatience of a lover, the first hour of expectation passes rapidly, but the second is mortally long. Yet the third and the fourth passed without my seeing my beloved mistress. I was in a state of fearful anxiety; I imagined the most terrible disasters. It seemed to me that if C—— C—— had been unable to go out her brother ought to have come to let me know it.

But some unexpected mishap might have detained him, and I could not go and fetch her myself at her house, even if I had feared nothing else than to miss them on the road. At last, as the church bells were tolling the Angelus, C—— C—— came alone, and masked.

"I was certain," she said, "that you were here, and here I am in spite of all my mother could say. You must be starving. My brother has not put in an appearance through the whole of this day. Let us go quickly to our garden, for I am very hungry too, and love will console us for all we have suffered today."

She had spoken very rapidly, and without giving me time to utter a single word; I had nothing more to ask her. We went off, and took a gondola to our garden. The wind was very high, it blew almost a hurricane, and the gondola having only one rower the danger was great. C—— C——, who had no idea of it, was playing with me to make up for the restraint under which she had been all day; but her movements exposed the gondolier to danger; if he had fallen into the water, nothing could have saved us, and we would have found death on our way to pleasure. I told her to keep quiet, but, being anxious not to frighten her, I dared not acquaint her with the danger we were running. The gondolier, however, had not the same reasons for sparing her feelings, and he called out to us in a stentorian voice that, if we did not keep quiet, we were all lost. His threat had the desired effect, and we reached the landing without mishap. I paid the man generously, and he laughed for joy when he saw the money for which he was indebted to the bad weather.

We spent six delightful hours in our casino; this time sleep was not allowed to visit us. The only thought which threw a cloud over our felicity was that, the carnival being over, we did not know how to contrive our future meetings.

We agreed, however, that on the following Wednesday morning I should pay a visit to her brother, and that she would come to his room as usual.

We took leave of our worthy hostess, who, entertaining no hope of seeing us again, expressed her sorrow and overwhelmed us with blessings. I escorted my darling, without any accident, as far as the door of her house, and went home.

I had just risen at noon, when to my great surprise I had a visit from De la Haye with his pupil Calvi, a handsome young man, but the very copy of his master in everything. He walked, spoke, laughed exactly like him; it was the same language as that of the Jesuits correct but rather harsh French. I thought that excess of imitation perfectly scandalous, and I could not help telling De la Haye that he ought to change his pupil's deportment, because such servile mimicry would only expose him to bitter raillery. As I was giving him my opinion on that subject, Bavois made his appearance, and when he had spent an hour in the company of the young man he was entirely of the same mind. Calvi died two or three years later. De la Haye, who was bent upon forming pupils, became, two or three months after Calvi's death, the tutor of the young Chevalier de Morosini, the nephew of the nobleman to whom Bavois was indebted for his rapid fortune, who was then the Commissioner of the Republic to settle its boundaries with the Austrian Government represented by Count Christiani.

I was in love beyond all measure, and I would not postpone an application on which my happiness depended any longer. After dinner, and as soon as everybody had retired, I begged M. de Bragadin and his two friends to grant me an audience of two hours in the room in which we were always inaccessible. There, without any preamble, I told them that I was in love with C—— C——, and determined on carrying her off if they could not contrive to obtain her from her father for my wife. "The question at issue," I said to M. de Bragadin, "is how to give me a respectable position, and to guarantee a dowry of ten thousand ducats which the young lady would bring me." They answered that, if Paralis gave them the necessary instructions, they were ready to fulfil them. That was all I wanted. I spent two hours in forming all the pyramids they wished, and the result was that M. de Bragadin himself would demand in my name the hand of the young lady; the oracle explaining the reason of that choice by stating that it must be the same person who would guarantee the dowry with his own fortune. The father of my mistress being then at his country-house, I told my friends that they would have due notice of his return, and that they were to be all three together when M. de Bragadin demanded the young lady's hand.

Well pleased with what I had done, I called on P—— C—— the next morning. An old woman, who opened the door for me, told me that he was not at home, but that his mother would see me. She came immediately with her daughter, and they both looked very sad, which at once struck me as a bad sign. C—— C—— told me that her brother was in prison for debt, and that it would be difficult to get him out of it because his debts amounted to a very large sum. The mother, crying bitterly, told me how deeply grieved she was at not being able to support him in the prison, and she shewed me the letter he had written to her, in which he requested her to deliver an enclosure to his sister. I asked C—— C—— whether I could read it; she handed it to me, and I saw that he begged her to speak to me in his behalf. As I returned it to her, I told her to write to him that I was not in a position to do anything for him, but I entreated the mother to accept twenty-five sequins, which would enable her to assist him by sending him one or two at a time. She made up her mind to take them only when her daughter joined her entreaties to mine.

After this painful scene I gave them an account of what I had done in order to obtain the hand of my young sweetheart. Madame C——thanked me, expressed her appreciation of my honourable conduct, but she told me not to entertain any hope, because her husband, who was very stubborn in his ideas, had decided that his daughter should marry a merchant, and not before the age of eighteen. He was expected home that very day. As I was taking leave of them, my mistress contrived to slip in my hand a letter in which she told me that I could safely make use of the key which I had in my possession, to enter the house at midnight, and that I would find her in her brother's room. This news made me very happy, for, notwithstanding all the doubts of her mother, I hoped for success in obtaining her hand.

When I returned home, I told M. de Bragadin of the expected arrival of the father of my charming C—— C——, and the kind old man wrote to him immediately in my presence. He requested him to name at what time he might call on him on important business. I asked M. de Bragadin not to send his letter until the following day.

The reader can very well guess that C—— C—— had not to wait for me long after midnight. I gained admittance without any difficulty, and I found my darling, who received me with open arms.

"You have nothing to fear," she said to me; "my father has arrived in excellent health, and everyone in the house is fast asleep."

"Except Love," I answered, "which is now inviting us to enjoy ourselves. Love will protect us, dearest, and to-morrow your father will receive a letter from my worthy protector."

At those words C—— C—— shuddered. It was a presentiment of the future.

She said to me,

"My father thinks of me now as if I were nothing but a child; but his eyes are going to be opened respecting me; he will examine my conduct, and God knows what will happen! Now, we are happy, even more than we were during our visits to Zuecca, for we can see each other every night without restraint. But what will my father do when he hears that I have a lover?"

"What can he do? If he refuses me your hand, I will carry you off, and the patriarch would certainly marry us. We shall be one another's for life"

"It is my most ardent wish, and to realize it I am ready to do anything; but, dearest, I know my father."

We remained two hours together, thinking less of our pleasures than of our sorrow; I went away promising to see her again the next night. The whole of the morning passed off very heavily for me, and at noon M. de Bragadin informed me that he had sent his letter to the father, who had answered that he would call himself on the following day to ascertain M. de Bragadin's wishes. At midnight I saw my beloved mistress again, and I gave her an account of all that had transpired. C—— C—— told me that the message of the senator had greatly puzzled her father, because, as he had never had any intercourse with that nobleman, he could not imagine what he wanted with him. Uncertainty, a sort of anxious dread, and a confused hope, rendered our enjoyment much less lively during the two hours which we spent together. I had no doubt that M. Ch. C—— the father of my young friend, would 'go home immediately after his interview with M. de Bragadin, that he would ask his daughter a great many questions, and I feared lest C—— C——, in her trouble and confusion, should betray herself. She felt herself that it might be so, and I could see how painfully anxious she was. I was extremely uneasy myself, and I suffered much because, not knowing how her father would look at the matter, I could not give her any advice. As a matter of course, it was necessary for her to conceal certain circumstances which would have prejudiced his mind against us; yet it was urgent to tell him the truth and to shew herself entirely submissive to his will. I found myself placed in a strange position, and above all, I regretted having made the all-important application, precisely because it was certain to have too decisive a result. I longed to get out of the state of indecision in which I was, and I was surprised to see my

young mistress less anxious than I was. We parted with heavy hearts, but with the hope that the next night would again bring us together, for the contrary did not seem to us possible.

The next day, after dinner, M. Ch. C—— called upon M. de Bragadin, but I did not shew myself. He remained a couple of hours with my three friends, and as soon as he had gone I heard that his answer had been what the mother had told me, but with the addition of a circumstance most painful to me—namely, that his daughter would pass the four years which were to elapse, before she could think of marriage, in a convent. As a palliative to his refusal he had added, that, if by that time I had a well-established position in the world, he might consent to our wedding.

That answer struck me as most cruel, and in the despair in which it threw me I was not astonished when the same night I found the door by which I used to gain admittance to C—— C—— closed and locked inside.

I returned home more dead than alive, and lost twenty-four hours in that fearful perplexity in which a man is often thrown when he feels himself bound to take a decision without knowing what to decide. I thought of carrying her off, but a thousand difficulties combined to prevent the execution of that scheme, and her brother was in prison. I saw how difficult it would be to contrive a correspondence with my wife, for I considered C—— C—— as such, much more than if our marriage had received the sanction of the priest's blessing or of the notary's legal contract.

Tortured by a thousand distressing ideas, I made up my mind at last to pay a visit to Madame C——. A servant opened the door, and informed me that madame had gone to the country; she could not tell me when she was expected to return to Venice. This news was a terrible thunder-bolt to me; I remained as motionless as a statue; for now that I had lost that last resource I had no means of procuring the slightest information.

I tried to look calm in the presence of my three friends, but in reality I was in a state truly worthy of pity, and the reader will perhaps realize it if I tell him that in my despair I made up my mind to call on P—— C—— in his prison, in the hope that he might give me some information.

My visit proved useless; he knew nothing, and I did not enlighten his ignorance. He told me a great many lies which I pretended to accept as gospel, and giving him two sequins I went away, wishing him a prompt release.

I was racking my brain to contrive some way to know the position of my mistress—for I felt certain it was a fearful one—and believing her to be

unhappy I reproached myself most bitterly as the cause of her misery. I had reached such a state of anxiety that I could neither eat nor sleep.

Two days after the refusal of the father, M. de Bragadin and his two friends went to Padua for a month. I had not had the heart to go with them, and I was alone in the house. I needed consolation and I went to the gaming-table, but I played without attention and lost a great deal. I had already sold whatever I possessed of any value, and I owed money everywhere. I could expect no assistance except from my three kind friends, but shame prevented me from confessing my position to them. I was in that disposition which leads easily to self-destruction, and I was thinking of it as I was shaving myself before a toilet-glass, when the servant brought to my room a woman who had a letter for me. The woman came up to me, and, handing me the letter, she said,

"Are you the person to whom it is addressed?"

I recognized at once a seal which I had given to C——— C———; I thought I would drop down dead. In order to recover my composure, I told the woman to wait, and tried to shave myself, but my hand refused to perform its office. I put the razor down, turned my back on the messenger, and opening the letter I read the following lines,

"Before I can write all I have to say, I must be sure of my messenger. I am boarding in a convent, and am very well treated, and I enjoy excellent health in spite of the anxiety of my mind. The superior has been instructed to forbid me all visitors and correspondence. I am, however, already certain of being able to write to you, notwithstanding these very strict orders. I entertain no doubt of your good faith, my beloved husband, and I feel sure that you will never doubt a heart which is wholly yours. Trust to me for the execution of whatever you may wish me to do, for I am yours and only yours. Answer only a few words until we are quite certain of our messenger.

"Muran, June 12th."

In less than three weeks my young friend had become a clever moralist; it is true that Love had been her teacher, and Love alone can work miracles. As I concluded the reading of her letter, I was in the state of a criminal pardoned at the foot of the scaffold. I required several minutes before I recovered the exercise of my will and my presence of mind.

I turned towards the messenger, and asked her if she could read.

"Ah, sir! if I could not read, it would be a great misfortune for me. There are seven women appointed for the service of the nuns of Muran. One of us comes in turn to Venice once a week; I come every Wednesday, and this day

week I shall be able to bring you an answer to the letter which, if you like, you can write now."

"Then you can take charge of the letters entrusted to you by the nuns?"

"That is not supposed to be one of our duties but the faithful delivery of letters being the most important of the commissions committed to our care, we should not be trusted if we could not read the address of the letters placed in our hands. The nuns wanted to be sure that we shall not give to Peter the letter addressed to Paul. The good mothers are always afraid of our being guilty of such blunders. Therefore I shall be here again, without fail, this day week at the same hour, but please to order your servant to wake you in case you should be asleep, for our time is measured as if it were gold. Above all, rely entirely upon my discretion as long as you employ me; for if I did not know how to keep a silent tongue in my head I should lose my bread, and then what would become of me—a widow with four children, a boy eight years old, and three pretty girls, the eldest of whom is only sixteen? You can see them when you come to Muran. I live near the church, on the garden side, and I am always at home when I am not engaged in the service of the nuns, who are always sending me on one commission or another. The young lady—I do not know her name yet, for she has only been one week with us—gave me this letter, but so cleverly! Oh! she must be as witty as she is pretty, for three nuns who were there were completely bamboozled. She gave it to me with this other letter for myself, which I likewise leave in your hands. Poor child! she tells me to be discreet! She need not be afraid. Write to her, I entreat you, sir, that she can trust me, and answer boldly. I would not tell you to act in the same manner with all the other messengers of the convent, although I believe them to be honest—and God forbid I should speak ill of my fellow-creature—but they are all ignorant, you see; and it is certain that they babble, at least, with their confessors, if with nobody else. As for me, thank God! I know very well that I need not confess anything but my sins, and surely to carry a letter from a Christian woman to her brother in Christ is not a sin. Besides, my confessor is a good old monk, quite deaf, I believe, for the worthy man never answers me; but that is his business, not mine!"

I had not intended to ask her any questions, but if such had been my intention she would not have given me time to carry it into execution; and without my asking her anything, she was telling me everything I cared to know, and she did so in her anxiety for me to avail myself of her services exclusively.

I immediately sat down to write to my dear recluse, intending at first to write only a few lines, as she had requested me; but my time was too short to

write so little. My letter was a screed of four pages, and very likely it said less than her note of one short page. I told her her letter had saved my life, and asked her whether I could hope to see her. I informed her that I had given a sequin to the messenger, that she would find another for herself under the seal of my letter, and that I would send her all the money she might want. I entreated her not to fail writing every Wednesday, to be certain that her letters would never be long enough to give me full particulars, not only of all she did, of all she was allowed to do, but also of all her thoughts respecting her release from imprisonment, and the overcoming of all the obstacles which were in the way of our mutual happiness; for I was as much hers as she was mine. I hinted to her the necessity of gaining the love of all the nuns and boarders, but without taking them into her confidence, and of shewing no dislike of her convent life. After praising her for the clever manner in which she had contrived to write to me, in spite of superior orders, I made her understand how careful she was to be to avoid being surprised while she was writing, because in such a case her room would certainly be searched and all her papers seized.

"Burn all my letters, darling," I added, "and recollect that you must go to confession often, but without implicating our love. Share with me all your sorrows, which interest me even more than your joys."

I sealed my letter in such a manner that no one could possibly guess that there was a sequin hidden under the sealing wax, and I rewarded the woman, promising her that I would give her the same reward every time that she brought me a letter from my friend. When she saw the sequin which I had put in her hand the good woman cried for joy, and she told me that, as the gates of the convent were never closed for her, she would deliver my letter the moment she found the young lady alone.

Here is the note which C—— C—— had given to the woman, with the letter addressed to me:

"God Himself, my good woman, prompts me to have confidence in you rather than in anybody else. Take this letter to Venice, and should the person to whom it is addressed not be in the city, bring it back to me. You must deliver it to that person himself, and if you find him you will most likely have an answer, which you must give me, but only when you are certain that nobody can see you."

If Love is imprudent, it is only in the hope of enjoyment; but when it is necessary to bring back happiness destroyed by some untoward accident, Love foresees all that the keenest perspicacity could possibly find out. The letter of my charming wife overwhelmed me with joy, and in one moment I passed

from a state of despair to that of extreme felicity. I felt certain that I should succeed in carrying her off even if the walls of the convent could boast of artillery, and after the departure of the messenger my first thought was to endeavour to spend the seven days, before I could receive the second letter, pleasantly. Gambling alone could do it, but everybody had gone to Padua. I got my trunk ready, and immediately sent it to the burchiello then ready to start, and I left for Frusina. From that place I posted, and in less than three hours I arrived at the door of the Bragadin Palace, where I found my dear protector on the point of sitting down to dinner. He embraced me affectionately, and seeing me covered with perspiration he said to me,

"I am certain that you are in no hurry."

"No," I answered, "but I am starving."

I brought joy to the brotherly trio, and I enhanced their happiness when I told my friends that I would remain six days with them. De la Haye dined with us on that day; as soon as dinner was over he closeted himself with M. Dandoio, and for two hours they remained together. I had gone to bed during that time, but M. Dandolo came up to me and told me that I had arrived just in time to consult the oracle respecting an important affair entirely private to himself. He gave me the questions, and requested me to find the answers. He wanted to know whether he would act rightly if he accepted a project proposed to him by De la Haye.

The oracle answered negatively.

M. Dandolo, rather surprised, asked a second question: he wished Paralis to give his reasons for the denial.

I formed the cabalistic pile, and brought out this answer:

"I asked Casanova's opinion, and as I find it opposed to the proposal made by De la Haye, I do not wish to hear any more about it."

Oh! wonderful power of self-delusion! This worthy man, pleased at being able to throw the odium of a refusal on me, left me perfectly satisfied. I had no idea of the nature of the affair to which he had been alluding, and I felt no curiosity about it; but it annoyed me that a Jesuit should interfere and try to make my friends do anything otherwise than through my instrumentality, and I wanted that intriguer to know that my influence was greater than his own.

After that, I dressed, masked myself, and went to the opera, where I sat down to a faro-table and lost all my money. Fortune was determined to shew me that it does not always agree with love. My heart was heavy, I felt miserable; I went to bed. When I woke in the morning, I saw De la Haye come into my room with a beaming countenance, and, assuming an air of

devoted friendship, he made a great show of his feelings towards me. I knew what to think of it all, and I waited for the 'denouement'.

"My dear friend," he said to me at last, "why did you dissuade M. Dandolo from doing what I had insinuated to him?"

"What had you insinuated to him?"

"You know well enough."

"If I knew it, I would not ask you"

"M. Dandolo himself told me that you had advised him against it."

"Advised against, that may be, but certainly not dissuaded, for if he had been persuaded in his own mind he would not have asked my advice."

"As you please; but may I enquire your reasons?"

"Tell me first what your proposal was."

"Has he not told you?"

"Perhaps he has; but if you wish to know my reasons, I must hear the whole affair from your own lips, because M. Dandolo spoke to me under a promise of secrecy."

"Of what good is all this reserve?"

"Everyone has his own principles and his own way of thinking: I have a sufficiently good opinion of you to believe that you would act exactly as I do, for I have heard you say that in all secret matters one ought to guard against surprise."

"I am incapable of taking such an advantage of a friend; but as a general rule your maxim is a right one; I like prudence. I will tell you the whole affair. You are aware that Madame Tripolo has been left a widow, and that M. Dandolo is courting her assiduously, after having done the same for fourteen years during the life of the husband. The lady, who is still young, beautiful and lovely, and also is very respectable, wishes to become his wife. It is to me that she has confided her wishes, and as I saw nothing that was not praiseworthy, either in a temporal or in a spiritual point of view, in that union, for after all we are all men, I took the affair in hand with real pleasure. I fancied even that M. Dandolo felt some inclination for that marriage when he told me that he would give me his decision this morning. I am not astonished at his having asked your advice in such an important affair, for a prudent man is right in asking the opinion of a wise friend before taking a decisive step; but I must tell you candidly that I am astonished at your disapproval of such a marriage. Pray excuse me if, in order to improve by the information, I ask why your opinion is exactly the reverse of mine."

Delighted at having discovered the whole affair, at having arrived in time to prevent my friend who was goodness itself contracting an absurd marriage,

I answered the hypocrite that I loved M. Dandolo, that I knew his temperament, and that I was certain that a marriage with a woman like Madame Tripolo would shorten his life.

"That being my opinion," I added, "you must admit that as a true friend I was right in advising him against your proposal. Do you recollect having told me that you never married for the very same reason? Do you recollect your strong arguments in favour of celibacy while we were at Parma? Consider also, I beg, that every man has a certain small stock of selfishness, and that I may be allowed to have mine when I think that if M. Dandolo took a wife the influence of that wife would of course have some weight, and that the more she gained in influence over him the more I should lose. So you see it would not be natural for me to advise him to take a step which would ultimately prove very detrimental to my interests. If you can prove that my reasons are either trifling or sophistical, speak openly: I will tell M. Dandolo that my mind has changed; Madame Tripolo will become his wife when we return to Venice. But let me warn you that thorough conviction can alone move me."

"I do not believe myself clever enough to convince you. I shall write to Madame Tripolo that she must apply to you."

"Do not write anything of the sort to that lady, or she will think that you are laughing at her. Do you suppose her foolish enough to expect that I will give way to her wishes? She knows that I do not like her."

"How can she possibly know that?"

"She must have remarked that I have never cared to accompany M. Dandolo to her house. Learn from me once for all, that as long as I live with my three friends they shall have no wife but me. You may get married as soon as you please; I promise not to throw any obstacle in your way; but if you wish to remain on friendly terms with me give up all idea of leading my three friends astray."

"You are very caustic this morning."

"I lost all my money last night.

"Then I have chosen a bad time. Farewell."

From that day, De la Haye became my secret enemy, and to him I was in a great measure indebted, two years later, for my imprisonment under The Leads of Venice; not owing to his slanders, for I do not believe he was capable of that, Jesuit though he was—and even amongst such people there is sometimes some honourable feeling—but through the mystical insinuations which he made in the presence of bigoted persons. I must give fair notice to my readers that, if they are fond of such people, they must not read these

Memoirs, for they belong to a tribe which I have good reason to attack unmercifully.

The fine marriage was never again alluded to. M. Dandolo continued to visit his beautiful widow every day, and I took care to elicit from Paralis a strong interdiction ever to put my foot in her house.

Don Antonio Croce, a young Milanese whom I had known in Reggio, a confirmed gambler, and a downright clever hand in securing the favours of Dame Fortune, called on me a few minutes after De la Haye had retired. He told me that, having seen me lose all my money the night before, he had come to offer me the means of retrieving my losses, if I would take an equal interest with him in a faro bank that he meant to hold at his house, and in which he would have as punters seven or eight rich foreigners who were courting his wife.

"If you will put three hundred sequins in my bank," he added, "you shall be my partner. I have three hundred sequins myself, but that is not enough because the punters play high. Come and dine at my house, and you will make their acquaintance. We can play next Friday as there will be no opera, and you may rely upon our winning plenty of gold, for a certain Gilenspetz, a Swede, may lose twenty thousand sequins."

I was without any resources, or at all events I could expect no assistance except from M. de Bragadin upon whom I felt ashamed of encroaching. I was well aware that the proposal made by Croce was not strictly moral, and that I might have chosen a more honourable society; but if I had refused, the purse of Madame Croce's admirers would not have been more mercifully treated; another would have profited by that stroke of good fortune. I was therefore not rigid enough to refuse my assistance as adjutant and my share of the pie; I accepted Croce's invitation.

CHAPTER XIV

I Get Rich Again—My Adventure At Dolo—Analysis of a Long
Letter From C. C.—Mischievous Trick Played Upon Me By P.
C.—At Vincenza—A Tragi-comedy At the Inn

Necessity, that imperious law and my only excuse, having made me almost
the partner of a cheat, there was still the difficulty of finding the three
hundred sequins required; but I postponed the task of finding them until after
I should have made the acquaintance of the dupes of the goddess to whom
they addressed their worship. Croce took me to the Prato delta Valle, where
we found madame surrounded with foreigners. She was pretty; and as a
secretary of the imperial ambassador, Count Rosemberg, had attached himself
to her, not one of the Venetian nobles dared court her. Those who interested
me among the satellites gravitating around that star were the Swede
Gilenspetz, a Hamburger, the Englishman Mendez, who has already been
mentioned, and three or four others to whore Croce called my attention.

We dined all together, and after dinner there was a general call for a faro
bank; but Croce did not accept. His refusal surprised me, because with three
hundred sequins, being a very skilful player, he had enough to try his fortune.
He did not, however, allow my suspicions to last long, for he took me to his
own room and shewed me fifty pieces of eight, which were equal to three
hundred sequins. When I saw that the professional gambler had not chosen
me as his partner with the intention of making a dupe of me, I told him that
I would certainly procure the amount, and upon that promise he invited
everybody to supper for the following day. We agreed that we would divide
the spoils before parting in the evening, and that no one should be allowed
to play on trust.

I had to procure the amount, but to whom could I apply? I could ask no
one but M. de Bragadin. The excellent man had not that sum in his
possession, for his purse was generally empty; but he found a usurer—a
species of animal too numerous unfortunately for young men—who, upon a
note of hand endorsed by him, gave me a thousand ducats, at five per cent.
for one month, the said interest being deducted by anticipation from the
capital. It was exactly the amount I required. I went to the supper; Croce held
the bank until daylight, and we divided sixteen hundred sequins between us.
The game continued the next evening, and Gilenspetz alone lost two
thousand sequins; the Jew Mendez lost about one thousand. Sunday was
sanctified by rest, but on Monday the bank won four thousand sequins. On

the Tuesday we all dined together, and the play was resumed; but we had scarcely begun when an officer of the podesta made his appearance and informed Croce that he wanted a little private conversation with him. They left the room together, and after a short absence Croce came back rather crestfallen; he announced that by superior orders he was forbidden to hold a bank at his house. Madame fainted away, the punters hurried out, and I followed their example, as soon as I had secured one-half of the gold which was on the table. I was glad enough it was not worse. As I left, Croce told me that we would meet again in Venice, for he had been ordered to quit Padua within twenty-four hours. I expected it would be so, because he was to well known; but his greatest crime, in the opinion of the podesta, was that he attracted the players to his own house, whilst the authorities wanted all the lovers of play to lose their money at the opera, where the bankers were mostly noblemen from Venice.

I left the city on horseback in the evening and in very bad weather, but nothing could have kept me back, because early the next morning I expected a letter from my dear prisoner. I had only travelled six miles from Padua when my horse fell, and I found my left leg caught under it. My boots were soft ones, and I feared I had hurt myself. The postillion was ahead of me, but hearing the noise made by the fall he came up and disengaged me; I was not hurt, but my horse was lame. I immediately took the horse of the postillion, to which I was entitled, but the insolent fellow getting hold of the bit refused to let me proceed. I tried to make him understand that he was wrong; but, far from giving way to my arguments, he persisted in stopping me, and being in a great hurry to continue my journey I fired one of my pistols in his face, but without touching him. Frightened out of his wits, the man let go, and I galloped off. When I reached the Dolo, I went straight to the stables, and I myself saddled a horse which a postillion, to whom I gave a crown, pointed out to me as being excellent. No one thought of being astonished at my other postillion having remained behind, and we started at full speed. It was then one o'clock in the morning; the storm had broken up the road, and the night was so dark that I could not see anything within a yard ahead of me; the day was breaking when we arrived in Fusina.

The boatmen threatened me with a fresh storm; but setting everything at defiance I took a four-oared boat, and reached my dwelling quite safe but shivering with cold and wet to the skin. I had scarcely been in my room for a quarter of an hour when the messenger from Muran presented herself and gave me a letter, telling me that she would call for the answer in two hours.

That letter was a journal of seven pages, the faithful translation of which might weary my readers, but here is the substance of it:

After the interview with M. de Bragadin, the father of C—— C—— had gone home, had his wife and daughter to his room, and enquired kindly from the last where she had made my acquaintance. She answered that she had seen me five or six times in her brother's room, that I had asked her whether she would consent to be my wife, and that she had told me that she was dependent upon her father and mother. The father had then said that she was too young to think of marriage, and besides, I had not yet conquered a position in society. After that decision he repaired to his son's room, and locked the small door inside as well as the one communicating with the apartment of the mother, who was instructed by him to let me believe that she had gone to the country, in case I should call on her.

Two days afterwards he came to C—— C——, who was beside her sick mother, and told her that her aunt would take her to a convent, where she was to remain until a husband had been provided for her by her parents. She answered that, being perfectly disposed to submit to his will, she would gladly obey him. Pleased with her ready obedience he promised to go and see her, and to let his mother visit her likewise, as soon as her health was better. Immediately after that conversation the aunt had called for her, and a gondola had taken them to the convent, where she had been ever since. Her bed and her clothes had been brought to her; she was well pleased with her room and with the nun to whom she had been entrusted, and under whose supervision she was. It was by her that she had been forbidden to receive either letters or visits, or to write to anybody, under penalty of excommunication from the Holy Father, of everlasting damnation, and of other similar trifles; yet the same nun had supplied her with paper, ink and books, and it was at night that my young friend transgressed the laws of the convent in order to write all these particulars to me. She expressed her conviction respecting the discretion and the faithfulness of the messenger, and she thought that she would remain devoted, because, being poor, our sequins were a little fortune for her.

She related to me in the most assuring manner that the handsomest of all the nuns in the convent loved her to distraction, gave her a French lesson twice a-day, and had amicably forbidden her to become acquainted with the other boarders. That nun was only twenty-two years of age; she was beautiful, rich and generous; all the other nuns shewed her great respect. "When we are alone," wrote my friend, "she kisses me so tenderly that you would be jealous if she were not a woman." As to our project of running away, she did not

think it would be very difficult to carry it into execution, but that it would be better to wait until she knew the locality better. She told me to remain faithful and constant, and asked me to send her my portrait hidden in a ring by a secret spring known only to us. She added that I might send it to her by her mother, who had recovered her usual health, and was in the habit of attending early mass at her parish church every day by herself. She assured me that the excellent woman would be delighted to see me, and to do anything I might ask her. "At all events," she concluded, "I hope to find myself in a few months in a position which will scandalize the convent if they are obstinately bent upon keeping me here."

I was just finishing my answer when Laura, the messenger, returned for it. After I had paid the sequin I had promised her, I gave her a parcel containing sealing-wax, paper, pens, and a tinder-box, which she promised to deliver to C—— C——. My darling had told her that I was her cousin, and Laura feigned to believe it.

Not knowing what to do in Venice, and believing that I ought for the sake of my honour to shew myself in Padua, or else people might suppose that I had received the same order as Croce, I hurried my breakfast, and procured a 'bolletta' from the booking-office for Rome; because I foresaw that the firing of my pistol and the lame horse might not have improved the temper of the post-masters; but by shewing them what is called in Italy a 'bolletta', I knew that they could not refuse to supply me with horses whenever they had any in their stables. As far as the pistol-shot was concerned I had no fear, for I had purposely missed the insolent postillion; and even if I had killed him on the spot it would not have been of much importance.

In Fusina I took a two-wheeled chaise, for I was so tired that I could not have performed the journey on horseback, and I reached the Dolo, where I was recognized and horses were refused me.

I made a good deal of noise, and the post-master, coming out, threatened to have me arrested if I did not pay him for his dead horse. I answered that if the horse were dead I would account for it to the postmaster in Padua, but what I wanted was fresh horses without delay.

And I shewed him the dread 'bolletta', the sight of which made him lower his tone; but he told me that, even if he supplied me with horses, I had treated the postillion so badly that not one of his men would drive me. "If that is the case," I answered, "you shall accompany me yourself." The fellow laughed in my face, turned his back upon me, and went away. I took two witnesses, and I called with them at the office of a public notary, who drew up a properly-worded document, by which I gave notice to the post-master that

I should expect an indemnity of ten sequins for each hour of delay until I had horses supplied to me.

As soon as he had been made acquainted with the contents of this, he gave orders to bring out two restive horses. I saw at once that his intention was to have me upset along the road, and perhaps thrown into the river; but I calmly told the postillion that at the very moment my chaise was upset I would blow his brains out with a pistol-shot; this threat frightened the man; he took his horses back to the stables, and declared to his master that he would not drive me. At that very moment a courier arrived, who called for six carriage horses and two saddle ones. I warned the post-master that no one should leave the place before me, and that if he opposed my will there would be a sanguinary contest; in order to prove that I was in earnest I took out my pistols. The fellow began to swear, but, everyone saying that he was in the wrong, he disappeared.

Five minutes afterwards whom should I see, arriving in a beautiful berlin drawn by six horses, but Croce with his wife, a lady's maid, and two lackeys in grand livery. He alighted, we embraced one another, and I told him, assuming an air of sadness, that he could not leave before me. I explained how the case stood; he said I was right, scolded loudly, as if he had been a great lord, and made everybody tremble. The postmaster had disappeared; his wife came and ordered the postillions to attend to my wants. During that time Croce said to me that I was quite right in going back to Padua, where the public rumour had spread the report of my having left the city in consequence of an order from the police. He informed me that the podesta had likewise expelled M. de Gondoin, a colonel in the service of the Duke of Modena, because he held a faro bank at his house. I promised him to pay him a visit in Venice in the ensuing week. Croce, who had dropped from the sky to assist me in a moment of great distress, had won ten thousand sequins in four evenings: I had received five thousand for my share; and lost no time in paying my debts and in redeeming all the articles which I had been compelled to pledge. That scamp brought me back the smiles of Fortune, and from that moment I got rid of the ill luck which had seemed to fasten on me.

I reached Padua in safety, and the postillion, who very likely out of fear had driven me in good style, was well pleased with my liberality; it was the best way of making peace with the tribe. My arrival caused great joy to my three friends, whom my sudden departure had alarmed, with the exception of M. de Bragadin, in whose hands I had placed my cash-box the day before. His two friends had given credence to the general report, stating that the podesta had ordered me to leave Padua. They forgot that I was a citizen of Venice,

and that the podesta could not pass such a sentence upon me without exposing himself to legal proceedings. I was tired, but instead of going to bed I dressed myself in my best attire in order to go to the opera without a mask. I told my friends that it was necessary for me to shew myself, so as to give the lie to all that had been reported about me by slandering tongues. De la Haye said to me,

"I shall be delighted if all those reports are false; but you have no one to blame but yourself, for your hurried departure gave sufficient cause for all sorts of surmises."

"And for slander."

"That may be; but people want to know everything, and they invent when they cannot guess the truth."

"And evil-minded fools lose no time in repeating those inventions everywhere."

"But there can be no doubt that you wanted to kill the postillion. Is that a calumny likewise?"

"The greatest of all. Do you think that a good shot can miss a man when he is firing in his very face, unless he does it purposely?"

"It seems difficult; but at all events it is certain that the horse is dead, and you must pay for it."

"No, sir, not even if the horse belonged to you, for the postillion preceded me. You know a great many things; do you happen to know the posting regulations? Besides, I was in a great hurry because I had promised a pretty woman to breakfast with her, and such engagements, as you are well aware, cannot be broken."

Master de la Haye looked angry at the rather caustic irony with which I had sprinkled the dialogue; but he was still more vexed when, taking some gold out of my pocket, I returned to him the sum he had lent me in Vienna. A man never argues well except when his purse is well filled; then his spirits are pitched in a high key, unless he should happen to be stupefied by some passion raging in his soul.

M. de Bragadin thought I was quite right to shew myself at the opera without a mask.

The moment I made my appearance in the pit everybody seemed quite astonished, and I was overwhelmed with compliments, sincere or not. After the first ballet I went to the card-room, and in four deals I won five hundred sequins. Starving, and almost dead for want of sleep, I returned to my friends to boast of my victory. My friend Bavois was there, and he seized the

opportunity to borrow from me fifty sequins, which he never returned; true, I never asked him for them.

My thoughts being constantly absorbed in my dear C—— C——, I spent the whole of the next day in having my likeness painted in miniature by a skilful Piedmontese, who had come for the Fair of Padua, and who in after times made a great deal of money in Venice. When he had completed my portrait he painted for me a beautiful St. Catherine of the same size, and a clever Venetian jeweller made the ring, the bezel of which shewed only the sainted virgin; but a blue spot, hardly visible on the white enamel which surrounded it, corresponded with the secret spring which brought out my portrait, and the change was obtained by pressing on the blue spot with the point of a pin.

On the following Friday, as we were rising from the dinner-table, a letter was handed to me. It was with great surprise that I recognized the writing of P—— C——. He asked me to pay him a visit at the "Star Hotel," where he would give me some interesting information. Thinking that he might have something to say concerning his sister, I went to him at once.

I found him with Madame C——, and after congratulating him upon his release from prison I asked him for the news he had to communicate.

"I am certain," he said, "that my sister is in a convent, and I shall be able to tell you the name of it when I return to Venice."

"You will oblige me," I answered, pretending not to know anything.

But his news had only been a pretext to make me come to him, and his eagerness to communicate it had a very different object in view than the gratification of my curiosity.

"I have sold," he said to me, "my privileged contract for three years for a sum of fifteen thousand florins, and the man with whom I have made the bargain took me out of prison by giving security for me, and advanced me six thousand florins in four letters of exchange."

He shewed me the letters of exchange, endorsed by a name which I did not know, but which he said was a very good one, and he continued,

"I intend to buy six thousand florins worth of silk goods from the looms of Vicenza, and to give in payment to the merchants these letters of exchange. I am certain of selling those goods rapidly with a profit of ten per cent. Come with us to Vicenza; I will give you some of my goods to the amount of two hundred sequins, and thus you will find yourself covered for the guarantee which you have been kind enough to give to the jeweller for the ring. We shall complete the transaction within twenty-four hours."

I did not feel much inclination for the trip, but I allowed myself to be blinded by the wish to cover the amount which I had guaranteed, and which I had no doubt I would be called upon to pay some day or other.

"If I do not go with him," I said to myself "he will sell the goods at a loss of twenty-five per cent., and I shall get nothing."

I promised to accompany him. He shewed me several letters of recommendation for the best houses in Vicenza, and our departure was fixed for early the next morning. I was at the "Star Hotel" by daybreak. A carriage and four was ready; the hotel-keeper came up with his bill, and P—— C—— begged me to pay it. The bill amounted to five sequins; four of which had been advanced in cash by the landlord to pay the driver who had brought them from Fusina. I saw that it was a put-up thing, yet I paid with pretty good grace, for I guessed that the scoundrel had left Venice without a penny. We reached Vicenza in three hours, and we put up at the "Cappello," where P—— C—— ordered a good dinner before leaving me with the lady to call upon the manufacturers.

When the beauty found herself alone with me, she began by addressing friendly reproaches to me.

"I have loved you," she said, "for eighteen years; the first time that I saw you we were in Padua, and we were then only nine years old."

I certainly had no recollection of it. She was the daughter of the antiquarian friend of M. Grimani, who had placed me as a boarder with the accursed Sclavonian woman. I could not help smiling, for I recollected that her mother had loved me.

Shop-boys soon began to make their appearance, bringing pieces of goods, and the face of Madame C—— brightened up. In less than two hours the room was filled with them, and P—— C—— came back with two merchants, whom he had invited to dinner. Madame allured them by her pretty manners; we dined, and exquisite wines were drunk in profusion. In the afternoon fresh goods were brought in; P—— C—— made a list of them with the prices; but he wanted more, and the merchants promised to send them the next day, although it was Sunday. Towards the evening several counts arrived, for in Vicenza every nobleman is a count. P—— C—— had left his letters of recommendation at their houses. We had a Count Velo, a Count Sesso, a Count Trento—all very amiable companions. They invited us to accompany them to the casino, where Madame C—— shone by her charms and her coquettish manners. After we had spent two hours in that place, P—— C—— invited all his new friends to supper, and it was a scene of gaiety and profusion. The whole affair annoyed me greatly, and therefore I was not

amiable; the consequence was that no one spoke to me. I rose from my seat and went to bed, leaving the joyous company still round the festive board. In the morning I came downstairs, had my breakfast, and looked about me. The room was so full of goods that I did not see how P—— C—— could possibly pay for all with his six thousand florins. He told me, however, that his business would be completed on the morrow, and that we were invited to a ball where all the nobility would be present. The merchants with whom he had dealt came to dine with us, and the dinner was remarkable for its extreme profusion.

We went to the ball; but I soon got very weary of it, for every body was speaking to Madame C—— and to P—— C——, who never uttered a word with any meaning, but whenever I opened my lips people would pretend not to hear me. I invited a lady to dance a minuet; she accepted, but she looked constantly to the right or to the left, and seemed to consider me as a mere dancing machine. A quadrille was formed, but the thing was contrived in such a manner as to leave me out of it, and the very lady who had refused me as a partner danced with another gentleman. Had I been in good spirits I should certainly have resented such conduct, but I preferred to leave the ball-room. I went to bed, unable to understand why the nobility of Vicenza treated me in such a way. Perhaps they neglected me because I was not named in the letters of introduction given to P—— C——, but I thought that they might have known the laws of common politeness. I bore the evil patiently, however, as we were to leave the city the next day.

On Monday, the worthy pair being tired, they slept until noon, and after dinner P—— C—— went out to pay for the goods.

We were to go away early on the Tuesday, and I instinctively longed for that moment. The counts whom P—— C—— had invited were delighted with his mistress, and they came to supper; but I avoided meeting them.

On the Tuesday morning I was duly informed that breakfast was ready, but as I did not answer the summons quickly enough the servant came up again, and told me that my wife requested me to make haste. Scarcely had the word "wife" escaped his lips than I visited the cheek of the poor fellow with a tremendous smack, and in my rage kicked him downstairs, the bottom of which he reached in four springs, to the imminent risk of his neck. Maddened with rage I entered the breakfast-room, and addressing myself to P—— C——, I asked him who was the scoundrel who had announced me in the hotel as the husband of Madame C——. He answered that he did not know; but at the same moment the landlord came into the room with a big knife in his hand, and asked me why I had kicked his servant down the stairs. I quickly

drew a pistol, and threatening him with it I demanded imperatively from him the name of the person who had represented me as the husband of that woman.

"Captain P—— C——," answered the landlord, "gave the names, profession, etc., of your party."

At this I seized the impudent villain by the throat, and pinning him against the wall with a strong hand I would have broken his head with the butt of my pistol, if the landlord had not prevented me. Madame had pretended to swoon, for those women can always command tears or fainting fits, and the cowardly P—— C—— kept on saying,

"It is not true, it is not true!"

The landlord ran out to get the hotel register, and he angrily thrust it under the nose of the coward, daring him to deny his having dictated: Captain P—— C——, with M. and Madame Casanova. The scoundrel answered that his words had certainly not been heard rightly, and the incensed landlord slapped the book in his face with such force that he sent him rolling, almost stunned, against the wall.

When I saw that the wretched poltroon was receiving such degrading treatment without remembering that he had a sword hanging by his side, I left the room, and asked the landlord to order me a carriage to take me to Padua.

Beside myself with rage, blushing for very shame, seeing but too late the fault I had committed by accepting the society of a scoundrel, I went up to my room, and hurriedly packed up my carpet-bag. I was just going out when Madame C—— presented herself before me.

"Begone, madam," I said to her, "or, in my rage, I might forget the respect due to your sex."

She threw herself, crying bitterly, on a chair, entreated me to forgive her, assuring me that she was innocent, and that she was not present when the knave had given the names. The landlady, coming in at that moment, vouched for the truth of her assertion. My anger began to abate, and as I passed near the window I saw the carriage I had ordered waiting for me with a pair of good horses. I called for the landlord in order to pay whatever my share of the expense might come to, but he told me that as I had ordered nothing myself I had nothing to pay. Just at that juncture Count Velo came in.

"I daresay, count," I said, "that you believe this woman to be my wife."

"That is a fact known to everybody in the city."

"Damnation! And you have believed such a thing, knowing that I occupy this room alone, and seeing me leave the ball-room and the supper-table yesterday alone, leaving her with you all!"

"Some husbands are blessed with such easy dispositions!"

"I do not think I look like one of that species, and you are not a judge of men of honour, let us go out, and I undertake to prove it to you."

The count rushed down the stairs and out of the hotel. The miserable C—— was choking, and I could not help pitying her; for a woman has in her tears a weapon which through my life I have never known to resist. I considered that if I left the hotel without paying anything, people might laugh at my anger and suppose that I had a share in the swindle; I requested the landlord to bring me the account, intending to pay half of it. He went for it, but another scene awaited me. Madame C——, bathed in tears, fell on her knees, and told me that if I abandoned her she was lost, for she had no money and nothing to leave as security for her hotel bill.

"What, madam! Have you not letters of exchange to the amount of six thousand florins, or the goods bought with them?"

"The goods are no longer here; they have all been taken away, because the letters of exchange, which you saw, and which we considered as good as cash, only made the merchants laugh; they have sent for everything. Oh! who could have supposed it?"

"The scoundrel! He knew it well enough, and that is why he was so anxious to bring me here. Well, it is right that I should pay the penalty of my own folly."

The bill brought by the landlord amounted to forty sequins, a very high figure for three days; but a large portion of that sum was cash advanced by the landlord, I immediately felt that my honour demanded that I should pay the bill in full; and I paid without any hesitation, taking care to get a receipt given in the presence of two witnesses. I then made a present of two sequins to the nephew of the landlord to console him for the thrashing he had received, and I refused the same sum to the wretched C——, who had sent the landlady to beg it for her.

Thus ended that unpleasant adventure, which taught me a lesson, and a lesson which I ought not to have required. Two or three weeks later, I heard that Count Trento had given those two miserable beings some money to enable them to leave the city; as far as I was concerned, I would not have anything to do with them. A month afterwards P—— C—— was again arrested for debt, the man who had been security for him having become a bankrupt. He had the audacity to write a long letter to me, entreating me to go and see him, but I did not answer him. I was quite as inflexible towards

Madame C——, whom I always refused to see. She was reduced to great poverty.

I returned to Padua, where I stopped only long enough to take my ring and to dine with M. de Bragadin, who went back to Venice a few days afterwards.

The messenger from the convent brought me a letter very early in the morning; I devoured its contents; it was very loving, but gave no news. In my answer I gave my dear C—— C—— the particulars of the infamous trick played upon me by her villainous brother, and mentioned the ring, with the secret of which I acquainted her.

According to the information I had received from C—— C——, I placed myself, one morning, so as to see her mother enter the church, into which I followed her. Kneeling close to her, I told her that I wished to speak with her, and she followed me to the cloister. I began by speaking a few consoling words; then I told her that I would remain faithful to her daughter, and I asked her whether she visited her.

"I intend," she said, "to go and kiss my dear child next Sunday, and I shall of course speak of you with her, for I know well enough that she will be delighted to have news of you; but to my great regret I am not at liberty to tell you where she is."

"I do not wish you to tell me, my good mother, but allow me to send her this ring by you. It is the picture of her patroness, and I wish you to entreat her to wear it always on her finger; tell her to look at the image during her daily prayers, for without that protection she can never become my wife. Tell her that, on my side, I address every day a credo to St. James."

Delighted with the piety of my feelings and with the prospect of recommending this new devotion to her daughter, the good woman promised to fulfil my commission. I left her, but not before I had placed in her hand ten sequins which I begged her to force upon her daughter's acceptance to supply herself with the trifles she might require. She accepted, but at the same time she assured me that her father had taken care to provide her with all necessaries. The letter which I received from C—— C——, on the following Wednesday, was the expression of the most tender affection and the most lively gratitude. She said that the moment she was alone nothing could be more rapid than the point of the pin which made St. Catherine cut a somersault, and presented to her eager eyes the beloved features of the being who was the whole world to her. "I am constantly kissing you," she added, "even when some of the nuns are looking at me, for whenever they come near me I have only to let the top part of the ring fall back and my dear patroness takes care to conceal everything. All the nuns are highly pleased with my devotion and with the confidence I have in the protection of my blessed patroness, whom they think very much like me in the face." It was nothing

but a beautiful face created by the fancy of the painter, but my dear little wife was so lovely that beauty was sure to be like her.

She said, likewise, that the nun who taught her French had offered her fifty sequins for the ring on account of the likeness between her and the portrait of the saint, but not out of veneration for her patroness, whom she turned into ridicule as she read her life. She thanked me for the ten sequins I had sent her, because, her mother having given them to her in the presence of several of the sisters, she was thus enabled to spend a little money without raising the suspicions of those curious and inquisitive nuns. She liked to offer trifling presents to the other boarders, and the money allowed her to gratify that innocent taste.

"My mother," added she, "praised your piety very highly; she is delighted with your feelings of devotion. Never mention again, I beg, the name of my unworthy brother."

For five or six weeks her letters were full of the blessed St. Catherine, who caused her to tremble with fear every time she found herself compelled to trust the ring to the mystic curiosity of the elderly nuns, who, in order to see the likeness better through their spectacles, brought it close to their eyes, and rubbed the enamel. "I am in constant fear," C—— C—— wrote, "of their pressing the invisible blue spot by chance. What would become of me, if my patroness, jumping up, discovered to their eyes a face—very divine, it is true, but which is not at all like that of a saint? Tell me, what could I do in such a case?"

One month after the second arrest of P—— C——, the jeweller, who had taken my security for the ring, called on me for payment of the bill. I made an arrangement with him; and on condition of my giving him twenty sequins, and leaving him every right over the debtor, he exonerated me. From his prison the impudent P—— C—— harassed me with his cowardly entreaties for alms and assistance.

Croce was in Venice, and engrossed a great share of the general attention. He kept a fine house, an excellent table, and a faro bank with which he emptied the pockets of his dupes. Foreseeing what would happen sooner or later, I had abstained from visiting him at his house, but we were friendly whenever we met. His wife having been delivered of a boy, Croce asked me to stand as god-father, a favour which I thought I could grant; but after the ceremony and the supper which was the consequence of it, I never entered the house of my former partner, and I acted rightly. I wish I had always been as prudent in my conduct.

CHAPTER XV

Croce Is Expelled From Venice—Sgombro—His Infamy and
Death—Misfortune Which Befalls My Dear C. C.—I Receive An
Anonymous Letter From a Nun, and Answer It—An Amorous
Intrigue

My former partner was, as I have said before, a skilful and experienced
hand at securing the favours of Fortune; he was driving a good trade in
Venice, and as he was amiable, and what is called in society a gentleman, he
might have held that excellent footing for a long time, if he had been satisfied
with gambling; for the State Inquisitors would have too much to attend to if
they wished to compel fools to spare their fortunes, dupes to be prudent, and
cheats not to dupe the fools; but, whether through the folly of youth or
through a vicious disposition, the cause of his exile was of an extraordinary
and disgusting nature.

A Venetian nobleman, noble by birth, but very ignoble in his propensities,
called Sgombro, and belonging to the Gritti family, fell deeply in love with
him, and Croce, either for fun or from taste, shewed himself very compliant.
Unfortunately the reserve commanded by common decency was not a guest
at their amorous feats, and the scandal became so notorious that the
Government was compelled to notify to Croce the order to quit the city, and
to seek his fortune in some other place.

Some time afterwards the infamous Sgombro seduced his own two sons,
who were both very young, and, unfortunately for him, he put the youngest
in such a state as to render necessary an application to a surgeon. The
infamous deed became publicly known, and the poor child confessed that he
had not had the courage to refuse obedience to his father. Such obedience
was, as a matter of course, not considered as forming a part of the duties
which a son owes to his father, and the State Inquisitors sent the disgusting
wretch to the citadel of Cataro, where he died after one year of confinement.

It is well known that the air of Cataro is deadly, and that the Tribunal
sentences to inhale it only such criminals as are not judged publicly for fear
of exciting too deeply the general horror by the publication of the trial.

It was to Cataro that the Council of Ten sent, fifteen years ago, the
celebrated advocate Cantarini, a Venetian nobleman, who by his eloquence
had made himself master of the great Council, and was on the point of
changing the constitution of the State. He died there at the end of the year.
As for his accomplices, the Tribunal thought that it was enough to punish the

four or five leaders, and to pretend not to know the others, who through fear of punishment returned silently to their allegiance.

That Sgombro, of whom I spoke before, had a charming wife who is still alive, I believe. Her name was Cornelia Gitti; she was as celebrated by her wit as by her beauty, which she kept in spite of her years. Having recovered her liberty through the death of her husband, she knew better than to make herself a second time the prisoner of the Hymenean god; she loved her independence too much; but as she loved pleasure too, she accepted the homage of the lovers who pleased her taste.

One Monday, towards the end of July, my servant woke me at day-break to tell me that Laura wished to speak to me. I foresaw some misfortune, and ordered the servant to shew her in immediately. These are the contents of the letter which she handed to me:

"My dearest, a misfortune has befallen me last evening, and it makes me very miserable because I must keep it a secret from everyone in the convent. I am suffering from a very severe loss of blood, and I do not know what to do, having but very little linen. Laura tells me I shall require a great deal of it if the flow of blood continues. I can take no one into my confidence but you, and I entreat you to send me as much linen as you can. You see that I have been compelled to make a confidante of Laura, who is the only person allowed to enter my room at all times. If I should die, my dear husband, everybody in the convent would, of course, know the cause of my death; but I think of you, and I shudder. What will you do in your grief? Ah, darling love! what a pity!"

I dressed myself hurriedly, plying Laura with questions all the time. She told me plainly that it was a miscarriage, and that it was necessary to act with great discretion in order to save the reputation of my young friend; that after all she required nothing but plenty of linen, and that it would be nothing. Commonplace words of consolation, which did not allay the fearful anxiety under which I was labouring. I went out with Laura, called on a Jew from whom I bought a quantity of sheets and two hundred napkins, and, putting it all in a large bag, I repaired with her to Muran. On our way there I wrote in pencil to my sweetheart, telling her to have entire confidence in Laura, and assuring her that I would not leave Muran until all danger had passed. Before we landed, Laura told me that, in order not to be remarked, I had better conceal myself in her house. At any other time it would have been shutting up the wolf in the sheep-fold. She left me in a miserable-looking small room on the ground floor, and concealing about herself as much linen as she could she hurried to her patient, whom she had not seen since the previous evening.

I was in hopes that she would find her out of danger, and I longed to see her come back with that good news.

She was absent about one hour, and when she returned her looks were sad. She told me that my poor friend, having lost a great deal of blood during the night, was in bed in a very weak state, and that all we could do was to pray to God for her, because, if the flooding of the blood did not stop soon, she could not possibly live twenty-four hours.

When I saw the linen which she had concealed under her clothes to bring it out, I could not disguise my horror, and I thought the sight would kill me. I fancied myself in a slaughter-house! Laura, thinking of consoling me, told me that I could rely upon the secret being well kept.

"Ah! what do I care!" I exclaimed. "Provided she lives, let the whole world know that she is my wife!"

At any other time, the foolishness of poor Laura would have made me laugh; but in such a sad moment I had neither the inclination nor the courage to be merry.

"Our dear patient," added Laura, "smiled as she was reading your letter, and she said that, with you so near her, she was certain not to die."

Those words did me good, but a man needs so little to console him or to soothe his grief.

"When the nuns are at their dinner," said Laura, "I will go back to the convent with as much linen as I can conceal about me, and in the mean time I am going to wash all this."

"Has she had any visitors?"

"Oh, yes! all the convent; but no one has any suspicion of the truth."

"But in such hot weather as this she can have only a very light blanket over her, and her visitors must remark the great bulk of the napkins."

"There is no fear of that, because she is sitting up in her bed."

"What does she eat?"

"Nothing, for she must not eat."

Soon afterwards Laura went out, and I followed her. I called upon a physician, where I wasted my time and my money, in order to get from him a long prescription which was useless, for it would have put all the convent in possession of the secret, or, to speak more truly, her secret would have been known to the whole world, for a secret known to a nun soon escapes out of the convent's walls. Besides, the physician of the convent himself would most likely have betrayed it through a spirit of revenge.

I returned sadly to my miserable hole in Laura's house. Half an hour afterwards she came to me, crying bitterly, and she placed in my hands this letter, which was scarcely legible:

"I have not strength enough to write to you, my darling; I am getting weaker and weaker; I am losing all my blood, and I am afraid there is no remedy. I abandon myself to the will of God, and I thank Him for having saved me from dishonour. Do not make yourself unhappy. My only consolation is to know that you are near me. Alas! if I could see you but for one moment I would die happy."

The sight of a dozen napkins brought by Laura made me shudder, and the good woman imagined that she afforded me some consolation by telling me that as much linen could be soaked with a bottle of blood. My mind was not disposed to taste such consolation; I was in despair, and I addressed to myself the fiercest reproaches, upbraiding myself as the cause of the death of that adorable creature. I threw myself on the bed, and remained there, almost stunned, for more than six hours, until Laura's return from the convent with twenty napkins entirely soaked. Night had come on, and she could not go back to her patient until morning. I passed a fearful night without food, without sleep, looking upon myself with horror, and refusing all the kind attentions that Laura's daughters tried to shew me.

It was barely daylight when Laura same to announce to me, in the saddest tone, that my poor friend did not bleed any more. I thought she was dead, and I screamed loudly,

"Oh! she is no more!"

"She is still breathing, sir; but I fear she will not outlive this day, for she is worn out. She can hardly open her eyes, and her pulse is scarcely to be felt."

A weight was taken off me; I was instinctively certain that my darling was saved.

"Laura," I said, "this is not bad news; provided the flooding has ceased entirely, all that is necessary is to give her some light food."

"A physician has been sent for. He will prescribe whatever is right, but to tell you the truth I have not much hope."

"Only give me the assurance that she is still alive."

"Yes, she is, I assure you; but you understand very well that she will not tell the truth to the doctor, and God knows what he will order. I whispered to her not to take anything, and she understood me."

"You are the best of women. Yes, if she does not die from weakness before to-morrow, she is saved; nature and love will have been her doctors."

"May God hear you! I shall be back by twelve."

"Why not before?"

"Because her room will be full of people."

Feeling the need of hope, and almost dead for want of food, I ordered some dinner, and prepared a long letter for my beloved mistress, to be delivered to her when she was well enough to read it. The instants given to repentance are very sad, and I was truly a fit subject for pity. I longed to see Laura again, so as to hear what the doctor had said. I had very good cause for laughing at all sorts of oracles, yet through some unaccountable weakness I longed for that of the doctor; I wanted, before all, to find it a propitious one.

Laura's young daughters waited upon me at dinner; I could not manage to swallow a mouthful, but it amused me to see the three sisters devour my dinner at the first invitation I gave them. The eldest sister, a very fine girl, never raised her large eyes once towards me. The two younger ones seemed to me disposed to be amiable, but if I looked at them it was only to feed my despair and the cruel pangs of repentance.

At last Laura, whom I expected anxiously, came back; she told me that the dear patient remained in the same state of debility; the doctor had been greatly puzzled by her extreme weakness because he did not know to what cause to attribute it. Laura added,

"He has ordered some restoratives and a small quantity of light broth; if she can sleep, he answers for her life. He has likewise desired her to have someone to watch her at night, and she immediately pointed her finger at me, as if she wished me to undertake that office. Now, I promise you never to leave her either night or day, except to bring you news."

I thanked her, assuring her that I would reward her generously. I heard with great pleasure that her mother had paid her a visit, and that she had no suspicion of the real state of things, for she had lavished on her the most tender caresses.

Feeling more at ease I gave six sequins to Laura, one to each of her daughters, and ate something for my supper: I then laid myself down on one of the wretched beds in the room. As soon as the two younger sisters saw me in bed, they undressed themselves without ceremony, and took possession of the second bed which was close by mine. Their innocent confidence pleased me. The eldest sister, who most likely had more practical experience, retired to the adjoining room; she had a lover to whom she was soon to be married. This time, however, I was not possessed with the evil spirit of concupiscence, and I allowed innocence to sleep peacefully without attempting anything against it.

Early the next morning Laura was the bearer of good news. She came in with a cheerful air to announce that the beloved patient had slept well, and that she was going back soon to give her some soup. I felt an almost maddening joy in listening to her, and I thought the oracle of AEsculapius a thousand times more reliable than that of Apollo. But it was not yet time to exult in our victory, for my poor little friend had to recover her strength and to make up for all the blood she had lost; that could be done only by time and careful nursing. I remained another week at Laura's house, which I left only after my dear C—— C—— had requested me to do so in a letter of four pages. Laura, when I left, wept for joy in seeing herself rewarded by the gift of all the fine linen I had bought for my C—— C——, and her daughters were weeping likewise, most probably because, during the ten days I had spent near them, they had not obtained a single kiss from me.

After my return to Venice, I resumed my usual habits; but with a nature like mine how could I possibly remain satisfied without positive love? My only pleasure was to receive a letter from my dear recluse every Wednesday, who advised me to wait patiently rather than to attempt carrying her off. Laura assured me that she had become more lovely than ever, and I longed to see her. An opportunity of gratifying my wishes soon offered itself, and I did not allow it to escape. There was to be a taking of the veil—a ceremony which always attracts a large number of persons. On those occasions the nuns always received a great many visitors, and I thought that the boarders were likely to be in the parlour on such an occasion. I ran no risk of being remarked any more than any other person, for I would mingle with the crowd. I therefore went without saying anything about it to Laura, and without acquainting my dear little wife of my intentions. I thought I would fall, so great was my emotion, when I saw her within four yards from me, and looking at me as if she had been in an ecstatic state. I thought her taller and more womanly, and she certainly seemed to me more beautiful than before. I saw no one but her; she never took her eyes off me, and I was the last to leave that place which on that day struck me as being the temple of happiness.

Three days afterwards I received a letter from her. She painted with such vivid colours the happiness she had felt in seeing me, that I made up my mind to give her that pleasure as often as I could. I answered at once that I would attend mass every Sunday at the church of her convent. It cost me nothing: I could not see her, but I knew that she saw me herself, and her happiness made me perfectly happy. I had nothing to fear, for it was almost impossible that anyone could recognize me in the church which was attended only by the people of Muran.

After hearing two or three masses, I used to take a gondola, the gondolier of which could not feel any curiosity about me. Yet I kept on my guard, for I knew that the father of C—— C—— wanted her to forget me, and I had no doubt he would have taken her away, God knew where if he had had the slightest suspicion of my being acquainted with the place where he had confined her.

Thus I was reasoning in my fear to lose all opportunity of corresponding with my dear C—— C——, but I did not yet know the disposition and the shrewdness of the sainted daughters of the Lord. I did not suppose that there was anything remarkable in my person, at least for the inmates of a convent; but I was yet a novice respecting the curiosity of women, and particularly of unoccupied hearts; I had soon occasion to be convinced.

I had executed my Sunday manoeuvering only for a month or five weeks, when my dear C—— C—— wrote me jestingly that I had become a living enigma for all the convent, boarders and nuns, not even excepting the old ones. They all expected me anxiously; they warned each other of my arrival, and watched me taking the holy water. They remarked that I never cast a glance toward the grating, behind which were all the inmates of the convent; that I never looked at any of the women coming in or going out of the church. The old nuns said that I was certainly labouring under some deep sorrow, of which I had no hope to be cured except through the protection of the Holy Virgin, and the young ones asserted that I was either melancholy or misanthropic.

My dear wife, who knew better than the others, and had no occasion to lose herself in suppositions, was much amused, and she entertained me by sending me a faithful report of it all. I wrote to her that, if she had any fear of my being recognized I would cease my Sunday visits to the church. She answered that I could not impose upon her a more cruel privation, and she entreated me to continue my visits. I thought it would be prudent, however, to abstain from calling at Laura's house, for fear of the chattering nuns contriving to know it, and discovering in that manner a great deal more than I wished them to find out. But that existence was literally consuming me by slow degrees, and could not last long. Besides, I was made to have a mistress, and to live happily with her. Not knowing what to do with myself, I would gamble, and I almost invariably won; but, in spite of that, weariness had got hold of me and I was getting thinner every day.

With the five thousand sequins which my partner Croce had won for me in Padua I had followed M. Bragadin's advice. I had hired a casino where I held a faro bank in partnership with a matador, who secured me against the

frauds of certain noblemen—tyrants, with whom a private citizen is always sure to be in the wrong in my dear country.

On All Saints' Day, in the year 1753, just as, after hearing mass, I was going to step into a gondola to return to Venice, I saw a woman, somewhat in Laura's style who, passing near me, looked at me and dropped a letter. I picked it up, and the woman, seeing me in possession of the epistle, quietly went on. The letter had no address, and the seal represented a running knot. I stepped hurriedly into the gondola, and as soon as we were in the offing I broke the seal. I read the following words.

"A nun, who for the last two months and a half has seen you every Sunday in the church of her convent, wishes to become acquainted with you. A pamphlet which you have lost, and which chance has thrown into her hands, makes her believe that you speak French; but, if you like it better, you can answer in Italian, because what she wants above all is a clear and precise answer. She does not invite you to call for her at the parlour of the convent, because, before you place yourself under the necessity of speaking to her, she wishes you to see her, and for that purpose she will name a lady whom you can accompany to the parlour. That lady shall not know you and need not therefore introduce you, in case you should not wish to be known.

"Should you not approve of that way to become acquainted, the nun will appoint a certain casino in Muran, in which you will find her alone, in the evening, any night you may choose. You will then be at liberty either to sup with her, or to retire after an interview of a quarter of an hour, if you have any other engagements.

"Would you rather offer her a supper in Venice? Name the night, the hour, the place of appointment, and you will see her come out of a gondola. Only be careful to be there alone, masked and with a lantern.

"I feel certain that you will answer me, and that you will guess how impatiently I am waiting for your letter. I entreat you, therefore, to give it to-morrow to the same woman through whom you will receive mine! you will find her one hour before noon in the church of St. Cancian, near the first altar on the right.

"Recollect that, if I did not suppose you endowed with a noble soul and a high mind, I could never have resolved on taking a step which might give you an unfavorable opinion of my character"

The tone of that letter, which I have copied word by word, surprised me even more than the offer it contained. I had business to attend to, but I gave up all engagements to lock myself in my room in order to answer it. Such an application betokened an extravagant mind, but there was in it a certain

dignity, a singularity, which attracted me. I had an idea that the writer might be the same nun who taught French to C—— C——. She had represented her friend in her letters as handsome, rich, gallant, and generous. My dear wife had, perhaps, been guilty of some indiscretion. A thousand fancies whirled through my brain, but I would entertain only those which were favourable to a scheme highly pleasing to me. Besides, my young friend had informed me that the nun who had given her French lessons was not the only one in the convent who spoke that language. I had no reason to suppose that, if C—— C—— had made a confidante of her friend, she would have made a mystery of it to me. But, for all that, the nun who had written to me might be the beautiful friend of my dear little wife, and she might also turn out to be a different person; I felt somewhat puzzled. Here is, however, the letter which I thought I could write without implicating myself:

"I answer in French, madam, in the hope that my letter will have the clearness and the precision of which you give me the example in yours.

"The subject is highly interesting and of the highest importance, considering all the circumstances. As I must answer without knowing the person to whom I am writing, you must feel, madam, that, unless I should possess a large dose of vanity, I must fear some mystification, and my honour requires that I should keep on my guard.

"If it is true that the person who has penned that letter is a respectable woman, who renders me justice in supposing me endowed with feeling as noble as her own, she will find, I trust, that I could not answer in any other way than I am doing now.

"If you have judged me worthy, madam, of the honour which you do me by offering me your acquaintance, although your good opinion can have been formed only from my personal appearance, I feel it my duty to obey you, even if the result be to undeceive you by proving that I had unwittingly led you into a mistaken appreciation of my person.

"Of the three proposals which you so kindly made in your letter, I dare not accept any but the first, with the restriction suggested by your penetrating mind. I will accompany to the parlour of your convent a lady who shall not know who I am, and, consequently, shall have no occasion to introduce me.

"Do not judge too severely, madam, the specious reasons which compel me not to give you my name, and receive my word of honour that I shall learn yours only to render you homage. If you choose to speak to me, I will answer with the most profound respect. Permit me to hope that you will come to the parlour alone. I may mention that I am a Venetian, and perfectly free.

"The only reason which prevents me from choosing one of the two other arrangements proposed by you, either of which would have suited me better because they greatly honour me, is, allow me to repeat it, a fear of being the victim of a mystification; but these modes of meeting will not be lost when you know me and when I have seen you. I entreat you to have faith in my honour, and to measure my patience by your own. Tomorrow, at the same place and at the same hour, I shall be anxiously expecting your answer."

I went to the place appointed, and having met the female Mercury I gave her my letter with a sequin, and I told her that I would come the next day for the answer. We were both punctual. As soon as she saw me, she handed me back the sequin which I had given her the day before, and a letter, requesting me to read it and to let her know whether she was to wait for an answer. Here is the exact copy of the letter:

"I believe, sir, that I have not been mistaken in anything. Like you, I detest untruth when it can lead to important consequences, but I think it a mere trifle when it can do no injury to anyone. Of my three proposals you have chosen the one which does the greatest honour to your intelligence, and, respecting the reasons which induce you to keep your incognito, I have written the enclosed to the Countess of S——, which I request you to read. Be kind enough to seal it before delivery of it to her. You may call upon her whenever convenient to yourself. She will name her own hour, and you will accompany her here in her gondola. The countess will not ask you any questions, and you need not give her any explanation. There will be no presentation; but as you will be made acquainted with my name, you can afterwards call on me here, masked, whenever you please, and by using the name of the countess. In that way we shall become acquainted without the necessity of disturbing you, or of your losing at night some hours which may be precious to you. I have instructed my servant to wait for your answer in case you should be known to the countess and object to her. If you approve of the choice I have made of her, tell the messenger that there is no answer."

As I was an entire stranger to the countess, I told the woman that I had no answer to give, and she left me.

Here are the contents of the note addressed by the nun to the countess, and which I had to deliver to her:

"I beg of you, my dear friend, to pay me a visit when you are at leisure, and to let the masked gentleman-bearer of this note know the hour, so that he can accompany you. He will be punctual. Farewell. You will much oblige your friend."

That letter seemed to me informed by a sublime spirit of intrigue; there was in it an appearance of dignity which captivated me, although I felt conscious that I was playing the character of a man on whom a favour seemed to be bestowed.

In her last letter, my nun, pretending not to be anxious to know who I was, approved of my choice, and feigned indifference for nocturnal meetings; but she seemed certain that after seeing her I would visit her. I knew very well what to think of it all, for the intrigue was sure to have an amorous issue. Nevertheless, her assurance, or rather confidence, increased my curiosity, and I felt that she had every reason to hope, if she were young and handsome. I might very well have delayed the affair for a few days, and have learned from C—— C—— who that nun could be; but, besides the baseness of such a proceeding, I was afraid of spoiling the game and repenting it afterwards. I was told to call on the countess at my convenience, but it was because the dignity of my nun would not allow her to shew herself too impatient; and she certainly thought that I would myself hasten the adventure. She seemed to me too deeply learned in gallantry to admit the possibility of her being an inexperienced novice, and I was afraid of wasting my time; but I made up my mind to laugh at my own expense if I happened to meet a superannuated female. It is very certain that if I had not been actuated by curiosity I should not have gone one step further, but I wanted to see the countenance of a nun who had offered to come to Venice to sup with me. Besides, I was much surprised at the liberty enjoyed by those sainted virgins, and at the facility with which they could escape out of their walls.

At three o'clock I presented myself before the countess and delivered the note, and she expressed a wish to see me the next day at the same hour. We dropped a beautiful reverence to one another, and parted. She was a superior woman, already going down the hill, but still very handsome.

The next morning, being Sunday, I need not say that I took care to attend mass at the convent, elegantly dressed, and already unfaithful—at least in idea—to my dear C—— C——, for I was thinking of being seen by the nun, young or old, rather than of shewing myself to my charming wife.

In the afternoon I masked myself again, and at the appointed time I repaired to the house of the countess who was waiting for me. We went in a two-oared gondola, and reached the convent without having spoken of anything but the weather. When we arrived at the gate, the countess asked for M—— M——. I was surprised by that name, for the woman to whom it belonged was celebrated. We were shewn into a small parlour, and a few minutes afterwards a nun came in, went straight to the grating, touched a

spring, and made four squares of the grating revolve, which left an opening sufficiently large to enable the two friends to embrace the ingenious window was afterwards carefully closed. The opening was at least eighteen inches wide, and a man of my size could easily have got through it. The countess sat opposite the nun, and I took my seat a little on one side so as to be able to observe quietly and at my ease one of the most beautiful women that it was possible to see. I had no doubt whatever of her being the person mentioned by my dear C—— C—— as teaching her French. Admiration kept me in a sort of ecstacy, and I never heard one word of their conversation; the beautiful nun, far from speaking to me, did not even condescend to honour me with one look. She was about twenty-two or twenty-three years of age, and the shape of her face was most beautiful. Her figure was much above the ordinary height, her complexion rather pale, her appearance noble, full of energy, but at the same time reserved and modest; her eyes, large and full, were of a lovely blue; her countenance was soft and cheerful; her fine lips seemed to breathe the most heavenly voluptuousness, and her teeth were two rows of the most brilliant enamel. Her head-dress did not allow me to see her hair, but if she had any I knew by the colour of her eyebrows that it was of a beautiful light brown. Her hand and her arm, which I could see as far as the elbow, were magnificent; the chisel of Praxiteles never carved anything more grace fully rounded and plump, I was not sorry to have refused the two rendezvous which had been offered to me by the beauty, for I was sure of possessing her in a few days, and it was a pleasure for me to lay my desires at her feet. I longed to find myself alone with her near that grating, and I would have considered it an insult to her if, the very next day, I had not come to tell her how fully I rendered to her charms the justice they deserved. She was faithful to her determination not to look at me once, but after all I was pleased with her reserve. All at once the two friends lowered their voices, and out of delicacy I withdrew further. Their private conversation lasted about a quarter of an hour, during which I pretended to be intently looking at a painting; then they kissed one another again by the same process as at the beginning of the interview; the nun closed the opening, turned her back on us, and disappeared without casting one glance in my direction.

As we were on our way back to Venice, the countess, tired perhaps of our silence, said to me, with a smile,

"M—— M—— is beautiful and very witty."

"I have seen her beauty, and I believe in her wit."

"She did not address one word to you."

"I had refused to be introduced to her, and she punished me by pretending not to know that I was present."

The countess made no answer, and we reached her house without exchanging another word. At her door a very ceremonious curtesy, with these words, "Adieu, sir!" warned me that I was not to go any further. I had no wish to do so, and went away dreaming and wondering at the singularity of the adventure, the end of which I longed to see.

Episode 8 — Convent Affairs

CHAPTER XVI

Countess Coronini—A Lover's Pique—Reconciliation—The
First Meeting—A Philosophical Parenthesis

My beautiful nun had not spoken to me, and I was glad of it, for I was so
astonished, so completely under the spell of her beauty, that I might have
given her a very poor opinion of my intelligence by the rambling answers
which I should very likely have given to her questions. I knew her to be
certain that she had not to fear the humiliation of a refusal from me, but I
admired her courage in running the risk of it in her position. I could hardly
understand her boldness, and I could not conceive how she contrived to enjoy
so much liberty. A casino at Muran! the possibility of going to Venice to sup
with a young man! It was all very surprising, and I decided in my own mind
that she had an acknowledged lover whose pleasure it was to make her happy
by satisfying her caprices. It is true that such a thought was rather unpleasant
to my pride, but there was too much piquancy in the adventure, the heroine
of it was too attractive, for me to be stopped by any considerations. I saw very
well that I was taking the high road to become unfaithful to my dear C——
C——, or rather that I was already so in thought and will, but I must confess
that, in spite of all my love for that charming child, I felt no qualms of
conscience. It seemed to me that an infidelity of that sort, if she ever heard
of it, would not displease her, for that short excursion on strange ground
would only keep me alive and in good condition for her, because it would save
me from the weariness which was surely killing me.

I had been presented to the celebrated Countess Coronini by a nun, a
relative of M. Dandolo. That countess, who had been very handsome and was
very witty, having made up her mind to renounce the political intrigues which
had been the study of her whole life, had sought a retreat in the Convent of
St. Justine, in the hope of finding in that refuge the calm which she wanted,
and which her disgust of society had rendered necessary to her. As she had
enjoyed a very great reputation, she was still visited at the convent by all the
foreign ambassadors and by the first noblemen of Venice; inside of the walls
of her convent the countess was acquainted with everything that happened
in the city. She always received me very kindly, and, treating me as a young

man, she took pleasure in giving me, every time I called on her, very agreeable lessons in morals. Being quite certain to find out from her, with a little manoeuvering, something concerning M—— M——, I decided on paying her a visit the day after I had seen the beautiful nun.

The countess gave me her usual welcome, and, after the thousand nothings which it is the custom to utter in society before anything worth saying is spoken, I led the conversation up to the convents of Venice. We spoke of the wit and influence of a nun called Celsi, who, although ugly, had an immense credit everywhere and in everything. We mentioned afterwards the young and lovely Sister Michali, who had taken the veil to prove to her mother that she was superior to her in intelligence and wit. After speaking of several other nuns who had the reputation of being addicted to gallantry, I named M—— M——, remarking that most likely she deserved that reputation likewise, but that she was an enigma. The countess answered with a smile that she was not an enigma for everybody, although she was necessarily so for most people.

"What is incomprehensible," she said, "is the caprice that she took suddenly to become a nun, being handsome, rich, free, well-educated, full of wit, and, to my knowledge, a Free-thinker. She took the veil without any reason, physical or moral; it was a mere caprice."

"Do you believe her to be happy, madam?"

"Yes, unless she has repented her decision, or if she does not repent it some day. But if ever she does, I think she will be wise enough never to say so to anyone."

Satisfied by the mysterious air of the countess that M—— M—— had a lover, I made up my mind not to trouble myself about it, and having put on my mask I went to Muran in the afternoon. When I reached the gate of the convent I rang the bell, and with an anxious heart I asked for M—— M—— in the name of Madame de S——. The small parlour being closed, the attendant pointed out to me the one in which I had to go. I went in, took off my mask, and sat down waiting for my divinity.

My heart was beating furiously; I was waiting with great impatience; yet that expectation was not without charm, for I dreaded the beginning of the interview. An hour passed pretty rapidly, but I began then to find the time rather long, and thinking that, perhaps, the attendant had not rightly understood me, I rang the bell, and enquired whether notice of my visit had being given to Sister M—— M——. A voice answered affirmatively. I took my seat again, and a few minutes afterwards an old, toothless nun came in and informed me that Sister M—— M—— was engaged for the whole day. Without giving me time to utter a single word, the woman left the parlour.

This was one of those terrible moments to which the man who worships at the shrine of the god of love is exposed! They are indeed cruel moments; they bring fearful sorrow, they may cause death.

Feeling myself disgraced, my first sensation was utter contempt for myself, an inward despair which was akin to rage; the second was disdainful indignation against the nun, upon whom I passed the severe judgment which I thought she deserved, and which was the only way I had to soothe my grief. Such behaviour proclaimed her to be the most impudent of women, and entirely wanting in good sense; for the two letters she had written to me were quite enough to ruin her character if I had wished to revenge myself, and she evidently could not expect anything else from me. She must have been mad to set at defiance my revengeful feelings, and I should certainly have thought that she was insane if I had not heard her converse with the countess.

Time, they say, brings good counsel; it certainly brings calm, and cool reflection gives lucidity to the mind. At last I persuaded myself that what had occurred was after all in no way extraordinary, and that I would certainly have considered it at first a very common occurrence if I had not been dazzled by the wonderful beauty of the nun, and blinded by my own vanity. As a very natural result I felt that I was at liberty to laugh at my mishap, and that nobody could possibly guess whether my mirth was genuine or only counterfeit. Sophism is so officious!

But, in spite of all my fine arguments, I still cherished the thought of revenge; no debasing element, however, was to form part of it, and being determined not to leave the person who had been guilty of such a bad practical joke the slightest cause of triumph, I had the courage not to shew any vexation. She had sent word to me that she was engaged; nothing more natural; the part I had to play was to appear indifferent. "Most likely she will not be engaged another time," I said to myself, "but I defy her to catch me in the snare again. I mean to shew her that I only laugh at her uncivil behaviour." Of course I intended to send back her letters, but not without the accompaniment of a billet-doux, the gallantry of which was not likely to please her.

The worse part of the affair for me was to be compelled to go to her church; because, supposing her not to be aware of my going there for C—— C——, she might imagine that the only object of my visits was to give her the opportunity of apologizing for her conduct and of appointing a new meeting. I wanted her to entertain no doubt of my utter contempt for her person, and I felt certain that she had proposed the other meetings in Venice and at the casino of Muran only to deceive me more easily.

I went to bed with a great thirst for revenge, I fell asleep thinking of it, and I awoke with the resolution of quenching it. I began to write, but, as I wished particularly that my letter should not show the pique of the disappointed lover, I left it on my table with the intention of reading it again the next day. It proved a useful precaution, for when I read it over, twenty-four hours afterwards, I found it unworthy of me, and tore it to pieces. It contained some sentences which savoured too much of my weakness, my love, and my spite, and which, far from humiliating her, would only have given her occasion to laugh at me.

On the Wednesday after I had written to C—— C—— that very serious reasons compelled me to give up my visits to the church of her convent, I wrote another letter to the nun, but on Thursday it had the same fate as the first, because upon a second perusal I found the same deficiencies. It seemed to me that I had lost the faculty of writing. Ten days afterwards I found out that I was too deeply in love to have the power of expressing myself in any other way than through the feelings of my heart.

'Sincerium est nisi vas, quodcunque infundis acescit.'

The face of M—— M—— had made too deep an impression on me; nothing could possibly obliterate it except the all-powerful influence of time.

In my ridiculous position I was sorely tempted to complain to Countess S——; but I am happy to say I was prudent enough not to cross the threshold of her door. At last I bethought myself that the giddy nun was certainly labouring under constant dread, knowing that I had in my possession her two letters, with which I could ruin her reputation and cause the greatest injury to the convent, and I sent them back to her with the following note, after I had kept them ten days:

"I can assure you, madam, that it was owing only to forgetfulness that I did not return your two letters which you will find enclosed. I have never thought of belying my own nature by taking a cowardly revenge upon you, and I forgive you most willingly the two giddy acts of which you have been guilty, whether they were committed thoughtlessly or because you wanted to enjoy a joke at my expense. Nevertheless, you will allow me to advise you not to treat any other man in the same way, for you might meet with one endowed with less delicacy. I know your name, I know who you are, but you need not be anxious; it is exactly as if I did not know it. You may, perhaps, care but little for my discretion, but if it should be so I should greatly pity you.

"You may be aware that I shall not shew myself again at your church; but let me assure you that it is not a sacrifice on my part, and that I can attend mass anywhere else. Yet I must tell you why I shall abstain from frequenting

the church of your convent. It is very natural for me to suppose that to the two thoughtless acts of which you have been guilty, you have added another not less serious, namely, that of having boasted of your exploits with the other nuns, and I do not want to be the butt of your jokes in cell or parlour. Do not think me too ridiculous if, in spite of being five or six years older than you, I have not thrown off all feelings of self-respect, or trodden under, my feet all reserve and propriety; in one word, if I have kept some prejudices, there are a few which in my opinion ought never to be forgotten. Do not disdain, madam, the lesson which I take the liberty to teach you, as I receive in the kindest spirit the one which you have given me, most likely only for the sake of fun, but by which I promise you to profit as long as I live."

I thought that, considering all circumstances, my letter was a very genial one; I made up my parcel, put on my mask, and looked out for a porter who could have no knowledge of me; I gave him half a sequin, and I promised him as much more when he could assure me that he had faithfully delivered my letter at the convent of Muran. I gave him all the necessary instructions, and cautioned him to go away the very moment he had delivered the letter at the gate of the convent, even if he were told to wait. I must say here that my messenger was a man from Forli, and that the Forlanese were then the most trustworthy men in Venice; for one of them to be guilty of a breach of trust was an unheard-of thing. Such men were formerly the Savoyards, in Paris; but everything is getting worse in this world.

I was beginning to forget the adventure, probably because I thought, rightly or wrongly, that I had put an insurmountable barrier between the nun and myself, when, ten days after I had sent my letter, as I was coming out of the opera, I met my messenger, lantern in hand. I called him, and without taking off my mask I asked him whether he knew me. He looked at me, eyed me from head to foot, and finally answered that he did not.

"Did you faithfully carry the message to Muran?"

"Ah, sir! God be praised! I am very happy to see you again, for I have an important communication to make to you. I took your letter, delivered it according to your instructions, and I went away as soon as it was in the hands of the attendant, although she requested me to wait. When I returned from Muran I did not see you, but that did not matter. On the following day, one of my companions, who happened to be at the gate of the convent when I delivered your letter, came early in the morning to tell me to go to Muran, because the attendant wanted particularly to speak to me. I went there, and after waiting for a few minutes I was shewn into the parlour, where I was kept for more than an hour by a nun as beautiful as the light of day, who asked me

a thousand questions for the purpose of ascertaining, if not who you are, at least where I should be likely to find you. You know that I could not give her any satisfactory information. She then left the parlour, ordering me to wait, and at the end of two hours she came back with a letter which she entrusted to my hands, telling me that, if I succeeded in finding you out and in bringing her an answer, she would give me two sequins. In the mean time I was to call at the convent every day, shew her the letter, and receive forty sons every time. Until now I have earned twenty crowns, but I am afraid the lady will get tired of it, and you can make me earn two sequins by answering a line."

"Where is the letter?"

"In my room under lock and key, for I am always afraid of losing it."

"Then how can I answer?"

"If you will wait for me here, you shall have the letter in less than a quarter of an hour."

"I will not wait, because I do not care about the letter. But tell me how you could flatter the nun with the hope of finding me out? You are a rogue, for it is not likely that she would have trusted you with the letter if you had not promised her to find me."

"I am not a rogue, for I have done faithfully what you told me; but it is true that I gave her a description of your coat, your buckles, and your figure, and I can assure you that for the last ten days I have examined all the masks who are about your size, but in vain. Now I recognize your buckles, but I do not think you have the same coat. Alas, sir! it will not cost you much to write only one line. Be kind enough to wait for me in the coffee-house close by."

I could not resist my curiosity any longer, and I made up my mind not to wait for him but to accompany him as far as his house. I had only to write, "I have received the letter," and my curiosity was gratified and the Forlanese earned his two sequins. I could afterwards change my buckles and my mask, and thus set all enquiries at defiance.

I therefore followed him to his door; he went in and brought me the letter. I took him to an inn, where I asked for a room with a good fire, and I told my man to wait. I broke the seal of the parcel—a rather large one, and the first papers that I saw were the two letters which I had sent back to her in order to allay her anxiety as to the possible consequences of her giddiness.

The sight of these letters caused me such a palpitation of the heart that I was compelled to sit down: it was a most evident sign of my defeat. Besides these two letters I found a third one signed "S." and addressed to M——M——. I read the following lines:

"The mask who accompanied me back to my house would not, I believe, have uttered a single word, if I had not told him that the charms of your witty mind were even more bewitching than those of your person; and his answer was, 'I have seen the one, and I believe in the other.' I added that I did not understand why you had not spoken to him, and he said, with a smile, 'I refused to be presented to her, and she punished me for it by not appearing to know that I was present.' These few words were all our dialogue. I intended to send you this note this morning, but found it impossible. Adieu."

After reading this note, which stated the exact truth, and which could be considered as proof, my heart began to beat less quickly. Delighted at seeing myself on the point of being convicted of injustice, I took courage, and I read the following letter:

"Owing to an excusable weakness, feeling curious to know what you would say about me to the countess after you had seen me, I took an opportunity of asking her to let me know all you said to her on the following day at latest, for I foresaw that you would pay me a visit in the afternoon. Her letter, which I enclose, and which I beg you to read, did not reach me till half an hour after you had left the convent.

"This was the first fatality.

"Not having received that letter when you called, I had not the courage to see you. This absurd weakness on my part was the second fatality, but the weakness you will; I hope; forgive. I gave orders to the lay-sister to tell you that I was ill for the whole day; a very legitimate excuse; whether true or false, for it was an officious untruth, the correction of which, was to be found in the words: for the whole day. You had already left the convent, and I could not possibly send anyone to run after you, when the old fool informed me of her having told you that I was engaged.

"This was the third fatality.

"You cannot imagine what I had a mind to do and to say to that foolish sister; but here one must say or do nothing; one must be patient and dissemble, thanking God when mistakes are the result of ignorance and not of wickedness—a very common thing in convents. I foresaw at once, at least partly; what would happen; and what has actually, happened; for no reasonable being could, I believe, have foreseen it all. I guessed that, thinking yourself the victim of a joke, you would be incensed, and I felt miserable, for I did not see any way of letting you know the truth before the following Sunday. My heart longed ardently for that day. Could I possibly imagine that you, would take a resolution not to come again to our church! I tried to be patient until that Sunday; but when I found myself disappointed in my hope,

my misery became unbearable, and it will cause my death if you refuse to listen to my justification. Your letter has made me completely unhappy, and I shall not resist my despair if you persist in the cruel resolve expressed by your unfeeling letter. You have considered yourself trifled with; that is all you can say; but will this letter convince you of your error? And even believing yourself deceived in the most scandalous manner, you must admit that to write such an awful letter you must have supposed me an abominable wretch—a monster, such as a woman of noble birth and of refined education cannot possibly be. I enclose the two letters you sent back to me, with the idea of allaying my fears which you cruelly supposed very different to what they are in reality. I am a better physiognomist than you, and you must be quite certain that I have not acted thoughtlessly, for I never thought you capable, I will not say of crime, but even of an indelicate action. You must have read on my features the signs only of giddy impudence, and that is not my nature. You may be the cause of my death, you will certainly make me miserable for the remainder of my life, if you do not justify yourself; on my side I think the justification is complete.

"I hope that, even if you feel no interest in my life, you will think that you are bound in honour to come and speak to me. Come yourself to recall all you have written; it is your duty, and I deserve it. If you do not realize the fatal effect produced upon me by your letter, I must indeed pity you, in spite of my misery, for it proves that you have not the slightest knowledge of the human heart. But I feel certain that you will come back, provided the man to whom I trust this letter contrives to find you. Adieu! I expect life or death from you."

I did not require to read that letter twice; I was ashamed and in despair. M—— M—— was right. I called the Forlanese, enquired from him whether he had spoken to her in the morning, and whether she looked ill. He answered that he had found her looking more unhappy every day, and that her eyes were red from weeping.

"Go down again and wait," I said to him.

I began to write, and I had not concluded my long screed before the dawn of day; here are, word by word, the contents of the letter which I wrote to the noblest of women, whom in my unreasonable spite I had judged so wrongly.

"I plead guilty, madam; I cannot possibly justify myself, and I am perfectly convinced of your innocence. I should be disconsolate if I did not hope to obtain pardon, and you will not refuse to forgive me if you are kind enough to recollect the cause of my guilt. I saw you; I was dazzled, and I could not realize a happiness which seemed to me a dream; I thought myself the prey of

one of those delightful illusions which vanish when we wake up. The doubt under which I was labouring could not be cleared up for twenty-four hours, and how could I express my feverish impatience as I was longing for that happy moment! It came at last! and my heart, throbbing with desire and hope, was flying towards you while I was in the parlour counting the minutes! Yet an hour passed almost rapidly, and not unnaturally, considering my impatience and the deep impression I felt at the idea of seeing you. But then, precisely at the very moment when I believed myself certain that I was going to gaze upon the beloved features which had been in one interview indelibly engraved upon my heart, I saw the most disagreeable face appear, and a creature announced that you were engaged for the whole day, and without giving me time to utter one word she disappeared! You may imagine my astonishment and... the rest. The lightning would not have produced upon me a more rapid, a more terrible effect! If you had sent me a line by that sister—a line from your hand—I would have gone away, if not pleased, at least submissive and resigned.

"But that was a fourth fatality which you have forgotten to add to your delightful and witty justification. Thinking myself scoffed at, my self-love rebelled, and indignation for the moment silenced love. Shame overwhelmed me! I thought that everybody could read on my face all the horror in my heart, and I saw in you, under the outward appearance of an angel, nothing but a fearful daughter of the Prince of Darkness. My mind was thoroughly upset, and at the end of eleven days I lost the small portion of good sense that was left in me—at least I must suppose so, as it is then that I wrote to you the letter of which you have so good a right to complain, and which at that time seemed to me a masterpiece of moderation.

"But I hope it is all over now, and this very day at eleven o'clock you will see me at your feet—tender, submissive and repentant. You will forgive me, divine woman, or I will myself avenge you for the insult I have hurled at you. The only thing which I dare to ask from you as a great favour is to burn my first letter, and never to mention it again. I sent it only after I had written four, which I destroyed one after the other: you may therefore imagine the state of my heart.

"I have given orders to my messenger to go to your convent at once, so that my letter can be delivered to you as soon as you wake in the morning. He would never have discovered me, if my good angel had not made me go up to him at the door of the opera-house. But I shall not require his services any more; do not answer me, and receive all the devotion of a heart which adores you."

When my letter was finished, I called my Forlanese, gave him one sequin, and I made him promise me to go to Muran immediately, and to deliver my letter only to the nun herself. As soon as he had gone I threw myself on my bed, but anxiety and burning impatience would not allow me to sleep.

I need not tell the reader who knows the state of excitement under which I was labouring, that I was punctual in presenting myself at the convent. I was shewn into the small parlour where I had seen her for the first time, and she almost immediately made her entrance. As soon as I saw her near the grating I fell on my knees, but she entreated me to rise at once as I might be seen. Her face was flushed with excitement, and her looks seemed to me heavenly. She sat down, and I took a seat opposite to her. We remained several minutes motionless, gazing at each other without speaking, but I broke the silence by asking her, in a voice full of love and anxiety, whether I could hope to obtain my pardon. She gave me her beautiful hand through the grating, and I covered it with tears and kisses.

"Our acquaintance," she said, "has begun with a violent storm; let us hope that we shall now enjoy it long in perfect and lasting calm. This is the first time that we speak to one another, but what has occurred must be enough to give us a thorough knowledge of each other. I trust that our intimacy will be as tender as sincere, and that we shall know how to have a mutual indulgence for our faults."

"Can such an angel as you have any?"

"Ah, my friend! who is without them?"

"When shall I have the happiness of convincing you of my devotion with complete freedom and in all the joy of my heart?"

"We will take supper together at my casino whenever you please, provided you give me notice two days beforehand; or I will go and sup with you in Venice, if it will not disturb your arrangements."

"It would only increase my happiness. I think it right to tell you that I am in very easy circumstances, and that, far from fearing expense, I delight in it: all I possess belongs to the woman I love."

"That confidence, my dear friend, is very agreeable to me, the more so that I have likewise to tell you that I am very rich, and that I could not refuse anything to my lover."

"But you must have a lover?"

"Yes; it is through him that I am rich, and he is entirely my master. I never conceal anything from him. The day after to-morrow, when I am alone with you, I will tell you more."

"But I hope that your lover...."

"Will not be there? Certainly not. Have you a mistress?"

"I had one, but, alas! she has been taken from me by violent means, and for the last six months I have led a life of complete celibacy."

"Do you love her still?"

"I cannot think of her without loving her. She has almost as great charms, as great beauty, as you have; but I foresee that you will make me forget her."

"If your happiness with her was complete, I pity you. She has been violently taken from you, and you shun society in order to feed your sorrow. I have guessed right, have I not? But if I happen to take possession of her place in your heart, no one, my sweet friend, shall turn me out of it."

"But what will your lover say?"

"He will be delighted to see me happy with such a lover as you. It is in his nature."

"What an admirable nature! Such heroism is quite beyond me!"

"What sort of a life do you lead in Venice?"

"I live at the theatres, in society, in the casinos, where I fight against fortune sometimes with good sometimes with bad success."

"Do you visit the foreign ambassadors?"

"No, because I am too much acquainted with the nobility; but I know them all."

"How can you know them if you do not see them?"

"I have known them abroad. In Parma the Duke de Montalegre, the Spanish ambassador; in Vienna I knew Count Rosemberg; in Paris, about two years ago, the French ambassador."

"It is near twelve o'clock, my dear friend; it is time for us to part. Come at the same hour the day after tomorrow, and I will give you all the instructions which you will require to enable you to come and sup with me."

"Alone?"

"Of course."

"May I venture to ask you for a pledge? The happiness which you promise me is so immense!"

"What pledge do you want?"

"To see you standing before that small window in the grating with permission for me to occupy the same place as Madame de S——."

She rose at once, and, with the most gracious smile, touched the spring; after a most expressive kiss, I took leave of her. She followed me with her eyes as far as the door, and her loving gaze would have rooted me to the spot if she had not left the room.

I spent the two days of expectation in a whirl of impatient joy, which prevented me from eating and sleeping; for it seemed to me that no other love had ever given me such happiness, or rather that I was going to be happy for the first time.

Irrespective of birth, beauty, and wit, which was the principal merit of my new conquest, prejudice was there to enhance a hundredfold my felicity, for she was a vestal: it was forbidden fruit, and who does not know that, from Eve down to our days, it was that fruit which has always appeared the most delicious! I was on the point of encroaching upon the rights of an all-powerful husband; in my eyes M—— M—— was above all the queens of the earth.

If my reason had not been the slave of passion, I should have known that my nun could not be a different creature from all the pretty women whom I had loved for the thirteen years that I had been labouring in the fields of love. But where is the man in love who can harbour such a thought? If it presents itself too often to his mind, he expels it disdainfully! M—— M—— could not by any means be otherwise than superior to all other women in the wide world.

Animal nature, which chemists call the animal kingdom, obtains through instinct the three various means necessary for the perpetuation of its species.

There are three real wants which nature has implanted in all human creatures. They must feed themselves, and to prevent that task from being insipid and tedious they have the agreeable sensation of appetite, which they feel pleasure in satisfying. They must propagate their respective species; an absolute necessity which proves the wisdom of the Creator, since without reproduction all would be annihilated—by the constant law of degradation, decay and death. And, whatever St. Augustine may say, human creatures would not perform the work of generation if they did not find pleasure in it, and if there was not in that great work an irresistible attraction for them. In the third place, all creatures have a determined and invincible propensity to destroy their enemies; and it is certainly a very wise ordination, for that feeling of self-preservation makes it a duty for them to do their best for the destruction of whatever can injure them.

Each species obeys these laws in its own way. The three sensations: hunger, desire, and hatred—are in animals the satisfaction of habitual instinct, and cannot be called pleasures, for they can be so only in proportion to the intelligence of the individual. Man alone is gifted with the perfect organs which render real pleasure peculiar to him; because, being endowed with the sublime faculty of reason, he foresees enjoyment, looks for it, composes, improves, and increases it by thought and recollection. I entreat you, dear

reader, not to get weary of following me in my ramblings; for now that I am but the shadow of the once brilliant Casanova, I love to chatter; and if you were to give me the slip, you would be neither polite nor obliging.

Man comes down to the level of beasts whenever he gives himself up to the three natural propensities without calling reason and judgment to his assistance; but when the mind gives perfect equilibrium to those propensities, the sensations derived from them become true enjoyment, an unaccountable feeling which gives us what is called happiness, and which we experience without being able to describe it.

The voluptuous man who reasons, disdains greediness, rejects with contempt lust and lewdness, and spurns the brutal revenge which is caused by a first movement of anger: but he is dainty, and satisfies his appetite only in a manner in harmony with his nature and his tastes; he is amorous, but he enjoys himself with the object of his love only when he is certain that she will share his enjoyment, which can never be the case unless their love is mutual; if he is offended, he does not care for revenge until he has calmly considered the best means to enjoy it fully. If he is sometimes more cruel than necessary, he consoles himself with the idea that he has acted under the empire of reason; and his revenge is sometimes so noble that he finds it in forgiveness. Those three operations are the work of the soul which, to procure enjoyment for itself, becomes the agent of our passions. We sometimes suffer from hunger in order to enjoy better the food which will allay it; we delay the amorous enjoyment for the sake of making it more intense, and we put off the moment of our revenge in order to mike it more certain. It is true, however, that one may die from indigestion, that we allow ourselves to be often deceived in love, and that the creature we want to annihilate often escapes our revenge; but perfection cannot be attained in anything, and those are risks which we run most willingly.

CHAPTER XVII

Continuation of the Last Chapter—My First Assignation With
M. M.—Letter From C. C.—My Second Meeting With the Nun At
My Splendid Casino In Venice I Am Happy

There is nothing, there can be nothing, dearer to a thinking being than life; yet the voluptuous men, those who try to enjoy it in the best manner, are the men who practise with the greatest perfection the difficult art of shortening life, of driving it fast. They do not mean to make it shorter, for they would like to perpetuate it in the midst of pleasure, but they wish enjoyment to render its course insensible; and they are right, provided they do not fail in fulfilling their duties. Man must not, however, imagine that he has no other duties but those which gratify his senses; he would be greatly mistaken, and he might fall the victim of his own error. I think that my friend Horace made a mistake when he said to Florus:

'Nec metuam quid de me judicet heres, Quod non plura datis inveniet.'

The happiest man is the one who knows how to obtain the greatest sum of happiness without ever failing in the discharge of his duties, and the most unhappy is the man who has adopted a profession in which he finds himself constantly under the sad necessity of foreseeing the future.

Perfectly certain that M—— M—— would keep her word, I went to the convent at ten o'clock in the morning, and she joined me in the parlour as soon as I was announced.

"Good heavens!" she exclaimed, "are you ill?"

"No, but I may well look so, for the expectation of happiness wears me out. I have lost sleep and appetite, and if my felicity were to be deferred my life would be the forfeit."

"There shall be no delay, dearest; but how impatient you are! Let us sit down. Here is the key of my casino. You will find some persons in it, because we must be served; but nobody will speak to you, and you need not speak to anyone. You must be masked, and you must not go there till two hours after sunset; mind, not before. Then go up the stairs opposite the street-door, and at the top of those stairs you will see, by the light of a lamp, a green door which you will open to enter the apartment which you will find lighted. You will find me in the second room, and in case I should not be there you will wait for me a few minutes; you may rely upon my being punctual. You can take off your mask in that room, and make yourself comfortable; you will find some books and a good fire."

The description could not be clearer; I kissed the hand which was giving me the key of that mysterious temple, and I enquired from the charming woman whether I should see her in her conventual garb.

"I always leave the convent with it," she said, "but I have at the casino a complete wardrobe to transform myself into an elegant woman of the world, and even to disguise myself."

"I hope you will do me the favour to remain in the dress of a nun."

"Why so, I beg?"

"I love to see you in that dress."

"Ah! ah! I understand. You fancy that my head is shaved, and you are afraid. But comfort yourself, dear friend, my wig is so beautifully made that it defies detection; it is nature itself."

"Oh, dear! what are you saying? The very name of wig is awful. But no, you may be certain that I will find you lovely under all circumstances. I only entreat you not to put on that cruel wig in my presence. Do I offend you? Forgive me; I am very sorry to have mentioned that subject. Are you sure that no one can see you leave the convent?"

"You will be sure of it yourself when you have gone round the island and seen the small door on the shore. I have the key of a room opening on the shore, and I have every confidence in the sister who serves me."

"And the gondola?"

"My lover himself answers for the fidelity of the gondoliers."

"What a man that lover is! I fancy he must be an old man."

"You are mistaken; if he were old, I should be ashamed. He is not forty, and he has everything necessary to be loved—beauty, wit, sweet temper, and noble behaviour."

"And he forgives your amorous caprices?"

"What do you mean by caprices? A year ago he obtained possession of me, and before him I had never belonged to a man; you are the first who inspired me with a fancy. When I confessed it to him he was rather surprised, then he laughed, and read me a short lecture upon the risk I was running in trusting a man who might prove indiscreet. He wanted me to know at least who you were before going any further, but it was too late. I answered for your discretion, and of course I made him laugh by my being so positively the guarantee of a man whom I did not know."

"When did you confide in him?"

"The day before yesterday, and without concealing anything from him. I have shewn him my letters and yours; he thinks you are a Frenchman, although you represent yourself as a Venetian. He is very curious to know

who you are, but you need not be afraid; I promise you faithfully never to take any steps to find it out myself."

"And I promise you likewise not to try to find out who is this wonderful man as wonderful as you are yourself. I am very miserable when I think of the sorrow I have caused you."

"Do not mention that subject any more; when I consider the matter, I see that only a conceited man would have acted differently."

Before leaving her, she granted me another token of her affection through the little window, and her gaze followed me as far as the door.

In the evening, at the time named by her, I repaired to the casino, and obeying all her instructions I reached a sitting-room in which I found my new conquest dressed in a most elegant costume. The room was lighted up by girandoles, which were reflected by the looking-glasses, and by four splendid candlesticks placed on a table covered with books. M—— M—— struck me as entirely different in her beauty to what she had seemed in the garb of a nun. She wore no cap, and her hair was fastened behind in a thick twist; but I passed rapidly over that part of her person, because I could not bear the idea of a wig, and I could not compliment her about it. I threw myself at her feet to shew her my deep gratitude, and I kissed with rapture her beautiful hands, waiting impatiently for the amorous contest which I was longing for; but M—— M—— thought fit to oppose some resistance. Oh, how sweet they are! those denials of a loving mistress, who delays the happy moment only for the sake of enjoying its delights better! As a lover respectful, tender, but bold, enterprising, certain of victory, I blended delicately the gentleness of my proceedings with the ardent fire which was consuming me; and stealing the most voluptuous kisses from the most beautiful mouth I felt as if my soul would burst from my body. We spent two hours in the preliminary contest, at the end of which we congratulated one another, on her part for having contrived to resist, on mine for having controlled my impatience.

Wanting a little rest, and understanding each other as if by a natural instinct, she said to me,

"My friend, I have an appetite which promises to do honour to the supper; are you able to keep me good company?"

"Yes," I said, knowing well what I could do in that line, "yes, I can; and afterwards you shall judge whether I am able to sacrifice to Love as well as to Comus."

She rang the bell, and a woman, middle-aged but well-dressed and respectable-looking, laid out a table for two persons; she then placed on another table close by all that was necessary to enable us to do without

attendance, and she brought, one after the other, eight different dishes in Sevres porcelain placed on silver heaters. It was a delicate and plentiful supper.

When I tasted the first dish I at once recognized the French style of cooking, and she did not deny it. We drank nothing but Burgundy and Champagne. She dressed the salad cleverly and quickly, and in everything she did I had to admire the graceful ease of her manners. It was evident that she owed her education to a lover who was a first-rate connoisseur. I was curious to know him, and as we were drinking some punch I told her that if she would gratify my curiosity in that respect I was ready to tell her my name.

"Let time, dearest," she answered, "satisfy our mutual curiosity."

M—— M—— had, amongst the charms and trinkets fastened to the chain of her watch, a small crystal bottle exactly similar to one that I wore myself. I called her attention to that fact, and as mine was filled with cotton soaked in otto of roses I made her smell it.

"I have the same," she observed.

And she made me inhale its fragrance.

"It is a very scarce perfume," I said, "and very expensive."

"Yes; in fact it cannot be bought."

"Very true; the inventor of that essence wears a crown; it is the King of France; his majesty made a pound of it, which cost him thirty thousand crowns."

"Mine was a gift presented to my lover, and he gave it to me:"

"Madame de Pompadour sent a small phial of it to M. de Mocenigo, the Venetian ambassador in Paris, through M. de B——, now French ambassador here."

"Do you know him?"

"I have had the honour to dine with him on the very day he came to take leave of the ambassador by whom I had been invited. M. de B—— is a man whom fortune has smiled upon, but he has captivated it by his merit; he is not less distinguished by his 'talents than by his birth; he is, I believe, Count de Lyon. I recollect that he was nicknamed 'Belle Babet,' on account of his handsome face. There is a small collection of poetry written by him which does him great honour."

It was near midnight; we had made an excellent supper, and we were near a good fire. Besides, I was in love with a beautiful woman, and thinking that time was precious—I became very pressing; but she resisted.

"Cruel darling, have you promised me happiness only to make me suffer the tortures of Tantalus? If you will not give way to love, at least obey the laws of nature after such a delicious supper, go to bed."

"Are you sleepy?"

"Of course I am not; but it is late enough to go to bed. Allow me to undress you; I will remain by your bedside, or even go away if you wish it."

"If you were to leave me, you would grieve me."

"My grief would be as great as yours, believe me, but if I remain what shall we do?"

"We can lie down in our clothes on this sofa."

"With our clothes! Well, let it be so; I will let you sleep, if you wish it; but you must forgive me if I do not sleep myself; for to sleep near you and without undressing would be impossible."

"Wait a little."

She rose from her seat, turned the sofa crosswise, opened it, took out pillows, sheets, blankets, and in one minute we had a splendid bed, wide and convenient. She took a large handkerchief, which she wrapped round my head, and she gave me another, asking me to render her the same service. I began my task, dissembling my disgust for the wig, but a precious discovery caused me the most agreeable surprise; for, instead of the wig, my, hands found the most magnificent hair I had ever seen. I uttered a scream of delight and admiration which made her laugh, and she told me that a nun was under no other obligation than to conceal her hair, from the uninitiated. Thereupon she pushed me adroitly, and made me fall' an the sofa. I got up again, and, having thrown off my clothes as quick as lightning I threw myself on her rather than near her. She was very strong; and folding me in her arms she thought that I ought to forgive her for all the torture she was condemning me to. I had not obtained any essential favour; I was burning, but I was trying to master my impatience, for I did not think that I had yet the right to be exacting. I contrived to undo five or six bows of ribbons, and satisfied, with her not opposing any resistance in that quarter my heart throbbed with pleasure, and I possessed myself of the most beautiful bosom, which I smothered under my kisses. But her favours went no further; and my excitement increasing in proportion to the new perfections I discovered in her, I doubled my efforts; all in vain. At last, compelled to give way to fatigue, I fell asleep in her arms, holding her tightly, against me. A noisy chime of bells woke us.

"What is the matter?" I exclaimed.

"Let us get up, dearest; it is time for me to return to the convent."

"Dress yourself, and let me have the pleasure of seeing you in the garb of a saint, since you are going away a virgin."

"Be satisfied for this time, dearest, and learn from me how to practice abstinence; we shall be happier another time. When I have gone, if you have nothing to hurry you, you can rest here."

She rang the bell, and the same woman who had appeared in the evening, and was most likely the secret minister and the confidante of her amorous mysteries, came in. After her hair had been dressed, she took off her gown, locked up her jewellery in her bureau, put on the stays of a nun, in which she hid the two magnificent globes which had been during that fatiguing night the principal agents of my happiness, and assumed her monastic robes. The woman having gone out to call the gondoliers, M—— M—— kissed me warmly and tenderly, and said to me,

"I expect to see you the day after to-morrow, so as to hear from you which night I am to meet you in Venice; and then, my beloved lover, you shall be happy and I too. Farewell."

Pleased without being satisfied, I went to bed and slept soundly until noon.

I left the casino without seeing anyone, and being well masked I repaired to the house of Laura, who gave me a letter from my dear C—— C——. Here is a copy of it:

"I am going to give you, my best beloved, a specimen of my way of thinking; and I trust that, far from lowering me in your estimation, you will judge me, in spite of my youth, capable of keeping a secret and worthy of being your wife. Certain that your heart is mine, I do not blame you for having made a mystery of certain things, and not being jealous of what can divert your mind and help you to bear patiently our cruel separation, I can only delight in whatever procures you some pleasure. Listen now. Yesterday, as I was going along one of the halls, I dropped a tooth-pick which I held in my hand, and to get it again, I was compelled to displace a stool which happened to be in front of a crack in the partition. I have already become as curious as a nun—a fault very natural to idle people—I placed my eye against the small opening, and whom did I see? You in person, my darling, conversing in the most lively manner with my charming friend, Sister M—— M——. It would be difficult for you to imagine my surprise and joy. But those two feelings gave way soon to the fear of being seen and of exciting the curiosity of some inquisitive nun. I quickly replaced the stool, and I went away. Tell me all, dearest friend, you will make me happy. How could I cherish you with all my soul, and not be anxious to know the history of your adventure? Tell me if she knows you, and how you have made her acquaintance. She is my best friend, the one of whom

I have spoken so often to you in my letters, without thinking it necessary to tell you her name. She is the friend who teaches me French, and has lent me books which gave me a great deal of information on a matter generally little known to women. If it had not been for her, the cause of the accident which has been so near costing me my life, would have been discovered. She gave me sheets and linen immediately; to her I owe my honour; but she has necessarily learned in that way that I have a lover, as I know that she has one; but neither of us has shewn any anxiety to know the secrets of the other. Sister M—— M—— is a rare woman. I feel certain, dearest, that you love one another; it cannot be otherwise since you are acquainted; but as I am not jealous of that affection, I deserve that you should tell me all. I pity you both, however; for all you may do will, I fear, only irritate your passion. Everyone in the convent thinks that you are ill, and I am longing to see you. Come, at least, once. Adieu!"

The letter of C—— C—— inspired me with the deepest esteem for her, but it caused me great anxiety, because, although I felt every confidence in my dear little wife, the small crack in the wall might expose M—— M—— and myself to the inquisitive looks of other persons. Besides, I found myself compelled to deceive that amiable, trusting friend, and to tell a falsehood, for delicacy and honour forbade me to tell her the truth. I wrote to her immediately that her friendship for M—— M—— made it her duty to warn her friend at once that she had seen her in the parlour with a masked gentleman. I added that, having heard a great deal of M—— M——'s merit, and wishing to make her acquaintance, I had called on her under an assumed name; that I entreated her not to tell her friend who I was, but she might say that she had recognized in me the gentleman who attended their church. I assured her with barefaced impudence that there was no love between M—— M—— and me, but without concealing that I thought her a superior woman.

On St. Catherine's Day, the patroness of my dear C—— C——, I bethought myself of affording that lovely prisoner the pleasure of seeing me. As I was leaving the church after mass, and just as I was going to take a gondola, I observed that a man was following me. It looked suspicious, and I determined to ascertain whether I was right. The man took a gondola and followed mine. It might have been purely accidental; but, keeping on my guard for fear of surprise, I alighted in Venice at the Morosini Palace; the fellow alighted at the same place; his intentions were evident. I left the palace, and turning towards the Flanders Gate I stopped in a narrow street, took my knife in my hand, waited for the spy, seized him by the collar, and pushing him against the wall with the knife at his throat I commanded him

to tell me what business he had with me. Trembling all over he would have confessed everything, but unluckily someone entered the street. The spy escaped and I was no wiser, but I had no doubt that for the future that fellow at least would keep at a respectful distance. It shewed me how easy it would be for an obstinate spy to discover my identity, and I made up my mind never to go to Muran but with a mask, or at night.

The next day I had to see my beautiful nun in order to ascertain which day she would sup with me in Venice, and I went early to the convent. She did not keep me waiting, and her face was radiant with joy. She complimented me upon my having resumed my attendance at their church; all the nuns had been delighted to see me again after an absence of three weeks.

"The abbess," she said, "told me how glad she was to see you, and that she was certain to find out who you are."

I then related to her the adventure of the spy, and we both thought that it was most likely the means taken by the sainted woman to gratify her curiosity about me.

"I have resolved not to attend your church any more."

"That will be a great deprivation to me, but in our common interest I can but approve your resolution."

She related the affair of the treacherous crack in the partition, and added, "It is already repaired, and there is no longer any fear in that quarter. I heard of it from a young boarder whom I love dearly, and who is much attached to me. I am not curious to know her name, and she has never mentioned it to me."

"Now, darling angel, tell me whether my happiness will be postponed."

"Yes, but only for twenty-four hours; the new professed sister has invited me to supper in her room, and you must understand I cannot invent any plausible excuse for refusing her invitation."

"You would not, then, tell her in confidence the very legitimate obstacle which makes me wish that the new sisters never take supper?"

"Certainly not: we never trust anyone so far in a convent. Besides, dearest, such an invitation cannot be declined unless I wish to gain a most bitter enemy."

"Could you not say that you are ill?"

"Yes; but then the visits!"

"I understand; if you should refuse, the escape might be suspected."

"The escape! impossible; here no one admits the possibility of breaking out of the convent."

"Then you are the only one able to perform that miracle?"

"You may be sure of that; but, as is always the case, it is gold which performs that miracle."

"And many others, perhaps."

"Oh! the time has gone by for them! But tell me, my love, where will you wait for me to-morrow, two hours after the setting of the sun?"

"Could I not wait for you at your casino?"

"No, because my lover will take me himself to Venice."

"Your lover?"

"Yes, himself."

"It is not possible."

"Yet it is true."

"I can wait for you in St. John and St. Paul's Square behind the pedestal of the statue of Bartholomew of Bergamo."

"I have never seen either the square or the statue except in engravings; it is enough, however, and I will not fail. Nothing but very stormy weather could prevent me from coming to a rendezvous for which my heart is panting."

"And if the weather were bad?"

"Then, dearest, there would be nothing lost; and you would come here again in order to appoint another day."

I had no time to lose, for I had no casino. I took a second rower so as to reach St. Mark's Square more rapidly, and I immediately set to work looking for what I wanted. When a mortal is so lucky as to be in the good graces of the god Plutus, and is not crackbrained, he is pretty sure to succeed in everything: I had not to search very long before I found a casino suiting my purpose exactly. It was the finest in the neighbourhood of Venice, but, as a natural consequence, it was likewise the most expensive. It had belonged to the English ambassador, who had sold it cheap to his cook before leaving Venice. The owner let it to me until Easter for one hundred sequins, which I paid in advance on condition that he would himself cook the dinners and the suppers I might order.

I had five rooms furnished in the most elegant style, and everything seemed to be calculated for love, pleasure, and good cheer. The service of the dining-room was made through a sham window in the wall, provided with a dumb-waiter revolving upon itself, and fitting the window so exactly that master and servants could not see each other. The drawing-room was decorated with magnificent looking-glasses, crystal chandeliers, girandoles in gilt, bronze, and with a splendid pier-glass placed on a chimney of white marble; the walls were covered with small squares of real china, representing

little Cupids and naked amorous couples in all sorts of positions, well calculated to excite the imagination; elegant and very comfortable sofas were placed on every side. Next to it was an octagonal room, the walls, the ceiling, and the floor of which were entirely covered with splendid Venetian glass, arranged in such a manner as to reflect on all sides every position of the amorous couple enjoying the pleasures of love. Close by was a beautiful alcove with two secret outlets; on the right, an elegant dressing-room, on the left, a boudoir which seemed to have been arranged by the mother of Love, with a bath in Carrara marble. Everywhere the wainscots were embossed in ormolu or painted with flowers and arabesques.

After I had given my orders for all the chandeliers to be filled with wax candles, and the finest linen to be provided wherever necessary, I ordered a most delicate and sumptuous supper for two, without regard to expense, and especially the most exquisite wines. I then took possession of the key of the principal entrance, and warned the master that I did not want to be seen by anyone when I came in or went out.

I observed with pleasure that the clock in the alcove had an alarum, for I was beginning, in spite of love, to be easily influenced by the power of sleep.

Everything being arranged according to my wishes, I went, as a careful and delicate lover, to purchase the finest slippers I could find, and a cap in Alencon point.

I trust my reader does not think me too particular; let him recollect that I was to receive the most accomplished of the sultanas of the master of the universe, and I told that fourth Grace that I had a casino. Was I to begin by giving her a bad idea of my truthfulness? At the appointed time, that is two hours after sunset, I repaired to my palace; and it would be difficult to imagine the surprise of his honour the French cook, when he saw me arrive alone. Not finding all the chandeliers lighted-up as I had ordered, I scolded him well, giving him notice that I did not like to repeat an order.

"I shall not fail; sir, another time, to execute your commands."

"Let the supper be served."

"Your honour ordered it for two."

"Yes, for two; and, this time, be present during my supper, so that I can tell you which dishes I find good or bad."

The supper came through the revolving dumb-waiter in very good order, two dishes at a tune. I passed some remarks upon everything; but, to tell the truth, everything was excellent: game, fish, oysters, truffles, wine, dessert, and the whole served in very fine Dresden china and silver-gilt plate.

I told him that he had forgotten hard eggs, anchovies, and prepared vinegar to dress a salad. He lifted his eyes towards heaven, as if to plead guilty, to a very heinous crime.

After a supper which lasted two hours, and during which I must certainly have won the admiration of my host, I asked him to bring me the bill. He presented it to me shortly afterwards, and I found it reasonable. I then dismissed him, and lay down in the splendid bed in the alcove; my excellent supper brought on very soon the most delicious sleep which, without the Burgundy and the Champagne, might very likely not have visited me, if I had thought that the following night would see me in the same place, and in possession of a lovely divinity. It was broad day-light when I awoke, and after ordering the finest fruit and some ices for the evening I left the casino. In order to shorten a day which my impatient desires would have caused me to find very long, I went to the faro-table, and I saw with pleasure that I was as great a favourite with fortune as with love. Everything proceeded according to my wishes, and I delighted in ascribing my happy success to the influence of my nun.

I was at the place of meeting one hour before the time appointed, and although the night was cold I did not feel it. Precisely as the hour struck I saw a two-oared gondola reach the shore and a mask come out of it, speak a few words to the gondolier, and take the direction of the statue. My heart was beating quickly, but seeing that it was a man I avoided him, and regretted not having brought my pistols. The mask, however, turning round the statue, came up to me with outstretched hands; I then recognized my angel, who was amused at my surprise and took my arm. Without speaking we went towards St. Mark's Square, and reached my casino, which was only one hundred yards from the St. Moses Theatre.

I found everything in good order; we went upstairs and I threw off my mask and my disguise; but M—— M—— took delight in walking about the rooms and in examining every nook of the charming place in which she was received. Highly gratified to see me admire the grace of her person, she wanted me likewise to admire in her attire the taste and generosity of her lover. She was surprised at the almost magic spell which, although she remained motionless, shewed her lovely person in a thousand different manners. Her multiplied portraits, reproduced by the looking-glasses, and the numerous wax candles disposed to that effect, offered to her sight a spectacle entirely new to her, and from which she could not withdraw her eyes. Sitting down on a stool I contemplated her elegant person with rapture. A coat of rosy velvet, embroidered with gold spangles, a vest to match, embroidered

likewise in the richest fashion, breeches of black satin, diamond buckles, a solitaire of great value on her little finger, and on the other hand a ring: such was her toilet. Her black lace mask was remarkable for its fineness and the beauty of the design. To enable me to see her better she stood before me. I looked in her pockets, in which I found a gold snuff-box, a sweetmeat-box adorned with pearls, a gold case, a splendid opera-glass, handkerchiefs of the finest cambric, soaked rather than perfumed with the most precious essences. I examined attentively the richness and the workmanship of her two watches, of her chains, of her trinkets, brilliant with diamonds. The last article I found was a pistol; it was an English weapon of fine steel, and of the most beautiful finish.

"All I see, my divine angel, is not worthy of you; yet I cannot refrain from expressing my admiration for the wonderful, I might almost say adorable, being who wants to convince you that you are truly his mistress."

"That is what he said when I asked him to bring me to Venice, and to leave me. 'Amuse yourself,' he said, 'and I hope that the man whom you are going to make happy will convince you that he is worthy of it.'"

"He is indeed an extraordinary man, and I do not think there is another like him. Such a lover is a unique being; and I feel that I could not be like him, as deeply as I fear to be unworthy of a happiness which dazzles me."

"Allow me to leave you, and to take off these clothes alone."

"Do anything you please."

A quarter of an hour afterwards my mistress came back to me. Her hair was dressed like a man's; the front locks came down her cheeks, and the black hair, fastened with a knot of blue ribbon, reached the bend of her legs; her form was that of Antinous; her clothes alone, being cut in the French style, prevented the illusion from being complete. I was in a state of ecstatic delight, and I could not realize my happiness.

"No, adorable woman," I exclaimed, "you are not made for a mortal, and I do not believe that you will ever be mine. At the very moment of possessing you some miracle will wrest you from my arms. Your divine spouse, perhaps, jealous of a simple mortal, will annihilate all my hope. It is possible that in a few minutes I shall no longer exist."

"Are you mad, dearest? I am yours this very instant, if you wish it."

"Ah! if I wish it! Although fasting, come! Love and happiness will be my food!"

She felt cold, we sat near the fire; and unable to master my impatience I unfastened a diamond brooch which pinned her ruffle. Dear reader, there are some sensations so powerful and so sweet that years cannot weaken the

remembrance of them. My mouth had already covered with kisses that ravishing bosom; but then the troublesome corset had not allowed me to admire all its perfection. Now I felt it free from all restraint and from all unnecessary support; I have never seen, never touched, anything more beautiful, and the two magnificent globes of the Venus de Medicis, even if they had been animated by the spark of life given by Prometheus, would have yielded the palm to hose of my divine nun.

I was burning with ardent desires, and I would have satisfied them on the spot, if my adorable mistress had not calmed my impatience by these simple words:

"Wait until after supper."

I rang the bell; she shuddered.

"Do not be anxious, dearest."

And I shewed her the secret of the sham window.

"You will be able to tell your lover that no one saw you."

"He will appreciate your delicate attention, and that will prove to him that you are not a novice in the art of love. But it is evident that I am not the only one who enjoys with you the delights of this charming residence."

"You are wrong, believe me: you are the first woman I have seen here. You are not, adorable creature, my first love, but you shall be the last."

"I shall be happy if you are faithful. My lover is constant, kind, gentle and amiable; yet my heart has ever been fancy-free with him."

"Then his own heart must be the same; for if his love was of the same nature as mine you would never have made me happy."

"He loves me as I love you; do you believe in my love for you?"

"Yes, I want to believe in it; but you would not allow me to...."

"Do not say any more; for I feel that I could forgive you in anything, provided you told me all. The joy I experience at this moment is caused more by the hope I have of gratifying your desires than by the idea that I am going to pass a delightful night with you. It will be the first in my life."

"What! Have you never passed such a night with your lover?"

"Several; but friendship, compliance, and gratitude, perhaps, were then the only contributors to our pleasures; the most essential—love—was never present. In spite of that, my lover is like you; his wit is lively, very much the same as yours, and, as far as his features are concerned, he is very handsome; yet it is not you. I believe him more wealthy than you, although this casino almost convinces me that I am mistaken, but what does love care for riches? Do not imagine that I consider you endowed with less merit than he, because you confess yourself incapable of his heroism in allowing me to enjoy another

love. Quite the contrary; I know that you would not love me as you do, if you told me that you could be as indulgent as he is for one of my caprices."

"Will he be curious to hear the particulars of this night?"

"Most likely he will think that he will please me by asking what has taken place, and I will tell him everything, except such particulars as might humiliate him."

After the supper, which she found excellent, she made some punch, and she was a very good hand at it. But I felt my impatience growing stronger every moment, and I said,

"Recollect that we have only seven hours before us, and that we should be very foolish to waste them in this room."

"You reason better than Socrates," she answered, "and your eloquence has convinced me. Come!"

She led me to the elegant dressing-room, and I offered her the fine night-cap which I had bought for her, asking her at the same time to dress her hair like a woman. She took it with great pleasure, and begged me to go and undress myself in the drawing-room, promising to call me as soon as she was in bed.

I had not long to wait: when pleasure is waiting for us, we all go quickly to work. I fell into her arms, intoxicated with love and happiness, and during seven hours I gave her the most positive proofs of my ardour and of the feelings I entertained for her. It is true that she taught me nothing new, materially speaking, but a great deal in sighs, in ecstasies, in enjoyments which can have their full development only in a sensitive soul in the sweetest of all moments. I varied our pleasures in a thousand different ways, and I astonished her by making her feel that she was susceptible of greater enjoyment than she had any idea of. At last the fatal alarum was heard: we had to stop our amorous transports; but before she left my arms she raised her eyes towards heaven as if to thank her Divine Master for having given her the courage to declare her passion to me.

We dressed ourselves, and observing that I put the lace night-cap in her pocket she assured me that she would keep it all her life as a witness of the happiness which overwhelmed her. After drinking a cup of coffee we went out, and I left her at St. John and St. Paul's Square, promising to call on her the day after the morrow; I watched her until I saw her safe in her gondola, and I then went to bed. Ten hours of profound sleep restored me to my usual state of vigour.

CHAPTER XVIII

Visit to the Convent and Conversation With M. M.—A Letter from Her, and My Answer—Another Interview At the Casino of Muran In the Presence of Her Lover

According to my promise, I went to see M—— M—— two days afterwards, but as soon as she came to the parlour she told me that her lover had said he was coming, and that she expected him every minute, and that she would be glad to see me the next day. I took leave of her, but near the bridge I saw a man, rather badly masked, coming out of a gondola. I looked at the gondolier, and I recognized him as being in the service of the French ambassador. "It is he," I said to myself, and without appearing to observe him I watched him enter the convent. I had no longer any doubt as to his identity, and I returned to Venice delighted at having made the discovery, but I made up my mind not to say anything to my mistress.

I saw her on the following day, and we, had a long conversation together, which I am now going to relate.

"My friend," she said to me, "came yesterday in order to bid farewell to me until the Christmas holidays. He is going to Padua, but everything has been arranged so that we can sup at his casino whenever we wish."

"Why not in Venice?"

"He has begged me not to go there during his absence. He is wise and prudent; I could not refuse his request."

"You are quite right. When shall we sup together?"

"Next Sunday, if you like."

"If I like is not the right expression, for I always like. On Sunday, then, I will go to the casino towards nightfall, and wait for you with a book. Have you told your friend that you were not very uncomfortable in my small palace?"

"He knows all about it, but, dearest, he is afraid of one thing—he fears a certain fatal plumpness...."

"On my life, I never thought of that! But, my darling, do you not run the same risk with him?"

"No, it is impossible."

"I understand you. Then we must be very prudent for the future. I believe that, nine days before Christmas, the mask is no longer allowed, and then I shall have to go to your casino by water, otherwise, I might easily be recognized by the same spy who has already followed me once."

"Yes, that idea proves your prudence, and I can easily, shew you the place. I hope you will be able to come also during Lent, although we are told that at that time God wishes us to mortify our senses. Is it not strange that there is a time during which God wants us to amuse ourselves almost to frenzy, and another during which, in order to please Him, we must live in complete abstinence? What is there in common between a yearly observance and the Deity, and how can the action of the creature have any influence over the Creator, whom my reason cannot conceive otherwise than independent? It seems to me that if God had created man with the power of offending Him, man would be right in doing everything that is forbidden to him, because the deficiencies of his organization would be the work of the Creator Himself. How can we imagine God grieved during Lent?"

"My beloved one, you reason beautifully, but will you tell me where you have managed, in a convent, to pass the Rubicon?"

"Yes. My friend has given me some good books which I have read with deep attention, and the light of truth has dispelled the darkness which blinded my eyes. I can assure you that, when I look in my own heart, I find myself more fortunate in having met with a person who has brought light to my mind than miserable at having taken the veil; for the greatest happiness must certainly consist in living and in dying peacefully—a happiness which can hardly be obtained by listening to all the idle talk with which the priests puzzle our brains."

"I am of your opinion, but I admire you, for it ought to be the work of more than a few months to bring light to a mind prejudiced as yours was."

"There is no doubt that I should have seen light much sooner if I had not laboured under so many prejudices. There was in my mind a curtain dividing truth from error, and reason alone could draw it aside, but that poor reason—I had been taught to fear it, to repulse it, as if its bright flame would have devoured, instead of enlightening me. The moment it was proved to me that a reasonable being ought to be guided only by his own inductions I acknowledged the sway of reason, and the mist which hid truth from me was dispelled. The evidence of truth shone before my eyes, nonsensical trifles disappeared, and I have no fear of their resuming their influence over my mind, for every day it is getting stronger; and I may say that I only began to love God when my mind was disabused of priestly superstitions concerning Him."

"I congratulate you; you have been more fortunate than I, for you have made more progress in one year than I have made in ten."

"Then you did not begin by reading the writings of Lord Bolingbroke? Five or six months ago, I was reading La Sagesse, by Charron, and somehow or other my confessor heard of it; when I went to him for confession, he took upon himself to tell me to give up reading that book. I answered that my conscience did not reproach me, and that I could not obey him. 'In that case,' replied he, 'I will not give you absolution.' 'That will not prevent me from taking the communion,' I said. This made him angry, and, in order to know what he ought to do, he applied to Bishop Diedo. His eminence came to see me, and told me that I ought to be guided by my confessor. I answered that we had mutual duties to perform, and that the mission of a priest in the confessional was to listen to me, to impose a reasonable penance, and to give me absolution; that he had not even the right of offering me any advice if I did not ask for it. I added that the confessor being bound to avoid scandal, if he dared to refuse me the absolution, which, of course, he could do, I would all the same go to the altar with the other nuns. The bishop, seeing that he was at his wit's end, told the priest to abandon me to my conscience. But that was not satisfactory to me, and my lover obtained a brief from the Pope authorizing me to go to confession to any priest I like. All the sisters are jealous of the privilege, but I have availed myself of it only once, for the sake of establishing a precedent and of strengthening the right by the fact, for it is not worth the trouble. I always confess to the same priest, and he has no difficulty in giving me absolution, for I only tell him what I like."

"And for the rest you absolve yourself?"

"I confess to God, who alone can know my thoughts and judge the degree of merit or of demerit to be attached to my actions."

Our conversation shewed me that my lovely friend was what is called a Free-thinker; but I was not astonished at it, because she felt a greater need of peace for her conscience than of gratification for her senses.

On the Sunday, after dinner, I took a two-oared gondola, and went round the island of Muran to reconnoitre the shore, and to discover the small door through which my mistress escaped from the convent. I lost my trouble and my time, for I did not become acquainted with the shore till the octave of Christmas, and with the small door six months afterwards. I shall mention the circumstance in its proper place.

As soon as it was time, I repaired to the temple, and while I was waiting for the idol I amused myself in examining the books of a small library in the boudoir. They were not numerous, but they were well chosen and worthy of the place. I found there everything that has been written against religion, and all the works of the most voluptuous writers on pleasure; attractive books, the

incendiary style of which compels the reader to seek the reality of the image they represent. Several folios, richly bound, contained nothing but erotic engravings. Their principal merit consisted much more in the beauty of the designs, in the finish of the work, than in the lubricity of the positions. I found amongst them the prints of the Portier des Chartreux, published in England; the engravings of Meursius, of Aloysia Sigea Toletana, and others, all very beautifully done. A great many small pictures covered the walls of the boudoir, and they were all masterpieces in the same style as the engravings.

I had spent an hour in examining all these works of art, the sight of which had excited me in the most irresistible manner, when I saw my beautiful mistress enter the room, dressed as a nun. Her appearance was not likely to act as a sedative, and therefore, without losing any time in compliments, I said to her,

"You arrive most opportunely. All these erotic pictures have fired my imagination, and it is in your garb of a saint that you must administer the remedy that my love requires."

"Let me put on another dress, darling, it will not take more than five minutes."

"Five minutes will complete my happiness, and then you can attend to your metamorphosis."

"But let me take off these woollen robes, which I dislike."

"No; I want you to receive the homage of my love in the same dress which you had on when you gave birth to it."

She uttered in the humblest manner a 'fiat voluntas tua', accompanied by the most voluptuous smile, and sank on the sofa. For one instant we forgot all the world besides. After that delightful ecstacy I assisted her to undress, and a simple gown of Indian muslin soon metamorphosed my lovely nun into a beautiful nymph.

After an excellent supper, we agreed not to meet again till the first day of the octave. She gave me the key of the gate on the shore, and told me that a blue ribbon attached to the window over the door would point it out by day, so as to prevent my making a mistake at night. I made her very happy by telling her that I would come and reside in her casino until the return of her friend. During the ten days that I remained there, I saw her four times, and I convinced her that I lived only for her.

During my stay in the casino I amused myself in reading, in writing to C—— C——, but my love for her had become a calm affection. The lines which interested me most in her letters were those in which she mentioned her friend. She often blamed me for not having cultivated the acquaintance

of M—— M——, and my answer was that I had not done so for fear of being known. I always insisted upon the necessity of discretion.

I do not believe in the possibility of equal love being bestowed upon two persons at the same time, nor do I believe it possible to keep love to a high degree of intensity if you give it either too much food or none at all. That which maintained my passion for M—— M —— in a state of great vigour was that I could never possess her without running the risk of losing her.

"It is impossible," I said to her once, "that some time or other one of the nuns should not want to speak to you when you are absent?"

"No," she answered, "that cannot happen, because there is nothing more religiously respected in a convent than the right of a nun to deny herself, even to the abbess. A fire is the only circumstance I have to fear, because in that case there would be general uproar and confusion, and it would not appear natural that a nun should remain quietly locked up in her cell in the midst of such danger; my escape would then be discovered. I have contrived to gain over the lay-sister and the gardener, as well as another nun, and that miracle was performed by my cunning assisted by my lover's gold.

"He answers for the fidelity of the cook and his wife who take care of the casino. He has likewise every confidence in the two gondoliers, although one of them is sure to be a spy of the State Inquisitors."

On Christmas Eve she announced the return of her lover, and she told him that on St. Stephen's Day she would go with him to the opera, and that they would afterwards spend the night together.

"I shall expect you, my beloved one," she added, "on the last day of the year, and here is a letter which I beg you not to read till you get home."

As I had to move in order to make room for her lover, I packed my things early in the morning, and, bidding farewell to a place in which during ten days I had enjoyed so many delights, I returned to the Bragadin Palace, where I read the following letter:

"You have somewhat offended me, my own darling, by telling me, respecting the mystery which I am bound to keep on the subject of my lover, that, satisfied to possess my heart, you left me mistress of my mind. That division of the heart and of the mind appears to me a pure sophism, and if it does not strike you as such you must admit that you do not love me wholly, for I cannot exist without mind, and you cannot cherish my heart if it does not agree with my mind. If your love cannot accept a different state of things it does not excel in delicacy. However, as some circumstance might occur in which you might accuse me of not having acted towards you with all the sincerity that true love inspires, and that it has a right to demand, I have

made up my mind to confide to you a secret which concerns my friend, although I am aware that he relies entirely upon my discretion. I shall certainly be guilty of a breach of confidence, but you will not love me less for it, because, compelled to choose between you two, and to deceive either one or the other, love has conquered friendship; do not punish me for it, for it has not been done blindly, and you will, I trust, consider the reasons which have caused the scale to weigh down in your favour.

"When I found myself incapable of resisting my wish to know you and to become intimate with you, I could not gratify that wish without taking my friend into my confidence, and I had no doubt of his compliance. He conceived a very favourable opinion of your character from your first letter, not only because you had chosen the parlour of the convent for our first interview, but also because you appointed his casino at Muran instead of your own. But he likewise begged of me to allow him to be present at our first meeting-place, in a small closet—a true hiding-place, from which one can see and hear everything without being suspected by those in the drawing-room. You have not yet seen that mysterious closet, but I will shew it to you on the last day of the year. Tell me, dearest, whether I could refuse that singular request to the man who was shewing me such compliant kindness? I consented, and it was natural for me not to let you know it. You are therefore aware now that my friend was a witness of all we did and said during the first night that we spent together, but do not let that annoy you, for you pleased him in everything, in your behaviour towards me as well as in the witty sayings which you uttered to make me laugh. I was in great fear, when the conversation turned upon him, lest you would say something which might hurt his self-love, but, very fortunately, he heard only the most flattering compliments. Such is, dearest love, the sincere confession of my treason, but as a wise lover you will forgive me because it has not done you the slightest harm. My friend is extremely curious to ascertain who you are. But listen to me, that night you were natural and thoroughly amiable, would you have been the same, if you had known that there was a witness? It is not likely, and if I had acquainted you with the truth, you might have refused your consent, and perhaps you would have been right.

"Now that we know each other, and that you entertain no doubt, I trust, of my devoted love, I wish to ease my conscience and to venture all. Learn then, dearest, that on the last day of the year, my friend will be at the casino, which he will leave only the next morning. You will not see him, but he will see us. As you are supposed not to know anything about it, you must feel that you will have to be natural in everything, otherwise, he might guess that I

have betrayed the secret. It is especially in your conversation that you must be careful. My friend possesses every virtue except the theological one called faith, and on that subject you can say anything you like. You will be at liberty to talk literature, travels, politics, anything you please, and you need not refrain from anecdotes. In fact you are certain of his approbation.

"Now, dearest, I have only this to say. Do you feel disposed to allow yourself to be seen by another man while you are abandoning yourself to the sweet voluptuousness of your senses? That doubt causes all my anxiety, and I entreat from you an answer, yes or no. Do you understand how painful the doubt is for me? I expect not to close my eyes throughout the night, and I shall not rest until I have your decision. In case you should object to shew your tenderness in the presence of a third person, I will take whatever determination love may suggest to me. But I hope you will consent, and even if you were not to perform the character of an ardent lover in a masterly manner, it would not be of any consequence. I will let my friend believe that your love has not reached its apogee"

That letter certainly took me by surprise, but all things considered, thinking that my part was better than the one accepted by the lover, I laughed heartily at the proposal. I confess, however, that I should not have laughed if I had not known the nature of the individual who was to be the witness of my amorous exploits. Understanding all the anxiety of my friend, and wishing to allay it, I immediately wrote to her the following lines:

"You wish me, heavenly creature, to answer you yes or no, and I, full of love for you, want my answer to reach you before noon, so that you may dine in perfect peace.

"I will spend the last night of the year with you, and I can assure you that the friend, to whom we will give a spectacle worthy of Paphos and Amathos, shall see or hear nothing likely to make him suppose that I am acquainted with his secret. You may be certain that I will play my part not as a novice but as a master. If it is man's duty to be always the slave of his reason; if, as long as he has control over himself, he ought not to act without taking it for his guide, I cannot understand why a man should be ashamed to shew himself to a friend at the very moment that he is most favoured by love and nature.

"Yet I confess that you would have been wrong if you had confided the secret to me the first time, and that most likely I should then have refused to grant you that mark of my compliance, not because I loved you less then than I do now, but there are such strange tastes in nature that I might have imagined that your lover's ruling taste was to enjoy the sight of an ardent and frantic couple in the midst of amorous connection, and in that case,

conceiving an unfavourable opinion of you, vexation might have frozen the love you had just sent through my being. Now, however, the case is very different. I know all I possess in you, and, from all you have told me of your lover, I am well disposed towards him, and I believe him to be my friend. If a feeling of modesty does not deter you from shewing yourself tender, loving, and full of amorous ardour with me in his presence, how could I be ashamed, when, on the contrary, I ought to feel proud of myself? I have no reason to blush at having made a conquest of you, or at shewing myself in those moments during which I prove the liberality with which nature has bestowed upon me the shape and the strength which assure such immense enjoyment to me, besides the certainty that I can make the woman I love share it with me. I am aware that, owing to a feeling which is called natural, but which is perhaps only the result of civilization and the effect of the prejudices inherent in youth, most men object to any witness in those moments, but those who cannot give any good reasons for their repugnance must have in their nature something of the cat. At the same time, they might have some excellent reasons, without their thinking themselves bound to give them, except to the woman, who is easily deceived. I excuse with all my heart those who know that they would only excite the pity of the witnesses, but we both have no fear of that sort. All you have told me of your friend proves that he will enjoy our pleasures. But do you know what will be the result of it? The intensity of our ardour will excite his own, and he will throw himself at my feet, begging and entreating me to give up to him the only object likely to calm his amorous excitement. What could I do in that case? Give you up? I could hardly refuse to do so with good grace, but I would go away, for I could not remain a quiet spectator.

"Farewell, my darling love; all will be well, I have no doubt. Prepare yourself for the athletic contest, and rely upon the fortunate being who adores you."

I spent the six following days with my three worthy friends, and at the 'ridotto', which at that time was opened on St. Stephen's Day. As I could not hold the cards there, the patricians alone having the privilege of holding the bank, I played morning and evening, and I constantly lost; for whoever punts must lose. But the loss of the four or five thousand sequins I possessed, far from cooling my love, seemed only to increase its ardour.

At the end of the year 1774 the Great Council promulgated a law forbidding all games of chance, the first effect of which was to close the 'ridotto'. This law was a real phenomenon, and when the votes were taken out of the urn the senators looked at each other with stupefaction. They had

made the law unwittingly, for three-fourths of the voters objected to it, and yet three-fourths of the votes were in favour of it. People said that it was a miracle of St. Mark's, who had answered the prayers of Monsignor Flangini, then censor-in-chief, now cardinal, and one of the three State Inquisitors.

On the day appointed I was punctual at the place of rendezvous, and I had not to wait for my mistress. She was in the dressing-room, where she had had time to attend to her toilet, and as soon as she heard me she came to me dressed with the greatest elegance.

"My friend is not yet at his post," she said to me, "but the moment he is there I will give you a wink."

"Where is the mysterious closet?"

"There it is. Look at the back of this sofa against the wall. All those flowers in relief have a hole in the centre which communicates with the closet behind that wall. There is a bed, a table, and everything necessary to a person who wants to spend the night in amusing himself by looking at what is going on in this room. I will skew it to you whenever you like."

"Was it arranged by your lover's orders?"

"No, for he could not foresee that he would use it."

"I understand that he may find great pleasure in such a sight, but being unable to possess you at the very moment nature will make you most necessary to him, what will he do?"

"That is his business. Besides, he is at liberty to go away when he has had enough of it, or to sleep if he has a mind to, but if you play your part naturally he will not feel any weariness."

"I will be most natural, but I must be more polite."

"No, no politeness, I beg, for if you are polite, goodbye to nature. Where have you ever seen, I should like to know, two lovers, excited by all the fury of love, think of politeness?"

"You are right, darling, but I must be more delicate."

"Very well, delicacy can do no harm, but no more than usual. Your letter greatly pleased me, you have treated the subject like a man of experience."

I have already stated that my mistress was dressed most elegantly, but I ought to have added that it was the elegance of the Graces, and that it did not in any way prevent ease and simplicity. I only wondered at her having used some paint for the face, but it rather pleased me because she had applied it according to the fashion of the ladies of Versailles. The charm of that style consists in the negligence with which the paint is applied. The rouge must not appear natural; it is used to please the eyes which see in it the marks of an

intoxication heralding the most amorous fury. She told me that she had put some on her face to please her inquisitive friend, who was very fond of it.

"That taste," I said, "proves him to be a Frenchman."

As I was uttering these words, she made a sign to me; the friend was at his post, and now the play began.

"The more I look at you, beloved angel, the more I think you worthy of my adoration."

"But are you not certain that you do not worship a cruel divinity?"

"Yes, and therefore I do not offer my sacrifices to appease you, but to excite you. You shall feel all through the night the ardour of my devotion."

"You will not find me insensible to your offerings."

"I would begin them at once, but I think that, in order to insure their efficiency, we ought to have supper first. I have taken nothing to-day but a cup of chocolate and a salad of whites of eggs dressed with oil from Lucca and Marseilles vinegar."

"But, dearest, it is folly! you must be ill?"

"Yes, I am just now, but I shall be all right when I have distilled the whites of eggs, one by one, into your amorous soul."

"I did not think you required any such stimulants."

"Who could want any with you? But I have a rational fear, for if I happened to prime without being able to fire, I would blow my brains out."

"My dear browny, it would certainly be a misfortune, but there would be no occasion to be in despair on that account."

"You think that I would only have to prime again."

"Of course."

While we were bantering in this edifying fashion, the table had been laid, and we sat down to supper. She ate for two and I for four, our excellent appetite being excited by the delicate cheer. A sumptuous dessert was served in splendid silver-gilt plate, similar to the two candlesticks which held four wax candles each. Seeing that I admired them, she said:

"They are a present from my friend."

"It is a magnificent present, has he given you the snuffers likewise?"

"No"

"It is a proof that your friend is a great nobleman."

"How so?"

"Because great lords have no idea of snuffing the candle."

"Our candles have wicks which never require that operation."

"Good! Tell me who has taught you French."

"Old La Forest. I have been his pupil for six years. He has also taught me to write poetry, but you know a great many words which I never heard from him, such as 'a gogo, frustratoire, rater, dorloter'. Who taught you these words?"

"The good company in Paris, and women particularly."

We made some punch, and amused ourselves in eating oysters after the voluptuous fashion of lovers. We sucked them in, one by one, after placing them on the other's tongue. Voluptuous reader, try it, and tell me whether it is not the nectar of the gods!

At last, joking was over, and I reminded her that we had to think of more substantial pleasures. "Wait here," she said, "I am going to change my dress. I shall be back in one minute." Left alone, and not knowing what to do, I looked in the drawers of her writing-table. I did not touch the letters, but finding a box full of certain preservative sheaths against the fatal and dreaded plumpness, I emptied it, and I placed in it the following lines instead of the stolen goods:

'Enfants de L'Amitie, ministres de la Peur, Je suis l'Amour, tremblez, respectez le voleur! Et toi, femme de Dieu, ne crains pas d'etre mere; Car si to le deviens, Dieu seal sera le pere. S'iL est dit cependant que tu veux le barren, Parle; je suis tout pret, je me ferai chatrer.'

My mistress soon returned, dressed like a nymph. A gown of Indian muslin, embroidered with gold lilies, spewed to admiration the outline of her voluptuous form, and her fine lace-cap was worthy of a queen. I threw myself at her feet, entreating her not to delay my happiness any longer.

"Control your ardour a few moments," she said, "here is the altar, and in a few minutes the victim will be in your arms."

"You will see," she added, going to her writing-table, "how far the delicacy and the kind attention of my friend can extend."

She took the box and opened it, but instead of the pretty sheaths that she expected to see, she found my poetry. After reading it aloud, she called me a thief, and smothering me with kisses she entreated me to give her back what I had stolen, but I pretended not to understand. She then read the lines again, considered for one moment, and under pretence of getting a better pen, she left the room, saying,

"I am going to pay you in your own coin."

She came back after a few minutes and wrote the following six lines:

'Sans rien oter au plaisir amoureux, L'objet de ton larcin sert a combier nos voeux. A l'abri du danger, mon ame satisfaite Savoure en surete parfaite; Et si tu veux jauer avec securite, Rends-moi mon doux ami, ces dons de l'amitie.

After this I could not resist any longer, and I gave her back those objects so precious to a nun who wants to sacrifice on the altar of Venus.

The clock striking twelve, I shewed her the principal actor who was longing to perform, and she arranged the sofa, saying that the alcove being too cold we had better sleep on it. But the true reason was that, to satisfy the curious lover, it was necessary for us to be seen.

Dear reader, a picture must have shades, and there is nothing, no matter how beautiful in one point of view, that does not require to be sometimes veiled if you look at it from a different one. In order to paint the diversified scene which took place between me and my lovely mistress until the dawn of day, I should have to use all the colours of Aretino's palette. I was ardent and full of vigour, but I had to deal with a strong partner, and in the morning, after the last exploit, we were positively worn out; so much so that my charming nun felt some anxiety on my account. It is true that she had seen my blood spurt out and cover her bosom during my last offering; and as she did not suspect the true cause of that phenomenon, she turned pale with fright. I allayed her anxiety by a thousand follies which made her laugh heartily. I washed her splendid bosom with rosewater, so as to purify it from the blood by which it had been dyed for the first time. She expressed a fear that she had swallowed a few drops, but I told her that it was of no consequence, even if were the case. She resumed the costume of a nun, and entreating me to lie down and to write to her before returning to Venice, so as to let her know how I was, she left the casino.

I had no difficulty in obeying her, for I was truly in great need of rest. I slept until evening. As soon as I awoke, I wrote to her that my health was excellent, and that I felt quite inclined to begin our delightful contest all over again. I asked her to let me know how she was herself, and after I had dispatched my letter I returned to Venice.

CHAPTER XIX

I Give My Portrait to M. M.—A Present From Her—I Go to the
Opera With Her—She Plays At the Faro Table and Replenishes
My Empty Purse—Philosophical Conversation With M. M.—
A Letter From C. C.—She Knows All—A Ball At the Convent; My
Exploits In the Character of Pierrot—C. C. Comes to the
Casino Instead of M. M.—I Spend the Night With Her In A
Very Silly Way.

My dear M—— M—— had expressed a wish to have my portrait,
something like the one I had given to C—— C——, only larger, to wear it as
a locket. The outside was to represent some saint, and an invisible spring was
to remove the sainted picture and expose my likeness. I called upon the artist
who had painted the other miniature for me, and in three sittings I had what
I wanted. He afterwards made me an Annunciation, in which the angel
Gabriel was transformed into a dark-haired saint, and the Holy Virgin into a
beautiful, light-complexioned woman holding her arms towards the angel.
The celebrated painter Mengs imitated that idea in the picture of the
Annunciation which he painted in Madrid twelve years afterwards, but I do
not know whether he had the same reasons for it as my painter. That allegory
was exactly of the same size as my portrait, and the jeweller who made the
locket arranged it in such a manner that no one could suppose the sacred
image to be there only for the sake of hiding a profane likeness.

The end of January, 1754, before going to the casino, I called upon Laura
to give her a letter for C—— C——, and she handed me one from her which
amused me. My beautiful nun had initiated that young girl, not only into the
mysteries of Sappho, but also in high metaphysics, and C—— C—— had
consequently become a Freethinker. She wrote to me that, objecting to give
an account of her affairs to her confessor, and yet not wishing to tell him
falsehoods, she had made up her mind to tell him nothing.

"He has remarked," she added, "that perhaps I do not confess anything to
him because I did not examine my conscience sufficiently, and I answered him
that I had nothing to say, but that if he liked I would commit a few sins for
the purpose of having something to tell him in confession."

I thought this reply worthy of a thorough sophist, and laughed heartily.

On the same day I received the following letter from my adorable nun "I
write to you from my bed, dearest browny, because I cannot remain standing
on my feet. I am almost dead. But I am not anxious about it; a little rest will

make me all right, for I eat well and sleep soundly. You have made me very happy by writing to me that your bleeding has not had any evil consequences, and I give you fair notice that I shall have the proof of it on Twelfth Night, at least if you like; that is understood, and you will let me know. In case you should feel disposed to grant me that favour, my darling, I wish to go to the opera. At all events, recollect that I positively forbid the whites of eggs for the future, for I would rather have a little less enjoyment and more security respecting your health. In future, when you go to the casino of Muran, please to enquire whether there is anybody there, and if you receive an affirmative answer, go away. My friend will do the same. In that manner you will not run the risk of meeting one another, but you need not observe these precautions for long, if you wish, for my friend is extremely fond of you, and has a great desire to make your acquaintance. He has told me that, if he had not seen it with his own eyes, he never would have believed that a man could run the race that you ran so splendidly the other night, but he says that, by making love in that manner, you bid defiance to death, for he is certain that the blood you lost comes from the brain. But what will he say when he hears that you only laugh at the occurrence? I am going to make you very merry: he wants to eat the salad of whites of eggs, and he wants me to ask you for some of your vinegar, because there is none in Venice. He said that he spent a delightful night, in spite of his fear of the evil consequences of our amorous sport, and he has found my own efforts superior to the usual weakness of my sex. That may be the case, dearest browny, but I am delighted to have done such wonders, and to have made such trial of my strength. Without you, darling of my heart, I should have lived without knowing myself, and I wonder whether it is possible for nature to create a woman who could remain insensible in your arms, or rather one who would not receive new life by your side. It is more than love that I feel for you, it is idolatry; and my mouth, longing to meet yours, sends forth thousands of kisses which are wasted in the air. I am panting for your divine portrait, so as to quench by a sweet illusion the fire which devours my amorous lips. I trust my likeness will prove equally dear to you, for it seems to me that nature has created us for one another, and I curse the fatal instant in which I raised an invincible barrier between us. You will find enclosed the key of my bureau. Open it, and take a parcel on which you will see written, 'For my darling.' It is a small present which my friend wishes me to offer you in exchange for the beautiful night-cap that you gave me. Adieu."

The small key enclosed in the letter belonged to a bureau in the boudoir. Anxious to know the nature of the present that she could offer me at the

instance of her friend, I opened the bureau, and found a parcel containing a letter and a morocco-leather case.

The letter was as follows:

"That which will, I hope, render this present dear to you is the portrait of a woman who adores you. Our friend had two of them, but the great friendship he entertains towards you has given him the happy idea of disposing of one in your favour. This box contains two portraits of me, which are to be seen in two different ways: if you take off the bottom part, of the case in its length, you will see me as a nun; and if you press on the corner, the top will open and expose me to your sight in a state of nature. It is not possible, dearest, that a woman can ever have loved you as I do. Our friend excites my passion by the flattering opinion that he entertains of you. I cannot decide whether I am more fortunate in my friend or in my lover, for I could not imagine any being superior to either one or the other."

The case contained a gold snuff-box, and a small quantity of Spanish snuff which had been left in it proved that it had been used. I followed the instructions given in the letter, and I first saw my mistress in the costume of a nun, standing and in half profile. The second secret spring brought her before my eyes, entirely naked, lying on a mattress of black satin, in the position of the Madeleine of Coreggio. She was looking at Love, who had the quiver at his feet, and was gracefully sitting on the nun's robes. It was such a beautiful present that I did not think myself worthy of it. I wrote to M——M—— a letter in which the deepest gratitude was blended with the most exalted love. The drawers of the bureau contained all her diamonds and four purses full of sequins. I admired her noble confidence in me. I locked the bureau, leaving everything undisturbed, and returned to Venice. If I had been able to escape out of the capricious clutches of fortune by giving up gambling, my happiness would have been complete.

My own portrait was set with rare perfection, and as it was arranged to be worn round the neck I attached it to six yards of Venetian chain, which made it a very handsome present. The secret was in the ring to which it was suspended, and it was very difficult to discover it. To make the spring work and expose my likeness it was necessary to pull the ring with some force and in a peculiar manner. Otherwise, nothing could be seen but the Annunciation; and it was then a beautiful ornament for a nun.

On Twelfth Night, having the locket and chain in my pocket, I went early in the evening to watch near the fine statue erected to the hero Colleoni after he had been poisoned, if history does not deceive us. 'Sit divus, modo non

vivus', is a sentence from the enlightened monarch, which will last as long as there are monarchs on earth.

At six o'clock precisely my mistress alighted from the gondola, well dressed and well masked, but this time in the garb of a woman. We went to the Saint Samuel opera, and after the second ballet we repaired to the 'ridotto', where she amused herself by looking at all the ladies of the nobility who alone had the right to walk about without masks. After rambling about for half an hour, we entered the hall where the bank was held. She stopped before the table of M. Mocenigo, who at that time was the best amongst all the noble gamblers. As nobody was playing, he was carelessly whispering to a masked lady, whom I recognized as Madame Marina Pitani, whose adorer he was.

M—— M—— enquired whether I wanted to play, and as I answered in the negative she said to me,

"I take you for my partner."

And without waiting for my answer she took a purse, and placed a pile of gold on a card. The banker without disturbing himself shuffled the cards, turned them up, and my friend won the paroli. The banker paid, took another pack of cards, and continued his conversation with his lady, shewing complete indifference for four hundred sequins which my friend had already placed on the same card. The banker continuing his conversations, M—— M—— said to me, in excellent French,

"Our stakes are not high enough to interest this gentleman; let us go."

I took up the gold, which I put in my pocket, without answering M. de Mocenigo, who said to me:

"Your mask is too exacting."

I rejoined my lovely gambler, who was surrounded. We stopped soon afterwards before the bank of M. Pierre Marcello, a charming young man, who had near him Madame Venier, sister of the patrician Momolo. My mistress began to play, and lost five rouleaux of gold one after the other. Having no more money, she took handfuls of gold from my pocket, and in four or five deals she broke the bank. She went away, and the noble banker, bowing, complimented her upon her good fortune. After I had taken care of all the gold she had won, I gave her my arm, and we left the 'ridotto', but remarking that a few inquisitive persons were following us, I took a gondola which landed us according to my instructions. One can always escape prying eyes in this way in Venice.

After supper I counted our winnings, and I found myself in possession of one thousand sequins as my share. I rolled the remainder in paper, and my friend asked me to put it in her bureau. I then took my locket and threw it

over her neck; it gave her the greatest delight, and she tried for a long time to discover the secret. At last I showed it her, and she pronounced my portrait an excellent likeness.

Recollecting that we had but three hours to devote to the pleasures of love, I entreated her to allow me to turn them to good account.

"Yes," she said, "but be prudent, for our friend pretends that you might die on the spot."

"And why does he not fear the same danger for you, when your ecstasies are in reality much more frequent than mine?"

"He says that the liquor distilled by us women does not come from the brain, as is the case with men, and that the generating parts of woman have no contact with her intellect. The consequence of it, he says, is that the child is not the offspring of the mother as far as the brain, the seat of reason, is concerned, but of the father, and it seems to me very true. In that important act the woman has scarcely the amount of reason that she is in need of, and she cannot have any left to enable her to give a dose to the being she is generating." "Your friend is a very learned man. But do you know that such a way of arguing opens my eyes singularly? It is evident that, if that system be true, women ought to be forgiven for all the follies which they commit on account of love, whilst man is inexcusable, and I should be in despair if I happened to place you in a position to become a mother."

"I shall know before long, and if it should be the case so much the better. My mind is made up, and my decision taken."

"And what is that decision?"

"To abandon my destiny entirely to you both. I am quite certain that neither one nor the other would let me remain at the convent."

"It would be a fatal event which would decide our future destinies. I would carry you off, and take you to England to marry you."

"My friend thinks that a physician might be bought, who, under the pretext of some disease of his own invention, would prescribe to me to go somewhere to drink the waters—a permission which the bishop might grant. At the watering-place I would get cured, and come back here, but I would much rather unite our destinies for ever. Tell me, dearest, could you manage to live anywhere as comfortably as you do here?"

"Alas! my love, no, but with you how could I be unhappy? But we will resume that subject whenever it may be necessary. Let us go to bed."

"Yes. If I have a son my friend wishes to act towards him as a father."

"Would he believe himself to be the father?"

"You might both of you believe it, but some likeness would soon enlighten me as to which of you two was the true father."

"Yes. If, for instance, the child composed poetry, then you would suppose that he was the son of your friend."

"How do you know that my friend can write poetry?"

"Admit that he is the author of the six lines which you wrote in answer to mine."

"I cannot possibly admit such a falsehood, because, good or bad, they were of my own making, and so as to leave you no doubt let me convince you of it at once."

"Oh, never mind! I believe you, and let us go to bed, or Love will call out the god of Parnassus."

"Let him do it, but take this pencil and write; I am Apollo, you may be Love:"

'Je ne me battrai pas; je te cede la place. Si Venus est ma soeur, L'Amour est de ma race. Je sais faire des vers. Un instant de perdu N'offense pas L'Amour, si je l'ai convaincu.

"It is on my knees that I entreat your pardon, my heavenly friend, but how could I expect so much talent in a young daughter of Venice, only twenty-two years of age, and, above all, brought up in a convent?"

"I have a most insatiate desire to prove myself more and more worthy of you. Did you think I was prudent at the gaming-table?"

"Prudent enough to make the most intrepid banker tremble."

"I do not always play so well, but I had taken you as a partner, and I felt I could set fortune at defiance. Why would you not play?"

"Because I had lost four thousand sequins last week and I was without money, but I shall play to-morrow, and fortune will smile upon me. In the mean time, here is a small book which I have brought from your boudoir: the postures of Pietro Aretino; I want to try some of them."

"The thought is worthy of you, but some of these positions could not be executed, and others are insipid."

"True, but I have chosen four very interesting ones."

These delightful labours occupied the remainder of the night until the alarum warned us that it was time to part. I accompanied my lovely nun as far as her gondola, and then went to bed; but I could not sleep. I got up in order to go and pay a few small debts, for one of the greatest pleasures that a spendthrift can enjoy is, in my opinion, to discharge certain liabilities. The gold won by my mistress proved lucky for me, for I did not pass a single day of the carnival without winning.

Three days after Twelfth Night, having paid a visit to the casino of Muran for the purpose of placing some gold in M—— M—— 's bureau, the door-keeper handed me a letter from my nun. Laura had, a few minutes before, delivered me one from C—— C——.

My new mistress, after giving me an account of her health, requested me to enquire from my jeweller whether he had not by chance made a ring having on its bezel a St. Catherine which, without a doubt, concealed another portrait; she wished to know the secret of that ring. "A young boarder," she added, "a lovely girl, and my friend, is the owner of that ring. There must be a secret, but she does not know it." I answered that I would do what she wished. But here is the letter of C—— C——. It was rather amusing, because it placed me in a regular dilemma; it bore a late date, but the letter of M—— M—— had been written two days before it.

"Ali! how truly happy I am, my beloved husband! You love Sister M—— M——, my dear friend. She has a locket as big as a ring, and she cannot have received it from anyone but you. I am certain that your dear likeness is to be found under the Annunciation. I recognized the style of the artist, and it is certainly the same who painted the locket and my ring. I am satisfied that Sister M——M——has received that present from you. I am so pleased to know all that I would not run the risk of grieving her by telling her that I knew her secret, but my dear friend, either more open or more curious, has not imitated my reserve. She told me that she had no doubt of my St. Catherine concealing the portrait of my lover. Unable to say anything better, I told her that the ring was in reality a gift from my lover, but that I had no idea of his portrait being concealed inside of it. 'If it is as you say,' observed M—— M——, 'and if you have no objection, I will try to find out the secret, and afterwards I will let you know mine.' Being quite certain that she would not discover it, I gave her my ring, saying that, if she could find out the secret, I should be very much pleased.

"Just as that moment my aunt paid me a visit, and I left my ring in the hands of M—— M——, who returned it to me after dinner, assuring me that, although she had not been able to find out the secret, she was certain there was one. I promise you that she shall never hear anything about it from me, because if she saw your portrait, she would guess everything, and then I should have to tell her who you are. I am sorry to be compelled to conceal anything from her, but I am very glad you love one another. I pity you both, however, with all my heart, because I know that you are obliged to make love through a grating in that horrid parlour. How I wish, dearest, I could give you my place! I would make two persons happy at the same time! Adieu!"

I answered that she had guessed rightly, that the locket of her friend was a present from me and contained my likeness, but that she was to keep the secret, and to be certain that my friendship for M—— M—— interfered in no way with the feeling which bound me to her for ever. I certainly was well aware that I was not behaving in a straightforward manner, but I endeavoured to deceive myself, so true it is that a woman, weak as she is, has more influence by the feeling she inspires than man can possibly have with all his strength. At all events, I was foolishly trying to keep up an intrigue which I knew to be near its denouement through the intimacy that had sprung up between these two friendly rivals.

Laura having informed me that there was to be on a certain day a ball in the large parlour of the convent, I made up my mind to attend it in such a disguise that my two friends could not recognize me. I decided upon the costume of a Pierrot, because it conceals the form and the gait better than any other. I was certain that my two friends would be behind the grating, and that it would afford me the pleasant opportunity of seeing them together and of comparing them. In Venice, during the carnival, that innocent pleasure is allowed in convents. The guests dance in the parlour, and the sisters remain behind the grating, enjoying the sight of the ball, which is over by sunset. Then all the guests retire, and the poor nuns are for a long time happy in the recollection of the pleasure enjoyed by their eyes. The ball was to take place in the afternoon of the day appointed for my meeting with M—— M——, in the evening at the casino of Muran, but that could not prevent me from going to the ball; besides, I wanted to see my dear C—— C——.

I have said before that the dress of a Pierrot is the costume which disguises the figure and the gait most completely. It has also the advantage, through a large cap, of concealing the hair, and the white gauze which covers the face does not allow the colour of the eyes or of the eyebrows to be seen, but in order to prevent the costume from hindering the movements of the mask, he must not wear anything underneath, and in winter a dress made of light calico is not particularly agreeable. I did not, however, pay any attention to that, and taking only a plate of soup I went to Muran in a gondola. I had no cloak, and—in my pockets I had nothing but my handkerchief, my purse, and the key of the casino.

I went at once to the convent. The parlour was full, but thanks to my costume of Pierrot, which was seen in Venice but very seldom, everybody made room for me. I walked on, assuming the gait of a booby, the true characteristic of my costume, and I stopped near the dancers. After I had examined the Pantaloons, Punches, Harlequins, and Merry Andrews, I went

near the grating, where I saw all the nuns and boarders, some seated, some standing, and, without appearing to, notice any of them in particular, I remarked my two friends together, and very intent upon the dancers. I then walked round the room, eyeing everybody from head to foot, and calling the general attention upon myself.

I chose for my partner in the minuet a pretty girl dressed as a Columbine, and I took her hand in so awkward a manner and with such an air of stupidity that everybody laughed and made room for us. My partner danced very well according to her costume, and I kept my character with such perfection that the laughter was general. After the minuet I danced twelve forlanas with the greatest vigour. Out of breath, I threw myself on a sofa, pretending to go to sleep, and the moment I began to snore everybody respected the slumbers of Pierrot. The quadrille lasted one hour, and I took no part in it, but immediately after it, a Harlequin approached me with the impertinence which belongs to his costume, and flogged me with his wand. It is Harlequin's weapon. In my quality of Pierrot I had no weapons. I seized him round the waist and carried him round the parlour, running all the time, while he kept on flogging me. I then put him down. Adroitly snatching his wand out of his hand, I lifted his Columbine on my shoulders, and pursued him, striking him with the wand, to the great delight and mirth of the company. The Columbine was screaming because she was afraid of my tumbling down and of shewing her centre of gravity to everybody in the fall. She had good reason to fear, for suddenly a foolish Merry Andrew came behind me, tripped me up, and down I tumbled. Everybody hooted Master Punch. I quickly picked myself up, and rather vexed I began a regular fight with the insolent fellow. He was of my size, but awkward, and he had nothing but strength. I threw him, and shaking him vigorously on all sides I contrived to deprive him of his hump and false stomach. The nuns, who had never seen such a merry sight, clapped their hands, everybody laughed loudly, and improving my opportunity I ran through the crowd and disappeared.

I was in a perspiration, and the weather was cold; I threw myself into a gondola, and in order not to get chilled I landed at the 'ridotto'. I had two hours to spare before going to the casino of Muran, and I longed to enjoy the astonishment of my beautiful nun when she saw M. Pierrot standing before her. I spent those two hours in playing at all the banks, winning, losing, and performing all sorts of antics with complete freedom, being satisfied that no one could recognize me; enjoying the present, bidding defiance to the future, and laughing at all those reasonable beings who exercise their reason to avoid

the misfortunes which they fear, destroying at the same time the pleasure that they might enjoy.

But two o'clock struck and gave me warning that Love and Comus were calling me to bestow new delights upon me. With my pockets full of gold and silver, I left the ridotto, hurried to Muran, entered the sanctuary, and saw my divinity leaning against the mantelpiece. She wore her convent dress. I come near her by stealth, in order to enjoy her surprise. I look at her, and I remain petrified, astounded.

The person I see is not M—— M——.

It is C—— C——, dressed as a nun, who, more astonished even than myself, does not utter one word or make a movement. I throw myself in an arm-chair in order to breathe and to recover from my surprise. The sight of C—— C—— had annihilated me, and my mind was as much stupefied as my body. I found myself in an inextricable maze.

It is M—— M——, I said to myself, who has played that trick upon me, but how has she contrived to know that I am the lover of C—— C——? Has C—— C—— betrayed my secret? But if she has betrayed it, how could M—— M—— deprive herself of the pleasure of seeing me, and consent to her place being taken by her friend and rival? That cannot be a mark of kind compliance, for a woman never carries it to such an extreme. I see in it only a mark of contempt—a gratuitous insult.

My self-love tried hard to imagine some reason likely to disprove the possibility of that contempt, but in vain. Absorbed in that dark discontent, I believed myself wantonly trifled with, deceived, despised, and I spent half an hour silent and gloomy, staring at C—— C——, who scarcely dared to breathe, perplexed, confused, and not knowing in whose presence she was, for she could only know me as the Pierrot whom she had seen at the ball.

Deeply in love with M—— M——, and having come to the casino only for her, I did not feel disposed to accept the exchange, although I was very far from despising C—— C——, whose charms were as great, at least, as those of M—— M——. I loved her tenderly, I adored her, but at that moment it was not her whom I wanted, because at first her presence had struck me as a mystification. It seemed to me that if I celebrated the return of C—— C—— in an amorous manner, I would fail in what I owed to myself, and I thought that I was bound in honour not to lend myself to the imposition. Besides, without exactly realizing that feeling, I was not sorry to have it in my power to reproach M—— M—— with an indifference very strange in a woman in love, and I wanted to act in such a manner that she should not be able to say

that she had procured me a pleasure. I must add that I suspected M——
M—— to be hiding in the secret closet, perhaps with her friend.

I had to take a decision, for I could not pass the whole night in my costume
of Pierrot, and without speaking. At first I thought of going away, the more
so that both C—— C—— and her friend could not be certain that I and
Pierrot were the same individual, but I soon abandoned the idea with horror,
thinking of the deep sorrow which would fill the loving soul of C—— C——
if she ever heard I was the Pierrot. I almost fancied that she knew it already,
and I shared the grief which she evidently would feel in that case. I had
seduced her. I had given her the right to call me her husband. These thoughts
broke my heart.

If M—— M—— is in the closet, said I to myself, she will shew herself in
good time. With that idea, I took off the gauze which covered my features. My
lovely C—— C—— gave a deep sigh, and said:

"I breathe again! it could not be anyone but you, my heart felt it. You
seemed surprised when you saw me, dearest; did you not know that I was
waiting for you?"

"I had not the faintest idea of it."

"If you are angry, I regret it deeply, but I am innocent."

"My adored friend, come to my arms, and never suppose that I can be angry
with you. I am delighted to see you; you are always my dear wife: but I entreat
you to clear up a cruel doubt, for you could never have betrayed my secret."

"I! I would never have been guilty of such a thing, even if death had stared
me in the face."

"Then, how did you come here? How did your friend contrive to discover
everything? No one but you could tell her that I am your husband. Laura
perhaps....'

"No, Laura is faithful, dearest, and I cannot guess how it was."

"But how could you be persuaded to assume that disguise, and to come
here? You can leave the convent, and you have never apprised me of that
important circumstance."

"Can you suppose that I would not have told you all about it, if I had ever
left the convent, even once? I came out of it two hours ago, for the first time,
and I was induced to take that step in the simplest, the most natural manner."

"Tell me all about it, my love. I feel extremely curious."

"I am glad of it, and I would conceal nothing from you. You know how
dearly M—— M—— and I love each other. No intimacy could be more
tender than ours; you can judge of it by what I told you in my letters. Well,
two days ago, my dear friend begged the abbess and my aunt to allow me to

sleep in her room in the place of the lay-sister, who, having a very bad cold, had carried her cough to the infirmary. The permission was granted, and you cannot imagine our pleasure in seeing ourselves at liberty, for the first time, to sleep in the same bed. To-day, shortly after you had left the parlour, where you so much amused us, without our discovering that the delightful Pierrot was our friend, my dear M—— M—— retired to her room and I followed her. The moment we were alone she told me that she wanted me to render her a service from which depended our happiness. I need not tell you how readily I answered that she had only to name it. Then she opened a drawer, and much to my surprise she dressed me in this costume. She was laughing; and I did the same without suspecting the end of the joke. When she saw me entirely metamorphosed into a nun, she told me that she was going to trust me with a great secret, but that she entertained no fear of my discretion. 'Let me tell you, clearest friend,' she said to me, 'that I was on the point of going out of the convent, to return only tomorrow morning. I have, however, just decided that you shall go instead. You have nothing to fear and you do not require any instructions, because I know that you will meet with no difficulty. In an hour, a lay-sister will come here, I will speak a few words apart to her, and she will tell you to follow her. You will go out with her through the small gate and across the garden as far as the room leading out to the low shore. There you will get into the gondola, and say to the gondolier these words: 'To the casino.' You will reach it in five minutes; you will step out and enter a small apartment, where you will find a good fire; you will be alone, and you will wait.' 'For whom? I enquired. 'For nobody. You need not know any more: you may only be certain that nothing unpleasant will happen to you; trust me for that. You will sup at the casino, and sleep, if you like, without being disturbed. Do not ask any questions, for I cannot answer them. Such is, my dear husband, the whole truth. Tell me now what I could do after that speech of my friend, and after she had received my promise to do whatever she wished. Do not distrust what I tell you, for my lips cannot utter a falsehood. I laughed, and not expecting anything else but an agreeable adventure, I followed the lay-sister and soon found myself here. After a tedious hour of expectation, Pierrot made his appearance. Be quite certain that the very moment I saw you my heart knew who it was, but a minute after I felt as if the lightning had struck me when I saw you step back, for I saw clearly enough that you did not expect to find me. Your gloomy silence frightened me, and I would never have dared to be the first in breaking it; the more so that, in spite of the feelings of my heart, I might have been mistaken. The dress of Pierrot might conceal some other man, but certainly no one that I could have

seen in this place without horror. Recollect that for the last eight months I have been deprived of the happiness of kissing you, and now that you must be certain of my innocence, allow me to congratulate you upon knowing this casino. You are happy, and I congratulate you with all my heart. M——
M—— is, after me, the only woman worthy of your love, the only one with whom I could consent to share it. I used to pity you, but I do so no longer, and your happiness makes me happy. Kiss me now."

I should have been very ungrateful, I should, even have been cruel, if I had not then folded in my arms with the warmth of true love the angel of goodness and beauty who was before me, thanks to the most wonderful effort of friendship.

After assuring her that I no longer entertained any doubt of her innocence, I told her that I thought the behaviour of her friend very ambiguous. I said that, notwithstanding the pleasure I felt in seeing her, the trick played upon me by her friend was a very bad one, that it could not do otherwise than displease me greatly, because it was an insult to me.

"I am not of your opinion," replied C—— C——.

"My dear M—— M—— has evidently contrived, somehow or other, to discover that, before you were acquainted with her, you were my lover. She thought very likely that you still loved me, and she imagined, for I know her well, that she could not give us a greater proof of her love than by procuring us, without forewarning us, that which two lovers fond of each other must wish for so ardently. She wished to make us happy, and I cannot be angry with her for it."

"You are right to think so, dearest, but my position is very different from yours. You have not another lover; you could not have another; but I being free and unable to see you, have not found it possible to resist the charms of M—— M——. I love her madly; she knows it, and, intelligent as she is, she must have meant to shew her contempt for me by doing what she has done. I candidly confess that I feel hurt in the highest degree. If she loved me as I love her, she never could have sent you here instead of coming herself."

"I do not think so, my beloved friend. Her soul is as noble as her heart is generous; and just in the same manner that I am not sorry to know that you love one another and that you make each other happy, as this beautiful casino proves to me, she does not regret our love, and she is, on the contrary, delighted to shew us that she approves of it. Most likely she meant to prove that she loved you for your own sake, that your happiness makes her happy, and that she is not jealous of her best friend being her rival. To convince you that you ought not to be angry with her for having discovered our secret, she

proves, by sending me here in her place, that she is pleased to see your heart divided between her and me. You know very well that she loves me, and that I am often either her wife or her husband, and as you do not object to my being your rival and making her often as happy as I can, she does not want you either to suppose that her love is like hatred, for the love of a jealous heart is very much like it."

"You plead the cause of your friend with the eloquence of an angel, but, dear little wife, you do not see the affair in its proper light. You have intelligence and a pure soul, but you have not my experience. M——— M———'s love for me has been nothing but a passing fancy, and she knows that I am not such an idiot as to be deceived by all this affair. I am miserable, and it is her doing."

"Then I should be right if I complained of her also, because she makes me feel that she is the mistress of my lover, and she shews me that, after seducing him from me, she gives him back to me without difficulty. Then she wishes me to understand that she despises also my tender affection for her, since she places me in a position to shew that affection for another person."

"Now, dearest, you speak without reason, for the relations between you two are of an entirely different nature. Your mutual love is nothing but trifling nonsense, mere illusion of the senses. The pleasures which you enjoy together are not exclusive. To become jealous of one another it would be necessary that one of you two should feel a similar affection for another woman but M——— M——— could no more be angry at your having a lover than you could be so yourself if she had one; provided, however, that the lover should not belong to the other"

"But that is precisely our case, and you are mistaken. We are not angry at your loving us both equally. Have I not written to you that I would most willingly give you my place near M——— M———? Then you must believe that I despise you likewise?"

"My darling, that wish of yours to give me up your place, when you did not know that I was happy with M——— M———, arose from your friendship rather than from your love, and for the present I must be glad to see that your friendship is stronger than your love, but I have every reason to be sorry when M——— M——— feels the same. I love her without any possibility of marrying her. Do you understand me, dearest? As for you, knowing that you must be my wife, I am certain of our love, which practice will animate with new life. It is not the same with M——— M———; that love cannot spring up again into existence. Is it not humiliating for me to have inspired her with nothing but a passing fancy? I understand your adoration for her very well. She has

initiated you into all her mysteries, and you owe her eternal friendship and everlasting gratitude."

It was midnight, and we went on wasting our time in this desultory conversation, when the prudent and careful servant brought us an excellent supper. I could not touch anything, my heart was too full, but my dear little wife supped with a good appetite. I could not help laughing when I saw a salad of whites of eggs, and C—— C—— thought it extraordinary because all the yolks had been removed. In her innocence, she could not understand the intention of the person who had ordered the supper. As I looked at her, I was compelled to acknowledge that she had improved in beauty; in fact C—— C—— was remarkably beautiful, yet I remained cold by her side. I have always thought that there is no merit in being faithful to the person we truly love.

Two hours before day-light we resumed our seats near the fire, and C—— C——, seeing how dull I was, was delicately attentive to me. She attempted no allurement, all her movements wore the stamp of the most decent reserve, and her conversation, tender in its expressions and perfectly easy, never conveyed the shadow of a reproach for my coolness.

Towards the end of our long conversation, she asked me what she should say to her friend on her return to the convent.

"My dear M—— M—— expects to see me full of joy and gratitude for the generous present she thought she was making me by giving me this night, but what shall I tell her?"

"The whole truth. Do not keep from her a single word of our conversation, as far as your memory will serve you, and tell her especially that she has made me miserable for a long time."

"No, for I should cause her too great a sorrow; she loves you dearly, and cherishes the locket which contains your likeness. I mean, on the contrary, to do all I can to bring peace between you two, and I must succeed before long, because my friend is not guilty of any wrong, and you only feel some spite, although with no cause. I will send you my letter by Laura, unless you promise me to go and fetch it yourself at her house."

"Your letters will always be dear to me, but, mark my words, M—— M—— will not enter into any explanation. She will believe you in everything, except in one."

"I suppose you mean our passing a whole night together as innocently as if we were brother and sister. If she knows you as well as I do, she will indeed think it most wonderful."

"In that case, you may tell her the contrary, if you like."

"Nothing of the sort. I hate falsehoods, and I will certainly never utter one in such a case as this; it would be very wrong. I do not love you less on that account, my darling, although, during this long night, you have not condescended to give me the slightest proof of your love."

"Believe me, dearest, I am sick from unhappiness. I love you with my whole soul, but I am in such a situation that...."

"What! you are weeping, my love! Oh! I entreat you, spare my heart! I am so sorry to have told you such a thing, but I can assure you I never meant to make you unhappy. I am sure that in a quarter of an hour M—— M—— will be crying likewise."

The alarum struck, and, having no longer any hope of seeing M—— M—— come to justify herself, I kissed C—— C——. I gave her the key of the casino, requesting her to return it for me to M—— M——, and my young friend having gone back to the convent, I put on my mask and left the casino.

CHAPTER XX

I Am in Danger of Perishing in the Lagunes—Illness—Letters
from C. C. and M. M.—The Quarrel is Made Up—Meeting at the
Casino of Muran I Learn the Name of M. M.'s Friend, and
Consent to Give Him A Supper at My Casino in the Company of
Our Common Mistress

The weather was fearful. The wind was blowing fiercely, and it was bitterly cold. When I reached the shore, I looked for a gondola, I called the gondoliers, but, in contravention to the police regulations, there was neither gondola nor gondolier. What was I to do? Dressed in light linen, I was hardly in a fit state to walk along the wharf for an hour in such weather. I should most likely have gone back to the casino if I had had the key, but I was paying the penalty of the foolish spite which had made me give it up. The wind almost carried me off my feet, and there was no house that I could enter to get a shelter.

I had in my pockets three hundred philippes that I had won in the evening, and a purse full of gold. I had therefore every reason to fear the thieves of Muran—a very dangerous class of cutthroats, determined murderers who enjoyed and abused a certain impunity, because they had some privileges granted to them by the Government on account of the services they rendered in the manufactories of looking-glasses and in the glassworks which are numerous on the island. In order to prevent their emigration, the Government had granted them the freedom of Venice. I dreaded meeting a pair of them, who would have stripped me of everything, at least. I had not, by chance, with me the knife which all honest men must carry to defend their lives in my dear country. I was truly in an unpleasant predicament.

I was thus painfully situated when I thought I could see a light through the crevices of a small house. I knocked modestly against the shutter. A voice called out:

"Who is knocking?"

And at the same moment the shutter was pushed open.

"What do you want?" asked a man, rather astonished at my costume.

I explained my predicament in a few words, and giving him one sequin I begged his permission to shelter myself under his roof. Convinced by my sequin rather than my words, he opened the door, I went in, and promising him another sequin for his trouble I requested him to get me a gondola to take me to Venice. He dressed himself hurriedly, thanking God for that piece

of good fortune, and went out assuring me that he would soon get me a gondola. I remained alone in a miserable room in which all his family, sleeping together in a large, ill-looking bed, were staring at me in consequence of my extraordinary costume. In half an hour the good man returned to announce that the gondoliers were at the wharf, but that they wanted to be paid in advance. I raised no objection, gave a sequin to the man for his trouble, and went to the wharf.

The sight of two strong gondoliers made me get into the gondola without anxiety, and we left the shore without being much disturbed by the wind, but when we had gone beyond the island, the storm attacked us with such fury that I thought myself lost, for, although a good swimmer, I was not sure I had strength enough to resist the violence of the waves and swim to the shore. I ordered the men to go back to the island, but they answered that I had not to deal with a couple of cowards, and that I had no occasion to be afraid. I knew the disposition of our gondoliers, and I made up my mind to say no more.

But the wind increased in violence, the foaming waves rushed into the gondola, and my two rowers, in spite of their vigour and of their courage, could no longer guide it. We were only within one hundred yards of the mouth of the Jesuits' Canal, when a terrible gust of wind threw one of the 'barcarols' into the sea; most fortunately he contrived to hold by the gondola and to get in again, but he had lost his oar, and while he was securing another the gondola had tacked, and had already gone a considerable distance abreast. The position called for immediate decision, and I had no wish to take my supper with Neptune. I threw a handful of philippes into the gondola, and ordered the gondoliers to throw overboard the 'felce' which covered the boat. The ringing of money, as much as the imminent danger, ensured instant obedience, and then, the wind having less hold upon us, my brave boatmen shewed AEolus that their efforts could conquer him, for in less than five minutes we shot into the Beggars' Canal, and I reached the Bragadin Palace. I went to bed at once, covering myself heavily in order to regain my natural heat, but sleep, which alone could have restored me to health, would not visit me.

Five or six hours afterwards, M. de Bragadin and his two inseparable friends paid me a visit, and found me raving with fever. That did not prevent my respectable protector from laughing at the sight of the costume of Pierrot lying on the sofa. After congratulating me upon having escaped with my life out of such a bad predicament, they left me alone. In the evening I perspired so profusely that my bed had to be changed. The next day my fever and delirium increased, and two days after, the fever having abated, I found myself

almost crippled and suffering fearfully with lumbago. I felt that nothing could relieve me but a strict regimen, and I bore the evil patiently.

Early on the Wednesday morning, Laura, the faithful messenger, called on me; I was still in my bed: I told her that I could neither read nor write, and I asked her to come again the next day. She placed on the table, near my bed, the parcel she had for me, and she left me, knowing what had occurred to me sufficiently to enable her to inform C—— C—— of the state in which I was.

Feeling a little better towards the evening, I ordered my servant to lock me in my room, and I opened C—— C——'s letter. The first thing I found in the parcel, and which caused me great pleasure, was the key of the casino which she returned to me. I had already repented having given it up, and I was beginning to feel that I had been in the wrong. It acted like a refreshing balm upon me. The second thing, not less dear after the return of the precious key, was a letter from M—— M——, the seal of which I was not long in breaking, and I read the following lines:

"The particulars which you have read, or which you are going to read, in the letter of my friend, will cause you, I hope, to forget the fault which I have committed so innocently, for I trusted, on the contrary, that you would be very happy. I saw all and heard all, and you would not have gone away without the key if I had not, most unfortunately, fallen asleep an hour before your departure. Take back the key and come to the casino to-morrow night, since Heaven has saved you from the storm. Your love may, perhaps, give you the right to complain, but not to ill-treat a woman who certainly has not given you any mark of contempt."

I afterwards read the letter of my dear C—— C——, and I will give a copy of it here, because I think it will prove interesting:

"I entreat you, dear husband, not to send back this key, unless you have become the most cruel of men, unless you find pleasure in tormenting two women who, love you ardently, and who love you for yourself only. Knowing your excellent heart, I trust you will go to the casino to-morrow evening and make it up with M—— M——, who cannot go there to-night. You will see that you are in the wrong, dearest, and that, far from despising you, my dear friend loves you only. In the mean time, let me tell you what you are not acquainted with, and what you must be anxious to know.

"Immediately after you had gone away in that fearful storm which caused me such anguish, and just as I was preparing to return to the convent, I was much surprised to see standing before me my dear M—— M——, who from some hiding-place had heard all you had said. She had several times been on the point of shewing herself, but she had always been prevented by the fear

of coming out of season, and thus stopping a reconciliation which she thought was inevitable between two fond lovers. Unfortunately, sleep had conquered her before your departure, and she only woke when the alarum struck, too late to detain you, for you had rushed with the haste of a man who is flying from some terrible danger. As soon as I saw her, I gave her the key, although I did not know what it meant, and my friend, heaving a deep sigh, told me that she would explain everything as soon as we were safe in her room. We left the casino in a dreadful storm, trembling for your safety, and not thinking of our own danger. As soon as we were in the convent I resumed my usual costume, and M—— M—— went to bed. I took a seat near her, and this is what she told me. 'When you left your ring in my hands to go to your aunt, who had sent for you, I examined it with so much attention that at last I suspected the small blue spot to be connected with the secret spring; I took a pin, succeeded in removing the top part, and I cannot express the joy I felt when I saw that we both loved the same man, but no more can I give you an idea of my sorrow when I thought that I was encroaching upon your rights. Delighted, however, with my discovery, I immediately conceived a plan which would procure you the pleasure of supping with him. I closed the ring again and returned it to you, telling you at the same time that I had not been able to discover anything. I was then truly the happiest of women. Knowing your heart, knowing that you were aware of the love of your lover for me, since I had innocently shewed you his portrait, and happy in the idea that you were not jealous of me, I would have despised myself if I had entertained any feelings different from your own, the more so that your rights over him were by far stronger than mine. As for the mysterious manner in which you always kept from me the name of your husband, I easily guessed that you were only obeying his orders, and I admired your noble sentiments and the goodness of your heart. In my opinion your lover was afraid of losing us both, if we found out that neither the one nor the other of us possessed his whole heart. I could not express my deep sorrow when I thought that, after you had seen me in possession of his portrait, you continued to act in the same manner towards me, although you could not any longer hope to be the sole object of his love. Then I had but one idea; to prove to both of you that M—— M—— is worthy of your affection, of your friendship, of your esteem. I was indeed thoroughly happy when I thought that the felicity of our trio would be increased a hundredfold, for is it not an unbearable misery to keep a secret from the being we adore? I made you take my place, and I thought that proceeding a masterpiece. You allowed me to dress you as a nun, and with a compliance which proves your confidence in me you went to my casino

without knowing where you were going. As soon as you had landed, the gondola came back, and I went to a place well known to our friend from which, without being seen, I could follow all your movements and hear everything you said. I was the author of the play; it was natural that I should witness it, the more so that I felt certain of seeing and hearing nothing that would not be very agreeable to me. I reached the casino a quarter of an hour after you, and I cannot tell you my delightful surprise when I saw that dear Pierrot who had amused us so much, and whom we had not recognized. But I was fated to feel no other pleasure than that of his appearance. Fear, surprise, and anxiety overwhelmed me at once when I saw the effect produced upon him by the disappointment of his expectation, and I felt unhappy. Our lover took the thing wrongly, and he went away in despair; he loves me still, but if he thinks of me it is only to try to forget me. Alas! he will succeed but too soon! By sending back that key he proves that he will never again go to the casino. Fatal night! When my only wish was to minister to the happiness of three persons, how is it that the very reverse of my wish has occurred? It will kill me, dear friend, unless you contrive to make him understand reason, for I feel that without him I cannot live. You must have the means of writing to him, you know him, you know his name. In the name of all goodness, send back this key to him with a letter to persuade him to come to the casino to-morrow or on the following day, if it is only to speak to me; and I hope to convince him of my love and my innocence. Rest to-day, dearest, but to-morrow write to him, tell him the whole truth; take pity on your poor friend, and forgive her for loving your lover. I shall write a few lines myself; you will enclose them in your letter. It is my fault if he no longer loves you; you ought to hate me, and yet you are generous enough to love me. I adore you; I have seen his tears, I have seen how well his soul can love; I know him now. I could not have believed that men were able to love so much. I have passed a terrible night. Do not think I am angry, dear friend, because you confided to him that we love one another like two lovers; it does not displease me, and with him it was no indiscretion, because his mind is as free of prejudices as his heart is good.'

"Tears were choking her. I tried to console her, and I most willingly promised her to write to you. She never closed her eyes throughout that day, but I slept soundly for four hours.

"When we got up we found the convent full of bad news, which interested us a great deal more than people imagined. It was reported that, an hour before daybreak, a fishing-boat had been lost in the lagune, that two gondolas had been capsized, and that the people in them had perished. You may

imagine our anguish! We dared not ask any questions, but it was just the hour at which you had left me, and we entertained the darkest forebodings. We returned to our room, where M—— M—— fainted away. More courageous than she is, I told her that you were a good swimmer, but I could not allay her anxiety, and she went to bed with a feverish chill. Just at that moment, my aunt, who is of a very cheerful disposition, came in, laughing, to tell us that during the storm the Pierrot who had made us laugh so much had had a narrow escape of being drowned. 'Ah! the poor Pierrot!' I exclaimed, 'tell us all about him, dear aunt. I am very glad he was saved. Who is he? Do you know?' 'Oh! yes,' she answered, 'everything is known, for he was taken home by our gondoliers. One of them has just told me that Pierrot, having spent the night at the Briati ball, did not find any gondola to return to Venice, and that our gondoliers took him for a sequin. One of the men fell into the sea, but then the brave Pierrot, throwing handfuls of silver upon the 'Zenia' pitched the 'felce' over board, and the wind having less hold they reached Venice safely through the Beggars' Canal. This morning the lucky gondoliers divided thirty philippes which they found in the gondola, and they have been fortunate enough to pick up their 'felce'. Pierrot will remember Muran and the ball at Briati. The man says that he is the son of M. de Bragadin, the procurator's brother. He was taken to the palace of that nobleman nearly dead from cold, for he was dressed in light calico, and had no cloak.'

"When my aunt had left us, we looked at one another for several minutes without uttering a word, but we felt that the good news had brought back life to us. M—— M—— asked me whether you were really the son of M, de Bragadin. 'It might be so,' I said to her, 'but his name does not shew my lover to be the bastard of that nobleman, and still less his legitimate child, for M. de Bragadin was never married.' 'I should be very sorry,' said M—— M——, 'if he were his son.' I thought it right, then, to tell her your true name, and of the application made to my father by M. de Bragadin for my hand, the consequence of which was that I had been shut up in the convent. Therefore, my own darling, your little wife has no longer any secret to keep from M—— M——, and I hope you will not accuse me of indiscretion, for it is better that our dear friend should know all the truth than only half of it. We have been greatly amused, as you may well suppose, by the certainty with which people say that you spent all the night at the Briati ball. When people do not know everything, they invent, and what might be is often accepted in the place of what is in reality; sometimes it proves very fortunate. At all events the news did a great deal of good to my friend, who is now much better. She has had an excellent night, and the hope of seeing you at the casino has restored all her

beauty. She has read this letter three or four times, and has smothered me with kisses. I long to give her the letter which you are going to write to her. The messenger will wait for it. Perhaps I shall see you again at the casino, and in a better temper, I hope. Adieu."

It did not require much argument to conquer me. When I had finished the letter, I was at once the admirer of C—— C—— and the ardent lover of M—— M——. But, alas! although the fever had left me, I was crippled. Certain that Laura would come again early the next morning, I could not refrain from writing to both of them a short letter, it is true, but long enough to assure them that reason had again taken possession of my poor brain. I wrote to C—— C—— that she had done right in telling her friend my name, the more so that, as I did not attend their church any longer, I had no reason to make a mystery of it. In everything else I freely acknowledged myself in the wrong, and I promised her that I would atone by giving M——M—— the strongest possible proofs of my repentance as soon as I could go again to her casino.

This is the letter that I wrote to my adorable nun:

"I gave C—— C—— the key of your casino, to be returned to you, my own charming friend, because I believed myself trifled with and despised, of malice aforethought, by the woman I worship. In my error I thought myself unworthy of presenting myself before your eyes, and, in spite of love, horror made me shudder. Such was the effect produced upon me by an act which would have appeared to me admirable, if my self-love had not blinded me and upset my reason. But, dearest, to admire it it would have been necessary for my mind to be as noble as yours, and I have proved how far it is from being so. I am inferior to you in all things, except in passionate love, and I will prove it to you at our next meeting, when I will beg on my knees a generous pardon. Believe me, beloved creature, if I wish ardently to recover my health, it is only to have it in my power to prove by my love a thousand times increased, how ashamed I am of my errors. My painful lumbago has alone prevented me from answering your short note yesterday, to express to you my regrets, and the love which has been enhanced in me by your generosity, alas! so badly rewarded. I can assure you that in the lagunes, with death staring me in the face, I regretted no one but you, nothing but having outraged you. But in the fearful danger then threatening me I only saw a punishment from Heaven. If I had not cruelly sent back to you the key of the casino, I should most likely have returned there, and should have avoided the sorrow as well as the physical pains which I am now suffering as an expiation. I thank you a thousand times for having recalled me to myself, and you may be certain that

for the future I will keep better control over myself; nothing shall make me doubt your love. But, darling, what do you say of C—— C——? Is she not an incarnate angel who can be compared to no one but you? You love us both equally. I am the only one weak and faulty, and you make me ashamed of myself. Yet I feel that I would give my life for her as well as for you. I feel curious about one thing, but I cannot trust it to paper. You will satisfy that curiosity the first time I shall be able to go to the casino before two days at the earliest. I will let you know two days beforehand. In the mean time, I entreat you to think a little of me, and to be certain of my devoted love. Adieu."

The next morning Laura found me sitting up in bed, and in a fair way to recover my health. I requested her to tell C—— C—— that I felt much better, and I gave her the letter I had written. She had brought me one from my dear little wife, in which I found enclosed a note from M—— M——. Those two letter were full of tender expressions of love, anxiety for my health, and ardent prayers for my recovery.

Six days afterwards, feeling much stronger, I went to Muran, where the keeper of the casino handed me a letter from M—— M——. She wrote to me how impatient she was for my complete recovery, and how desirous she was to see me in possession of her casino, with all the privileges which she hoped I would retain for ever.

"Let me know, I entreat you," she added, "when we are likely to meet again, either at Muran or in Venice, as you please. Be quite certain that whenever we meet we shall be alone and without a witness."

I answered at once, telling her that we would meet the day after the morrow at her casino, because I wanted to receive her loving absolution in the very spot where I had outraged the most generous of women.

I was longing to see her again, for I was ashamed of my cruel injustice towards her, and panting to atone for my wrongs. Knowing her disposition, and reflecting calmly upon what had taken place, it was now evident to me that what she had done, very far from being a mark of contempt, was the refined effort of a love wholly devoted to me. Since she had found out that I was the lover of her young friend, could she imagine that my heart belonged only to herself? In the same way that her love for me did not prevent her from being compliant with the ambassador, she admitted the possibility of my being the same with C—— C——. She overlooked the difference of constitution between the two sexes, and the privileges enjoyed by women.

Now that age has whitened my hair and deadened the ardour of my senses, my imagination does not take such a high flight, and I think differently. I am conscious that my beautiful nun sinned against womanly reserve and modesty,

the two most beautiful appanages of the fair sex, but if that unique, or at least rare, woman was guilty of an eccentricity which I then thought a virtue, she was at all events exempt from that fearful venom called jealousy—an unhappy passion which devours the miserable being who is labouring under it, and destroys the love that gave it birth.

Two days afterwards, on the 4th of February, 1754, I had the supreme felicity of finding myself again alone with my beloved mistress. She wore the dress of a nun. As we both felt guilty, the moment we saw each other, by a spontaneous movement, we fell both on our knees, folded in each other's arms. We had both ill-treated Love; she had treated him like a child, I had adored him after the fashion of a Jansenist. But where could we have found the proper language for the excuses we had to address to each other for the mutual forgiveness we had to entreat and to grant? Kisses—that mute, yet expressive language, that delicate, voluptuous contact which sends sentiment coursing rapidly through the veins, which expresses at the same time the feeling of the heart and the impressions of the mind—that language was the only one we had recourse to, and without having uttered one syllable, dear reader, oh, how well we agreed!

Both overwhelmed with emotion, longing to give one another some proofs of the sincerity of our reconciliation and of the ardent fire which was consuming us, we rose without unclasping our arms, and falling (a most amorous group!) on the nearest sofa, we remained there until the heaving of a deep sigh which we would not have stopped, even if we had known that it was to be the last!

Thus was completed our happy reconciliation, and the calm infused into the soul by contentment, burst into a hearty laugh when we noticed that I had kept on my cloak and my mask. After we had enjoyed our mirth, I unmasked myself, and I asked her whether it was quite true that no one had witnessed our reconciliation.

She took up one of the candlesticks, and seizing my hand:

"Come," she said.

She led me to the other end of the room, before a large cupboard which I had already suspected of containing the secret. She opened it, and when she had moved a sliding plank I saw a door through which we entered a pretty closet furnished with everything necessary to a person wishing to pass a few hours there. Near the sofa was a sliding panel. M—— M—— removed it, and through twenty holes placed at a distance from each other I saw every part of the room in which nature and love had performed for our curious friend a

play in six acts, during which I did not think he had occasion to be dissatisfied with the actors.

"Now," said M—— M——, "I am going to satisfy the curiosity which you were prudent enough not to trust to paper."

"But you cannot guess...."

"Silence, dearest! Love would not be of divine origin did he not possess the faculty of divination. He knows all, and here is the proof. Do you not wish to know whether my friend was with me during the fatal night which has cost me so many tears?"

"You have guessed rightly."

"Well, then, he was with me, and you must not be angry, for you then completed your conquest of him. He admired your character, your love, your sentiments, your honesty. He could not help expressing his astonishment at the rectitude of my instinct, or his approval of the passion I felt for you. It was he who consoled me in the morning assuring me that you would certainly come back to me as soon as you knew my real feelings, the loyalty of my intentions and my good faith."

"But you must often have fallen asleep, for unless excited by some powerful interest, it is impossible to pass eight hours in darkness and in silence."

"We were moved by the deepest interest: besides, we were in darkness only when we kept these holes open. The plank was on during our supper, and we were listening in religious silence to your slightest whisper. The interest which kept my friend awake was perhaps greater than mine. He told me that he never had had before a better opportunity of studying the human heart, and that you must have passed the most painful night. He truly pitied you. We were delighted with C—— C——, for it is indeed wonderful that a young girl of fifteen should reason as she did to justify my conduct, without any other weapons but those given her by nature and truth; she must have the soul of an angel. If you ever marry her, you will have the most heavenly wife. I shall of course feel miserable if I lose her, but your happiness will make amends for all. Do you know, dearest, that I cannot understand how you could fall in love with me after having known her, any more than I can conceive how she does not hate me ever since she has discovered that I have robbed her of your heart. My dear C—— C—— has truly something divine in her disposition. Do you know why she confided to you her barren loves with me? Because, as she told me herself, she wished to ease her conscience, thinking that she was in some measure unfaithful to you."

"Does she think herself bound to be entirely faithful to me, with the knowledge she has now of my own unfaithfulness?"

"She is particularly delicate and conscientious, and though she believes herself truly your wife, she does not think that she has any right to control your actions, but she believes herself bound to give you an account of all she does."

"Noble girl!"

The prudent wife of the door-keeper having brought the supper, we sat down to the well-supplied table. M—— M—— remarked that I had become much thinner.

"The pains of the body do not fatten a man," I said, "and the sufferings of the mind emaciate him. But we have suffered sufficiently, and we must be wise enough never to recall anything which can be painful to us."

"You are quite right, my love; the instants that man is compelled to give up to misfortune or to suffering are as many moments stolen from his life, but he doubles his existence when he has the talent of multiplying his pleasures, no matter of what nature they may be."

We amused ourselves in talking over past dangers, Pierrot's disguise, and the ball at Briati, where she had been told that another Pierrot had made his appearance.

M—— M—— wondered at the extraordinary effect of a disguise, for, said she to me:

"The Pierrot in the parlour of the convent seemed to me taller and thinner than you. If chance had not made you take the convent gondola, if you had not had the strange idea of assuming the disguise of Pierrot, I should not have known who you were, for my friends in the convent would not have been interested in you. I was delighted when I heard that you were not a patrician, as I feared, because, had you been one, I might in time have run some great danger."

I knew very well what she had to fear, but pretending complete ignorance:

"I cannot conceive," I said, "what danger you might run on account of my being a patrician."

"My darling, I cannot speak to you openly, unless you give me your word to do what I am going to ask you."

"How could I hesitate, my love, in doing anything to please you, provided my honour is not implicated? Have we not now everything in common? Speak, idol of my heart, tell me your reasons, and rely upon my love; it is the guarantee of my ready compliance in everything that can give you pleasure:"

"Very well. I want you to give a supper in your casino to me and my friend, who is dying to make your acquaintance."

"And I foresee that after supper you will leave me to go with him."

"You must feel that propriety compels me to do so."

"Your friend already knows, I suppose, who I am?"

"I thought it was right to tell him, because if I had not told him he could not have entertained the hope of supping with you, and especially at your house."

"I understand. I guess your friend is one of the foreign ambassadors."

"Precisely."

"But may I hope that he will so far honour me as to throw up his incognito?"

"That is understood. I shall introduce him to you according to accepted forms, telling his name and his political position."

"Then it is all for the best, darling. How could you suppose that I would have any difficulty in procuring you that pleasure, when on the contrary, nothing could please me more myself? Name the day, and be quite certain that I shall anxiously look for it."

"I should have been sure of your compliance, if you had not given me cause to doubt it."

"It is a home-thrust, but I deserve it."

"And I hope it will not make you angry. Now I am happy. Our friend is M. de Bernis, the French ambassador. He will come masked, and as soon as he shews his features I shall present him to you. Recollect that you must treat him as my lover, but you must not appear to know that he is aware of our intimacy."

"I understand that very well, and you shall have every reason to be pleased with my urbanity. The idea of that supper is delightful to me, and I hope that the reality will be as agreeable. You were quite right, my love, to dread my being a patrician, for in that case the State-Inquisitors, who very often think of nothing but of making a show of their zeal, would not have failed to meddle with us, and the mere idea of the possible consequences makes me shudder. I under The Leads—you dishonoured—the abbess—the convent! Good God! Yes, if you had told me what you thought, I would have given you my name, and I could have done so all the more easily that my reserve was only caused by the fear of being known, and of C—— C—— being taken to another convent by her father. But can you appoint a day for the supper? I long to have it all arranged."

"To-day is the fourth; well, then, in four days."

"That will be the eighth?"

"Exactly so. We will go to your casino after the second ballet. Give me all necessary particulars to enable us to find the house without enquiring from anyone."

I sat down and I wrote down the most exact particulars to find the casino either by land or by water. Delighted with the prospect of such a party of pleasure, I asked my mistress to go to bed, but I remarked to her that, being convalescent and having made a hearty supper, I should be very likely to pay my first homages to Morpheus. Yielding to the circumstances, she set the alarum for ten o'clock, and we went to bed in the alcove. As soon as we woke up, Love claimed our attention and he had no cause of complaint, but towards midnight we fell asleep, our lips fastened together, and we found ourselves in that position in the morning when we opened our eyes. Although there was no time to lose, we could not make up our minds to part without making one more offering to Venus.

I remained in the casino after the departure of my divinity, and slept until noon. As soon as I had dressed myself, I returned to Venice, and my first care was to give notice to my cook, so that the supper of the 8th of February should be worthy of the guests and worthy of me.

Episode 9 — the False Nun

CHAPTER XXI

Supper at My Casino With M. M. and M. de Bernis, the French
Ambassador—A Proposal from M. M.; I Accept It—
Consequences—C. C. is Unfaithful to Me, and I Cannot
Complain

I felt highly pleased with the supper-party I had arranged with M——
M——, and I ought to have been happy. Yet I was not so; but whence came
the anxiety which was a torment to me? Whence? From my fatal habit of
gambling. That passion was rooted in me; to live and to play were to me two
identical things, and as I could not hold the bank I would go and punt at the
ridotto, where I lost my money morning and night. That state of things made
me miserable. Perhaps someone will say to me:

"Why did you play, when there was no need of it, when you were in want
of nothing, when you had all the money you could wish to satisfy your
fancies?"

That would be a troublesome question if I had not made it a law to tell the
truth. Well, then, dear inquisitive reader, if I played with almost the certainty
of losing, although no one, perhaps, was more sensible than I was to the losses
made in gambling, it is because I had in me the evil spirit of avarice; it is
because I loved prodigality, and because my heart bled when I found myself
compelled to spend any money that I had not won at the gaming-table. It is
an ugly vice, dear reader, I do not deny it. However, all I can say is that,
during the four days previous to the supper, I lost all the gold won for me by
M—— M——

On the anxiously-expected day I went to my casino, where at the appointed
hour M—— M—— came with her friend, whom she introduced to me as
soon as he had taken off his mask.

"I had an ardent wish, sir," said M. de Bernis to me, "to renew
acquaintance with you, since I heard from madame that we had known each
other in Paris."

With these words he looked at me attentively, as people will do when they
are trying to recollect a person whom they have lost sight of. I then told him

that we had never spoken to one another, and that he had not seen enough of me to recollect my features now.

"I had the honour," I added, "to dine with your excellency at M. de Mocenigo's house, but you talked all the time with Marshal Keith, the Prussian ambassador, and I was not fortunate enough to attract your attention. As you were on the point of leaving Paris to return to Venice, you went away almost immediately after dinner, and I have never had the honour of seeing you since that time."

"Now I recollect you," he answered, "and I remember asking whether you were not the secretary of the embassy. But from this day we shall not forget each other again, for the mysteries which unite us are of a nature likely to establish a lasting intimacy between us."

The amiable couple were not long before they felt thoroughly at ease, and we sat down to supper, of which, of course, I did the honours. The ambassador, a fine connoisseur in wines, found mine excellent, and was delighted to hear that I had them from Count Algarotti, who was reputed as having the best cellar in Venice.

My supper was delicate and abundant, and my manners towards my handsome guests were those of a private individual receiving his sovereign and his mistress. I saw that M—— M—— was charmed with the respect with which I treated her, and with my conversation, which evidently interested the ambassador highly. The serious character of a first meeting did not prevent the utterance of witty jests, for in that respect M. de Bernis was a true Frenchman. I have travelled much, I have deeply studied men, individually and in a body, but I have never met with true sociability except in Frenchmen; they alone know how to jest, and it is rare, delicate, refined jesting, which animates conversation and makes society charming.

During our delightful supper wit was never wanting, and the amiable M—— M—— led the conversation to the romantic combination which had given her occasion to know me. Naturally, she proceeded to speak of my passion for C—— C——, and she gave such an interesting description of that young girl that the ambassador listened with as much attention as if he had never seen the object of it. But that was his part, for he was not aware that I had been informed of his having witnessed from his hiding-place my silly interview with C—— C——. He told M—— M—— that he would have been delighted if she had brought her young friend to sup with us.

"That would be running too great a risk," answered the cunning nun, "but if you approve of it," she added, looking at me, "I can make you sup with her at my casino, for we sleep in the same room."

That offer surprised me much, but it was not the moment to shew it, so I replied:

"It is impossible, madam, to add anything to the pleasure of your society, yet I confess I should be pleased if you could contrive to do us that great favour:"

"Well, I will think of it."

"But," observed the ambassador, "if I am to be one of the party, I think it would be right to apprize the young lady of it."

"It is not necessary, for I will write to her to agree to whatever madam may propose to her. I will do so to-morrow."

I begged the ambassador to prepare himself with a good stock of indulgence for a girl of fifteen who had no experience of the world. In the course of the evening I related the history of O-Morphi, which greatly amused him. He entreated me to let him see her portrait. He informed me that she was still an inmate of the 'Parc-aux-cerfs', where she continued to be the delight of Louis XV., to whom she had given a child. My guests left me after midnight, highly pleased, and I remained alone.

The next morning, faithful to the promise I had made to my beautiful nun, I wrote to C—— C—— without informing her that there would be a fourth person at the projected supper, and having given my note to Laura I repaired to Muran, where I found the following letter from M—— M—— :

"I could not sleep soundly, my love, if I did not ease my conscience of an unpleasant weight. Perhaps you did not approve of the 'partie carree' with our young friend, and you may not have objected out of mere politeness. Tell me the truth, dearest, for, should you not look forward to that meeting with pleasure, I can contrive to undo it without implicating you in any way; trust me for that. If, however, you have no objection to the party, it will take place as agreed. Believe me, I love your soul more than your heart—I mean than your person. Adieu."

Her fear was very natural, but out of shamefacedness I did not like to retract. M—— M—— knew me well, and as a skilful tactician she attacked my weak side.

Here is my answer:

"I expected your letter, my best beloved, and you cannot doubt it, because, as you know me thoroughly, you must be aware that I know you as well. Yes, I know your mind, and I know what idea you must entertain of mine, because I have exposed to you all my weakness and irritability by my sophisms. I do penance for it, dearest, when I think that having raised your suspicions your tenderness for me must have been weakened. Forget my visions, I beg, and be

quite certain that for the future my soul will be in unison with yours. The supper must take place, it will be a pleasure for me, but let me confess that in accepting it I have shewn myself more grateful than polite. C—— C—— is a novice, and I am not sorry to give her an opportunity of seeing the world. In what school could she learn better than yours? Therefore I recommend her to you, and you will please me much by continuing to shew your care and friendship towards her, and by increasing, if possible, the sum of your goodness. I fear that you may entice her to take the veil, and if she did I would never console myself. Your friend has quite captivated me; he is a superior man, and truly charming."

Thus did I wittingly deprive myself of the power of drawing back, but I was able to realize the full force of the situation. I had no difficulty in guessing that the ambassador was in love with C—— C——, and that he had confessed as much to M—— M——, who, not being in a position to object to it, was compelled to shew herself compliant, and to assist him in everything that could render his passion successful. She could certainly not do anything without my consent, and she had evidently considered the affair too delicate to venture upon proposing the party point-blank to me. They had, no doubt, put their heads together, so that by bringing the conversation on that subject I should find myself compelled, for the sake of politeness and perhaps of my inward feelings, to fall into the snare. The ambassador, whose profession it was to carry on intrigues skilfully, had succeeded well, and I had taken the bait as he wished. There was nothing left for me but to put a good face on the matter, not only so as not to shew myself a very silly being, but also in order not to prove myself shamefully ungrateful towards a man who had granted me unheard-of privileges. Nevertheless, the consequence of it all was likely to be some coolness in my feelings towards both my mistresses. M—— M—— had become conscious of this after she had returned to the convent, and wishing to screen herself from all responsibility she had lost no time in writing to me that she would cause the projected supper to be abandoned, in case I should disapprove of it, but she knew very well that I would not accept her offer. Self-love is a stronger passion even than jealousy; it does not allow a man who has some pretension to wit to shew himself jealous, particularly towards a person who is not tainted by that base passion, and has proved it.

The next day, having gone early to the casino, I found the ambassador already there, and he welcomed me in the most friendly manner. He told me that, if he had known me in Paris he would have introduced me at the court, where I should certainly have made my fortune. Now, when I think of that, I say to myself, "That might have been the case, but of what good would it

have been to me?" Perhaps I should have fallen a victim of the Revolution, like so many others. M. de Bernis himself would have been one of those victims if Fate had not allowed him to die in Rome in 1794. He died there unhappy, although wealthy, unless his feelings had undergone a complete change before his death, and I do not believe it.

I asked him whether he liked Venice, and he answered that he could not do otherwise than like that city, in which he enjoyed excellent health, and in which, with plenty of money, life could be enjoyed better than anywhere else.

"But I do not expect," he added, "to be allowed to keep this embassy very long. Be kind enough to let that remain between us. I do not wish to make M—— M—— unhappy."

We were conversing in all confidence when M—— M—— arrived with her young friend, who showed her surprise at seeing another man with me, but I encouraged her by the most tender welcome; and she recovered all her composure when she saw the delight of the stranger at being answered by her in good French. It gave us both an opportunity of paying the warmest compliments to the mistress who had taught her so well.

C—— C—— was truly charming; her looks, bright and modest at the same time, seemed to say to me, "You must belong to me:" I wished to see her shine before our friends; and I contrived to conquer a cowardly feeling of jealousy which, in spite of myself, was beginning to get hold of me. I took care to make her talk on such subjects as I knew to be familiar to her. I developed her natural intelligence, and had the satisfaction of seeing her admired.

Applauded, flattered, animated by the satisfaction she could read in my eyes, C—— C—— appeared a prodigy to M. de Bernis, and, oh! what a contradiction of the human heart! I was pleased, yet I trembled lest he should fall in love with her! What an enigma! I was intent myself upon a work which would have caused me to murder any man who dared to undertake it.

During the supper, which was worthy of a king, the ambassador treated C—— C—— with the most delicate attentions. Wit, cheerfulness, decent manners, attended our delightful party, and did not expel the gaiety and the merry jests with which a Frenchman knows how to season every conversation.

An observing critic who, without being acquainted with us, wished to guess whether love was present at our happy party, might have suspected, perhaps, but he certainly could not have affirmed, that it was there. M—— M—— treated the ambassador as a friend. She shewed no other feeling towards me than that of deep esteem, and she behaved to C—— C—— with the tender affection of a sister. M. de Bernis was kind, polite, and amiable with M—— M——, but he never ceased to take the greatest interest in every word uttered

by C—— C——, who played her part to perfection, because she had only to follow her own nature, and, that nature being beautiful, C—— C—— could not fail to be most charming.

We had passed five delightful hours, and the ambassador seemed more pleased even than any of us. M—— M—— had the air of a person satisfied with her own work, and I was playing the part of an approving spectator. C—— C—— looked highly pleased at having secured the general approbation, and there was, perhaps, a slight feeling of vanity in her arising from the special attention which the ambassador had bestowed on her. She looked at me, smiling, and I could easily understand the language of her soul, by which she wished to tell me that she felt perfectly well the difference between the society in which she was then, and that in which her brother had given us such a disgusting specimen of his depravity.

After midnight it was time to think of our departure, and M. de Bernis undertook all the complimentary part. Thanking M—— M—— for the most agreeable supper he had ever made in his life, he contrived to make her offer a repetition of it for two days afterwards, and he asked me, for the sake of appearance, whether I should not find as much delight in that second meeting as himself. Could he have any doubt of my answering affirmatively? I believe not, for I had placed myself under the necessity of being compliant. All being agreed, we parted company.

The next day, when I thought of that exemplary supper, I had no difficulty in guessing what the ultimate result would be. The ambassador owed his great fortune entirely to the fair sex, because he possessed to the highest degree the art of coddling love; and as his nature was eminently voluptuous he found his advantage in it, because he knew how to call desires into existence, and this procured him enjoyments worthy of his delicate taste. I saw that he was deeply in love with C—— C——, and I was far from supposing him the man to be satisfied with looking at her lovely eyes. He certainly had some plan arranged, and M—— M——, in spite of all her honesty, was the prime manager of it. I knew that she would carry it on with such delicate skill that I should not see any evidence of it. Although I did not feel disposed to shew more compliance than was strictly just, I foresaw that in the end I should be the dupe, and my poor C—— C—— the victim, of a cunningly-contrived trick. I could not make up my mind either to consent with a good grace, or to throw obstacles in the way, and, believing my dear little wife incapable of abandoning herself to anything likely to displease me, I allowed myself to be taken off my guard, and to rely upon the difficulty of seducing her. Stupid calculation! Self-love and shamefacedness prevented me from using my

common sense. At all events, that intrigue kept me in a state of fever because I was afraid of its consequences, and yet curiosity mastered me to such an extent that I was longing for the result. I knew very well that a second edition of the supper did not imply that the same play would be performed a second time, and I foresaw that the changes would be strongly marked. But I thought myself bound in honour not to retract. I could not lead the intrigue, but I believed myself sufficiently skilful to baffle all their manoeuvrings.

After all those considerations, however, considerations which enabled me to assume the countenance of false bravery, the inexperience of C——— C———, who, in spite of all the knowledge she had lately acquired, was only a novice, caused me great anxiety. It was easy to abuse her natural wish to be polite, but that fear gave way very soon before the confidence I had in M——— M——— s delicacy. I thought that, having seen how I had spent six hours with that young girl, knowing for a certainty that I intended to marry her, M——— M——— would never be guilty of such base treason. All these thoughts, worthy only of a weak and bashful jealousy, brought no conclusive decision. I had to follow the current and watch events.

At the appointed time I repaired to the casino, where I found my two lovely friends sitting by the fire.

"Good evening, my two divinities, where is our charming Frenchman?"

"He has not arrived yet," answered M——— M———, "but he will doubtless soon be here."

I took off my mask, and sitting between them, I gave them a thousand kisses, taking good care not to shew any preference, and although I knew that they were aware of the unquestionable right I had upon both of them, I kept within the limits of the utmost decency. I congratulated them upon the mutual inclination they felt for each other, and I saw that they were pleased not to have to blush on that account.

More than one hour was spent in gallant and friendly conversation, without my giving any satisfaction to my burning desires. M——M——— attracted me more than C——— C———, but I would not for the world have offended the charming girl. M——— M——— was beginning to shew some anxiety about the absence of M. de Bernis, when the door-keeper brought her a note from him.

"A courier," he wrote, "who arrived two hours ago, prevents my being happy to-night, for I am compelled to pass it in answering the dispatches I have received. I trust that you will forgive and pity me. May I hope that you will kindly grant me on Friday the pleasure of which I am so unfortunately deprived to-day? Let me know your answer by to-morrow. I wish ardently, in

that case, to find you with the same guests, to whom I beg you will present my affectionate compliments."

"Well," said M——— M———, "it is not his fault. We will sup without him. Will you come on Friday?"

"Yes, with the greatest pleasure. But what is the matter with you, dear C——— C———? You look sad."

"Sad, no, unless it should be for the sake of my friend, for I have never seen a more polite and more obliging gentleman."

"Very well, dear, I am glad he has rendered you so sensible."

"What do you mean? Could anyone be insensible to his merit?"

"Better still, but I agree with you. Only tell me if you love him?"

"Well, even if I loved him, do you think I would go and tell him? Besides, I am certain that he loves my friend."

So saying, she sat down on M——— M———'s knee, calling her her own little wife, and my two beauties began to bestow on one another caresses which made me laugh heartily. Far from troubling their sport, I excited them, in order to enjoy a spectacle with which I had long been acquainted.

M——— M——— took up a book full of the most lascivious engravings, and said, with a significant glance in my direction:

"Do you wish me to have a fire lighted in the alcove?"

I understood her, and replied:

"You would oblige me, for the bed being large we can all three sleep comfortably in it."

I guessed that she feared my suspecting the ambassador of enjoying from the mysterious closet the sight of our amorous trio, and she wished to destroy that suspicion by her proposal.

The table having been laid in front of the alcove, supper was served, and we all did honour to it. We were all blessed with a devouring appetite. While M——— M——— was teaching her friend how to mix punch, I was admiring with delight the progress made in beauty by C——— C———.

"Your bosom," I said to her, "must have become perfect during the last nine months."

"It is like mine," answered M——— M———, "would you like to see for yourself?"

Of course I did not refuse. M——— M——— unlaced her friend, who made no resistance, and performing afterwards the same office upon herself, in less than two minutes I was admiring four rivals contending for the golden apple like the three goddesses, and which would have set at defiance the handsome Paris himself to adjudge the prize without injustice. Need I say what an ardent

fire that ravishing sight sent coursing through my veins? I placed immediately
an the table the Academie des Dames, and pointed out a certain position to
M—— M——, who, understanding my wishes, said to C—— C—— :

"Will you, darling, represent that group with me?"

A look of compliance was C—— C——'s only answer; she was not yet
inured to amorous pleasures as much as her lovely teacher. While I was
laughing with delight, the two friends were getting ready, and in a few
minutes we were all three in bed, and in a state of nature. At first, satisfied
with enjoying the sight of the barren contest of my two bacchanalians, I was
amused by their efforts and by the contrast of colours, for one was dark and
the other fair, but soon, excited myself, and consumed by all the fire of
voluptuousness, I threw myself upon them, and I made them, one after the
other, almost faint away from the excess of love and enjoyment.

Worn out and satiated with pleasure, I invited them to take some rest. We
slept until we were awakened by the alarum, which I had taken care to set at
four o'clock. We were certain of turning to good account the two hours we
had then to spare before parting company, which we did at the dawn of day,
humiliated at having to confess our exhaustion, but highly pleased with each
other, and longing for a renewal of our delightful pleasures.

The next day, however, when I came to think of that rather too lively
night, during which, as is generally the case, Love had routed Reason, I felt
some remorse. M—— M—— wanted to convince me of her love, and for
that purpose she had combined all the virtues which I attached to my own
affection—namely, honour, delicacy, and truth, but her temperament, of
which her mind was the slave, carried her towards excess, and she prepared
everything in order to give way to it, while she awaited the opportunity of
making me her accomplice. She was coaxing love to make it compliant, and
to succeed in mastering it, because her heart, enslaved by her senses, never
reproached her. She likewise tried to deceive herself by endeavouring to
forget that I might complain of having been surprised. She knew that to utter
such a complaint I would have to acknowledge myself weaker or less
courageous than she was, and she relied upon my being ashamed to make
such a confession. I had no doubt whatever that the absence of the
ambassador had been arranged and concerted beforehand. I could see still
further, for it seemed evident to me that the two conspirators had foreseen
that I would guess the artifice, and that, feeling stung to the quick, in spite of
all my regrets, I would not shew myself less generous than they had been
themselves. The ambassador having first procured me a delightful night, how
could I refuse to let him enjoy as pleasant a one? My friends had argued very

well, for, in spite of all the objections of my mind, I saw that I could not on my side put any obstacle in their way. C—— C—— was no impediment to them. They were certain of conquering her the moment she was not hindered by my presence. It rested entirely with M—— M——, who had perfect control over her. Poor girl! I saw her on the high road to debauchery, and it was my own doing! I sighed when I thought how little I had spared them in our last orgie, and what would become of me if both of them should happen to be, by my doing, in such a position as to be compelled to run away from the convent? I could imagine both of them thrown upon my hands, and the prospect was not particularly agreeable. It would be an 'embarras de richesse'. In this miserable contest between reason and prejudice, between nature and sentiment, I could not make up my mind either to go to the supper or to remain absent from it. "If I go," said I to myself, "that night will pass with perfect decency, but I shall prove myself very ridiculous, jealous, ungrateful, and even wanting in common politeness: if I remain absent, C—— C—— is lost, at least, in my estimation, for I feel that my love will no longer exist, and then good-bye to all idea of a marriage with her." In the perplexity of mind in which I found myself, I felt a want of something more certain than mere probabilities to base my decision upon. I put on my mask, and repaired to the mansion of the French ambassador. I addressed myself to the gate-keeper, saying that I had a letter for Versailles, and that I would thank him to deliver it to the courier when he went back to France with his excellency's dispatches.

"But, sir," answered the man, "we have not had a special courier for the last two months."

"What? Did not a special cabinet messenger arrive here last night?"

"Then he must have come in through the garret window or down the chimney, for, on the word of an honest man, none entered through the gate."

"But the ambassador worked all night?"

"That may be, sir, but not here, for his excellency dined with the Spanish ambassador, and did not return till very late."

I had guessed rightly. I could no longer entertain any doubt. It was all over; I could not draw back without shame. C—— C—— must resist, if the game was distasteful to her; no violence would of course be offered to her. The die was cast!

Towards evening I went to the casino of Muran, and wrote a short note to M—— M——, requesting her to excuse me if some important business of M. de Bragadin's prevented me from spending the night with her and with our two friends, to whom I sent my compliments as well as my apologies. After

that I returned to Venice, but in rather an unpleasant mood; to divert myself I went to the gaming table, and lost all night.

Two days afterwards, being certain that a letter from M—— M—— awaited me at Muran, I went over, and the door-keeper handed me a parcel in which I found a note from my nun and a letter from C—— C——, for everything was now in common between them.

Here is C—— C——'s letter"

"We were very sorry, dearest friend, when we heard that we should not have the happiness of seeing you. My dear M—— M——'s friend came shortly afterwards, and when he read your note he likewise expressed his deep regret. We expected to have a very dull supper, but the witty sayings of that gentleman enlivened us and you cannot imagine of what follies we were guilty after partaking of some champagne punch. Our friend had become as gay as ourselves, and we spent the night in trios, not very fatiguing, but very pleasant. I can assure you that that man deserves to be loved, but he must acknowledge himself inferior to you in everything. Believe me, dearest, I shall ever love you, and you must for ever remain the master of my heart."

In spite of all my vexation, that letter made me laugh, but the note of M—— M—— was much more singular. Here are the contents of it:

"I am certain, my own beloved, that you told a story out of pure politeness, but you had guessed that I expected you to do so. You have made our friend a splendid present in exchange for the one he made you when he did not object to his M—— M—— bestowing her heart upon you. You possess that heart entirely, dearest, and you would possess it under all circumstances, but how sweet it is to flavour the pleasures of love with the charms of friendship! I was sorry not to see you, but I knew that if you had come we would not have had much enjoyment; for our friend, notwithstanding all his wit, is not exempt from some natural prejudices. As for C—— C——, her mind is now quite as free of them as our own, and I am glad she owes it to me. You must feel thankful to me for having completed her education, and for rendering her in every way worthy of you. I wish you had been hiding in the closet, where I am certain you would have spent some delightful hours. On Wednesday next I shall be yours, and all alone with you in your casino in Venice; let me know whether you will be at the usual hour near the statue of the hero Colleoni. In case you should be prevented, name any other day."

I had to answer those two letters in the same spirit in which they had been written, and in spite of all the bitter feelings which were then raging in my heart, my answers were to be as sweet as honey. I was in need of great courage, but I said to myself: "George Dandin, tu las voulu!" I could not refuse to pay the penalty of my own deeds, and I have never been able to

ascertain whether the shame I felt was what is called shamefacedness. It is a problem which I leave to others.

In my letter to C—— C—— I had the courage, or the effrontery, to congratulate her, and to encourage her to imitate M—— M——, the best model, I said, I could propose to her.

I wrote to my nun that I would be punctual at the appointment near the statue, and amidst many false compliments, which ought to have betrayed the true state of my heart, I told her that I admired the perfect education she had given to C—— C——, but that I congratulated myself upon having escaped the torture I should have suffered in the mysterious observatory, for I felt that I could not have borne it.

On the Wednesday I was punctual at the rendezvous, and I had not to wait long for M—— M——, who came disguised in male attire. "No theatre to-night," she said to me; "let us go to the 'ridotto', to lose or double our money." She had six hundred sequins. I had about one hundred. Fortune turned her back upon us, and we lost all. I expected that we would then leave that cutthroat place, but M—— M——, having left me for a minute, came back with three hundred sequins which had been given to her by her friend, whom she knew where to find. That money given by love or by friendship brought her luck for a short time, and she soon won back all we had lost, but in our greediness or imprudence we continued to play, and finally we lost our last sequin.

When we could play no longer, M—— M—— said to me,

"Now that we need not fear thieves, let us go to our supper."

That woman, religious and a Free-thinker, a libertine and gambler, was wonderful in all she did. She had just lost five hundred pounds, and she was as completely at her ease as if she had won a very large sum. It is true that the money she had just lost had not cost her much.

As soon as we were alone, she found me sad and low-spirited, although I tried hard not to appear so, but, as for her, always the same, she was handsome, brilliant, cheerful, and amorous.

She thought she would bring back my spirits by giving me the fullest particulars of the night she had passed with C—— C—— and her friend, but she ought to have guessed that she was going the wrong way. That is a very common error, it comes from the mind, because people imagine that what they feel themselves others must feel likewise.

I was on thorns, and I tried everything to avoid that subject, and to lead the conversation into a different channel, for the amorous particulars, on which she was dwelling with apparent delight, vexed me greatly, and spite causing coldness, I was afraid of not playing my part very warmly in the amorous

contest which was at hand. When a lover doubts his own strength, he may almost always be sure that he will fail in his efforts.

After supper we went to bed in the alcove, where the beauty, the mental and physical charms, the grace and the ardour of my lovely nun, cast all my bad temper to the winds, and soon restored me to my usual good-spirits. The nights being shorter we spent two hours in the most delightful pleasures, and then parted, satisfied and full of love.

Before leaving, M—— M—— asked me to go to her casino, to take some money and to play, taking her for my partner. I did so. I took all the gold I found, and playing the martingale, and doubling my stakes continuously, I won every day during the remainder of the carnival. I was fortunate enough never to lose the sixth card, and, if I had lost it, I should have been without money to play, for I had two thousand sequins on that card. I congratulated myself upon having increased the treasure of my dear mistress, who wrote to me that, for the sake of civility, we ought to have a supper 'en partie carree' on Shrove Monday. I consented.

That supper was the last I ever had in my life with C—— C——. She was in excellent spirits, but I had made up my mind, and as I paid all my attentions to M—— M——, C—— C—— imitated my example without difficulty, and she devoted herself wholly to her new lover.

Foreseeing that we would, a little later, be all of us in each other's way, I begged M—— M—— to arrange everything so that we could be apart, and she contrived it marvellously well.

After supper, the ambassador proposed a game of faro, which our beauties did not know; he called for cards, and placed one hundred Louis on the table before him; he dealt, and took care to make C—— C—— win the whole of that sum. It was the best way to make her accept it as pin-money. The young girl, dazzled by so much gold, and not knowing what to do with it, asked her friend to take care of it for her until such time as she should leave the convent to get married.

When the game was over, M—— M—— complained of a headache, and said that she would go to bed in the alcove: she asked me to come and lull her to sleep. We thus left the new lovers free to be as gay as they chose. Six hours afterwards, when the alarum warned us that it was time to part, we found them asleep in each other's embrace. I had myself passed an amorous and quiet night, pleased with M—— M——, and with out giving one thought to C—— C——.

CHAPTER XXII

M. De Bernis Goes Away Leaving Me the Use of His Casino—His
Good Advice: How I Follow It—Peril of M. M. and Myself—Mr.
Murray, the English Ambassador—Sale of the Casino and End
of Our Meetings—Serious Illness of M. M.—Zorzi and
Condulmer—Tonnie

Though the infidelities of C—— C—— made me look at her with other
eyes than before, and I had now no intention of making her the companion
of my life, I could not help feeling that it had rested with me to stop her on
the brink of the stream, and I therefore considered it my duty always to be her
friend.

If I had been more logical, the resolution I took with respect to her would
doubtless have been of another kind. I should have said to myself: After
seducing her, I myself have set the example of infidelity; I have bidden her to
follow blindly the advice of her friend, although I knew that the advice and
the example of M——M—— would end in her ruin; I had insulted, in the most
grievous manner, the delicacy of my mistress, and that before her very eyes,
and after all this how could I ask a weak woman to do what a man, priding
himself on his strength, would shrink from at tempting? I should have stood
self-condemned, and have felt that it was my duty to remain the same to her,
but flattering myself that I was overcoming mere prejudices, I was in fact that
most degraded of slaves, he who uses his strength to crush the weak.

The day after Shrove Tuesday, going to the casino of Muran, I found there
a letter from M—— M——, who gave me two pieces of bad news: that
C—— C—— had lost her mother, and that the poor girl was in despair; and
that the lay-sister, whose rheum was cured, had returned to take her place.
Thus C—— C—— was deprived of her friend at a time when she would have
given her consolation, of which she stood in great need. C—— C——, it
seemed, had gone to share the rooms of her aunt, who, being very fond of her,
had obtained permission from the superior. This circumstance would prevent
the ambassador taking any more suppers with her, and I should have been
delighted if chance had put this obstacle in his path a few days sooner.

All these misfortunes seemed of small account compared with what I was
afraid of, for C—— C—— might have to pay the price for her pleasures, and
I so far regarded myself as the origin of her unhappiness as to feel bound
never to abandon her, and this might have involved me in terrible
complications.

M—— M—— asked me to sup with her and her lover on the following Monday. I went and found them both sad—he for the loss of his new mistress, and she because she had no longer a friend to make the seclusion of the convent pleasant.

About midnight M. de Bemis left us, saying in a melancholy manner that he feared he should be obliged to pass several months in Vienna on important diplomatic business. Before parting we agreed to sup together every Friday.

When we were alone M—— M—— told me that the ambassador would be obliged to me if in the future I would come to the casino two hours later. I understood that the good-natured and witty profligate had a very natural prejudice against indulging his amorous feelings except when he was certain of being alone.

M. de Bemis came to all our suppers till he left for Vienna, and always went away at midnight. He no longer made use of his hiding-place, partly because we now only lay in the recess, and partly because, having had time to make love before my arrival, his desires were appeased. M—— M—— always found me amorous. My love, indeed, was even hotter than it had been, since, only seeing her once a week and remaining faithful to her, I had always an abundant harvest to gather in. C—— C——'s letters which she brought to me softened me to tears, for she said that after the loss of her mother she could not count upon the friendship of any of her relations. She called me her sole friend, her only protector, and in speaking of her grief in not being able to see me any more whilst she remained in the convent, she begged me to remain faithful to her dear friend.

On Good Friday, when I got to the casino, I found the lovers over-whelmed with grief. Supper was served, but the ambassador, downcast and absent, neither ate nor spoke; and M—— M—— was like a statue that moves at intervals by some mechanism. Good sense and ordinary politeness prevented me from asking any questions, but on M—— M—— leaving us together, M. de Bemis told me that she was distressed, and with reason, since he was obliged to set out for Vienna fifteen days after Easter. "I may tell you confidentially," he added, "that I believe I shall scarcely be able to return, but she must not be told, as she would be in despair." M—— M—— came back in a few minutes, but it was easy to see that she had been weeping.

After some commonplace conversation, M. de Bernis, seeing M—— M—— still low-spirited, said,

"Do not grieve thus, sweetheart, go I must, but my return is a matter of equal certainty when I have finished the important business which summons me to Vienna. You will still have the casino, but, dearest, both friendship and

prudence make me advise you not to come here in my absence, for after I
have left Venice I cannot depend upon the faith of the gondoliers in my
service, and I suspect our friend here cannot flatter himself on his ability to
get reliable ones. I may also tell you that I have strong reasons for suspecting
that our intercourse is known to the State Inquisitors, who conceal their
knowledge for political reasons, but I fancy the secret would soon come to
light when I am no longer here, and when the nun who connives at your
departure from the convent knows that it is no longer for me that you leave
it. The only people whom I would trust are the housekeeper and his wife. I
shall order them, before I go, to look upon our friend here as myself, and you
can make your arrangements with them. I trust all will go well till my return,
if you will only behave discreetly. I will write to you under cover of the
housekeeper, his wife will give you my letters as before, and in the same way
you may reply. I must needs go, dearest one, but my heart is with you, and I
leave you, till my return, in the hands of a friend, whom I rejoice to have
known. He loves you, he has a heart and knowledge of the world, and he will
not let you make any mistakes."

M—— M—— was so affected by what the ambassador had said that she
entreated us to let her go, as she wished to be alone and to lie down. As she
went we agreed to sup together on the following Thursday.

As soon as we were alone the ambassador impressed me with the absolute
necessity of concealing from her that he was going to return no more. "I am
going," said he, "to work in concert with the Austrian cabinet on a treaty
which will be the talk of Europe. I entreat you to write to me unreservedly,
and as a friend, and if you love our common mistress, have a care for her
honour, and above all have the strength of mind to resist all projects which
are certain to involve you in misfortune, and which will be equally fatal to
both. You know what happened to Madame de Riva, a nun in the convent of
St.——. She had to disappear after it became known that she was with child,
and M. de Frulai, my predecessor, went mad, and died shortly after. J. J.
Rousseau told me that he died of poison, but he is a visionary who sees the
black side of everything. For my part, I believe that he died of grief at not
being able to do anything for the unfortunate woman, who afterwards
procured a dispensation from her vows from the Pope, and having got married
is now living at Padua without any position in society.

"Let the prudent and loyal friend master the lover: go and see M——
M—— sometimes in the parlour of the convent, but not here, or the boatmen
will betray you. The knowledge which we both have that the girls are in a
satisfactory condition is a great alleviation to my distress, but you must

confess that you have been very imprudent. You have risked a terrible misfortune; consider the position you would have been in, for I am sure you would not have abandoned her. She had an idea that the danger might be overcome by means of drugs but I convinced her that she was mistaken. In God's name, be discreet in the future, and write to me fully, for I shall always be interested in her fate, both from duty and sentiment."

We returned together to Venice, where we separated, and I passed the rest of the night in great distress. In the morning I wrote to the fair afflicted, and whilst endeavouring to console her to the best of my ability, I tried to impress on her the necessity for prudence and the avoidance of such escapades as might eventually ruin us.

Next day I received her reply, every word of which spelt despair. Nature had given her a disposition which had become so intensified by indulgence that the cloister was unbearable to her, and I foresaw the hard fights I should have to undergo.

We saw each other the Thursday after Easter, and I told her that I should not come to the casino before midnight. She had had four hours to pass with her lover in tears and regrets, amongst which she had often cursed her cruel fate and the foolish resolution which made her take the veil. We supped together, and although the meal was a rich and delicate one we did it little honour. When we had finished, the ambassador left, entreating me to remain, which I did, without thinking at all of the pleasures of a party of two, for Love lighteth not his torch at the hearts of two lovers who are full of grief and sorrow. M—— M—— had grown thin, and her condition excited my pity and shut out all other feelings. I held her a long time in my arms, covering her with tender and affectionate kisses, but I shewed no intention of consoling her by amusements in which her spirit could not have taken part. She said, before we parted, that I had shewn myself a true lover, and she asked me to consider myself from henceforth as her only friend and protector.

Next week, when we were together as usual, M. de Bemis called the housekeeper just before supper, and in his presence executed a deed in my behalf, which he made him sign. In this document he transferred to me all rights over the contents of the casino, and charged him to consider me in all things as his master.

We arranged to sup together two days after, to make our farewells, but on my arrival I found by herself, standing up, and pale as death, or rather as white as a statue of Carrara marble.

"He is gone," she said, "and he leaves me to your care. Fatal being, whom perchance I shall see no more, whom I thought I loved but as a friend, now

you are lost to me I see my mistake. Before I knew him I was not happy, but neither was I unhappy as I now am."

I passed the whole night beside her, striving by the most delicate attentions to soften her grief, but with out success. Her character, as abandoned to sorrow as to pleasure, was displayed to me during that long and weary night. She told me at what hour I should come to the convent parlour, the next day, and on my arrival I was delighted to find her not quite so sad. She shewed me a letter which her lover had written to her from Trevisa, and she then told me that I must come and see her twice a week, warning me that she would be accompanied sometimes by one nun and sometimes by another, for she foresaw that my visits would become the talk of the convent, when it became known that I was the individual who used to go to mass at their church. She therefore told me to give in another name, to prevent C—— C——'s aunt from becoming suspicious.

"Nevertheless," she added, "this will not prevent my coming alone when I have any matter of importance to communicate to you. Promise me, sweetheart, to sup and sleep at the casino at least once a week, and write me a note each time by the housekeeper's wife."

I made no difficulty in promising her that much.

We thus passed a fortnight quietly enough, as she was happy again, and her amorous inclinations had returned in full force. About this time she gave me a piece of news which delighted me—namely, that C—— C—— had no longer anything to fear.

Full of amorous wishes and having to be content with the teasing pleasure of seeing one another through a wretched grating, we racked our brains to find out some way to be alone together to do what we liked, without any risk.

"I am assured," she said, "of the good faith of the gardener's sister. I can go out and come in without fear of being seen, for the little door leading to the convent is not overlooked by any window—indeed it is thought to be walled up. Nobody can see me crossing the garden to the little stream, which is considered unnavigable. All we want is a one-oared gondola, and I cannot believe that with the help of money you will be unable to find a boatman on whom we may rely."

I understood from these expressions that she suspected me of becoming cold towards her, and this suspicion pierced me to the heart.

"Listen," said I, "I will be the boatman myself. I will come to the quay, pass by the little door, and you shall lead me to your room where I will pass the whole night with you, and the day, too, if you think you can hide me."

"That plan," said she, "makes me shudder. I tremble at the danger to which you might be exposed. No, I should be too unfortunate if I were to be the cause of your misfortune, but, as you can row, come in the boat, let me know the time as closely as possible; the trusty woman will be on the watch, and I will not keep you four minutes waiting. I will get into the boat, we will go to our beloved casino, and then we shall be happy without fearing anything."

"I will think it over"

The way I took to satisfy her was as follows: I bought a small boat, and without telling her I went one night all by myself round the island to inspect the walls of the convent on the side of the lagune. With some difficulty I made out a little door, which I judged to be the only one by which she could pass, but to go from there to the casino was no small matter, since one was obliged to fetch a wide course, and with one oar I could not do the passage in less than a quarter of an hour, and that with much toil. Nevertheless, feeling sure of success, I told my pretty nun of the plan, and never was news received with so much pleasure. We set our watches together, and fixed our meeting for the Friday following.

On the day appointed, an hour before sunset, I betook myself to St. Francis de la Vigne, where I kept my boat, and having set it in order and dressed myself as a boatman, I got upon the poop and held a straight course for the little door, which opened the moment I arrived. M—— M—— came out wrapped in a cloak, and someone shutting the door after her she got on board my frail bark, and in a quarter of an hour we were at the casino. M—— M—— made haste to go in, but I stayed to belay my boat with a lock and chain against thieves, who pass the night pleasantly by stealing whatever they can lay hands on.

Though I had rowed easily enough, I was in a bath of perspiration, which, however, by no means hindered my charming mistress from falling on my neck; the pleasure of meeting seemed to challenge her love, and, proud of what I had done, I enjoyed her transports.

Not dreaming that I should have any occasion for a change of linen, I had brought none with me, but she soon found a cure for this defect; for after having undressed me she dried me lovingly, gave me one of her smocks, and I found myself dressed to admiration.

We had been too long deprived of our amorous pleasures to think of taking supper before we had offered a plenteous sacrifice to love. We spent two hours in the sweetest of intoxications, our bliss seeming more acute than at our first meeting. In spite of the fire which consumed me, in spite of the ardour of my mistress, I was sufficiently master of myself to disappoint her at

the critical moment, for the picture which our friend had drawn was always before my eyes. M—— M——, joyous and wanton, having me for the first time in the character of boatman, augmented our delights by her amorous caprices, but it was useless for her to try to add fuel to my flame, since I loved her better than myself.

The night was short, for she was obliged to return at three in the morning, and it struck one as we sat down to table. As the climax of ill luck a storm came on whilst we were at supper. Our hair stood on end; our only hope was founded in the nature of these squalls, which seldom last more than an hour. We were in hopes, also, that it would not leave behind it too strong a wind, as is sometimes the case, for though I was strong and sturdy I was far from having the skill or experience of a professional boatman.

In less than half an hour the storm became violent, one flash of lightning followed another, the thunder roared, and the wind grew to a gale. Yet after a heavy rain, in less than an hour, the sky cleared, but there was no moon, it being the day after the Ascension. Two o'clock stuck. I put my head out at the window, but perceive that a contrary gale is blowing.

'Ma tiranno del mar Libecchio resta.'

This Libecchio which Ariosto calls—and with good reason—the tyrant of the sea, is the southwesterly wind, which is commonly called 'Garbin' at Venice. I said nothing, but I was frightened. I told my sweetheart that we must needs sacrifice an hour of pleasure, since prudence would have it so.

"Let us set out forthwith, for if the gale gets stronger I shall not be able to double the island."

She saw my advice was not to be questioned, and taking the key of her strong box, whence she desired to get some money, she was delighted to find her store increased fourfold. She thanked me for having told her nothing about it, assuring me she would have of me nothing but my heart, and following me she got into my boat and lay down at full length so as not to hinder its motion, I got upon the poop, as full of fear as courage, and in five minutes I had the good luck to double the point. But there it was that the tyrant was waiting for me, and it was not long before I felt that my strength would not outlast that of the winds. I rowed with all my strength, but all I could do was to prevent my boat from going back. For half an hour I was in this pitiful state, and I felt my strength failing without daring to say a word. I was out of breath, but could not rest a moment, since the least relaxation would have let the boat slip a far way back, and this would have been a distance hard to recover. M—— M—— lay still and silent, for she perceived I had no breath wherewith to answer her. I began to give ourselves up as lost.

At that instant I saw in the distance a barque coming swiftly towards us. What a piece of luck! I waited till she caught us up, for if I had not done so I should not have been able to make myself heard, but as soon as I saw her at my left hand, twelve feet off, I shouted, "Help! I will give two sequins!"

They lowered sail and came towards me, and on their hailing me I asked for a man to take us to the opposite point of the island. They asked a sequin in advance, I gave it them, and promised the other to the man who would get on my poop and help me to make the point. In less than ten minutes we were opposite to the little stream leading to the convent, but the secret of it was too dear to be hazarded, so as soon as we reached the point I paid my preserver and sent him back. Henceforth the wind was in our favour, and we soon got to the little door, where M—— M—— landed, saying to me, "Go and sleep in the casino." I thought her advice wise, and I followed it, and having the wind behind me I got to the casino without trouble, and slept till broad day. As soon as I had risen I wrote to my dear mistress that I was well, and that we should see each other at the grating. Having taken my boat back to St. Francis, I put on my mask and went to Liston.

In the morning M—— M—— came to the grating by herself, and we made all such observations as our adventures of the night would be likely to suggest, but in place of deciding to follow the advice which prudence should have given us-namely, not to expose ourselves to danger for the future, we thought ourselves extremely prudent in resolving that if we were again threatened by a storm we would set out as soon as we saw it rising. All the same we had to confess that if chance had not thrown the barque in our way we should have been obliged to return to the casino, for M—— M—— could not have got to the convent, and how could she ever have entered its walls again? I should have been forced to leave Venice with her, and that for ever. My life would have been finally and irretrievably linked with hers, and, without doubt, the various adventures which at the age of seventy-two years impel me to write these Memoirs, would never have taken place.

For the next three months we continued to meet each other once a week, always amorous, and never disturbed by the slightest accidents.

M—— M—— could not resist giving the ambassador a full account of our adventures, and I had promised to write to him, and always to write the whole truth. He replied by congratulating us on our good fortune, but he prophesied inevitable disaster if we had not the prudence to stop our intercourse.

Mr. Murray, the English ambassador, a witty and handsome man, and a great amateur of the fair sex, wine, and good cheer, then kept the fair Ancilla, who introduced me to him. This fine fellow became my friend in much the

same way as M. de Bernis, the only difference being that the Frenchman liked to look on while the Englishman preferred to give the show. I was never unwelcome at their amorous battles, and the voluptuous Ancilla was delighted to have me for a witness. I never gave them the pleasure of mingling in the strife. I loved M—— M——, but I should avow that my fidelity to her was not entirely dependent on my love. Though Ancilla was handsome she inspired me with repugnance, for she was always hoarse, and complained of a sharp pain in the throat, and though her lover kept well, I was afraid of her, and not without cause, for the disease which ended the days of Francis I. of France brought her to the grave in the following autumn. A quarter of an hour before she died, her brave Briton, yielding to the lascivious requests of this new Messalina, offered in my presence the last sacrifice, in spite of a large sore on her face which made her look hideous.

This truly heroic action was known all over the town, and it was Murray himself who made it known, citing me as his witness.

This famous courtezan, whose beauty was justly celebrated, feeling herself eaten away by an internal disease, promised to give a hundred louis to a doctor named Lucchesi, who by dint of mercury undertook to cure her, but Ancilla specified on the agreement that she was not to pay the aforesaid sum till Lucchesi had offered with her an amorous sacrifice.

The doctor having done his business as well as he could wished to be paid without submitting to the conditions of the treaty, but Ancilla held her ground, and the matter was brought before a magistrate.

In England, where all agreements are binding, Ancilla would have won her case, but at Venice she lost it.

The judge, in giving sentence, said a condition, criminal per se, not fulfilled, did not invalidate an agreement—a sentence abounding in wisdom, especially in this instance.

Two months before this woman had become disgusting, my friend M. Memmo, afterwards procurator, asked me to take him to her house. In the height of the conversation, what should come but a gondola, and we saw Count Rosemberg, the ambassador from Vienna, getting out of it. M. Memmo was thunderstruck (for a Venetian noble conversing with a foreign ambassador becomes guilty of treason to the state), and ran in hot haste from Ancilla's room, I after him, but on the stair he met the ambassador, who, seeing his distress, burst into a laugh, and passed on. I got directly into M. Memmo's gondola, and we went forthwith to M. Cavalli, secretary to the State Inquisitors. M. Memmo could have taken no better course to avoid the troublesome consequences which this fatal meeting might have had, and he

was very glad that I was with him to testify to his innocence and to the harmlessness of the occurrence.

M. Cavalli received M. Memmo with a smile, and told him he did well to come to confession without wasting any time. M. Memmo, much astonished at this reception, told him the brief history of the meeting, and the secretary replied with a grave air that he had no doubt as to the truth of his story, as the circumstances were in perfect correspondence with what he knew of the matter.

We came away extremely puzzled at the secretary's reply, and discussed the subject for some time, but then we came to the conclusion that M. Cavalli could have had no positive knowledge of the matter before we came, and that he only spoke as he did from the instinct of an Inquisitor, who likes it to be understood that nothing is hid from him for a moment.

After the death of Ancilla, Mr. Murray remained without a titular mistress, but, fluttering about like a butterfly, he had, one after another, the prettiest girls in Venice. This good-natured Epicurean set out for Constantinople two years later, and was for twenty years the ambassador of the Court of St. James at the Sublime Porte. He returned to Venice in 1778 with the intention of ending his days there, far from affairs of state, but he died in the lazaretto eight days before the completion of his quarantine.

At play fortune continued to favour me; my commerce with M—— M—— could not be discovered now that I was my own waterman; and the nuns who were in the secret were too deeply involved not to keep it. I led them a merry life, but I foresaw that as soon as M. de Bernis decided to let M—— M—— know that he would not return to Venice, he would recall his people, and we should then have the casino no longer. I knew, besides, that when the rough season came on it would be impossible for me by myself to continue our voyages.

The first Monday in October, when the theatres are opened and masks may be worn, I went to St. Francis to get my boat, and thence to Muran for my mistress, afterwards making for the casino. The nights were now long enough for us to have ample time for enjoyment, so we began by making an excellent supper, and then devoted ourselves to the worship of Love and Sleep. Suddenly, in the midst of a moment of ecstasy, I heard a noise in the direction of the canal, which aroused my suspicions, and I rushed to the window. What was my astonishment and anger to see a large boat taking mine in tow! Nevertheless, without giving way to my passion, I shouted to the robbers that I would give them ten sequins if they would be kind enough to return me my boat.

A shout of laughter was all the reply they made, and not believing what I said they continued their course. What was I to do? I dared not cry, "Stop thief!" and not being endued with the power of walking on the water dry-footed, I could not give chase to the robbers. I was in the utmost distress, and for the moment M—— M—— shewed signs of terror, for she did not see how I could remedy this disaster.

I dressed myself hastily, giving no more thoughts to love, my only comfort being that I had still two hours to get the indispensable boat, should it cost me a hundred sequins. I should have been in no perplexity if I had been able to take one, but the gondoliers would infallibly make proclamation over the whole of Muran that they had taken a nun to such a convent, and all would have been lost.

The only way, then, that was open to me was either to buy a boat or to steal one. I put my pistols and dagger in my pocket, took some money, and with an oar on my shoulder set out.

The robbers had filed the chain of my boat with a silent file; this I could not do, and I could only reckon on having the good luck to find a boat moored with cords.

Coming to the large bridge I saw boats and to spare, but there were people on the quay, and I would not risk taking one. Seeing a tavern open at the end of the quay I ran like a madman, and asked if there were any boatmen there; the drawer told me there were two, but that they were drunk. I came up to them, and said, "Who will take me to Venice for eighty sous?"

"I," and "I"; and they began to quarrel as to who should go. I quieted them by giving forty sous to the more drunken of the two, and I went out with the other.

As soon as we were on our way, I said,

"You are too drunk to take me, lend me your boat, and I will give it you back to-morrow."

"I don't know you."

"I will deposit ten sequins, but your boat is not worth that. Who will be your surety?"

He took me back to the tavern, and the drawer went bail for him. Well pleased, I took my man to the boat, and having furnished it with a second oar and two poles he went away, chuckling at having made a good bargain, while I was as glad to have had the worst of it. I had been an hour away, and on entering the casino found my dear M—— M—— in an agony, but as soon as she saw my beaming face all the laughter came back on hers. I took her to the convent, and then went to St. Francis, where the keeper of the boathouse

Arthur Machen

looked as if he thought me a fool, when I told him that I had trucked away my boat for the one I had with me. I put on my mask, and went forthwith to my lodging and to bed, for these annoyances had been too much for me.

About this time my destiny made me acquainted with a nobleman called Mark Antony Zorzi, a man of parts and famous for his skill in writing verses in the Venetian dialect. Zorzi, who was very fond of the play, and desired to offer a sacrifice to Thalia, wrote a comedy which the audience took the liberty of hissing; but having persuaded himself that his piece only failed through the conspiracies of the Abbe Chiari, who wrote for the Theatre of St. Angelo, he declared open war against all the abbe's plays.

I felt no reluctance whatever to visit M. Zorzi, for he possessed an excellent cook and a charming wife. He knew that I did not care for Chiari as an author, and M. Zorzi had in his pay people who, without pity, rhyme, or reason, hissed all the compositions of the ecclesiastical playwright. My part was to criticise them in hammer verses—a kind of doggerel then much in fashion, and Zorzi took care to distribute my lucubrations far and wide. These manoeuvres made me a powerful enemy in the person of M. Condulmer, who liked me none the better for having all the appearance of being in high favour with Madame Zorzi, to whom before my appearance he had paid diligent court. This M. Condulmer was to be excused for not caring for me, for, having a large share in the St. Angelo Theatre, the failure of the abbe's pieces was a loss to him, as the boxes had to be let at a very low rent, and all men are governed by interested motives.

This M. Condulmer was sixty years old, but with all the greenness of youth he was still fond of women, gaming, and money, and he was, in fact, a money-lender, but he knew how to pass for a saint, as he took care to go to mass every morning at St. Mark's, and never omitted to shed tears before the crucifix. The following year he was made a councillor, and in that capacity he was for eight months a State Inquisitor. Having thus attained this diabolically-eminent, or eminently-diabolical, position, he had not much difficulty in shewing his colleagues the necessity of putting me under The Leads as a disturber of the peace of the Republic. In the beginning of the winter the astounding news of the treaty between France and Austria was divulged—a treaty by which the political balance was entirely readjusted, and which was received with incredulity by the Powers. The whole of Italy had reason to rejoice, for the treaty guarded that fair land from becoming the theatre of war on the slightest difference which might arise between the two Powers. What astonished the most acute was that this wonderful treaty was conceived and carried out by a young ambassador who had hitherto been

famed only as a wit. The first foundations had been laid in 1750 by Madame de Pompadour, Count Canes (who was created a prince), and M. l'Abbe de Bernis, who was not known till the following year, when the king made him ambassador to Venice. The House of Bourbon and the House of Hapsburg had been foes for two hundred and forty years when this famous treaty was concluded, but it only lasted for forty years, and it is not likely that any treaty will last longer between two courts so essentially opposed to one another.

The Abbe de Bernis was created minister for foreign affairs some time after the ratification of the treaty; three years after he re-established the parliament, became a cardinal, was disgraced, and finally sent to Rome, where he died. 'Mors ultimo linea rerum est'.

Affairs fell out as I had foreseen, for nine months after he left Venice he conveyed to M—— M—— the news of his recall, though he did it in the most delicate manner. Nevertheless, M—— M—— felt the blow so severely that she would very possibly have succumbed, had I not been preparing her for it in every way I could think of M. de Bernis sent me all instructions.

He directed that all the contents of the casino should be sold and the proceeds given to M—— M——, with the exception of the books and prints which the housekeeper was ordered to bring to Paris. It was a nice breviary for a cardinal, but would to God they had nothing worse!

Whilst M—— M—— abandoned herself to grief I carried out the orders of M. de Bernis, and by the middle of January we had no longer a casino. She kept by her two thousand sequins and her pearls, intending to sell them later on to buy herself an annuity.

We were now only able to see each other at the grating; and soon, worn with grief, she fell dangerously ill, and on the 2nd of February I recognized in her features the symptoms of approaching death. She sent me her jewel-case, with all her diamonds and nearly all her money, all the scandalous books she possessed, and all her letters, telling me that if she did not die I was to return her the whole, but that all belonged to me if, as she thought, she should succumb to the disease. She also told me that C—— C—— was aware of her state, and asked me to take pity on her and write to her, as my letters were her only comfort, and that she hoped to have strength to read them till her latest breath.

I burst into tears, for I loved her passionately, and I promised her to come and live in Muran until she recovered her health.

Having placed the property in a gondola, I went to the Bragadin Palace to deposit it, and then returned to Muran to get Laura to find me a furnished room where I could live as I liked. "I know of a good room, with meals

provided," she said; "you will be quite comfortable and will get it cheaply, and if you like to pay in advance, you need not even say who you are. The old man to whom the house belongs lives on the ground floor; he will give you all the keys and if you like you need see no one."

She gave me the address, and I went there on the spot, and having found everything to my liking I paid a month in advance and the thing was done. It was a little house at the end of a blind alley abutting on the canal. I returned to Laura's house to tell her that I wanted a servant to get my food and to make my bed, and she promised to get me one by the next day.

Having set all in order for my new lodging, I returned to Venice and packed my mails as if I were about to make a long journey. After supper I took leave of M. de Bragadin and of his two friends, telling them that I was going to be away for several weeks on important business.

Next day, going to my new room, I was surprised to find there Tonine, Laura's daughter, a pretty girl not more than fifteen years old, who told me with a blush, but with more spirit than I gave her credit for, that she would serve me as well as her mother would have done.

I was in too much distress to thank Laura for this pretty present, and I even determined that her daughter should not stay in my service. We know how much such resolutions are commonly worth. In the meanwhile I was kind to the girl: "I am sure," I said, "of your goodwill, but I must talk to your mother. I must be alone," I added, "as I have to write all day, and I shall not take anything till the evening." She then gave me a letter, begging pardon for not having given it me sooner. "You must never forget to deliver messages," I said, "for if you had waited any longer before bringing me this letter, it might have had the most serious consequences." She blushed, begged pardon, and went out of the room. The letter was from C—— C——, who told me that her friend was in bed, and that the doctor had pronounced her illness to be fever. I passed the rest of the day in putting my room in order, and in writing to C—— C—— and her suffering friend.

Towards evening Tonine brought in the candles, and told me that my supper was ready. "Follow me," I said. Seeing that she had only laid supper for one—a pleasing proof of her modesty, I told her to get another knife and fork, as I wished her always to take her meals with me. I can give no account of my motives. I only wished to be kind to her, and I did everything in good faith. By and by, reader, we shall see whether this is not one of the devices by which the devil compasses his ends.

Not having any appetite, I ate little, but I thought everything good with the exception of the wine; but Tonine promised to get some better by the next day, and when supper was over she went to sleep in the ante-room.

After sealing my letters, wishing to know whether the outer door was locked, I went out and saw Tonine in bed, sleeping peacefully, or pretending to do so. I might have suspected her thoughts, but I had never been in a similar situation, and I measured the extremity of my grief by the indifference with which I looked at this girl; she was pretty, but for all that I felt that neither she nor I ran any risk.

Next day, waking very early, I called her, and she came in neatly dressed. I gave her my letter to C—— C——, which enclosed the letter to M—— M——, telling her to take it to her mother and then to return to make my coffee.

"I shall dine at noon, Tonine," I said, "take care to get what is necessary in good time."

"Sir, I prepared yesterday's supper myself, and if you like I can cook all your meals."

"I am satisfied with your abilities, go on, and here is a sequin for expenses."

"I still have a hundred and twenty sous remaining from the one you gave me yesterday, and that will be enough."

"No, they are for yourself, and I shall give you as much every day."

Her delight was so great that I could not prevent her covering my hand with kisses. I took care to draw it back and not to kiss her in return, for I felt as if I should be obliged to laugh, and this would have dishonoured my grief.

The second day passed like the first. Tonine was glad that I said no more about speaking to her mother, and drew the conclusion that her services were agreeable to me. Feeling tired and weak, and fearing that I should not wake early enough to send the letter to the convent, but not wishing to rouse Tonine if she were asleep, I called her softly. She rose immediately and came into my room with nothing on but a slight petticoat. Pretending to see nothing, I gave her my letter, and told her to take it to her mother in the morning before she came into my room. She went out, saying that my instructions should be carried out, but as soon as she was gone I could not resist saying to myself that she was very pretty; and I felt both sad and ashamed at the reflection that this girl could very easily console me. I hugged my grief, and I determined to separate myself from a being who made me forget it.

"In the morning," I said, "I will tell Laura to get me something less seducing;" but the night brought counsel, and in the morning I put on the

armour of sophism, telling myself that my weakness was no fault of the girl's, and that it would therefore be unjust to punish her for it. We shall see, dear reader, how all this ended.

CHAPTER XXIII

Continues the Preceding Chapter—M. M. Recovers—I Return to
Venice—Tonine Consoles Me—Decrease of My Love For M. M.—
Doctor Righelini—Curious Conversation With Him—How This
Conversation Affected M. M.—Mr. Murray Undeceived and
Avenged

Tontine had what is called tact and common sense, and thinking these
qualities were required in our economy she behaved with great delicacy, not
going to bed before receiving my letters, and never coming into my room
except in a proper dress, and all this pleased me. For a fortnight M——
M—— was so ill that I expected every moment to hear the news of her death.
On Shrove Tuesday C—— C—— wrote that her friend was not strong
enough to read my letter, and that she was going to receive 'extreme unction'.
This news so shocked me that I could not rise, and passed the whole day in
weeping and writing, Tonine not leaving me till midnight. I could not sleep.
On Ash Wednesday I got a letter, in which C—— C—— told me that the
doctor had no hopes for her friend, and that he only gave her a fortnight to
live. A low fever was wasting her away, her weakness was extreme, and she
could scarcely swallow a little broth. She had also the misfortune to be
harassed by her confessor, who made her foretaste all the terrors of death. I
could only solace my grief by writing, and Tonine now and again made bold
to observe that I was cherishing my grief, and that it would be the death of
me. I knew myself that I was making my anguish more poignant, and that
keeping to my bed, continued writing, and no food, would finally drive me
mad. I had told my grief to poor Tonine, whose chief duty was to wipe away
my tears. She had compassion on me.

A few days later, after assuring C—— C—— that if our friend died I
should not survive her, I asked her to tell M—— M—— that if she wanted
me to take care of my life she must promise to let me carry her off on her
recovery.

"I have," I said, "four thousand sequins and her diamonds, which are worth
six thousand; we should, therefore, have a sufficient sum to enable us to live
honourably in any part of Europe."

C—— C—— wrote to me on the following day, and said that my mistress,
after hearing my letter read, had fallen into a kind of convulsion, and,
becoming delirious, she talked incessantly in French for three whole hours in
a fashion which would have made all the nuns take to their heels, if they had

understood her. I was in despair, and was nearly raving as wildly as my poor nun. Her delirium lasted three days, and as soon as she got back her reason she charged her young friend to tell me that she was sure to get well if I promised to keep to my word, and to carry her off as soon as her health would allow. I hastened to reply that if I lived she might be sure my promise would be fulfilled.

Thus continuing to deceive each other in all good faith, we got better, for every letter from C—— C——, telling me how the convalescence of her friend was progressing, was to me as balm. And as my mind grew more composed my appetite also grew better, and my health improving day by day, I soon, though quite unconsciously, began to take pleasure in the simple ways of Tonine, who now never left me at night before she saw that I was asleep.

Towards the end of March M—— M—— wrote to me herself, saying that she believed herself out of danger, and that by taking care she hoped to be able to leave her room after Easter. I replied that I should not leave Muran till I had the pleasure of seeing her at the grating, where, without hurrying ourselves, we could plan the execution of our scheme.

It was now seven weeks since M. de Bragadin had seen me, and thinking that he would be getting anxious I resolved to go and see him that very day. Telling Tonine that I should not be back till the evening, I started for Venice without a cloak, for having gone to Muran masked I had forgotten to take one. I had spent forty-eight days without going out of my room, chiefly in tears and distress, and without taking any food. I had just gone through an experience which flattered my self-esteem. I had been served by a girl who would have passed for a beauty anywhere in Europe. She was gentle, thoughtful, and delicate, and without being taxed with foppishness I think I may say that, if she was not in love with me, she was at all events inclined to please me to the utmost of her ability; for all that I had been able to withstand her youthful charms, and I now scarcely dreaded them. Seeing her every day, I had dispersed my amorous fancies, and friendship and gratitude seemed to have vanquished all other feelings, for I was obliged to confess that this charming girl had lavished on me the most tender and assiduous care.

She had passed whole nights on a chair by my bedside, tending me like a mother, and never giving me the slightest cause for complaint.

Never had I given her a kiss, never had I allowed myself to undress in her presence, and never (with one exception) had she come into my room without being properly dressed. For all that, I knew that I had fought a battle, and I felt inclined to boast at having won the victory. There was only one circumstance that vexed me—namely, that I was nearly certain that neither

M. M. nor C. C. would consider such continence to be within the bounds of possibility, if they heard of it, and that Laura herself, to whom her daughter would tell the whole story, would be sceptical, though she might out of kindness pretend to believe it all.

I got to M. de Bragadin's just as the soup was being served. He welcomed me heartily, and was delighted at having foreseen that I should thus surprise them. Besides my two other old friends, there were De la Haye, Bavois, and Dr. Righelini at table.

"What! you without a cloak!" said M. Dandolo.

"Yes," said I; "for having gone out with my mask on I forgot to bring one:"

At this they laughed, and, without putting myself out, I sat down. No one asked where I had been so long, for it was understood that that question should be left to me to answer or not. Nevertheless, De la Haye, who was bursting with curiosity, could not refrain from breaking some jests on me.

"You have got so thin," said he, "that uncharitable people will be rather hard on you."

"I trust they will not say that I have been passing my time with the Jesuits."

"You are sarcastic. They may say, perhaps, that you have passed your time in a hot-house under the influence of Mercury."

"Don't be afraid, sir, for to escape this hasty judgment I shall go back this evening."

"No, no, I am quite sure you will not."

"Believe me, sir," said I, with a bantering tone, "that I deem your opinion of too much consequence not to be governed by it."

Seeing that I was in earnest, my friends were angry with him; and the Aristarchus was in some confusion.

Righelini, who was one of Murray's intimate friends, said to me in a friendly way that he had been longing to tell Murray of my re-appearance, and of the falsity of all the reports about me.

"We will go to sup with him," said I, "and I will return after supper."

Seeing that M. de Bragadin and his two friends were uneasy about me, I promised to dine with them on April 25th, St. Mark's Day.

As soon as Mr. Murray saw me, he fell on my neck and embraced me. He introduced me to his wife, who asked me to supper with great politeness. After Murray had told me the innumerable stories which had been made about my disappearance, he asked me if I knew a little story by the Abbe Chiari, which had come out at the end of the carnival. As I said that I knew nothing about it, he gave me a copy, telling me that I should like it. He was right. It was a satire in which the Zorzi clique was pulled to pieces, and in

which I played a very poor part. I did not read it till some time after, and in the mean time put it in my pocket. After a very good supper I took a gondola to return to Muran.

It was midnight and very dark, so that I did not perceive the gondola to be ill covered and in wretched order. A fine rain was falling when I got in, and the drops getting larger I was soon wet to the skin. No great harm was done, as I was close to my quarters. I groped my way upstairs and knocked at the door of the ante-room, where Tonine, who had not waited for me, was sleeping. Awake in a moment she came to open the door in her smock, and without a light. As I wanted one, I told her to get the flint and steel, which she did, warning me in a modest voice that she was not dressed. "That's of no consequence," said I, "provided you are covered." She said no more, and soon lighted a candle, but she could not help laughing when she saw me dripping wet.

"I only want you, my dear," said I, "to dry my hair." She quickly set to work with powder and powder-puff in hand, but her smock was short and loose at the top, and I repented, rather too late, that I had not given her time to dress. I felt that all was lost, all the more as having to use both her hands she could not hold her smock and conceal two swelling spheres more seductive than the apples of the Hesperides. How could I help seeing them? I shut my eyes and, said "For shame!" but I gave in at last, and fixed such a hungry gaze upon poor Tonine that she blushed. "Come," said I, "take your smock between your teeth and then I shall see no more." But it was worse than before, and I had only added fuel to the fire; for, as the veil was short, I could see the bases and almost the frieze of two marble columns; and at this sight I gave a voluptuous cry. Not knowing how to conceal everything from my gaze, Tonine let herself fall on the sofa, and I, my passions at fever-heat, stood beside her, not knowing what to do.

"Well," she said, "shall I go and dress myself and then do your hair?"

"No, come and sit on my knee, and cover my eyes with your hands." She came obediently, but the die was cast, and my resistance overcome. I clasped her between my arms, and without any more thoughts of playing at blind man's buff I threw her on the bed and covered her with kisses. And as I swore that I would always love her, she opened her arms to receive me in a way that shewed how long she had been waiting for this moment.

I plucked the rose, and then, as ever, I thought it the rarest I had ever gathered since I had laboured in the harvest of the fruitful fields of love.

When I awoke in the morning I found myself more deeply in love with Tonine than I had been with any other woman. She had got up without

waking me, but as soon as she heard me stirring she came, and I tenderly chid her for not waiting for me to give her good morrow. Without answering she gave me M—— M——'s letter. I thanked her, but putting the letter on one side I took her in my arms, and set her by my side. "What a wonder!" cried Tonine. "You are not in a hurry to read that letter! Faithless man, why did you not let me cure you six weeks ago. How lucky I am; thanks to the rain! I do not blame you, dear, but love me as you love her who writes to you every day, and I shall be satisfied."

"Do you know who she is?"

"She lives in a boarding-house, and is as beautiful as an angel; but she is there, and I am here. You are my master, and I will be your servant as long as you like."

I was glad to leave her in error, and swore an ever-lasting love; but during our conversation she had let herself drop down in the bottom of the bed, and I entreated her to lie down again; but she said that on the contrary it was time for me to get up for dinner, for she wanted to give me a dainty meal cooked in the Venetian manner.

"Who is the cook?" said I.

"I am, and I have been using all my skill on it since five, when I got up."

"What time is it now, then?"

"Past one."

The girl astonished me. She was no longer the shy Tonine of last night; she had that exultant air which happiness bestows, and the look of pleasure which the delights of love give to a young beauty. I could not understand how I had escaped from doing homage to her beauty when I first saw her at her mother's house. But I was then too deeply in love with C—— C——; I was in too great distress; and, moreover, Tonine was then unformed. I got up, and making her bring me a cup of coffee I asked her to keep the dinner back for a couple of hours.

I found M—— M——'s letter affectionate, but not so interesting as it would have been the day before. I set myself to answer it, and was almost thunderstruck to find the task, for the first time, a painful one. However, my short journey to Venice supplied me with talk which covered four pages.

I had an exquisite dinner with my charming Tonine. Looking at her as at the same time my wife, my mistress, and my housekeeper, I was delighted to find myself made happy at such a cheap rate. We spent the whole day at the table talking of our love, and giving each other a thousand little marks of it; for there is no such rich and pleasant matter for conversation as when they who talk are parties to an amorous suit. She told with charming simplicity

that she knew perfectly well that she could not make me amorous of her, because I loved another, and that her only hope was therefore in a surprise, and that she had foreseen the happy moment when I told her that she need not dress herself to light a candle.

Tonine was naturally quick-witted, but she did not know either how to read or to write. She was enchanted to see herself become rich (for she thought herself so) without a soul at Muran being able to breathe a word against her honour. I passed three weeks in the company of this delightful girl—weeks which I still reckon among the happiest of my life; and what embitters my old age is that, having a heart as warm as ever, I have no longer the strength necessary to secure a single day as blissful as those which I owed to this charming girl.

Towards the end of April I saw M. M. at the grating, looking thin and much changed, but out of danger. I therefore returned to Venice. In my interview, calling my attachment and tender feelings to my aid, I succeeded in behaving myself in such wise that she could not possibly detect the change which a new love had worked in my heart. I shall be, I trust, easily believed when I say that I was not imprudent enough to let her suspect that I had given up the idea of escaping with her, upon which she counted more than ever. I was afraid lest she should fall ill again, if I took this hope away from her. I kept my casino, which cost me little, and as I went to see M. M. twice a week I slept there on those occasions, and made love with my dashing Tonine.

Having kept my word with my friends by dining with them on St. Mark's Day, I went with Dr. Righelini to the parlour of the Vierges to see the taking of the veil.

The Convent of the Vierges is within the jurisdiction of the Doge, whom the nuns style "Most Serene Father." They all belong to the first families in Venice.

While I was praising the beauty of Mother M—— E—— to Dr. Righelini, he whispered to me that he could get her me for a money payment, if I were curious in the matter. A hundred sequins for her and ten sequins for the go-between was the price fixed on. He assured me that Murray had had her, and could have her again. Seeing my surprise, he added that there was not a nun whom one could not have by paying for her: that Murray had the courage to disburse five hundred sequins for a nun of Muran—a rare beauty, who was afterwards the mistress of the French ambassador.

Though my passion for M—— M—— was on the wane, I felt my heart gripped as by a hand of ice, and it was with the greatest difficulty that I made

no sign. Notwithstanding, I took the story for an atrocious calumny, but yet the matter was too near my heart for me to delay in bringing it to light at the earliest opportunity. I therefore replied to Righelini in the calmest manner possible, that one or two nuns might be had for money, but that it could happen very rarely on account of the difficulties in most convents.

"As for the nun of Muran, justly famous for her beauty, if she be M—— M——, nun of the convent..., I not only disbelieve that Murray ever had her, but I am sure she was never the French ambassador's mistress. If he knew her it could only have been at the grating, where I really cannot say what happens."

Righelini, who was an honourable and spirited man, answered me coldly that the English ambassador was a man of his word, and that he had the story from his own lips.

"If Mr. Murray," he continued, "had not told it me under the seal of secrecy I would make him tell it you himself. I shall be obliged if you will take care that he never knows I told you of it."

"You may rely on my discretion."

The same evening, supping at Murray's casino with Righelini, having the matter at heart, and seeing before me the two men who could clear up everything to my satisfaction, I began to speak with enthusiasm of the beauty of M—— E——, whom I had seen at the Vierges.

Here the ambassador struck in, taking the ball on the hop:

"Between friends," said he, "you can get yourself the enjoyment of those charms, if you are willing to sacrifice a sum of money—not too much, either, but you must have the key."

"Do you think you have it?"

"No, I am sure; and had less trouble than you might suppose."

"If you are sure; I congratulate you, and doubt no more. I envy your fortune, for I don't believe a more perfect beauty could be found in all the convents of Venice."

"There you are wrong. Mother M—— M——, at—— in Muran, is certainly handsomer."

"I have heard her talked of and I have seen her once, but I do not think it possible that she can be procured for money."

"I think so," said he, laughing, "and when I think I mostly have good reasons."

"You surprise me; but all the same I don't mind betting you are deceived."

"You would lose. As you have only seen her once, I suppose you would not recognize her portrait?"

"I should, indeed, as her face left a strong impression on my mind."

"Wait a minute."

He got up from the table, went out, and returned a minute after with a box containing eight or ten miniatures, all in the same style, namely, with hair in disorder and bare necks.

"These," said I, "are rare charms, with which you have doubtless a near acquaintance?"

"Yes, and if you recognize any of them be discreet."

"You need not be afraid. Here are three I recognize, and this looks like M—— M——; but confess that you may have been deceived—at least, that you did not have her in the convent or here, for there are women like her."

"Why do you think I have been deceived? I have had her here in her religious habit, and I have spent a whole night with her; and it was to her individually that I sent a purse containing five hundred sequins. I gave fifty to the good procurer."

"You have, I suppose, visited her in the parlour, after having her here?"

"No, never, as she was afraid her titular lover might hear of it. You know that was the French ambassador."

"But she only saw him in the parlour."

"She used to go to his house in secular dress whenever he wanted her. I was told that by the man who brought her here."

"Have you had her several times?"

"Only once and that was enough, but I can have her whenever I like for a hundred sequins."

"All that may be the truth, but I would wager five hundred sequins that you have been deceived."

"You shall have your answer in three days."

I was perfectly certain, I repeat, that the whole affair was a piece of knavery; but it was necessary to have it proved, and I shuddered when the thought came into my head that after all it might be a true story. In this case I should have been freed from a good many obligations, but I was strongly persuaded of her innocence. At all events, if I were to find her guilty (which was amongst possible occurrences), I resigned myself to lose five hundred sequins as the price of this horrible discovery and addition to my experience of life. I was full of restless anguish—the worst, perhaps, of the torments of the mind. If the honest Englishman had been the victim of a mystification, or rather knavery, my regard for M—— M——'s honour compelled me to find a way to undeceive him without compromising her; and such was my plan,

and thus fortune favoured me. Three or four days after, Mr. Murray told the doctor that he wished to see me. We went to him, and he greeted me thus:

"I have won; for a hundred sequins I can have the fair nun!"

"Alas!" said I, "there go my five hundred sequins."

"No, not five hundred, my dear fellow, for I should be ashamed to win so much of you, but the hundred she would cost me. If I win, you shall pay for my pleasure, and if I lose I shall give her nothing."

"How is the problem to be solved?" "My Mercury tells me that we must wait for a day when masks are worn. He is endeavouring at present to find out a way to convince both of us; for otherwise neither you nor I would feel compelled to pay the wager, and if I really have M. M. my honour would not allow me to let her suspect that I had betrayed the secret."

"No, that would be an unpardonable crime. Hear my plan, which will satisfy us both; for after it has been carried out each of us will be sure that he has fairly won or fairly lost.

"As soon as you have possessed yourself of the real or pretended nun, leave her on some pretext, and meet me in a place to be agreed upon. We will then go together to the convent, and I will ask for M. M.

"Will seeing her and speaking to her convince you that the woman you have left at home is a mere impostor?"

"Perfectly, and I shall pay my wager with the greatest willingness."

"I may say the same. If, when I summon M. M. to the parlour, the lay-sister tells us she is ill or busy, we will go, and the wager will be yours; you will sup with the fair, and I will go elsewhere."

"So be it; but since all this will be at nighttime, it is possible that when you ask for her, the sister will tell you that no one can be seen at such an hour."

"Then I shall lose."

"You are quite sure, then, that if she be in the convent she will come down?"

"That's my business. I repeat, if you don't speak to her, I shall hold myself to have lost a hundred sequins, or a thousand if you like."

"One can't speak plainer than that, my dear fellow, and I thank you beforehand."

"The only thing I ask you is to come sharp to time; and not to come too late for a convent."

"Will an hour after sunset suit you?"

"Admirably."

"I shall also make it my business to compel my masked mistress to stop where she is, even though it be M. M. herself."

"Some won't have long to wait, if you will take her to a casino which I myself possess at Muran, and where I secretly keep a girl of whom I am amorous. I will take care that she shall not be there on the appointed day, and I will give you the key of the casino. I shall also see that you find a delicate cold supper ready."

"That is admirable, but I must be able to point out the place to my Mercury."

"True! I will give you a supper to-morrow, the greatest secrecy to be observed between us. We will go to my casino in a gondola, and after supper we will go out by the street door; thus you will know the way by land and water. You will only have to tell the procurer the name of the canal and of the house, and on the day fixed you shall have the key. You will only find there an old man who lives on the ground floor, and he will see neither those who go out nor those who come in. My sweetheart will see nothing and will not be seen; and all, trust me, will turn out well."

"I begin to think that I have lost my bet," said the Englishman, who was delighted with the plan; "but it matters not, I can gaily encounter either loss or gain." We made our appointment for the next day, and separated.

On the following morning I went to Muran to warn Tonine that I was going to sup with her, and to bring two of my friends; and as my English friend paid as great court to Bacchus as to Cupid, I took care to send my little housekeeper several bottles of excellent wine.

Charmed with the prospect of doing the honours of the table, Tonine only asked me if my friends would go away after supper. I said yes, and this reply made her happy; she only cared for the dessert.

After leaving her I went to the convent and passed an hour with M. M. in the parlour. I was glad to see that she was getting back her health and her beauty every day, and having complimented her upon it I returned to Venice. In the evening my two friends kept their appointments to the minute, and we went to my little casino at two hours after sunset.

Our supper was delicious, and my Tonine charmed me with the gracefulness of her carriage. I was delighted to see Righelini enchanted, and the ambassador dumb with admiration. When I was in love I did not encourage my friends to cajole my sweetheart, but I became full of complaisance when time had cooled the heat of my passion.

We parted about midnight, and having taken Mr. Murray to the spot where I was to wait for him on the day of trial, I returned to compliment my charming Tonine as she deserved. She praised my two friends, and could not express her surprise at seeing our English friend going away, fresh and nimble

on his feet, notwithstanding his having emptied by himself six bottles of my best wine. Murray looked like a fine Bacchus after Rubens.

On Whit Sunday Righelini came to tell me that the English ambassador had made all arrangements with the pretended procurer of M. M. for Whit Tuesday. I gave him the keys of my abode at Muran, and told him to assure Murray that I would keep the appointment at the exact time arranged upon.

My impatience brought on palpitation of the heart, which was extremely painful, and I passed the two nights without closing an eye; for although I was convinced of M—— M——'s innocence, my agitation was extreme. But whence all this anxiety? Merely from a desire to see the ambassador undeceived. M. M. must in his eyes have seemed a common prostitute, and the moment in which he would be obliged to confess himself the victim of roguery would re-establish the honour of the nun.

Mr. Murray was as impatient as myself, with this difference, that whereas he, looking upon the adventure as a comic one, only laughed, I who found it too tragic shuddered with indignation.

On Tuesday morning I went to Muran to tell Tonine to get a cold supper after my instruction, to lay the table for two, to get wax lights ready, and having sent in several bottles of wine I bade her keep to the room occupied by the old landlord, and not to come out till the people who were coming in the evening were gone. She promised to do so, and asked no questions. After leaving her I went to the convent parlour, and asked to see M—— M——. Not expecting to see me, she asked me why I had not gone to the pageant of the Bucentaur, which, the weather being favourable, would set out on this day. I do not know what I answered, but I know that she found my words little to the purpose. I came at last to the important point, and told her I was going to ask a favour of her, on which my peace of mind depended, but which she must grant blindly without asking any questions.

"Tell me what I am to do, sweetheart," said she, "and be sure I will refuse nothing which may be in my power."

"I shall be here this evening an hour after sunset, and ask for you at this grating; come. I shall be with another man, to whom I beg of you to say a few words of politeness; you can then leave us. Let us find some pretext to justify the unseasonable hour."

"I will do what you ask, but you cannot imagine how troublesome it is in a convent, for at six o'clock the parlours are shut up and the keys are taken to the abbess' room. However, as you only want me for five minutes, I will tell the abbess that I am expecting a letter from my brother, and that it can be

sent to me on this evening only. You must give me a letter that the nun who will be with me may be able to say that I have not been guilty of deception."

"You will not come alone, then?"

"I should not dare even to ask for such a privilege."

"Very good, but try to come with some old nun who is short-sighted."

"I will keep the light in the background."

"Pray do not do so, my beloved; on the contrary, place it so that you may be distinctly seen."

"All this is very strange, but I have promised passive obedience, and I will come down with two lights. May I hope that you will explain this riddle to me at your next interview?"

"By to-morrow, at latest, you shall know the whole story."

"My curiosity will prevent me from sleeping."

"Not so, dear heart; sleep peacefully, and be sure of my gratitude."

The reader will think that after this conversation my heart was perfectly at rest; but how far was I from resting! I returned to Venice, tortured lest I should be told in the evening at the door of the cathedral, where we were to meet, that the nun had been obliged to put off her appointment. If that had happened, I should not have exactly suspected M—— M——, but the ambassador would have thought that I had caused the scheme to miscarry. It is certain that in that case I should not have taken my man to the parlour, but should have gone there sadly by myself.

I passed the whole day in these torments, thinking it would never come to an end, and in the evening I put a letter in my pocket, and went to my post at the hour agreed upon.

Fortunately, Murray kept the appointment exactly.

"Is the nun there?" said I, as soon as he was near me.

"Yes, my dear fellow. We will go, if you like, to the parlour; but you will find that we shall be told she is ill or engaged. If you like, the bet shall be off."

"God forbid, my dear fellow! I cling to that hundred ducats. Let us be gone."

We presented ourselves at the wicket, and I asked for M—— M——, and the doorkeeper made me breathe again by saying that I was expected. I entered the parlour with my English friend, and saw that it was lighted by four candles. I cannot recall these moments without being in love with life. I take note not only of my noble mistress's innocence, but also of the quickness of her wit. Murray remained serious, without a smile on his face. Full of grace and beauty, M—— M—— came into the room with a lay-sister, each of them holding a candlestick. She paid me a compliment in good French; I gave her

the letter, and looking at the address and the seal she put it in her pocket. After thanking me and saying she would reply in due course, she turned towards my companion:

"I shall, perhaps, make you lose the first act of the opera," said she.

"The pleasure of seeing you, madam, is worth all the operas in the world."

"You are English, I think?"

"Yes, madam."

"The English are now the greatest people in the world, because they are free and powerful. Gentlemen, I wish you a very good evening."

I had never seen M—— M—— looking so beautiful as then, and I went out of the parlour ablaze with love, and glad as I had never been before. I walked with long strides towards my casino, without taking notice of the ambassador, who did not hurry himself in following me; I waited for him at my door.

"Well," said I, "are you convinced now that you have been cheated?"

"Be quiet, we have time enough to talk about that. Let us go upstairs."

"Shall I come?"

"Do. What do you think I could do by myself for four hours with that creature who is waiting for me? We will amuse ourselves with her."

"Had we not better turn her out?"

"No; her master is coming for her at two o'clock in the morning. She would go and warn him, and he would escape my vengeance. We will throw them both out of the window."

"Be moderate, for M—— M—— s honour depends on the secrecy we observe. Let us go upstairs. We shall have some fun. I should like to see the hussy."

Murray was the first to enter the room. As soon as the girl saw me, she threw her handkerchief over her face, and told the ambassador that such behaviour was unworthy of him. He made no answer. She was not so tall as M—— M——, and she spoke bad French.

Her cloak and mask were on the bed, but she was dressed as a nun. As I wanted to see her face, I politely asked her to do me the favour of shewing it.

"I don't know you," said she; "who are you?"

"You are in my house, and don't know who I am?"

"I am in your house because I have been betrayed. I did not think that I should have to do with a scoundrel."

At this word Murray commanded her to be silent, calling her by the name of her honourable business; and the slut got up to take her cloak, saying she would go. Murray pushed her back, and told her that she would have to wait

for her worthy friend, warning her to make no noise if she wanted to keep out of prison.

"Put me in prison!"

With this she directed her hand towards her dress, but I rushed forward and seized one hand while Murray mastered the other. We pushed her back on a chair while we possessed ourselves of the pistols she carried in her pockets.

Murray tore away the front of her holy habit, and I extracted a stiletto eight inches long, the false nun weeping bitterly all the time.

"Will you hold your tongue, and keep quiet till Capsucefalo comes," said the ambassador, "or go to prison?"

"If I keep quiet what will become of me?"

"I promise to let you go."

"With him?"

"Perhaps."

"Very well, then, I will keep quiet."

"Have you got any more weapons?"

Hereupon the slut took off her habit and her petticoat, and if we had allowed her she would have soon been in a state of nature, no doubt in the expectation of our passions granting what our reason refused. I was much astonished to find in her only a false resemblance to M.M. I remarked as much to the ambassador, who agreed with me, but made me confess that most men, prepossessed with the idea that they were going to see M. M., would have fallen into the same trap. In fact, the longing to possess one's self of a nun who has renounced all the pleasures of the world, and especially that of cohabitation with the other sex, is the very apple of Eve, and is more delightful from the very difficulty of penetrating the convent grating.

Few of my readers will fail to testify that the sweetest pleasures are those which are hardest to be won, and that the prize, to obtain which one would risk one's life, would often pass unnoticed if it were freely offered without difficulty or hazard.

In the following chapter, dear reader, you will see the end of this farcical adventure. In the mean time, let us take a little breath.

CHAPTER XXIV

Pleasant Ending of the Adventure of the False Nun—M. M. Finds Out That I Have d Mistress—She is Avenged on the Wretch Capsucefalo—I Ruin Myself at Play, and at the Suggestion of M. M. I Sell all Her Diamonds, One After Another—I Hand Over Tonine to Murray, Who Makes Provision for Her—Her Sister Barberine Takes Her Place.

"How did you make this nice acquaintance?" I asked the ambassador.

"Six months ago," he replied, "while standing at the convent gate with Mr. Smith, our consul, in whose company I had been to see some ceremony or other, I remarked to him, as we were talking over some nuns we had noticed, 'I would gladly give five hundred sequins for a few hours of Sister M—— M—— s company.' Count Capsucefalo heard what I said, but made no remark. Mr. Smith answered that one could only see her at the grating as did the ambassador of France, who often came to visit her. Capsucefalo called on me the next morning, and said that if I had spoken in good faith he was sure he could get me a night with the nun in whatever place I liked, if she could count on my secrecy. 'I have just been speaking to her,' said he, 'and on my mentioning your name she said she had noticed you with Mr. Smith, and vowed she would sup with you more for love than money. 'I,' said the rascal, 'am the only man she trusts, and I take her to the French ambassador's casino in Venice whenever she wants to go there. You need not be afraid of being cheated, as you will give the money to her personally when you have possessed yourself of her.' With this he took her portrait from his pocket and shewed it me; and here it is. I bought it of him two days after I believed myself to have spent a night with the charming nun, and a fortnight after our conversation. This beauty here came masked in a nun's habit, and I was fool enough to think I had got a treasure. I am vexed with myself for not having suspected the cheat—at all events, when I saw her hair, as I know that nuns' hair should be cut short. But when I said something about it to the hussy, she told me they were allowed to keep their hair under their caps, and I was weak enough to believe her."

I knew that on this particular Murray had not been deceived, but I did not feel compelled to tell him so then and there.

I held the portrait Murray had given me in my hand, and compared it with the face before me. In the portrait the breast was bare, and as I was remarking that painters did those parts as best they could, the impudent wench seized

the opportunity to shew me that the miniature was faithful to nature. I turned my back upon her with an expression of contempt which would have mortified her, if these creatures were ever capable of shame. As we talked things over, I could not help laughing at the axiom, Things which are equal to the same thing are equal to one another, for the miniature was like M. M. and like the courtezan, and yet the two women were not like each other. Murray agreed with me, and we spent an hour in a philosophical discussion on the matter. As the false M. M. was named Innocente, we expressed a wish to know how her name agreed with her profession, and how the knave had induced her to play the part she had taken; and she told us the following story:

"I have known Count Capsucefalo for two years, and have found him useful, for, though he has given me no money, he has made me profit largely through the people he has introduced to me. About the end of last autumn he came to me one day, and said that if I could make up as a nun with some clothes he would get me, and in that character pass a night with an Englishman, I should be the better by five hundred sequins. 'You need not be afraid of anything,' said he, 'as I myself will take you to the casino where the dupe will be awaiting you, and I will come and take you back to your imaginary convent towards the end of the night. He shewed me how I must behave, and told me what to reply if my lover asked any questions about the discipline of the convent.

"I liked the plot, gentlemen, and I told him I was ready to carry it out. And be pleased to consider that there are not many women of my profession who would hesitate over a chance of getting five hundred sequins. Finding the scheme both agreeable and profitable, I promised to play my part with the greatest skill. The bargain was struck, and he gave me full instructions as to my dialogue. He told me that the Englishman could only talk about my convent and any lovers I might have had; that on the latter point I was to cut him short, and to answer with a laugh that I did not know what he was talking about, and even to tell him that I was a nun in appearance only, and that in the course of toying I might let him see my hair. 'That,' said Capsucefalo, 'won't prevent him from thinking you a nun—yes! and the very nun he is amorous of, for he will have made up his mind that you cannot possibly be anyone else.' Seizing the point of the jest, I did not take the trouble to find out the name of the nun I was to represent, nor the convent whence I was to come; the only thing in my head was the five hundred sequins. So little have I troubled about aught else that, though I passed a delicious night with you, and found you rather worthy of being paid for than

paying, I have not ascertained who and what you are, and I don't know at this moment to whom I am speaking. You know what a night I had; I have told you it was delicious, and I was happy in the idea that I was going to have another. You have found everything out. I am sorry, but I am not afraid of anything, since I can put on any disguise I like, and can't prevent my lovers taking me for a saint if they like to do so. You have found weapons in my possession, but everyone is allowed to bear arms in self-defence. I plead not guilty on all counts."

"Do you know me?" said I.

"No, but I have often seen you passing under my window. I live at St. Roch, near the bridge."

The way in which the woman told her yarn convinced us that she was an adept in the science of prostitution, but we thought Capsucefalo, in spite of the count, worthy of the pillory. The girl was about ten years older than M. M., she was pretty, but light-complexioned, while my beautiful nun had fine dark brown hair and was at least three inches taller.

After twelve o'clock we sat down to supper, and did honour to the excellent meal which my dear Antoinette had prepared for us. We were cruel enough to leave the poor wretch without offering her so much as a glass of wine, but we thought it our duty.

While we were talking, the jolly Englishman made some witty comments on my eagerness to convince him that he had not enjoyed M. M.'s favours.

"I can't believe," said he, "that you have shewn so much interest without being in love with the divine nun."

I answered by saying that if I were her lover I was much to be pitied in being condemned to go to the parlour, and no farther.

"I would gladly give a hundred guineas a month," said he, "to have the privilege of visiting her at the grating."

So saying he gave me my hundred sequins, complimenting me on my success, and I slipped them forthwith into my pocket.

At two o'clock in the morning we heard a soft knock on the street door.

"Here is our friend," I said, "be discreet, and you will see that he will make a full confession."

He came in and saw Murray and the lady, but did not discover that a third party was present till he heard the ante-room door being locked. He turned round and saw me, and as he knew me, merely said, without losing countenance:

"Ah, you are here; you know, of course, that the secret must be kept?"

Murray laughed and calmly asked him to be seated, and he enquired, with the lady's pistols in his hands, where he was going to take her before day-break.

"Home."

"I think you may be mistaken, as it is very possible that when you leave this place you will both of you be provided with a bed in prison."

"No, I am not afraid of that happening; the thing would make too much noise, and the laugh would not be on your side. Come," said he to his mate, "put on your cloak and let us be off."

The ambassador, who like an Englishman kept quite cool the whole time, poured him out a glass of Chambertin, and the blackguard drank his health. Murray seeing he had on a fine ring set with brilliants, praised it, and shewing some curiosity to see it more closely he drew it off the fellow's finger, examined it, found it without flaw, and asked how much it was worth. Capsucefalo, a little taken aback, said it cost him four hundred sequins.

"I will hold it as a pledge for that sum," said the ambassador, putting the ring into his pocket. The other looked chop-fallen, and Murray laughing at his retiring manners told the girl to put on her cloak and to pack off with her worthy acolyte. She did so directly, and with a low bow they disappeared.

"Farewell, nun procurer!" said the ambassador, but the count made no answer.

As soon as they were gone I thanked Murray warmly for the moderation he had shewn, as a scandal would have only injured three innocent people.

"Be sure," said he, "that the guilty parties shall be punished without anyone's knowing the reason"

I then made Tonine come upstairs, and my English friend offered her a glass of wine, which she declined with much modesty and politeness. Murray looked at her with flaming glances, and left after giving me his heartiest thanks.

Poor little Tonine had been resigned, and obedient for many hours, and she had good cause to think I had been unfaithful to her; however, I gave her the most unmistakable proofs of my fidelity. We stayed in bed for six hours, and rose happy in the morning.

After dinner I hurried off to my noble M—— M——, and told her the whole story. She listened eagerly, her various feelings flitting across her face. Fear, anger, wrath, approval of my method of clearing up my natural suspicions, joy at discovering me still her lover—all were depicted in succession in her glance, and in the play of her features, and in the red and white which followed one another on her cheeks and forehead. She was

delighted to hear that the masker who was with me in the parlour was the English ambassador, but she became nobly disdainful when I told her that he would gladly give a hundred guineas a month for the pleasure of visiting her in the parlour. She was angry with him for fancying that she had been in his power, and for finding a likeness between her and a portrait, when, so she said, there was no likeness at all; I had given her the portrait. She added, with a shrewd smile, that she was sure I had not let my little maid see the false nun, as she might have been mistaken.

"You know, do you, that I have a young servant?"

"Yes, and a pretty one, too. She is Laura's daughter, and if you love her I am very glad, and so is C—— C——. I hope you will let me have a sight of her. C—— C—— has seen her before."

As I saw that she knew too much for me to be able to deceive her, I took my cue directly and told her in detail the history of my amours. She shewed her satisfaction too openly not to be sincere. Before I left her she said her honour obliged her to get Capsucefalo assassinated, for the wretch had wronged her beyond pardon. By way of quieting her I promised that if the ambassador did not rid us of him within the week I would charge myself with the execution of our common vengeance.

About this time died Bragadin the procurator, brother of my patron, leaving M. de Bragadin sufficiently well off. However, as the family threatened to become extinct, he desired a woman who had been his mistress, and of whom he had had a natural son, to become his wife. By this marriage the son would have become legitimate, and the family renewed again. The College of Cardinals would have recognized the wife for a small fee, and all would have gone admirably.

The woman wrote to me, asking me to call on her; and I was going to, curious to know what a woman, whom I did not know from Adam, could want with me, when I received a summons from M. de Bragadin. He begged me to ask Paralis if he ought to follow De la Haye's advice in a matter he had promised not to confide to me, but of which the oracle must be informed. The oracle, naturally opposed to the Jesuit, told him to consult his own feelings and nothing else. After this I went to the lady.

She began by telling me the whole story. She introduced her son to me, and told me that if the marriage could be performed, a deed would be delivered in my favour by which, at the death of M. de Bragadin, I should become entitled to an estate worth five thousand crowns per annum.

As I guessed without much trouble that this was the same matter which De la Haye had proposed to M. de Bragadin, I answered without hesitation that

since De la Haye was before me I could do nothing, and thereupon made her my bow.

I could not help wondering at this Jesuit's continually intriguing to marry my old friends without my knowledge. Two years ago, if I had not set my face against it, he would have married M. Dandolo. I cared not a whit whether the family of Bragadin became extinct or not, but I did care for the life of my benefactor, and was quite sure that marriage would shorten it by many years; he was already sixty-three, and had recovered from a serious apoplectic stroke.

I went to dine with Lady Murray (English-women who are daughters of lords keep the title), and after dinner the ambassador told me that he had told M. Cavalli the whole story of the false nun, and that the secretary had informed him, the evening before, that everything had been done to his liking. Count Capsucefalo had been sent to Cephalonia, his native country, with the order never to return to Venice, and the courtezan had disappeared.

The fine part, or rather the fearful part, about these sentences is that no one ever knows the reason why or wherefore, and that the lot may fall on the innocent as well as the guilty. M. M. was delighted with the event, and I was more pleased than she, for I should have been sorry to have been obliged to soil my hands with the blood of that rascally count.

There are seasons in the life of men which may be called 'fasti' and 'nefasti'; I have proved this often in my long career, and on the strength of the rubs and struggles I have had to encounter. I am able, as well as any man, to verify the truth of this axiom. I had just experienced a run of luck. Fortune had befriended me at play, I had been happy in the society of men, and from love I had nothing to ask; but now the reverse of the medal began to appear. Love was still kind, but Fortune had quite left me, and you will soon see, reader, that men used me no better than the blind goddess. Nevertheless, since one's fate has phases as well as the moon, good follows evil as disasters succeed to happiness.

I still played on the martingale, but with such bad luck that I was soon left without a sequin. As I shared my property with M. M. I was obliged to tell her of my losses, and it was at her request that I sold all her diamonds, losing what I got for them; she had now only five hundred sequins by her. There was no more talk of her escaping from the convent, for we had nothing to live on! I still gamed, but for small stakes, waiting for the slow return of good luck.

One day the English ambassador, after giving me a supper at his casino with the celebrated Fanny Murray, asked me to let him sup at my casino at Muran, which I now only kept up for the sake of Tonine. I granted him the

favour, but did not imitate his generosity. He found my little mistress smiling and polite, but always keeping within the bounds of decency, from which he would have very willingly excused her. The next morning he wrote to me as follows:

"I am madly in love with Tonine. If you like to hand her over to me I will make the following provision for her: I will set her up in a suitable lodging which I will furnish throughout, and which I will give to her with all its contents, provided that I may visit her whenever I please, and that she gives me all the rights of a fortunate lover. I will give her a maid, a cook, and thirty sequins a month as provision for two people, without reckoning the wine, which I will procure myself. Besides this I will give her a life income of two hundred crowns per annum, over which she will have full control after living with me for a year. I give you a week to send your answer."

I replied immediately that I would let him know in three days whether his proposal were accepted, for Tonine had a mother of whom she was fond, and she would possibly not care to do anything without her consent. I also informed him that in all appearance the girl was with child.

The business was an important one for Tonine. I loved her, but I knew perfectly well that we could not pass the rest of our lives together, and I saw no prospect of being able to make her as good a provision as that offered by the ambassador. Consequently I had no doubts on the question, and the very same day I went to Muran and told her all.

"You wish to leave me, then," said she, in tears.

"I love you, dearest, and what I propose ought to convince you of my love."

"Not so; I cannot serve two masters."

"You will only serve your new lover, sweetheart. I beg of you to reflect that you will have a fine dowry, on the strength of which you may marry well; and that however much I love you I cannot possibly make so good a provision for you."

"Leave me to-day for tears and reflection, and come to supper with me to-morrow."

I did not fail to keep the appointment.

"I think your English friend is a very pretty man," she said, "and when he speaks in the Venetian dialect it makes me die with laughter. If my mother agrees, I might, perhaps, force myself to love him. Supposing we did not agree we could part at the end of a year, and I should be the richer by an income of two hundred crowns."

"I am charmed with the sense of your arguments; speak about it to your mother."

"I daren't, sweetheart; this kind of thing is too delicate to be discussed between a mother and her daughter speak to her yourself."

"I will, indeed."

Laura, whom I had not seen since she had given me her daughter, asked for no time to think it over, but full of glee told me that now her daughter would be able to soothe her declining years, and that she would leave Muran of which she was tired. She shewed me a hundred and thirty sequins which Tonine had gained in my service, and which she had placed in her hands.

Barberine, Tonine's younger sister, came to kiss my hand. I thought her charming, and I gave her all the silver in my pocket. I then left, telling Laura that I should expect her at my house. She soon followed me, and gave her child a mother's blessing, telling her that she and her family could go and live in Venice for sixty sous a day. Tonine embraced her, and told her that she should have it.

This important affair having been managed to everybody's satisfaction, I went to see M—— M——, who came into the parlour with C—— C——, whom I found looking sad, though prettier than ever. She was melancholy, but none the less tender. She could not stay for more than a quarter of an hour for fear of being seen, as she was forbidden ever to go into the parlour. I told M. M. the story of Tonine, who was going to live with Murray in Venice; she was sorry to hear it, "for," said she, "now that you have no longer any attraction at Muran, I shall see you less than ever." I promised to come and see her often, but vain promises! The time was near which parted us for ever.

The same evening I went to tell the good news to my friend Murray. He was in a transport of joy, and begged me to come and sup with him at his casino the day after next, and to bring the girl with me, that the surrender might be made in form. I did not fail him, for once the matter was decided, I longed to bring it to an end. In my presence he assigned to her the yearly income for her life of two hundred Venetian ducats, and by a second deed he gave her all the contents of the house with which he was going to provide her, provided always that she lived with him for a year. He allowed her to receive me as a friend, also to receive her mother and sisters, and she was free to go and see them when she would. Tonine threw her arms about his neck, and assured him that she would endeavour to please him to the utmost of her ability. "I will see him," said she, pointing to me, "but as his friend he shall have nothing more from me." Throughout this truly affecting scene she kept back her tears, but I could not conceal mine. Murray was happy, but I was not long a witness of his good fortune, the reason of which I will explain a little later.

Three days afterwards Laura came to me, told me that she was living in Venice, and asked me to take her to her daughter's. I owed this woman too much to refuse her, and I took her there forthwith. Tonine gave thanks to God, and also to me, and her mother took up the song, for they were not quite sure whether they were more indebted to God or to me. Tonine was eloquent in her praise of Murray, and made no complaint at my not having come to see her, at which I was glad. As I was going Laura asked me to take her back in my gondola, and as we had to pass by the house in which she lived she begged me to come in for a moment, and I could not hurt her feelings by refusing. I owe it to my honour to remark here that I was thus polite without thinking that I should see Barberine again.

This girl, as pretty as her sister, though in another style, began by awakening my curiosity—a weakness which usually renders the profligate man inconstant. If all women were to have the same features, the same disposition, and the same manners, men would not only never be inconstant, but would never be in love. Under that state of things one would choose a wife by instinct and keep to her till death, but our world would then be under a different system to the present. Novelty is the master of the soul. We know that what we do not see is very nearly the same as what we have seen, but we are curious, we like to be quite sure, and to attain our ends we give ourselves as much trouble as if we were certain of finding some prize beyond compare.

Barberine, who looked upon me as an old friend—for her mother had accustomed her to kiss my hand whenever I went there, who had undressed more than once in my presence without troubling about me, who knew I had made her sister's fortune and the family fortune as well, and thought herself prettier than Tonine because her skin was fairer, and because she had fine black eyes, desiring to take her sister's place, knew that to succeed she must take me by storm. Her common sense told her that as I hardly ever came to the house, I should not be likely to become amorous of her unless she won me by storm; and to this end she shewed the utmost complaisance when she had the chance, so that I won her without any difficulty. All this reasoning came from her own head, for I am sure her mother gave her no instructions. Laura was a mother of a kind common the world over, but especially in Italy. She was willing to take advantage of the earnings of her daughters, but she would never have induced them to take the path of evil. There her virtue stopped short.

After I had inspected her two rooms and her little kitchen, and had admired the cleanness which shone all around, Barberine asked me if I would like to see their small garden.

"With pleasure," I replied, "for a garden is a rarity in Venice."

Her mother told her to give me some figs if there were any ripe ones. The garden consisted of about thirty square feet, and grew only salad herbs and a fine fig tree. It had not a good crop, and I told her that I could not see any figs.

"I can see some at the top," said Barberine, "and I will gather them if you will hold me the ladder."

"Yes, climb away; I will hold it quite firmly."

She stepped up lightly, and stretching out an arm to get at some figs to one side of her, she put her body off its balance, holding on to the ladder with the other hand.

"My dear Barberine, what do you think I can see?"

"What you have often seen with my sister."

"That's true! but you are prettier than she is."

The girl made no reply, but, as if she could not reach the fruit, she put her foot on a high branch, and spewed me the most seductive picture. I was in an ecstasy, and Barberine, who saw it, did not hurry herself. At last I helped her to come down, and letting my hand wander indiscreetly, I asked her if the fruit I held had been plucked, and she kept me a long time telling me it was quite fresh. I took her within my arms, and already her captive, I pressed her amorously to my heart, printing on her lips a fiery kiss, which she gave me back with as much ardour.

"Will you give me what I have caught, dearest?"

"My mother is going to Muran to-morrow, and she will stay there all the day; if you come, there is nothing I will refuse you."

When speech like this proceeds from a mouth still innocent, the man to whom it is addressed ought to be happy, for desires are but pain and torment, and enjoyment is sweet because it delivers us from them. This shews that those who prefer a little resistance to an easy conquest are in the wrong; but a too easy conquest often points to a depraved nature, and this men do not like, however depraved they themselves may be.

We returned to the house, and I gave Barberine a tender kiss before Laura's eyes, telling her that she had a very jewel in her daughter—a compliment which made her face light up with pleasure. I gave the dear girl ten sequins, and I went away congratulating myself, but cursing my luck at not being able to make as good provision for Barberine as Murray had made for her sister.

Tonine had told me that for manners' sake I should sup once with her. I went the same evening and found Righelini and Murray there. The supper was delicious, and I was delighted with the excellent understanding the two

lovers had already come to. I complimented the ambassador on the loss of one of his tastes, and he told me he should be very sorry at such a loss, as it would warn him of his declining powers.

"But," said I, "you used to like to perform the mysterious sacrifice of Love without a veil."

"It was not I but Ancilla who liked it, and as I preferred pleasing her to pleasing myself, I gave in to her taste without any difficulty."

"I am delighted with your answer, as I confess it would cost me something to be the witness of your exploits with Tonine."

Having casually remarked that I had no longer a house in Muran, Righelini told me that if I liked he could get me a delightful house at a low rent on the Tondamente Nuovo.

As this quarter facing north, and as agreeable in summer as disagreeable in winter, was opposite to Muran, where I should have to go twice a week, I told the doctor I should be glad to look at the house.

I took leave of the rich and fortunate ambassador at midnight, and before passing the day with my new prize I went to sleep so as to be fresh and capable of running a good course.

I went to Barberine at an early hour, and as soon as she saw me she said,

"My mother will not be back till the evening, and my brother will take his dinner at the school. Here is a fowl, a ham, some cheese, and two bottles of Scopolo wine. We will take our mess whenever you like:"

"You astonish me, sweetheart, for how did you manage to get such a good dinner?"

"We owe it to my mother, so to her be the praise."

"You have told her, then, what we are going to do?"

"No, not I, for I know nothing about it; but I told her you were coming to see me, and at the same time I gave her the ten sequins."

"And what did your mother say?"

"She said she wouldn't be sorry if you were to love me as you loved my sister."

"I love you better, though I love her well."

"You love her? Why have you left her, then?"

"I have not left her, for we supped together yesterday evening; but we no longer live together as lovers, that is all. I have yielded her up to a rich friend of mine, who has made her fortune."

"That is well, though I don't understand much about these affairs. I hope you will tell Tonine that I have taken her place, and I should be very pleased if you would let her know that you are quite sure you are my first lover."

"And supposing the news vexes her?"

"So much the better. Will you do it for me? it's the first favour I have asked of you."

"I promise to do so."

After this rapid dialogue we took breakfast, and then, perfectly agreed, we went to bed, rather as if we were about to sacrifice to Hymen than to love.

The game was new to Barberine, and her transports, her green notions—which she told me openly—her inexperience, or rather her awkwardness, enchanted me. I seemed for the first time to pluck the fruit of the tree of knowledge, and never had I tasted fruit so delicious. My little maid would have been ashamed to let me see how the first thorn hurt her, and to convince me that she only smelt the rose, she strove to make me think she experienced more pleasure than is possible in a first trial, always more or less painful. She was not yet a big girl, the roses on her swelling breasts were as yet but buds, and she was a woman only in her heart.

After more than one assault delivered and sustained with spirit, we got up for dinner, and after we had refreshed ourselves we mounted once more the altar of love, where we remained till the evening. Laura found us dressed and well pleased with each other on her return. I made Barberine another present of twenty sequins, I swore to love her always, and went on my way. At the time I certainly meant to keep to my oath, but that which destiny had in store for me could not be reconciled with these promises which welled forth from my soul in a moment of excitement.

The next morning Righelini took me to see the lodging he had spoken to me about. I liked it and took it on the spot, paying the first quarter in advance. The house belonged to a widow with two daughters, the elder of whom had just been blooded. Righelini was her doctor, and had treated her for nine months without success. As he was going to pay her a visit I went in with him, and found myself in the presence of a fine waxen statue. Surprise drew from me these words:

"She is pretty, but the sculptor should give her some colour."

On which the statue smiled in a manner which would have been charming if her lips had but been red.

"Her pallor," said Righelini, "will not astonish you when I tell you she has just been blooded for the hundred and fourth time."

I gave a very natural gesture of surprise.

This fine girl had attained the age of eighteen years without experiencing the monthly relief afforded by nature, the result being that she felt a deathly faintness three or four times a week, and the only relief was to open the vein.

"I want to send her to the country," said the doctor, "where pure and wholesome air, and, above all, more exercise, will do her more good than all the drugs in the world."

After I had been told that my bed should be made ready by the evening, I went away with Righelini, who told me that the only cure for the girl would be a good strong lover.

"But my dear doctor," said I, "can't you make your own prescription?"

"That would be too risky a game, for I might find myself compelled to marry her, and I hate marriage like the devil."

Though I was no better inclined towards marriage than the doctor, I was too near the fire not to get burnt, and the reader will see in the next chapter how I performed the miraculous cure of bringing the colours of health into the cheeks of this pallid beauty.

CHAPTER XXV

The Fair Invalid I Cure Her—A Plot Formed to Ruin Me—What
Happened at the House of the Young Countess Bonafede—The
Erberia—Domiciliary Visit—My Conversation with M. de
Bragadin—I Am Arrested by Order of the State Inquisitors.

After leaving Dr. Righelini I went to sup with M. de Bragadin, and gave the
generous and worthy old man a happy evening. This was always the case; I
made him and his two good friends happy whenever I took meals with them.

Leaving them at an early hour, I went to my lodging and was greatly
surprised to find my bedroom balcony occupied. A young lady of an exquisite
figure rose as soon as she saw me, and gracefully asked me pardon for the
liberty she had taken.

"I am," she said, "the statue you saw this morning. We do not light the
candles in the evening for fear of attracting the gnats, but when you want to
go to bed we will shut the door and go away. I beg to introduce you to my
younger sister, my mother has gone to bed."

I answered her to the effect that the balcony was always at her service, and
that since it was still early I begged their permission to put on my
dressing-gown and to keep them company. Her conversation was charming;
she made me spend two most delightful hours, and did not leave me till
twelve o'clock. Her younger sister lighted me a candle, and as they went they
wished me a good night.

I lay down full of this pretty girl, and I could not believe that she was really
ill. She spoke to the point, she was cheerful, clever, and full of spirits. I could
not understand how it came to pass that she had not been already cured in a
town like Venice, if her cure was really only to be effected in the manner
described by Dr. Righelini; for in spite of her pallor she seemed to me quite
fair enough to charm a lover, and I believed her to be spirited enough to
determine to take the most agreeable medicine a doctor can prescribe.

In the morning I rang the bell as I was getting up, and the younger sister
came into my room, and said that as they kept no servant she had come to do
what I wanted. I did not care to have a servant when I was not at M. de
Bragadin's, as I found myself more at liberty to do what I liked. After she had
done me some small services, I asked her how her sister was.

"Very well," said she, "for her pale complexion is not an illness, and she
only suffers when her breath fails her. She has a very good appetite, and sleeps
as well as I do."

"Whom do I hear playing the violin?"

"It's the dancing master giving my sister a lesson."

I hurried over my dressing that I might see her; and I found her charming, though her old dancing master allowed her to turn in her toes. All that this young and beautiful girl wanted was the Promethean spark, the colour of life; her whiteness was too like snow, and was distressing to look at.

The dancing master begged me to dance a minuet with his pupil, and I assented, asking him to play larghissimo. "The signorina would find it too tiring," said he; but she hastened to answer that she did not feel weak, and would like to dance thus. She danced very well, but when we had done she was obliged to throw herself in a chair. "In future, my dear master," said she, "I will only dance like that, for I think the rapid motion will do me good."

When the master was gone, I told her that her lessons were too short, and that her master was letting her get into bad habits. I then set her feet, her shoulders, and her arms in the proper manner. I taught her how to give her hand gracefully, to bend her knees in time; in fine, I gave her a regular lesson for an hour, and seeing that she was getting rather tired I begged her to sit down, and I went out to pay a visit to M. M.

I found her very sad, for C—— C——'s father was dead, and they had taken her out of the convent to marry her to a lawyer. Before leaving C—— C—— had left a letter for me, in which she said that if I would promise to marry her at some time suitable to myself, she would wait for me, and refuse all other offers. I answered her straightforwardly that I had no property and no prospects, that I left her free, advising her not to refuse any offer which might be to her advantage.

In spite of this dismissal C—— C—— did not marry N—— till after my flight from The Leads, when nobody expected to see me again in Venice. I did not see her for nineteen years, and then I was grieved to find her a widow, and poorly off. If I went to Venice now I should not marry her, for at my age marriage is an absurdity, but I would share with her my little all, and live with her as with a dear sister.

When I hear women talking about the bad faith and inconstancy of men, and maintaining that when men make promises of eternal constancy they are always deceivers, I confess that they are right, and join in their complaints. Still it cannot be helped, for the promises of lovers are dictated by the heart, and consequently the lamentations of women only make me want to laugh. Alas! we love without heeding reason, and cease to love in the same manner.

About this time I received a letter from the Abbe de Bernis, who wrote also to M—— M——. He told me that I ought to do my utmost to make our nun

take a reasonable view of things, dwelling on the risks I should run in carrying her off and bringing her to Paris, where all his influence would be of no avail to obtain for us that safety so indispensable to happiness. I saw M——— M———; we shewed each other our letters, she had some bitter tears, and her grief pierced me to the heart. I still had a great love for her in spite of my daily infidelities, and when I thought of those moments in which I had seen her given over to voluptuousness I could not help pitying her fate as I thought of the days of despair in store for her. But soon after this an event happened which gave rise to some wholesome reflections. One day, when I had come to see her, she said,

"They have just been burying a nun who died of consumption the day before yesterday in the odour of sanctity. She was called 'Maria Concetta.' She knew you, and told C——— C——— your name when you used to come to mass on feast days. C——— C——— begged her to be discreet, but the nun told her that you were a dangerous man, whose presence should be shunned by a young girl. C——— C——— told me all this after the mask of Pierrot."

"What was this saint's name when she was in the world?"

"Martha."

"I know her."

I then told M——— M——— the whole history of my loves with Nanette and Marton, ending with the letter she wrote me, in which she said that she owed me, indirectly, that eternal salvation to which she hoped to attain.

In eight or ten days my conversation with my hostess' daughter—conversation which took place on the balcony, and which generally lasted till midnight—and the lesson I gave her every morning, produced the inevitable and natural results; firstly, that she no longer complained of her breath failing, and, secondly, that I fell in love with her. Nature's cure had not yet relieved her, but she no longer needed to be let blood. Righelini came to visit her as usual, and seeing that she was better he prophesied that nature's remedy, without which only art could keep her alive, would make all right before the autumn. Her mother looked upon me as an angel sent by God to cure her daughter, who for her part shewed me that gratitude which with women is the first step towards love. I had made her dismiss her old dancing master, and I had taught her to dance with extreme grace.

At the end of these ten or twelve days, just as I was going to give her her lesson, her breath failed instantaneously, and she fell back into my arms like a dead woman. I was alarmed, but her mother, who had become accustomed to see her thus, sent for the surgeon, and her sister unlaced her. I was

enchanted with her exquisite bosom, which needed no colouring to make it more beautiful. I covered it up, saying that the surgeon would make a false stroke if he were to see her thus uncovered; but feeling that I laid my hand upon her with delight, she gently repulsed me, looking at me with a languishing gaze which made the deepest impression on me.

The surgeon came and bled her in the arm, and almost instantaneously she recovered full consciousness. At most only four ounces of blood were taken from her, and her mother telling me that this was the utmost extent to which she was blooded, I saw it was no such matter for wonder as Righelini represented it, for being blooded twice a week she lost three pounds of blood a month, which she would have done naturally if the vessels had not been obstructed.

The surgeon had hardly gone out of the door when to my astonishment she told me that if I would wait for her a moment she would come back and begin her dancing. This she did, and danced as if there had been nothing the matter.

Her bosom, on which two of my senses were qualified to give evidence, was the last stroke, and made me madly in love with her. I returned to the house in the evening, and found her in her room with the sister. She told me that she was expecting her god-father, who was an intimate friend of her father's, and had come every evening to spend an hour with her for the last eighteen years.

"How old is he?"

"He is over fifty."

"Is he a married man?"

"Yes, his name is Count S——. He is as fond of me as a father would be, and his affection has continued the same since my childhood. Even his wife comes to see me sometimes, and to ask me to dinner. Neat autumn I am going into the country with her, and I hope the fresh air will do me good. My god-father knows you are staying with us and is satisfied. He does not know you, but if you like you can make his acquaintance."

I was glad to hear all this, as I gained a good deal of useful information without having to ask any awkward questions. The friendship of this Greek looked very like love. He was the husband of Countess S——, who had taken me to the convent at Muran two years before.

I found the count a very polite man. He thanked me in a paternal manner for my kindness to his daughter, and begged me to do him the honour of dining with him on the following day, telling me that he would introduce me to his wife. I accepted his invitation with pleasure, for I was fond of dramatic

situations, and my meeting with the countess promised to be an exciting one. This invitation bespoke the courteous gentleman, and I charmed my pretty pupil by singing his praises after he had gone.

"My god-father," said she, "is in possession of all the necessary documents for withdrawing from the house of Persico our family fortune, which amounts to forty thousand crowns. A quarter of this sum belongs to me, and my mother has promised my sister and myself to share her dowry between us."

I concluded from this that she would bring her husband fifteen thousand Venetian ducats.

I guessed that she was appealing to me with her fortune, and wished to make me in love with her by shewing herself chary of her favours; for whenever I allowed myself any small liberties, she checked me with words, of remonstrance to which I could find no answer. I determined to make her pursue another course.

Next day I took her with me to her god-father's without telling her that I knew the countess. I fancied the lady would pretend not to know me, but I was wrong, as she welcomed me in the handsomest manner as if I were an old friend. This, no doubt, was a surprise for the count, but he was too much a man of the world to, shew any astonishment. He asked her when she had made my acquaintance, and she, like a woman of experience, answered without the slightest hesitation that we had seen each other two years ago at Mira. The matter was settled, and we spent a very pleasant day.

Towards evening I took the young lady in my gondola back to the house, but wishing to shorten the journey I allowed myself to indulge in a few caresses. I was hurt at being responded to by reproaches, and for that reason, as soon as she had set foot on her own doorstep, instead of getting out I went to Tonine's house, and spent nearly the whole night there with the ambassador, who came a little after me. Next day, as I did not get up till quite late, there was no dancing lesson, and when I excused myself she told me not to trouble any more about it. In the evening I sat on the balcony far into the night, but she did not come. Vexed at this air of indifference I rose early in the morning and went out, not returning till nightfall. She was on the balcony, but as she kept me at a respectful distance I only talked to her on commonplace subjects. In the morning I was roused by a tremendous noise. I got up, and hurriedly putting on my dressing-gown ran into her room to see what was the matter, only to find her dying. I had no need to feign an interest in her, for I felt the most tender concern. As it was at the beginning of July it was extremely hot, and my fair invalid was only covered by a thin sheet. She could only speak to me with her eyes, but though the lids were lowered she

looked upon me so lovingly! I asked her if she suffered from palpitations, and laying my hand upon her heart I pressed a fiery kiss upon her breast. This was the electric spark, for she gave a sigh which did her good. She had not strength to repulse the hand which I pressed amorously upon her heart, and becoming bolder I fastened my burning lips upon her languid mouth. I warmed her with my breath, and my audacious hand penetrated to the very sanctuary of bliss. She made an effort to push me back, and told me with her eyes, since she could not speak, how insulted she felt. I drew back my hand, and at that moment the surgeon came. Hardly was the vein opened when she drew a long breath, and by the time the operation was over she wished to get up. I entreated her to stay in bed, and her mother added her voice to mine; at last I persuaded her, telling her that I would not leave her for a second, and that I would have my dinner by her bedside. She then put on a corset and asked her sister to draw a sarcenet coverlet over her, as her limbs could be seen as plainly as through a crape veil.

Having given orders for my dinner, I sat down by her bedside, burning with love, and taking her hand and covering it with kisses I told her that I was sure she would get better if she would let herself love.

"Alas!" she said, "whom shall I love, not knowing whether I shall be loved in return?"

I did not leave this question unanswered, and continuing the amorous discourse with animation I won a sigh and a lovelorn glance. I put my hand on her knee, begging her to let me leave it there, and promising to go no farther, but little by little I attained the center, and strove to give her some pleasant sensations.

"Let me alone," said she, in a sentimental voice, drawing away, "'tis perchance the cause of my illness."

"No, sweetheart," I replied, "that cannot be." And my mouth stopped all her objections upon her lips.

I was enchanted, for I was now in a fair way, and I saw the moment of bliss in the distance, feeling certain that I could effect a cure if the doctor was not mistaken. I spared her all indiscreet questions out of regard for her modesty; but I declared myself her lover, promising to ask nothing of her but what was necessary to feed the fire of my love. They sent me up a very good dinner, and she did justice to it; afterwards saying that she was quite well she got up, and I went away to dress myself for going out. I came back early in the evening, and found her on my balcony. There, as I sat close to her looking into her face, speaking by turns the language of the eyes and that of sighs, fixing my amorous gaze upon those charms which the moonlight rendered sweeter, I

made her share in the fire which consumed me; and as I pressed her amorously to my bosom she completed my bliss with such warmth that I could easily see that she thought she was receiving a favour and not granting one. I sacrificed the victim without staining the altar with blood.

Her sister came to tell her that it grew late.

"Do you go to bed," she answered; "the fresh air is doing me good, and I want to enjoy it a little longer."

As soon as we were alone we went to bed together as if we had been doing it for a whole year, and we passed a glorious night, I full of love and the desire of curing her, and she of tender and ardent voluptuousness. At day-break she embraced me, her eyes dewy with bliss, and went to lie down in her own bed. I, like her, stood in need of a rest, and on that day there was no talk of a dancing lesson. In spite of the fierce pleasure of enjoyment and the transports of this delightful girl, I did not for a moment lay prudence aside. We continued to pass such nights as these for three weeks, and I had the pleasure of seeing her thoroughly cured. I should doubtless have married her, if an event had not happened to me towards the end of the month, of which I shall speak lower down.

You will remember, dear reader, about a romance by the Abbe Chiari, a satirical romance which Mr. Murray had given me, and in which I fared badly enough at the author's hands I had small reason to be pleased with him, and I let him know my opinion in such wise that the abbe who dreaded a caning, kept upon his guard. About the same time I received an anonymous letter, the writer of which told me that I should be better occupied in taking care of myself than in thoughts of chastising the abbe, for I was threatened by an imminent danger. Anonymous letter-writers should be held in contempt, but one ought to know how, on occasion, to make the best of advice given in that way. I did nothing, and made a great mistake.

About the same time a man named Manuzzi, a stone setter for his first trade, and also a spy, a vile agent of the State Inquisitors—a man of whom I knew nothing—found a way to make my acquaintance by offering to let me have diamonds on credit, and by this means he got the entry of my house. As he was looking at some books scattered here and there about the room, he stopped short at the manuscripts which were on magic. Enjoying foolishly enough, his look of astonishment, I shewed him the books which teach one how to summon the elementary spirits. My readers will, I hope, do me the favour to believe that I put no faith in these conjuring books, but I had them by me and used to amuse myself with them as one does amuse one's self with the multitudinous follies which proceed from the heads of visionaries. A few

The Story of my Life 357

days after, the traitor came to see me and told me that a collector, whose name he might not tell me, was ready to give me a thousand sequins for my five books, but that he would like to examine them first to see if they were genuine. As he promised to let me have them back in twenty-four hours, and not thinking much about the matter, I let him have them. He did not fail to bring them back the next day, telling me that the collector thought them forgeries. I found out, some years after, that he had taken them to the State Inquisitors, who thus discovered that I was a notable magician.

Everything that happened throughout this fatal month tended to my ruin, for Madame Memmo, mother of Andre, Bernard, and Laurent Memmo, had taken it into her head that I had inclined her sons to atheistic opinions, and took counsel with the old knight Antony Mocenigo, M. de Bragadin's uncle, who was angry with me, because, as he said, I had conspired to seduce his nephew. The matter was a serious one, and an auto-da-fe was very possible, as it came under the jurisdiction of the Holy Office—a kind of wild beast, with which it is not good to quarrel. Nevertheless, as there would be some difficulty in shutting me up in the ecclesiastical prisons of the Holy Office, it was determined to carry my case before the State Inquisitors, who took upon themselves the provisional duty of putting a watch upon my manner of living.

M. Antony Condulmer, who as a friend of Abbe Chiari's was an enemy of mine, was then an Inquisitor of State, and he took the opportunity of looking upon me in the light of a disturber of the peace of the commonwealth. A secretary of an embassy, whom I knew some years after, told me that a paid informer, with two other witnesses, also, doubtless, in the pay of this grand tribunal, had declared that I was guilty of only believing in the devil, as if this absurd belief, if it were possible, did not necessarily connote a belief in God! These three honest fellows testified with an oath that when I lost money at play, on which occasion all the faithful are wont to blaspheme, I was never heard to curse the devil. I was further accused of eating meat all the year round, of only going to hear fine masses, and I was vehemently suspected of being a Freemason. It was added that I frequented the society of foreign ministers, and that living as I did with three noblemen, it was certain that I revealed, for the large sums which I was seen to lose, as many state secrets as I could worm out of them.

All these accusations, none of which had any foundation in fact, served the Tribunal as a pretext to treat me as an enemy of the commonwealth and as a prime conspirator. For several weeks I was counselled by persons whom I might have trusted to go abroad whilst the Tribunal was engaged on my case. This should have been enough, for the only people who can live in peace at

Venice are those whose existence the Tribunal is ignorant of, but I obstinately despised all these hints. If I had listened to the indirect advice which was given me, I should have become anxious, and I was the sworn foe of all anxiety. I kept saying to myself, "I feel remorse for nothing and I am therefore guilty of nothing, and the innocent have nothing to fear." I was a fool, for I argued as if I had been a free man in a free country. I must also confess that what to a great extent kept me from thinking of possible misfortune was the actual misfortune which oppressed me from morning to night. I lost every day, I owed money everywhere, I had pawned all my jewels, and even my portrait cases, taking the precaution, however, of removing the portraits, which with my important papers and my amorous letters I had placed in the hands of Madame Manzoni. I found myself avoided in society. An old senator told me, one day, that it was known that the young Countess Bonafede had become mad in consequence of the love philtres I had given her. She was still at the asylum, and in her moments of delirium she did nothing but utter my name with curses. I must let my readers into the secret of this small history.

This young Countess Bonafede, to whom I had given some sequins a few days after my return to Venice, thought herself capable of making me continue my visits, from which she had profited largely. Worried by her letters I went to see her several times, and always left her a few sequins, but with the exception of my first visit I was never polite enough to give her any proofs of my affection. My coldness had baulked all her endeavours for a year, when she played a criminal part, of which, though I was never able absolutely to convict her, I had every reason to believe her guilty.

She wrote me a letter, in which she importuned me to come and see her at a certain hour on important business.

My curiosity, as well as a desire to be of service to her, took me there at the appointed time; but as soon as she saw me she flung her arms round my neck, and told me that the important business was love. This made me laugh heartily, and I was pleased to find her looking neater than usual, which, doubtless, made me find her looking prettier. She reminded me of St. Andre, and succeeded so well in her efforts that I was on the point of satisfying her desires. I took off my cloak, and asked her if her father were in. She told me he had gone out. Being obliged to go out for a minute, in coming back I mistook the door, and I found myself in the next room, where I was much astonished to see the count and two villainous-looking fellows with him.

"My dear count," I said, "your daughter has just told me that you were out."

"I myself told her to do so, as I have some business with these gentlemen, which, however, can wait for another day."

I would have gone, but he stopped me, and having dismissed the two men he told me that he was delighted to see me, and forthwith began the tale of his troubles, which were of more than one kind. The State Inquisitors had stopped his slender pension, and he was on the eve of seeing himself driven out with his family into the streets to beg his bread. He said that he had not been able to pay his landlord anything for three years, but if he could pay only a quarter's rent, he would obtain a respite, or if he persisted in turning him out, he could make a night-flitting of it, and take up his abode somewhere else. As he only wanted twenty ducats, I took out six sequins and gave them to him. He embraced me, and shed tears of joy; then, taking his poor cloak, he called his daughter, told her to keep me company, and went out.

Alone with the countess, I examined the door of communication between the two rooms and found it slightly open.

"Your father," I said, "would have surprised me, and it is easy to guess what he would have done with the two sbirri who were with him. The plot is clear, and I have only escaped from it by the happiest of chances."

She denied, wept, called God to witness, threw herself on her knees; but I turned my head away, and taking my cloak went away without a word. She kept on writing to me, but her letters remained unanswered, and I saw her no more.

It was summer-time, and between the heat, her passions, hunger, and wretchedness, her head was turned, and she became so mad that she went out of the house stark naked, and ran up and down St. Peter's Place, asking those who stopped her to take her to my house. This sad story went all over the town and caused me a great deal of annoyance. The poor wretch was sent to an asylum, and did not recover her reason for five years. When she came out she found herself reduced to beg her bread in the streets, like all her brothers, except one, whom I found a cadet in the guards of the King of Spain twelve years afterwards.

At the time of which I am speaking all this had happened a year ago, but the story was dug up against me, and dressed out in the attire of fiction, and thus formed part of those clouds which were to discharge their thunder upon me to my destruction.

In the July of 1755 the hateful court gave Messer-Grande instructions to secure me, alive or dead. In this furious style all orders for arrests proceeding from the Three were issued, for the least of their commands carried with it the penalty of death.

Three or four days before the Feast of St. James, my patron saint, M——M—— made me a present of several ells of silver lace to trim a sarcenet dress

which I was going to wear on the eve of the feast. I went to see her, dressed in my fine suit, and I told her that I should come again on the day following to ask her to lend me some money, as I did not know where to turn to find some. She was still in possession of the five hundred sequins which she had put aside when I had sold her diamonds.

As I was sure of getting the money in the morning I passed the night at play, and I lost the five hundred sequins in advance. At day-break, being in need of a little quiet, I went to the Erberia, a space of ground on the quay of the Grand Canal. Here is held the herb, fruit, and flower market.

People in good society who come to walk in the Erberia at a rather early hour usually say that they come to see the hundreds of boats laden with vegetables, fruit and flowers, which hail from the numerous islands near the town; but everyone knows that they are men and women who have been spending the night in the excesses of Venus or Bacchus, or who have lost all hope at the gaming-table, and come here to breath a purer air and to calm their minds. The fashion of walking in this place shews how the character of a nation changes. The Venetians of old time who made as great a mystery of love as of state affairs, have been replaced by the modern Venetians, whose most prominent characteristic is to make a mystery of nothing. Those who come to the Erberia with women wish to excite the envy of their friends by thus publishing their good fortune. Those who come alone are on the watch for discoveries, or on the look-out for materials to make wives or husbands jealous, the women only come to be seen, glad to let everybody know that they are without any restraint upon their actions. There was certainly no question of smartness there, considering the disordered style of dress worn. The women seemed to have agreed to shew all the signs of disorder imaginable, to give those who saw them something to talk about. As for the men, on whose arms they leaned, their careless and lounging airs were intended to give the idea of a surfeit of pleasure, and to make one think that the disordered appearance of their companions was a sure triumph they had enjoyed. In short it was the correct thing to look tired out, and as if one stood in need of sleep.

This veracious description, reader, will not give you a very high opinion of the morals of my dear fellow citizens; but what object should I have at my age for deceiving? Venice is not at the world's end, but is well enough known to those whose curiosity brings them into Italy; and everyone can see for himself if my pictures are overdrawn.

After walking up and down for half an hour, I came away, and thinking the whole house still a-bed I drew my key out to open the door, but what was my

astonishment to find it useless, as the door was open, and what is more, the lock burst off. I ran upstairs, and found them all up, and my landlady uttering bitter lamentations.

"Messer-Grande," she told me, "has entered my house forcibly, accompanied by a band of sbirri. He turned everything upside down, on the pretext that he was in search of a portmanteau full of salt—a highly contraband article. He said he knew that a portmanteau had been landed there the evening before, which was quite true; but it belonged to Count S——, and only contained linen and clothes. Messer-Grande, after inspecting it, went out without saying a word."

He had also paid my room a visit. She told me that she must have some reparation made her, and thinking she was in the right I promised to speak to M. de Bragadin on the matter the same day. Needing rest above all things, I lay down, but my nervous excitement, which I attributed to my heavy losses at play, made me rise after three or four hours, and I went to see M. de Bragadin, to whom I told the whole story begging him to press for some signal amends. I made a lively representation to him of all the grounds on which my landlady required proportionate amends to be made, since the laws guaranteed the peace of all law-abiding people.

I saw that the three friends were greatly saddened by what I said, and the wise old man, quietly but sadly, told me that I should have my answer after dinner.

De la Haye dined with us, but all through the meal, which was a melancholy one, he spoke not a word. His silence should have told me all, if I had not been under the influence of some malevolent genii who would not allow me to exercise my common sense: as to the sorrow of my three friends, I put that down to their friendship for me. My connection with these worthy men had always been the talk of the town, and as all were agreed that it could not be explained on natural grounds, it was deemed to be the effect of some sorcery exercised by me. These three men were thoroughly religious and virtuous citizens; I was nothing if not irreligious, and Venice did not contain a greater libertine. Virtue, it was said, may have compassion on vice, but cannot become its friend.

After dinner M. de Bragadin took me into his closet with his two friends, from whom he had no secrets. He told me with wonderful calmness that instead of meditating vengeance on Messer-Grande I should be thinking of putting myself in a place of safety. "The portmanteau," said he, "was a mere pretext; it was you they wanted and thought to find. Since your good genius has made them miss you, look out for yourself; perhaps by to-morrow it may

be too late. I have been a State Inquisitor for eight months, and I know the way in which the arrests ordered by the court are carried out. They would not break open a door to look for a box of salt. Indeed, it is possible that they knew you were out, and sought to warn you to escape in this manner. Take my advice, my dear son, and set out directly for Fusina, and thence as quickly as you can make your way to Florence, where you can remain till I write to you that you may return with safety. If you have no money I will give you a hundred sequins for present expenses. Believe me that prudence bids you go."

Blinded by my folly, I answered him that being guilty of nothing I had nothing to fear, and that consequently, although I knew his advice was good, I could not follow it.

"The high court," said he, "may deem you guilty of crimes real or imaginary; but in any case it will give you no account of the accusations against you. Ask your oracle if you shall follow my advice or not." I refused because I knew the folly of such a proceeding, but by way of excuse I said that I only consulted it when I was in doubt. Finally, I reasoned that if I fled I should be shewing fear, and thus confessing my guilt, for an innocent man, feeling no remorse, cannot reasonably be afraid of anything.

"If secrecy," said I, "is of the essence of the Court, you cannot possibly judge, after my escape, whether I have done so rightly or wrongly. The same reasons, which, according to your excellence, bid me go, would forbid my return. Must I then say good-bye for ever to my country, and all that is dear to me?" As a last resource he tried to persuade me to pass the following day and night, at least, at the palace. I am still ashamed of having refused the worthy old man to whom I owed so much this favour; for the palace of a noble is sacred to the police who dare not cross its threshold without a special order from the Tribunal, which is practically never given; by yielding to his request I should have avoided a grievous misfortune, and spared the worthy old man some acute grief.

I was moved to see M. de Bragadin weeping, and perhaps I might have granted to his tears that which I had obstinately refused to his arguments and entreaties. "For Heaven's sake!" said I, "spare me the harrowing sight of your tears." In an instant he summoned all his strength to his assistance, made some indifferent remarks, and then, with a smile full of good nature, he embraced me, saying, "Perhaps I may be fated never to see you again, but 'Fata viam invenient'."

I embraced him affectionately, and went away, but his prediction was verified, for I never saw him again; he died eleven years afterwards. I found myself in the street without feeling the slightest fear, but I was in a good deal

of trouble about my debts. I had not the heart to go to Muran to take away from M. M. her last five hundred sequins, which sum I owed to the man who won it from me in the night; I preferred asking him to wait eight days, and I did so. After performing this unpleasant piece of business I returned home, and, having consoled my landlady to the utmost of my power, I kissed the daughter, and lay down to sleep. The date was July 25th, 1755.

Next morning at day-break who should enter my room but the awful Messer-Grande. To awake, to see him, and to hear him asking if I were Jacques Casanova, was the work of a moment. At my "yes, I am Casanova," he told me to rise, to put on my clothes, to give him all the papers and manuscripts in my possession, and to follow him.

"On whose authority do you order me to do this?"

"By the authority of the Tribunal."

Episode 10 — under the Leads

CHAPTER XXVI

Under The Leads—The Earthquake

What a strange and unexplained power certain words exercise upon the soul! I, who the evening before so bravely fortified myself with my innocence and courage, by the word tribunal was turned to a stone, with merely the faculty of passive obedience left to me.

My desk was open, and all my papers were on a table where I was accustomed to write.

"Take them," said I, to the agent of the dreadful Tribunal, pointing to the papers which covered the table. He filled a bag with them, and gave it to one of the sbirri, and then told me that I must also give up the bound manuscripts which I had in my possession. I shewed him where they were, and this incident opened my eyes. I saw now, clearly enough, that I had been betrayed by the wretch Manuzzi. The books were, "The Key of Solomon the King," "The Zecorben," a "Picatrix," a book of "Instructions on the Planetary Hours," and the necessary incantations for conversing with demons of all sorts. Those who were aware that I possessed these books took me for an expert magician, and I was not sorry to have such a reputation.

Messer-Grande took also the books on the table by my bed, such as Petrarch, Ariosto, Horace. "The Military' Philosopher" (a manuscript which Mathilde had given me), "The Porter of Chartreux," and "The Aretin," which Manuzzi had also denounced, for Messer-Grande asked me for it by name. This spy, Manuzzi, had all the appearance of an honest man—a very necessary qualification for his profession. His son made his fortune in Poland by marrying a lady named Opeska, whom, as they say, he killed, though I have never had any positive proof on the matter, and am willing to stretch Christian charity to the extent of believing he was innocent, although he was quite capable of such a crime.

While Messer-Grande was thus rummaging among my manuscripts, books and letters, I was dressing myself in an absent-minded manner, neither hurrying myself nor the reverse. I made my toilette, shaved myself, and combed my hair; putting on mechanically a laced shirt and my holiday suit without saying a word, and without Messer-Grande—who did not let me

escape his sight for an instant—complaining that I was dressing myself as if I were going to a wedding.

As I went out I was surprised to see a band of forty men-at-arms in the ante-room. They had done me the honour of thinking all these men necessary for my arrest, though, according to the axiom 'Ne Hercules quidem contra duos', two would have been enough. It is curious that in London, where everyone is brave, only one man is needed to arrest another, whereas in my dear native land, where cowardice prevails, thirty are required. The reason is, perhaps, that the coward on the offensive is more afraid than the coward on the defensive, and thus a man usually cowardly is transformed for the moment into a man of courage. It is certain that at Venice one often sees a man defending himself against twenty sbirri, and finally escaping after beating them soundly. I remember once helping a friend of mine at Paris to escape from the hands of forty bum-bailiffs, and we put the whole vile rout of them to flight.

Messer-Grande made me get into a gondola, and sat down near me with an escort of four men. When we came to our destination he offered me coffee, which I refused; and he then shut me up in a room. I passed these four hours in sleep, waking up every quarter of an hour to pass water—an extraordinary occurrence, as I was not at all subject to stranguary; the heat was great, and I had not supped the evening before. I have noticed at other times that surprise at a deed of oppression acts on me as a powerful narcotic, but I found out at the time I speak of that great surprise is also a diuretic. I make this discovery over to the doctors, it is possible that some learned man may make use of it to solace the ills of humanity. I remember laughing very heartily at Prague six years ago, on learning that some thin-skinned ladies, on reading my flight from The Leads, which was published at that date, took great offence at the above account, which they thought I should have done well to leave out. I should have left it out, perhaps, in speaking to a lady, but the public is not a pretty woman whom I am intent on cajoling, my only aim is to be instructive. Indeed, I see no impropriety in the circumstance I have narrated, which is as common to men and women as eating and drinking; and if there is anything in it to shock too sensitive nerves, it is that we resemble in this respect the cows and pigs.

It is probable that just as my overwhelmed soul gave signs of its failing strength by the loss of the thinking faculty, so my body distilled a great part of those fluids which by their continual circulation set the thinking faculty in motion. Thus a sudden shock might cause instantaneous death, and send one to Paradise by a cut much too short.

In course of time the captain of the men-at-arms came to tell me that he was under orders to take me under the Leads. Without a word I followed him. We went by gondola, and after a thousand turnings among the small canals we got into the Grand Canal, and landed at the prison quay. After climbing several flights of stairs we crossed a closed bridge which forms the communication between the prisons and the Doge's palace, crossing the canal called Rio di Palazzo. On the other side of this bridge there is a gallery which we traversed. We then crossed one room, and entered another, where sat an individual in the dress of a noble, who, after looking fixedly at me, said, "E quello, mettetelo in deposito:"

This man was the secretary of the Inquisitors, the prudent Dominic Cavalli, who was apparently ashamed to speak Venetian in my presence as he pronounced my doom in the Tuscan language.

Messer-Grande then made me over to the warden of The Leads, who stood by with an enormous bunch of keys, and accompanied by two guards, made me climb two short flights of stairs, at the top of which followed a passage and then another gallery, at the end of which he opened a door, and I found myself in a dirty garret, thirty-six feet long by twelve broad, badly lighted by a window high up in the roof. I thought this garret was my prison, but I was mistaken; for, taking an enormous key, the gaoler opened a thick door lined with iron, three and a half feet high, with a round hole in the middle, eight inches in diameter, just as I was looking intently at an iron machine. This machine was like a horse shoe, an inch thick and about five inches across from one end to the other. I was thinking what could be the use to which this horrible instrument was put, when the gaoler said, with a smile,

"I see, sir, that you wish to know what that is for, and as it happens I can satisfy your curiosity. When their excellencies give orders that anyone is to be strangled, he is made to sit down on a stool, the back turned to this collar, and his head is so placed that the collar goes round one half of the neck. A silk band, which goes round the other half, passes through this hole, and the two ends are connected with the axle of a wheel which is turned by someone until the prisoner gives up the ghost, for the confessor, God be thanked! never leaves him till he is dead."

"All this sounds very ingenious, and I should think that it is you who have the honour of turning the wheel."

He made no answer, and signing to me to enter, which I did by bending double, he shut me up, and afterwards asked me through the grated hole what I would like to eat.

"I haven't thought anything about it yet," I answered. And he went away, locking all the doors carefully behind him.

Stunned with grief, I leant my elbows on the top of the grating. It was crossed, by six iron bars an inch thick, which formed sixteen square holes. This opening would have lighted my cell, if a square beam supporting the roof which joined the wall below the window had not intercepted what little light came into that horrid garret. After making the tour of my sad abode, my head lowered, as the cell was not more than five and a half feet high, I found by groping along that it formed three-quarters of a square of twelve feet. The fourth quarter was a kind of recess, which would have held a bed; but there was neither bed, nor table, nor chair, nor any furniture whatever, except a bucket—the use of which may be guessed, and a bench fixed in the wall a foot wide and four feet from the ground. On it I placed my cloak, my fine suit, and my hat trimmed with Spanish paint and adorned with a beautiful white feather. The heat was great, and my instinct made me go mechanically to the grating, the only place where I could lean on my elbows. I could not see the window, but I saw the light in the garret, and rats of a fearful size, which walked unconcernedly about it; these horrible creatures coming close under my grating without shewing the slightest fear. At the sight of these I hastened to close up the round hole in the middle of the door with an inside shutter, for a visit from one of the rats would have frozen my blood. I passed eight hours in silence and without stirring, my arms all the time crossed on the top of the grating.

At last the clock roused me from my reverie, and I began to feel restless that no one came to give me anything to eat or to bring me a bed whereon to sleep. I thought they might at least let me have a chair and some bread and water. I had no appetite, certainly; but were my gaolers to guess as much? And never in my life had I been so thirsty. I was quite sure, however, that somebody would come before the close of the day; but when I heard eight o'clock strike I became furious, knocking at the door, stamping my feet, fretting and fuming, and accompanying this useless hubbub with loud cries. After more than an hour of this wild exercise, seeing no one, without the slightest reason to think I could be heard, and shrouded in darkness, I shut the grating for fear of the rats, and threw myself at full length upon the floor. So cruel a desertion seemed to me unnatural, and I came to the conclusion that the Inquisitors had sworn my death. My investigation as to what I had done to deserve such a fate was not a long one, for in the most scrupulous examination of my conduct I could find no crimes. I was, it is true, a profligate, a gambler, a bold talker, a man who thought of little besides

enjoying this present life, but in all that there was no offence against the state. Nevertheless, finding myself treated as a criminal, rage and despair made me express myself against the horrible despotism which oppressed me in a manner which I will leave my readers to guess, but which I will not repeat here. But notwithstanding my brief and anxiety, the hunger which began to make itself felt, and the thirst which tormented me, and the hardness of the boards on which I lay, did not prevent exhausted nature from reasserting her rights; I fell asleep.

My strong constitution was in need of sleep; and in a young and healthy subject this imperious necessity silences all others, and in this way above all is sleep rightly termed the benefactor of man.

The clock striking midnight awoke me. How sad is the awaking when it makes one regret one's empty dreams. I could scarcely believe that I had spent three painless hours. As I lay on my left side, I stretched out my right hand to get my handkerchief, which I remembered putting on that side. I felt about for it, when—heavens! what was my surprise to feel another hand as cold as ice. The fright sent an electric shock through me, and my hair began to stand on end.

Never had I been so alarmed, nor should I have previously thought myself capable of experiencing such terror. I passed three or four minutes in a kind of swoon, not only motionless but incapable of thinking. As I got back my senses by degrees, I tried to make myself believe that the hand I fancied I had touched was a mere creature of my disordered imagination; and with this idea I stretched out my hand again, and again with the same result. Benumbed with fright, I uttered a piercing cry, and, dropping the hand I held, I drew back my arm, trembling all over:

Soon, as I got a little calmer and more capable of reasoning, I concluded that a corpse had been placed beside me whilst I slept, for I was certain it was not there when I lay down.

"This," said I, "is the body of some strangled wretch, and they would thus warn me of the fate which is in store for me."

The thought maddened me; and my fear giving place to rage, for the third time I stretched my arm towards the icy hand, seizing it to make certain of the fact in all its atrocity, and wishing to get up, I rose upon my left elbow, and found that I had got hold of my other hand. Deadened by the weight of my body and the hardness of the boards, it had lost warmth, motion, and all sensation.

In spite of the humorous features in this incident, it did not cheer me up, but, on the contrary, inspired me with the darkest fancies. I saw that I was in

a place where, if the false appeared true, the truth might appear false, where understanding was bereaved of half its prerogatives, where the imagination becoming affected would either make the reason a victim to empty hopes or to dark despair. I resolved to be on my guard; and for the first time in my life, at the age of thirty, I called philosophy to my assistance. I had within me all the seeds of philosophy, but so far I had had no need for it.

I am convinced that most men die without ever having thought, in the proper sense of the word, not so much for want of wit or of good sense, but rather because the shock necessary to the reasoning faculty in its inception has never occurred to them to lift them out of their daily habits.

After what I had experienced, I could think of sleep no more, and to get up would have been useless as I could not stand upright, so I took the only sensible course and remained seated. I sat thus till four o'clock in the morning, the sun would rise at five, and I longed to see the day, for a presentiment which I held infallible told me that it would set me again at liberty. I was consumed with a desire for revenge, nor did I conceal it from myself. I saw myself at the head of the people, about to exterminate the Government which had oppressed me; I massacred all the aristocrats without pity; all must be shattered and brought to the dust. I was delirious; I knew the authors of my misfortune, and in my fancy I destroyed them. I restored the natural right common to all men of being obedient only to the law, and of being tried only by their peers and by laws to which they have agreed-in short, I built castles in Spain. Such is man when he has become the prey of a devouring passion. He does not suspect that the principle which moves him is not reason but wrath, its greatest enemy.

I waited for a less time than I had expected, and thus I became a little more quiet. At half-past four the deadly silence of the place—this hell of the living—was broken by the shriek of bolts being shot back in the passages leading to my cell.

"Have you had time yet to think about what you will take to eat?" said the harsh voice of my gaoler from the wicket.

One is lucky when the insolence of a wretch like this only shews itself in the guise of jesting. I answered that I should like some rice soup, a piece of boiled beef, a roast, bread, wine, and water. I saw that the lout was astonished not to hear the lamentations he expected. He went away and came back again in a quarter of an hour to say that he was astonished I did not require a bed and the necessary pieces of furniture, "for" said he, "if you flatter yourself that you are only here for a night, you are very much mistaken."

"Then bring me whatever you think necessary."

"Where shall I go for it? Here is a pencil and paper; write it down."

I skewed him by writing where to go for my shirts, stockings, and clothes of all sorts, a bed, table, chair, the books which Messer-Grande had confiscated, paper, pens, and so forth. On my reading out the list to him (the lout did not know how to read) he cried, "Scratch out," said he, "scratch out books, paper, pens, looking-glass and razors, for all that is forbidden fruit here, and then give me some money to get your dinner." I had three sequins so I gave him one, and he went off. He spent an hour in the passages engaged, as I learnt afterwards, in attending on seven other prisoners who were imprisoned in cells placed far apart from each other to prevent all communication.

About noon the gaoler reappeared followed by five guards, whose duty it was to serve the state prisoners. He opened: the cell door to bring in my dinner and the furniture I had asked for. The bed was placed in the recess; my dinner was laid out on a small table, and I had to eat with an ivory spoon he had procured out of the money I had given him; all forks, knives, and edged tools being forbidden.

"Tell me what you would like for to-morrow," said he, "for I can only come here once a day at sunrise. The Lord High Secretary has told me to inform you that he will send you some suitable books, but those you wish for are forbidden."

"Thank him for his kindness in putting me by myself."

"I will do so, but you make a mistake in jesting thus."

"I don't jest at all, for I think truly that it is much better to be alone than to mingle with the scoundrels who are doubtless here."

"What, sir! scoundrels? Not at all, not at all. They are only respectable people here, who, for reasons known to their excellencies alone, have to be sequestered from society. You have been put by yourself as an additional punishment, and you want me to thank the secretary on that account?"

"I was not aware of that."

The fool was right, and I soon found it out. I discovered that a man imprisoned by himself can have no occupations. Alone in a gloomy cell where he only sees the fellow who brings his food once a day, where he cannot walk upright, he is the most wretched of men. He would like to be in hell, if he believes in it, for the sake of the company. So strong a feeling is this that I got to desire the company of a murderer, of one stricken with the plague, or of a bear. The loneliness behind the prison bars is terrible, but it must be learnt by experience to be understood, and such an experience I would not wish even to my enemies. To a man of letters in my situation, paper and ink would take

away nine-tenths of the torture, but the wretches who persecuted me did not dream of granting me such an alleviation of my misery.

After the gaoler had gone, I set my table near the grating for the sake of the light, and sat down to dinner, but I could only swallow a few spoonfuls of soup. Having fasted for nearly forty-eight hours, it was not surprising that I felt ill. I passed the day quietly enough seated on my sofa, and proposing myself to read the "suitable books" which they had been good enough to promise me. I did not shut my eyes the whole night, kept awake by the hideous noise made by the rats, and by the deafening chime of the clock of St. Mark's, which seemed to be striking in my room. This double vexation was not my chief trouble, and I daresay many of my readers will guess what I am going to speak of-namely, the myriads of fleas which held high holiday over me. These small insects drank my blood with unutterable voracity, their incessant bites gave me spasmodic convulsions and poisoned my blood.

At day-break, Lawrence (such was the gaoler's name) came to my cell and had my bed made, and the room swept and cleansed, and one of the guards gave me water wherewith to wash myself. I wanted to take a walk in the garret, but Lawrence told me that was forbidden. He gave me two thick books which I forbore to open, not being quite sure of repressing the wrath with which they might inspire me, and which the spy would have infallibly reported to his masters. After leaving me my fodder and two cut lemons he went away.

As soon as I was alone I ate my soup in a hurry, so as to take it hot, and then I drew as near as I could to the light with one of the books, and was delighted to find that I could see to read. I looked at the title, and read, "The Mystical City of Sister Mary of Jesus, of Agrada." I had never heard of it. The other book was by a Jesuit named Caravita. This fellow, a hypocrite like the rest of them, had invented a new cult of the "Adoration of the Sacred Heart of our Lord Jesus Christ." This, according to the author, was the part of our Divine Redeemer, which above all others should be adored a curious idea of a besotted ignoramus, with which I got disgusted at the first page, for to my thinking the heart is no more worthy a part than the lungs, stomach; or any other of the inwards. The "Mystical City" rather interested me.

I read in it the wild conceptions of a Spanish nun, devout to superstition, melancholy, shut in by convent walls, and swayed by the ignorance and bigotry of her confessors. All these grotesque, monstrous, and fantastic visions of hers were dignified with the name of revelations. The lover and bosom-friend of the Holy Virgin, she had received instructions from God

Himself to write the life of His divine mother; the necessary information was furnished her by the Holy Ghost.

This life of Mary began, not with the day of her birth, but with her immaculate conception in the womb of Anne, her mother. This Sister Mary of Agrada was the head of a Franciscan convent founded by herself in her own house. After telling in detail all the deeds of her divine heroine whilst in her mother's womb, she informs us that at the age of three she swept and cleansed the house with the assistance of nine hundred servants, all of whom were angels whom God had placed at her disposal, under the command of Michael, who came and went between God and herself to conduct their mutual correspondence.

What strikes the judicious reader of the book is the evident belief of the more than fanatical writer that nothing is due to her invention; everything is told in good faith and with full belief. The work contains the dreams of a visionary, who, without vanity but inebriated with the idea of God, thinks to reveal only the inspirations of the Divine Spirit.

The book was published with the permission of the very holy and very horrible Inquisition. I could not recover from my astonishment! Far from its stirring up in my breast a holy and simple zeal of religion, it inclined me to treat all the mystical dogmas of the Faith as fabulous.

Such works may have dangerous results; for example, a more susceptible reader than myself, or one more inclined to believe in the marvellous, runs the risk of becoming as great a visionary as the poor nun herself.

The need of doing something made me spend a week over this masterpiece of madness, the product of a hyper-exalted brain. I took care to say nothing to the gaoler about this fine work, but I began to feel the effects of reading it. As soon as I went off to sleep I experienced the disease which Sister Mary of Agrada had communicated to my mind weakened by melancholy, want of proper nourishment and exercise, bad air, and the horrible uncertainty of my fate. The wildness of my dreams made me laugh when I recalled them in my waking moments. If I had possessed the necessary materials I would have written my visions down, and I might possibly have produced in my cell a still madder work than the one chosen with such insight by Cavalli.

This set me thinking how mistaken is the opinion which makes human intellect an absolute force; it is merely relative, and he who studies himself carefully will find only weakness. I perceived that though men rarely become mad, still such an event is well within the bounds of possibility, for our reasoning faculties are like powder, which, though it catches fire easily, will never catch fire at all without a spark. The book of the Spanish nun has all

the properties necessary to make a man crack-brained; but for the poison to take effect he must be isolated, put under the Leads, and deprived of all other employments.

In November, 1767, as I was going from Pampeluna to Madrid, my coachman, Andrea Capello, stopped for us to dine in a town of Old Castille. So dismal and dreary a place did I find it that I asked its name. How I laughed when I was told that it was Agrada!

"Here, then," I said to myself, "did that saintly lunatic produce that masterpiece which but for M. Cavalli I should never have known."

An old priest, who had the highest possible opinion of me the moment I began to ask him about this truthful historian of the mother of Christ, shewed me the very place where she had written it, and assured me that the father, mother, sister, and in short all the kindred of the blessed biographer, had been great saints in their generation. He told me, and spoke truly, that the Spaniards had solicited her canonization at Rome, with that of the venerable Palafox. This "Mystical City," perhaps, gave Father Malagrida the idea of writing the life of St. Anne, written, also, at the dictation of the Holy Ghost, but the poor devil of a Jesuit had to suffer martyrdom for it—an additional reason for his canonization, if the horrible society ever comes to life again, and attains the universal power which is its secret aim.

At the end of eight or nine days I found myself moneyless. Lawrence asked me for some, but I had not got it.

"Where can I get some?"

"Nowhere."

What displeased this ignorant and gossiping fellow about me was my silence and my laconic manner of talking.

Next day he told me that the Tribunal had assigned me fifty sous per diem of which he would have to take charge, but that he would give me an account of his expenditure every month, and that he would spend the surplus on what I liked.

"Get me the Leyden Gazette twice a week."

"I can't do that, because it is not allowed by the authorities."

Sixty-five livres a month was more than I wanted, since I could not eat more than I did: the great heat and the want of proper nourishment had weakened me. It was in the dog-days; the strength of the sun's rays upon the lead of the roof made my cell like a stove, so that the streams of perspiration which rolled off my poor body as I sat quite naked on my sofa-chair wetted the floor to right and left of me.

I had been in this hell-on-earth for fifteen days without any secretion from the bowels. At the end of this almost incredible time nature re-asserted herself, and I thought my last hour was come. The haemorrhoidal veins were swollen to such an extent that the pressure on them gave me almost unbearable agony. To this fatal time I owe the inception of that sad infirmity of which I have never been able to completely cure myself. The recurrence of the same pains, though not so acute, remind me of the cause, and do not make my remembrance of it any the more agreeable. This disease got me compliments in Russia when I was there ten years later, and I found it in such esteem that I did not dare to complain. The same kind of thing happened to me at Constantinople, when I was complaining of a cold in the head in the presence of a Turk, who was thinking, I could see, that a dog of a Christian was not worthy of such a blessing.

The same day I sickened with a high fever and kept my bed. I said nothing to Lawrence about it, but the day after, on finding my dinner untouched, he asked me how I was.

"Very well."

"That can't be, sir, as you have eaten nothing. You are ill, and you will experience the generosity of the Tribunal who will provide you, without fee or charge, with a physician, surgeon, and all necessary medicines."

He went out, returning after three hours without guards, holding a candle in his hand, and followed by a grave-looking personage; this was the doctor. I was in the height of the fever, which had not left me for three days. He came up to me and began to ask me questions, but I told him that with my confessor and my doctor I would only speak apart. The doctor told Lawrence to leave the room, but on the refusal of that Argus to do so, he went away saying that I was dangerously ill, possibly unto death. For this I hoped, for my life as it had become was no longer my chiefest good. I was somewhat glad also to think that my pitiless persecutors might, on hearing of my condition, be forced to reflect on the cruelty of the treatment to which they had subjected me.

Four hours afterwards I heard the noise of bolts once more, and the doctor came in holding the candle himself. Lawrence remained outside. I had become so weak that I experienced a grateful restfulness. Kindly nature does not suffer a man seriously ill to feel weary. I was delighted to hear that my infamous turnkey was outside, for since his explanation of the iron collar I had looked an him with loathing.

In a quarter of an hour I had told the doctor all.

"If we want to get well," said he, "we must not be melancholy."

"Write me the prescription, and take it to the only apothecary who can make it up. M. Cavalli is the bad doctor who exhibited 'The Heart of Jesus,' and 'Tire Mystical City.'"

"Those two preparations are quite capable of having brought on the fever and the haemorrhoids. I will not forsake you"

After making me a large jug of lemonade, and telling the to drink frequently, he went away. I slept soundly, dreaming fantastic dreams.

In he morning the doctor came again with Lawrence and a surgeon, who bled me. The doctor left me some medicine which he told me to take in the evening, and a bottle of soap. "I have obtained leave," said he, "for you to move into the garret where the heat is less, and the air better than here."

"I decline the favour, as I abominate the rats, which you know nothing about, and which would certainly get into my bed."

"What a pity! I told M. Cavalli that he had almost killed you with his books, and he has commissioned me to take them back, and to give you Boethius; and here it is."

"I am much obliged to you. I like it better than Seneca, and I am sure it will do me good."

"I am leaving you a very necessary instrument, and some barley water for you to refresh yourself with."

He visited me four times, and pulled me through; my constitution did the rest, and my appetite returned. At the beginning of September I found myself, on the whole, very well, suffering from no actual ills except the heat, the vermin, and weariness, for I could not be always reading Boethius.

One day Lawrence told me that I might go out of my cell to wash myself whilst the bed was being made and the room swept. I took advantage of the favour to walk up and down for the ten minutes taken by these operations, and as I walked hard the rats were alarmed and dared not shew themselves. On the same day Lawrence gave me an account of my money, and brought himself in as my debtor to the amount of thirty livres, which however, I could not put into my pocket. I left the money in his hands, telling him to lay it out on masses on my behalf, feeling sure that he would make quite a different use of it, and he thanked me in a tone that persuaded me he would be his own priest. I gave him the money every month, and I never saw a priest's receipt. Lawrence was wise to celebrate the sacrifice at the tavern; the money was useful to someone at all events.

I lived from day to day, persuading myself every night that the next day I should be at liberty; but as I was each day deceived, I decided in my poor brain that I should be set free without fail on the 1st of October, on which

day the new Inquisitors begin their term of office. According to this theory, my imprisonment would last as long as the authority of the present Inquisitors, and thus was explained the fact that I had seen nothing of the secretary, who would otherwise have undoubtedly come to interrogate, examine, and convict me of my crimes, and finally to announce my doom. All this appeared to me unanswerable, because it seemed natural, but it was fallacious under the Leads, where nothing is done after the natural order. I imagined the Inquisitors must have discovered my innocence and the wrong they had done me, and that they only kept me in prison for form's sake, and to protect their repute from the stain of committing injustice; hence I concluded that they would give me my freedom when they laid down their tyrannical authority. My mind was so composed and quiet that I felt as if I could forgive them, and forget the wrong that they had done me. "How can they leave me here to the mercy of their successors," I thought, "to whom they cannot leave any evidence capable of condemning me?" I could not believe that my sentence had been pronounced and confirmed, without my being told of it, or of the reasons by which my judges had been actuated. I was so certain that I had right on my side, that I reasoned accordingly; but this was not the attitude I should have assumed towards a court which stands aloof from all the courts in the world for its unbounded absolutism. To prove anyone guilty, it is only necessary for the Inquisitors to proceed against him; so there is no need to speak to him, and when he is condemned it would be useless to announce to the prisoner his sentence, as his consent is not required, and they prefer to leave the poor wretch the feeling of hope; and certainly, if he were told the whole process, imprisonment would not be shortened by an hour. The wise man tells no one of his business, and the business of the Tribunal of Venice is only to judge and to doom. The guilty party is not required to have any share in the matter; he is like a nail, which to be driven into a wall needs only to be struck.

To a certain extent I was acquainted with the ways of the Colossus which was crushing me under foot, but there are things on earth which one can only truly understand by experience. If amongst my readers there are any who think such laws unjust, I forgive them, as I know they have a strong likeness to injustice; but let me tell them that they are also necessary, as a tribunal like the Venetian could not subsist without them. Those who maintain these laws in full vigour are senators, chosen from amongst the fittest for that office, and with a reputation for honour and virtue.

The last day of September I passed a sleepless night, and was on thorns to see the dawn appear, so sure was I that that day would make me free. The

reign of those villains who had made me a captive drew to a close; but the dawn appeared, Lawrence came as usual, and told me nothing new. For five or six days I hovered between rage and despair, and then I imagined that for some reasons which to me were unfathomable they had decided to keep me prisoner for the remainder of my days. This awful idea only made me laugh, for I knew that it was in my power to remain a slave for no long time, but only till I should take it into my own hands to break my prison. I knew that I should escape or die: 'Deliberata morte ferocior'.

In the beginning of November I seriously formed the plan of forcibly escaping from a place where I was forcibly kept. I began to rack my brains to find a way of carrying the idea into execution, and I conceived a hundred schemes, each one bolder than the other, but a new plan always made me give up the one I was on the point of accepting.

While I was immersed in this toilsome sea of thought, an event happened which brought home to me the sad state of mind I was in.

I was standing up in the garret looking towards the top, and my glance fell on the great beam, not shaking but turning on its right side, and then, by slow and interrupted movement in the opposite direction, turning again and replacing itself in its original position. As I lost my balance at the same time, I knew it was the shock of an earthquake. Lawrence and the guards, who just then came out of my room, said that they too, had felt the earth tremble. In such despair was I that this incident made me feel a joy which I kept to myself, saying nothing. Four or five seconds after the same movement occurred, and I could not refrain from saying,

"Another, O my God! but stronger."

The guards, terrified with what they thought the impious ravings of a desperate madman, fled in horror.

After they were gone, as I was pondering the matter over, I found that I looked upon the overthrow of the Doge's palace as one of the events which might lead to liberty; the mighty pile, as it fell, might throw me safe and sound, and consequently free, on St. Mark's Place, or at the worst it could only crush me beneath its ruins. Situated as I was, liberty reckons for all, and life for nothing, or rather for very little. Thus in the depths of my soul I began to grow mad.

This earthquake shock was the result of those which at the same time destroyed Lisbon.

CHAPTER XXVII

Various Adventures—My Companions—I Prepare to Escape—
Change of Cell

To make the reader understand how I managed to escape from a place like
the Leads, I must explain the nature of the locality.

The Leads, used for the confinement of state prisoners, are in fact the lofts
of the ducal palace, and take their name from the large plates of lead with
which the roof is covered. One can only reach them through the gates of the
palace, the prison buildings, or by the bridge of which I have spoken called
the Bridge of Sighs. It is impossible to reach the cells without passing through
the hall where the State Inquisitors hold their meetings, and their secretary
has the sole charge of the key, which he only gives to the gaoler for a short
time in the early morning whilst he is attending to the prisoners. This is done
at day-break, because otherwise the guards as they came and went would be
in the way of those who have to do with the Council of Ten, as the Council
meets every day in a hall called The Bussola, which the guards have to cross
every time they go to the Leads.

The prisons are under the roof on two sides of the palace; three to the west
(mine being among the number) and four to the east. On the west the roof
looks into the court of the palace, and on the east straight on to the canal
called Rio di Palazzo. On this side the cells are well lighted, and one can stand
up straight, which is not the case in the prison where I was, which was
distinguished by the name of 'Trave', on account of the enormous beam
which deprived me of light. The floor of my cell was directly over the ceiling
of the Inquisitors' hall, where they commonly met only at night after the
sitting of the Council of Ten of which the whole three are members.

As I knew my ground and the habits of the Inquisitors perfectly well, the
only way to escape—the only way at least which I deemed likely to
succeed—was to make a hole in the floor of my cell; but to do this tools must
be obtained—a difficult task in a place where all communication with the
outside world was forbidden, where neither letters nor visits were allowed. To
bribe a guard a good deal of money would be necessary, and I had none. And
supposing that the gaoler and his two guards allowed themselves to be
strangled—for my hands were my only weapons—there was always a third
guard on duty at the door of the passage, which he locked and would not
open till his fellow who wished to pass through gave him the password. In
spite of all these difficulties my only thought was how to escape, and as

Boethius gave me no hints on this point I read him no more, and as I was certain that the difficulty was only to be solved by stress of thinking I centered all my thoughts on this one object.

It has always been my opinion that when a man sets himself determinedly to do something, and thinks of nought but his design, he must succeed despite all difficulties in his path: such an one may make himself Pope or Grand Vizier, he may overturn an ancient line of kings—provided that he knows how to seize on his opportunity, and be a man of wit and pertinacity. To succeed one must count on being fortunate and despise all ill success, but it is a most difficult operation.

Towards the middle of November, Lawrence told me that Messer-Grande had a prisoner in his hands whom the new secretary, Businello, had ordered to be placed in the worst cell, and who consequently was going to share mine. He told me that on the secretary's reminding him that I looked upon it as a favour to be left alone, he answered that I had grown wiser in the four months of my imprisonment. I was not sorry to hear the news or that there was a new secretary. This M. Pierre Businello was a worthy man whom I knew at Paris. He afterwards went to London as ambassador of the Republic.

In the afternoon I heard the noise of the bolts, and presently Lawrence and two guards entered leading in a young man who was weeping bitterly; and after taking off his handcuffs they shut him up with me, and went out without saying a word. I was lying on my bed, and he could not see me. I was amused at his astonishment. Being, fortunately for himself, seven or eight inches shorter than I, he was able to stand upright, and he began to inspect my arm-chair, which he doubtless thought was meant for his own use. Glancing at the ledge above the grating he saw Boethius, took it up, opened it, and put it down with a kind of passion, probably because being in Latin it was of no use to him. Continuing his inspection of the cell he went to the left, and groping about was much surprised to find clothes. He approached the recess, and stretching out his hand he touched me, and immediately begged my pardon in a respectful manner. I asked him to sit down and we were friends.

"Who are you?" said I.

"I am Maggiorin, of Vicenza. My father, who was a coachman, kept me at school till I was eleven, by which time I had learnt to read and write; I was afterwards apprenticed to a barber, where I learnt my business thoroughly. After that I became valet to the Count of X——. I had been in the service of the nobleman for two years when his daughter came from the convent. It was my duty to do her hair, and by degrees I fell in love with her, and inspired her with a reciprocal passion. After having sworn a thousand times to exist only

for one another, we gave ourselves up to the task of shewing each other marks of our affection, the result of which was that the state of the young countess discovered all. An old and devoted servant was the first to find out our connection and the condition of my mistress, and she told her that she felt in duty bound to tell her father, but my sweetheart succeeded in making her promise to be silent, saying that in the course of the week she herself would tell him through her confessor. She informed me of all this, and instead of going to confession we prepared for flight. She had laid hands on a good sum of money and some diamonds which had belonged to her mother, and we were to set out for Milan to-night. But to-day the count called me after dinner, and giving me a letter, he told me to start at once and to deliver it with my own hand to the person to whom it was addressed at Venice. He spoke to me so kindly and quietly that I had not the slightest suspicion of the fate in store for me. I went to get my cloak, said good-bye to my little wife, telling her that I should soon return. Seeing deeper below the surface than I, and perchance having a presentiment of my misfortune, she was sick at heart. I came here in hot haste, and took care to deliver the fatal letter. They made me wait for an answer, and in the mean time I went to an inn; but as I came out I was arrested and put in the guard-room, where I was kept till they brought me here. I suppose, sir, I might consider the young countess as my wife?"

"You make a mistake."

"But nature—— "

"Nature, when a man listens to her and nothing else, takes him from one folly to another, till she puts him under the Leads."

"I am under the Leads, then, am I?"

"As I am."

The poor young man shed some bitter tears. He was a well-made lad, open, honest, and amorous beyond words. I secretly pardoned the countess, and condemned the count for exposing his daughter to such temptation. A shepherd who shuts up the wolf in the fold should not complain if his flock be devoured. In all his tears and lamentations he thought not of himself but always of his sweetheart. He thought that the gaoler would return and bring him some food and a bed; but I undeceived him, and offered him a share of what I had. His heart, however, was too full for him to eat. In the evening I gave him my mattress, on which he passed the night, for though he looked neat and clean enough I did not care to have him to sleep with me, dreading the results of a lover's dreams. He neither understood how wrongly he had acted, nor how the count was constrained to punish him publicly as a cloak

to the honour of his daughter and his house. The next day he was given a mattress and a dinner to the value of fifteen sous, which the Tribunal had assigned to him, either as a favour or a charity, for the word justice would not be appropriate in speaking of this terrible body. I told the gaoler that my dinner would suffice for the two of us, and that he could employ the young man's allowance in saying masses in his usual manner. He agreed willingly, and having told him that he was lucky to be in my company, he said that we could walk in the garret for half an hour. I found this walk an excellent thing for my health and my plan of escape, which, however, I could not carry out for eleven months afterwards. At the end of this resort of rats, I saw a number of old pieces of furniture thrown on the ground to the right and left of two great chests, and in front of a large pile of papers sewn up into separate volumes. I helped myself to a dozen of them for the sake of the reading, and I found them to be accounts of trials, and very diverting; for I was allowed to read these papers, which had once contained such secrets. I found some curious replies to the judges' questions respecting the seduction of maidens, gallantries carried a little too far by persons employed in girls' schools, facts relating to confessors who had abused their penitents, schoolmasters convicted of pederasty with their pupils, and guardians who had seduced their wards. Some of the papers dating two or three centuries back, in which the style and the manners illustrated gave me considerable entertainment. Among the pieces of furniture on the floor I saw a warming-pan, a kettle, a fire-shovel, a pair of tongs, some old candle-sticks, some earthenware pots, and even a syringe. From this I concluded that some prisoner of distinction had been allowed to make use of these articles. But what interested me most was a straight iron bar as thick as my thumb, and about a foot and a half long. However, I left everything as it was, as my plans had not been sufficiently ripened by time for me to appropriate any object in particular.

One day towards the end of the month my companion was taken away, and Lawrence told me that he had been condemned to the prisons known as The Fours, which are within the same walls as the ordinary prisons, but belong to the State Inquisitors. Those confined in them have the privilege of being able to call the gaoler when they like. The prisons are gloomy, but there is an oil lamp in the midst which gives the necessary light, and there is no fear of fire as everything is made of marble. I heard, a long time after, that the unfortunate Maggiorin was there for five years, and was afterwards sent to Cerigo for ten. I do not know whether he ever came from there. He had kept me good company, and this I discovered as soon as he was gone, for in a few days I became as melancholy as before. Fortunately, I was still allowed my

walk in the garret, and I began to examine its contents with more minuteness. One of the chests was full of fine paper, pieces of cardboard, uncut pens, and clews of pack thread; the other was fastened down. A piece of polished black marble, an inch thick, six inches long, and three broad, attracted my attention, and I possessed myself of it without knowing what I was going to do with it, and I secreted it in my cell, covering it up with my shirts.

A week after Maggiorin had gone, Lawrence told me that in all probability I should soon get another companion. This fellow Lawrence, who at bottom was a mere gabbling fool, began to get uneasy at my never asking him any questions. This fondness for gossip was not altogether appropriate to his office, but where is one to find beings absolutely vile? There are such persons, but happily they are few and far between, and are not to be sought for in the lower orders. Thus my gaoler found himself unable to hold his tongue, and thought that the reason I asked no questions must be that I thought him incapable of answering them; and feeling hurt at this, and wishing to prove to me that I made a mistake, he began to gossip without being solicited.

"I believe you will often have visitors," said he, "as the other six cells have each two prisoners, who are not likely to be sent to the Fours." I made him no reply, but he went on, in a few seconds, "They send to the Fours all sorts of people after they have been sentenced, though they know nothing of that. The prisoners whom I have charge of under the Leads are like yourself, persons of note, and are only guilty of deeds of which the inquisitive must know nothing. If you knew, sir, what sort of people shared your fate, you would be astonished, It's true that you are called a man of parts; but you will pardon me.... You know that all men of parts are treated well here. You take me, I see. Fifty sous a day, that's something. They give three livres to a citizen, four to a gentleman, and eight to a foreign count. I ought to know, I think, as everything goes through my hands."

He then commenced to sing his own praises, which consisted of negative clauses.

"I'm no thief, nor traitor, nor greedy, nor malicious, nor brutal, as all my predecessors were, and when I have drunk a pint over and above I am all the better for it. If my father had sent me to school I should have learnt to read and write, and I might be Messer-Grande to-day, but that's not my fault. M. Andre Diedo has a high opinion of me. My wife, who cooks for you every day, and is only twenty-four, goes to see him when she will, and he will have her come in without ceremony, even if he be in bed, and that's more than he'll do for a senator. I promise you you will be always having the new-comers in your cell, but never for any length of time, for as soon as the secretary has got what

he wants to know from them, he sends them to their place—to the Fours, to some fort, or to the Levant; and if they be foreigners they are sent across the frontier, for our Government does not hold itself master of the subjects of other princes, if they be not in its service. The clemency of the Court is beyond compare; there's not another in the world that treats its prisoners so well. They say it's cruel to disallow writing and visitors; but that's foolish, for what are writing and company but waste of time? You will tell me that you have nothing to do, but we can't say as much."

Such was, almost word for word, the first harangue with which the fellow honoured me, and I must say I found it amusing. I saw that if the man had been less of a fool he would most certainly have been more of a scoundrel.

The next day brought me a new messmate, who was treated as Maggiorin had been, and I thus found it necessary to buy another ivory spoon, for as the newcomers were given nothing on the first day of their imprisonment I had to do all the honours of the cell.

My new mate made me a low bow, for my beard, now four inches long, was still more imposing than my figure. Lawrence often lent me scissors to cut my nails, but he was forbidden, under pain of very heavy punishment, to let me touch my beard. I knew not the reason of this order, but I ended by becoming used to my beard as one gets used to everything.

The new-comer was a man of about fifty, approaching my size, a little bent, thin, with a large mouth, and very bad teeth. He had small grey eyes hidden under thick eyebrows of a red colour, which made him look like an owl; and this picture was set off by a small black wig, which exhaled a disagreeable odour of oil, and by a dress of coarse grey cloth. He accepted my offer of dinner, but was reserved, and said not a word the whole day, and I was also silent, thinking he would soon recover the use of his tongue, as he did the next day.

Early in the morning he was given a bed and a bag full of linen. The gaoler asked him, as he had asked me, what he would have for dinner, and for money to pay for it.

"I have no money."

"What! a moneyed man like you have no money?"

"I haven't a sou."

"Very good; in that case I will get you some army biscuit and water, according to instructions."

He went out, and returned directly afterwards with a pound and a half of biscuit, and a pitcher, which he set before the prisoner, and then went away.

Left alone with this phantom I heard a sigh, and my pity made me break the silence.

"Don't sigh, sir, you shall share my dinner. But I think you have made a great mistake in coming here without money."

"I have some, but it does not do to let those harpies know of it:"

"And so you condemn yourself to bread and water. Truly a wise proceeding! Do you know the reason of your imprisonment?"

"Yes, sir, and I will endeavour in a few words to inform you of it."

"My name is Squaldo Nobili. My father was a countryman who had me taught reading and writing, and at his death left me his cottage and the small patch of ground belonging to it. I lived in Friuli, about a day's journey from the Marshes of Udine. As a torrent called Corno often damaged my little property, I determined to sell it and to set up in Venice, which I did ten years ago. I brought with me eight thousand livres in fair sequins, and knowing that in this happy commonwealth all men enjoyed the blessings of liberty, I believed that by utilizing my capital I might make a little income, and I began to lend money, on security. Relying on my thrift, my judgment, and my, knowledge of the world, I chose this business in preference to all others. I rented a small house in the neighbourhood of the Royal Canal, and having furnished it I lived there in comfort by myself; and in the course of two years I found I had made a profit of ten thousand livres, though I had expended two thousand on household expenses as I wished to live in comfort. In this fashion I saw myself in a fair way of making a respectable fortune in time; but one, day, having lent a Jew two sequins upon some books, I found one amongst them called 'La Sagesse,' by Charron. It was then I found out how good a thing it is to be able to read, for this book, which you, sir, may not have read, contains all that a man need know—purging him of all the prejudices of his childhood. With Charron good-bye to hell and all the empty terrors of a future life; one's eyes are opened, one knows the way to bliss, one becomes wise indeed. Do you, sir, get this book, and pay no heed to those foolish persons who would tell you this treasure is not to be approached."

This curious discourse made me know my man. As to Charron, I had read the book though I did not know it had been translated into Italian. The author who was a great admirer of Montaigne thought to surpass his model, but toiled in vain. He is not much read despite the prohibition to read his works, which should have given them some popularity. He had the impudence to give his book the title of one of Solomon's treatises—a circumstance which does not say much for his modesty. My companion went on as follows:

"Set free by Charron from any scruples I still might have, and from those false ideas so hard to rid one's self of, I pushed my business in such sort, that at the end of six years I could lay my hand on ten thousand sequins. There is no need for you to be astonished at that, as in this wealthy city gambling, debauchery, and idleness set all the world awry and in continual need of money; so do the wise gather what the fool drops.

"Three years ago a certain Count Seriman came and asked me to take from him five hundred sequins, to put them in my business, and to give him half profits. All he asked for was an obligation in which I promised to return him the whole sum on demand. At the end of a year I sent him seventy-five sequins, which made fifteen per cent. on his money; he gave me a receipt for it, but was ill pleased. He was wrong, for I was in no need of money, and had not used his for business purposes. At the end of the second year, out of pure generosity, I sent him the same amount; but we came to a quarrel and he demanded the return of the five hundred sequins. 'Certainly,' I said, 'but I must deduct the hundred and fifty you have already received.' Enraged at this he served me with a writ for the payment of the whole sum. A clever lawyer undertook my defence and was able to gain me two years. Three months ago I was spoken to as to an agreement, and I refused to hear of it, but fearing violence I went to the Abbe Justiniani, the Spanish ambassador's secretary, and for a small sum he let me a house in the precincts of the Embassy, where one is safe from surprises. I was quite willing to let Count Seriman have his money, but I claimed a reduction of a hundred sequins on account of the costs of the lawsuit. A week ago the lawyers on both sides came to me. I shewed them a purse of two hundred and fifty sequins, and told them they might take it, but not a penny more. They went away without saying a word, both wearing an ill-pleased air, of which I took no notice. Three days ago the Abbe Justiniani told me that the ambassador had thought fit to give permission to the State Inquisitors to send their men at once to my house to make search therein. I thought the thing impossible under the shelter of a foreign ambassador, and instead of taking the usual precautions, I waited the approach of the men-at-arms, only putting my money in a place of safety. At daybreak Messer-Grande came to the house, and asked me for three hundred and fifty sequins, and on my telling him that I hadn't a farthing he seized me, and here I am."

I shuddered, less at having such an infamous companion than at his evidently considering me as his equal, for if he had thought of me in any other light he would certainly not have told me this long tale, doubtless in the belief that I should take his part. In all the folly about Charron with which he

tormented me in the three days we were together, I found by bitter experience the truth of the Italian proverb: 'Guardati da colui che non ha letto che un libro solo'. By reading the work of the misguided priest he had become an Atheist, and of this he made his boast all the day long. In the afternoon Lawrence came to tell him to come and speak with the secretary. He dressed himself hastily, and instead of his own shoes he took mine without my seeing him. He came back in half an hour in tears, and took out of his shoes two purses containing three hundred and fifty sequins, and, the gaoler going before, he went to take them to the secretary. A few moments afterwards he returned, and taking his cloak went away. Lawrence told me that he had been set at liberty. I thought, and with good reason, that, to make him acknowledge his debt and pay it, the secretary had threatened him with the torture; and if it were only used in similar cases, I, who detest the principle of torture, would be the first to proclaim its utility.

On New Year's Day, 1733, I received my presents. Lawrence brought me a dressing-gown lined with foxskin, a coverlet of wadded silk, and a bear-skin bag for me to put my legs in, which I welcomed gladly, for the coldness was unbearable as the heat in August. Lawrence told me that I might spend to the amount of six sequins a month, that I might have what books I liked, and take in the newspaper, and that this present came from M. de Bragadin. I asked him for a pencil, and I wrote upon a scrap of paper: "I am grateful for the kindness of the Tribunal and the goodness of M. de Bragadin."

The man who would know what were my feelings at all this must have been in a similar situation to my own. In the first gush of feeling I forgave my oppressors, and was on the point of giving up the idea of escape; so easily shall you move a man that you have brought low and overwhelmed with misfortune. Lawrence told me that M. de Bragadin had come before the three Inquisitors, and that on his knees, and with tears in his eyes, he had entreated them to let him give me this mark of his affection if I were still in the land of the living; the Inquisitors were moved, and were not able to refuse his request.

I wrote down without delay the names of the books I wanted.

One fine morning, as I was walking in the garret, my eyes fell on the iron bar I have mentioned, and I saw that it might very easily be made into a defensive or offensive weapon. I took possession of it, and having hidden it under my dressing-gown I conveyed it into my cell. As soon as I was alone, I took the piece of black marble, and I found that I had to my hand an excellent whetstone; for by rubbing the bar with the stone I obtained a very good edge.

My interest roused in this work in which I was but an apprentice, and in the fashion in which I seemed likely to become possessed of an instrument totally prohibited under the Leads, impelled, perhaps, also by my vanity to make a weapon without any of the necessary tools, and incited by my very difficulties (for I worked away till dark without anything to hold my whetstone except my left hand, and without a drop of oil to soften the iron), I made up my mind to persevere in my difficult task. My saliva served me in the stead of oil, and I toiled eight days to produce eight edges terminating in a sharp point, the edges being an inch and a half in length. My bar thus sharpened formed an eight-sided dagger, and would have done justice to a first-rate cutler. No one can imagine the toil and trouble I had to bear, nor the patience required to finish this difficult task without any other tools than a loose piece of stone. I put myself, in fact, to a kind of torture unknown to the tyrants of all ages. My right arm had become so stiff that I could hardly move it; the palm of my hand was covered with a large scar, the result of the numerous blisters caused by the hardness and the length of the work. No one would guess the sufferings I underwent to bring my work to completion.

Proud of what I had done, without thinking what use I could make of my weapon, my first care was to hide it in such a manner as would defy a minute search. After thinking over a thousand plans, to all of which there was some objection, I cast my eyes on my arm-chair, and there I contrived to hide it so as to be secure from all suspicion. Thus did Providence aid me to contrive a wonderful and almost inconceivable plan of escape. I confess to a feeling of vanity, not because I eventually succeeded—for I owed something to good luck—but because I was brave enough to undertake such a scheme in spite of the difficulties which might have ruined my plans and prevented my ever attaining liberty.

After thinking for three or four days as to what I should do with the bar I had made into an edged tool, as thick as a walking-stick and twenty inches long, I determined that the best plan would be to make a hole in the floor under my bed.

I was sure that the room below my cell was no other than the one in which I had seen M. Cavalli. I knew that this room was opened every morning, and I felt persuaded that, after I had made my hole, I could easily let myself down with my sheets, which I would make into a rope and fasten to my bed. Once there, I would hide under the table of the court, and in the morning, when the door was opened, I could escape and get to a place of safety before anyone could follow me. I thought it possible that a sentry might be placed in the hall, but my short pike ought to soon rid me of him. The floor might be of double

or even of triple thickness, and this thought puzzled me; for in that case how was I to prevent the guard sweeping out the room throughout the two months my work might last. If I forbade them to do so, I might rouse suspicion; all the more as, to free myself of the fleas, I had requested them to sweep out the cell every day, and in sweeping they would soon discover what I was about. I must find some way out of this difficulty.

I began by forbidding them to sweep, without giving any reason. A week after, Lawrence asked me why I did so. I told him because of the dust which might make me cough violently and give me some fatal injury.

"I will make them water the floor," said he.

"That would be worse, Lawrence, for the damp might cause a plethora."

In this manner I obtained a week's respite, but at the end of that time the lout gave orders that my cell should be swept. He had the bed carried out into the garret, and on pretence of having the sweeping done with greater care, he lighted a candle. This let me know that the rascal was suspicious of something; but I was crafty enough to take no notice of him, and so far from giving up my plea, I only thought how I could put it on good train. Next morning I pricked my finger and covered my handkerchief with the blood, and then awaited Lawrence in bed. As soon as he came I told him that I had coughed so violently as to break a blood-vessel, which had made me bring up all the blood he saw. "Get me a doctor." The doctor came, ordered me to be bled, and wrote me a prescription. I told him it was Lawrence's fault, as he had persisted in having the room swept. The doctor blamed him for doing so, and just as if I had asked him he told us of a young man who had died from the same cause, and said that there was nothing more dangerous than breathing in dust. Lawrence called all the gods to witness that he had only had the room swept for my sake, and promised it should not happen again. I laughed to myself, for the doctor could not have played his part better if I had given him the word. The guards who were there were delighted, and said they would take care only to sweep the cells of those prisoners who had angered them.

When the doctor was gone, Lawrence begged my pardon, and assured me that all the other prisoners were in good health although their cells were swept out regularly.

"But what the doctor says is worth considering," said he, "and I shall tell them all about it, for I look upon them as my children."

The blood-letting did me good, as it made me sleep, and relieved me of the spasms with which I was sometimes troubled. I had regained my appetite and was getting back my strength every day, but the time to set about my work was

not yet come; it was still too cold, and I could not hold the bar for any length of time without my hand becoming stiff. My scheme required much thought. I had to exercise boldness and foresight to rid myself of troubles which chance might bring to pass or which I could foresee. The situation of a man who had to act as I had, is an unhappy one, but in risking all for all half its bitterness vanishes.

The long nights of winter distressed me, for I had to pass nineteen mortal hours in darkness; and on the cloudy days, which are common enough at Venice, the light I had was not sufficient for me to be able to read. Without any distractions I fell back on the idea of my escape, and a man who always thinks on one subject is in danger of becoming a monomaniac. A wretched kitchen-lamp would have made me happy, but how am I to get such a thing? O blessed prerogative of thought! how happy was I when I thought I had found a way to possess myself of such a treasure! To make such a lamp I required a vase, wicks, oil, a flint and steel, tinder, and matches. A porringer would do for the vase, and I had one which was used for cooking eggs in butter. Pretending that the common oil did not agree with me, I got them to buy me Lucca oil for my salad, and my cotton counterpane would furnish me with wicks. I then said I had the toothache, and asked Lawrence to get me a pumice-stone, but as he did not know what I meant I told him that a musket-flint would do as well if it were soaked in vinegar for a day, and, then being applied to the tooth the pain would be eased. Lawrence told me that the vinegar I had was excellent, and that I could soak the stone myself, and he gave me three or four flints he had in his pocket. All I had to do was to get some sulphur and tinder, and the procuring of these two articles set all my wits to work. At last fortune came to my assistance.

I had suffered from a kind of rash, which as it came off had left some red spots on my arms, and occasionally caused me some irritation. I told Lawrence to ask the doctor for a cure, and the next day he brought me a piece of paper which the secretary had seen, and on which the doctor had written, "Regulate the food for a day, and the skin will be cured by four ounces of oil of sweet almonds or an ointment of flour of sulphur, but this local application is hazardous."

"Never mind the danger," said I to Lawrence; "buy me the ointment, or rather get me the sulphur, as I have some butter by me, and I can make it up myself. Have you any matches? Give me a few."

He found some in his pockets, and he gave me them.

What a small thing brings comfort in distress! But in my place these matches were no small thing, but rather a great treasure.

I had puzzled my head for several hours as to what substitute I could find for tinder—the only thing I still lacked, and which I could not ask for under any pretense whatsoever—when I remembered that I had told the tailor to put some under the armpits of my coat to prevent the perspiration spoiling the stuff. The coat, quite new, was before me, and my heart began to beat, but supposing the tailor had not put it in! Thus I hung between hope and fear. I had only to take a step to know all; but such a step would have been decisive, and I dared not take it. At last I drew nigh, and feeling myself unworthy of such mercies I fell on my knees and fervently prayed of God that the tailor might not have forgotten the tinder. After this heartfelt prayer I took my coat, unsewed it, and found the tinder! My joy knew no bounds. I naturally gave thanks to God, since it was with confidence in Him that I took courage and searched my coat, and I returned thanks to Him with all my heart.

I now had all the necessary materials, and I soon made myself a lamp. Let the reader imagine my joy at having in a manner made light in the midst of darkness, and it was no less sweet because against the orders of my infamous oppressors. Now there was no more night for me, and also no more salad, for though I was very fond of it the need of keeping the oil to give light caused me to make this sacrifice without it costing me many pangs. I fixed upon the first Monday in Lent to begin the difficult work of breaking through the floor, for I suspected that in the tumult of the carnival I might have some visitors, and I was in the right.

At noon, on Quinquagesima Sunday, I heard the noise of the bolts, and presently Lawrence entered, followed by a thick-set man whom I recognized as the Jew, Gabriel Schalon, known for lending money to young men.

We knew each other, so exchanged compliments. His company was by no means agreeable to me, but my opinion was not asked. He began by congratulating me on having the pleasure of his society; and by way of answer I offered him to share my dinner, but he refused, saying he would only take a little soup, and would keep his appetite for a better supper at his own house.

"When?"

"This evening. You heard when I asked for my bed he told me that we would talk about that to-morrow. That means plainly that I shall have no need of it. And do you think it likely that a man like me would be left without anything to eat?"

"That was my experience."

"Possibly, but between ourselves our cases are somewhat different; and without going any farther into that question, the Inquisitors have made a

mistake in arresting me, and they will be in some trouble, I am certain, as to how to atone for doing so."

"They will possibly give you a pension. A man of your importance has to be conciliated."

"True, there's not a broker on the exchange more useful than myself, and the five sages have often profited by the advice I have given them. My detention is a curious incident, which, perchance, will be of service to you."

"Indeed. How, may I ask?"

"I will get you out of here in a month's time. I know to whom to speak and what way to do it:"

"I reckon on you, then."

"You may do so."

This knave and fool together believed himself to be somebody. He volunteered to inform me as to what was being said of me in the town, but as he only related the idle tales of men as ignorant as himself, he wearied me, and to escape listening to him I took up a book. The fellow had the impudence to ask me not to read, as he was very fond of talking, but henceforth he talked only to himself. I did not dare to light my lamp before this creature, and as night drew on he decided on accepting some bread and Cyprus wine, and he was afterwards obliged to do as best he could with my mattress, which was now the common bed of all new-comers.

In the morning he had a bed and some food from his own house. I was burdened with this wretched fellow for two months, for before condemning him to the Fours the secretary had several interviews with him to bring to light his knaveries, and to oblige him to cancel a goodly number of illegal agreements. He confessed to me himself that he had bought of M. Domenico Micheli the right to moneys which could not belong to the buyer till after the father of the seller was dead. "It's true," said he, "that he agreed to give me fifty per cent., but you must consider that if he died before his father I should lose all." At last, seeing that my cursed fellow did not go, I determined to light my lamp again after having made him promise to observe secrecy. He only kept his promise while he was with me, as Lawrence knew all about it, but luckily he attached no importance to the fact.

This unwelcome guest was a true burden to me, as he not only prevented me from working for my escape but also from reading. He was troublesome, ignorant, superstitious, a braggart, cowardly, and sometimes like a madman. He would have had me cry, since fear made him weep, and he said over and over again that this imprisonment would ruin his reputation. On this count I reassured him with a sarcasm he did not understand. I told him that his

reputation was too well known to suffer anything from this little misfortune, and he took that for a compliment. He would not confess to being a miser, but I made him admit that if the Inquisitors would give him a hundred sequins for every day of his imprisonment he would gladly pass the rest of his life under the Leads.

He was a Talmudist, like all modern Jews, and he tried to make me believe that he was very devout; but I once extracted a smile of approbation from him by telling him that he would forswear Moses if the Pope would make him a cardinal. As the son of a rabbi he was learned in all the ceremonies of his religion, but like most men he considered the essence of a religion to lie in its discipline and outward forms.

This Jew, who was extremely fat, passed three-quarters of his life in bed; and though he often dozed in the daytime, he was annoyed at not being able to sleep at night—all the more as he saw that I slept excellently. He once took it into his head to wake me up as I was enjoying my sleep.

"What do you want?" said I; "waking me up with a start like this."

"My dear fellow, I can't sleep a wink. Have compassion on me and let us have a little talk."

"You scoundrel! You act thus and you dare to call yourself my friend! I know your lack of sleep torments you, but if you again deprive me of the only blessing I enjoy I will arise and strangle you."

I uttered these words in a kind of transport.

"Forgive me, for mercy's sake! and be sure that I will not trouble you again."

It is possible that I should not have strangled him, but I was very much tempted to do so. A prisoner who is happy enough to sleep soundly, all the while he sleeps is no longer a captive, and feels no more the weight of his chains. He ought to look upon the wretch who awakens him as a guard who deprives him of his liberty, and makes him feel his misery once more, since, awakening, he feels all his former woes. Furthermore, the sleeping prisoner often dreams that he is free again, in like manner as the wretch dying of hunger sees himself in dreams seated at a sumptuous feast.

I congratulated myself on not having commenced my great work before he came, especially as he required that the room should be swept out. The first time he asked for it to be dote, the guards made me laugh by saying that it would kill me. However, he insisted; and I had my revenge by pretending to be ill, but from interested motives I made no further opposition.

On the Wednesday in Holy Week Lawrence told us that the secretary would make us the customary visit in the afternoon, the object being to give

peace to them that would receive the sacrament at Easter, and also to know if they had anything to say against the gaoler. "So, gentlemen," said Lawrence, "if you have any complaints to make of me make them. Dress yourselves fully, as is customary." I told Lawrence to get me a confessor for the day.

I put myself into full dress, and the Jew followed my example, taking leave of me in advance, so sure was he that the secretary would set him free on hearing what he had to say. "My presentiment," said he, "is of the same kind as I have had before, and I have never been deceived."

"I congratulate you, but don't reckon without your host." He did not understand what I meant.

In course of time the secretary came, and as soon as the cell-door was opened the Jew ran out and threw himself at his feet on both knees, I heard for five minutes nothing but his tears and complaints, for the secretary said not one word. He came back, and Lawrence told me to go out. With a beard of eight months' growth, and a dress made for love-making in August, I must have presented a somewhat curious appearance. Much to my disgust I shivered with cold, and was afraid that the secretary would think I was trembling with fear. As I was obliged to bend low to come out of my hole, my bow was ready made, and drawing myself up, I looked at him calmly without affecting any unseasonable hardihood, and waited for him to speak. The secretary also kept silence, so that we stood facing each other like a pair of statues. At the end of two minutes, the secretary, seeing that I said nothing, gave me a slight bow, and went away. I re-entered my cell, and taking off my clothes in haste, got into bed to get warm again. The Jew was astonished at my not having spoken to the secretary, although my silence had cried more loudly than his cowardly complaints. A prisoner of my kind has no business to open his mouth before his judge, except to answer questions. On Maundy Thursday a Jesuit came to confess me, and on Holy Saturday a priest of St. Mark's came to administer to me the Holy Communion. My confession appearing rather too laconic to the sweet son of Ignatius he thought good to remonstrate with me before giving me his absolution.

"Do you pray to God?" he said.

"From the morning unto the evening, and from the evening unto the morning, for, placed as I am, all that I feel—my anxiety, my grief, all the wanderings of my mind—can be but a prayer in the eyes of the Divine Wisdom which alone sees my heart."

The Jesuit smiled slightly and replied by a discourse rather metaphysical than moral, which did not at all tally with my views. I should have confuted him on every point if he had not astonished me by a prophecy he made.

"Since it is from us," said he, "that you learnt what you know of religion, practise it in our fashion, pray like us, and know that you will only come out of this place on the day of the saint whose name you bear." So saying he gave me absolution, and left me. This man left the strongest possible impression on my mind. I did my best, but I could not rid myself of it. I proceeded to pass in review all the saints in the calendar.

The Jesuit was the director of M. Flaminio Corner, an old senator, and then a State Inquisitor. This statesman was a famous man of letters, a great politician, highly religious, and author of several pious and ascetic works written in Latin. His reputation was spotless.

On being informed that I should be set free on the feast-day of my patron saint, and thinking that my informant ought to know for certain what he told me, I felt glad to have a patron-saint. "But which is it?" I asked myself. "It cannot be St. James of Compostella, whose name I bear, for it was on the feast-day of that saint that Messer-Grande burst open my door." I took the almanac and looking for the saints' days nearest at hand I found St. George—a saint of some note, but of whom I had never thought. I then devoted myself to St. Mark, whose feast fell on the twenty-fifth of the month, and whose protection as a Venetian I might justly claim. To him, then, I addressed my vows, but all in vain, for his feast came round and still I was in prison. Then I took myself to St. James, the brother of Christ, who comes before St. Philip, but again in the wrong. I tried St. Anthony, who, if the tale told at Padua be true, worked thirteen miracles a day. He worked none for me. Thus I passed from one to the other, and by degrees I got to hope in the protection of the saints just as one hopes for anything one desires, but does not expect to come to pass; and I finished up by hoping only in my Saint Bar, and in the strength of my arms. Nevertheless the promise of the Jesuit came to pass, since I escaped from The Leads on All Hallows Day; and it is certain that if I had a patron-saint, he must be looked for in their number since they are all honoured on that day.

A fortnight after Easter I was delivered from my troublesome Israelite, and the poor devil instead of being sent back to his home had to spend two years in The Fours, and on his gaining his freedom he went and set up in Trieste, where he ended his days.

No sooner was I again alone than I set zealously about my work. I had to make haste for fear of some new visitor, who, like the Jew, might insist on the cell being swept. I began by drawing back my bed, and after lighting my lamp I lay down on my belly, my pike in my hand, with a napkin close by in which to gather the fragments of board as I scooped them out. My task was to

destroy the board by dint of driving into it the point of my tool. At first the pieces I got away were not much larger than grains of wheat, but they soon increased in size.

The board was made of deal, and was sixteen inches broad. I began to pierce it at its juncture with another board, and as there were no nails or clamps my work was simple. After six hours' toil I tied up the napkin, and put it on one side to empty it the following day behind the pile of papers in the garret. The fragments were four or five times larger in bulk than the hole from whence they came. I put back my bed in its place, and on emptying the napkin the next morning I took care so to dispose the fragments that they should not be seen.

Having broken through the first board, which I found to be two inches thick, I was stopped by a second which I judged to be as thick as the first. Tormented by the fear of new visitors I redoubled my efforts, and in three weeks I had pierced the three boards of which the floor was composed; and then I thought that all was lost, for I found I had to pierce a bed of small pieces of marble known at Venice as terrazzo marmorin. This forms the usual floor of venetian houses of all kinds, except the cottages, for even the high nobility prefer the terrazzo to the finest boarded floor. I was thunderstruck to find that my bar made no impression on this composition; but, nevertheless, I was not altogether discouraged and cast down. I remembered Hannibal, who, according to Livy, opened up a passage through the Alps by breaking the rocks with axes and other instruments, having previously softened them with vinegar. I thought that Hannibal had succeeded not by aceto, but aceta, which in the Latin of Padua might well be the same as ascia; and who can guarantee the text to be free from the blunders of the copyist? All the same, I poured into the hole a bottle of strong vinegar I had by me, and in the morning, either because of the vinegar or because I, refreshed and rested, put more strength and patience into the work, I saw that I should overcome this new difficulty; for I had not to break the pieces of marble, but only to pulverize with the end of my bar the cement which kept them together. I soon perceived that the greatest difficulty was on the surface, and in four days the whole mosaic was destroyed without the point of my pike being at all damaged.

Below the pavement I found another plank, but I had expected as much. I concluded that this would be the last; that is the first to be put down when the rooms below were being ceiled. I pierced it with some difficulty, as, the hole being ten inches deep, it had become troublesome to work the pike. A thousand times I commended myself to the mercy of God. Those

Free-thinkers who say that praying is no good do not know what they are talking about; for I know by experience that, having prayed to God, I always felt myself grow stronger, which fact amply proves the usefulness of prayer, whether the renewal of strength come straight from God, or whether it comes only from the trust one has in Him.

On the 25th of June, on which day the Republic celebrates the wonderful appearance of St. Mark under the form of a winged lion in the ducal church, about three o'clock in the afternoon, as I was labouring on my belly at the hole, stark naked, covered with sweat, my lamp beside me. I heard with mortal fear the shriek of a bolt and the noise of the door of the first passage. It was a fearful moment! I blew out my lamp, and leaving my bar in the hole I threw into it the napkin with the shavings it contained, and as swift as lightning I replaced my bed as best I could, and threw myself on it just as the door of my cell opened. If Lawrence had come in two seconds sooner he would have caught me. He was about to walk over me, but crying out dolefully I stopped him, and he fell back, saying,

"Truly, sir, I pity you, for the air here is as hot as a furnace. Get up, and thank God for giving you such good company."

"Come in, my lord, come in," said he to the poor wretch who followed him. Then, without heeding my nakedness, the fellow made the noble gentleman enter, and he seeing me to be naked, sought to avoid me while I vainly tried to find my shirt.

The new-comer thought he was in hell, and cried out,

"Where am I? My God! where have I been put? What heat! What a stench! With whom am I?"

Lawrence made him go out, and asked me to put on my shirt to go into the garret for a moment. Addressing himself to the new prisoner, he said that, having to get a bed and other necessaries, he would leave us in the garret till he came back, and that, in the mean time, the cell would be freed from the bad smell, which was only oil. What a start it gave me as I heard him utter the word "oil." In my hurry I had forgotten to snuff the wick after blowing it out. As Lawrence asked me no questions about it, I concluded that he knew all, and the accursed Jew must have betrayed me. I thought myself lucky that he was not able to tell him any more.

From that time the repulsion which I had felt for Lawrence disappeared.

After putting on my shirt and dressing-gown, I went out and found my new companion engaged in writing a list of what he wanted the gaoler to get him. As soon as he saw me, he exclaimed, "Ah! it's Casanova." I, too, recognised him as the Abbe and Count Fenarolo, a man of fifty, amiable, rich, and a

favourite in society. He embraced me, and when I told him that I should have expected to see anybody in that place rather than him, he could not keep back his tears, which made me weep also.

When we were alone I told him that, as soon as his bed came, I should offer him the recess, begging him at the same time not to accept it. I asked him, also, not to ask to have the cell swept, saying that I would tell him the reason another time. He promised to keep all secrecy in the matter, and said he thought himself fortunate to be placed with me. He said that as no one knew why I was imprisoned, everyone was guessing at it. Some said that I was the heresiarch of a new sect; others that Madame Memmo had persuaded the Inquisitors that I had made her sons Atheists, and others that Antony Condulmer, the State Inquisitor, had me imprisoned as a disturber of the peace, because I hissed Abbe Chiari's plays, and had formed a design to go to Padua for the express purpose of killing him.

All these accusations had a certain foundation in fact which gave them an air of truth, but in reality they were all wholly false. I cared too little for religion to trouble myself to found a new one. The sons of Madame Memmo were full of wit, and more likely to seduce than to be seduced; and Master Condulmer would have had too much on his hands if he had imprisoned all those who hissed the Abbe Chiari; and as for this abbe, once a Jesuit, I had forgiven him, as the famous Father Origo, himself formerly a Jesuit, had taught me to take my revenge by praising him everywhere, which incited the malicious to vent their satire on the abbe; and thus I was avenged without any trouble to myself.

In the evening they brought a good bed, fine linen, perfumes, an excellent supper, and choice wines. The abbe ate nothing, but I supped for two. When Lawrence had wished us good night and had shut us up till the next day, I got out my lamp, which I found to be empty, the napkin having sucked up all the oil. This made me laugh, for as the napkin might very well have caught and set the room on fire, the idea of the confusion which would have ensued excited my hilarity. I imparted the cause of my mirth to my companion, who laughed himself, and then, lighting the lamp, we spent the night in pleasant talk. The history of his imprisonment was as follows:

"Yesterday, at three o'clock in the afternoon, Madame Alessandria, Count Martinengo, and myself, got into a gondola. We went to Padua to see the opera, intending to return to Venice afterwards. In the second act my evil genius led me to the gaming-table, where I unfortunately saw Count Rosenberg, the Austrian ambassador, without his mask, and about ten paces from him was Madame Ruzzini, whose husband is going to Vienna to

represent the Republic. I greeted them both, and was just going away, when the ambassador called out to me, so as to be heard by everyone, 'You are very fortunate in being able to pay your court to so sweet a lady. At present the personage I represent makes the fairest land in the world no better for me than a galley. Tell the lady, I beseech you, that the laws which now prevent me speaking to her will be without force at Venice, where I shall go next year, and then I shall declare war against her.' Madame Ruzzini, who saw that she was being spoken of, asked me what the count had said, and I told her, word for word. 'Tell him,' said she, 'that I accept his declaration of war, and that we shall see who will wage it best.' I did not think I had committed a crime in reporting her reply, which was after all a mere compliment. After the opera we set out, and got here at midnight. I was going to sleep when a messenger brought me a note ordering me to go to the Bussola at one o'clock, Signor Bussinello, Secretary of the Council of Ten, having something to say to me. Astonished at such an order—always of bad omen, and vexed at being obliged to obey, I went at the time appointed, and my lord secretary, without giving me a word, ordered me to be taken here."

Certainly no fault could be less criminal than that which Count Fenarolo had committed, but one can break certain laws in all innocence without being any the less punishable. I congratulated him on knowing what his crime had been, and told him that he would be set free in a week, and would be requested to spend six months in the Bressian. "I can't think," said he, "that they will leave me here for a week." I determined to keep him good company, and to soften the bitterness of his imprisonment, and so well did I sympathize with his position that I forgot all about my own.

The next morning at day-break, Lawrence brought coffee and a basket filled with all the requisites for a good dinner. The abbe was astonished, for he could not conceive how anyone could eat at such an early hour. They let us walk for an hour in the garret and then shut us up again, and we saw no more of them throughout the day. The fleas which tormented us made the abbe ask why I did not have the cell swept out. I could not let him think that dirt and untidiness was agreeable to me, or that my skin was any harder than his own, so I told him the whole story, and shewed him what I had done. He was vexed at having as it were forced me to make him my confidant, but he encouraged me to go on, and if possible to finish what I was about that day, as he said he would help me to descend and then would draw up the rope, not wishing to complicate his own difficulties by an escape. I shewed him the model of a contrivance by means of which I could certainly get possession of the sheets which were to be my rope; it was a short stick attached by one end

to a long piece of thread. By this stick I intended to attach my rope to the bed, and as the thread hung down to the floor of the room below, as soon as I got there I should pull the thread and the rope would fall down. He tried it, and congratulated me on my invention, as this was a necessary part of my scheme, as otherwise the rope hanging down would have immediately discovered me. My noble companion was convinced that I ought to stop my work, for I might be surprised, having to do several days' work before finishing the hole which would cost Lawrence his life. Should the thought of gaining my liberty at the expense of a fellow-creature have made me desist? I should have still persisted if my escape had meant death to the whole body of Venetian guards, and even to the Inquisitors themselves. Can the love of country, all holy though it be, prevail in the heart of the man whose country is oppressing him?

My good humour did not prevent my companion having some bad quarters of an hour. He was in love with Madame Alessandria, who had been a singer, and was either the mistress or the wife of his friend Martinengo; and he should have deemed himself happy, but the happier a lover is, so much the more his unhappiness when he is snatched from the beloved object. He sighed, wept, and declared that he loved a woman in whom all the noble virtues were contained. I compassionated him, and took care not to comfort him by saying that love is a mere trifle—a cold piece of comfort given to lovers by fools, and, moreover, it is not true that love is a mere trifle.

The week I had mentioned as the probable term of his imprisonment passed quickly enough, and I lost my friend, but did not waste my time by mourning for him; he was set free, and I was content. I did not beg him to be discreet, for the least doubt on that score would have wounded his noble spirit. During the week he was with me he only ate soup and fruit, taking a little Canary wine. It was I who made good cheer in his stead and greatly to his delight. Before he left we swore eternal friendship.

The next day Lawrence gave me an account of my money, and on finding that I had a balance of four sequins I gave them to him, telling him it was a present from me to his wife. I did not tell him that it was for the rent of my lamp, but he was free to think so if he chose. Again betaking myself to my work, and toiling without cessation, on the 23rd of August I saw it finished. This delay was caused by an inevitable accident. As I was hollowing out the last plank, I put my eye to a little hole, through which I ought to have seen the hall of the Inquisitors-in fact, I did see it, but I saw also at one side of the hole a surface about eight inches thick. It was, as I had feared all the time it would be, one of the beams which kept up the ceiling. I was thus compelled to enlarge my hole on the other side, for the beam would have made it so

narrow that a man of my size could never have got through. I increased the hole, therefore, by a fourth, working—between fear and hope, for it was possible that the space between two of the beams would not be large enough. After I had finished, a second little hole assured me that God had blessed my labour. I then carefully stopped up the two small holes to prevent anything falling down into the hall, and also lest a ray from my lamp should be perceived, for this would have discovered all and ruined me.

I fixed my escape for the eve of St. Augustine's Day, because I knew that the Grand Council assembled on that feast, and there would consequently be nobody near the room through which I must pass in getting away. This would have been on the twenty-seventh of the month, but a misfortune happened to me on the twenty-fifth which makes me still shudder when I think of it, notwithstanding the years which have passed since then.

Precisely at noon I heard the noise of bolts, and I thought I should die; for a violent beating of the heart made me imagine my last hour was come. I fell into my easy chair, and waited. Lawrence came into the garret and put his head at the grating, and said, "I give you joy, sir, for the good news I am bringing you." At first, not being able to think of any other news which could be good to me, I fancied I had been set at liberty, and I trembled, for I knew that the discovery of the hole I had made would have caused my pardon to be recalled.

Lawrence came in and told me to follow him.

"Wait till I put on my clothes."

"It's of no consequence, as you only have to walk from this abominable cell to another, well lighted and quite fresh, with two windows whence you can see half Venice, and you can stand upright too."—— I could bear no more, I felt that I was fainting. "Give me the vinegar," said I, "and go and tell the secretary that I thank the Court for this favour, and entreat it to leave me where I am."

"You make me laugh, sir. Have you gone mad? They would take you from hell to put you in heaven, and you would refuse to stir? Come, come, the Court must be obeyed, pray rise, sir. I will give you my arm, and will have your clothes and your books brought for you." Seeing that resistance was of no avail, I got up, and was much comforted at hearing him give orders for my arm-chair to be brought, for my pike was to follow me, and with it hope. I should have much liked to have been able to take the hole—the object of so much wasted trouble and hope—with me. I may say with truth that, as I came forth from that horrible and doleful place, my spirit remained there.

Leaning on Lawrence's shoulder, while he, thinking to cheer me up, cracked his foolish jokes, I passed through two narrow passages, and going down three steps I found myself in a well-lighted hall, at the end of which, on the left-hand side, was a door leading into another passage two feet broad by about twelve long, and in the corner was my new cell. It had a barred window which was opposite to two windows, also barred, which lighted the passage, and thus one had a fine view as far as Lido. At that trying moment I did not care much for the view; but later on I found that a sweet and pleasant wind came through the window when it was opened, and tempered the insufferable heat; and this was a true blessing for the poor wretch who had to breathe the sultry prison air, especially in the hot season.

As soon as I got into my new cell Lawrence had my arm-chair brought in, and went away, saying that he would have the remainder of my effects brought to me. I sat on my arm-chair as motionless as a statue, waiting for the storm, but not fearing it. What overwhelmed me was the distressing idea that all my pains and contrivances were of no use, nevertheless I felt neither sorry nor repentant for what I had done, and I made myself abstain from thinking of what was going to happen, and thus kept myself calm.

Lifting up my soul to God I could not help thinking that this misfortune was a Divine punishment for neglecting to escape when all was ready. Nevertheless, though I could have escaped three days sooner, I thought my punishment too severe, all the more as I had put off my escape from motives of prudence, which seemed to me worthy of reward, for if I had only consulted my own impatience to be gone I should have risked everything. To controvert the reasons which made me postpone my flight to the 27th of August, a special revelation would have been requisite; and though I had read "Mary of Agrada" I was not mad enough for that.

CHAPTER XXVIII

The Subterranean Prisons Known as the Wells—Lawrence's
Vengeance—I Enter into a Correspondence With Another
Prisoner, Father Balbi: His Character—I Plan With Him a
Means of Escape—How I Contrived to Let Him Have My Pike I
Am Given a Scoundrelly Companion: His Portrait.

I was thus anxious and despairing when two of the guards brought me my
bed. They went back to fetch the rest of my belongings, and for two hours I
saw no one, although the door of my cell remained open. This unnatural
delay engendered many thoughts, but I could not fix exactly on the reason of
it. I only knew that I had everything to fear, and this knowledge made me
brace up my mind so that I should be able to meet calmly all possible
misfortunes.

Besides The Leads and The Fours the State Inquisitors also possess certain
horrible subterranean cells beneath the ducal palace, where are sent men
whom they do not wish to put to death, though they be thought worthy of it.

These subterranean prisons are precisely like tombs, but they call them
"wells," because they always contain two feet of water, which penetrates from
the sea by the same grating by which light is given, this grating being only a
square foot in size. If the unfortunates condemned to live in these sewers do
not wish to take a bath of filthy water, they have to remain all day seated on
a trestle, which serves them both for bed and cupboard. In the morning they
are given a pitcher of water, some thin soup, and a ration of army bread which
they have to eat immediately, or it becomes the prey of the enormous water
rats who swarm in those dreadful abodes. Usually the wretches condemned
to The Wells are imprisoned there for life, and there have been prisoners who
have attained a great age. A villain who died whilst I was under the Leads had
passed thirty-seven years in The Wells, and he was forty-four when
sentenced. Knowing that he deserved death, it is possible that he took his
imprisonment as a favour, for there are men who fear nought save death. His
name was Beguelin. A Frenchman by birth, he had served in the Venetian
army during the last war against the Turks in 1716, under the command of
Field-Marshal the Count of Schulenbourg, who made the Grand Vizier raise
the siege of Corfu. This Beguelin was the marshal's spy. He disguised himself
as a Turk, and penetrated into the Mussulman quarters, but at the same time
he was also in the service of the Grand Vizier, and being detected in this
course he certainly had reason to be thankful for being allowed to die in The

Wells. The rest of his life must have been divided between weariness and hunger, but no doubt he often said, 'Dum vita superest, bene est'.

I have seen at Spiegelberg, in Moravia, prisons fearful in another way. There mercy sends the prisoners under sentence of death, and not one of them ever survives a year of imprisonment. What mercy!

During the two mortal hours of suspense, full of sombre thoughts and the most melancholy ideas, I could not help fancying that I was going to be plunged in one of these horrible dens, where the wretched inhabitants feed on idle hopes or become the prey of panic fears. The Tribunal might well send him to hell who had endeavoured to escape from purgatory.

At last I heard hurried steps, and I soon saw Lawrence standing before me, transformed with rage, foaming at the mouth, and blaspheming God and His saints. He began by ordering me to give him the hatchet and the tools I had used to pierce the floor, and to tell him from which of the guards I had got the tools. Without moving, and quite calmly, I told him that I did not know what he was talking about. At this reply he gave orders that I should be searched, but rising with a determined air I shook my fist at the knaves, and having taken off my clothes I said to them, "Do your duty, but let no one touch me."

They searched my mattress, turned my bed inside out, felt the cushions of my arm-chair, and found nothing.

"You won't tell me, then, where are the instruments with which you made the hole. It's of no matter, as we shall find a way to make you speak."

"If it be true that I have made a hole at all, I shall say that you gave me the tools, and that I have returned them to you."

At this threat, which made his followers smile with glee, probably because he had been abusing them, he stamped his feet, tore his hair, and went out like one possessed. The guards returned and brought me all my properties, the whetstone and lamp excepted. After locking up my cell he shut the two windows which gave me a little air. I thus found myself confined in a narrow space without the possibility of receiving the least breath of air from any quarter. Nevertheless, my situation did not disturb me to any great extent, as I must confess I thought I had got off cheaply. In spite of his training, Lawrence had not thought of turning the armchair over; and thus, finding myself still possessor of the iron bar, I thanked Providence, and thought myself still at liberty to regard the bar as means by which, sooner or later, I should make my escape.

I passed a sleepless night, as much from the heat as the change in my prospects. At day-break Lawrence came and brought some insufferable wine, and some water I should not have cared to drink. All the rest was of a piece;

Arthur Machen

dry salad, putrid meat, and bread harder than English biscuit. He cleaned nothing, and when I asked him to open the windows he seemed not to hear me; but a guard armed with an iron bar began to sound all over my room, against the wall, on the floor, and above all under my bed. I looked on with an unmoved expression, but it did not escape my notice that the guard did not sound the ceiling. "That way," said I to myself, "will lead me out of this place of torments." But for any such project to succeed I should have to depend purely on chance, for all my operations would leave visible traces. The cell was quite new, and the least scratch would have attracted the notice of my keepers.

I passed a terrible day, for the heat was like that of a furnace, and I was quite unable to make any use of the food with which I had been provided. The perspiration and the lack of nourishment made me so weak that I could neither walk nor read. Next day my dinner was the same; the horrible smell of the veal the rascal brought me made me draw back from it instantly. "Have you received orders," said I, "to kill me with hunger and heat?"

He locked the door, and went out without a word. On the third day I was treated in the same manner. I asked for a pencil and paper to write to the secretary. Still no answer.

In despair, I eat my soup, and then soaking my bread in a little Cyprus wine I resolved to get strength to avenge myself on Lawrence by plunging my pike into his throat. My rage told me that I had no other course, but I grew calmer in the night, and in the morning, when the scoundrel appeared, I contented myself with saying that I would kill him as soon as I was at liberty. He only laughed at my threat, and again went out without opening his lips.

I began to think that he was acting under orders from the secretary, to whom he must have told all. I knew not what to do. I strove between patience and despair, and felt as if I were dying for want of food. At last on the eighth day, with rage in my heart and in a voice of thunder, I bade him, under the name of "hangman," and in the presence of the archers, give me an account of my money. He answered drily that I should have it the next day. Then as he was about to go I took my bucket, and made as if I would go and empty it in the passage. Foreseeing my design, he told a guard to take it, and during the disgusting operation opened a window, which he shut as soon as the affair was done, so that in spite of my remonstrances I was left in the plague-stricken atmosphere. I determined to speak to him still worse the next day; but as soon as he appeared my anger cooled, for before giving me the account of my money he presented me with a basket of lemons which M. de Bragadin had sent me, also a large bottle of water, which seemed drinkable,

and a nice roasted fowl; and, besides this, one of the guards opened the two windows. When he gave me the account I only looked at the sum total, and I told him to give the balance to his wife with the exception of a sequin, which I told him to give the guards who were with him. I thus made friends with these fellows, who thanked me heartily.

Lawrence, who remained alone with me on purpose, spoke as follows:

"You have already told me, sir, that I myself furnished you with the tools to make that enormous hole, and I will ask no more about it; but would you kindly tell me where you got the materials to make a lamp?"

"From you."

"Well, for the moment, sir, I'm dashed, for I did not think that wit meant impudence."

"I am not telling you any lies. You it was who with your own hands gave me all the requisites—oil, flint, and matches; the rest I had by me."

"You are right; but can you shew me as simply that I gave you the tools to make that hole?"

"Certainly, for you are the only person who has given me anything."

"Lord have mercy upon me! what do I hear? Tell me, then, how I gave you a hatchet?"

"I will tell you the whole story and I will speak the truth, but only in the presence of the secretary."

"I don't wish to know any more, and I believe everything you say. I only ask you to say nothing about it, as I am a poor man with a family to provide for." He went out with his head between his hands.

I congratulated myself heartily on having found a way to make the rascal afraid of me; he thought that I knew enough to hang him. I saw that his own interest would keep him from saying anything to his superiors about the matter.

I had told Lawrence to bring me the works of Maffei, but the expense displeased him though he did not dare to say so. He asked me what I could want with books with so many to my hand.

"I have read them all," I said, "and want some fresh ones."

"I will get someone who is here to lend you his books, if you will lend yours in return; thus you will save your money."

"Perhaps the books are romances, for which I do not care."

"They are scientific works; and if you think yours is the only long head here, you are very much mistaken."

"Very good, we shall see. I will lend this book to the 'long head,' and do you bring me one from him."

I had given him Petau's Rationarium, and in four minutes he brought me the first volume of Wolff's works. Well pleased with it I told him, much to his delight, that I would do without Maffei.

Less pleased with the learned reading than at the opportunity to begin a correspondence with someone who might help me in my plan of escape (which I had already sketched out in my head), I opened the book as soon as Lawrence was gone, and was overjoyed to find on one of the leaves the maxim of Seneca, 'Calamitosus est animus futuri anxius', paraphrased in six elegant verses. I made another six on the spot, and this is the way in which I contrived to write them, I had let the nail of my little finger grow long to serve as an earpick; I out it to a point, and made a pen of it. I had no ink, and I was going to prick myself and write in my blood, when I bethought me that the juice of some mulberries I had by me would be an excellent substitute for ink. Besides the six verses I wrote out a list of my books, and put it in the back of the same book. It must be understood that Italian books are generally bound in parchment, and in such a way that when the book is opened the back becomes a kind of pocket. On the title page I wrote, 'latet'. I was anxious to get an answer, so the next day I told Lawrence that I had read the book and wanted another; and in a few minutes the second volume was in my hands.

As soon as I was alone I opened the book, and found a loose leaf with the following communication in Latin:

"Both of us are in the same prison, and to both of us it must be pleasant to find how the ignorance of our gaoler procures us a privilege before unknown to such a place. I, Marin Balbi, who write to you, am a Venetian of high birth, and a regular cleric, and my companion is Count Andre Asquin, of Udine, the capital of Friuli. He begs me to inform you that all the books in his possession, of which you will find a list at the back of this volume, are at your service; but we warn you that we must use all possible care to prevent our correspondence being discovered by Lawrence."

In our position there was nothing wonderful in our both pitching on the idea of sending each other the catalogues of our small libraries, or in our choosing the same hiding-place—the back of the books; all this was plain common sense; but the advice to be careful contained on the loose leaf struck me with some astonishment. It seemed next to impossible that Lawrence should leave the book unopened, but if he had opened it he would have seen the leaf, and not knowing how to read he would have kept it in his pocket till he could get someone to tell him the contents, and thus all would have been strangled at its birth. This made me think that my correspondent was an arrant block-head.

After reading through the list, I wrote who I was, how I had been arrested, my ignorance as to what crime I had committed, and my hope of soon becoming free. Balbi then wrote me a letter of sixteen pages, in which he gave me the history of all his misfortunes. He had been four years in prison, and the reason was that he had enjoyed the good graces of three girls, of whom he had three children, all of whom he baptized under his own name.

The first time his superior had let him off with an admonition, the second time he was threatened with punishment, and on the third and last occasion he was imprisoned. The father-superior of his convent brought him his dinner every day. He told me in his letter that both the superior and the Tribunal were tyrants, since they had no lawful authority over his conscience: that being sure that the three children were his, he thought himself constrained as a man of honour not to deprive them of the advantage of bearing his name. He finished by telling me that he had found himself obliged to recognize his children to prevent slander attributing them to others, which would have injured the reputation of the three honest girls who bore them; and besides he could not stifle the voice of nature, which spoke so well on behalf of these little ones. His last words were, "There is no danger of the superior falling into the same fault, as he confines his attention to the boys."

This letter made me know my man. Eccentric, sensual, a bad logician, vicious, a fool, indiscreet, and ungrateful, all this appeared in his letter, for after telling me that he should be badly off without Count Asquin who was seventy years old, and had books and money, he devoted two pages to abusing him, telling me of his faults and follies. In society I should have had nothing more to do with a man of his character, but under the Leads I was obliged to put everything to some use. I found in the back of the book a pencil, pens, and paper, and I was thus enabled to write at my ease.

He told me also the history of the prisoners who were under the Leads, and of those who had been there since his imprisonment. He said that the guard who secretly brought him whatever he wanted was called Nicolas, he also told me the names of the prisoners, and what he knew about them, and to convince me he gave me the history of the hole I had made. It seems I had been taken from my cell to make room for the patrician Priuli, and that Lawrence had taken two hours to repair the damage I had done, and that he had imparted the secret to the carpenter, the blacksmith, and all the guards under pain of death if they revealed it. "In another day," the guard had said, "Casanova would have escaped, and Lawrence would have swung, for though he pretended great astonishment when he saw the hole, there can be no doubt that he and no other provided the tools." "Nicolas has told me," added

my correspondent, "that M. de Bragadin has promised him a thousand sequins if he will aid you to make your escape but that Lawrence, who knows of it, hopes to get the money without risking his neck, his plan being to obtain your liberty by means of the influence of his wife with M. Diedo. None of the guards dare to speak of what happened for fear Lawrence might get himself out of the difficulty, and take his revenge by having them dismissed." He begged me to tell him all the details, and how I got the tools, and to count upon his keeping the secret.

I had no doubts as to his curiosity, but many as to his discretion, and this very request shewed him to be the most indiscreet of men. Nevertheless, I concluded that I must make use of him, for he seemed to me the kind of man to assist me in my escape. I began to write an answer to him, but a sudden suspicion made me keep back what I had written. I fancied that the correspondence might be a mere artifice of Lawrence's to find out who had given me the tools, and what I had done with them. To satisfy him without compromising myself I told him that I had made the hole with a strong knife in my possession, which I had placed on the window-ledge in the passage. In less than three days this false confidence of mine made me feel secure, as Lawrence did not go to the window, as he would certainly have done if the letter had been intercepted. Furthermore, Father Balbi told me that he could understand how I might have a knife, as Lawrence had told him that I had not been searched previous to my imprisonment. Lawrence himself had received no orders to search me, and this circumstance might have stood him in good stead if I had succeeded in escaping, as all prisoners handed over to him by the captain of the guard were supposed to have been searched already. On the other hand, Messer-Grande might have said that, having seen me get out of my bed, he was sure that I had no weapons about me, and thus both of them would have got out of trouble. The monk ended by begging me to send him my knife by Nicolas, on whom I might rely.

The monk's thoughtlessness seemed to me almost incredible. I wrote and told him that I was not at all inclined to put my trust in Nicolas, and that my secret was one not to be imparted in writing. However, I was amused by his letters. In one of them he told me why Count Asquin was kept under the Leads, in spite of his helplessness, for he was enormously fat, and as he had a broken leg which had been badly set he could hardly put one foot before another. It seems that the count, not being a very wealthy man, followed the profession of a barrister at Udine, and in that capacity defended the country-folk against the nobility, who wished to deprive the peasants of their vote in the assembly of the province. The claims of the farmers disturbed the

public peace, and by way of bringing them to reason the nobles had recourse to the State Inquisitors, who ordered the count-barrister to abandon his clients. The count replied that the municipal law authorized him to defend the constitution, and would not give in; whereon the Inquisitors arrested him, law or no law, and for the last five years he had breathed the invigorating air of The Leads. Like myself he had fifty sous a day, but he could do what he liked with the money. The monk, who was always penniless, told me a good deal to the disadvantage of the count, whom he represented as very miserly. He informed me that in the cell on the other side of the hall there were two gentlemen of the "Seven Townships," who were likewise imprisoned for disobedience, but one of them had become mad, and was in chains; in another cell, he said, there were two lawyers.

My suspicions quieted, I reasoned as follows:

I wish to regain my liberty at all hazards. My pike is an admirable instrument, but I can make no use of it as my cell is sounded all over (except the ceiling) every day. If I would escape, it is by the ceiling, therefore, that way I must go, but to do that I must make a hole through it, and that I cannot do from my side, for it would not be the work of a day. I must have someone to help me; and not having much choice I had to pick out the monk. He was thirty-eight, and though not rich in common sense I judged that the love of liberty—the first need of man—would give him sufficient courage to carry out any orders I might give. I must begin by telling him my plan in its entirety, and then I shall have to find a way to give him the bar. I had, then, two difficult problems before me.

My first step was to ask him if he wished to be free, and if he were disposed to hazard all in attempting his escape in my company. He replied that his mate and he would do anything to break their chains, but, added he, "it is of no use to break one's head against a stone wall." He filled four pages with the impossibilities which presented themselves to his feeble intellect, for the fellow saw no chance of success on any quarter. I replied that I did not trouble myself with general difficulties, and that in forming my plan I had only thought of special difficulties, which I would find means to overcome, and I finished by giving him my word of honour to set him free, if he would promise to carry out exactly whatever orders I might give.

He gave me his promise to do so. I told him that I had a pike twenty inches long, and with this tool he must pierce the ceiling of his cell next the wall which separated us, and he would then be above my head; his next step would be to make a hole in the ceiling of my cell and aid me to escape by it. "Here

your task will end and mine will begin, and I will undertake to set both you and Count Asquin at liberty."

He answered that when I had got out of my cell I should be still in prison, and our position would be the same as now, as we should only be in the garrets which were secured by three strong doors.

"I know that, reverend father," I replied, "but we are not going to escape by the doors. My plan is complete, and I will guarantee its success. All I ask of you is to carry out my directions, and to make no difficulties. Do you busy yourself to find out some way of getting my bar without the knowledge of the gaoler. In the meanwhile, make him get you about forty pictures of saints, large enough to cover all the walls of your cell. Lawrence will suspect nothing, and they will do to conceal the opening you are to make in the ceiling. To do this will be the work of some days, and of mornings Lawrence will not see what you have done the day before, as you will have covered it up with one of the pictures. If you ask me why I do not undertake the work myself, I can only say that the gaoler suspects me, and the objection will doubtless seem to you a weighty one."

Although I had told him to think of a plan to get hold of the pike, I thought of nothing else myself, and had a happy thought which I hastened to put into execution. I told Lawrence to buy me a folio Bible, which had been published recently; it was the Vulgate with the Septuagint. I hoped to be able to put the pike in the back of the binding of this large volume, and thus to convey it to the monk, but when I saw the book I found the tool to be two inches longer.

My correspondent had written to tell me that his cell was covered with pictures, and I had communicated him my idea about the Bible and the difficulty presented by its want of length. Happy at being able to display his genius, he rallied me on the poverty of my imagination, telling me that I had only to send him the pike wrapped up in my fox-skin cloak.

"Lawrence," said he, "had often talked about your cloak, and Count Asquin would arouse no suspicion by asking to see it in order to buy one of the same kind. All you have to do is to send it folded up. Lawrence would never dream of unfolding it."

I, on the other hand, was sure that he would. In the first place, because a cloak folded up is more troublesome to carry than when it is unfolded. However, not to rebuff him and at the same time to shew him that I was the wiser, I wrote that he had only to send for the cloak. The next day Lawrence asked me for it, and I gave it folded up, but without the bar, and in a quarter

of an hour he brought it back to me, saying that the gentleman had admired it very much.

The monk wrote me a doleful letter, in which he confessed he had given me a piece of bad advice, adding that I was wrong to follow it. According to him the pike was lost, as Lawrence had brought in the cloak all unfolded. After this, all hope was gone. I undeceived him, and begged him for the future to be a little more sparing of his advice. It was necessary to bring the matter to a head, and I determined to send him the bar under cover of my Bible, taking measures to prevent the gaoler from seeing the ends of the great volume. My scheme was as follows:

I told Lawrence that I wanted to celebrate St. Michael's Day with a macaroni cheese; but wishing to shew my gratitude to the person who had kindly lent me his books, I should like to make him a large dish of it, and to prepare it with my own hands. Lawrence told me (as had been arranged between the monk and myself) that the gentleman in question wished to read the large book which cost three sequins.

"Very good," said I, "I will send it him with the macaroni; but get me the largest dish you have, as I wish to do the thing on a grand scale."

He promised to do what I asked him. I wrapped up the pike in paper and put it in the back of the Bible, taking care that it projected an equal distance at each end. Now, if I placed on the Bible a great dish of macaroni full of melted butter I was quite sure that Lawrence would not examine the ends. All his gaze would be concentrated upon the plate, to avoid spilling the grease on the book. I told Father Balbi of my plan, charging him to take care how he took the dish, and above all to take dish and Bible together, and not one by one. On the day appointed Lawrence came earlier than usual, carrying a saucepan full of boiling macaroni, and all the necessary ingredients for seasoning the dish. I melted a quantity of butter, and after putting the macaroni into the dish I poured the butter over it till it was full to the brim. The dish was a huge one, and was much larger than the book on which I placed it. I did all this at the door of my cell, Lawrence being outside.

When all was ready I carefully took up the Bible and dish, placing the back of the book next to the bearer, and told Lawrence to stretch out his arms and take it, to be careful not to spill the grease over the book, and to carry the whole to its destination immediately. As I gave him this weighty load I kept my eyes fixed on his, and I saw to my joy that he did not take his gaze off the butter, which he was afraid of spilling. He said it would be better to take the dish first, and then to come back for the book; but I told him that this would spoil the present, and that both must go together. He then complained that

I had put in too much butter, and said, jokingly, that if it were spilt he would not be responsible for the loss. As soon as I saw the Bible in the lout's arms I was certain of success, as he could not see the ends of the pike without twisting his head, and I saw no reason why he should divert his gaze from the plate, which he had enough to do to carry evenly. I followed him with my eyes till he disappeared into the ante-chamber of the monk's cell, and he, blowing his nose three times, gave me the pre-arranged signal that all was right, which was confirmed by the appearance of Lawrence in a few moments afterwards.

Father Balbi lost no time in setting about the work, and in eight days he succeeded in making a large enough opening in the ceiling, which he covered with a picture pasted to the ceiling with breadcrumbs. On the 8th of October he wrote to say that he had passed the whole night in working at the partition wall, and had only succeeded in loosening one brick. He told me the difficulty of separating the bricks joined to one another by a strong cement was enormous, but he promised to persevere, "though," he said, "we shall only make our position worse than it is now." I told him that I was certain of success; that he must believe in me and persevere. Alas! I was certain of nothing, but I had to speak thus or to give up all. I was fain to escape from this hell on earth, where I was imprisoned by a most detestable tyranny, and I thought only of forwarding this end, with the resolve to succeed, or at all events not to stop before I came to a difficulty which was insurmountable. I had read in the great book of experience that in important schemes action is the grand requisite, and that the rest must be left to fortune. If I had entrusted Father Balbi with these deep mysteries of moral philosophy he would have pronounced me a madman. His work was only toilsome on the first night, for the more he worked the easier it became, and when he had finished he found he had taken out thirty-six bricks.

On the 16th of October, as I was engaged in translating an ode of Horace, I heard a trampling noise above my head, and then three light blows were struck. This was the signal agreed upon to assure us that our calculations were correct. He worked till the evening, and the next day he wrote that if the roof of my cell was only two boards thick his work would be finished that day. He assured me that he was carefully making the hole round as I had charged him, and that he would not pierce the ceiling. This was a vital point, as the slightest mark would have led to discovery. "The final touch," he said, "will only take a quarter of an hour." I had fixed on the day after the next to escape from my cell at night-time to enter no more, for with a mate I was quite sure that I could make in two or three hours a hole in the roof of the ducal palace,

and once on the outside of the roof I would trust to chance for the means of getting to the ground.

I had not yet got so far as this, for my bad luck had more than one obstacle in store for me. On the same day (it was a Monday) at two o'clock in the afternoon, whilst Father Balbi was at work, I heard the door of the hall being opened. My blood ran cold, but I had sufficient presence of mind to knock twice-the signal of alarm—at which it had been agreed that Father Balbi was to make haste back to his cell and set all in order. In less than a minute afterwards Lawrence opened the door, and begged my pardon for giving me a very unpleasant companion. This was a man between forty and fifty, short, thin, ugly, and badly dressed, wearing a black wig; while I was looking at him he was unbound by two guards. I had no reason to doubt that he was a knave, since Lawrence told me so before his face without his displaying the slightest emotion. "The Court," I said, "can do what seems good to it." After Lawrence had brought him a bed he told him that the Court allowed him ten sous a day, and then locked us up together.

Overwhelmed by this disaster, I glanced at the fellow, whom his every feature proclaimed rogue. I was about to speak to him when he began by thanking me for having got him a bed. Wishing to gain him over, I invited him to take his meals with me. He kissed my hand, and asked me if he would still be able to claim the ten sous which the Court had allowed him. On my answering in the affirmative he fell on his knees, and drawing an enormous rosary from his pocket he cast his gaze all round the cell.

"What do you want?"

"You will pardon me, sir, but I am looking for some statue of the Holy Virgin, for I am a Christian; if there were even a small crucifix it would be something, for I have never been in so much need of the protection of St. Francis d'Assisi, whose name I bear, though all unworthy."

I could scarcely help laughing, not at his Christian piety, since faith and conscience are beyond control, but at the curious turn he gave his remonstrance. I concluded he took me for a Jew; and to disabuse him of this notion I made haste to give him the "Hours of the Holy Virgin," whose picture he kissed, and then gave me the book back, telling me in a modest voice that his father—a, galley officer—had neglected to have him taught to read. "I am," said he, "a devotee of the Holy Rosary," and he told me a host of miracles, to which I listened with the patience of an angel. When he had come to an end I asked him if he had had his dinner, and he replied that he was dying of hunger. I gave him everything I had, which he devoured rather than ate; drinking all my wine, and then becoming maudlin he began to weep,

and finally to talk without rhyme or reason. I asked him how he got into trouble, and he told me the following story:

"My aim and my only aim has always been the glory of God, and of the holy Republic of Venice, and that its laws may be exactly obeyed. Always lending an attentive ear to the plots of the wicked, whose end is to deceive, to deprive their prince of his just dues, and to conspire secretly, I have over and again unveiled their secret plans, and have not failed to report to Messer-Grande all I know. It is true that I am always paid, but the money has never given me so much pleasure as the thought that I have been able to serve the blessed St. Mark. I have always despised those who think there is something dishonourable in the business of a spy. The word sounds ill only to the ill-affected; for a spy is a lover of the state, the scourge of the guilty, and faithful subject of his prince. When I have been put to the test, the feeling of friendship, which might count for something with other men, has never had the slightest influence over me, and still less the sentiment which is called gratitude. I have often, in order to worm out a secret, sworn to be as silent as the grave, and have never failed to reveal it. Indeed, I am able to do so with full confidence, as my director who is a good Jesuit has told me that I may lawfully reveal such secrets, not only because my intention was to do so, but because, when the safety of the state is at stake, there is no such thing as a binding oath. I must confess that in my zeal I have betrayed my own father, and that in me the promptings of our weak nature have been quite mortified. Three weeks ago I observed that there was a kind of cabal between four or five notables of the town of Isola, where I live. I knew them to be disaffected to the Government on account of certain contraband articles which had been confiscated. The first chaplain—a subject of Austria by birth—was in the plot. They gathered together of evenings in an inn, in a room where there was a bed; there they drank and talked, and afterwards went their ways. As I was determined to discover the conspiracy, I was brave enough to hide under the bed on a day on which I was sure I would not be seen. Towards the evening my gentlemen came, and began to talk; amongst other things, they said that the town of Isola was not within the jurisdiction of St. Mark, but rather in the principality of Trieste, as it could not possibly be considered to form part of the Venetian territory. The chaplain said to the chief of the plot, a man named Pietro Paolo, that if he and the others would sign a document to that effect, he himself would go to the imperial ambassador, and that the Empress would not only take possession of the island, but would reward them for what they had done. They all professed themselves ready to go on, and the chaplain

promised to bring the document the next day, and afterwards to take it to the ambassadors.

"I determined to frustrate this detestable project, although one of the conspirators was my gossip—a spiritual relationship which gave him a greater claim on me than if he had been my own brother.

"After they were gone, I came out of my hiding-place and did not think it necessary to expose myself to danger by hiding again as I had found out sufficient for my purpose. I set out the same night in a boat, and reached here the next day before noon. I had the names of the six rebels written down, and I took the paper to the secretary of the Tribunal, telling him all I had heard. He ordered me to appear, the day following, at the palace, and an agent of the Government should go back with me to Isola that I might point the chaplain out to him, as he had probably not yet gone to the Austrian ambassador's. 'That done,' said the lord secretary, 'you will no longer meddle in the matter.' I executed his orders, and after having shewn the chaplain to the agent, I was at leisure for my own affairs.

"After dinner my gossip called me in to shave him (for I am a barber by profession), and after I had done so he gave me a capital glass of refosco with some slices of sausages, and we ate together in all good fellowship. My love for him had still possession of my soul, so I took his hand, and, shedding some heartfelt tears, I advised him to have no more to do with the canon, and above all, not to sign the document he knew of. He protested that he was no particular friend of the chaplain's, and swore he did not know what document I was talking about. I burst into a laugh, telling him it was only my joke, and went forth very sorry at having yielded to a sentiment of affection which had made me commit so grievous a fault. The next day I saw neither the man nor the chaplain. A week after, having paid a visit to the palace, I was promptly imprisoned, and here I am with you, my dear sir. I thank St. Francis for having given me the company of a good Christian, who is here for reasons of which I desire to know nothing, for I am not curious. My name is Soradaci, and my wife is a Legrenzi, daughter of a secretary to the Council of Ten, who, in spite of all prejudice to the contrary, determined to marry me. She will be in despair at not knowing what has become of me, but I hope to be here only for a few days, since the only reason of my imprisonment is that the secretary wishes to be able to examine me more conveniently."

I shuddered to think of the monster who was with me, but feeling that the situation was a risky one, And that I should have to make use of him, I compassionated him, praised his patriotism, and predicted that he would be set at liberty in a few days. A few moments after he fell asleep, and I took the

opportunity of telling the whole story to Father Balbi, shewing him that we should be obliged to put off our work to a more convenient season. Next day I told Lawrence to buy me a wooden crucifix, a statue of Our Lady, a portrait of St. Francis, and two bottles of holy water. Soradaci asked for his ten sous, and Lawrence, with an air of contempt, gave him twenty. I asked Lawrence to buy me four times the usual amount of garlic, wine, and salt—a diet in which my hateful companion delighted. After the gaoler was gone I deftly drew out the letter Balbi had written me, and in which he drew a vivid picture of his alarm. He thought all was lost, and over and over again thanked Heaven that Lawrence had put Soradaci in my cell, "for," said he, "if he had come into mine, he would not have found me there, and we should possibly have shared a cell in The Wells as a reward for our endeavours."

Soradaci's tale had satisfied me that he was only imprisoned to be examined, as it seemed plain that the secretary had arrested him on suspicion of bearing false witness. I thereupon resolved to entrust him with two letters which would do me neither good nor harm if they were delivered at their addresses, but which would be beneficial to me if the traitor gave them to the secretary as a proof of his loyalty, as I had not the slightest doubt he would do.

I spent two hours in writing these two letters in pencil. Next day Lawrence brought me the crucifix, the two pictures, and the holy water, and having worked the rascal well up to the point, I said, "I reckon upon your friendship and your courage. Here are two letters I want you to deliver when you recover your liberty. My happiness depends on your loyalty, but you must hide the letters, as they were found upon you we should both of us be undone. You must swear by the crucifix and these holy pictures not to betray me."

"I am ready, dear master, to swear to anything you like, and I owe you too much to betray you."

This speech was followed by much weeping and lamentation. He called himself unhappy wretch at being suspected of treason towards a man for whom he would have given his life. I knew my man, but I played out the comedy. Having given him a shirt and a cap, I stood up bare-headed, and then having sprinkled the cell with holy water, and plentifully bedewed him with the same liquid, I made him swear a dreadful oath, stuffed with senseless imprecations, which for that very reason were the better fitted to strike terror to his soul. After his having sworn the oath to deliver my letters to their addresses, I gave him them, and he himself proposed to sew them up at the back of his waistcoat, between the stuff and the lining, to which proceedings I assented.

I was morally sure that he would deliver my letters to the secretary in the first opportunity, so I took the utmost care that my style of writing should not discover the trick. They could only gain me the esteem of the Court, and possibly its mercy. One of the letters was addressed to M. de Bragadin and the other to the Abbe Grimani, and I told them not to be anxious about me as I was in good hopes of soon being set at liberty, that they would find when I came out that my imprisonment had done me more good than harm, as there was no one in Venice who stood in need of reform more than I.

I begged M. de Bragadin to be kind enough to send me a pair of fur boots for the winter, as my cell was high enough for me to stand upright and to walk up and down.

I took care that Soradaci should not suspect the innocent nature of these letters, as he might then have been seized with the temptation to do an honest thing for me, and have delivered them, which was not what I was aiming at. You will see, dear reader, in the following chapter, the power of oaths over the vile soul of my odious companion, and also if I have not verified the saying 'In vino veritas', for in the story he told me the wretch had shewn himself in his true colours.

CHAPTER XXIX

Treason of Soradaci—How I Get the Best of Him—Father Balbi
Ends His Work—I Escape from My Cell—Unseasonable
Observations of Count Asquin The Critical Moment

Soradaci had had my letters for two or three days when Lawrence came one afternoon to take him to the secretary. As he was several hours away, I hoped to see his face no more; but to my great astonishment he was brought back in the evening. As soon as Lawrence had gone, he told me that the secretary suspected him of having warned the chaplain, since that individual had never been near the ambassador's and no document of any kind was found upon him. He added that after a long examination he had been confined in a very small cell, and was then bound and brought again before the secretary, who wanted him to confess that he told someone at Isola that the priest would never return, but that he had not done so as he had said no such thing. At last the secretary got tired, called the guards, and had him brought back to my cell.

I was distressed to hear his account, as I saw that the wretch would probably remain a long time in my company. Having to inform Father Balbi of this fatal misadventure, I wrote to him during the night, and being obliged to do so more than once, I got accustomed to write correctly enough in the dark.

On the next day, to assure myself that my suspicions were well founded, I told the spy to give me the letter I had written to M. de Bragadin as I wanted to add something to it. "You can sew it up afterwards," said I.

"It would be dangerous," he replied, "as the gaoler might come in in the mean time, and then we should be both ruined."

"No matter. Give me my letters:"

Thereupon the hound threw himself at my feet, and swore that on his appearing for a second time before the dreaded secretary, he had been seized with a severe trembling; and that he had felt in his back, especially in the place where the letters were, so intolerable an oppression, that the secretary had asked him the cause, and that he had not been able to conceal the truth. Then the secretary rang his bell, and Lawrence came in, unbound him, and took off his waist-coat and unsewed the lining. The secretary then read the letters and put them in a drawer of his bureau, telling him that if he had taken the letters he would have been discovered and have lost his life.

I pretended to be overwhelmed, and covering my face with my hands I knelt down at the bedside before the picture of the Virgin, and asked, her to avenge me on the wretch who had broken the most sacred oaths. I afterwards lay down on the bed, my face to the wall, and remained there the whole day without moving, without speaking a word, and pretending not to hear the tears, cries, and protestations of repentance uttered by the villain. I played my part in the comedy I had sketched out to perfection. In the night I wrote to Father Balbi to come at two o'clock in the afternoon, not a minute sooner or later, to work for four hours, and not a minute more. "On this precision," I wrote, "our liberty depends and if you observe it all will be well."

It was the 25th of October, and the time for me to carry out my design or to give it up for ever drew near. The State Inquisitors and their secretary went every year to a village on the mainland, and passed there the first three days of November. Lawrence, taking advantage of his masters' absence, did not fail to get drunk every evening, and did not appear at The Leads in the morning till a late hour.

Advised of these circumstances, I chose this time to make my escape, as I was certain that my flight would not be noticed till late in the morning. Another reason for my determination to hurry my escape, when I could no longer doubt the villainy of my detestable companion, seems to me to be worthy of record.

The greatest relief of a man in the midst of misfortune is the hope of escaping from it. He sighs for the hour when his sorrows are to end; he thinks he can hasten it by his prayers; he will do anything to know when his torments shall cease. The sufferer, impatient and enfeebled, is mostly inclined to superstition. "God," says he, "knows the time, and God may reveal it to me, it matters not how." Whilst he is in this state he is ready to trust in divination in any manner his fancy leads him, and is more or less disposed to believe in the oracle of which he makes choice.

I then was in this state of mind; but not knowing how to make use of the Bible to inform me of the moment in which I should recover my liberty, I determined to consult the divine Orlando Furioso, which I had read a hundred times, which I knew by heart, and which was my delight under the Leads. I idolized the genius of Ariosto, and considered him a far better fortune-teller than Virgil.

With this idea I wrote a question addressed to the supposed Intelligence, in which I ask in what canto of Ariosto I should find the day of my deliverance. I then made a reversed pyramid composed of the number formed from the words of the question, and by subtracting the number nine I

obtained, finally, nine. This told me that I should find my fate in the ninth canto. I followed the same method to find out the exact stanza and verse, and got seven for the stanza and one for the verse.

I took up the poem, and my heart beating as if I trusted wholly in the oracle, I opened it, turned down the leaf, and read;

'Fra il fin d'ottobre, a il capo di novembre'.

The precision of the line and its appropriateness to my circumstances appeared so wonderful to me, that I will not confess that I placed my faith entirely in it; but the reader will pardon me if I say that I did all in my power to make the prediction a correct one. The most singular circumstance is that between the end of October and the beginning of November, there is only the instant midnight, and it was just as the clock was striking midnight on the 31st of October that I escaped from my cell, as the reader will soon see.

The following is the manner in which I passed the morning to strike awe into the soul of that vicious brute, to confound his feeble intellect, and to render him harmless to me.

As soon as Lawrence had left us I told Soradaci to come and take some soup. The scoundrel was in bed, and he had told Lawrence that he was ill. He would not have dared to approach me if I had not called him. However, he rose from his bed, and threw himself flat upon the ground at my feet, and said, weeping violently, that if I would not forgive him he would die before the day was done, as he already felt the curse and the vengeance of the Holy Virgin which I had denounced against him. He felt devouring pains in his bowels, and his mouth was covered with sores. He shewed it me, and I saw it was full of ulcers, but I cannot say whether it was thus the night before. I did not much care to examine him to see if he were telling me the truth. My cue was to pretend to believe him, and to make him hope for mercy. I began by making him eat and drink. The traitor most likely intended to deceive me, but as I was myself determined to deceive him it remained to be seen which was the a cuter. I had planned an attack against which it was improbable that he could defend himself.

Assuming an inspired air, I said, "Be seated and take this soup, and afterwards I will tell you of your good fortune, for know that the Virgin of the Rosary appeared to me at day-break, and bids me pardon you. Thou shalt not die but live, and shalt come out of this place with me." In great wonderment, and kneeling on the ground for want of a chair, he ate the soup with me, and afterwards seated himself on the bed to hear what I had to say. Thus I spoke to him:

"The grief I experienced at your dreadful treason made me pass a sleepless night, as the letters might condemn me to spend here the remnant of my days. My only consolation, I confess, was the certainty that you would die here also before my eyes within three days. Full of this thought not worthy of a Christian (for God bids us forgive our enemies) my weariness made me sleep, and in my sleep I had a vision. I saw that Holy Virgin, Mother of God, whose likeness you behold—I saw her before me, and opening her lips she spoke thus:

"'Soradaci is a devotee of my Holy Rosary. I protect him, and I will that you forgive him, and then the curse he has drawn on himself will cease. In return for your generosity, I will order one of my angels to take the form of man, to come down from heaven, to break open the roof of your prison, and set you free within five or six days. The angel will begin his task this day at two o'clock precisely, and he will work till half an hour before sunset, since he must ascend again into heaven while the daylight lasts. When you come out of this place, take Soradaci with you, and have a care for him if he will renounce his business of spying. Tell him all.'

"With these words the Holy Virgin vanished out of my sight, and I awoke."

I spoke all the while with a serious face and the air of one inspired, and I saw that the traitor was petrified. I then took my Book of Hours, sprinkled the cell with holy water, and pretended to pray, kissing from time to time the picture of the Virgin. An hour afterwards the brute, who so far had not opened his mouth, asked me bluntly at what time the angel would come down from heaven, and if we should hear him breaking in the cell.

"I am certain that he will begin at two o'clock, that we shall hear him at his work, and that he will depart at the hour named by the Holy Virgin."

"You may have dreamt it all."

"Nay, not so. Will you swear to me to spy no more?"

Instead of answering he went off to sleep, and did not awake for two hours after, when he asked if he could put off taking the oath. I asked of him,

"You can put off taking it," I said, "till the angel enters to set me free; but if you do not then renounce by an oath the infamous trade which has brought you here, and which will end by bringing you to the gallows, I shall leave you in the cell, for so the Mother of God commands, and if you do not obey you will lose her protection."

As I had expected, I saw an expression of satisfaction on his hideous features, for he was quite certain that the angel would not come. He looked at me with a pitying air. I longed to hear the hour strike. The play amused me intensely, for I was persuaded that the approach of the angel would set his

miserable wits a-reeling. I was sure, also, that the plan would succeed if Lawrence had not forgotten to give the monk the books, and this was not likely.

An hour before the time appointed I was fain to dine. I only drank water, and Soradaci drank all the wine and consumed all the garlic I had, and thus made himself worse.

As soon as I heard the first stroke of two I fell on my knees, ordering him, in an awful voice, to do the like. He obeyed, looking at me in a dazed way. When I heard the first slight noise I examined, "Lo! the angel cometh!" and fell down on my face, and with a hearty fisticuff forced him into the same position. The noise of breaking was plainly heard, and for a quarter of an hour I kept in that troublesome position, and if the circumstances had been different I should have laughed to see how motionless the creature was; but I restrained myself, remembering my design of completely turning the fellow's head, or at least of obsessing him for a time. As soon as I got up I knelt and allowed him to imitate me, and I spent three hours in saying the rosary to him. From time to time he dozed off, wearied rather by his position than by the monotony of the prayer, but during the whole time he never interrupted me. Now and again he dared to raise a furtive glance towards the ceiling. With a sort of stupor on his face, he turned his head in the direction of the Virgin, and the whole of his behaviour was for me the highest comedy. When I heard the clock strike the hour for the work to cease, I said to him,

"Prostrate thyself, for the angel departeth."

Balbi returned to his cell, and we heard him no more. As I rose to my feet, fixing my gaze on the wretched fellow, I read fright on every feature, and was delighted. I addressed a few words to him that I might see in what state of mind he was. He shed tears in abundance, and what he said was mostly extravagant, his ideas having no sequence or connection. He spoke of his sins, of his acts of devotion, of his zeal in the service of St. Mark, and of the work he had done for the Commonwealth, and to this attributed the special favours Mary had shewn him. I had to put up with a long story about the miracles of the Rosary which his wife, whose confessor was a young Dominican, had told him. He said that he did not know what use I could make of an ignorant fellow like him.

"I will take you into my service, and you shall have all that you need without being obliged to pursue the hazardous trade of a spy."

"Shall we not be able to remain at Venice?"

"Certainly not. The angel will take us to a land which does not belong to St. Mark. Will you swear to me that you will spy no more? And if you swear, will you become a perjurer a second time?"

"If I take the oath, I will surely keep it, of that there can be no doubt; but you must confess that if I had not perjured myself you would never have received such favour at the hands of the Virgin. My broken faith is the cause of your bliss. You ought, therefore, to love me and to be content with my treason."

"Dost love Judas who betrayed Jesus Christ?"

"No."

"You perceive, then, that one detests the traitor and at the same time adores the Divine Providence, which knows how to bring good out of evil. Up to the present time you have done wickedly. You have offended God and the Virgin His Mother, and I will not receive your oath till you have expiated your sins."

"What sin have I done?"

"You have sinned by pride, Soradaci, in thinking that I was under an obligation to you for betraying me and giving my letters to the secretary."

"How shall I expiate this sin?"

"Thus. To-morrow, when Lawrence comes, you must lie on your bed, your face towards the wall, and without the slightest motion or a single glance at Lawrence. If he address you, you must answer, without looking at him, that you could not sleep, and need rest. Do you promise me entirely to do this thing?"

"I will do whatsoever you tell me."

"Quick, then, take your oath before this holy picture."

"I promise, Holy Mother of God, that when Lawrence comes I will not look at him, nor stir from my bed."

"And I, Most Holy Virgin, swear by the bowels of your Divine Son that if I see Soradaci move in the least or look towards Lawrence, I will throw myself straightway upon him and strangle him without mercy, to your honour and glory."

I counted on my threat having at least as much effect upon him as his oath. Nevertheless, as I was anxious to make sure, I asked him if he had anything to say against the oath, and after thinking for a moment he answered that he was quite content with it. Well pleased myself, I gave him something to eat, and told him to go to bed as I needed sleep.

As soon as he was asleep I began to write, and wrote on for two hours. I told Balbi all that had happened, and said that if the work was far enough

advanced he need only come above my cell to put the final stroke to it and break through. I made him note that we should set out on the night of the 31st of October, and that we should be four in all, counting his companion and mine. It was now the twenty-eighth of the month.

In the morning the monk wrote me that the passage was made, and that he should only require to work at the ceiling of my cell to break through the last board and this would be done in four minutes. Soradaci observed his oath, pretending to sleep, and Lawrence said nothing to him. I kept my eyes upon him the whole time, and I verily believe I should have strangled him if he had made the slightest motion towards Lawrence, for a wink would have been enough to betray me.

The rest of the day was devoted to high discourses and exalted expressions, which I uttered as solemnly as I could, and I enjoyed the sight of seeing him become more and more fanatical. To heighten the effect of my mystic exhortation I dosed him heavily with wine, and did not let him go till he had fallen into a drunken sleep.

Though a stranger to all metaphysical speculations, and a man who had never exercised his reasoning faculties except in devising some piece of spy-craft, the fellow confused me for a moment by saying that he could not conceive how an angel should have to take so much trouble to break open our cell. But after lifting my eyes to heaven, or rather to the roof of my dungeon-cell, I said,

"The ways of God are inscrutable; and since the messenger of Heaven works not as an angel (for then a slight single blow would be enough), he works like a man, whose form he has doubtless taken, as we are not worthy to look upon his celestial body. And, furthermore," said I, like a true Jesuit, who knows how to draw advantage from everything, "I foresee that the angel, to punish us for your evil thought, which has offended the Holy Virgin, will not come to-day. Wretch, your thoughts are not those of an honest, pious, and religious man, but those of a sinner who thinks he has to do with Messer-Grande and his myrmidons."

I wanted to drive him to despair, and I had succeeded. He began to weep bitterly, and his sobs almost choked him, when two o'clock struck and not sign of the angel was heard. Instead of calming him I endeavoured to augment his misery by my complaints. The next morning he was obedient to my orders, for when Lawrence asked him how he was, he replied without moving his head. He behaved in the same manner on the day following, and until I saw Lawrence for the last time on the morning of the 31st October. I gave him the book for Barbi, and told the monk to come at noon to break through the

ceiling. I feared nothing, as Lawrence had told me that the Inquisitors and the secretary had already set out for the country. I had no reason to dread the arrival of a new companion, and all I had to do was to manage my knave.

After Lawrence was gone I told Soradaci that the angel would come and make an opening in the ceiling about noon.

"He will bring a pair of scissors with him," I said, "and you will have to cut the angel's beard and mine."

"Has the angel a beard?"

"Yes, you shall see it for yourself. Afterwards we will get out of the cell and proceed to break the roof of the palace, whence we shall descend into St. Mark's Place and set out for Germany."

He answered nothing. He had to eat by himself, for my mind was too much occupied to think about dinner—indeed, I had been unable to sleep.

The appointed hour struck—and the angel came, Soradaci was going to fall down on his face, but I told him it was not necessary. In three minutes the passage was completed, the piece of board fell at my feet, and Father Balbi into my arms. "Your work is ended and mine begun," said I to him. We embraced each other, and he gave me the pike and a pair of scissors. I told Soradaci to cut our beards, but I could not help laughing to see the creature—his mouth all agape-staring at the angel, who was more like a devil. However, though quite beside himself, he cut our beards admirably.

Anxious to see how the land lay, I told the monk to stay with Soradaci, as I did not care to leave him alone, and I went out. I found the hole in the wall narrow, but I succeeded in getting through it. I was above the count's cell, and I came in and greeted the worthy old man. The man before me was not fitted to encounter such difficulties as would be involved in an escape by a steep roof covered with plates of lead. He asked me what my plan was, and told me that he thought I had acted rather inconsiderately. "I only ask to go forward," said I, "till I find death or freedom." "If you intend," he answered, "to pierce the roof and to descend from thence, I see no prospect of success, unless you have wings; and I at all events have not the courage to accompany you. I will remain here, and pray to God on your behalf."

I went out again to look at the roof, getting as close as I could to the sides of the loft. Touching the lower part of the roof, I took up a position between the beams, and feeling the wood with the end of the bar I luckily found them to be half rotten. At every blow of the bar they fell to dust, so feeling certain of my ability to make a large enough hole in less than an hour I returned to my cell, and for four hours employed myself in cutting up sheets, coverlets, and bedding, to make ropes. I took care to make the knots myself and to be

assured of their strength, for a single weak knot might cost us our lives. At last I had ready a hundred fathoms of rope.

In great undertakings there are certain critical points which the leader who deserves to succeed trusts to no one but himself. When the rope was ready I made a parcel of my suit, my cloak, a few shirts, stockings, and handkerchiefs, and the three of us went into the count's cell. The first thing the count did was to congratulate Soradaci on having been placed in the same cell as myself, and on being so soon about to regain his liberty. His air of speechless confusion made me want to laugh. I took no more trouble about him, for I had thrown off the mask of Tartuffe which I had found terribly inconvenient all the time I had worn it for the rascal's sake. He knew, I could see, that he had been deceived, but he understood nothing else, as he could not make out how I could have arranged with the supposed angel to come and go at certain fixed times. He listened attentively to the count, who told us we were going to our destruction, and like the coward that he was, he began to plan how to escape from the dangerous journey. I told the monk to put his bundle together while I was making the hole in the roof by the side of the loft.

At eight o'clock, without needing any help, my opening was made. I had broken up the beams, and the space was twice the size required. I got the plate of lead off in one piece. I could not do it by myself, because it was riveted. The monk came to my aid, and by dint of driving the bar between the gutter and the lead I succeeded in loosening it, and then, heaving at it with our shoulders, we beat it up till the opening was wide enough. On putting my head out through the hole I was distressed to see the brilliant light of the crescent moon then entering in its first quarter. This was a piece of bad luck which must be borne patiently, and we should have to wait till midnight, when the moon would have gone to light up the Antipodes. On such a fine night as this everybody would be walking in St. Mark's Place, and I dared not shew myself on the roof as the moonlight would have thrown a huge shadow of me on the place, and have drawn towards me all eyes, especially those of Messer-Grande and his myrmidons, and our fine scheme would have been brought to nothing by their detestable activity. I immediately decided that we could not escape till after the moon set; in the mean time I prayed for the help of God, but did not ask Him to work any miracles for me. I was at the mercy of Fortune, and I had to take care not to give her any advantages; and if my scheme ended in failure I should be consoled by the thought that I had not made a single mistake. The moon would set at eleven and sunrise was at six, so we had seven hours of perfect darkness at our service; and though we had a hard task, I considered that in seven hours it would be accomplished.

I told Father Balbi that we could pass the three hours in talking to Count Asquin. I requested him to go first and ask the count to lend me thirty sequins, which would be as necessary to me as my pike had been hitherto. He carried my message, and a few minutes after came and asked me to go myself, as the count wished to talk to me alone. The poor old man began by saying with great politeness that I really stood in no need of money to escape, that he had none, that he had a large family, that if I was killed the money would be lost, with a thousand other futilities of the same kind to disguise his avarice, or the dislike he felt to parting with his money. My reply lasted for half an hour, and contained some excellent arguments, which never have had and never will have any force, as the finest weapons of oratory are blunted when used against one of the strongest of the passions. It was a matter of a 'nolenti baculus'; not that I was cruel enough to use force towards an unhappy old man like the count. I ended my speech by saying that if he would flee with us I would carry him upon my back like AEneas carried Anchises; but if he was going to stay in prison to offer up prayers for our success, his prayers would be observed, as it would be a case of praying God to give success when he himself had refused to contribute the most ordinary aid.

He replied by a flood of tears, which affected me. He then asked if two sequins would be enough, and I answered in the affirmative. He then gave them to me begging me to return them to him if after getting on the roof I saw my wisest course would be to come back. I promised to do so, feeling somewhat astonished that he should deem me capable of a retreat. He little knew me, for I would have preferred death to an imprisonment which would have been life-long.

I called my companions, and we set all our baggage near the hole. I divided the hundred fathoms of rope into two packets, and we spent two hours in talking over the chances of our undertaking. The first proof which Father Balbi gave me of his fine character was to tell me, ten times over, that I had broken my word with him, since I had assured him that my scheme was complete and certain, while it was really nothing of the kind. He went so far as to tell me that if he had known as much he would not have taken me from my cell. The count also, with all the weight of his seventy years, told me that I should do well to give up so hazardous an undertaking, in which success was impossible and death probable. As he was a barrister he made me a speech as follows, and I had not much difficulty in guessing that he was inspired by the thought of the two sequins which I should have had to give him back, if he had succeeded in persuading me to stay where I was:

"The incline of the roof covered with lead plates," said he, "will render it impossible for you to walk, indeed you will scarcely be able to stand on your feet. It is true that the roof has seven or eight windows, but they are all barred with iron, and you could not keep your footing near them since they are far from the sides. Your ropes are useless, as you will find nothing whereon to fasten them; and even if you did, a man descending from such a height cannot reach the ground by himself. One of you will therefore have to lower the two others one at a time as one lowers a bucket or a bundle of wood, and he who does so will have to stay behind and go back to his cell. Which of you three has a vocation for this dangerous work of charity? And supposing that one of you is heroic enough to do so, can you tell me on which side you are going to descend? Not by the side towards the palace, for you would be seen; not by the church, as you would find yourselves still shut up, and as to the court side you surely would not think of it, for you would fall into the hands of the 'arsenalotti' who are always going their rounds there. You have only the canal side left, and where is your gondola to take you off? Not having any such thing, you will be obliged to throw yourself in and escape by swimming towards St. Appollonia, which you will reach in a wretched condition, not knowing where to turn to next. You must remember that the leads are slippery, and that if you were to fall into the canal, considering the height of the fall and the shallowness of the water, you would most certainly be killed if you could swim like sharks. You would be crushed to death, for three or four feet of water are not sufficient to counteract the effect of a fall from such a height. In short, the best fate you can expect is to find yourselves on the ground with broken arms and legs."

The effect of this discourse—a very unseasonable one, under the circumstances—was to make my blood boil, but I listened with a patience wholly foreign to my nature. The rough reproaches of the monk enraged me, and inclined me to answer him in his own way; but I felt that my position was a difficult one, and that unless I was careful I might ruin all, for I had to do with a coward quite capable of saying that he was not going to risk his life, and by myself I could not hope to succeed. I constrained myself, therefore, and as politely as I could I told them that I was sure of success, though I could not as yet communicate the details of my plan. "I shall profit by your wise counsels," said I to Count Asquin, "and be very prudent, but my trust in God and in my own strength will carry me through all difficulties."

From time to time I stretched out my hand to assure myself that Soradaci was there, for he did not speak a word. I laughed to myself to think what he might be turning in his head now that he was convinced that I had deceived

him. At half-past ten I told him to go and see what was the position of the moon. He obeyed and returned, saying that in an hour and a-half it would have disappeared, and that there was a thick fog which would make the leads very dangerous.

"All I ask," I said, "is that the fog be not made of oil. Put your cloak in a packet with some of the rope which must be divided equally between us."

At this I was astonished to find him at my knees kissing my hands, and entreating me not to kill him. "I should be sure," said he, "to fall over into the canal, and I should not be of any use to you. Ah! leave me here, and all the night I will pray to St. Francis for you. You can kill me or save me alive; but of this I am determined, never to follow you."

The fool never thought how he had responded to my prayers.

"You are right," I said, "you may stop here on the condition that you will pray to St. Francis; and that you go forthwith and fetch my books, which I wish to leave to the count."

He did so without answering me, doubtless with much joy. My books were worth at least a hundred crowns. The count told me that he would give them back on my return.

"You may be sure," I said, "that you will never see me here again. The books will cover your expenditure of two sequins. As to this rascal, I am delighted, as he cannot muster sufficient courage to come with me. He would be in the way, and the fellow is not worthy of sharing with Father Balbi and myself the honours of so brave a flight."

"That's true," said the count, "provided that he does not congratulate himself to-morrow."

I asked the count to give me pens, ink, and paper, which he possessed in spite of the regulations to the contrary, for such prohibitions were nothing to Lawrence, who would have sold St. Mark himself for a crown. I then wrote the following letter, which I gave to Soradaci, not being able to read it over, as I had written it in the dark. I began by a fine heading, which I wrote in Latin, and which in English would run thus:

"'I shall not die, but live and declare the works of the Lord.'"

"Our lords of state are bound to do all in their power to keep a prisoner under the Leads, and on the other hand the prisoner, who is fortunately not on parole, is bound also to make his escape. Their right to act thus is founded on justice, while the prisoner follows the voice of nature; and since they have not asked him whether he will be put in prison, so he ought not to ask them leave to escape.

"Jacques Casanova, writing in the bitterness of his heart, knows that he may have the ill luck to be recaptured before he succeeds in leaving the Venetian territory and escaping to a friendly state; but if so, he appeals to the humanity of the judges not to add to the misery of the condition from which, yielding to the voice of nature, he is endeavouring to escape. He begs them, if he be taken, to return him whatever may be in his cell, but if he succeed he gives the whole to Francis Soradaci, who is still a captive for want of courage to escape, not like me preferring liberty to life. Casanova entreats their excellencies not to refuse the poor wretch this gift. Dated an hour before midnight, in the cell of Count Asquin, on October 31st, 1756."

I warned Soradaci not to give this letter to Lawrence, but to the secretary in person, who, no doubt, would interrogate him if he did not go himself to the cell, which was the more likely course. The count said my letter was perfect, but that he would give me back all my books if I returned. The fool said he wished to see me again to prove that he would return everything gladly.

But our time was come. The moon had set. I hung the half of the ropes by Father Balbi's neck on one side and his clothes on the other. I did the same to myself, and with our hats on and our coats off we went to the opening.

E quindi uscimmo a rimirar le stelle.—DANTE.

CHAPTER XXX

The Escape I Nearly Lose My Life on the Roof I Get out of
the Ducal Palace, Take a Boat, and Reach the Mainland—
Danger to Which I Am Exposed by Father Balbi—My Scheme for
Ridding Myself of Him

I got out the first, and Father Balbi followed me. Soradaci who had come
as far as the opening, had orders to put the plate of lead back in its place, and
then to go and pray to St. Francis for us. Keeping on my hands and knees, and
grasping my pike firmly I pushed it obliquely between the joining of the plates
of lead, and then holding the side of the plate which I had lifted I succeeded
in drawing myself up to the summit of the roof. The monk had taken hold of
my waistband to follow me, and thus I was like a beast of burden who has to
carry and draw along at the same time; and this on a steep and slippery roof.

When we were half-way up the monk asked me to stop, as one of his
packets had slipped off, and he hoped it had not gone further than the gutter.
My first thought was to give him a kick and to send him after his packet, but,
praised be to God! I had sufficient self-control not to yield to it, and indeed
the punishment would have been too heavy for both of us, as I should have
had no chance of escaping by myself. I asked him if it were the bundle of rope,
and on his replying that it was a small packet of his own containing
manuscript he had found in one of the garrets under the Leads, I told him he
must bear it patiently, as a single step might be our destruction. The poor
monk gave a sigh, and he still clinging to my waist we continued climbing.

After having surmounted with the greatest difficulty fifteen or sixteen
plates we got to the top, on which I sat astride, Father Balbi imitating my
example. Our backs were towards the little island of St. George the Greater,
and about two hundred paces in front of us were the numerous cupolas of St.
Mark's Church, which forms part of the ducal palace, for St. Mark's is really
the Doge's private chapel, and no monarch in the world can boast of having
a finer. My first step was to take off my bundle, and I told my companion to
do the same. He put the rope as best he could upon his thighs, but wishing to
take off his hat, which was in his way, he took hold of it awkwardly, and it
was soon dancing from plate to plate to join the packet of linen in the gutter.
My poor companion was in despair.

"A bad omen," he exclaimed; "our task is but begun and here am I deprived
of shirt, hat, and a precious manuscript, containing a curious account of the
festivals of the palace."

I felt calmer now that I was no longer crawling on hands and knees, and I told him quietly that the two accidents which had happened to him had nothing extraordinary in them, and that not even a superstitious person would call them omens, that I did not consider them in that light, and that they were far from damping my spirits.

"They ought rather," said I, "to warn you to be prudent, and to remind you that God is certainly watching over us, for if your hat had fallen to the left instead of to the right, we should have been undone; as in that case it would have fallen into the palace court, where it would have caught the attention of the guards, and have let them know that there was someone on the roof; and in a few minutes we should have been retaken."

After looking about me for some time I told the monk to stay still till I came back, and I set out, my pike in my hand, sitting astride the roof and moving along without any difficulty. For nearly an hour I went to this side and that, keeping a sharp look-out, but in vain; for I could see nothing to which the rope could be fastened, and I was in the greatest perplexity as to what was to be done. It was of no use thinking of getting down on the canal side or by the court of the palace, and the church offered only precipices which led to nothing. To get to the other side of the church towards the Canonica, I should have had to climb roofs so steep that I saw no prospect of success. The situation called for hardihood, but not the smallest piece of rashness.

It was necessary, however, either to escape, or to reenter the prison, perhaps never again to leave it, or to throw myself into the canal. In such a dilemma it was necessary to leave a good deal to chance, and to make a start of some kind. My eye caught a window on the canal sides, and two-thirds of the distance from the gutter to the summit of the roof. It was a good distance from the spot I had set out from, so I concluded that the garret lighted by it did not form part of the prison I had just broken. It could only light a loft, inhabited or uninhabited, above some rooms in the palace, the doors of which would probably be opened by day-break. I was morally sure that if the palace servants saw us they would help us to escape, and not deliver us over to the Inquisitors, even if they recognized us as criminals of the deepest dye; so heartily was the State Inquisition hated by everyone.

It was thus necessary for me to get in front of the window, and letting myself slide softly down in a straight line I soon found myself astride on top of the dormer-roof. Then grasping the sides I stretched my head over, and succeeded in seeing and touching a small grating, behind which was a window of square panes of glass joined with thin strips of lead. I did not trouble myself

about the window, but the grating, small as it was, appeared an insurmountable difficulty, failing a file, and I had only my pike.

I was thoroughly perplexed, and was beginning to lose courage, when an incident of the simplest and most natural kind came to my aid and fortified my resolution.

Philosophic reader, if you will place yourself for a moment in my position, if you will share the sufferings which for fifteen months had been my lot, if you think of my danger on the top of a roof, where the slightest step in a wrong direction would have cost me my life, if you consider the few hours at my disposal to overcome difficulties which might spring up at any moment, the candid confession I am about to make will not lower me in your esteem; at any rate, if you do not forget that a man in an anxious and dangerous position is in reality only half himself.

It was the clock of St. Mark's striking midnight, which, by a violent shock, drew me out of the state of perplexity I had fallen into. The clock reminded me that the day just beginning was All Saints' Day—the day of my patron saint (at least if I had one)—and the prophecy of my confessor came into my mind. But I confess that what chiefly strengthened me, both bodily and mentally, was the profane oracle of my beloved Ariosto: 'Fra il fin d'ottobre, a il capo di novembre'.

The chime seemed to me a speaking talisman, commanding me to be up and doing,—and—promising me the victory. Lying on my belly I stretched my head down towards the grating, and pushing my pike into the sash which held it I resolved to take it out in a piece. In a quarter of an hour I succeeded, and held the whole grate in my hands,—and putting it on one side I easily broke the glass window, though wounding my left hand.

With the aid of my pike, using it as I had done before, I regained the ridge of the roof, and went back to the spot where I had left Balbi. I found him enraged and despairing, and he abused me heartily for having left him for so long. He assured me that he was only waiting for it to get light to return to the prison.

"What did you think had become of me?"

"I thought you must have fallen over."

"And you can find no better way than abuse to express the joy you ought to feel at seeing me again?"

"What have you been doing all this time?"

"Follow me, and you shall see."

I took up my packets again and made my way towards the window. As soon as were opposite to it I told Balbi what I had done, and asked him if he could

think of any way of getting into the loft. For one it was easy enough, for the other could lower him by the rope; but I could not discover how the second of us was to get down afterwards, as there was nothing to which the rope could be fastened. If I let myself fall I might break my arms and legs, for I did not know the distance between the window and the floor of the room. To this chain of reasoning uttered in the friendliest possible tone, the brute replied thus:

"You let me down, and when I have got to the bottom you will have plenty of time to think how you are going to follow me."

I confess that my first indignant impulse was to drive my pike into his throat. My good genius stayed my arm, and I uttered not a word in reproach of his base selfishness. On the contrary, I straightway untied my bundle of rope and bound him strongly under the elbows, and making him lie flat down I lowered him feet foremost on to the roof of the dormer-window. When he got there I told him to lower himself into the window as far as his hips, supporting himself by holding his elbows against the sides of the window. As soon as he had done so, I slid down the roof as before, and lying down on the dormer-roof with a firm grasp of the rope I told the monk not to be afraid but to let himself go. When he reached the floor of the loft he untied himself, and on drawing the rope back I found the fall was one of fifty feet-too dangerous a jump to be risked. The monk who for two hours had been a prey to terror; seated in a position which I confess was not a very reassuring one, was not quite cool, and called out to me to throw him the ropes for him to take care of—a piece of advice you may be sure I took care not to follow.

Not knowing what to do next, and waiting for some fortunate idea, I made my way back to the ridge of the roof, and from there spied out a corner near a cupola; which I had not visited. I went towards it and found a flat roof, with a large window closed with two shutters. At hand was a tubful of plaster, a trowel, and ladder which I thought long enough for my purpose. This was enough, and tying my rope to the first round I dragged this troublesome burden after me to the window. My next task was to get the end of the ladder (which was twelve fathoms long) into the opening, and the difficulties I encountered made me sorry that I had deprived myself of the aid of the monk. [The unit of measure:'fathoms' describing the ladder and earlier the 100 fathoms of rope, is likely a translation error: Casanova might have manufactured 100 feet of rope and might have dragged a 12 foot ladder up the steep roof, but not a longer. D.W.]

I had set the ladder in such a way that one end touched the window, and the other went below the gutter. I next slid down to the roof of the window,

and drawing the ladder towards me I fastened the end of my rope to the eighth round, and then let it go again till it was parallel with the window. I then strove to get it in, but I could not insert it farther than the fifth round, for the end of the ladder being stopped by the inside roof of the window no force on earth could have pushed it any further without breaking either the ladder or the ceiling. There was nothing to be done but to lift it by the other end; it would then slip down by its own weight. I might, it is true, have placed the ladder across the window, and have fastened the rope to it, in which manner I might have let myself down into the loft without any risk; but the ladder would have been left outside to shew Lawrence and the guards where to look for us and possibly to find us in the morning.

I did not care to risk by a piece of imprudence the fruit of so much toil and danger, and to destroy all traces of our whereabouts the ladder must be drawn in. Having no one to give me a helping hand, I resolved to go myself to the parapet to lift the ladder and attain the end I had in view. I did so, but at such a hazard as had almost cost me my life. I could let go the ladder while I slackened the rope without any fear of its falling over, as it had caught to the parapet by the third rung. Then, my pike in my hand, I slid down beside the ladder to the parapet, which held up the points of my feet, as I was lying on my belly. In this position I pushed the ladder forward, and was able to get it into the window to the length of a foot, and that diminished by a good deal its weight. I now only had to push it in another two feet, as I was sure that I could get it in altogether by means of the rope from the roof of the window. To impel the ladder to the extent required I got on my knees, but the effort I had to use made me slip, and in an instant I was over the parapet as far as my chest, sustained by my elbows.

I shudder still when I think of this awful moment, which cannot be conceived in all its horror. My natural instinct made me almost unconsciously strain every nerve to regain the parapet, and—I had nearly said miraculously—I succeeded. Taking care not to let myself slip back an inch I struggled upwards with my hands and arms, while my belly was resting on the edge of the parapet. Fortunately the ladder was safe, for with that unlucky effort which had nearly cost me so dearly I had pushed it in more than three feet, and there it remained.

Finding myself resting on my groin on the parapet, I saw that I had only to lift up my right leg and to put up first one knee and then the other to be absolutely out of danger; but I had not yet got to the end of my trouble. The effort I made gave me so severe a spasm that I became cramped and unable to use my limbs. However, I did not lose my head, but kept quiet till the pain

had gone off, knowing by experience that keeping still is the best cure for the false cramp. It was a dreadful moment! In two minutes I made another effort, and had the good fortune to get my two knees on to the parapet, and as soon as I had taken breath I cautiously hoisted the ladder and pushed it half-way through the window. I then took my pike, and crawling up as I had done before I reached the window, where my knowledge of the laws of equilibrium and leverage aided me to insert the ladder to its full length, my companion receiving the end of it. I then threw into the loft the bundles and the fragments that I had broken off the window, and I stepped down to the monk, who welcomed me heartily and drew in the ladder. Arm in arm, we proceeded to inspect the gloomy retreat in which we found ourselves, and judged it to be about thirty paces long by twenty wide.

At one end were folding-doors barred with iron. This looked bad, but putting my hand to the latch in the middle it yielded to the pressure, and the door opened. The first thing we did was to make the tour of the room, and crossing it we stumbled against a large table surrounded by stools and armchairs. Returning to the part where we had seen windows, we opened the shutters of one of them, and the light of the stars only shewed us: the cupolas and the depths beneath them. I did not think for a moment of lowering myself down, as I wished to know where I was going, and I did not recognize our surroundings. I shut the window up, and we returned to the place where we had left our packages. Quite exhausted I let myself fall on the floor, and placing a bundle of rope under my head a sweet sleep came to my, relief. I abandoned myself to it without resistance, and indeed, I believe if death were to have been the result, I should have slept all the same, and I still remember how I enjoyed that sleep.

It lasted for three and a half hours, and I was awakened by the monk's calling out and shaking me. He told me that it had just struck five. He said it was inconceivable to him how I could sleep in the situation we were in. But that which was inconceivable to him was not so to me. I had not fallen asleep on purpose, but had only yielded to the demands of exhausted nature, and, if I may say so, to the extremity of my need. In my exhaustion there was nothing to wonder at, since I had neither eaten nor slept for two days, and the efforts I had made—efforts almost beyond the limits of mortal endurance—might well have exhausted any man. In my sleep my activity had come back to me, and I was delighted to see the darkness disappearing, so that we should be able to proceed with more certainty and quickness.

Casting a rapid glance around, I said to myself, "This is not a prison, there ought, therefore, be some easy exit from it." We addressed ourselves to the

end opposite to the folding-doors, and in a narrow recess I thought I made out a doorway. I felt it over and touched a lock, into which I thrust my pike, and opened it with three or four heaves. We then found ourselves in a small room, and I discovered a key on a table, which I tried on a door opposite to us, which, however, proved to be unlocked. I told the monk to go for our bundles, and replacing the key we passed out and came into a gallery containing presses full of papers. They were the state archives. I came across a short flight of stone stairs, which I descended, then another, which I descended also, and found a glass door at the end, on opening which I entered a hall well known to me: we were in the ducal chancery. I opened a window and could have got down easily, but the result would have been that we should have been trapped in the maze of little courts around St. Mark's Church. I saw on a desk an iron instrument, of which I took possession; it had a rounded point and a wooden handle, being used by the clerks of the chancery to pierce parchments for the purpose of affixing the leaden seals. On opening the desk I saw the copy of a letter advising the Proveditore of Corfu of a grant of three thousand sequins for the restoration of the old fortress. I searched for the sequins but they were not there. God knows how gladly I would have taken them, and how I would have laughed the monk to scorn if he had accused me of theft! I should have received the money as a gift from Heaven, and should have regarded myself as its master by conquest.

Going to the door of the chancery, I put my bar in the keyhole, but finding immediately that I could not break it open, I resolved on making a hole in the door. I took care to choose the side where the wood had fewest knots, and working with all speed I struck as hard and as cleaving strokes as I was able. The monk, who helped me as well as he could with the punch I had taken from the desk, trembled at the echoing clamour of my pike which must have been audible at some distance. I felt the danger myself, but it had to be risked.

In half an hour the hole was large enough—a fortunate circumstance, for I should have had much trouble in making it any larger without the aid of a saw. I was afraid when I looked at the edges of the hole, for they bristled with jagged pieces of wood which seemed made for tearing clothes and flesh together. The hole was at a height of five feet from the ground. We placed beneath it two stools, one beside the other, and when we had stepped upon them the monk with arms crossed and head foremost began to make his way through the hole, and taking him by the thighs, and afterwards by the legs, I succeeded in pushing him through, and though it was dark I felt quite secure, as I knew the surroundings. As soon as my companion had reached the other side I threw him my belongings, with the exception of the ropes, which I left

behind, and placing a third stool on the two others, I climbed up, and got through as far as my middle, though with much difficulty, owing to the extreme narrowness of the hole. Then, having nothing to grasp with my hands, nor anyone to push me as I had pushed the monk, I asked him to take me, and draw me gently and by slow degrees towards him. He did so, and I endured silently the fearful torture I had to undergo, as my thighs and legs were torn by the splinters of wood.

As soon as I got through I made haste to pick up my bundle of linen, and going down two flights of stairs I opened without difficulty the door leading into the passage whence opens the chief door to the grand staircase, and in another the door of the closet of the 'Savio alla scrittura'. The chief door was locked, and I saw at once that, failing a catapult or a mine of gunpowder, I could not possibly get through. The bar I still held seemed to say, "Hic fines posuit. My use is ended and you can lay me down." It was dear to me as the instrument of freedom, and was worthy of being hung as an 'ex voto' on the altar of liberty.

I sat down with the utmost tranquillity, and told the monk to do the same. "My work is done," I said, "the rest must be left to God and fortune.

"Abbia chi regge il ciel cura del resto, O la fortuna se non tocca a lui.

"I do not know whether those who sweep out the palace will come here to-day, which is All Saints' Day, or tomorrow, All Souls' Day. If anyone comes, I shall run out as soon as the door opens, and do you follow after me; but if nobody comes, I do not budge a step, and if I die of hunger so much the worse for me."

At this speech of mine he became beside himself. He called me a madman, seducer, deceiver, and a liar. I let him talk, and took no notice. It struck six; only an hour had passed since I had my awakening in the loft.

My first task was to change my clothes. Father Balbi looked like a peasant, but he was in better condition than I, his clothes were not torn to shreds or covered with blood, his red flannel waistcoat and purple breeches were intact, while my figure could only inspire pity or terror, so bloodstained and tattered was I. I took off my stockings, and the blood gushed out of two wounds I had given myself on the parapet, while the splinters in the hole in the door had torn my waistcoat, shirt, breeches, legs and thighs. I was dreadfully wounded all over my body. I made bandages of handkerchiefs, and dressed my wounds as best I could, and then put on my fine suit, which on a winter's day would look odd enough. Having tied up my hair, I put on white stockings, a laced shirt, failing any other, and two others over it, and then stowing away some stockings and handkerchiefs in my pockets, I threw everything else into a

corner of the room. I flung my fine cloak over the monk, and the fellow looked as if he had stolen it. I must have looked like a man who has been to a dance and has spent the rest of the night in a disorderly house, though the only foil to my reasonable elegance of attire was the bandages round my knees.

In this guise, with my exquisite hat trimmed with Spanish lace and adorned with a white feather on my head, I opened a window. I was immediately remarked by some lounger in the palace court, who, not understanding what anyone of my appearance was doing there at such an early hour, went to tell the door-keeper of the circumstance. He, thinking he must have locked somebody in the night before, went for his keys and came towards us. I was sorry to have let myself be seen at the window, not knowing that therein chance was working for our escape, and was sitting down listening to the idle talk of the monk, when I heard the jingling of keys. Much perturbed I got up and put my eye to a chink in the door, and saw a man with a great bunch of keys in his hand mounting leisurely up the stairs. I told the monk not to open his mouth, to keep well behind me, and to follow my steps. I took my pike, and concealing it in my right sleeve I got into a corner by the door, whence I could get out as soon as it was opened and run down the stairs. I prayed that the man might make no resistance, as if he did I should be obliged to fell him to the earth, and I determined to do so.

The door opened; and the poor man as soon as he saw me seemed turned to a stone. Without an instant's delay and in dead silence, I made haste to descend the stairs, the monk following me. Avoiding the appearance of a fugitive, but walking fast, I went by the giants' Stairs, taking no notice of Father Balbi, who kept cabling: out "To the church! to the church!"

The church door was only about twenty paces from the stairs, but the churches were no longer sanctuaries in Venice; and no one ever took refuge in them. The monk knew this, but fright had deprived him of his faculties. He told me afterwards that the motive which impelled him to go to the church was the voice of religion bidding him seek the horns of the altar.

"Why didn't you go by yourself?" said I.

"I did not, like to abandon you," but he should rather have said, "I did not like to lose the comfort of your company."

The safety I sought was beyond the borders of the Republic, and thitherward I began to bend my steps. Already there in spirit, I must needs be there in body also. I went straight towards the chief door of the palace, and looking at no one that might be tempted to look at me I got to the canal and

entered the first gondola that I came across, shouting to the boatman on the poop,

"I want to go to Fusina; be quick and, call another gondolier."

This was soon done, and while the gondola was being got off I sat down on the seat in the middle, and Balbi at the side. The odd appearance of the monk, without a hat and with a fine cloak on his shoulders, with my unseasonable attire, was enough to make people take us for an astrologer and his man.

As soon as we had passed the custom-house, the gondoliers began to row with a will along the Giudecca Canal, by which we must pass to go to Fusina or to Mestre, which latter place was really our destination. When we had traversed half the length of the canal I put my head out, and said to the waterman on the poop,

"When do you think we shall get to Mestre?"

"But you told me to go to Fusina."

"You must be mad; I said Mestre."

The other boatman said that I was mistaken, and the fool of a monk, in his capacity of zealous Christian and friend of truth, took care to tell me that I was wrong. I wanted to give him a hearty kick as a punishment for his stupidity, but reflecting that common sense comes not by wishing for it I burst into a peal of laughter, and agreed that I might have made a mistake, but that my real intention was to go to Mestre. To that they answered nothing, but a minute after the master boatman said he was ready to take me to England if I liked.

"Bravely spoken," said I, "and now for Mestre, ho!" "We shall be there in three quarters of an hour, as the wind and tide are in our favour."

Well pleased I looked at the canal behind us, and thought it had never seemed so fair, especially as there was not a single boat coming our way. It was a glorious morning, the air was clear and glowing with the first rays of the sun, and my two young watermen rowed easily and well; and as I thought over the night of sorrow, the dangers I had escaped, the abode where I had been fast bound the day before, all the chances which had been in my favour, and the liberty of which I now began to taste the sweets, I was so moved in my heart and grateful to my God that, well nigh choked with emotion, I burst into tears.

My nice companion who had hitherto only spoken to back up the gondoliers, thought himself bound to offer me his consolations. He did not understand why I was weeping, and the tone he took made me pass from sweet affliction to a strange mirthfulness which made him go astray once

more, as he thought I had got mad. The poor monk, as I have said, was a fool, and whatever was bad about him was the result of his folly. I had been under the sad necessity of turning him to account, but though without intending to do so he had almost been my ruin. It was no use trying to make him believe that I had told the gondoliers to go to Fusina whilst I intended to go to Mestre; he said I could not have thought of that till I got on to the Grand Canal.

In due course we reached Mestre. There were no horses to ride post, but I found men with coaches who did as well, and I agreed with one of them to take me to Trevisa in an hour and a quarter. The horses were put in in three minutes, and with the idea that Father Balbi was behind me I turned round to say "Get up," but he was not there. I told an ostler to go and look for him, with the intention of reprimanding him sharply, even if he had gone for a necessary occasion, for we had no time to waste, not even thus. The man came back saying he could not find' him, to my great rage and indignation. I was tempted to abandon him, but a feeling of humanity restrained me. I made enquiries all round; everybody had seen him, but not a soul knew where he was. I walked along the High Street, and some instinct prompting me to put my head in at the window of a cafe. I saw the wretched man standing at the bar drinking chocolate and making love to the girl. Catching sight of me, he pointed to the girl and said—

"She's charming," and then invited me to take a cup of chocolate, saying that I must pay, as he hadn't a penny. I kept back my wrath and answered,

"I don't want any, and do you make haste!" and caught hold of his arm in such sort that he turned white with pain. I paid the money and we went out. I trembled with anger. We got into our coach, but we had scarcely gone ten paces before I recognised: an inhabitant, of Mestre named Balbi Tommasi, a good sort of man; but reported to be one of the familiars of the Holy Office. He knew me, too, and coming up called out,

"I am delighted to see you here. I suppose you have just escaped. How did you do it?"

"I have not escaped, but have been set at liberty."

"No, no, that's not possible, as I was at M. Grimani's yesterday evening, and I should have heard of it."

It will be easier for the reader to imagine my state of mind than for me to describe it. I was discovered by a man whom I believed to be a hired agent of the Government, who only had to give a glance to one of the sbirri with whom Mestre swarmed to have me arrested. I told him to speak softly, and getting down I asked him to come to one side. I took him behind a house, and

seeing that there was nobody in sight, a ditch in front, beyond which the open country extended, I grasped my pike and took him by the neck. At this: he gave a struggle, slipped out of my hands, leapt over the ditch, and without turning round set off to run at, full speed. As soon as he was some way off he slackened his course, turned round and kissed his hand to me, in token of wishing me a prosperous journey. And as soon; as he was out of my sight I gave thanks to God that, this man by his quickness had preserved me from the commission of a crime, for I would have killed him; and he, as it turned out, bore me no ill will.

I was in a terrible position. In open war with all the powers of-the Republic, everything had to give way to my safety, which made me neglect no means of attaining my ends.

With the gloom of a man who has passed through a great peril, I gave a glance of contempt towards the monk, who now saw to what danger he had exposed us, and then got up again into the carriage. We reached Trevisa without further adventure, and I told the posting-master to get me a carriage and two horses ready by ten o'clock; though I had no intention of continuing my journey along the highway, both because. I lacked means; and because I feared pursuit. The inn-keeper asked me, if I would take any breakfast, of which I stood in great need, for I was dying with hunger, but I did not dare to, accept his offer, as a quarter of an hour's delay might, prove fatal. I was afraid of being retaken, and of being ashamed of it for the rest of my life; for a man of sense ought to be able to snap his fingers at four hundred thousand men in the open country, and if he cannot escape capture he must be a fool.

I went out by St. Thomas's Gate as if I was going for a short walk, and after walking for a mile on the highway I struck into the fields, resolving not to leave them as long as I should be within the borders of the Republic. The shortest way was by Bassano, but I took the longer path, thinking I might possibly be expected on the more direct road, while they would never think of my leaving the Venetian territory by way of Feltre, which is the longest way of getting into the state subject to the Bishop of Trent.

After walking for three hours I let myself drop to the ground, for I could not move a step further. I must either take some food or die there, so I told the monk to leave the cloak with me and go to a farm I saw, there to buy something to eat. I gave him the money, and he set off, telling me that he thought I had more courage. The miserable man did not know what courage was, but he was more robust than myself, and he had, doubtless, taken in provisions before leaving the prison. Besides he had had some chocolate; he was thin and wiry, and a monk, and mental anxieties were unknown to him.

Although the house was not an inn, the good farmer's wife sent me a sufficient meal which only cost me thirty Venetian sous. After satisfying my appetite, feeling that sleep was creeping on me, I set out again on the tramp, well braced up. In four hours' time I stopped at a hamlet, and found that I was twenty-four miles from Trevisa. I was done up, my ankles were swollen, and my shoes were in holes. There was only another hour of day-light before us. Stretching myself out beneath a grove of trees I made Father Balbi sit by me, and discoursed to him in the manner following:

"We must make for Borgo di Valsugano, it is the first town beyond the borders of the Republic. We shall be as safe there as if we were in London, and we can take our ease for awhile; but to get there we must go carefully to work, and the first thing we must do is to separate. You must go by Mantello Woods, and I by the mountains; you by the easiest and shortest way, and I by the longest and most difficult; you with money and I without a penny. I will make you a present of my cloak, which you must exchange for a great coat and a hat, and everybody will take you for a countryman, as you are luckily rather like one in the face. Take these seventeen livres, which is all that remains to me of the two sequins Count Asquin gave me. You will reach Borgo by the day after to-morrow, and I shall be twenty-four hours later. Wait for me in the first inn on the left-hand side of the street, and be sure I shall come in due season. I require a good night's rest in a good bed; and Providence will get me one somewhere, but I must sleep without fear of being disturbed, and in your company that would be out of the question. I am certain that we are being sought for on all sides, and that our descriptions have been so correctly given that if we went into any inn together we should be certain to be arrested. You see the state I am in, and my urgent necessity for a ten hours' rest. Farewell, then, do you go that way and I will take this, and I will find somewhere near here a rest for the sole of my foot."

"I have been expecting you to say as much," said Father Balbi, "and for answer I will remind you of the promise you gave me when I let myself be persuaded to break into your cell. You promised me that we should always keep company; and so don't flatter yourself that I shall leave you, your fate and mine are linked together. We shall be able to get a good refuge for our money, we won't go to the inns, and no one will arrest us."

"You are determined, are you, not to follow the good advice I have given you?"

"I am."

"We shall see about that."

I rose to my feet, though with some difficulty, and taking the measure of his height I marked it out upon the ground, then drawing my pike from my pocket, I proceeded with the utmost coolness to excavate the earth, taking no notice of the questions the monk asked me. After working: for a quarter of an hour I set myself to gaze sadly upon him, and I told him that I felt obliged as a Christian to warn him to commend his soul to God, "since I am about to bury you here, alive or dead; and if you prove the stronger, you will bury me. You can escape if you wish to, as I shall not pursue you."

He made no reply, and I betook myself to my work again, but I confess that I began to be afraid of being rushed to extremities by this brute, of whom I was determined to rid myself.

At last, whether convinced by my arguments or afraid Of my pike, he came towards me. Not guessing. What he was about, I presented the point of my pike towards him, but I had nothing to fear.

"I will do what you want," said he.

I straightway gave him all the money I had, and promising to rejoin him at Borgo I bade him farewell. Although I had not a penny in my pocket and had two rivers to cross over, I congratulated myself on having got rid of a man of his character, for by myself I felt confident of being able to cross the bounds of the Republic.

CHAPTER XXXI

I Find a Lodging in the House of the Chief of the Sbirri—I
Pass a Good Night There and Recover My Strength—I Go to
Mass—A Disagreeable Meeting I Am Obliged to Take Six
Sequins by Force—Out of Danger—Arrived at Munich—Balbi I
Set Out for Paris—My Arrival—Attempt on the Life of Louis
XV

As soon as I saw Father Balbi far enough off I got up, and seeing at a little distance a shepherd keeping his flock on the hill-side, I made my way towards him to obtain such information as I needed. "What is the name of this village, my friend?" said I.

"Valde Piadene, signor," he answered, to my surprise, for I found I was much farther on my way that I thought. I next asked him the owners of five or six houses which I saw scattered around, and the persons he mentioned chanced to be all known to me, but were not the kind of men I should have cared to trouble with my presence. On my asking him the name of a palace before me, he said it belonged to the Grimanis, the chief of whom was a State Inquisitor, and then resident at the palace, so I had to take care not to let him see me. Finally, an my enquiring the owner of a red house in the distance, he told me, much to my surprise, that it belonged to the chief of the sbirri. Bidding farewell to the kindly shepherd I began to go down the hill mechanically, and I am still puzzled to know what instinct directed my steps towards that house, which common sense and fear also should have made me shun. I steered my course for it in a straight line, and I can say with truth that I did so quite unwittingly. If it be true that we have all of us an invisible intelligence—a beneficent genius who guides our steps aright—as was the case with Socrates, to that alone I should attribute the irresistible attraction which drew me towards the house where I had most to dread. However that may be, it was the boldest stroke I have played in my whole life.

I entered with an easy and unconstrained air, and asked a child who was playing at top in the court-yard where his father was. Instead of replying, the child went to call his mother, and directly afterwards appeared a pretty woman in the family way, who politely asked me my business with her husband, apologizing for his absence.

"I am sorry," I said, "to hear that my gossip is not in, though at the same time I am delighted to make the acquaintance of his charming wife."

"Your gossip? You will be M. Vetturi, then? My husband told me that you had kindly promised to be the god-father of our next child. I am delighted to know you, but my husband will be very vexed to have been away:

"I hope he will soon return, as I wanted to ask him for a night's lodging. I dare not go anywhere in the state you see me."

"You shall have the best bed in the house, and I will get you a good supper. My husband when he comes back will thank your excellence for doing us so much honour. He went away with all his people an hour ago, and I don't expect him back for three or four days."

"Why is he away for such a long time, my dear madam?"

"You have not heard, then, that two prisoners have escaped from The Leads? One is a noble and the other a private individual named Casanova. My husband has received a letter from Messer-Grande ordering him to make a search for them; if he find them he will take them back to Venice, and if not he will return here, but he will be on the look-out for three days at least."

"I am sorry for this accident, my dear madam, but I should not like to put you out, and indeed I should be glad to lie down immediately."

"You shall do so, and my mother shall attend to your wants. But what is the matter with your knees?"

"I fell down whilst hunting on the mountains, and gave myself some severe wounds, and am much weakened by loss of blood."

"Oh! my poor gentleman, my poor gentleman! But my mother will cure you."

She called her mother, and having told her of my necessities she went out. This pretty sbirress had not the wit of her profession, for the story I had told her sounded like a fairy-tale. On horseback with white silk stockings! Hunting in sarcenet, without cloak and without a man! Her husband would make fine game of her when he came back; but God bless her for her kind heart and benevolent stupidity. Her mother tended me with all the politeness I should have met with in the best families. The worthy woman treated me like a mother, and called me "son" as she attended to my wounds. The name sounded pleasantly in my ears, and did no little towards my cure by the sentiments it awoke in my breast. If I had been less taken up with the position I was in I should have repaid her care with some evident marks of the gratitude I felt, but the place I was in and the part I was playing made the situation too serious a one for me to think of anything else.

This kindly woman, after looking at my knees and my thighs, told me that I must make my mind to suffer a little pain, but I might be sure of being cured by the morning. All I had to do was to bear the application of medicated linen

to my wounds, and not to stir till the next day. I promised to bear the pain patiently, and to do exactly as she told me.

I was given an excellent supper, and I ate and drank with good appetite. I then gave myself up to treatment, and fell asleep whilst my nurse was attending to me. I suppose she undressed me as she would a child, but I remembered nothing about it when I woke up—I was, in fact, totally unconscious. Though I had made a good supper I had only done so to satisfy my craving for food and to regain my strength, and sleep came to me with an irresistible force, as my physical exhaustion did not leave me the power of arguing myself out of it. I took my supper at six o'clock in the evening, and I heard six striking as I awoke. I seemed to have been enchanted. Rousing myself up and gathering my wits together, I first took off the linen bandages, and I was astonished to find my wounds healed and quite free from pain. I did my hair, dressed myself in less than five minutes, and finding the door of my room open I went downstairs, crossed the court, and left the house behind me, without appearing to notice two individuals who were standing outside, and must have been sbirri. I made haste to lengthen the distance between me and the place where I had found the kindliest hospitality, the utmost politeness, the most tender care, and best of all, new health and strength, and as I walked I could not help feeling terrified at the danger I had been in. I shuddered involuntarily; and at the present moment, after so many years, I still shudder when I think of the peril to which I had so heedlessly exposed myself. I wondered how I managed to go in, and still more how I came out; it seemed absurd that I should not be followed. For five hours I tramped on, keeping to the woods and mountains, not meeting a soul besides a few countryfolk, and turning neither to the right nor left.

It was not yet noon, when, as I went along my way, I stopped short at the sound of a bell. I was on high ground, and looking in the direction from which the sound came I saw, a little church in the valley, and many, people going towards it to hear mass. My heart desired to express thankfulness for the protection of Providence, and, though all nature was a temple worthy of its Creator, custom drew me to the church. When men are in trouble, every passing thought seems an inspiration. It was All Souls' Day. I went down the hill, and came into the church, and saw, to my astonishment, M. Marc Antoine Grimani, the nephew of the State Inquisitor, with Madame Marie Visani, his wife. I made my bow; which was returned, and after I had heard mass I left the church. M. Grimani followed me by himself, and when he had got near me, called me by name, saying, "What are you doing here, Casanova, and what has become of your friend?"

"I have given him what little money I had for him to escape by another road, whilst I, without a penny in my pocket, am endeavouring to reach a place of safety by this way. If your excellence would kindly give me some help, it would speed my journey for me."

"I can't give you anything, but you will find recluses on your way who won't let you die of hunger. But tell me how you contrived to pierce the roof of The Leads."

"The story is an interesting one, but it would take up too much time, and in the meanwhile the recluses might eat up the food which is to keep me from dying of hunger."

With this sarcasm I made him a profound bow, and went upon my way. In spite of my great want, his refusal pleased me, as it made me think myself a better gentleman than the "excellence" who had referred me to the charity of recluses. I heard at Paris afterwards that when his wife heard of it she reproached him for his hard-hearted behaviour. There can be no doubt that kindly and generous feelings are more often to be found in the hearts of women than of men.

I continued my journey till sunset. Weary and faint with hunger I stopped at a good-looking house, which stood by itself. I asked to speak to the master, and the porter told me that he was not in as he had gone to a wedding on the other side of the river, and would be away for two days, but that he had bidden him to welcome all his friends while he was away. Providence! luck! chance! whichever you like.

I went in and was treated to a good supper and a good bed. I found by the addresses of some letters which were lying about that I was being entertained in the house of M. Rombenchi—a consul, of what nation I know not. I wrote a letter to him and sealed it to await his return. After making an excellent supper and having had a good sleep, I rose, and dressing myself carefully set out again without being able to leave the porter any mark of my gratitude, and shortly afterwards crossed the river, promising to pay when I came back. After walking for five hours I dined in a monastery of Capuchins, who are very useful to people in my position. I then set out again, feeling fresh and strong, and walked along at a good pace till three o'clock. I halted at a house which I found from a countryman belonged to a friend of mine. I walked in, asked if the master was at home, and was shewn into a room where he was writing by himself. I stepped forward to greet him, but as soon as he saw me he seemed horrified and bid me be gone forthwith, giving me idle and insulting reasons for his behaviour. I explained to him how I was situated, and asked him to let me have sixty sequins on my note of hand, drawn on M. de

Bragadin. He replied that he could not so much as give me a glass of water, since he dreaded the wrath of the Tribunal for my very presence in his house. He was a stockbroker, about sixty years old, and was under great obligations to me. His inhuman refusal produced quite a different effect on me than that of M. Grimani. Whether from rage, indignation, or nature, I took him by the collar, I shewed him my pike, and raising my voice threatened to kill him. Trembling all over, he took a key from his pocket and shewing me a bureau told me he kept money there, and I had only to open it and take what I wanted; I told him to open it himself. He did so, and on his opening a drawer containing gold, I told him to count me out six sequins.

"You asked me for sixty."

"Yes, that was when I was asking a loan of you as a friend; but since I owe the money to force, I require six only, and I will give you no note of hand. You shall be repaid at Venice, where I shall write of the pass to which you forced me, you cowardly wretch!"

"I beg your pardon! take the sixty sequins, I entreat you."

"No, no more. I am going on my way, and I advise you not to hinder me, lest in my despair I come back and burn your house about your ears."

I went out and walked for two hours, until the approach of night and weariness made me stop short at the house of a farmer, where I had a bad supper and a bed of straw. In the morning, I bought an old overcoat, and hired an ass to journey on, and near Feltre I bought a pair of boots. In this guise I passed the hut called the Scala. There was a guard there who, much to my delight, as the reader will guess, did not even honour me by asking my name. I then took a two-horse carriage and got to Borgo de Valsugano in good time, and found Father Balbi at the inn I had told him of. If he had not greeted me first I should not have known him. A great overcoat, a low hat over a thick cotton cap, disguised him to admiration. He told me that a farmer had given him these articles in exchange for my cloak, that he had arrived without difficulty, and was faring well. He was kind enough to tell me that he did not expect to see me, as he did not believe my promise to rejoin him was made in good faith. Possibly I should have been wise not to undeceive him on this account.

I passed the following day in the inn, where, without getting out of my bed, I wrote more than twenty letters to Venice, in many of which I explained what I had been obliged to do to get the six sequins.

The monk wrote impudent letters to his superior, Father Barbarigo, and to his brother nobles, and love-letters to the servant girls who had been his ruin. I took the lace off my dress, and sold my hat, and thus got rid of a gay

appearance unsuitable to my position, as it made me too much an object of notice.

The next day I went to Pergina and lay there, and was visited by a young Count d'Alberg, who had discovered, in some way or another, that we had escaped from the state-prisons of Venice. From Pergina I went to Trent and from there to Bolzan, where, needing money for my dress, linen, and the continuation of my journey, I introduced myself to an old banker named Mensch, who gave me a man to send to Venice with a letter to M. de Bragadin. In the mean time the old banker put me in a good inn where I spent the six days the messenger was away in bed. He brought me the sum of a hundred sequins, and my first care was to clothe my companion, and afterwards myself. Every day I found the society of the wretched Balbi more intolerable. "Without me you would never have escaped" was continually in his mouth, and he kept reminding me that I had promised him half of whatever money I got. He made love to all the servant girls, and as he had neither the figure nor the manners to please them, his attentions were returned with good hearty slaps, which he bore patiently, but was as outrageous as ever in the course of twenty-four hours. I was amused, but at the same time vexed to be coupled to a man of so low a nature.

We travelled post, and in three days we got to Munich, where I went to lodge at the sign of the "Stag." There I found two young Venetians of the Cantarini family, who had been there some time in company with Count Pompei, a Veronese; but not knowing them, and having no longer any need of depending on recluses for my daily bread, I did not care to pay my respects to them. It was otherwise with Countess Coronini, whom I knew at St. Justine's Convent at Venice, and who stood very well with the Bavarian Court.

This illustrious lady, then seventy years old, gave me a good reception and promised to speak on my behalf to the Elector, with a view to his granting me an asylum in his country. The next day, having fulfilled her promise, she told me that his highness had nothing to say against me, but as for Balbi there was no safety for him in Bavaria, for as a fugitive monk he might be claimed by the monks at Munich, and his highness had no wish to meddle with the monks. The countess advised me therefore to get him out of the town as soon as possible, for him to fly to some other quarter, and thus to avoid the bad turn which his beloved brethren the monks were certain to do him.

Feeling in duty bound to look after the interests of the wretched fellow, I went to the Elector's confessor to ask him to give Balbi letters of introduction to some town in Swabia. The confessor, a Jesuit, did not give the lie to the

fine reputation of his brethren of the order; his reception of me was as discourteous as it well could be. He told me in a careless way that at Munich I was well known. I asked him without flinching if I was to take this as a piece of good or bad news; but he made no answer, and left me standing. Another priest told me that he had gone out to verify the truth of a miracle of which the whole town was talking.

"What miracle is that, reverend father?" I said.

"The empress, the widow of Charles VII, whose body is still exposed to the public gaze, has warm feet, although she is dead."

"Perhaps something keeps them warm."

"You can assure yourself personally of the truth of this wonderful circumstance."

To neglect such an opportunity would have been to lose the chance of mirth or edification, and I was as desirous of the one as of the other. Wishing to be able to boast that I had seen a miracle—and one, moreover, of a peculiar interest for myself, who have always had the misfortune to suffer from cold feet—I went to see the mighty dead. It was quite true that her feet were warm, but the matter was capable of a simple explanation, as the feet of her defunct majesty were turned towards a burning lamp at a little distance off. A dancer of my acquaintance, whom curiosity had brought there with the rest, came up to me, complimented me upon my fortunate escape, and told me everybody was talking about it. His news pleased me, as it is always a good thing to interest the public. This son of Terpsichore asked me to dinner, and I was glad to accept his invitation. His name was Michel de l'Agata, and his wife was the pretty Gandela, whom I had known sixteen years ago at the old Malipiero's. The Gandela was enchanted to see me, and to hear from my own lips the story of my wondrous escape. She interested herself on behalf of the monk, and offered me to give him a letter of introduction for Augsburg Canon Bassi, of Bologna, who was Dean of St. Maurice's Chapter, and a friend of hers. I took advantage of the offer, and she forthwith wrote me the letter, telling me that I need not trouble myself any more about the monk, as she was sure that the dean would take care of him, and even make it all right at Venice.

Delighted at getting rid of him in so honourable a manner, I ran to the inn, told him what I had done, gave him the letter, and promised not to abandon him in the case of the dean's not giving him a warm welcome. I got him a good carriage, and started him off the next day at daybreak. Four days after, Balbi wrote that the dean had received him with great kindness, that he had given him a room in the deanery, that he had dressed him as an abbe, that he

had introduced him to the Prince-Bishop of Armstadt, and that he had received assurances of his safety from the civil magistrates. Furthermore, the dean had promised to keep him till he obtained his secularization from Rome, and with it freedom to return to Venice, for as soon as he ceased to be a monk the Tribunal would have no lien upon him. Father Balbi finished by asking me to send him a few sequins for pocket-money, as he was too much of a gentleman to ask the dean who, quoth the ungrateful fellow, "is not gentleman enough to offer to give me anything." I gave him no answer.

As I was now alone in peace and quietness, I thought seriously of regaining my health, for my sufferings had given me nervous spasms which might become dangerous. I put myself on diet, and in three weeks I was perfectly well. In the meanwhile Madame Riviere came from Dresden with her son and two daughters. She was going to Paris to marry the elder. The son had been diligent, and would have passed for a young man of culture. The elder daughter, who was going to marry an actor, was extremely beautiful, an accomplished dancer, and played on the clavichord like a professional, and was altogether most charming and graceful. This pleasant family was delighted to see me again, and I thought myself fortunate when Madame Riviere, anticipating my wishes, intimated to me that my company as far as Paris would give them great pleasure. I had nothing to say respecting the expenses of the journey. I had to accept their offer in its entirety. My design was to settle in Paris, and I took this stroke of fortune as an omen of success in the only town where the blind goddess freely dispenses her favours to those who leave themselves to be guided by her, and know how to take advantage of her gifts. And, as the reader will see by and by, I was not mistaken; but all the gifts of fortune were of no avail, since I abused them all by my folly. Fifteen months under the Leads should have made me aware of my weak points, but in point of fact I needed a little longer stay to learn how to cure myself of my failings.

Madame Riviere wished to take me with her, but she could not put off her departure, and I required a week's delay to get money and letters from Venice. She promised to wait a week in Strassburg, and we agreed that if possible I would join her there. She left Munich on the 18th of December.

Two days afterwards I got from Venice the bill of exchange for which I was waiting. I made haste to pay my debts, and immediately afterwards I started for Augsburg, not so much for the sake of seeing Father Balbi, as because I wanted to make the acquaintance of the kindly dean who had rid me of him. I reached Augsburg in seven hours after leaving Munich, and I went immediately to the house of the good ecclesiastic. He was not in, but I found

Balbi in an abbe's dress, with his hair covered with white powder, which set off in a new but not a pleasing manner the beauties of his complexion of about the same colour as a horse chestnut. Balbi was under forty, but he was decidedly ugly, having one of those faces in which baseness, cowardice, impudence, and malice are plainly expressed, joining to this advantage a tone of voice and manners admirably calculated to repulse anyone inclined to do him a service. I found him comfortably housed, well looked after, and well clad; he had books and all the requisites for writing. I complimented him upon his situation, calling him a fortunate fellow, and applying the same epithet to myself for having gained him all the advantages he enjoyed, and the hope of one day becoming a secular priest. But the ungrateful hound, instead of thanking me, reproached me for having craftily rid myself of him, and added that, as I was going to Paris, I might as well take him with me, as the dullness of Augsburg was almost killing him.

"What do you want at Paris?"

"What do you want yourself?"

"To put my talents to account."

"So do I."

"Well, then, you don't require me, and can fly on your own wings. The people who are taking me to Paris would probably not care for me if I had you for a companion."

"You promised not to abandon me."

"Can a man who leaves another well provided for and an assured future be said to abandon him?"

"Well provided! I have not got a penny."

"What do you want with money? You have a good table, a good lodging, clothes, linen, attendance, and so forth. And if you want pocket-money, why don't you ask your brethren the monks?"

"Ask monks for money? They take it, but they don't give it."

"Ask your friends, then."

"I have no friends."

"You are to be pitied, but the reason probably is that you have never been a friend to anyone. You ought to say masses, that is a good way of getting money."

"I am unknown."

"You must wait, then, till you are known, and then you can make up for lost time."

"Your suggestions are idle; you will surely give me a few sequins."

"I can't spare any."

"Wait for the dean. He will be back to-morrow. You can talk to him and persuade him to lend me some money. You can tell him that I will pay it back."

"I cannot wait, for I am setting out on my journey directly, and were he here this moment I should not have the face to tell him to lend you money after all his generous treatment of you, and when he or anyone can see that you have all you need."

After this sharp dialogue I left him, and travelling post I set out, displeased with myself for having given such advantages to a man wholly unworthy of them. In the March following I had a letter from the good Dean Bassi, in which he told me how Balbi had run away, taking with him one of his servant girls, a sum of money, a gold watch, and a dozen silver spoons and forks. He did not know where he was gone.

Towards the end of the same year I learnt at Paris that the wretched man had taken refuge at Coire, the capital of the Grisons, where he asked to be made a member of the Calvinistic Church, and to be recognized as lawful husband of the woman with him; but in a short time the community discovered that the new convert was no good, and expelled him from the bosom of the Church of Calvin. Our ne'er-do-well having no more money, his wife left him, and he, not knowing what to do next, took the desperate step of going to Bressa, a town within the Venetian territory, where he sought the governor, telling him his name, the story of his flight, and his repentance, begging the governor to take him under his protection and to obtain his pardon.

The first effect of the podesta's protection was that the penitent was imprisoned, and he then wrote to the Tribunal to know what to do with him. The Tribunal told him to send Father Balbi in chains to Venice, and on his arrival Messer-Grande gave him over to the Tribunal, which put him once more under the Leads. He did not find Count Asquin there, as the Tribunal, out of consideration for his great age, had moved him to The Fours a couple of months after our escape.

Five or six years later, I heard that the Tribunal, after keeping the unlucky monk for two years under the Leads, had sent him to his convent. There, his superior fearing lest his flock should take contagion from this scabby sheep, sent him to their original monastery near Feltre, a lonely building on a height. However, Balbi did not stop there six months. Having got the key of the fields, he went to Rome, and threw himself at the feet of Pope Rezzonico, who absolved him of his sins, and released him from his monastic vows. Balbi, now

a secular priest, returned to Venice, where he lived a dissolute and wretched life. In 1783 he died the death of Diogenes, minus the wit of the cynic.

At Strassburg I rejoined Madame Riviere and her delightful family, from whom I received a sincere and hearty welcome. We were staying at the "Hotel de l'Esprit," and we passed a few days there most pleasurably, afterwards setting out in an excellent travelling carriage for Paris the Only, Paris the Universal. During the journey I thought myself bound to the expense of making it a pleasant one, as I had not to put my hand in my pocket for other expenses. The charms of Mdlle. Riviere enchanted me, but I should have esteemed myself wanting in gratitude and respect to this worthy family if I had darted at her a single amorous glance, or if I had let her suspect my feelings for her by a single word. In fact I thought myself obliged to play the heavy father, though my age did not fit me for the part, and I lavished on this agreeable family all the care which can be given in return for pleasant society, a seat in a comfortable travelling carriage, an excellent table, and a good bed.

We reached Paris on the 5th of January, 1757, and I went to the house of my friend Baletti, who received me with open arms, and assured me that though I had not written he had been expecting me, since he judged that I would strive to put the greatest possible distance between myself and Venice, and he could think of no other retreat for me than Paris. The whole house kept holiday when my arrival became known, and I have never met with more sincere regard than in that delightful family. I greeted with enthusiasm the father and mother, whom I found exactly the same as when I had seen them last in 1752, but I was struck with astonishment at the daughter whom I had left a child, for she was now a tall and well-shaped girl. Mdlle. Baletti was fifteen years old, and her mother had brought her up with care, had given her the best masters, virtue, grace, talents, a good manner, tact, a knowledge of society-in short, all that a clever mother can give to a dear daughter.

After finding a pleasant lodging near the Baletti's, I took a coach and went to the "Hotel de Bourbon" with the intention of calling on M. de Bernis, who was then chief secretary for foreign affairs. I had good reasons for relying on his assistance. He was out; he had gone to Versailles. At Paris one must go sharply to work, and, as it is vulgarly but forcibly said, "strike while the iron's hot." As I was impatient to see what kind of a reception I should get from the liberal-minded lover of my fair M—— M——, I went to the Pont-Royal, took a hackney coach, and went to Versailles. Again bad luck!

Our coaches crossed each other on the way, and my humble equipage had not caught his excellency's eye. M. de Bernis had returned to Paris with Count de Castillana, the ambassador from Naples, and I determined to return

also; but when I got to the gate I saw a mob of people running here and there in the greatest confusion, and from all sides I heard the cry, "The king is assassinated! The king is assassinated!"

My frightened coachman only thought of getting on his way, but the coach was stopped. I was made to get out and taken to the guard-room, where there were several people already, and in less than three minutes there were twenty of us, all under arrest, all astonished at the situation, and all as much guilty as I was. We sat glum and silent, looking at each other without daring to speak. I knew not what to think, and not believing in enchantment I began to think I must be dreaming. Every face expressed surprise, as everyone, though innocent, was more or less afraid.

We were not left in this disagreeable position for long, as in five minutes an officer came in, and after some polite apologies told us we were free.

"The king is wounded," he said, "and he has been taken to his room. The assassin, whom nobody knows, is under arrest. M. de la Martiniere is being looked for everywhere."

As soon as I had got back to my coach, and was thinking myself lucky for being there, a gentlemanly-looking young man came up to me and besought me to give him a seat in my coach, and he would gladly pay half the fare; but in spite of the laws of politeness I refused his request. I may possibly have been wrong. On any other occasion I should have been most happy to give him a place, but there are times when prudence does not allow one to be polite. I was about three hours on the way, and in this short time I was overtaken every minute by at least two hundred couriers riding at a breakneck pace. Every minute brought a new courier, and every courier shouted his news to the winds. The first told me what I already knew; then I heard that the king had been bled, that the wound was not mortal, and finally, that the wound was trifling, and that his majesty could go to the Trianon if he liked.

Fortified with this good news, I went to Silvia's and found the family at table. I told them I had just come from Versailles.

"The king has been assassinated."

"Not at all; he is able to go to the Trianon, or the Parc-aux-cerfs, if he likes. M. de la Martiniere has bled him, and found him to be in no danger. The assassin has been arrested, and the wretched man will be burnt, drawn with red-hot pincers, and quartered."

This news was soon spread abroad by Silvia's servants, and a crowd of the neighbours came to hear what I had to say, and I had to repeat the same thing ten times over. At this period the Parisians fancied that they loved the king. They certainly acted the part of loyal subjects to admiration. At the present

day they are more enlightened, and would only love the sovereign whose sole desire is the happiness of his people, and such a king—the first citizens of a great nation—not Paris and its suburbs, but all France, will be eager to love and obey. As for kings like Louis XV., they have become totally impracticable; but if there are any such, however much they may be supported by interested parties, in the eyes of public opinion they will be dishonoured and disgraced before their bodies are in a grave and their names are written in the book of history.

CHAPTER XXXII

The Minister of Foreign Affairs M. de Boulogne, the
Comptroller—M. le Duc de Choiseul—M. Paris du Vernai—
Establishment of the Lottery—My Brother's Arrival at Paris;
His Reception by the Academy

Once more, then, I was in Paris, which I ought to regard as my fatherland,
since I could return no more to that land which gave me birth: an unworthy
country, yet, in spite of all, ever dear to me, possibly on account of early
impressions and early prejudices, or possibly because the beauties of Venice
are really unmatched in the world. But mighty Paris is a place of good luck or
ill, as one takes it, and it was my part to catch the favouring gale.

Paris was not wholly new to me, as my readers know I had spent two years
there, but I must confess that, having then no other aim than to pass the time
pleasantly, I had merely devoted myself to pleasure and enjoyment. Fortune,
to whom I had paid no court, had not opened to me her golden doors; but I
now felt that I must treat her more reverently, and attach myself to the
throng of her favoured sons whom she loads with her gifts. I understood now
that the nearer one draws to the sun the more one feels the warmth of its
rays. I saw that to attain my end I should have to employ all my mental and
physical talents, that I must make friends of the great, and take cue from all
whom I found it to be my interest to please. To follow the plans suggested by
these thoughts, I saw that I must avoid what is called bad company, that I
must give up my old habits and pretensions, which would be sure to make me
enemies, who would have no scruple in representing me as a trifler, and not
fit to be trusted with affairs of any importance.

I think I thought wisely, and the reader, I hope, will be of the same opinion.
"I will be reserved," said I, "in what I say and what I do, and thus I shall get
a reputation for discretion which will bring its reward."

I was in no anxiety on the score of present needs, as I could reckon on a
monthly allowance of a hundred crowns, which my adopted father, the good
and generous M. de Bragadin, sent me, and I found this sum sufficient in the
meanwhile, for with a little self-restraint one can live cheaply at Paris, and cut
a good figure at the same time. I was obliged to wear a good suit of clothes,
and to have a decent lodging; for in all large towns the most important thing
is outward show, by which at the beginning one is always judged. My anxiety
was only for the pressing needs of the moment, for to speak the truth I had
neither clothes nor linen—in a word, nothing.

If my relations with the French ambassador are recalled, it will be found natural that my first idea was to address myself to him, as I knew him sufficiently well to reckon on his serving me.

Being perfectly certain that the porter would tell me that my lord was engaged, I took care to have a letter, and in the morning I went to the Palais Bourbon. The porter took my letter, and I gave him my address and returned home.

Wherever I went I had to tell the story of my escape from The Leads. This became a service almost as tiring as the flight itself had been, as it took me two hours to tell my tale, without the slightest bit of fancy-work; but I had to be polite to the curious enquirers, and to pretend that I believed them moved by the most affectionate interest in my welfare. In general, the best way to please is to take the benevolence of all with whom one has relation for granted.

I supped at Silvia's, and as the evening was quieter than the night before, I had time to congratulate myself on all the friendship they shewed me. The girl was, as I had said, fifteen years old, and I was in every way charmed with her. I complimented the mother on the good results of her education, and I did not even think of guarding myself from falling a victim to her charms. I had taken so lately such well-founded and philosophical resolutions, and I was not yet sufficiently at my ease to value the pain of being tempted. I left at an early hour, impatient to see what kind of an answer the minister had sent me. I had not long to wait, and I received a short letter appointing a meeting for two o'clock in the afternoon. It may be guessed that I was punctual, and my reception by his excellence was most flattering. M. de Bernis expressed his pleasure at seeing me after my fortunate escape, and at being able to be of service to me. He told me that M—— M—— had informed him of my escape, and he had flattered himself that the first person I should go and see in Paris would be himself. He shewed me the letters from M—— M—— relating to my arrest and escape, but all the details in the latter were purely imaginary and had no foundation in fact. M—— M—— was not to blame, as she could only write what she had heard, and it was not easy for anyone besides myself to know the real circumstances of my escape. The charming nun said that, no longer buoyed up by the hope of seeing either of the men who alone had made her in love with life, her existence had become a burden to her, and she was unfortunate in not being able to take any comfort in religion. "C——·C—— often comes to see me," she said, "but I grieve to say she is not happy with her husband."

I told M. de Bernis that the account of my flight from The Leads, as told by our friend, was wholly inaccurate, and I would therefore take the liberty of writing out the whole story with the minutest details. He challenged me to keep my word, assuring me that he would send a copy to M—— M——, and at the same time, with the utmost courtesy, he put a packet of a hundred Louis in my hand, telling me that he would think what he could do for me, and would advise me as soon as he had any communication to make.

Thus furnished with ample funds, my first care was for my dress; and this done I went to work, and in a week sent my generous protector the result, giving him permission to have as many copies printed as he liked, and to make any use he pleased of it to interest in my behalf such persons as might be of service to me.

Three weeks after, the minister summoned me to say that he had spoken of me to M. Erizzo, the Venetian ambassador, who had nothing to say against me, but for fear of embroiling himself with the State Inquisitors declined to receive me. Not wanting anything from him—his refusal did me no harm. M. de Bernis then told me that he had given a copy of my history to Madame la Marquise de Pompadour, and he promised to take the first opportunity of presenting me to this all-powerful lady. "You can present yourself, my dear Casanova," added his excellence, "to the Duc de Choiseul, and M. de Boulogne, the comptroller. You will be well received, and with a little wit you ought to be able to make good use of the letter. He himself will give you the cue, and you will see that he who listens obtains. Try to invent some useful plan for the royal exchequer; don't let it be complicated or chimerical, and if you don't write it out at too great length I will give you my opinion on it."

I left the minister in a pleased and grateful mood, but extremely puzzled to find a way of increasing the royal revenue. I knew nothing of finance, and after racking my brains all that I could think of was new methods of taxation; but all my plans were either absurd or certain to be unpopular, and I rejected them all on consideration.

As soon as I found out that M. de Choiseul was in Paris I called on him. He received me in his dressing-room, where he was writing while his valet did his hair. He stretched his politeness so far as to interrupt himself several times to ask me questions, but as soon as I began to reply his grace began to write again, and I suspect did not hear what I was saying; and though now and again he seemed to be looking at me, it was plain that his eyes and his thoughts were occupied on different objects. In spite of this way of receiving visitors—or me, at all events, M. de Choiseul was a man of wit.

When he had finished writing he said in Italian that M. de Bernis had told him of some circumstances of my escape, and he added,

"Tell me how you succeeded."

"My lord, it would be too long a story; it would take me at least two hours, and your grace seems busy."

"Tell me briefly about it."

"However much I speak to the point, I shall take two hours."

"You can keep the details for another time."

"The story is devoid of interest without the details"

"Well, well, you can tell me the whole story in brief, without losing much of the interest:"

"Very good; after that I can say no more. I must tell your lordship, then, that, the State Inquisitors shut me up under the Leads; that after fifteen months and five days of imprisonment I succeeded in piercing the roof; that after many difficulties I reached the chancery by a window, and broke open the door; afterwards I got to St. Mark's Place, whence, taking a gondola which bore me to the mainland, I arrived at Paris, and have had the honour to pay my duty to your lordship."

"But.... what are The Leads?"

"My lord, I should take a quarter of an hour, at least, to explain."

"How did you pierce the roof?"

"I could not tell your lordship in less than half an hour:"

"Why were you shut up?"

"It would be a long tale, my lord."

"I think you are right. The interest of the story lies chiefly in the details."

"I took the liberty of saying as much to your grace."

"Well, I must go to Versailles, but I shall be delighted if you will come and see me sometimes. In the meanwhile, M. Casanova, think what I can do for you."

I had been almost offended at the way in which M. de Choiseul had received me, and I was inclined to resent it; but the end of our conversation, and above all the kindly tone of his last words, quieted me, and I left him, if not satisfied, at least without bitterness in my heart.

From him I went to M. de Boulogne's, and found him a man of quite a different stamp to the duke—in manners, dress, and appearance. He received me with great politeness, and began by complimenting me on the high place I enjoyed in the opinion of M. de Bernis, and on my skill in matters of finance.

I felt that no compliment had been so ill deserved, and I could hardly help bursting into laughter. My good angel, however, made me keep my countenance.

M. de Boulogne had an old man with him, every feature bore the imprint of genius, and who inspired me with respect.

"Give me your views;" said the comptroller, "either on paper or 'viva voce'. You will find me willing to learn and ready to grasp your ideas. Here is M. Paris du Vernai, who wants twenty millions for his military school; and he wishes to get this sum without a charge on the state or emptying the treasury."

"It is God alone, sir, who has the creative power."

"I am not a god," said M. du Vernai, "but for all that I have now and then created but the times have changed."

"Everything," I said, "is more difficult than it used to be; but in spite of difficulties I have a plan which would give the king the interest of a hundred millions."

"What expense would there be to the Crown?"

"Merely the cost of receiving."

"The nation, then, would furnish the sum in question?"

"Undoubtedly, but voluntarily."

"I know what you are thinking of."

"You astonish me, sir, as I have told nobody of my plan."

"If you have no other engagement, do me the honour of dining with me to-morrow, and I will tell you what your project is. It is a good one, but surrounded, I believe, with insuperable difficulties. Nevertheless, we will talk it over and see what can be done. Will you come?"

"I will do myself that honour."

"Very good, I will expect you at Plaisance."

After he had gone, M. de Boulogne praised his talents and honesty. He was the brother of M. de Montmartel, whom secret history makes the father of Madame de Pompadour, for he was the lover of Madame Poisson at the same time as M. le Normand.

I left the comptroller's and went to walk in the Tuileries, thinking over the strange stroke of luck which had happened to me. I had been told that twenty millions were wanted, and I had boasted of being able to get a hundred, without the slightest idea of how it was to be done; and on that a well-known man experienced in the public business had asked me to dinner to convince me that he knew what my scheme was. There was something odd and comic about the whole affair; but that corresponded very well with my modes of thought and action. "If he thinks he is going to pump me," said I, "he will find

himself mistaken. When he tells me what the plan is, it will rest with me to say he has guessed it or he is wrong as the inspiration of the moment suggests. If the question lies within my comprehension I may, perhaps, be able to suggest something new; and if I understand nothing I will wrap myself up in a mysterious silence, which sometimes produces a good effect. At all events, I will not repulse Fortune when she appears to be favourable to me."

M. de Bernis had only told M. de Boulogne that I was a financier to get me a hearing, as otherwise he might have declined to see me. I was sorry not to be master, at least, of the jargon of the business, as in that way men have got out of a similar difficulty, and by knowing the technical terms, and nothing more, have made their mark. No matter, I was bound to the engagement. I must put a good face on a bad game, and if necessary pay with the currency of assurance. The next morning I took a carriage, and in a pensive mood I told the coachman to take me to M. du Vernai's, at Plaisance—a place a little beyond Vincennes.

I was set down at the door of the famous man who, forty years ago, had rescued France on the brink of the precipice down which Law had almost precipitated her. I went in and saw a great fire burning on the hearth, which was surrounded by seven or eight persons, to whom I was introduced as a friend of the minister for foreign affairs and of the comptroller; afterwards he introduced these gentlemen to me, giving to each his proper title, and I noted that four of them were treasury officials. After making my bow to each, I gave myself over to the worship of Harpocrates, and without too great an air of listening was all ears and eyes.

The conversation at first was of no special interest as they were talking of the Seine being frozen over, the ice being a foot thick. Then came the recent death of M. de Fontenelle, then the case of Damien, who would confess nothing, and of the five millions his trial would cost the Crown. Then coming to war they praised M. de Soubise, who had been chosen by the king to command the army. Hence the transition was easy to the expenses of the war, and how they were to be defrayed.

I listened and was weary, for all they said was so full of technicalities that I could not follow the meaning; and if silence can ever be imposing, my determined silence of an hour and a half's duration ought to have made me seem a very important personage in the eyes of these gentlemen. At last, just as I was beginning to yawn, dinner was announced, and I was another hour and a half without opening my mouth, except to do honour to an excellent repast. Directly the dessert had been served, M. du Vernai asked me to follow him into a neighbouring apartment, and to leave the other guests at the table.

I followed him, and we crossed a hall where we found a man of good aspect, about fifty years old, who followed us into a closet and was introduced to me by M. du Vernai under the name of Calsabigi. Directly after, two superintendents of the treasury came in, and M. du Vernai smilingly gave me a folio book, saying,

"That, I think, M. Casanova, is your plan."

I took the book and read, Lottery consisting of ninety tickets, to be drawn every month, only one in eighteen to be a winning number. I gave him back the book and said, with the utmost calmness,

"I confess, sir, that is exactly my idea."

"You have been anticipated, then; the project is by M. de Calsabigi here."

"I am delighted, not at being anticipated, but to find that we think alike; but may I ask you why you have not carried out the plan?"

"Several very plausible reasons have been given against it, which have had no decisive answers."

"I can only conceive one reason against it," said I, coolly; "perhaps the king would not allow his subjects to gamble."

"Never mind that, the king will let his subjects gamble as much as they like: the question is, will they gamble?"

"I wonder how anyone can have any doubt on that score, as the winners are certain of being paid."

"Let us grant, then, that they will gamble: how is the money to be found?"

"How is the money to be found? The simplest thing in the world. All you want is a decree in council authorizing you to draw on the treasury. All I want is for the nation to believe that the king can afford to pay a hundred millions."

"A hundred millions!"

"Yes, a hundred millions, sir. We must dazzle people."

"But if France is to believe that the Crown can afford to pay a hundred millions, it must believe that the Crown can afford to lose a hundred millions, and who is going to believe that? Do you?"

"To be sure I do, for the Crown, before it could lose a hundred millions, would have received at least a hundred and fifty millions, and so there need be no anxiety on that score."

"I am not the only person who has doubts on the subject. You must grant the possibility of the Crown losing an enormous sum at the first drawing?"

"Certainly, sir, but between possibility and reality is all the region of the infinite. Indeed, I may say that it would be a great piece of good fortune if the Crown were to lose largely on the first drawing."

"A piece of bad fortune, you mean, surely?"

"A bad fortune to be desired. You know that all the insurance companies are rich. I will undertake to prove before all the mathematicians in Europe that the king is bound to gain one in five in this lottery. That is the secret. You will confess that the reason ought to yield to a mathematical proof?"

"Yes, of course; but how is it that the Castelletto cannot guarantee the Crown a certain gain?"

"Neither the Castelletto nor anybody in the world can guarantee absolutely that the king shall always win. What guarantees us against any suspicion of sharp practice is the drawing once a month, as then the public is sure that the holder of the lottery may lose."

"Will you be good enough to express your sentiments on the subject before the council?"

"I will do so with much pleasure."

"You will answer all objections?"

"I think I can promise as much."

"Will you give me your plan?"

"Not before it is accepted, and I am guaranteed a reasonable profit."

"But your plan may possibly be the same as the one before us."

"I think not. I see M. de Calsabigi for the first time, and as he has not shewn me his scheme, and I have not communicated mine to him, it is improbable, not to say impossible, that we should agree in all respects. Besides, in my plan I clearly shew how much profit the Crown ought to get per annum."

"It might, therefore, be formed by a company who would pay the Crown a fixed sum?"

"I think not."

"Why?"

"For this reason. The only thing which would make the lottery pay, would be an irresistible current of public opinion in its favour. I should not care to have anything to do with it in the service of a company, who, thinking to increase their profits, might extend their operations—a course which would entail certain loss."

"I don't see how."

"In a thousand ways which I will explain to you another time, and which I am sure you can guess for yourself. In short, if I am to have any voice in the matter, it must be a Government lottery or nothing."

"M. de Calsabigi thinks so, too."

"I am delighted to hear it, but not at all surprised; for, thinking on the same lines, we are bound to arrive at the same results."

"Have you anybody ready for the Castelletto?"

"I shall only want intelligent machines, of whom there are plenty in France."

I went out for a moment and found them in groups on my return, discussing my project with great earnestness.

M. Calsabigi after asking me a few questions took my hand, which he shook heartily, saying he should like to have some further conversation with me; and returning the friendly pressure, I told him that I should esteem it as an honour to be numbered amongst his friends. Thereupon I left my address with M. du Vernai and took my leave, satisfied, by my inspection of the faces before me, that they all had a high opinion of my talents.

Three days after, M. de Calsabigi called on me; and after receiving him in my best style I said that if I had not called on him it was only because I did not wish to be troublesome. He told me that my decisive way of speaking had made a great impression, and he was certain that if I cared to make interest with the comptroller we could set up the lottery and make a large profit.

"I think so, too," said I, "but the financiers will make a much larger profit, and yet they do not seem anxious about it. They have not communicated with me, but it is their look-out, as I shall not make it my chief aim."

"You will undoubtedly hear something about it today, for I know for a fact that M. de Boulogne has spoken of you to M. de Courteuil."

"Very good, but I assure you I did not ask him to do so."

After some further conversation he asked me, in the most friendly manner possible, to come and dine with him, and I accepted his invitation with a great pleasure; and just as we were starting I received a note from M. de Bernis, in which he said that if I could come to Versailles the next day he would present me to Madame de Pompadour, and that I should have an opportunity of seeing M. de Boulogne.

In high glee at this happy chance, less from vanity than policy I made M. de Calsabigi read the letter, and I was pleased to see him opening his eyes as he read it.

"You can force Du Vernai himself to accept the lottery," he said, "and your fortune is made if you are not too rich already to care about such matters."

"Nobody is ever rich enough to despise good fortune, especially when it is not due to favour."

"Very true. We have been doing our utmost for two years to get the plan accepted, and have met with nothing beyond foolish objections which you

have crushed to pieces. Nevertheless, our plans must be very similar. Believe me it will be best for us to work in concert, for by yourself you would find insuperable difficulties in the working, and you will find no 'intelligent machines' in Paris. My brother will do all the work, and you will be able to reap the advantages at your ease."

"Are you, then, not the inventor of the scheme which has been shewn me?"

"No, it is the work of my brother."

"Shall I have the pleasure or seeing him?"

"Certainly. His body is feeble, but his mind is in all its vigour. We shall see him directly."

The brother was not a man of a very pleasing appearance, as he was covered with a kind of leprosy; but that did not prevent him having a good appetite, writing, and enjoying all his bodily and intellectual faculties; he talked well and amusingly. He never went into society, as, besides his personal disfigurement, he was tormented with an irresistible and frequent desire of scratching himself, now in one place, and now in another; and as all scratching is accounted an abominable thing in Paris, he preferred to be able to use his fingernails to the pleasures of society. He was pleased to say that, believing in God and His works, he was persuaded his nails had been given him to procure the only solace he was capable of in the kind of fury with which he was tormented.

"You are a believer, then, in final causes? I think you are right, but still I believe you would have scratched yourself if God had forgotten to give you any nails."

My remarks made him laugh, and he then began to speak of our common business, and I soon found him to be a man of intellect. He was the elder of the two brothers, and a bachelor. He was expert in all kinds of calculations, an accomplished financier, with a universal knowledge of commerce, a good historian, a wit, a poet, and a man of gallantry. His birthplace was Leghorn, he had been in a Government office at Naples, and had come to Paris with M. de l'Hopital. His brother was also a man of learning and talent, but in every respect his inferior.

He shewed me the pile of papers, on which he had worked out all the problems referring to the lottery.

"If you think you can do without me," said he, "I must compliment you on your abilities; but I think you will find yourself mistaken, for if you have no practical knowledge of the matter and no business men to help you, your theories will not carry you far. What will you do after you have obtained the decree? When you speak before the council, if you take my advice, you will

fix a date after which you are not to be held responsible—that is to say, after which you will have nothing more to do with it. Unless you do so, you will be certain to encounter trifling and procrastination which will defer your plan to the Greek Kalends. On the other hand, I can assure you that M. du Vernai would be very glad to see us join hands:"

Very much inclined to take these gentlemen into partnership, for the good reason that I could not do without them, but taking care that they should suspect nothing, I went down with the younger brother, who introduced me to his wife before dinner. I found present an old lady well known at Paris under the name of General La Mothe, famous for her former beauty and her gout, another lady somewhat advanced in years, who was called Baroness Blanche, and was still the mistress of M. de Vaux, another styled the President's lady, and a fourth, fair as the dawn, Madame Razzetti, from Piedmont, the wife of one of the violin players at the opera, and said to be courted by M. de Fondpertuis, the superintendent of the opera.

We sat down to dinner, but I was silent and absorbed, all my thoughts being monopolized by the lottery. In the evening, at Silvia's, I was pronounced absent and pensive, and so I was in spite of the sentiment with which Mademoiselle Baletti inspired me—a sentiment which every day grew in strength.

I set out for Versailles next morning two hours before day-break, and was welcomed by M. de Bernis, who said he would bet that but for him I should never have discovered my talent for finance.

"M. de Boulogne tells me you astonished M. du Vernai, who is generally esteemed one of the acutest men in France. If you will take my advice, Casanova, you will keep up that acquaintance and pay him assiduous court. I may tell you that the lottery is certain to be established, that it will be your doing, and that you ought to make something considerable out of it. As soon as the king goes out to hunt, be at hand in the private apartments, and I will seize a favourable moment for introducing you to the famous marquise. Afterwards go to the Office for Foreign Affairs, and introduce yourself in my name to the Abbe de la Ville. He is the chief official there, and will give you a good reception."

M. de Boulogne told me that, as soon as the council of the military school had given their consent, he would have the decree for the establishment of the lottery published, and he urged me to communicate to him any ideas which I might have on the subject of finance.

At noon Madame de Pompadour passed through the private apartments with the Prince de Soubise, and my patron hastened to point me out to the

illustrious lady. She made me a graceful curtsy, and told me that she had been much interested in the subject of my flight.

"Do you go," said she, "to see your ambassador?"

"I shew my respect to him, madam, by keeping away."

"I hope you mean to settle in France."

"It would be my dearest wish to do so, madam, but I stand in need of patronage, and I know that in France patronage is only given to men of talent, which is for me a discouraging circumstance."

"On the contrary, I think you have reason to be hopeful, as you have some good friends. I myself shall be delighted if I can be of any assistance to you."

As the fair marquise moved on, I could only stammer forth my gratitude.

I next went to the Abbe de la Ville, who received me with the utmost courtesy, and told me that he would remember me at the earliest opportunity.

Versailles was a beautiful spot, but I had only compliments and not invitations to expect there, so after leaving M. de la Ville I went to an inn to get some dinner. As I was sitting down, an abbe of excellent appearance, just like dozens of other French abbes, accosted me politely, and asked me if I objected to our dining together. I always thought the company of a pleasant man a thing to be desired, so I granted his request; and as soon as he sat down he complimented me on the distinguished manner in which I had been treated by M. de la Ville. "I was there writing a letter," said he, "and I could hear all the obliging things the abbe said to you. May I ask, sir, how you obtained access to him?"

"If you really wish to know, I may be able to tell you."

"It is pure curiosity on my part."

"Well, then, I will say nothing, from pure prudence."

"I beg your pardon."

"Certainly, with pleasure."

Having thus shut the mouth of the curious impertinent, he confined his conversation to ordinary and more agreeable topics. After dinner, having no further business at Versailles, I made preparations for leaving, on which the abbe begged to be of my company. Although a man who frequents the society of abbes is not thought much more of than one who frequents the society of girls. I told him that as I was going to Paris in a public conveyance—far from its being a question of permission—I should be only too happy to have the pleasure of his company. On reaching Paris we parted, after promising to call on each other, and I went to Silvia's and took supper there. The agreeable mistress of the house complimented me on my noble acquaintances, and made me promise to cultivate their society.

As soon as I got back to my own lodging, I found a note from M. du Vernai, who requested me to come to the military school at eleven o'clock on the next day, and later in the evening Calsabigi came to me from his brother, with a large sheet of paper containing all the calculations pertaining to the lottery.

Fortune seemed to be in my favour, for this tabular statement came to me like a blessing from on high. Resolving, therefore, to follow the instructions which I pretended to receive indifferently. I went to the military school, and as soon as I arrived the conference began. M. d'Alembert had been requested to be present as an expert in arithmetical calculations. If M. du Vernai had been the only person to be consulted, this step would not have been necessary; but the council contained some obstinate heads who were unwilling to give in. The conference lasted three hours.

After my speech, which only lasted half an hour, M. de Courteuil summed up my arguments, and an hour was passed in stating objections which I refuted with the greatest ease. I finally told them that no man of honour and learning would volunteer to conduct the lottery on the understanding that it was to win every time, and that if anyone had the impudence to give such an undertaking they should turn him out of the room forthwith, for it was impossible that such an agreement could be maintained except by some roguery.

This had its effect, for nobody replied; and M. du Vernai remarked that if the worst came to the worst the lottery could be suppressed. At this I knew my business was done, and all present, after signing a document which M. du Vernai gave them, took their leave, and I myself left directly afterwards with a friendly leave-taking from M. du Vernal.

M. Calsabigi came to see me the next day, bringing the agreeable news that the affair was settled, and that all that was wanting was the publication of the decree.

"I am delighted to hear it," I said, "and I will go to M. de Boulogne's every day, and get you appointed chief administrator as soon as I know what I have got for myself."

I took care not to leave a stone unturned in this direction, as I knew that, with the great, promising and keeping a promise are two different things. The decree appeared a week after. Calsabigi was made superintendent, with an allowance of three thousand francs for every drawing, a yearly pension of four thousand francs for us both, and the chief of the lottery. His share was a much larger one than mine, but I was not jealous as I knew he had a greater claim than I. I sold five of the six offices that had been allotted to me for two thousand francs each, and opened the sixth with great style in the Rue St.

Denis, putting my valet there as a clerk. He was a bright young Italian, who had been valet to the Prince de la Catolica, the ambassador from Naples.

The day for the first drawing was fixed, and notice was given that the winning numbers would be paid in a week from the time of drawing at the chief office.

With the idea of drawing custom to my office, I gave notice that all winning tickets bearing my signature would be paid at my office in twenty-four hours after the drawing. This drew crowds to my office and considerably increased my profits, as I had six per cent. on the receipts. A number of the clerks in the other offices were foolish enough to complain to Calsabigi that I had spoilt their gains, but he sent them about their business telling them that to get the better of me they had only to do as I did—if they had the money.

My first taking amounted to forty thousand francs. An hour after the drawing my clerk brought me the numbers, and shewed me that we had from seventeen to eighteen thousand francs to pay, for which I gave him the necessary funds.

Without my thinking of it I thus made the fortune of my clerk, for every winner gave him something, and all this I let him keep for himself.

The total receipts amounted to two millions, and the administration made a profit of six hundred thousand francs, of which Paris alone had contributed a hundred thousand francs. This was well enough for a first attempt.

On the day after the drawing I dined with Calsabigi at M. du Vernai's, and I had the pleasure of hearing him complain that he had made too much money. Paris had eighteen or twenty ternes, and although they were small they increased the reputation of the lottery, and it was easy to see that the receipts at the next drawing would be doubled. The mock assaults that were made upon me put me in a good humour, and Calsabigi said that my idea had insured me an income of a hundred thousand francs a year, though it would ruin the other receivers.

"I have played similar strokes myself," said M. du Vernai, "and have mostly succeeded; and as for the other receivers they are at perfect liberty to follow M. Casanova's example, and it all tends to increase the repute of an institution which we owe to him and to you."

At the second drawing a terne of forty thousand francs obliged me to borrow money. My receipts amounted to sixty thousand, but being obliged to deliver over my chest on the evening before the drawing, I had to pay out of my own funds, and was not repaid for a week.

In all the great houses I went to, and at the theatres, as soon as I was seen, everybody gave me money, asking me to lay it out as I liked and to send them

the tickets, as, so far, the lottery was strange to most people. I thus got into the way of carrying about me tickets of all sorts, or rather of all prices, which I gave to people to choose from, going home in the evening with my pockets full of gold. This was an immense advantage to me, as kind of privilege which I enjoyed to the exclusion of the other receivers who were not in society, and did not drive a carriage like myself—no small point in one's favour, in a large town where men are judged by the state they keep. I found I was thus able to go into any society, and to get credit everywhere.

I had hardly been a month in Paris when my brother Francis, with whom I had parted in 1752, arrived from Dresden with Madame Sylvestre. He had been at Dresden for four years, taken up with the pursuit of his art, having copied all the battle pieces in the Elector's Galley. We were both of us glad to meet once more, but on my offering to see what my great friends could do for him with the Academicians, he replied with all an artist's pride that he was much obliged to me, but would rather not have any other patrons than his talents. "The French," said he, "have rejected me once, and I am far from bearing them ill-will on that account, for I would reject myself now if I were what I was then; but with their love of genius I reckon on a better reception this time."

His confidence pleased me, and I complimented him upon it, for I have always been of the opinion that true merit begins by doing justice to itself.

Francis painted a fine picture, which on being exhibited at the Louvre, was received with applause. The Academy bought the picture for twelve thousand francs, my brother became famous, and in twenty-six years he made almost a million of money; but in spite of that, foolish expenditure, his luxurious style of living, and two bad marriages, were the ruin of him.